ART AND ARTISTS OF TWENTIETH-CENTURY CHINA

AHMANSON · MURPHY
FINE ARTS IMPRINT

THE AHMANSON FOUNDATION
has endowed this imprint
to honor the memory of
FRANKLIN D. MURPHY
who for half a century
served arts and letters,
beauty and learning, in
equal measure by shaping
with a brilliant devotion
those institutions upon
which they rely.

Art and Artists

of

MICHAEL SULLIVAN

Twentieth-Century

China

UNIVERSITY OF CALIFORNIA PRESS BERKELEY LOS ANGELES LONDON

University of California Press
Berkeley and Los Angeles, California

University of California Press, Ltd.
London, England

© 1996 by The Regents of the University of
California

Library of Congress Cataloging-in-Publication Data

Sullivan, Michael, 1916–
 Art and artists of twentieth-century China /
Michael Sullivan.
 p. cm.
Includes bibliographical references and index.
ISBN 0-520-07556-0 (alk. paper)
1. Art, Chinese. 2. Art, Modern—20th
century—China. I. Title.
N7345.S79 1996
709'.51'0904–dc20 95-25673
 CIP

Printed in South Korea
9 8 7 6 5 4 3 2 1

The publisher gratefully acknowledges

the contribution provided by

THE CHRISTENSEN FUND

toward the publication

of this book

FOR KHOAN
as always

ILLUSTRATIONS

12. Wang Yachen, *Mountain Village* (1935). Oils. 41 × 53 cm. China Art Gallery, Beijing. From Tao Yongbai, *Zhongguo youhua 1700–1985* (Nanjing, 1988).

13. Zhou Bichu, *Nude* (c. 1932). Oils.

14. Zhang Xian, *Beauty Looking at a Picture* (1935). Oils. China Art Gallery, Beijing. From Tao Yongbai, *Zhongguo youhua 1700–1985* (Nanjing, 1988).

15. Yang Taiyang, *Landscape along the Yangzi River* (c. 1981). Watercolor. From *Meishujia* 44 (1985–86).

16. Xu Beihong, *Self-Portrait* (1931). Oils. 95.5 × 68.5 cm. Xu Beihong Memorial Museum, Beijing.

17. Liu Haisu, *Express Train* (1929). Oils. 65 × 53 cm. From *Liu Haisu youhua xuanji* (Shanghai, 1981).

18. Liu Haisu, *Balinese Girls* (1940). Oils. 92 × 74 cm. From *Liu Haisu youhua xuanji* (Shanghai, 1981).

19. Lin Fengmian, *Crucifixion* (late 1980s). Gouache. 132.7 × 68.6 cm. Collection of Mr. T. C. Wong.

20. Lin Fengmian, *Landscape* (1980s?). Gouache. 68 × 133 cm. Collection of the late Dr. K. S. Lo and Elizabeth Lo.

21. Hu Yichuan, *Bringing Up the Guns* (1932). Colored woodcut.

22. Li Xiongcai, *The Forest* (early 1950s). Ink and color on paper. Private collection.

23. Pang Xunqin, *The Letter* (c. 1945). Light ink and color on paper. Ht. 42.7 cm. Private collection.

24. Wu Zuoren, *Market in Qinghai* (1944). Oils. 28.8 × 40 cm. Private collection.

25. Zhang Daqian, *Dancers* (1943). Gouache on paper. 80 × 116 cm. Private collection.

26. Chen Baoyi, *Hong Kong Harbor* (1938). Oils. Ht. 72 cm. From *Meishujia* 59 (1987.12).

27. Yu Ben, *Rural Scene in Hong Kong* (c. 1938). Oils. 44.5 × 40.6 cm. Collection of the late Dr. K. S. Lo and Elizabeth Lo.

28. Dong Xiwen, *Mao Zedong Declaring the People's Republic from Tiananmen*. Revised version (c. 1980). Oils. 230 × 405 cm. Museum of the Revolution, Beijing.

29. Liao Bingxiong, *Gambling with Human Beings* (c. 1945). Ink on paper.

30. Luo Gongliu, *Tunnel Warfare* (1951). Oils. 140 × 169 cm. Museum of the Revolution, Beijing.

31. Fu Baoshi and Guan Shanyue, *Such Is the Beauty of Our Mountains and Streams* (1959). 650 × 900 cm. Wall painting in the Great Hall of the People, Beijing.

32. Bai Tianxue, *Learning to Sing Revolutionary Songs* (c. 1950). Gouache on paper.

33. Hua Shuang, *Fisherman* (c. 1987). Gouache on paper. Courtesy of the artist.

34. Anonymous Suzhou artist, new year picture (1950s). Hand-colored woodblock print. Private collection.

35. Huang Xuanzhi, *The Island in the Lake* (1980). *Shuiyin* print. 38.2 × 43 cm. Private collection.

36. Li Quanwu and Xu Yongmin, illustration to Lao She's *Yue Ya'er* (Crescent moon) (1983). Ink and color on paper. 54 × 38 cm. From Zhu Boxiong and Chen Ruilin, *Zhongguo xihua wushinian* (Beijing, 1989).

37. Chen Jin, *Old Instrument* (1982). Chinese ink and color. 110 × 53 cm. Collection of the Taipei Fine Arts Museum; courtesy of Madame Chen Chin.

38. Liu Kuo-sung, *Landscape* (1966). Ink and color on paper. 51 × 91 cm. Private collection.

39. Chen Tingshi, *Day and Night #25* (1981). Block print on rice paper. 121.9 × 243.8 cm. Dr. and Mrs. I-ch'i Hsü Collection, Houston, Texas.

40. Liao Xiuping, *Future Life* (1972). Embossed serigraph. 51 × 66 cm. From Liao Xiuping, *Banhua yishu* (Taipei, 1974).

41. Chu Ge, *Life Is a Ritual of Offering* (1988). Ink and color on paper. 172 × 120 cm. Taipei Fine Arts Museum.

42. Yu Peng, *Father and Son* (1990). Hanging scroll; ink and color on paper. 34 × 17 cm. Private collection.

43. Chen Laixing, *No. 94* (1984). Oils. Courtesy of the Hanart Gallery, Taipei.

44. Chen Qikuan, *Vertigo* (1967). Ink and color on paper. 197.5 × 22.7 cm. Shuisongshi Shanfang Collection, Hong Kong.

45. Chen Qikuan, *Peaceful Coexistence* (1988). Ink and color on paper. 61.5 × 61.5 cm. Lo Shan Tang Collection, London.

46. Yu Chengyao, *Rocky Mountains with Gurgling Streams* (1984). Hanging scroll; ink and color on paper. 120 × 60 cm. Private collection.

47. Ju Ming, *Single Dip Whip* (1985). Bronze. 280 × 475 × 215 cm. Courtesy of the artist.

48. Ju Ming, *Fish* (1984). Glazed pottery. Ht. 53.5 cm. Private collection.

49. Ng Yiu-chung, leaf from an album (1971). Ink and color on paper. 30.2 × 42 cm. Private collection.

50. Irene Chou, leaf from an album (1971). Ink and color on paper. 44 × 31 cm. Private collection.

51. Kwok Hon Sum, *Enlightenment* (1989). Oils. 135 × 41 cm. Lo Shan Tang Collection, London.

52. Wucius Wong, *Purification No. 2* (1979). Chinese ink and gouache on paper. 182.9 × 86.4 cm. Courtesy of the artist.

53. Cheung Yee, *Tortoise Shells for Divination* (1968). Leaf from an album; oils on paper. 26.7 × 37.2 cm. Private collection.

54. Cheong Soo-pieng, *Kampong, Evening* (1959). Ink and color on paper. 92.7 × 45.1 cm. Private collection.

55. Cheong Soo-pieng, *Portrait of K. S.* (1959). Ink and color on paper. 92.7 × 45.1 cm. Private collection.

56. Chhuah Thean Teng, *Opening the Curtains* (c. 1960s). Batik painting. Singapore National Museum of Art.

57. Pan Yuliang, *Nude Study* (1957). Ink and color on paper. Anhui Museum, Hefei.

58. Zao Wou-ki, *Wind* (1954). Oils. 195 × 87 cm. Courtesy of the artist.

59. Zao Wou-ki, *27–1–86* (1986). Oils. Courtesy of the artist.

60. Chu Teh-Chun, *Amplitude* (1986). Acrylic on canvas. 130 × 195 cm. Courtesy of the artist.

61. C. C. Wang, *Landscape* (1967). Ink and color on paper. 41 × 57.4 cm. Private collection.

62. Anonymous, *The Gang of Four* (c. 1977). Ink and color on paper.

63. Liao Bingxiong, *Himself Liberated after Nineteen Years* (1979). Ink and color on paper. Courtesy of the artist.

64. Huang Guanyu, *July* (c. 1978). Oils.

65. Yuan Yunfu, *Rivers and Mountains of Sichuan* (1979). Acrylics on panels; Beijing International Airport. Photo by Joan Lebold Cohen.

66. Yuan Yunsheng, *Song of Life* (1979). Acrylics on canvas on plaster; restaurant of Beijing International Airport. Photo by Joan Lebold Cohen.

67. Liu Bingjiang and Zhou Ling, *Creativity Reaping Happiness* (1980–82). Acrylic on canvas on plaster; restaurant of the Beijing Hotel. Photo by Joan Lebold Cohen.

68. Feng Guodong, *Self-Portrait* (1979). Oils. Photo by Joan Lebold Cohen.

69. Wang Huaiqing, *Papercut* (c. 1979). Oils.

70. Ge Pengren, *Water* (1986). Oils.

71. Pang Tao, composition inspired by archaic bronze motif. Oils. Courtesy of the artist.

72. Wang Yidong, *Shandong Peasant Girl* (c. 1983). Oils. 75.5 × 72.3 cm. Private collection.

73. Zhan Jianjun, *Portrait of Xiao Mi* (c. 1980). Oils. Private collection.

74. Luo Erchun, *Old Town* (c. 1984). Oils. 74.9 × 109.8 cm. Collection of Mr. and Mrs. Richard Reminger, North Palm Beach, Florida.

75. Luo Zhongli, *Father* (1980). Oils. 241 × 160 cm. China Art Gallery, Beijing.

76. Ai Xuan, *Stranger* (1984). Oils. 76.2 × 53.3 cm. Private collection.

77. Zhao Xiuhuan, *Mountain Spring* (1982). Hanging scroll; ink, color, and gold on paper. 133.5 × 88.5 cm. Photo courtesy of Lucy Lim.

78. Wu Guanzhong, *The Lakeside at Wuxi* (1972). Oils. 24 × 36 cm. Private collection.

79. Wu Guanzhong, *Spring and Autumn* (1986). Ink, color, and gouache on paper. 81 × 69 cm. Courtesy of Museum of Fine Arts, Boston; gift of Mr. and Mrs. Kwan S. Wong.

80. Yang Yanping, *Rocky Mountain with Snow* (1990). Ink and color on paper. 61 × 92 cm. Courtesy of the artist.

81. Li Huasheng, *Cock-Crow at Dawn* (1989). Ink and color on paper. 153.5 × 83 cm. Private collection.

82. Du Jiansen, *Frame of Mind* (1982). Oils. Private collection.

83. Yang Feiyun, *Pengpeng* (1985). Oils. 85 × 70 cm. Private collection.

84. Wei Ershen, *Mongolian Bride: Praying for Good Fortune* (1988). Oils. 177 × 157 cm. From Pok Art House, *Zhongguo diqi jie quanguo meishu zuopin zhanlan huojiang zuopin ji* (Beijing, 1989).

85. Mao Lizhi, *Old House with New Life* (1988). Oils. 66 × 86 cm. Courtesy of the Robert A. Hefner III Collection of Contemporary Chinese Oil Paintings.

86. Zhang Ding, *Cock* (c. 1981). Tapestry. Made by the Beijing Institute of Research for Carpets.

87. Zhu Wei, *Upwards* (c. 1986–87). Hemp, wool, and silk. 138 × 330 cm. Courtesy Alisan Fine Arts Ltd.

88. Yu Feng, *The Spectre of the Middle Ages III: Lash Marks* (1987). Ink and color on paper. 64 × 76.5 cm. Courtesy of the artist.

FIGURES

FOREWORD AND ACKNOWLEDGMENTS

The theme of this book is the rebirth of Chinese art in the twentieth century under the influence of Western art and culture, a confrontation between two great traditions that has had momentous consequences for Chinese art. If it were a book about masters and masterpieces, it would be illustrated mostly with paintings in the traditional Chinese style, for even the least original of them is technically accomplished and pleasing to the eye. Some of the pictures in this book are major works by any standard. But I have chosen others not so much for aesthetic reasons as for the circumstances of their making and for what they illustrate of a historical process unfolding. Here the experience of the artist in an age of crisis and upheaval and the part that he or she played in the drama of rejection, synthesis, and self-discovery are often at least as interesting and important as the works of art they produced.

Only since the 1980s have Chinese scholars begun seriously to study their own modern art. Before 1937 the new movements were too fresh, too unformed, to be seen in perspective, while the eight-year war with Japan and its aftermath was not a time for reflection on the recent past. Critical and historical writing in the age of Mao Zedong was so tainted with ideology as to be almost worthless. No interest was shown in what was condemned as "bourgeois" or "feudal" art. Visiting the Zhejiang Academy of Art in Hangzhou in 1980, I noted in my diary, "The only link with the past is through two or three old teachers, survivors from an earlier age. The younger men have no sense of the past. All vestiges of the earlier history of the school seem to be gone. Is it because they really don't care, or because of political pressure to denigrate the past? I find this snapping of the links disturbing."

Happily, that chapter is closed. In spite of the destruction of records and works of art, particularly during the Cultural Revolution, all was not lost. In recent years the development of modern art in China, the lives of painters and their recollections of the past, have been featured prominently in art journals such as *Meishu* (Fine art), *Xin meishu* (New art), and *Meishu yanjiu* (Art research). On its fiftieth anniversary, the Zhejiang Academy published a valuable collection of records and reminiscences, and the biographies and memoirs of leading artists such as Qi Baishi, Xu Beihong, Liu Haisu, and Pang Xunqin have been published.

There are still huge gaps, however, and much is left unsaid. Artists and their admirers, reluctant to give offence, can be excessively discreet and uninformative about the darker side of things—about, for example, the activities of artists who stayed behind in Occupied China during World War II, and the conflicts and rivalries between them, most famously that between Xu Beihong and Liu Haisu. Until very recently, moreover, criticism has been conventional, bland, and inoffensive.

Another problem for the historian of this period in Chinese art is the difficulty in assessing the value of evidence. Those documents that have not been lost are imprecise or contradictory. Old men cannot remember when they were born, or, like Qi Baishi, they add a year or two to their age for reasons of their own. Western writers—even those who have enjoyed, as I have, the friendship and help of so many Chinese artists—are at great disadvantage when it comes to checking what they are told by helpful (and often highly partisan) friends and informants. In spite of the problems, however, there

seems to be a place for a broad survey for Western readers to replace my own brief, long out of date and out of print *Chinese Art in the Twentieth Century,* from which a half-dozen pages have been preserved.

When that book was published, in 1959, the author was criticized for devoting his attention to a subject not worthy of a scholar. Western critics and historians regarded twentieth-century Chinese art as either traditional and invariable, and hence of little historical interest, or as a feeble attempt to copy Western art. Since that time the change in the critical attitude, particularly in the United States, has been astonishing. Historians hitherto wedded to traditional Chinese art are writing on the twentieth century; an increasing number of doctoral dissertations are being devoted to the subject; major exhibitions have brought modern Chinese art before a large public and stimulated the birth of important public and private collections. So happy a state of affairs would have been inconceivable twenty years ago. Now at last it is becoming possible to see modern Chinese art whole, to understand that its meaning and value lie in a complex interplay of aesthetics, politics, cultural and social history, and, not least, the search for identity that has confronted every thinking Chinese artist who has played a role in the drama.

Even as this book goes to press a flood of new material is appearing in China. Soon the point will be reached when no serious scholars will be prepared to risk their reputation on writing a general survey of modern Chinese art not because there is too little material but because there is too much. In the meantime, I offer this book, not as a definitive study but as the personal view of an observer over fifty years.

It would not have been possible for me to write this book without the help of a great many people. Among the artists no longer living to whom I owe so much are Zhang Daqian, Pang Xunqin, Liu Kaiqu, Zhang Anzhi, Lui Show Kwan, Cheong Soo Pieng, Liu Haisu, Chang Shuhong. It would be difficult to name all the artists with whom we are still in touch and who have provided me with factual and biographical information, who in conversations and much-valued correspondence have shared with me their reminiscences and thoughts about modern Chinese art, and—most generous of all—have given us fine examples of their work. If I have omitted any, I hope they will accept my thanks and apologies. But I cannot fail to record the generosity of the following:

In Beijing: Wu Zuoren, Ding Cong, Wu Guanzhong, Pang Tao, Wen Lipeng, Wang Huaiqing, Li Shaowen, Shao Fei. Formerly in Beijing and now living outside the P.R.C. are Huang Yongyu, Yu Feng, Ma Desheng.

In Shanghai: Cheng Shifa, Yuan Shun, Zhao Baogang, Qiu Deshu, Zhang Zishen, Jiang Changyi.

In Chongqing: Ye Yushan and the staff of the Sichuan Academy of Fine Arts, Huang Xuanzi.

In Hangzhou: Xiao Feng and the staff of the Zhejiang Academy of Fine Arts, Fan Xiaoming, Zhao Zongzao, and Yu Dongdong and Liu Wenhu of the Zhejiang Provincial Popular Art Centre.

In Canton: Liang Dingying and my former teacher, Guan Shanyue.

In Xiamen: Wei Chuanyi and the staff of the Arts and Education College of Xiamen University.

During the 1980s, scores of gifted young artists emerged from obscurity, some of whom have kindly sent me slides of their work. If I have not reproduced their paintings here, I hope they will nevertheless accept my thanks and understand that there had to be a limit to what we could include in a book of manageable size. Indeed, in spite of the publishers' willing cooperation, it has not been possible to include more than a fraction of the artists and works that should illustrate a comprehensive history of modern Chinese art.

An increasing number of Chinese historians and critics are now putting the study of twentieth-century Chinese art on a scholarly basis. I would like particularly to thank Shui Tianzhong and Lang Shaojun of the Art Research Institute of the Chinese Academy of Arts in Beijing, who generously showed me rare art journals of the 1920s and 1930s, sent photographs and slides, and arranged a slide show in our room in the Beijing Hotel. Kong Chang'an gave me valuable insights into the modern movement of the late 1980s. Gong Jisui and Meng Luding have taped for me an illuminating discussion about their participation in the avant-garde movement. Others to whom I owe a great debt include the art historians Tao Yongbai and Jin Weino in Beijing and Wang Bomin, Zhu Boxiong, and Hong Zaixin in Hangzhou. Professor Zhu very kindly allowed me an all too brief glimpse of his then unpublished history of twentieth-century Chinese art.

I should also like to record my thanks to the late Jiang Feng, Hua Junwu, Zhai Xinjian, and the staffs of the local branches of the Chinese Artists Association for arranging our study tour in 1984.

In the spring of 1989 we visited China as guests of the Chinese People's Association for Friendship with Foreign Countries. This tour was arranged by the association's chairman, Ambassador Zhang Wenjin, a very old friend whom we had first met more than fifty years ago at the headquarters of the Chinese Red Cross in Guiyang. To him and to his staff in Beijing, Chongqing, Dazu, Nanjing, Yangzhou, Shanghai, Hangzhou, and Xiamen are due our warmest thanks for a tour undertaken at a high point of freedom and hope, just before the June massacre in the streets of Beijing.

A number of the illustrations in this book were taken

from Chinese magazines and volumes of reproductions, which do not provide any information about the ownership or location of the works reproduced. Considerable effort has been made to trace and contact copyright holders and to secure replies prior to publication. However, this has not been possible in many cases, particularly with old material. The publishers and I apologize for any inadvertent errors or omissions. If notified, the publisher will endeavor to correct them at the earliest opportunity.

Since we first met, also in Guiyang fifty years ago, Yang Xianyi and Gladys Yang have been our friends, and in long conversations over the years have shared with us their knowledge and thoughts—sometimes intimate, sometimes ironic or detached, as often painful and even tragic—about the state of art and culture in China during five turbulent decades. In many ways, they have deepened our understanding of the complex undercurrents of modern Chinese intellectual life.

Among friends in Taiwan who have helped by providing me with catalogues, photographs, and slides, I should particularly like to thank Huang Kuang-nan and the staff of the Taipei Fine Arts Museum, Lo Ch'ing, and Rita Chang of Dimensions Endowment of Art for her help with wartime paintings by Pang Xunqin. To Yu Ch'eng-yao, Ju Ming, and Yu Peng, all of whom have, in their great generosity, presented us with fine examples of their work, the mere expression of our thanks is hardly enough.

In Hong Kong, the late Huang Pao-hsi was a good and kind friend, while his son, Harold Wong, has long been a friend and helper. His former partner Chang Tsong-zung (Johnson Chang), director of Hanart II (now Hanart TZ Gallery), has been untiringly energetic, resourceful, and generous, not only in providing me with illustrations, catalogues, and information but in the introductions he has provided and the help he has given me in collecting material for this book, particularly about the art scene in Hong Kong and Taiwan and the most recent developments of the avant-garde on the Mainland. I would like to record my thanks also to Maych-ing Kao, both for her pioneer work on the early history of modern Chinese art and for sending me exhibition catalogues and photographs of works in the art gallery of the Chinese University of Hong Kong.

I am happy to express my warmest thanks to the late, and sadly missed, Dr. K. S. Lo and to his wife, Elizabeth, not only for their generous hospitality and many kindnesses to me and my wife in Hong Kong but also for taking the great trouble to have photographs made for this book of several paintings in their collection.

Other Hong Kong friends who have helped with catalogues, photographs, and transparencies include Fung Yat-kong of Hong Kong University Press, Alice King and Alisan Fine Arts Ltd., Lawrence Tam, Christina Chu and the staff of the Hong Kong Museum of Art, Alice Yuan Piccus of Christie's Swire (Hong Kong) Ltd., Alan Wong of the Hong Kong Arts Centre, Lisa Chow of Sotheby's, King Chia-lun, Liu Kuo-sung, and Jao Tsung-i. Cheung Yee, Van Lau, Ng Yiu-chung, Beatrice Ts'o, and Irene Chou all contributed their work to an album that has become one of our most treasured possessions. Only since this book was completed have I been able to benefit from the kindness and wide knowledge of Dr. Wan Qingli. Although I have known and admired the work of Lin Fengmian for fifty years, it was not until 1988 in Hong Kong that my wife and I met at last the man who, more than any other, was the creator of modern Chinese painting. His spirit pervades this book.

In Singapore, Christopher Hooi and C. G. Kwa, director of the National Museum, have been helpful with illustrations of the work of Singapore artists.

In Europe, I have received help with illustrations from Marie-Thérèse Bobot at the Musée Cernuschi, Paris; Herbert Lutz at the Museum Rietberg, Zürich; Anne Farrer at the British Museum; and Mary Tregear at the Ashmolean Museum, Oxford. K. J. D. Walker and M. L. Williams have kindly sent me photographs of their paintings by Jiang Zhaohe, collected by their father, Mr. Kenneth Walker, in Shanghai. Maria Galikowski kindly lent me some issues of *Zhongguo meishu bao* unavailable in Oxford. In Paris, Zao Wou-ki, a friend of many years, has shared with me his reminiscences of the Hangzhou Academy in the 1930s and 1940s; while Wang Keping, whom we first met at the second Stars exhibition in 1980, has also become our admired friend and informant about art and artists in the modern movement in China and abroad. Both he and Chu Teh-chun, long resident in Paris, have generously given us examples of their work.

To the following in the United States and Canada I would like to express my gratitude for help, information, or the gift or loan of transparencies, photographs, or slides: Edwin and Evelyn Lim, Washington D.C.; Hsü I-ch'i and Priscilla Hsü, Houston, Texas; Robert Ellsworth, Joan Lebold Cohen, and Mr. and Mrs. A. M. Pilaro, New York; Mr. and Mrs. Richard Reminger, Cleveland, Ohio; Robert Hefner III and Jan Burris, curator of the Hefner Collection, Oklahoma City; Lucy Lim and Eileen Seeto of the Chinese Culture Foundation, San Francisco; Alfreda Murck and Nina Sweet of the Metropolitan Museum of Art, New York City; Arnold Chang, lately of Sotheby's; Li Chu-ts'ing and the staff of the Spencer Museum of Art, Lawrence, Kansas; Wu Tung of the Museum of Fine Arts, Boston; James Cahill and Ts'ao Hsing-yuan Cahill, Berkeley; Y. T. Cho; Richard Strassberg; and Wang Fangyu. Tseng Yu-ho Ecke, Yang Yanping, Zeng Shanqing, Wucius

Wong, Pat Hui, and C. C. Wang have all generously given us their works, most of which are illustrated in this book. Yuan Yunfu and Sheng Tian Zheng have generously sent me material about Chinese artists now living in the United States and elsewhere around the world, while Jason Kuo has very kindly provided me with material about Gu Wenda. Ralph Croizier at the University of Virginia has helped me in many ways, particularly in sharing with me his knowledge of the artists of the Lingnan School.

An early draft of the manuscript of this book has been read by Jerome Silbergeld, Julia Andrews, and Irving Scheiner. All of them have made extremely helpful criticisms, comments, and suggestions, for which I am happy to express my appreciation. I greatly regret that Professor Andrews's important book *Painters and Politics in the People's Republic of China, 1949–1979* reached me too recently to be of any benefit in writing this one.

The Biographical Index grew out of the brief entries at the end of *Chinese Art in the Twentieth Century.* They were augmented by Mayching Kao in the 1970s, since when the index has grown considerably. My thanks go to Cao Yiqiang for checking many of the entries and adding new material, and Eugene Qian for secretarial help. Since she came to Oxford from Beijing on a Swire Fellowship in 1990, Julie Xiu Huajing Maske has given me valuable research assistance with recent Chinese sources and has collected important material for her D.Phil. thesis on artistic contacts between China and Paris in the 1920s and 1930s, on which she has kindly allowed me to draw for the relevant chapters of this book. Also at Oxford, Clare Senior has given me valuable help with correspondence and has performed the laborious task of typing the Biographical Index. I should also like to express my thanks and appreciation for all the help I have received from the Fellows' Secretaries at St. Catherine's College: Audrey Hiscock, Susan Sevile, and Elizabeth Andrews.

I am happy to express my warmest thanks to Deborah Kirshman, Kim Darwin, and their colleagues at the University of California Press for their work on this book, which has been so long in the making; to Steve Renick for his fine design and layout; to Lynne dal Pogetto for her work on permissions; to Jean Kim for Chinese proofreading; to Susan Stone for her careful preparation of the index; to Lillian Robyn and Danette Davis for managing the production of the book; and above all to Evan Camfield, whose suggestions about the organization of the chapters, and whose meticulous and tactful editing, have removed many blemishes from my manuscript. For any that remain, the responsibility is mine.

The generous contribution that George and Jane Russell have made to my research fund at St. Catherine's College has been not only a help in our work but a tangible expression of a friendship that is a source of great happiness to my wife Khoan and to me.

To Khoan herself, whose gift for interpreting her culture, for opening doors for me, and for casting a scintillating light on everything she touches, I have paid tribute in earlier books. Her help, support, and patience in this long endeavor have been as constant and stimulating as ever. It was through her that I first made friends with Chinese artists in Chengdu in 1943; those still living are old masters now. Since then, in spite of the Mao years and the tragic events of 1989, our links with artists in China—and, sadly, increasingly with those living abroad as refugees from their own country—have become even stronger. Our debt to them for their help with this book, and our admiration for their courage and constancy, are very great.

Finally, it is a pleasure for me to record the very great debt that we owe to the late Allen Christensen and to his wife, Carmen, our friends for thirty years, and to their family. Not only has the support of the Christensen Fund over a quarter of a century been an incalculable help to our work and to that of my students, but it is their generosity that has enabled the University of California Press to illustrate this book far more copiously than would otherwise have been possible. The greatest regret that Khoan and I have is that Allen Christensen did not live to see the book in print. Since that gift was made, Carmen Christensen has personally continued the support that she and her husband always gave with such unquestioning generosity.

A NOTE ON ROMANIZATION

The *pinyin* system is used throughout the book, though the names of cities in Taiwan are spelled according to the Wade-Giles system and the city of Guangzhou is referred to by its usual Western name, Canton. The correct usage for the names of foreign countries and cities is to call them by the anglicized form (e.g., China, Italy, Rome), just as the Chinese, when speaking or writing Chinese, refer to New York as "Niuyue." It is only with great misgivings that in this book I have yielded to editorial pressure to call Peking "Beijing."

Artists' names are generally given in *pinyin* as well. However, the names of artists working outside the People's Republic are often given in Wade-Giles (e.g., Ch'en Ch'i-k'uan) or in a form of their own choosing by which they are best known (e.g., Luis Chan, Onion Shyu). Both forms are listed in the Biographical Index.

1900–1937: The

Impact of the West

At the beginning of the twentieth century, the Chinese

empire was in a state of deep decay. In 1898 a group of

reformers had made a heroic effort to bring China into the

modern world and to strengthen the country so that it would

never again be the helpless victim of foreign expansion. From

the moment the reformers made it clear that modernization

meant Westernization, they were locked in battle with

conservatives who saw them as striking at the very

heart of Chinese culture.

Long before anyone in China was interested in the fine art

of the West, Western drawing techniques were being studied

as an essential tool of Western technology. But after 1900,

and far more rapidly after the Revolution of 1911 overthrew

the Manchus, Western art came to be seen by many as the

expression of all that was useful, progressive, and outward-

looking. Since that time, art in China has been one expres-

sion of a huge dialectical struggle—or rather two struggles:

between Chinese and Western culture, and between tradition

and modernization. To understand the intensity of that

struggle, we need to know how Western art was introduced

into China, the condition of the great tradition of Chinese

painting at the moment of the Western impact, and how

the two traditions confronted each other.

TRADITIONAL PAINTING

For two thousand years the great stream of Chinese painting has flowed on, widening and deepening as the language became richer, the artist's ties to tradition stronger and more binding. The ideas it expressed—apart from Buddhist ones—were purely Chinese, as were the styles and forms that gave those ideas expression. If, around 1900, one had entered the studio of a Chinese artist—even the rare artist who painted by electric light—one would have discovered no hint of foreign influence in his painting. He would have been astonished at the suggestion that there was anything lacking in his art, that his forms were not always accurately drawn, that his perspective was false, that there was no shading or cast shadows—in short, that his painting was not true to life. He would have replied that these technical devices had nothing to do with real art, which was an expression of the feeling and personality of the artist, and of a generalized view of the world of experience in which individual things only had meaning as aspects of the whole.

Indeed, our Chinese artist would have maintained not only that the scientific accuracy of Western painting was not a proper pursuit for a gentleman but that if, by depicting transient or accidental effects, it destroyed the general, timeless truth of the work of art, such accuracy was positively harmful. He would have found just as alien the Western idea that a picture could be conceived in terms of interrelated solid forms defined by color and shading and that the elements could be built up by means of preliminary sketches into a deliberately thought-out composition. In traditional Chinese painting (*guohua*) all these elements that so stimulate and challenge the West-

ern artist, and interest and please the Western viewer, would have seemed of little value when compared with the effect of wholeness and harmony that he aimed to achieve. Moreover, the idea that he should depict unedifying, violent, or prurient subject matter would have been unthinkable to him; such things denied the very purpose of art, which was fundamentally ethical and philosophical.[1]

The Western artist has never been ashamed to be called a professional. In China, by contrast, although there was a class of professional artists, no educated man or woman would have liked to be thought of as earning his or her living by the brush. When the educated artist painted pictures on commission or to be given as presents, or wrote inscriptions or memorial essays, great care was taken to see that payment was made indirectly, so that his status as an amateur was not compromised. His painting was closely bound up with his accomplishment as a poet and calligrapher—the latter a skill that he acquired long before learning to paint. He aimed, therefore, to unite in his work the "three perfect things": calligraphy, poetry, and painting. Also essential were a profound knowledge of the styles of earlier masters and a sense of the sustaining power of the tradition, of which the individual artist was at the very least a custodian and to which he made constant reference through his style and brushwork. The resulting work of art was a very sophisticated performance indeed.

The Western viewer is sometimes wearied by the constant repetition in Chinese painting of a few conventional themes: bamboo, birds and flowers, landscapes with scholars chatting in a garden pavilion while fishing or

pretending to fish. But these themes, conventionally pleasing in themselves, are vehicles for the expression, through the individual touch of the artist's brush, of the most delicate nuances of feeling. A just comparison is not with Western art but with the performance of Western music, in which a familiar work is brought to life by the touch of the performer. As in traditional Chinese painting, originality in itself is no virtue. This is not to say that originality was not appreciated; but even the works of the most daring individualists were daring only in their technique, never in expressing unfamiliar or disconcerting ideas. Harmony was all. The resonances of the masterpieces of Song and Yuan, Ming and early Qing, ranging from the monumental landscapes of Fan Kuan and Guo Xi to the brilliant individualism of Shitao and Bada Shanren, reverberate down the centuries, inspiring and sustaining successive generations of artists and ensuring the purity of the tradition.

During the nineteenth century, the grip of tradition had become stifling. With few exceptions, artists painted in the manner of the ancients or of each other, and it seemed that there was nothing left to be said in the traditional language. The revival that began around 1860 in Shanghai and eventually spread to Beijing was an aspect of China's painful awakening. At the end of this chapter, after discussing the work of those artists who brought it about, we will consider the causes of this revival, and the inherent limitations of traditional guohua that made it so inadequate for the expression of modern Chinese ideas and experience.

BEIJING CONSERVATISM

By the nineteenth century Beijing culture, less touched by the aggressive West than that of Shanghai or Canton, had sunk into a stifling conservatism. Educated Chinese were fearful of change, their art reflecting their belief that tradition must be preserved at all costs. The brilliant individualism of the early Qing masters had become a faint memory, while even the Sino-European manner taught by the Jesuit artist Giuseppe Castiglione, who between 1716 and 1766 served three emperors and devised a cunning synthesis of Chinese technique and Western realism, had degenerated to the level of competent copying. Court painters whose very names are unknown crept about the Forbidden City, receiving their instructions from the eunuchs, never setting eyes on the emperor, turning out vast numbers of conventional works to hang in the palace apartments or to serve as imperial gifts or as decorations for birthdays and other festivities.[2] The best were teachers and ghost painters to the imperial family. One of the very few about whom anything at all is known was a woman, Miao Jiahui, who was a particu-

lar favorite of the Empress Dowager in the 1880s and 1890s.[3] She both ghosted for the old tyrant and painted flowers (beautifully) under her own name. A charming example of the latter is her *Bouquet of Peonies* (plate 1), painted for a noble court lady on her eightieth birthday. But among court artists, Miao Jiahui was exceptionally privileged.

After the 1911 revolution, the Manchu imperial family was allowed to live on in the Forbidden City until 1924, when the "Christian General" Feng Yuxiang ejected them. Among members of the last generation to enjoy that sybaritic existence—albeit in circumstances so reduced that they were forced to sell a constant stream of treasures from the imperial collection to maintain their extravagant way of life—were three cousins who achieved some reputation as painters in their own right. The eldest was Pu Jin (Pu Xuezhai), who inherited the large palace Gongwangfu, later to become the Girls' College of the Catholic Furen University. After his removal from the palace, Pu Jin did the unthinkable for a Manchu prince—he took a job, accepting a position as a teacher of painting at Furen University. His post, however, was a sinecure, and there were complaints that he was never there. Among the pupils that he preferred to teach at home was the gifted young woman painter Tseng Yu-ho (Zeng Youhe), who as we shall see was to make an astonishing metamorphosis into a modernist in the 1950s.

The second son of this last imperial generation sank to the level of a rickshaw coolie; the third, Pu Yi, rose to dizzying heights as the puppet emperor of Manchukuo under the Japanese, was imprisoned by the People's Republic, and eventually was rehabilitated to die in tranquil retirement. His accomplishments were few; certainly he was no painter. His brother Pu Quan (Pu Songquan) was a sound follower of the orthodox landscape style of the seventeenth-century master Wang Hui. He also painted gibbons and horses in landscapes in the manner of Castiglione, whose work he must have known well from the many examples of it in the imperial collection. He too taught painting at Furen, where in the 1940s the young Tseng Yu-ho assisted him for two years. His speciality was horses.

Better known than these imperial amateurs was their cousin Pu Ru (Pu Xinyu).[4] He was a scholarly man, a poet, calligrapher, and a refined and skillful landscape painter in the orthodox tradition of the four Yuan masters and the Four Wangs of the early Qing, although he made occasional half-hearted excursions into the playful wildness of Zhu Da (Bada Shanren). Like his cousins, he had been taught painting by palace tutors whose names they took great care to conceal. Perhaps it was because of his early contact with German culture—he had as a boy attended the German school in Qingdao—

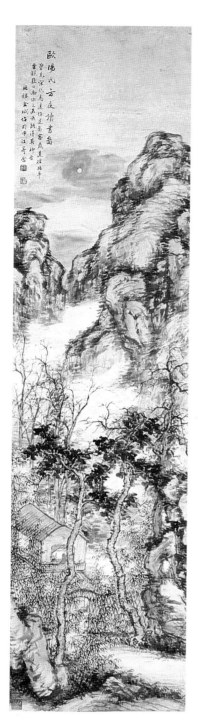

1.1

Jin Cheng, *Ouyang Xiu Reading at Midnight*. Ink and color on paper.

that some writers have stated that he spent a number of years in Germany, returning with doctoral degrees in biology and astronomy. He never denied this, but in fact his only contact with Germany was a brief visit he made after Tseng Yu-ho's husband, Gustav Ecke, had introduced him to some German friends. In 1929 and 1930 Pu Xinyu taught Chinese literature at Kyoto University.

On his return he was appointed to teach painting at the National Academy of Art in Beijing, staying on through the Japanese occupation. In 1949 he went to Taipei, where he taught painting at Taiwan Normal University until his death, his reputation as a pillar of scholarly orthodoxy bringing him many pupils.

The life that these imperial cousins led in Beijing seems hardly to have been touched by reality. A former student of one of them told me years ago, "They lived in a little world of their own as their palaces became more and more impoverished. They were all spoiled and irresponsible, with no idea how to manage their affairs, unstable, quick in their enthusiasms, recklessly extravagant. Pu Jin, for instance, kept dozens of dogs. Pu Ru's collection was pawned bit by bit, and he finally lived in a little temple with a despotic concubine who forced him to paint for his meals, so his work deteriorated badly." In Taipei, where Pu Ru was revered as something of a national treasure, he was more prosperous, but the pressure still to paint for his meals led him to turn out many competent but uninspired works. He, like his cousins, must be regarded as a custodian rather than an enricher of the mainstream tradition.

Palace-style conservatism also colored the painting of many of the scholar-officials who lived in Beijing in the last decades of the Qing Dynasty and the early years of the Republic. Zhang Zhiwang painted uninspired but competent landscapes in the manner of Wang Hui. Chen Baochen, in the 1880s commissioner for education in Jiangxi province and later tutor to the young Pu Yi, was a scholarly traditionalist, as were Zheng Xiaoxu, a Fujianese who became the first prime minister of Manchukuo, and Yao Hua, a native of Guizhou, painter, antiquarian, and close friend of Chen Hengke (see below, page 8) who became known as one of the Eight Masters of the Early Republic. Weng Tonghe, a high official in the great tradition, tutor for over twenty years to the Guangxu emperor, and a chief architect of the Hundred Days of Reform in 1898, was also a noted calligrapher and a painter of landscapes, orchids, and bamboos.

A little removed from Beijing court circles, yet still ardent traditionalists, were Jiang Yun, an admirer of Li Liufang and Wang Yuanqi; Wu Guxiang, who later moved to Shanghai; and Lin Shu (Lin Qinnan), best known as the translator into classical Chinese of over 150 works in Western drama and literature, including Sherlock Holmes and *Alice in Wonderland*.

These names I have chosen almost at random from among hundreds of scholar-officials who painted competently in their spare time. The Hu Society (Hushe), one of the two main circles of scholar-painters in Beijing after 1900, was organized by Jin Cheng (Jin Gongbo), a native of Wuxing, the homeland of the old Wu School

of gentlemen's painting.[5] Jin Cheng had studied law in England and was to visit Japan in 1921 and 1924 in a program of exchange exhibitions of Chinese and Japanese painting held alternately in the two countries. Many traditional artists in Beijing after World War I were at some time members of his society, although one who knew them told me that they quarreled a good deal. Dubbed "the Wang Hui of the Republic," after the most widely known eclectic master of the seventeenth century, Jin Cheng was not a great painter, but he was a competent one, a wealthy patron, and an effective educator and organizer. For several years he published the monthly *Hushe yuekan,* which was later taken over by his rival Zhou Zhaoxiang.

All these men were professedly amateurs, but many of them were forced to make their living with the brush. Chen Shaomei, for example, a Hunanese member of the Hushe, was not ashamed to advertise prices for his paintings in the *Hushe yuekan,* listing his skills in landscape, bamboo, flowers, and so on,[6] while Hu Peiheng even founded a correspondence school for teaching landscape painting on the progressive method set out in the famous *Painting Manual of the Mustard-Seed Garden.*

SOME NOTABLE BEIJING ARTISTS Chen Hengke (Chen Shizeng) was one guohua painter in Beijing in the 1920s for whom conservative competence was not enough.[7] The son of a well-known poet in Jiangxi, he returned from studying in Japan to take up a post in Nantong, where in 1906, almost certainly with Chen's encouragement, the first public museum in China was established. After the Revolution of 1911 he settled in Beijing as an inspector in the department of education and taught in the Beijing College of Art and the Higher Normal College. In 1919 he organized the Society for Research in Chinese Painting (Zhongguo huaxue yanjiu hui), created to promote the styles of the Song and Yuan masters, in which he was joined by Jin Cheng, Xiao Sun, and others.

While in Japan he had seen the work of the early Qing individualists Zhu Da and Shitao, which at that time was almost completely ignored in China. This encounter inspired him to encourage young painters to break free from Qing academicism and start out on their own. When the young and little-known Qi Baishi settled in Beijing in 1917, it was to Chen Hengke that he went for guidance and encouragement. Although he had studied Western art in Japan, Chen's own painting—except for traces of Western influence in his figures—is completely Chinese, vigorous, free, and spontaneous (fig. 1.2). As well as being a painter, he was a poet and seal-carver, author of several books on the history of

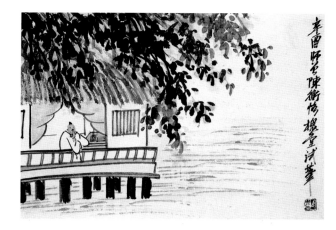

1.2
Chen Hengke, *Studio by the Water* (1921). Ink and color on paper.

Chinese painting, and the mentor of Beijing art circles until his untimely death in 1924.

One of the painters drawn to Chen Hengke was Xiao Sun, a native of Anhui, who had begun as a ghost painter for his teacher, Jiang Yun. He was steeped in the southern tradition of Hongren, Xiao Yuncong, Gong Xian, and Cha Shibiao, and influenced too by the seventeenth-century individualists Daoji and Mei Qing. In the 1930s a professor in the Beijing Academy, Xiao Sun was noted for his landscapes in thick black ink (plate 2) and for his dry brush technique, although he occasionally used strong color in the manner of the Shanghai School (see below).

Another busy teacher was Wang Yun (Wang Mengbai), who had begun his career as a businessman in Shanghai. There he took up painting in his spare time, studying with Wu Changshuo (below, pages 13–14) before moving to Beijing. Like so many others, he attracted the interest of Chen Hengke, who invited him to teach in the academy. (Among his pupils were a number of actors, including the great Mei Lanfang.) Wang Yun painted chiefly flowers, birds, and animals, and occasionally landscapes. His brushwork most often was strong and spiky, influenced by that of Wu Changshuo but lacking the Shanghai master's warmth. Perhaps his problem was a physical one, for Wang Yun was a martyr to piles, which, together with his addiction to alcohol, made him very quarrelsome and contributed to his early death at the age of forty-seven from a rectal hemorrhage, after he had abandoned painting for poetry.

QI BAISHI The most famous victim of Wang Yun's irascible temperament was his contemporary Qi Baishi (Qi Huang), who for a short time was his colleague at the Beijing Academy and is said to have left, or perhaps

merely stayed away, because of problems with Wang Yun—although one person who knew them both has told me that Qi Baishi himself was proud and conceited and could be difficult.[8] Whatever the truth, by the time of the Wang-Qi confrontation, if indeed it took place at all, Qi Baishi had already made his mark. His beginnings had been very humble. Born in 1863 into a peasant family near Xiangtan in Hunan, he spent his childhood working in the fields. In 1877 he was apprenticed to a local carpenter, in the following year to a wood carver. He later recalled how he liked to draw the costumed figures in the local opera. "I was quite well known in my village now. Most people asked me to paint pictures of gods such as the Jade Emperor, Lao Zi, God of the Kitchen, Yama, the Dragon God"—he goes on to list a whole pantheon of deities in the popular religion, and adds, "Although I didn't like drawing these things, I did it for the money."

After studying painting under two local teachers, Xiao Xianggai (1888) and Hu Ziwei (1889), Qi Baishi became a professional portrait painter in Xiangtan, learned seal-carving, and enjoyed the patronage of the eccentric scholar-official and historian Liang Kaiyun. From 1899 to 1902 he studied with a well-known local scholar-painter. In 1902, with the help of his scholar-official friends, he began his travels, first to Xi'an and then, in 1903, to Beijing as the guest of the governor of Shaanxi, seeing the famous mountains on the way. Between 1903 and 1910 he made five tours of north China, always returning to his family in Hunan, but by 1917 he had moved to Beijing. Coming from a peasant background in distant Hunan, his first years among the literary elite in the capital were not easy ones.

Hitherto Qi Baishi had been little more than a talented craftsman painter, expert in the meticulous technique and fine lines of *gongbi* (craftsman's brush) painting, although he had occasionally imitated more unconventional masters such as Jin Nong, Daoji, and Zhu Da. But this was the "feeling around" period of an artist who had not yet found himself. Now, under the influence of Chen Hengke and with the generous support of Mei Lanfang, he came to be accepted in the circle of Beijing painters and collectors. In their company, he had a sustained encounter with the art of the great early Qing individualists and was set free to pursue the path that suited his talents best. The energy, freedom, and simplicity of Zhu Da appealed to him above all. To this he added the bold use of strong color that had been developed in Shanghai by Zhao Zhiqian and Wu Changshuo, with whom, by 1920, he was flattered to be compared, as connoisseurs spoke of "Wu in the South and Qi in the North." When in 1922 Chen Hengke introduced Qi Baishi's paintings into Japanese art circles, he was as-

tonished to find that they fetched far higher prices in Tokyo, where collectors were alive to new trends, than they did in Beijing.

From this time on Beijing was Qi Baishi's home. When Lin Fengmian was director of the Beijing Academy he persuaded Qi to teach there, and the old master was delighted to be addressed as "professor." Among his students were Chen Nian, Xu Beihong, Yao Hua, Yu Fei'an, Li Kuchan, and Mei Lanfang. Under the Japanese occupation of 1937–45, Qi lived in great straits because he refused to accept commissions from his Japanese admirers—although he continued to sell his paintings through agents, in some cases to people who had grown rich by hoarding. He died in 1957, full of years and honor, having been appointed chairman of the Chinese Artists Association under the People's Republic, named in 1953 as "Outstanding Artist of the Chinese People," and in 1955 awarded the International Peace Prize by the World Peace Council in Stockholm. His status in these final years was no doubt partly due to the fact that, like Mao Zedong, he had begun life as a peasant in Hunan, although after Qi's death Mao was heard to say that he did not personally like Qi's spontaneous style of painting, preferring more "finished" work.

Among Qi Baishi's most original works are his relatively few landscapes (fig. 1.3), composed in simple forms with strong colors and a bold, cheerful air, which of all his paintings owe the least to the influence of any other artist. Indeed, he said he painted so few because it took so much trouble *not* to imitate the old masters! (And perhaps he remembered the old Yangzhou artists' saying, "If you want gold, paint figures. If you want silver, paint flowers. If you want to be a beggar, paint landscapes.") Like Daoji, who had claimed that "the beards and eyebrows of the ancient masters don't grow on my face," Qi seems almost defiantly to ignore tradition, and that defiance gives his landscapes a pleasurable shock of purely visual surprise, for they are certainly not landscapes to wander in.

Qi Baishi is best known for his flowers, birds, shrimps, crabs and frogs, grapes and gourds, wine pots and chrysanthemums, subjects he painted over and over again with enormous verve, strong color, and powerful brushwork. If his style owes much to Wu Changshuo, his compositions are often simpler, his sense of space freer and more open—his pictures "breathe" easily (although he would sometimes paint insects with a minuteness that recalls his early *gongbi* training). He was not good at bamboo, which is surprising since his calligraphy is so full of strength and character. Like many Chinese painters, he often repeated himself, dashing off shrimps and frogs to pay the bills and oblige friends. In his later years many of these were painted for him by his son Qi Liang, and

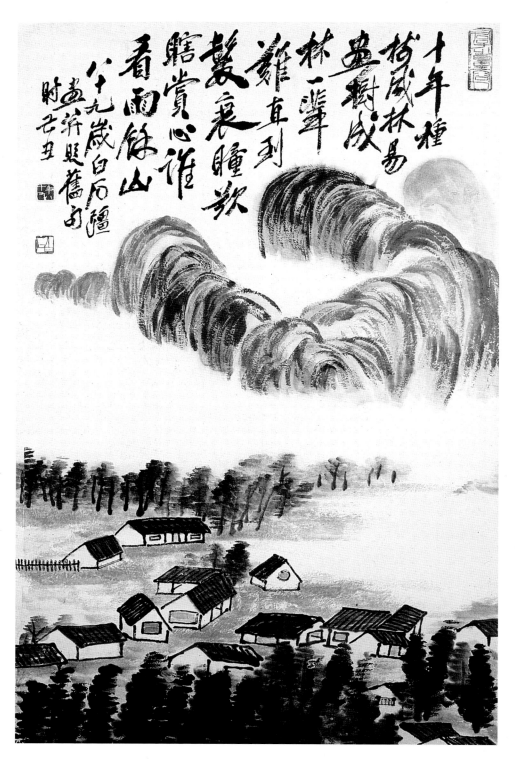

1.3

Qi Baishi, *Landscape* (1952). Ink and color on paper.

forgeries abound. Nor was he ever ashamed of his graduated scale of fees. When we consider how businesslike he was, how vast was his output—he is said to have painted over ten thousand pictures in his lifetime, six hundred in 1953 alone—it is astonishing how fresh and lively even the least of his paintings look. At his best, he was a major master, and he was always a stimulating influence on younger *guohua* painters.

Among Qi Baishi's most talented students was Li Kuchan.[9] Born in 1898 into a poor peasant family in Gaotangxian, Shandong, Li came in 1919 to Beijing, where he joined the Diligent Work Frugal Study Association (Qingong jianxue hui), which attracted many eager young men and women, and attended meetings of the After Hours Painting Research Society (Yeyu huafa yanjiu hui), pulling a rickshaw in the daytime to earn the fees. There he met the young Xu Beihong, who fired him with his ideals of creating a *xin guohua* ("new Chinese painting"). From 1922 to 1925 he studied Western art at the Beijing Academy, where he came under the influence of Qi Baishi. Thereafter, though always retaining his interest in Western art, he spent his life as a teacher of Chinese painting, first in Hangzhou (1930 to 1934) and then in Beijing. After great suffering during the Cultural Revolution, he resumed his career as a professor at the Central Academy, and died in June 1983. His admiration for Zhu Da and Shitao is manifest in his birds (fig. 1.5), flowers, fish, and pine trees, which he painted with a more consistent control of the brush than

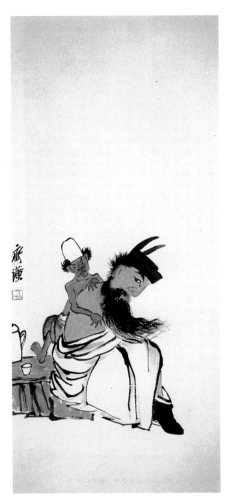

1.4
Qi Baishi, *A Ghost Scratches Zhong Kui's Back* (1964). Ink and color on paper.

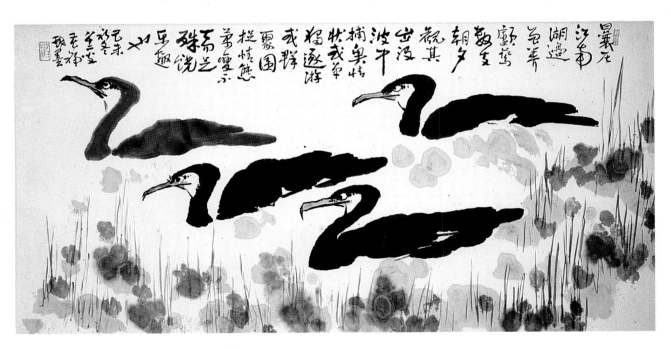

1.5
Li Kuchan, *Cormorants* (1964). Ink and color on paper.

was maintained by the often careless Qi Baishi. His compositions can be complex without losing their vitality and coherence.

But the patronage of men such as Chen Hengke and the talent of Qi Baishi were not enough to make Beijing the real focus for twentieth-century guohua, for the city had become the visible symbol of dynastic decay, from which the Revolution of 1911 did not entirely revive it. Until Chiang Kaishek unified China in 1926 the north was fought over by a succession of imperial claimants and warlords, while the seat of government was moved south to Nanjing. After the heady years of the May Fourth Movement (dedicated to modernizing and strengthening China, and led by staff and students of Beijing University), Beijing had by the mid-1920s become something of a backwater, living on the echoes of its great past. Shanghai, by contrast, was relatively stable, outward-looking, prosperous, and beginning to eclipse Beijing as a center of artistic activity.

THE SHANGHAI SCHOOL

Since the Southern Song Dynasty, the southeast had been the economic heartland of China. Shanghai, once little more than a village on the mudflats, had grown by the late nineteenth century into a city that was drawing wealth and artistic patronage away from older centers such as Hangzhou, Yangzhou, and Suzhou. Yangzhou had been taken by the Taiping rebels in the mid-1850s, Hangzhou and Suzhou devastated in 1860. In 1862, Shanghai was twice attacked but did not fall. For ten years, refugees, poor and rich, had been crowding into the city, until by the time the Taipings were defeated, in 1864, Shanghai was on its way to becoming the richest city in China not only in material wealth but also in private art collections and enthusiastic patrons. Literary and artistic societies flourished (see below, page 14) as the newly rich and the lower gentry surrounded themselves with the culture of the literati and the official class. A vigorous school of painting, variously called the *Shanghai pai, Haishang pai,* or simply *Hai pai,* grew up on foundations laid early in the nineteenth century. As in Yangzhou a century earlier, artists strove both to satisfy and to educate their patrons, who had no taste for the academicism of the Four Wangs. They wanted pictures that were enjoyable, bold, and easy to understand: figure subjects, "feathers and fur," and especially flowers, rather than landscapes or bamboo.

The doyen of the Shanghai flower painters was Zhang Xiong (1803–86), whose loose, free style with delicate color washes showed the influence of the great early Qing master Yun Shouping. This manner he passed on to his most famous pupil, Ren Yi (generally known by his pen name, Ren Bonian), who had been trained by his father as a professional portrait painter before being apprenticed to a fan-painting shop, where he attracted the attention of Ren Xiong (Ren Weichang, 1820–57) by forging the latter's work. For a few years Ren Bonian assisted Ren Xiong (they were not related) in Suzhou with woodblock book illustrations, but soon he was back in Shanghai.

By the time of his comparatively early death in 1895, Ren Bonian was probably the best known of all the Shanghai artists, no doubt because his style—or styles, for he had several—so exactly suited Shanghai taste.[10] He painted few pure landscapes, which required a background in scholarly painting that he lacked. His early paintings are mostly portraits and easily recognized characters from history and legend, such as the demon-queller Zhong Kui and the loyal Han Dynasty envoy Su Wu, banished by his Xiongnu captors to herd sheep in the remote northeast. One of his most delightful portraits is of his friend and later pupil, Wu Changshuo, sitting stripped to well below the waist under a wilting banana plant, his eyes half closed, too overcome by the heat of a Shanghai summer to bother to open the books on the bench beside him (fig. 1.6). This humorous, slightly indecorous realism appears quite often in the portraits of the Shanghai School. In Ren Bonian's work Western influence is barely perceptible, but it is stronger in Ren Xiong's portrait of himself standing bareheaded, legs apart, staring straight at the viewer like a defiant young samurai. This most arresting of all the Shanghai School portraits suggests that if Ren Xiong had lived he would have eclipsed even the gifted Ren Bonian.

Among Ren Bonian's many friends was Xu Gu, an Anhui man who had escaped involvement in the Taiping Rebellion (or in the suppression of it—there is some disagreement about which side he was on) by becoming a monk and later a professional painter, chiefly of plants and goldfish, in Shanghai.[11] His style is unique in its combination of transparent color washes and black ink strokes set down with the side of the brush yet with the brush-tip sharp. He admired Shitao and occasionally painted landscapes in his manner. Although lacking that master's depth and range, and too often merely decorative, Xu Gu's style was sufficiently curious to bring him a number of admirers among twentieth-century Chinese artists, notably Qi Baishi and Zhang Daqian.

All of these Shanghai painters—and there were many more—were dead before the end of the nineteenth century. Their influence on the art of the twentieth, however, is great, for in the seething, corrupt vortex of Shanghai they brought traditional painting to life again and gave it a character expressive of the time and place.

The work of the Shanghai landscapists is often less vi-

1.6

Ren Bonian, *Portrait of Wu Changshuo* (detail) (1880s).

sually arresting than that of the masters of figures and flowers, rocks and wine pots, perhaps because landscape was still a literary man's art that did not lend itself to emphatic design and strong colors. On the whole, the Shanghai landscapists were content to follow in the safe footsteps of the four Yuan masters and Wang Hui. Nevertheless, there were exceptions. Pu Hua painted dashing wet-ink landscapes and bamboos that show the influence of Zhu Da and Li Shan, while here and there—as in some of the landscapes of Ren Bonian's friend Hu Gongshou—something of Shanghai vitality shines through.

WU CHANGSHUO "Wu in the South, and Qi in the North"—the parallel is apt up to a point, for both Wu Changshuo and Qi Baishi played dominant roles in their own art worlds. But their backgrounds were very different. Wu Changshuo was born in 1844 into a gentry family in Zhejiang.[12] After the turbulence of the Taiping years he passed the civil service examinations, but apart from holding a magistracy in Andongxian for a month in 1895, he was never offered an official appointment.

1.7

Wu Changshuo, *Bodhidharma* (1915). Ink and color on paper.

1.8
Wang Zhen, *Lotus* (1921). Ink on paper.

He had begun to learn to paint as a pastime in 1877, from a painter who had also taught Ren Bonian. But like so many gentlemen after the 1911 revolution, when the Confucian bureaucracy was virtually destroyed, he came to live by his brush as a calligrapher (chiefly as a master of the "stone drum" seal script of the early Zhou dynasty), as a painter, and as a carver of seals, an art in which he already had a great reputation. When the Xiling Seal-Engraving Society (Xiling yinshe) was revived in Hangzhou in 1903, he was the natural person to elect as its first president.[13]

Wu Changshuo was greatly admired in Japan, and when Japanese officials came to Shanghai in the early 1920s they would invite him to banquets in the Liusan Garden in Hongkou north of the Suzhou Creek, sending a limousine to pick up him and his painter friends,

often Wang Geyi and Wang Yiting.[14] Before dinner he would do some quick sketches and calligraphy for his hosts, and there would be much drinking and merriment. During the chaotic weeks of Chiang Kaishek's takeover of Shanghai in 1927, Wu took refuge with his pupil Wang Geyi in Hangzhou. One day they went together to the Xiling Hill, home of the famous society he had helped to found, where they were astonished to see people kowtowing and burning incense before a bronze image.[15] This was no Buddha but a bust of Wu Changshuo himself, fashioned by the prominent academic Japanese sculptor Asakura Fumio (1883–1964). It was destroyed in the Cultural Revolution but has since been replaced by a replica by another Japanese sculptor. After Wu's death, his Japanese admirers held an exhibition of his work in the Liusan Garden.

Wu Changshuo had none of Ren Bonian's natural facility in painting, while his range in technique and subject matter was never great. But he was a powerful artist who used the strong color and forms typical of the Shanghai School to structure compositions based on the calligraphic brushstrokes that wonderfully unite the painting with the poem that so often accompanies it (and sometimes dominates it). His earlier work is richly colorful, but as he grew older his brushwork became harder and drier. Although his best period was said to be between 1905 and 1915, his painting was always fresh and vigorous, raising the Shanghai School to a new level of achievement.

Wu Changshuo's influence was great and his pupils many. Among the best of Wu's students was Wang Zhen (Wang Yiting), who began life as an apprentice in a picture-mounting shop and became a very successful merchant and businessman with interests in Japan. He was a generous supporter of artists in Shanghai, chairman of the Yuyuan Calligraphy and Painting Benevolent Association, and an active member of the Haishang Tijing-guan Art Club. As a painter, he was thoroughly eclectic. Some of his works show the influence of Ren Bonian, others of Wu Changshuo, whom he looked after in his old age, even arranging his burial. In later life Wang was an ardent Buddhist, and his visits to Japan gave him an enthusiasm for Chan painting which shows in his many paintings of Bodhidharma and other Buddhist subjects. In 1931 he headed (and very probably paid for) a party of over twenty guohua artists, including Zhang Daqian, Wang Geyi, and Qian Shoutie, on a month-long tour of Japan.[16]

Other pupils of Wu Changshuo included Chen Nian (Chen Banding), a native of Zhejiang who spent the first part of his career as a painter and connoisseur in Shanghai. He came from Ren Bonian's native village and so felt his influence also. In 1906 he moved to Beijing,

where he later taught at the academy, becoming its deputy principal. His reputation as a connoisseur suffered something of a setback when at a gathering of art lovers in Beijing he produced from his collection a scroll by Shitao, and Zhang Daqian—an expert forger of that master—announced that he had painted it himself. Chen Nian painted landscapes influenced by Shitao but was most famous as a painter of birds and flowers who brought to Beijing something of the freshness and vigor of his Shanghai training. He was beaten to death by the Red Guards in 1970.

Wang Geyi (plate 3) became Wu Changshuo's pupil only three years before Wu's death. He remained with the family for seven years, acquiring so intimate a familiarity with Wu's style and his collection of antiques, paintings, and calligraphy that it was said that the mantle of the master had fallen on his shoulders. A highly accomplished artist, he had a long career teaching in Shanghai. Gu Linshi, Di Pingzi, and Wu Zheng were other students of Wu Changshuo who became well known in Shanghai in the 1920s and 1930s.

PAN TIANSHOU Chinese critics spoke, as I noted, of Wu in the South and Qi in the North. Descending a generation, we might speak of Li in the North and Pan in the South. The subjects, style, use of color, and overall flavor of the work of Li Kuchan and Pan Tianshou are sometimes so alike that without the signatures it could be hard to tell them apart. Yet Pan Tianshou spent the whole of his life in the south, and he and Li Kuchan (discussed above) were only closely associated when Li was teaching at Hangzhou in the early 1930s.

Pan Tianshou was born in Ninghaixian, Zhejiang, in 1897.[17] After studying Chinese painting with Li Shutong in the Zhejiang First Normal College in Hangzhou, he taught from 1923 to 1928 in Shanghai. Thereafter, apart from a visit to Japan in 1929, he spent the rest of his life as a teacher in the Hangzhou Academy, which he followed in its wanderings through west China during World War II. His professional life was active. In Hangzhou in 1932 he organized the Baishe Painting Society and published the *Baishe Pictorial;* in 1937 he was appointed a commissioner for the National Art Exhibition in Nanjing. After Liberation he became an honorary fellow of the Arts and Sciences Academy of the USSR, chairman of the Zhejiang Artists Association (1961), and vice president of the Xiling Seal-Engraving Society (1963). Yet he managed to maintain a high output of works of remarkable freshness and energy and was a key figure in the regeneration of guohua after Liberation. Like Li Kuchan he was a victim of the Cultural Revolution, and he died as a result of his sufferings in 1971.

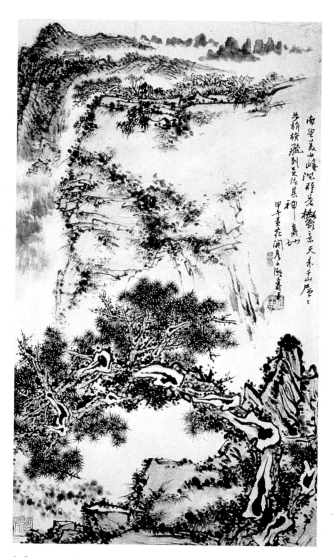

1.9

Pan Tianshou, *Landscape with Ancient Pine Tree* (1954). Ink and color on paper.

As a young man, Pan Tianshou felt the influence of Wu Changshuo, Qi Baishi, and Huang Binhong. It is hard to believe, looking at his paintings today, that in the 1920s he had been a serious student of Western art and had written a study of the introduction of foreign painting into China, which he traced back to the time of Qin Shihuangdi, 220 years B.C.! Very little of his early work has been published, but what is available for study suggests that at that time he did sometimes paint in the Western manner or experiment with Western techniques. His true style seems to have matured, rather suddenly, around 1948, and he maintained and developed it (apart from his work of the early 1950s, when the fruits of his studies of Western art surfaced again, briefly, in some of the realistic paintings of workers and peasants he produced) until his death.

Pan Tianshou painted all the traditional subjects, but his landscapes are his most striking works (figs. 1.9, 1.10).

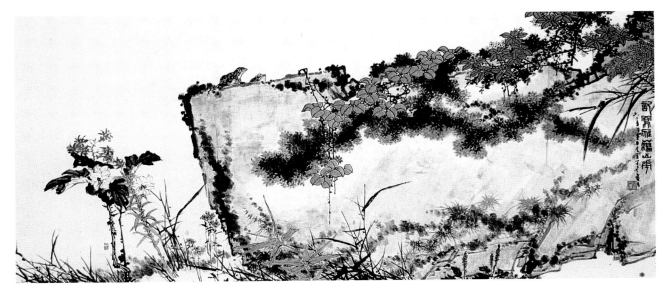

1.10

Pan Tianshou, *Remembering the Flowers of Yandangshan* (1962). Ink and color on paper.

Here we find no open panoramas, no misty distances, no scholarly reticence. Rather we have close-ups, often dominated by a single slab of rock set about with bamboo, pine, or flowers, with a fierce eagle perching on it, or a cluster of birds reminiscent of Zhu Da's. Pan Tianshou was never afraid of straight lines, or of leaving his rock face blank in the manner of Hongren—although as a product of the Shanghai tradition his work entirely lacks Hongren's ethereal restraint. Most remarkable is a sense of form more acute, more Western, than that of any other modern guohua artist. His son Pan Gongkai has published a fascinating series of sketches and diagrams in which Pan Tianshou shows how to construct a picture, how to convey mass, space, stress, movement, and balance.

A Chinese critic, comparing Pan Tianshou with Li Kuchan, called his work eccentric. It is certainly less consistent and carries a stronger personal stamp, though in sheer quality there is little to choose between them. The work of these two masters shows that in mid-century the revitalized guohua was in safe hands indeed.

THREE INDEPENDENT MASTERS

Most traditional painters of the first half of the twentieth century fit comfortably into one of the three main schools or traditions: of Beijing, of the Shanghai area, and of Canton. But three prominent masters stand apart, either because their art was highly individual or, in the case of Zhang Daqian, because his range was so wide as to defy classification.

HUANG BINHONG Admired in his lifetime, Huang Binhong has become the object of almost excessive adulation since his death.[18] Born into a prosperous family in Zhejiang in 1864, he grew up in the center of the province in Jinhua. At thirteen he saw the works of the old masters for the first time in local collections; two years later he was taking painting lessons. He spent his young manhood studying, painting, and visiting famous beauty spots such as Huangshan, whose spectacular scenery was to become a constant source of inspiration to him as a landscape painter.

After failing the civil service examinations several times, Huang Binhong spent the years from 1894 to 1907 in retirement in Shexian, living the life of a responsible local gentleman and soaking up the landscape and cultural atmosphere of that lovely region. In 1907 he went to Shanghai, where he joined the editorial staff of the Shenzhou Guoguang She publishing house, which put out volumes of reproductions of masterpieces of painting and calligraphy. Huang himself wrote a number of books on Chinese painting and was a chief editor of the sixty-volume anthology of writings on Chinese painting, *Meishu congshu,* published in 1928.[19] Although he traveled much (spending 1932 and 1933 in Sichuan, for example), most of his career as a painter, editor, and art expert was spent in Shanghai, where he was active in a number of societies for the promotion of traditional painting.

When the Japanese occupied Beijing in July 1937, Huang Binhong had just arrived to take up a professorship at the Beijing National Academy of Art (Beiping

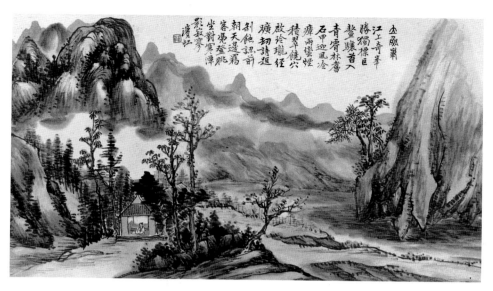

1.11
Huang Binhong, *Landscape* (before 1917). Ink and color on paper.

yishu zhuanke xuexiao). He was not to see his beloved Jiangnan region for another eleven years. Finally, at the age of eighty-five, he was appointed professor at the Hangzhou Academy, where he remained in tranquil old age, still painting, until his death from cancer in March 1955 at the age of ninety-two.

Huang Binhong's knowledge of Chinese painting was profound, but he was perhaps too much the committed artist always to show cool judgment in matters of connoisseurship. Zhang Daqian (see below) told with somewhat shameless glee how he had once fooled Huang into parting with a genuine work of Shitao in exchange for a forged Shitao (which Huang pronounced an authentic masterpiece) that Zhang Daqian had concocted for the purpose.[20] In 1934, as the director of the Palace Museum, Dr. Yi Peiji, was being tried for having attempted to remove from the collection a number of works of art, Huang was called in to authenticate them. Any object considered a fake was not returned to the museum but rather confiscated by the court, later to be left behind when the Guomindang removed the bulk of the collection to Taiwan in 1948.[21] Huang Binhong's snap judgments deprived the Beijing Palace Museum of a number of important paintings—not an unmitigated catastrophe, of course, for when the new Palace Museum was established after Liberation, these rejected masterpieces formed the nucleus of the collection. As Robert van Gulik has noted, Huang Binhong's editorship of the *Meishu congshu* also left a great deal to be desired.[22]

But Huang Binhong should no more be judged by the vagaries of his connoisseurship than any other artist.

His early work (fig. 1.11, for example) was eclectic in style, much influenced by Dong Qichang, although it was often highly evocative of the lovely countryside of southern Anhui and eastern Zhejiang. To travel through the gentle hills and rice fields, to visit the white-walled, grey-tiled villages around Shexian and Tunqi, is to understand how sensitively Huang captured the flavor of his homeland. Everywhere he went, he sketched, making notes of the light and colors of the moment like an impressionist, often jotting down these impressions with a pencil on small pieces of paper or in dry ink in a cheap lined school exercise book, very swiftly, as if to capture the fleeting vision before it vanished. By the 1920s he was at the height of his powers, his landscapes being marked by a strong, lively, and restless brushwork that gave them a quality not seen since Shitao. He felt particularly at home on Huangshan, and in the early 1930s wrote a study of the great seventeenth-century individualists Hongren, Daoji, and Mei Qing, who like him had found inspiration there.

Although not well known as a flower painter, flowers were, next to landscapes, Huang Binhong's favorite subject: he never painted figures or bamboo. His fresh, spontaneous, often boldly colored flower paintings have been characterized as expressing "simplicity, blandness, intentional awkwardness [*zhuo*] and strength"[23]—although "blandness" is perhaps an odd word to describe paintings so vibrantly rich in ink and color.

It was in Huang Binhong's last years, from the age of eighty onwards, that his handling of ink became particularly daring, his forms most fantastic. He now aptly

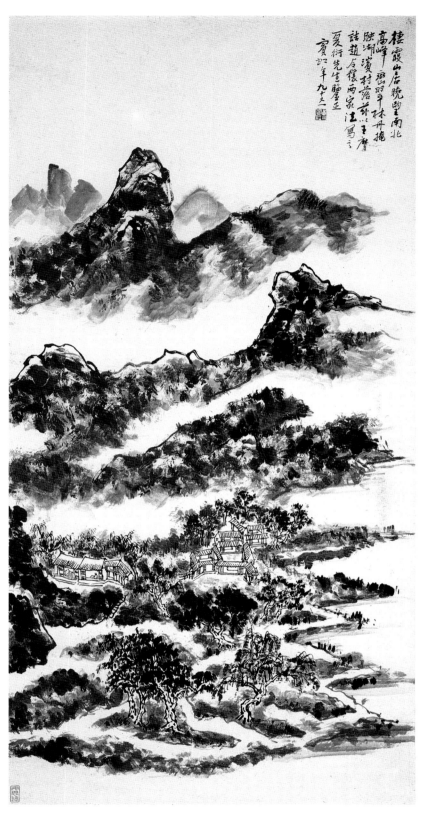

1.12

Huang Binhong, *Recluse on Xixia Mountain* (1954). Ink and color on paper.

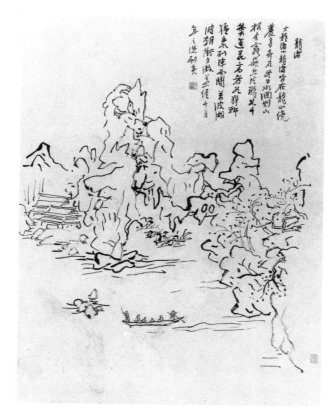

1.13

Huang Binhong, *Dragon Islet*. Ink on paper.

century, had been dealt a crippling blow by the Taiping Rebellion. Almost single-handedly, Huang Binhong brought it to life again.

ZHANG DAQIAN Zhang Daqian's reputation as a forger and enfant terrible among the traditional connoisseurs would have been enough to secure him a place of some sort in the history of twentieth-century Chinese art. But he was also a very considerable painter whose reputation rests on his encyclopedic knowledge of the tradition, on his phenomenal technical skill, on his capacity for work, and—when he gave his talent free rein, as he did in his later years—on his power to produce paintings that were often huge in scale and conception and bold in their handling of ink and color. In some of these last works he showed that he could respond, in his own way, to the challenge of abstract expressionism.

Zhang Daqian—or, as he preferred to spell his name, Chang Dai Chien—was born on May 19, 1899, into a comfortably well-off family in Neijiang, Sichuan.[24] After being held prisoner by local bandits for a hundred days in 1916, he was sent to join his elder brother Shanzi in Kyoto, where for two years he studied textile weaving and dyeing. He later said that his studies in Japan had no effect on his development as a painter, although his later paintings of beautiful women clearly show the influence of *nihonga* artists such as Uemura Shōen and Shimomura Kanzan.[25] (In the work of his brother, the *nihonga* influence is much more obvious.) Returning to China in 1919, Zhang Daqian became briefly a Buddhist novice in Nanchang (some say Songjiang and Ningpo); then, in Shanghai, he studied painting with Zeng Xi and calligraphy with Li Ruiqing, the former Qing official who in 1906 had opened the first painting department in a Chinese school, in the Liangjiang Shifan Xuetang in Nanjing (see page 27).

During the 1920s and 1930s Zhang Daqian lived chiefly in Shanghai and in Suzhou, where the owner of the Wangshiyuan lent this famous garden, once the resort of the Ming master Wen Zhengming, to the two brothers for five years. There Shanzi kept and painted the tigers on which his reputation was to rest, while his far more talented brother was becoming a master of an astonishing range of styles and techniques. By now, this confident young man could turn out forgeries and imitations that deceived the experts and made him some enemies. He was not above causing a famous collector to lose face; his humiliation of Chen Nian (see above) made him, for a time at least, persona non grata in Beijing. He returned to Shanghai. When the family business collapsed in 1927, he had no difficulty in supporting himself with his brush. Meantime, as a connoisseur

called his style "thick, dark, dense, and heavy," deriving his textures from his own Seven Methods of Ink: the Thick, the Light, the Broken, the Splashed, the Leftover, the Accumulated, and the Scorched. In these late works, contact with nature is barely maintained (fig. 1.12). The impressionist has become the expressionist.

For two years, around 1953–54, Huang Binhong was almost blinded by cataracts. Yet he continued to paint, piling ink on ink in ever thicker layers by instinct, for he could no longer see what he was doing. At their best these paintings have intensity and power, but too often they are so chaotic and gloomy that only his most uncritical devotees could admire them. Then suddenly his cataracts were cured, he could see clearly again, and a miraculous change came in his work. As if sweeping away the darkness and confusion, his last landscapes have an air of almost ethereal openness and simplicity (fig. 1.13). He seems to have arrived, before his death, at an unclouded freedom and lightness of spirit that makes one think of the philosopher Zhuang Zi.

The influence of Huang Binhong's dense textures and nervous brushwork can sometimes be seen in the work of his students, notably Li Keran, Song Wenzhi, and Ya Ming. The Anhui School (to which he is often said to belong), which had been in decline since the eighteenth

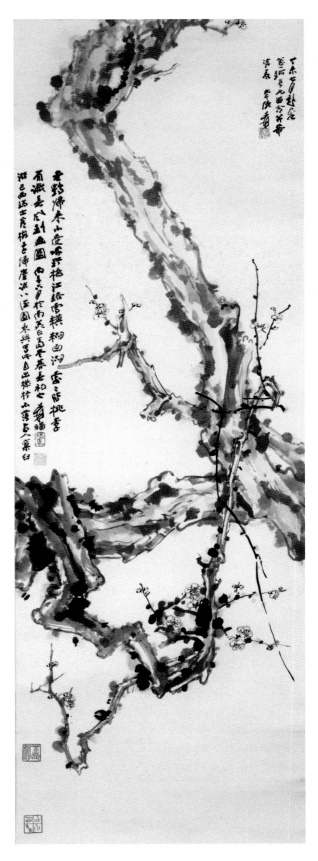

1.14
Zhang Daqian, *Plum Blossom* (1966). Ink and color on paper. Painted in Brazil; inscribed to the owners, 1967.

and dealer, he had begun to form the collection of important (and mostly genuine) old masters that subsequently enriched so many museums across the world.

The beginning of the Sino-Japanese war in 1937 found Zhang Daqian back in Beijing, but he was able to return home to Sichuan in the following year. The culmination of his development as a scholarly artist came when he spent nearly three years (1941–43) with his family and assistants at the remote Dunhuang caves in Gansu, copying the Buddhist wall-paintings under extremes of heat, cold, and primitive living conditions, an extraordinary enterprise that is described in chapter 9. Just why he devoted these years to this gigantic task is hard to grasp, but it certainly increased his understanding of Chinese figure painting. By drawing public attention to this neglected treasure-house of ancient wall-painting, and by exhibiting over two hundred of his copies in Chongqing in 1943, he contributed significantly to the establishment of the Dunhuang Research Institute in the same year.[26]

When peace came two years later, Zhang Daqian moved "down river." Six restless years followed, including sojourns in Beijing, Shanghai, India, Hong Kong, Taiwan, and Argentina, before Zhang settled at Mogimirim, north of São Paulo in Brazil, where in his typical extravagant fashion he created a huge Chinese garden and gathered his family and friends around him, and where he painted the large vibrant study of a blossoming old plum tree illustrated here. In 1966 they migrated to Carmel in California, where again, though on a smaller scale, he made a world around himself. Finally, homesick for China, he retired in 1977 to Taipei. A house was built for him near the Palace Museum, and he acquired something of the status of a living national treasure. In these last years he produced some of his most spectacular works, including giant paintings of lotuses (plate 4) and a panorama of Mount Lu, 1.8 meters high and ten meters long, which was exhibited three months before his death on April 2, 1983. Generous, extravagant, mischievous, always a star and reveling in it, his friends and students were many; even more were those who claimed that honor.

For much of his career, Zhang Daqian's work was so eclectic that it had little individual character—far less than that of Huang Binhong or Pan Tianshou, for instance. Moreover, his ability to turn out a forged Bada Shanren or a convincing Northern Song landscape prevented him from being taken seriously as a creative artist. But after about 1960, quite possibly stimulated or challenged by the abstract or semiabstract work of younger Chinese painters on the international scene, he set out to show that he could do it too, painting a series of striking expressionistic works in which ink and strong mineral colors merge with, repel, or fight against one an-

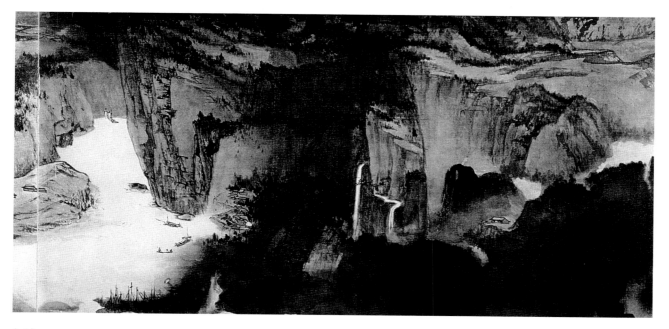

1.15
Zhang Daqian, *Ten Thousand Miles of the Yangzi* (detail) (1967). Ink and color on silk.

other. With the addition of a few telling details and accents, the composition becomes a landscape. It is this late technical breakthrough which makes his *Ten Thousand Miles of the Yangzi* (fig. 1.15), painted for General Zhang Chun (Chang Ch'un) in 1968, a masterpiece of modern Chinese painting. Never afraid to experiment, Zhang Daqian produced in San Francisco, in 1972 and 1974, two sets of six lithographs of landscapes and birds and flowers (fig. 1.16). He mastered the medium once he had gotten used to the idea—bizarre, to him—of putting one color on one stone, one on another, and working back to front.[27]

FU BAOSHI In the early decades of the twentieth century, Japan played a key role in the development of new schools of Chinese painting. On the one hand, artists such as Xu Beihong and Liu Haisu studied Western art in Tokyo and subsequently taught oil painting in China, while on the other painters of the Cantonese school learned ways of modernizing traditional techniques from the *nihonga* style. (Both groups will be discussed later in this book.) Fu Baoshi occupies a unique place in modern Chinese painting because, although he studied both Western and Japanese art in Tokyo, he always remained a very Chinese artist.[28]

Born into the family of a poor umbrella-repairer in Nanchang, Jiangxi, in 1904, Fu Baoshi was apprenticed at the age of ten to a ceramics shop, where he began to study calligraphy, painting, and seal-carving in his spare

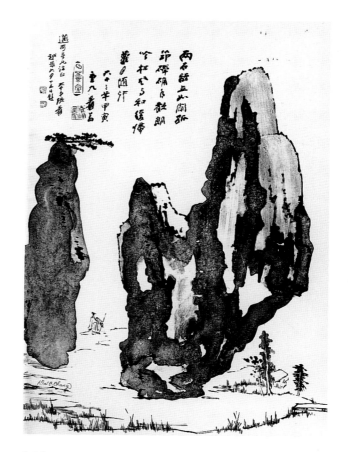

1.16
Zhang Daqian, *Giant Rocks* (1974). Lithograph.

time. In 1921 he graduated from the College of Education in Nanchang, staying on there as a teacher until 1931. Two years later, with the help of Xu Beihong and the ceramics establishment to which he had been apprenticed, he went to the Tokyo School of Fine Arts, where he learned the history of Eastern and Western art by reading and translating works by Japanese art historians such as Kanehara Shōjo and Umezawa Waken and where, as a painter, he could not but feel the pervasive influence of the famous *nihonga* painters Takeuchi Seihō and Yokoyama Taikan. Another possible influence, as James Cahill has suggested, may have been Kosugi Misei, who joined the school in 1935, the year Fu Baoshi graduated and returned to China.[29] Kosugi, who had spent a year (1913–14) in Europe and began his career as a Western-style artist, had by this time returned to the Nihonga School and become a leading light in the revived Japan Fine Art Institute (Nihon bijutsu in). In spite of these pressures, Fu Baoshi may well have taken to heart the remark made to him by Yokoyama Taikan himself: "It is ridiculous for a Chinese to come to Japan to learn Chinese painting, for it is just like coming to Japan to learn to cook Chinese food. You know that Chinese ink painting is the greatest and highest form of art in the world."[30] By May 1934, Fu Baoshi was well enough established in Tokyo to hold a one-man show in the Matsuzakaya Department Store in the Ginza.

Much of the rest of his career as painter, teacher, and historian of Chinese painting was spent on the staff of the National Central University in Nanjing, including the war years when the school fled to Chongqing. After Liberation he was honored by the new regime and was given a number of important commissions, including the landscape in the Great Hall of the People in Beijing illustrating Mao Zedong's line "Such is the beauty of our mountains and streams" (see plate 31). This huge, labored, and rather cold work was painted in 1959 with the collaboration of the Cantonese painter Guan Shanyue.[31] By this time Fu Baoshi's greatest period was over. He never really fitted into the new society; his efforts to adjust the style and content of his painting to new requirements (for which, see chapters 12 and 13) were not happy, while his less orthodox work was wild and undisciplined. He died in 1965 of a cerebral hemorrhage brought on by excessive drinking. Had he still been living when the Cultural Revolution broke out, it is hard to imagine that he would have survived it.

Fu Baoshi painted little except figures, landscapes, and figures in landscapes. His slender, elongated women recall the style of the Six Dynasties, while the long faces and bushy eyebrows of his scholars and poets echo the mannerisms of Chen Hongshou. But his brushwork is

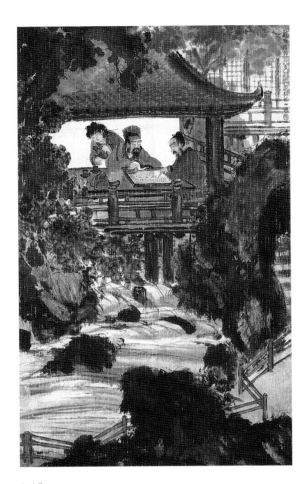

1.17
Fu Baoshi, *Playing Chess at the Water Pavilion* (1940s). Ink and color on paper.

more subtle and sensitive than the *gongbi* technique of the Ming master, his ink and color handled with greater refinement and delicacy.

It is for his landscapes that Fu Baoshi will be chiefly remembered. His early work was eclectic and hardly distinguished, but by the 1940s his own style was fully mature. A typical landscape is dominated by towering mountains that almost fill the picture space, formed of no strong calligraphic lines but rather of a multitude of light strokes worked over and enriched into a complex texture of broken ink and soft color washes. Most striking is a monumentality of scale that recalls the Northern Song masters. After a pleasurable hunt, knowing they must be there somewhere, we discover the minute, exquisitely painted figures of his scholars and poets in a little clearing in the foreground, dwarfed by the crags (plate 5). This characteristic feature, together with a restless shimmering surface enlivened by dots and short strokes derived from his idol Shitao (to whose life and work he devoted many years of study), gives even his

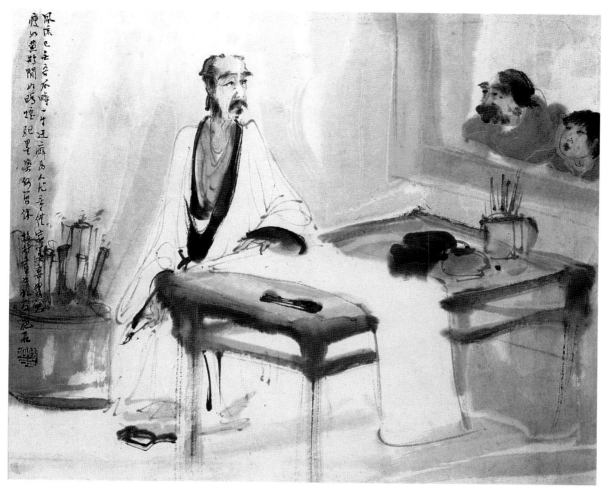

1.18
Fu Baoshi, *The Scholar in His Studio* (c. 1945), recalling the eccentric Ming dynasty painter Shao Mi. Ink and color on paper.

small album leaves a breadth of vision, an air of mystery, a poetic intensity, not matched by any other modern Chinese artist. He was an inspiring influence on many painters of the Jiangnan region, notably Cheng Shifa, Ya Ming, and Song Wenzhi.

SOME MINOR MASTERS OF THE GUOHUA REVIVAL

Although not as interesting or original as the masters we have been discussing, a number of other traditional painters achieved a high reputation between the wars and deserve at least a mention in any survey of twentieth-century Chinese art.

Yu Fei'an was a well-known and very conservative Beijing painter of birds and flowers with a passion for pigeons, which he trained and wrote a book about.[32] He started to paint in the *gongbi* style around 1935. His southern counterpart would be Chen Zhifo in Nanjing, who had studied design in Tokyo from 1919 to 1923. (His striking art deco designs for books and magazine

jackets are discussed in chapter 11.) In the 1930s he abandoned modernism for a very conservative style blending the Song and Ming decorative traditions with a smooth skill derived at least partly from his exposure to *nihonga* artists such as Shimomura Kanzan.

In Beijing, Wang Xuetao, student of Chen Hengke and Wang Yun, was noted for his flowers and plants, while Tang Di also made his reputation in the north though he spent his last years in Shanghai. In Nanjing, Qian Songyan, a close friend of Liu Haisu, painted orthodox landscapes that reflect the influence of Huang Binhong. Wu Hufan (fig. 1.19), grandson of the statesman-painter Wu Dacheng, was a famous scholarly landscape painter, collector, and connoisseur in Shanghai, while more recently Xie Zhiliu, who began his career under the guidance of Zhang Daqian, has fulfilled the same role there. Also in Shanghai, Zhang Dazhuang was distinguished not only by his birds and flowers, often painted in a lively boneless technique—that is, in ink and color without outlines—but also by unusual still life sub-

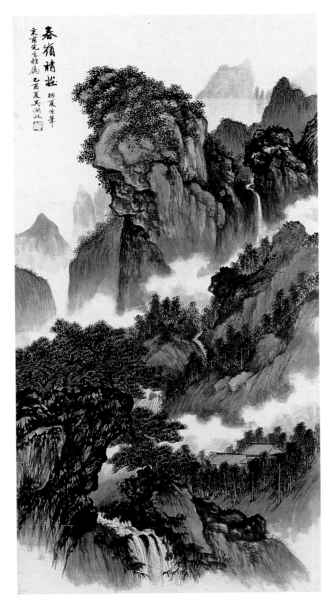

1.19
Wu Hufan, *Spring Landscape* (1945). Ink and color on paper.

1.20
Lü Fengzi, *Lohan* (1946). Ink and color on paper.

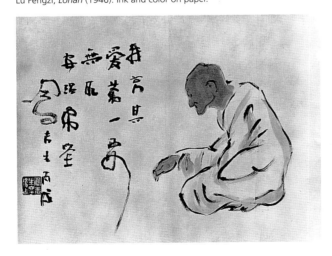

jects not part of the standard repertoire. A more studied unconventionality was practiced by the Nanjing master Lü Fengzi, who painted Buddhist subjects (such as lohans, fig. 1.20) in the exaggeratedly grotesque manner of the early Chan monk artists. He was no recluse himself, for he spent much of his career teaching orthodox guohua techniques in Hangzhou, Nanjing, and elsewhere.

SOME FACTORS IN THE GUOHUA REVIVAL

One might well wonder why traditional painting enjoyed so vigorous a revival just at the time when traditional culture was in a state of decay and the modernization and Westernization of Chinese cultural life were gathering momentum. The most plausible reason, and the most difficult to demonstrate, is that the guohua revival was a spontaneous response to the challenge of Western art. This may well have been the case, but other forces were at work also. The rebirth of guohua, which began under the stimulus of Shanghai wealth and patronage in the last decades of the nineteenth century, was carried forward by the anti-Manchu feeling and the growth of a national consciousness that led to the Revolution of 1911. The Promote the National Heritage Movement (*chengli guogu yundong*) that swept the country was an expression of China's new self-awareness. To paint in the traditional style, therefore, was to declare one's faith in Chinese culture.

The social revolution of the early twentieth century broke down the traditional elitism of the scholar gentry, while painting as a pastime was becoming popular among the new professional classes. Moreover, Liang Qichao, Hu Shi, and Cai Yuanpei were all declaring that culture must be available to everyone. So long as the best paintings remained hidden behind the walls of the Forbidden City or in private collections to which only the privileged had access, that would never happen. But when the former emperor, Pu Yi, was expelled from the palace in 1924 and the Palace Museum established two years later, China's artistic legacy became, potentially, common property. Soon more museums were being created; by 1937, it has been calculated, there were 146 museums and art galleries of one sort or another across China. Thirty-five years earlier there had been none.

Yet at the same time China was neglecting her own artistic heritage, as unscrupulous dealers hacked sculpture from the walls of Buddhist caves, encouraged illicit tomb-robbing, and sold to foreign collectors and museums vast numbers of works of art that should never have left the country. This foreign hunger for Chinese art, however, also had the effect of raising its value in the eyes of the Chinese public. The great International Ex-

hibition of Chinese Art, held at Burlington House in London in 1935–36, to which treasures from the Forbidden City were transported in a British Royal Navy cruiser, set a seal on China's recovered artistic prestige.

In China the practice of the arts has always been a social activity. Painters paint for their friends, often in their company; an enjoyable blend of connoisseurship, wine, and gossip creates the ideal atmosphere in which to perform. There had always been societies of gentlemen devoted to the arts of the brush, but these societies now proliferated, taking on a new, more public role as custodians of the artistic heritage and as meeting places for painters and calligraphers, connoisseurs and collectors, who made their knowledge and collections widely known through the societies' exhibitions and publications. In his old age Wang Geyi recalled the Shanghai guohua circle of the 1920s, where artists would gather in Wu Changshuo's house to show their paintings to each other.[33] Liu Haisu was often to be found there.

Two or three years after Wu died, his grandson Wu Dongmai set up a small private guohua school, the Changming Art Training School (Changming yishu zhuanke xuexiao). With the patronage of Cai Yuanpei, during its short life it attracted a number of Wu Changshuo's friends and former pupils. Another circle formed around Xie Gongzhan and Sun Xueming, in whose homes could often be found Liu Haisu, Zheng Wuchang, Qian Shoutie, Wang Geyi, and Wang Yiting. There were many exhibitions, often in bookstores which had small galleries. It was the custom, when holding one's first solo exhibition, to give a banquet and invite famous people, painting friends, and journalists—an expensive undertaking, but there were many rich patrons in Shanghai, and the outlay generally paid off. Western-style oil painters had no such support to sustain them.

Another factor in the guohua revival was the inclusion of traditional painting in the curriculum of the new art schools. The teaching was always old-fashioned and conventional—as indeed it still is today—but it now included the novel subject of Chinese art history, although this seldom meant more than the history of painting and calligraphy. The textbooks were mostly translated from the Japanese; Japan was teaching China her own art history. Art students who went to Japan to study, such as Huang Binhong and Fu Baoshi, learned there of Chinese schools and traditions that were far less known and appreciated at home. Fu Baoshi, for example, seems to have been less influenced in Tokyo by Japanese painting than he was by the great seventeenth-century individualists Shitao and Zhu Da, who had long been studied and collected in Japan. He also encountered there the works of the great seventeenth-century Yimin, the Ming painters who lived as left-over loyalists into the early Qing Dynasty. These new educational trends, combined with the activities of the painting societies, meant that by the 1930s a growing number of educated people knew something about the tradition, and there were probably more guohua painters, amateur and professional, than at any previous period in Chinese history.

GUOHUA'S LIMITATIONS

In spite of the revival, guohua could never by itself meet the needs or express the feelings of all modern Chinese artists, as many artists and critics pointed out. In 1924, for example, Dai You (who had translated Bushell's *Chinese Art* into Chinese) noted three limitations in Chinese painting: it lacks accurate depiction of particular things, presenting only generalized type-forms; its subjects tend to be imaginary, so it cannot portray the real appearance of the world today; and its techniques are "irrational and unscientific," without perspective or modeling.[34] The guohua master Pan Tianshou, in his *History of Chinese Painting,* published in 1926, gave four reasons why Western art had suddenly become essential to the development of Chinese painting in the twentieth century:

> First, European painting in the last thirty to fifty years had developed a great [appreciation] for the purity of line, tending towards the spiritual taste of the Orient. Second, because of the influence of the reform movements, anything that was not new or foreign was not worth studying. Third, Chinese painting, after the study of artists and scholars of the successive dynasties for three or four thousand years, had reached its highest point. It was not easy to open [new paths] for the future. Therefore, it was necessary to welcome new principles from the outside. Fourth, the materials and the modes of representation in Western painting possessed unique characteristics; thus, it would be meaningful to experiment. For these reasons, young people of China develop the tendency to pursue the study of Western painting directly and thoroughly.[35]

Ten years later, the critic and litterateur Wen Yuanning wrote that the guohua painters seemed quite out of touch with modern life. He deplored "the very hackneyed nature of the subjects treated by our present-day artists. . . . We see one after [another] the same monotonous succession of birds on branches, tigers, eagles on rocks, lotus flowers, pines etc. drawn with very little variation in the manner of the ancients. We look in vain for an expression of the perplexing and troubled scene around us. Surely, we say to ourselves, the business of present-day art is to make us at home in this world of steam, electricity and radio: why have our artists"—he

made an exception of the Lingnan School, discussed in chapter 5—"turned their backs on the 'now' and 'here' and chosen for their art the themes of a bygone age?"[36] The painter Feng Zikai told his students: "If I find any of you painting scholars gazing at waterfalls, I shall expel you. You haven't seen them. Don't paint what you don't know."[37]

The vast majority of guohua painters were little more than skillful performers with the brush. Only a few spoke with a voice of their own or had anything interesting to say. The more gifted they were, the more their time and talent were drained away turning out the so-called *yingchou* (courtesy) paintings to secure a favor, fulfill an obligation, or oil the wheels of social intercourse.

To tamper with the rich, coherent tradition of Chinese painting—by, for instance, replacing a general statement about nature with a visually accurate rendering of a particular place, by delineating features rather than character in a portrait, by rendering transient effects such as cast shadows, by depicting a naked woman or a scene of violence—would be to attack its very essence. Yet that was precisely the challenge that Western art was to present to the Chinese artist. That challenge proved impossible to ignore, and for many Chinese artists impossible to resist. The revolution in Chinese twentieth-century art most profound in its implications for the future was not the introduction of new media and styles, or even the change from conventionalization to realism, but the questioning—and for many the total abandonment—of the traditional Chinese belief that the chief purposes of art were to express the ideal of harmony between men or between man and nature, to uphold tradition, and to give pleasure. With this stirring of doubt about the value of the guohua tradition, it is not surprising that the eyes and thoughts of artists and critics began to turn toward the West. In the titanic confrontation between two great traditions, Chinese art entered upon the most revolutionary, the most dramatic, and, in my belief, the most creative period in its entire history.

THE REVOLUTION IN
CHINESE ART

BEGINNINGS

Chinese artists were much more reluctant than the Japanese to take up the challenge of Western art. China, unlike Japan, had never looked across the sea for cultural stimulus. So there was no sweeping reform in Chinese art teaching such as the Meiji government had introduced by decree to Japan; rather, the process of change was slow, cautious, and severely practical.[1]

Some time after its founding in 1863, Western drawing techniques were introduced into the curriculum of the School of Linguistics and Western Studies, and later in several naval and military academies. John Fryer (1839–1928), a Church of England missionary and for twenty-eight years an instructor in the Jiangnan Arsenal in Shanghai, translated with Chinese collaborators a number of books on science, international history, engineering, and technical drawing.[2] Another practical handbook, *First Lessons in Drawing,* by J. M. W. Farnham, was also on sale at this time. These books, however, could have done little to awaken an interest in Western art.

One very popular source of Western themes and techniques was the *Dianshizhai huabao* (Dianshi studio illustrated), launched in Shanghai in 1884 by Frederick Major. This weekly flourished for fourteen years, illustrated with lithographs in the Western manner by the prolific Wu Youru and his team of collaborators. It featured sensational events at home and abroad, horrific disasters, and bizarre foreign activities ranging from a cricket match to a factory making soap from ground-up corpses, all presented in vivid detail (fig. 2.1). The lure of the subject matter alone, much of it lifted from journals such as *The Illustrated London News* and *The Graphic,*

did much to familiarize the Shanghai reading public with Western graphic techniques.

In 1902 drawing and painting (*tuhua*) were included in the curriculum of all schools, from primary up to colleges and technical institutes. Although the traditional civil service examinations were abolished in 1905, a special examination was retained to confer the old *jinshi* and *juren* titles on students returning from abroad. One man who took this test, Jiang Danshu, later a teacher and chronicler of the early progress of Western art in China, wrote that in addition to doing a flower painting he was required to paint a composition in watercolor depicting "a night scene in which a gigantic battleship is floating on the sea; the distant shore is foggy and misty, and buildings can vaguely be seen."[3] This extraordinary assignment suggests the kind of painting that was very popular in Japan in the year in which the Imperial Navy destroyed the Russian fleet off Port Arthur, and may well have been proposed by a Japanese instructor.

With Western-style drawing now compulsory in Chinese schools, there was an urgent need for teachers. In 1902, accordingly, departments of painting, drawing, and handicrafts were opened in two teachers' training colleges: the Beiyang Shifan Xuetang in Baoding, southwest of Beijing, and the Liangjiang (i.e., Jiangsu/Jiangxi) Shifan Xuetang in Nanjing. In the Nanjing school, courses in drawing, oil painting, and watercolor were taught by Japanese instructors, among them Shiomi Kyō and Watari Hironosuke, who naturally encouraged their more promising pupils to go to Tokyo for further study. By 1909, there were 461 Japanese teachers in schools

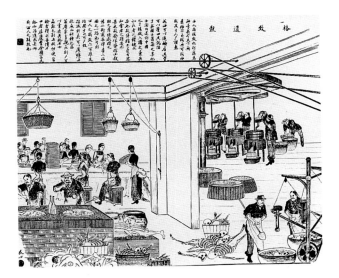

2.1

Fu Jie, *Europeans Boiling Corpses to Make Soap.* A page from the *Dianshizhai huabao* (August 1888).

2.2

A Bridge in the Countryside. Instructional drawing from *A New Edition of Model Paintings for Middle Schools* (Shanghai, 1907).

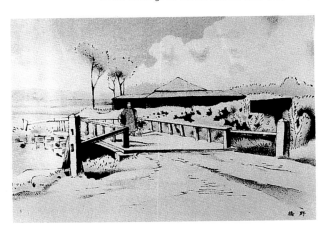

and colleges in China, of whom sixteen were listed as instructors in drawing and painting. The number fell in the chaos that followed the Revolution of 1911, when Chinese art teachers were beginning to graduate from the normal schools, but in the meantime these two schools had trained the first generation of art teachers in modern China and laid the shallow foundations on which the Western movement was to grow.

In the meantime, a handful of Chinese scholar-officials had seen Western art at the source. The diplomat Xue Fucheng (1838–94), after visiting Paris, wrote admiringly of Raphael, and particularly of the perspective, chiaroscuro, and illusion of solidity in his paintings.[4] One of the most eloquent attacks on the painting of the

Chinese literati was made by Kang Youwei (1858–1927). Banished to the West in 1898 after the failure of the Hundred Days of Reform, he wrote at length in his *Travels in Eleven European Countries* of works by Raphael and Guido Reni. Comparing a work of Raphael he had seen in Venice with painting in China after the Song and Yuan, he concluded, "Four or five hundred years ago Chinese painting was the best. What a pity that it has not developed since then." He appealed to Chinese artists: "If we can correct the false painting doctrine of the past five hundred years [the rejection of Song Dynasty realism in favor of the 'abstraction' of the literary painting of Yuan, Ming, and Qing] then Chinese painting will recover and even develop further. Today, industry, commerce and everything else are related to art. Without art reform those fields cannot develop. . . . Chinese painting has declined terribly because its theory is ridiculous." He deplored the lack of realism: "How can those who paint just for fun in their spare time capture the true character of all things on earth? It is totally wrong to regard the literati spirit as *the* orthodox school of painting." Although Kang insists on a return to orthodoxy, by which he means the old *gongbi* tradition, "if we adhere to the old way without change, Chinese painting will become extinct. Now, at this historic moment, it is up to those who are up to the challenge to arise. They must begin a new era by combining Chinese and Western art."[5] For this, they must see Western art at first hand.

The first notable Chinese artist to go abroad to study was Li Tiefu, who was born in 1869 into a poor family in Guangdong.[6] In 1885 he was taken by relatives to England and then to the United States, where he became a close associate of Sun Yatsen in the revolutionary Tongmenghui before settling down to study art in Arlington, Massachusetts, and New York. He subsequently had a moderately successful career as a professional oil painter in the U.S., declaring himself on his visiting card as "Lee Y. Tien A.M., Professor of Portrait, Follower of Mr. William M. Chase and Mr. John Sargent 1905–1925." He returned to China in 1930 and spent the rest of his life chiefly in Canton and Hong Kong. After the Japanese occupation of Hong Kong in 1942 he made his way to Guilin, then in 1946 to Chongqing and on downriver to Nanjing and Shanghai, where he exhibited the oils and watercolors he had painted in the States and Hong Kong and more recent work in the style of the Lingnan School (see chapter 5). After celebrating his eightieth birthday to much acclaim in Hong Kong, he returned as a titular professor to the South China Institute of Literature and Art (Huanan wenyi xueyuan) in Canton, where he died in 1952. Although he was a competent and assured oil painter, particularly in his earlier

years, he taught very little, so his contribution to the development of modern Chinese painting was not great. A number of his early oils survive in Canton (plate 6, for example), in deplorable condition.

A more interesting and influential figure in these early days was Li Shutong, who was born in Tianjin in 1880.[7] As a young man he was already interested in Western art and its potential in China when, around 1900, he came under the influence of Cai Yuanpei (see below), who was teaching Japanese at the Nanyang Public School in Shanghai. In 1905 he entered the Tokyo School of Fine Arts in Ueno Park, where he was a pupil of Kuroda Seiki, who had returned from Paris in 1893 to become the leading teacher of oil painting in Japan. Back in Shanghai in 1910, Li Shutong taught art and music in a girls' school, became for a short time art and literature editor for the *Taipingyang bao* (Pacific monthly), and exhibited the pictures he had painted in Tokyo. To judge from poor reproductions—his only surviving work seems to be one watercolor in Tianjin; his last oil, of a woman reclining in a chair, was destroyed in the Cultural Revolution—his early drawings and oils were free and assured (fig. 2.3). By 1912 he was teaching in the Zhejiang First Normal College in Hangzhou. There he devised a course based on that of the Tokyo School of Fine Arts, which included not only Western painting and music but also art history and drawing from the male model.

Li Shutong's innovations were remarkable for the time. At Hangzhou he was the first to send his students out to draw from nature, a procedure so unheard-of that one of them was arrested for conducting what the police thought was an illegal land survey. He was the first to develop the woodcut as an art form, cutting and printing his own blocks along with his student Wu Mengfei. At that time Chinese newspapers carried no graphics; Li Shutong not only introduced graphics into the pages of *Taipingyang bao* but drew them himself (fig. 2.4). He was the first to stress the importance of teaching advertising and commercial art in the art schools. He wrote the first history of Western art for the Chinese reader, though it was never published and the manuscript was lost. A lover of the theater, he wrote some of the first modern dialogue plays in China. He was, finally, one of the first to advocate the reform of Chinese traditional painting.

Li Shutong's pupil Feng Zikai many years later said of him that he was very serious and strict with himself, keeping always before him an inscription with the four characters *shen ben li xing,* "earnestly practice what you preach."[8] In the few years he was at Hangzhou, he laid the foundation for the kind of modern art education that was to flower in the Zhejiang Academy under Lin Fengmian (see chapter 7). In 1915 Pan Tianshou, who would become one of China's finest masters of guohua, stud-

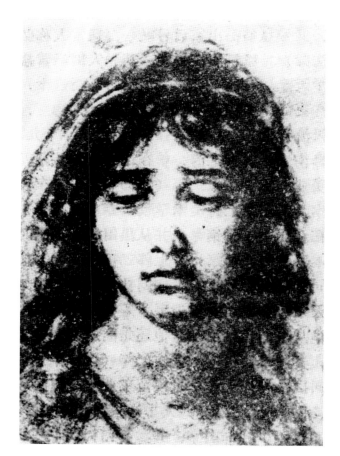

2.3
Li Shutong, *Head of a Girl* (before 1918). Charcoal on paper.

2.4
Li Shutong, designs and titles for Shanghai newspapers (c. 1919).

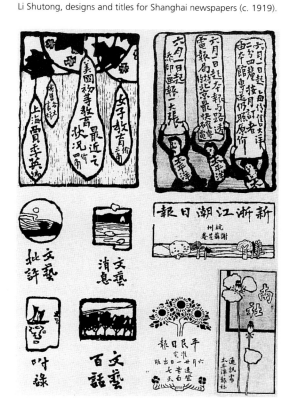

ied Western drawing and painting under Li Shutong, and many artists who were never his pupils, including Xu Beihong and Liu Haisu, felt his influence. Yet, in spite of his own talent and dedication, standards in his school cannot have been very high. When in 1915 he sent a number of his students' paintings to the San Francisco World's Fair, all the Western-style works were rejected.

In 1917 Li Shutong, deeply unhappy at the corrupt and chaotic state of society, quit the school to study Daoism. In the following year, having given away all his worldly goods and shaved his head, he became a Buddhist monk, taking the name Hongyi. Thereafter, although he painted a few Buddhist pictures and continued to practice calligraphy, his career as the first great art educator in China was over. He died in Fujian in 1942.

The art of Li Shutong and other pioneers is not to be judged by the standards of Western art; it does not even bear comparison with what Japanese modernists had achieved forty years earlier. We must rather see them fighting against a dead weight of ignorance, indifference, and hostility such as no Western-style painter in Japan during the Meiji period ever had to face, conscious all the time that while they were trying heroically to revive Chinese culture they were being widely accused of destroying it.

WESTERN-STYLE ART IN SHANGHAI

Before the fall of the Manchus in 1912, Western art was being taught in a small way by the Jesuits in their Tushanwan Arts and Crafts Center (known as "Siccawei" or "Ziccawei") at Xujiahui outside Shanghai. The school, originally an orphanage, was built on the birthplace of Paul Xu Guangqi, the great seventeenth-century Catholic convert and friend of Matteo Ricci. By 1903 it had been incorporated into the new Université Aurore, a tiny institution of higher learning which moved into the French Concession of Shanghai after the 1911 revolution. The main purpose of the Arts and Crafts Center was to serve the needs of the Catholic Church. In his guide to Shanghai, C. E. Darwent writes: "In the painting room boys are taught drawing and tracing, and they copy pictures of ecclesiastical subjects for churches and schools and for private purchasers." And he comments: "Whether the Chinese can be taught to paint imaginative subjects 'out of their heads' or to paint from nature is not settled by the work done here."[9]

Although Darwent does not mention this, I was told by Pang Xunqin many years ago that the Jesuit fathers gave informal tuition in drawing from casts and in landscape painting to several of the pioneers, for Siccawei was one of the few places in China (Canton was perhaps another) where they could pick up some knowledge of Western techniques from Westerners. Among those who spent some time there were Xu Beihong, who, in 1915–16, studied art and the French language, and Xu Yongqing, who later made a name for himself as a painter of calendars.

THE SHANGHAI MEIZHUAN Sometime before 1911 (the date is uncertain), Zhou Xiang, a progressive Qing official who had fled Beijing in 1898 after the failure of the Hundred Days of Reform, founded his own little school, the Shanghai Oil Painting Institute (Shanghai youhua yuan), to provide scenic backgrounds for portrait photographers. Later, combined with his correspondence school for guohua, it became known as the Shanghai Sino-Western Drawing and Painting School (Shanghai zhongxi tuhua xuexiao).[10] Among his pupils were several pioneers of Western art in China: Chen Baoyi, Ding Song (father of the cartoonist Ding Cong), Liu Haisu, and Zhang Yuguang (fig. 2.5), a traditional artist who also picked up some knowledge of Western techniques in Japan and from the Jesuits at Siccawei and was later to head the Xinhua Art Academy, which would play an important role in art teaching in the city.

In February 1912, dissatisfied with what Zhou Xiang's little school had to offer, six of his pupils, headed by Liu Haisu and two lesser figures, rented a house in Baxianqiao and started their own school.[11] Beginning with twelve students, enrollment increased, the founders claimed, to seven or eight hundred. In July 1912 they held their first exhibition in Bubbling Well Road, showing only guohua scrolls, well aware, no doubt, that their Western-style paintings would arouse little respect for Western art in the still hostile Shanghai public.[12]

Like Li Shutong, Liu Haisu and his colleagues introduced life drawing into their classes, beginning in 1914 with a young boy model nicknamed "Monk." In 1915 the bold young Liu held an exhibition of his own and his students' work. Their nude figure studies were attacked by the principal of a Shanghai girls' school as injurious to education, and Liu himself was branded a "traitor in art," a label he never ceased to treasure.

Though spurred on by their search for something new and foreign, the young teachers, as Mayching Kao has noted, were probably just as restless and confused as their students. Nevertheless, by 1915 the school had made its mark sufficiently for it to be registered with the municipality as the Shanghai Painting and Art Institute (Shanghai tuhua meishu yuan). Familiarly known as the Shanghai Meizhuan, and to the cosmopolitans of the French Concession as l'Ecole de Peinture de Shanghai, this institution became, with the Xinhua and Hangzhou academies, one of the three chief centers for the develop-

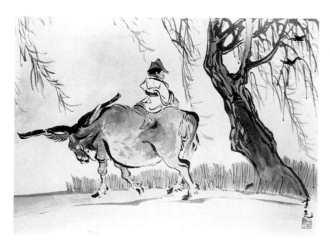

2.5
Zhang Yuguang, *Boy on a Buffalo* (c. 1940–45). Ink on paper.

ment of Western art in China before the Second World
War.

The school moved in that first year from Baxianqiao
to Elgin Road, and again in December to North Sichuan
Road; then in the summer of 1914 once more, to
Haiyunlu. Because of its frequent early wanderings, Xu
Beihong—who studied briefly under Liu Haisu, al-
though later he would never admit it—contemptuously
called it a *yeji xuexiao,* or "wild chicken [i.e., street girl]
school."[13] But no one could deny its success. The
Shanghai Meizhuan was the true birthplace of modern
art in China, owing largely to Liu Haisu's courage, en-
ergy, gifts as an organizer, and total freedom from prej-
udice against any particular school of painting.

Another influential figure in the early Western art
movement was Chen Baoyi (fig. 2.6).[14] Born into a
wealthy business family in Shanghai, he entered Zhou
Xiang's little academy in 1912, a fellow student with Liu
Haisu and Zhang Yuguang. In the following year he
went to Japan, where he spent most of the next eight
years, studying under (among others) the distinguished
oil painter Fujishima Takeji, who had spent several years
in Paris. In 1921 Chen graduated from the Tokyo Acad-
emy and returned to Shanghai to set up his own studio.
Thereafter he taught for many years in various art schools
in the city and became a leading spirit in the Dawn Art
Association (Zhenguang meishu hui), a very successful
atelier with three hundred members; they employed a
White Russian model in their life classes, as the Chinese
were rarely willing to pose. Chen's 1926 book, *Youhua
fazhi jichu* (Foundations of oil painting technique), was
widely read. By this time he was so well known that a
documentary film was made about him by the drama-
tist Tian Han.

During Chen Baoyi's brief return to Shanghai in 1915
he had joined the Eastern Art Association (Dongfang

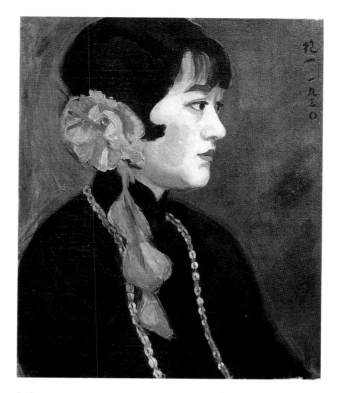

2.6
Chen Baoyi, *Portrait of the Painter Guan Lilan* (1930). Oils.

huahui), or Institute of Pictorial Arts, which had been
founded in the previous year by Wang Yachen (another
of Zhou Xiang's former students) and his friends for the
study of Western painting. Although it soon closed be-
cause so many of its members went off to Japan, its very
existence was a sign of the direction young artists'
thoughts were taking. The director was Gao Qifeng, one
of the pioneers of modern painting in Canton (of
whom more in chapter 5). His brother Gao Jianfu,
meantime, had returned from Japan to establish the
Zhenxiang huabao (The true record, or Revue artistique
de la réalité), one of the first journals in China to pro-
mote Western art. It ran from May 6, 1912, to March
6, 1913. The cover of the first issue, set in an art nou-
veau border and depicting an artist in velvet coat and
floppy cravat painting the journal's title against a back-
ground of cows, shows how quickly—if, compared
with Japan, how belatedly—the novel Western notion
of the artist as bohemian had caught on.

By the end of the second decade of the twentieth cen-
tury, urban Chinese were becoming a little familiar with
Western styles in art—although most of what they saw
was so bad that they might well have wondered how it
could possibly become a challenge to their own tradi-
tion. Even before 1911 the first public exhibitions had
been held. In the autumn of 1908, if the memory of

Yan Wenliang (see below, p. 48) in old age is reliable, he exhibited at the Industrial Exposition in Nanjing a colored pencil drawing of the Suzhou railway station.[15] A privately sponsored exhibition, chiefly of arts and crafts but including oil paintings sent up from Canton, was held in Shanghai in 1908–09. Jiang Danshu recalled the Nanjing exhibition of 1910, in which Western-style oils, watercolors, and pencil sketches were displayed—not in the fine art section with the scrolls but in the hall of education, together with maps, charts, mechanical and geometric drawings.[16] Western art, in the eyes of the organizers, was not art at all. It had its practical uses, but was not to be seen in company with Chinese painting.

CAI YUANPEI AND THE CULTURAL RENAISSANCE

The tremendous change in attitudes to Western art that took place in the decade after the 1911 revolution was due above all to the influence of a truly remarkable figure in modern China—Cai Yuanpei (Ts'ai Yüan-p'ei, 1868–1940), a dissident Confucian scholar who had joined the Revolutionary Alliance (Tongmenghui) under Sun Yatsen in 1905 and studied philosophy in Berlin and Leipzig from 1907 to 1912.[17] There he had come under the influence of Friedrich Paulsen, who, in the words of William J. Duiker, had "attempted to construct a system of metaphysics which would sound scientifically plausible and satisfy the yearnings of humanity for belief in a core of goodness in the world."[18]

In 1912, while visiting an exhibition of the Berlin Secession, Cai Yuanpei met the critic Wilhelm Uhde and encountered the work of Slevogt, Käthe Kollwitz, Vlaminck, Kandinsky, and Picasso. In Paris three years later, he called on Picasso in his studio, but found no example for China in Cubism.[19] Only Realism, he was convinced, could save Chinese painting.

On the establishment of the Republic in 1912, Cai Yuanpei had been appointed minister of education. He immediately began to make plans for art education and for the establishment of museums and art galleries. In this he was supported by the great short-story writer and polemicist Lu Xun, just back from Japan, whom he put in charge of the cultural section of his social education office. That summer, Cai organized a lecture series for teachers on politics, economics, culture, and art, to which Lu Xun contributed four lectures on art in society—possibly the first public lectures on art ever given in China. In the few months that he held ministerial office, Cai published his five principles of education, in which he ranked aesthetic education equal with utilitarian, moral, military, and world-view education.

In a speech made in 1917, shortly after assuming the key post of chancellor of Beijing University, Cai Yuanpei went even further, proposing that aesthetics be substituted for religion. His wide-ranging thinking was centered on a concept of a "world soul" that could be expressed in Buddhist, Daoist, or Western metaphysical terms. He held that the spiritual world could become manifest to man not through religious experience but in the contemplation of beauty, through which the emotions of love and hate, sadness and joy, are transferred to the object of contemplation. To Cai Yuanpei the understanding of beauty, and thus of harmony, was an ethical activity. His view of the ethical purpose of art was thoroughly traditional, but his assertion that artistic values were universal, crossing all national and cultural frontiers, seemed revolutionary, even shocking, to many of his ethnocentric compatriots, who had hitherto regarded Western culture as barbarian and Western art as little more than a useful technique for representing objects. Though his opponents objected that aesthetic education was no kind of solution to China's urgent problems, his concept of universal aesthetic values took hold, proving a powerful tool in bringing about acceptance of Western art in early twentieth-century China and in firing young artists with the desire to go abroad to study it at first hand.

THE NEW CULTURE MOVEMENT Cai Yuanpei's vision of new values and new attitudes was but part of a movement to regenerate Chinese culture that swept the country in the years after the Revolution and was to have a profound influence, first on literature and not long after on art. Earlier reformers such as Liang Qichao had held that, while the "shell" of Chinese society should be Western and scientific, the "kernel" must remain purely Confucian; a reformed and enlightened imperial system might even survive. The Revolution swept the dynasty away, but that in itself did not bring the millennium. After Yuan Shikai's attempt in 1916 to restore the old regime, for ten years China was torn apart by the struggles of rival warlords. It is against this chaotic and often violent background that the New Culture Movement (xin wenhua yundong) was born.

The opening shots in the battle for cultural reform were fired in September 1915 when, in the first issue of the magazine Xin qingnian (New youth), editor Chen Duxiu made a "solemn appeal" to China's youth to take up the struggle and assume responsibility for creating a new culture. But new ideas and new emotions could not be conveyed in the old literary language; they needed new forms of expression. In January 1917, Hu Shi sent to Xin qingnian from the United States an article in which he demonstrated that, at critical moments in Chinese history, literature and poetry had been revitalized by the impact of popular storytelling and song, and more specifically that

since the Tang Dynasty certain kinds of perfectly respectable poetry had been written in *baihua*, the vernacular, which he proposed be henceforth used for all kinds of writing.[20] Even more radical was the declaration that Chen Duxiu made shortly after Cai Yuanpei appointed him dean of the college of letters at Beijing University, which Hu Shi quotes in *The Chinese Renaissance:*

> I am willing to brave the enmity of all the pedantic scholars of the country, and hoist the great banner of the "Army of Revolution in Literature" in support of my friend Hu Shi. On this banner shall be written in big characters the three great principles of the Army of Revolution:
>
> 1. To destroy the painted, powdered and obsequious literature of the aristocratic few, and to create the plain, simple and expressive literature of the people
> 2. To destroy the stereotyped and monotonous literature of classicism, and to create the fresh and sincere literature of realism
> 3. To destroy the pedantic, unintelligible and obscurantist literature of the hermit and the recluse, and to create the plain-speaking and popular literature of a living society.[21]

Not surprisingly, the horrified conservatives accused Hu Shi and Chen Duxiu of striking at the very heart of Chinese culture. Cai Yuanpei threw his considerable weight behind the progressives, and for five years the struggle between old and new raged in the hundreds of new periodicals that sprang into existence all over China. The outcome was inevitable, for, as the name *Xin qingnian* implied, the reformers had youth on their side. The new universities had become the bastions of educated and informed opinion, and both staff and students were solidly behind the reform of the language. Here at last were the means of expressing the overwhelming emotions that the Revolution had both generated and set free. Some of these impulses were too intoxicated with the new freedom to have much lasting value as literature, chief among them the idea of *ziwo*—"I myself"—in which thoughts, emotions, and impressions, however trivial or ill-digested, were spilled out without restraint, as in these Whitmanesque lines from Guo Moruo's *Heavenly Hound:*

> . . . I am the splendour of the moon,
> I am the splendour of the sun,
> I am the splendour of the myriad stars,
> I am the total energy of the Universe.
>
> I run swiftly,
> I cry wildly,
> I burn fiercely.
> I am I!
> My ego is about to burst![22]

These romantics were much influenced by the Japanese "I-novel" (*watakushi shosetsu*), which Merle Goldman has described as "a unique form of Japanese naturalism characterised by . . . an unrestrained self-revelation, intense lyricism, and occasional self-pity, and by a sentimental search for the so-called *kindai-jiga* (modern selfhood)."[23] Traces of this sentimentalism and subjectivity can be seen in Chinese literature, poetry, and painting even today.

Indeed, the example of Japan could not be ignored, whatever Chinese feelings might be about the island race. In the first two decades of the twentieth century, Japanese novelists had explored every type of Western fiction, from tragic to social realist to autobiographical. Writing in 1918, Lu Xun's brother, Zhou Zuoren, declared, "If we want to remedy the sick condition [of our fiction] we have to free ourselves from the past tradition and, before anything else, imitate others wholeheartedly. Only through the process of imitation can we hope to create an original literature of our own. Japan is an example. . . . The condition of Chinese fiction at this moment is similar to that of 1884 or 1885 in Meiji Japan. The surest and most appropriate task for us right now is, therefore, to promote the translation and studies of foreign works. . . . In sum, if we Chinese want to develop our new fiction, we ought to start from the very beginning."[24] For Chinese painters, who inherited an incomparably richer tradition than did the novelists, to start again from the very beginning was not easy. Yet many artists became convinced that this was just what they had to do.

THE NEW LITERARY SOCIETIES The question of what was to be done with the new freedom they had acquired, what aims were to be expressed and in what form, now engaged writers in long and often bitter controversies which came to be known as *lunzhan,* the battle of the books, which greatly stimulated the growth of a new literature. "We believe," declared a manifesto of 1919 in *Xin qingnian,* "that politics, ethics, science, the arts, religion, and education should all meet practical needs in the achievement of progress. . . . We have to give up the useless and irrelevant elements of traditional literature and ethics, because we want to create those needed for the progress of the new era and new society."[25]

It was writers who took the lead, but some at least of the artists and art critics, fired by the same ideals, were not far behind. A writer in *Xin qingnian* insisted that the revolution in art must go hand in hand with the revolution in literature: "Down with the Four Wangs!" he cried, referring to the four famous scholar painters of the early Qing. "Down with the Temple of the Confucians!" But it was easier to attack traditional painting than to replace it. Unlike the writers, the painters had no liv-

ing vernacular tradition on which to found a new art movement.

As the traditionalists watched helplessly while history overtook them, the ideological struggles which as yet had only just begun to touch the visual arts were fought out between liberals and romantics on the one side and believers in the writer's total commitment to political and social reform on the other. In January 1921, Mao Dun and Zheng Zhenduo in Beijing had founded the Literary Research Society (Wenxue yanjiuhui), proclaiming a new humanist approach to writing. Rejecting both the form and the content of traditional literature, they aimed, through original fiction and translations of such Western realists as Tolstoy, Gorky, Turgenev, and de Maupassant, "to describe the darkness of society and solve problems by analysis."[26]

Six months after the founding of the Literary Research Society, a group of young writers who had returned to Shanghai from Tokyo, including Yu Dafu, Guo Moruo, and Cheng Fangwu, founded the Creation Society (Chuangzao she) and launched a journal dedicated to creative writing and art for art's sake. Its tastes were catholic: it featured, in addition to original fiction, translations from Tagore, Walter Pater, Rossetti, the Yellow Book writers (chiefly Oscar Wilde), Maeterlinck, and Shelley. Guo Moruo (Kuo Mo-jo), at that time an ardent young Romantic, attacked the Literary Research writers for vulgarity and minor errors of translation, proclaiming that "art, like a spring breeze rippling the surface of a lake, has no real aim."[27] A true ivory tower (xiangya zhita) school, the Creationists demanded the separation of literature from social doctrine, for, said Cheng Fangwu, echoing the theories of Cai Yuanpei, "the genuine artist is dedicated to perfect beauty, since in beauty lies truth and virtue itself."[28]

Guo Moruo's conversion to Marxism in 1924 heralded an important shift in the direction of the Creation Society.[29] Gradually the more progressive members, among them the young oil painter Ni Yide, gained a stronger voice, using the society's journal as a "public platform for youth," to attack "whatever hinders the development of youth's mind—in thinking, life, politics, and economics." It was these young radicals who began to promote "proletarian literature." By 1928, the Guomindang persecution of the Left had driven many of them into the Marxist camp. Romanticism, among the writers if not the artists, was going out of fashion.

In 1925 Tian Han quit the Creation Society to take a professorship at the Shanghai University of Arts (Shanghai yishu daxue), which he later made the base for his theater and film projects (including the documentary on Chen Baoyi referred to above). Two years later he resigned to found the short-lived Nanguo Art Academy (Nanguo yishu xueyuan), which included an embryonic art department. The French Concession intelligentsia knew it as l'Académie du Midi. The young bohemians could imagine they were living not in the urban jungle controlled by Du Yuesheng's Green Gang that was Shanghai, but in some imagined corner of Montmartre or the Left Bank.

To show their liberation from the chains of Chinese literary tradition, many of these writers, as Leo Lee has noted, identified themselves with some figure in world literature.[30] Tian Han called himself "a budding Ibsen in China"; Yu Dafu, the very epitome of sophisticated decadence, found a kindred soul in Ernest Dowson, Xu Zhimo in Tagore, Guo Moruo in Shelley and Goethe. Did Xu Beihong see himself as China's Delacroix, or Bastien-Lepage perhaps? To be sure, Liu Haisu may well have called himself, as he was called by others, China's van Gogh.

The last of these glittering constellations of literary talent flared with special luminosity, though it was soon to be extinguished too. In 1925 Xu Zhimo returned from England, his head full of the beauty and freedom of Cambridge and of his never-to-be-forgotten encounters with Thomas Hardy and Katherine Mansfield, Bertrand Russell and Roger Fry, and founded a literary club in Beijing chiefly composed of returned students from Britain and America.[31] When the approaching Northern Expedition of Chiang Kaishek closed the universities in 1927, Xu Zhimo and his friends took refuge in Shanghai. The first issue of their journal Xin yue (Crescent moon—the name was borrowed from Tagore), which appeared on March 10, 1928, contained (along with his portrait of Hardy) a truly terrible oil painting by Xu Beihong entitled Forward!, depicting a naked Atlanta figure with arm upraised, attended by lions. The pose, minus the lions, seems to be copied from that of the aristocrat in Thomas Couture's The Enrollment of the Volunteers, studies for which Xu could well have seen in the museum in Beauvais. As for the lions, Xu Beihong had spent months drawing lions in the Berlin Zoo.

The founders of the Crescent Moon Society, Xu Zhimo and Wen Yiduo, demanded the restoration to poetry of the discipline of form and diction that had been an early casualty in the war against the dead past. They advocated the introduction of the Western lyric and sonnet forms, in which they both wrote with great intensity of feeling and richness of imagery: Wen Yiduo's celebrated "Dead Water" of 1928 well reflects his dictum that poetry should embody the three arts of music (in sound), painting (imagery), and architecture (structure). Written in 1926, when he was a reluctant dean in the politics-ridden Beijing College of Fine Arts, it is also a cry of despair at the hopeless state of China.

It begins:

> Here is a ditch of dead and hopeless water;
> No breeze can raise a ripple on it.
> Best to throw in it scraps of rusty iron and
> copper,
> And pour out in it the refuse of meat and soup.

And it ends:

> Here is a ditch of dead and hopeless water,
> A region where beauty can never stay.
> Better abandon it to God—
> Then, perhaps, some beauty will come out of
> it.[32]

Both the strength and the weakness of the Crescent Moon movement stemmed from its close spiritual and artistic ties with Europe. Although it had a considerable influence on the development of modern forms of Chinese poetry, it was unable to survive the political polarization of the arts in the early 1930s and the death of Xu Zhimo, its leading spirit, in an air crash in 1931.

By this time, many artists had become caught up in the ideological battles that writers and intellectuals had been fighting for the last ten years. They too found themselves torn between the demands of a newly discovered self-expression, the problems of form and technique such as engaged the Crescent Moon writers, and the challenge, now becoming ever more clamorous, to use their talent not for their own or for art's sake but for the sake of society.

THE CALL OF THE WEST

Even before the 1911 revolution, adventurous young Chinese artists had gone abroad to study Western art. Li Yishi went to Japan in 1903 and in the following year on to Glasgow;[1] Li Shutong went to Japan in 1905, Gao Jianfu and Chen Shuren in 1906, Gao Qifeng in 1907. With the revolution, the movement gathered pace. In 1912 Li Chaoshi set off for Paris. Two years later, the new "diligent work and frugal study" program was launched by Cai Yuanpei. After World War I ended in 1918, many students were sent to France under this program. One of its achievements was the establishment in 1921 of the Institut Franco-chinois at the University of Lyon, where the oil painter Chang Shuhong was a distinguished student.[2] Also in Li Chaoshi's party were the young revolutionary Wang Jingwei, the thirteen-year-old Fang Junbi with her family, and the man she was later to marry, Zeng Zongming, who became secretary of the Institut Franco-chinois.[3] Fang Junbi later claimed that she was the first Chinese woman student at the Ecole des Beaux Arts, and the first represented in a Paris Salon. She did not return to China until 1925.

During these early years students learned about Western art through poor reproductions and articles in magazines. In the first issues of the journal *Dongfang zazhi* (Eastern miscellany), in 1912, Yao Baoming had written appreciatively of the work of Dürer, which he had seen in Berlin, and had even tried to describe the work of the German Expressionists, which must have utterly bewildered his readers. In the same year Lu Xun's brother Zhou Shuren published in *Zhenxiang huabao* a series of articles tracing and comparing the histories of Western and Eastern art, contrasting the main trends of realism and idealism in nineteenth-century European painting, and discussing the leading masters from David and Ingres to Constable, Manet, Whistler, and the Impressionists.[4] In 1916 the Commercial Press published four volumes of color reproductions of European paintings, but the quality was very poor. Of original Western works of even average quality in China there were almost none. Perhaps the nearest the students could get to appreciating the true flavor of Western art was provided by the books and reproductions sold in at least two bookshops in Shanghai, and by reproductions of the works of Japanese oil painters that students brought back from Tokyo.[5]

By 1917 Lu Qinzhong was introducing into the pages of *Dongfang zazhi* theories of Western modernism, including Cubism and Futurism, which he said had been popular in Japan for a decade but were quite unknown in China. The students' appetite was further whetted in 1918 when Cai Yuanpei established the Beijing University Society for the Study of Painting Methods (Beijing daxue huafa yanjiu hui), to which he lectured on art, both Eastern and Western.

With so many novel ideas, styles, and movements assailing their eyes and minds all at once, ambitious young Chinese art students knew they would never really understand Western art until they had studied it at first hand. During World War I, though, Europe's doors were closed, while within a few months of the armistice many of these young artists were swept up in the May Fourth Movement, the nationwide protest against the terms of the Treaty of Versailles, under which the victorious Allies had granted to Japan the former German Conces-

sions in China. Patriotic passions spilled out in student demonstrations across the breadth of the country. A heightened national consciousness and violent anti-Western feeling became interwoven with the equally urgent desire to reject traditional culture and embrace that of the West.

Europe being still inaccessible, Japan was the destination of choice for ardent young artists eager to explore new styles and traditions. Xu Beihong set off for Tokyo in 1917, but he ran out of funds in a few months and had to come home. The ever enterprising Liu Haisu went in 1918 and stayed in Japan for a year. He got to know many leading artists, and managed to be present at the official opening of the Imperial Fine Arts Academy (Teigoku geijutsu in) in Tokyo. The Cantonese painter Ding Yanyong spent 1919 to 1925 in Japan, attending first the private Kawabata Academy and later going on, as did several others, to study at the Tokyo Academy, at which he is said to have carried off a first prize. He later became a noted eccentric artist in the Chinese brush.[6] Another Cantonese, Guan Liang, studied oil painting under Fujishima Takeji, Kuroda Seiki's successor, from 1918 until 1922 or 1923—although he was later to make his much-inflated reputation as a painter of Chinese opera scenes in the traditional medium. He was a passionate opera fan who loved to dress up and perform.

From the mid-1920s, visits to Japan tended to be fewer and shorter. Ni Yide, who had helped to radicalize the Creation Society and was later to play an important part in the Storm Society (see below, page 62), studied from 1927 to 1928 in the Kawabata Academy. Even in this short time he managed to organize the Art Research Society for Chinese Students in Japan (Zhongguo liuri meishu yanjiu hui), which shows that there were still quite a number of them, although few, apart from those I have mentioned, were to make much of a mark after their return to China. Nevertheless, Li Dongping was able to organize in the French Concession of Shanghai an exhibition of realistic and modernist oil paintings by young artists, most of whom had recently studied in Tokyo. The group he formed, the Chinese Independent Artists Association (Zhonghua duli meishu xiehui), soon split up, the modernists staying with Li in Shanghai while the academic realists departed for Canton.

WEN YIDUO

Although many Chinese still admired Japan and took her modernization as their model, anti-Japanese feeling kept many others away. If after the May Fourth Movement young artists still went there, it was mainly because they had had Japanese-trained teachers, and because, in com-

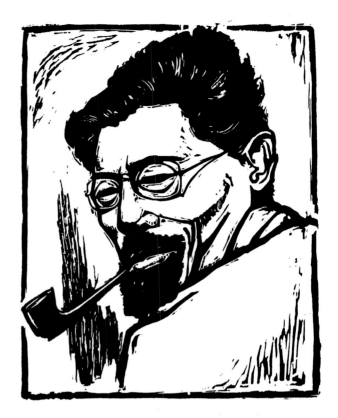

3.1
Xia Ziyi, *Wen Yiduo* (1946). Woodcut.

parison to Paris, Tokyo was closer, cheaper, less frighteningly alien, and they could at least read the language, if they could not speak it. But there were other possibilities also. One of the few to go to America was Wen Yiduo (fig. 3.1), who years later was to achieve fame as a scholar, poet, and anti-Guomindang dissident.[7] While a student at Qinghua University in Beijing in 1920–21, he had already shown considerable talent as a draftsman and designer in the covers he drew for the university annual. In July 1922 he sailed for the States, where he enrolled at the Art Institute of Chicago, studying oil painting and immersing himself in English and American literature and poetry. A year later, lonely and depressed, he left to join his friend Liang Shiqiu at Colorado College in Colorado Springs, where, an American student later remembered, his work was "meticulous and beautiful. . . . He had a feeling of rhythm of line and color that was so natural and easy."[8] From September 1924 to May 1925, Wen Yiduo was enrolled in the Art Students' League in New York. As a book illustrator, he was skillful and inventive (fig. 3.2).[9]

On returning to China that summer, Wen Yiduo became dean of instruction in the Beijing Academy of Art.

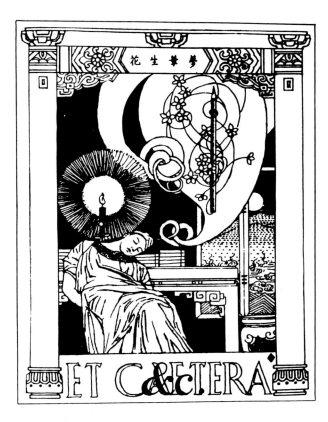

3.2
Wen Yiduo, design for the cover of *Et Caetera*.

students from Beijing to Kunming in 1938 (see chapter 9), he made pencil sketches along the way.

Very few of his works survive. One that existed until very recently (and may still) is his painting of the beautiful Feng Xiaoqing, a girl of the late Ming period who was confined by her husband's jealous first wife, poured out her sorrow in poetry, and, dying at the age of eighteen, asked a portraitist to paint her, which he did many times. Together Wen Yiduo and the novelist Pan Guangdan visited her grave, and Wen's picture of her sitting languidly before her mirror, intended as a frontispiece to Pan's novel about her, may be his only painting to survive in China (plate 7). Wen Yiduo was a great admirer of the impressionists, particularly of Cézanne, but he seems to have influenced his students more by his scholarship, his poetry, and his heroic political stand than by his painting, although this 1927 work has a curiously haunting individuality that hints at what he might have achieved had he stuck to painting.

THE LURE OF FRANCE

From the moment peace was declared in Europe, Paris was the goal—or the unfulfilled dream.[11] One of the first to make this expensive, fearful, and exciting pilgrimage was Lin Fengmian, who left for France under the work-study scheme in 1919, studied for a while in Dijon, and in 1920 entered the Ecole des Beaux Arts in Paris, where he worked in the atelier of the very academic Fernand Cormon (1854–1924), history painter, portraitist, and teacher of Gauguin. Xu Beihong's patron, meanwhile, had sent him to Europe in 1919 on a Japanese cargo boat.

Pan Yuliang set off for France with a scholarship after graduating from the Shanghai Meizhuan in 1921.[12] As a girl, she had been consigned to a brothel following the death of her parents. She had been rescued by Pan Zhanhua, whose concubine she became through a wedding ceremony (her original surname was Zhang); upon discovering that she had artistic talent, he had paid for her to study in Shanghai under Liu Haisu. She studied first in Lyon, then under Lucien Simon in Paris, and finally in 1925 in Rome, where Liu Haisu on a visit invited her to return to teach at his academy.

One artist who chose not to go to Paris—at first— was Zhang Daofan, who studied in London from 1921 to 1924 and is said to have graduated from the Slade School of Art.[13] He then spent two years at the Ecole des Beaux Arts, where he made the sensitive drawing illustrated here (fig. 3.3). On his return to China he taught both Chinese and Western art, painted in a stiff synthetic style, wrote plays, translated an essay by W. G. Constable on recent European art, and devoted himself increasingly to academic administration and to developing cultural

This is how his friend Xu Zhimo described his courtyard home in a poetry journal they launched together:

> The three studio rooms were decorated with unusual taste. He fixed all the walls black, highlighting them with a narrow gold strip. The effect was like a naked African beauty wearing only a pair of gold bracelets and anklets. In one of the rooms a niche was carved in the wall, in which was placed, naturally, a sculpture of Venus de Milo about a foot high. . . . Against the totally black backdrop, the soft and warm-colored marble statue was rich in dreamy suggestiveness. . . . At dusk, shadows would invade the rooms, bringing in footprints of Mephistopheles to walk all over the place. The interplay of light and shadow during the night would present strange images of unrecognizable forms.[10]

By the time of his assassination by Guomindang agents in Kunming in July 1946, Wen Yiduo had long given up painting and *la vie bohème* for poetry, scholarship, and political activism, although in 1927 he had attempted to portray, in a large composition in oils that has since been lost, the horrific Guomindang suppression of student dissent. During the long trek with his

3.3
Zhang Daofan, *Nude* (1925). Ink on paper.

policies for the Guomindang government, retiring with Chiang Kaishek to Taiwan in 1948.

To the serious students who managed to get to Paris, a number of choices were open, according to their talent and, more important, their means. Those gifted and wealthy enough could secure formal entry to the Ecole Supérieure des Beaux Arts and qualify for its diploma, while those who could not afford its fees could still enroll as *élèves libres* (free students) and use the school's models and facilities. Outside its doors lay the independent studios of masters such as Cormon and Pierre-Adolphe-Jean Dagnan-Bouveret (1852–1929), a pupil of Gérôme and Corot, influenced also by Bastien-Lepage; Xu Beihong became his devoted disciple.

Many foreign artists, denied the privilege of working with a master or too independent to tolerate the salon atmosphere, joined l'Académie Julian, a huge atelier founded by a tough gentleman who looked like, and probably was, an ex-boxer, and who managed to persuade a number of leading masters to drop in and teach there. As Sir William Rothenstein remembered it, "Our easels were closely wedged together, the atmosphere was stifling, the noise at times deafening. Sometimes for a few minutes there was silence; then suddenly the men would burst into song. Songs of all kinds and all nations were sung. The Frenchmen were extraordinarily quick to catch foreign tunes and the sounds of foreign words. There was merciless chaff among the students, and frequently practical jokes, some of them very cruel."[14] Julian died in 1907, and by the time the Chinese artists arrived in the 1920s and 1930s the atmosphere had become a good deal more sober and serious; but it must still have been very intimidating for the innocent young art student fresh from Shanghai.

For those who could not even afford the modest fees (paid in advance) of Julian's academy, there was La Grande Chaumière, a cheap, crowded atelier that provided only a model—and warmth in winter for those lucky enough to be able to work their way closer and closer to the enormous stove.

THE STRASBOURG EXHIBITION By 1924 the Chinese art students in France were gathering to launch societies and journals to promote modern Chinese art.[15] A group that included Lin Fengmian, Li Jinfa, Wu Dayu, Wang Daizhi, Zeng Yilu, and Cai Yuanpei's son-in-law, Lin Wenzheng, founded the Opus Society (Huopusi hui) for students of art history and aesthetics. It later changed its name to the Apollo Society (Yapole hui), later still to the "Overseas Art Movement Society" (Haiwai yishu yundong she). The same group also set up the Société Chinoise des Arts Décoratifs à Paris (Meishu gongxue she). Their greatest achievement was the exhibition held from May to July in the Palais du Rhin in Strasbourg.[16] The moving spirit behind this important event was, once again, Cai Yuanpei, in Paris at the time, who as honorary chairman of the preparatory committee wrote the introduction to the catalogue. In his address at the formal opening ceremony, which was attended by French officials in morning coats and top hats, Cai said that as the West had since the Renaissance adopted some elements of Chinese painting, Chinese artists must now learn concepts and techniques from the West. The

works in this exhibition, he declared, showed how successfully Chinese artists had achieved a synthesis of the Chinese and Western traditions. Cai was perhaps claiming too much: the best works were either wholly in one tradition or in the other. The efforts of some artists, such as Fang Junbi, to paint "Chinese" pictures in oils were not very successful.

The exhibitors, coming from France, Belgium, Germany, and Italy, included artists (such as Xu Beihong and, surprisingly, Fang Junbi) who offered works in the traditional style, but most of the paintings were in oils or watercolor. The oils included an elaborately composed painting by Liu Jipiao of the Tang beauty Yang Guifei stepping naked from her bath, done in the salon style of Bouguereau and Couture. Lin Fengmian's most ambitious work was a freely, even passionately painted group of the great thinkers of the world, entitled *Groping in the Dark,* which he had recently completed in Berlin. Lin, with his insatiable appetite for modern art, here showed that he was, for the moment at least, under the spell of German Expressionism. This huge picture made a deep impression, not least on Cai Yuanpei, who was soon to give the young artist his strong support and encouragement.

The Strasbourg exhibition (which included over a thousand items of painting and sculpture, calligraphy and crafts) and the meetings that accompanied it gave the young Chinese artists and designers who took part the exhilarating feeling that they were at the very center of the New Art Movement (*xin yishu yundong*). "The ancient art of China," they declared, "urgently awaits reorganisation. The artistic theories of East and West urgently await harmonious synthesis and study, and the new art of the future urgently awaits creation."[17] Now, at last, they had a mission. Yet the exhibition itself did little to improve the image of modern Chinese art in French eyes. The Chinese critic Li Feng frankly admitted that by comparison with that of Japan, Chinese art and culture were held in low esteem in Europe. The Japanese government, he wrote, was already preparing for the 1925 Exposition Internationale, while the Chinese authorities seemed unaware of its existence.[18] As it turned out, the Chinese contribution to that event seems to have consisted chiefly of decorative arts and antiques provided by dealers in Paris, London, and Shanghai to showcase their goods.

In 1933 Zhou Ling, a student of literature, became chairman of a reinvigorated Association des Artistes Chinois en France (Zhongguo liufa yishu xuehui), which had been founded in the 1920s. Its thirty members included the painters Lü Sibai, Li Fengbai, Tang Yihe, and Chang Shuhong, who was later to make his name as director of the Dunhuang Research Institute (see page 106); the sculptors Liu Kaiqu and Hua Tianyou; and the painter-sculptors Wang Linyi and Wang Ziyun.[19] As new members joined, others returned to China, where, as Zhou Ling put it in the foreword to the catalogue of the society's 1947 exhibition, "They all work with a profound memory of French friendship and the radiance of French art."

THE EUROPEAN EXPERIENCE Not all the Chinese students worked in Paris. Lin Fengmian, for instance, spent six months in Dijon. Lyon had been the main center for Chinese students in France since the founding in July 1921 of the Institut Franco-chinois, of which Cai Yuanpei was joint president; art students were of course a small minority. By 1926–27, five Chinese were studying in the local Ecole Nationale des Beaux Arts. In 1930, Chang Shuhong carried off no less than five first prizes for drawing, while Wang Linyi won a first and a third for sculpture, Lü Sibai a first and four seconds for painting and drawing. Chang Shuhong, in fact, was something of a star. At the Lyon Spring Salon of 1934 his reclining *Nude* in oils was bought by the state, the first time that *any* student at the Lyon Academy had been so honored.[20]

But life for the poor Chinese art student in France was no bed of roses. In a lecture he gave on the work-study movement in 1933, Hu Shi said, "Thousands of young men deserted their families and ran away to seek their new education and new life in post-War France, only to find no work and no employment open to them, and to find themselves stranded in a strange land. Some of them had to request their families to send them money; others simply drifted or landed in the midst of radical revolutionaries and communists."[21] Their problems began long before they reached Europe. Wu Guanzhong later recalled how the Chinese students sailing fourth class clubbed together to raise a tip for the ship's steward, only to have it rejected with contempt.[22]

In the winter of 1920–21 Xu Beihong, studying in Paris, suffered so severely from hunger and cold that his health was permanently damaged; he had to settle for two years in Berlin, where living was cheaper.[23] In 1935 the sculptor Hua Tianyou fainted from hunger in the Paris métro, but after three weeks in hospital he was back at work, and before he returned to China in 1948 he had won bronze, silver, and finally gold medals at the Salon.[24]

There were other difficulties for the foreigners. At the Ecole Supérieure, first-year students had to pose for the life classes; when it came the turn of Fang Ganmin, he pleaded, extremely embarrassed, that it was not the custom in the East to display one's naked body before others, so they let him off. And although Paris was one of

the most liberal cities in Europe, some Chinese students encountered racial prejudice. When Huang Zhixin, Cai Yuanpei's nephew, took his French girlfriend to a café, the other customers (thinking he was Vietnamese) stared with frigid disapproval and complained that the girl shouldn't go out with colonial subjects.

For the painter-sculptor Liao Xinxue, it seems, nothing existed but his work.[25] After long celibacy, he fell in love with a girl. On their wedding day, he prepared a dinner and went down to his studio to work. When, some hours later, he remembered his wedding, he dashed upstairs, only to find that everyone, including his bride, had left. He never tried again. Many Chinese art students, less talented or less single-minded, took odd jobs or led aimless and unhappy existences on the fringes of Montmartre and the Quartier Latin, returning eventually to China to abandon painting altogether. Only the handful of successes are remembered today.

A few years before he died in 1985, Pang Xunqin recorded his memories of his years in Paris from 1925 to 1930.[26] He was introduced into a French family by Li Fengbai, one of the few Chinese to gain admission to the Ecole des Beaux Arts, and Pang studied everything he could with equal enthusiasm—but chiefly music, until a Polish musician friend tactfully told him he was wasting his energies. "I silently sat down at the piano," Pang recalled, "and almost unconsciously placed my hands on the keyboard. I gazed intently at my hands, my fingers. And then I thought that I would soon be twenty. . . . It was too late to study music, too late! I was depressed and dejected for a day. Then my mind was at rest. Henceforth I would devote myself to painting."

Pang resumed his study at l'Académie Julian, copying painting after painting, until another Polish friend, after watching in silence, told him, "It's no good your spending all your time copying. This artist has painted so many pictures. Are you going to copy them all? You should use your brush to express your own feelings." Following the advice of the very independent Zhang Yu (see page 203), Pang then quit l'Académie Julian and went to work at La Grande Chaumière, which provided a model but nothing else—which did not worry Pang, who wrote that in any case one learned far less from one's teachers than from one's friends, of whom he had many. One, a Chinese pedicurist who treated Mistinguett every night before she went on stage at the Moulin Rouge, told Pang that several struggling artists had gotten recognition by showing their works to the famous dancer and offered to introduce him. But Pang would have none of it. If one couldn't establish oneself by one's own efforts, he thought, all else was in vain. There were no shortcuts.

Pang Xunqin knew that the time to go home was approaching. His friends tried hard to dissuade him: "There is no second Paris," they told him. In Paris he could keep body and soul together by selling a painting from time to time; who would buy his pictures in China? But he returned to Shanghai, armed with a letter from Liu Haisu introducing him to Wang Jiyuan, who had recently set up an art "research institute." Pang held an exhibition there of the pictures he had painted in Paris. He was so discouraged by its reception that he burned almost all of them and retired for a year to his family home in the country. He was to take a rather different direction when he resumed work, as we shall see. Of his Paris paintings, only one survives (plate 8).

If the Chinese artists' experience in Paris was exciting and stimulating, it was also profoundly bewildering and unsettling. They had come to learn to draw and paint in the Western manner—but what *was* the Western manner? The application of color on a foundation of *dessin* that Xu Beihong had learned from Cormon was but one of the many ways they found, and now the most discredited. Lin Fengmian, more aware than most, wrote almost in despair, "I cannot understand why there are so many styles in Paris." Kohara's comment is apt: "If Lin Fengmian, having studied in Paris for seven years, could not understand Western painting, it is not hard to imagine how difficult it was for Chinese painters in the Concessions in Shanghai to do so."[27]

CENTERS OF MODERN ART

BEIJING

Until the mid-1920s, Beijing was the battleground of the New Culture Movement, dominated by Cai Yuanpei and the staff and students of Beijing University. Reformers old and young, cosmopolitan intellectuals, writers and artists—all were drawn to the city. There in 1922, for example, Liu Haisu met Kang Youwei and Hu Shi; Wen Yiduo painted a portrait of Liang Qichao; Xu Zhimo gave a dinner for Liang Qichao, Wang Mengbai, Yao Mengfu, and Hu Shi. The National Beijing College of Art (Guoli Beijing meishu xuexiao), ancestor of today's Central Academy of Fine Arts, had been opened there in 1918 as the first national art school. By 1919 it had become an academy (*xueyuan*), with departments of guohua, design, and *xihua* (Western-style painting), where Wu Fading, just back from Paris, taught oil painting. In 1925, now known as the Beijing Art College (Beijing yishu xuexiao), it added departments of music and drama. In 1920 Cheng Jin, a traditional painter who had learned about Western art in Tokyo, gave a series of lectures at the academy on impressionism, post-impressionism, cubism, fauvism, and futurism. It would be interesting to know how he illustrated these lectures and what his audience thought of them, but no record seems to have survived.

In 1918 Cai Yuanpei, recognizing that there were hundreds of young men and women longing to study art who could not afford to do so, set up with Hu Shi the After Hours Painting Research Society (Yeyu huafa yanjiu hui), under the aegis of the Diligent Work and Frugal Study Association (Qingong jianxue hui). His staff included Li Yishi, Wu Fading, and Xu Beihong,

just back from Tokyo, who produced a journal, *Huixue zazhi*. Among the After Hours school's early students was Li Kuchan, who later abandoned Western painting to become a master of guohua. Two years later Beijing University set up its own Common People's Night School, where in addition to regular subjects poor students off the streets could study such things as boxing, dancing, sewing, painting, and drama. Another after-hours school, started by Beijing University students, was a more haphazard affair.

The heady years of the May Fourth Movement saw intense activity in the art world. Two organizations for the promotion of Western art came into being in Beijing in 1922: the North China Academy (Huabei xueyuan), founded by Cai Yuanpei, and the Apollo Art Society (Yapole meishu xiehui), established by Wang Ziyun, Wu Fading, and Li Yishi, in whose house they held their meetings. The society's second exhibition was attended by Lu Xun, while at its third Wu Fading showed his *Heroes of Qinglongqiao,* a large oil painting depicting an incident in revolutionary history; its size and dramatic realism caused something of a stir. In 1924 the society became a "research institute" (*yanjiu suo*), while in the same year the Beijing Art Institute (Beijing meishu xueyuan) was founded by Wang Ziyun and Wang Yuezhi, a Taiwanese who had graduated from the Tokyo School of Fine Arts in 1921 and joined the Apollo Society.[1] He later taught briefly (1928–30) in the Hangzhou Academy, returning to spend the rest of his short life in Beijing. He was an eclectic artist, at one stage strongly influenced by the *nihonga* style.

LIN FENGMIAN AND THE BEIJING ACADEMY Early in 1926 Lin Fengmian, stepping off the boat at Shanghai on his return from Europe, was astonished to be greeted by people waving small banners bearing the legend "Welcome, President Lin!" He had missed the telegram sent him by Yi Peiji, Minister of Education, appointing him principal in absentia of the Beijing Academy—principally as a device to prevent Chen Yanlin, unhappy with the title of vice president, from being confirmed in the directorship.[2]

By the time Lin Fengmian arrived in Beijing, the city's cultural life had sunk into the doldrums, but as soon as he took over the school began to expand once more. Yu Shaosong taught art history and Li Chaoshi Western art, while Qi Baishi became, somewhat to his surprise, a professor. Lin Fengmian also engaged an art teacher from Dijon whom he had met during his student days in France, André Claudot (known to his colleagues as "Keloduo"), to teach oil painting.[3] By the time Claudot arrived in Beijing Lin had already left for Hangzhou, where Claudot later joined him. After he returned to France in 1931, Claudot exhibited his work done in China. The brush sketch in the Chinese manner illustrated here (fig. 4.1) was done in Beijing. He was a minor artist at best, and the question of how much he may have influenced Lin Fengmian's rediscovery of the Chinese brush is not easy to answer.

Claudot was not the first foreign artist in Beijing to attempt to blend Chinese and Western techniques. In 1917 the young Czech diplomat and amateur painter Vojtech Chytil (1896–1936) had arrived from Prague. He exhibited his watercolors in the Beijing Hotel in 1922, and in the same year was appointed by the Beijing authorities to create and supervise the department of western art in the Beijing Academy. In 1926 he organized an exhibition of Western-style works by himself, his students, Katherine Carl (who had painted the Empress Dowager), and other Westerners in the city. He became intimate also with a number of traditional painters, most notably Qi Baishi, and gathered an important collection of Qi's works. It was through Chytil's introduction to the Czech minister that Wang Meng and his wife, Sun Shida, entered the Prague Academy of Art in 1926, the only Chinese at that time to do so. Wang Meng held successful exhibitions in several European countries before returning to China. The last record I have of him is of an exhibition of his competent but conventional oils, chiefly still lifes and portraits, in Shanghai in 1948.[4]

Even as Lin Fengmian was stirring the Beijing Academy to new life, the conservative painters closed ranks in opposition to this wild modernist, while political storm clouds gathered over Beijing. In January 1926,

4.1
André Claudot, *Beijing Street Scene* (1927). Chinese brush painting.

forty-seven students had been shot down by the government when they tried to present a petition against surrender to Japanese expansion in China. The chief executive of the Chinese government in Beijing arrested more than fifty "over-radical" professors and intellectuals. A mass exodus of leading figures followed, and the city's decline as a center of progressive thinking began. Among the hundreds who left to take refuge in the comparative safety of the foreign concessions of Shanghai was Lu Xun.

Beijing was becoming an unhealthy place for a man with Lin Fengmian's radical ideas. With the help and protection of the "Young Marshall," Zhang Xueliang, he escaped to Nanjing, the new national capital. There Cai Yuanpei, after several years abroad, was devoting his enormous energies to the development of higher education across the land. His authority in the art world was still paramount, and in 1927 he offered Lin Fengmian the opportunity to found a new art academy at Hangzhou, where he could put his progressive ideas into practice. Lin leaped at the chance.

Had Lin Fengmian remained in Beijing, the modernism that he taught and practiced with such courage

and enthusiasm might well have taken root there. In May 1927, just before he went south, he had boldly planted the seed by organizing the Great Beijing Art Meeting (Beijing yishu dahui) and issuing this challenging manifesto, echoing Chen Duxiu's resounding call to the writers of 1917:

> Down with the tradition of copying!
> Down with the art of the aristocratic minority!
> Down with the antisocial art that is divorced from the masses!
> Up with the creative art that represents the times!
> Up with the art that can be shared by all the people!
> Up with the people's art that stands at the crossroads![5]

But the aims of Lin's successor, the orthodox Xu Beihong, were very different, and the impetus was lost. In 1928 Xu too moved to Nanjing, where the indefatigable Cai Yuanpei had set up an art department in Nanjing University (then called the Fourth Sun Yatsen University). After Xu the Beijing Academy was headed by a succession of more or less significant figures, until in 1930 it had no principal at all. Thereafter it drifted along with frequent changes of name and director, providing little more than sinecure professorships for a number of Beijing guohua artists. Although it was reconstituted in 1934 under Yuan Zhikai as the National Art Training College (Guoli yishu zhuanke xuexiao), with departments of painting, design, art education, and sculpture, it never recovered the central position it had occupied in the early 1920s. With the centers of the New Art Movement now settled firmly in Shanghai, Nanjing, Hangzhou, and Canton, the number of important xihua painters graduating from Beijing shrank to a handful.

SHANGHAI

By the 1920s, Shanghai had become the economic and cultural powerhouse of modern China. The International Settlement and the French Concession occupied the prime area along the Huangpu River and to the west of the crowded "Chinese City," as the foreigners called it, which provided inexhaustible human resources and a flourishing traditional culture. From the 1911 revolution until the city was occupied by Chiang Kaishek's troops in January 1927, Shanghai was ruled by a succession of warlords, the last being General Sun Chuanfang, Warlord of the Five Provinces—who in 1926, as we shall see, was to play a brief and dramatic role in the story of modern art in Shanghai.

Chiang Kaishek could not have taken over the city, or waged a long and ultimately successful campaign against the communists and their sympathizers who operated there, without the help of the Shanghai mafia, the vastly ramified Green Gang controlled by Du Yuesheng. This elegant gangster handed out murder, extortion, kidnappings, and charity with equal largesse; he was director of the Chinese Red Cross and, when war came, an enthusiastic organizer (from Hong Kong) of anti-Japanese resistance. It was his agents who hunted down dissident intellectuals and artists and handed them over to the Guomindang, or to the authorities in the settlements, who in turn passed them on to the Chinese secret police for torture and execution. Yet protection could sometimes be found in the foreign enclaves. Sun Yatsen, Mao Zedong, Zhou Enlai, and countless others at one time or another worked or hid in the French Concession, while among those who returned from Tokyo to find refuge and companionship in the Japanese Concession, the most notable was Lu Xun.

But the foreign settlements were more than a refuge. They were the bridgeheads of foreign culture in the city, where artists and writers returning from the West could feel more or less at home. Societies such as the Association Amicale Sino-française, founded in November 1933, became meeting places for sinophile French and francophile Chinese; their *Bulletin* included much about artists and art exhibitions.[6]

In the Shanghai of the 1920s and 1930s, to be cosmopolitan was to be smart. Men and women in the swim often took foreign names, wore Western clothes, and interlarded their conversation and letters with English and French words and phrases, often addressing each other as "Misiti" (Mister), "Misi," "Daling." There were European fashion houses and bookshops, while the Lyceum Theatre (now the Shanghai Art Theatre) staged Western plays and weekly symphony concerts under the baton of Maestro Paci, with an orchestra consisting largely of White Russian and Jewish refugees. Indeed, White Russians were everywhere, taking any jobs they could get and providing models for the art schools when Chinese women were too shy to pose.

LIU HAISU AND THE SHANGHAI ACADEMY Shanghai was the natural center for the spread of Western art in China. Already in 1912 the brash young Liu Haisu, seventeen years old and himself hardly more than a beginner, had opened his little art school (page 30), under the most primitive conditions, with eighteen students. The school grew steadily, changing its name almost as often as it changed its premises. In 1921, the Shanghai College of Fine Arts (Shanghai meishu zhuanke xuexiao), as it was

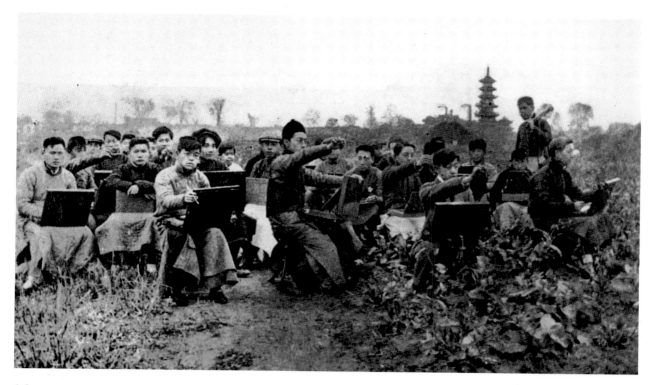

4.2

Students from the Shanghai Academy of Art sketching in the open air (1920s).

now called, raised ten thousand dollars and started to build. In the following year, with Cai Yuanpei as chairman of the board, the college took some of Siccawei's former school buildings in the Zhabei (or Chapei) district north of "Soochow Creek" and converted them into the Department of Western Art. In 1924 it acquired two acres next door. Finally in 1930 the Shanghai Academy was consolidated in one site in North Sichuan Road with the erection of new buildings of somewhat forbidding aspect.[7]

The teaching had expanded also. Women students were admitted beginning in 1920, and by 1925 the courses included Chinese painting, Western painting, three years of Normal School training, and two years of art, music, and handicrafts. At that time the staff included both Russian and Spanish teachers (although I have not been able to find out anything about them). Meantime Liu Haisu had founded, with his colleagues and students, the Heavenly Horse Painting Society (Tianma huahui). The horse flying through the air symbolized the energy and freedom of the group. Their annual exhibitions became a feature of Shanghai artistic life from 1920 until 1929, by which time many of the principals had gone to Europe.

Running a Chinese art school along Western lines was not smooth sailing, particularly when it came to life drawing and exhibiting nudes. When his students showed studies of the human figure at their exhibition in 1915, Liu Haisu was attacked by the headmaster of a girls' school as a "traitor in art" and a "harmful pest in the educational world."[8] (Liu then had a seal carved reading "Traitor in Art," which he affixed to some of his guohua paintings with special pride.) He had to fight that battle all over again in Nanchang in 1924, when the provincial military authorities banned the figure studies being exhibited by one of his students, Yao Guiju. To show nudes in a Chinese provincial city at that time—and particularly female nudes, though we do not know for sure that that is what they were—was asking for trouble. This time the government authorities came to the rescue.

Liu's third collision with the powers of darkness was more serious. In 1925 Jiang Huaisu, a city councillor, and Zhu Baosan, chairman of the Shanghai Chamber of Commerce, demanded the abolition of nude models in the Shanghai Academy. In the following year they gained the support of Sun Chuanfang, Warlord of the Five Provinces, who forbade the painting and drawing of nudes in all art schools. Liu Haisu and his friends protested in the press that Westerners used nude models freely. Sun Chuanfang, it is said, lost his temper and tried to arrest Liu, who took sanctuary in the French Concession, where the French authorities told him to stay at home and stop writing to the papers. Finally, a

deal was struck whereby Liu Haisu was fined ten (some say fifty) dollars because of his "disgraceful personality and insulting behavior." Sun's honor was satisfied, the case was closed, and the use of nude models resumed.[9] Liu Haisu always thought this a high moment in his colorful career; he loved to show people his press cuttings. In the meantime, however, his school, constantly harassed by the military and affected by the general strike that paralyzed the city, was closed down. Some of the buildings were damaged, and the library was destroyed.

The early 1930s was a period of great expansion. The school moved into new buildings in 1930, and in 1931 Liu returned from two years in France. In 1932 Japan attacked Shanghai and many students became radicalized, setting up the Epoch Art Club (Shidai meishu she), inspired by the left-wing art movement that had begun in Hangzhou in the previous year. But the radicals were soon driven underground, and in spite of heavy casualties and much destruction in the Japanese attack on the Zhabei district, the school continued to prosper.

By the time it celebrated its twenty-fifth anniversary in 1936, the Shanghai Meizhuan, as it was henceforth popularly known, had a powerful board of directors that included Cai Yuanpei, Liang Qichao, and Wang Zhen; a staff of eighty-one; and 329 students. Of these, 29 percent were studying Western art, half that number guohua, while 32 percent trained as art teachers for the schools, 8 percent studied design, 16 percent music, and only 0.6 percent sculpture, never a popular subject in China.[10] The atmosphere of the school was free and casual. Part-time students like the cartoonists Zhang Guangyu and Ding Cong could, for three dollars a month, come in as they wished and attend the studios of any of the teachers, whom the critic Huang Miaozi remembered as being always polite and uncalculating.

In spite of the outbreak of war in July 1937, the school lingered on until 1942, when staff and students quit Shanghai to join the National United Southeastern University (Guoli dongnan lianhe daxue) in the interior. Liu Haisu was able to reestablish the academy in Shanghai when the war ended, but like all other private institutions it fell victim to Liberation.

OTHER SHANGHAI SCHOOLS The Shanghai Meizhuan was by no means the only art school in Shanghai between the wars. Few of the many academies and private ateliers lasted very long; I shall only mention some of the more important ones.

On returning from Tokyo in 1921, Chen Baoyi had established the Chen Baoyi Painting Research Institute (Chen Baoyi huihua yanjiu suo), a private atelier on the lines of La Grande Chaumière, for the promotion of Western drawing and oil painting.[11] His studio in North Sichuan Road near the academy was reduced to rubble in the war of 1932, but he managed to salvage enough to reestablish himself nearby. (Lu Xun, who was his neighbor, was luckier; although he had to leave in a hurry when the fighting started, he came back to find his books, papers, and art collection intact.) Before that short, sharp war, Chen Baoyi also taught life drawing and oil painting in several other art schools in Shanghai, including the Shanghai Meizhuan. Although somewhat overshadowed by Liu Haisu, he was a talented oil painter and a major figure in the establishment of Western art in Shanghai, and he attracted a large following. He had married a Japanese woman, and his ties with Japan were always close. *Mountain Village,* an oil painted in 1927, has a fauvist, almost expressionistic freedom of handling. His serious and solidly realized *Exiles* (fig. 4.3), painted in 1939, shows how the war and the plight of the refugees lent a new gravity to his style.

In 1920 Feng Zikai and other students of Li Shutong had founded an art teachers' training school, which in 1926, upon amalgamating with another, more ephemeral institution, the Eastern Art Training College (Dongfang yishu zhuanmen xuexiao), took the rather grand name of the Shanghai Private Arts University (Sili Shanghai yishu daxue). By the time the combined school was forced to close by the political crisis of 1930, it claimed to have trained seven or eight hundred art teachers.[12] In 1925 some of them, led by Ding Yanyong, left to found their own private art college; that too closed in 1930.

The White Goose Painting Society (Bai'e huahui, 1924) was another private studio that came into being to meet the apparently insatiable demand for teaching in Western art.[13] It was founded by former students of Liu Haisu, including Pan Sitong, Chen Qiucao, Fang Xuegu, and others. Their atelier blossomed into the White Goose Preparatory Painting School (Bai'e buxi xuexiao) and then, in 1928, into a research institute. A later account tells how Pan Sitong "emptied his pockets to buy two four-story buildings in Sichuan Road in Shanghai to house his . . . Institute for young art lovers from all walks of life."[14] Among those who studied there were Jiang Feng, later to become a communist, a woodengraver, and after Liberation president of the Central Academy in Beijing; the calligrapher Fei Xinwo; and the woman writer Xiao Hong. The atmosphere was liberal, and quite a few of its students went abroad for further study. It closed in 1937.

The more important Xinhua Academy (Xinhua yishu zhuanke xuexiao) was established in 1926 by secession from the Shanghai Meizhuan.[15] With the blessing of Cai Yuanpei and a faculty that included the pioneering Zhang Yuguang, Tokyo-trained Zhu Qizhan (at that

time an oil painter, strongly influenced by the Post-Impressionists), Pan Tianshou, and (after his return from Europe in 1931) Wang Yachen, the Xinhua Academy flourished in Shanghai until 1937, when its buildings were destroyed by Japanese bombs. After that it lingered on for another four years in the French Concession. The school published several influential art journals: *Wenyi zhoukan* (Literature and art weekly), *Wenyi yuekan* (monthly), and *Xinhua jikan* (New China quarterly).

Many leading members of the Shanghai intelligentsia had close ties with Japan. In 1913 the young Christian Uchiyama Kanzō (1885–1959) arrived from Tokyo; in 1919 he opened his famous bookstore Uchiyama Shoten, which sold books on all subjects, including art. Lu Xun was a constant visitor there, and it was Uchiyama who hid him upstairs when the Guomindang agents were at his heels.[16] When in 1926 the great novelist Tanizaki Jun'ichirō came to Shanghai, Uchiyama introduced him to leading intellectuals, including Guo Moruo, the novelist Ouyang Yüqian, and Tian Han, dramatist and leading light in the theater world. They were all present, with artists, musicians, businessmen, film producers, and an aviator, at a memorable banquet given for Tanizaki, at which the guest in his drunken address proclaimed "A new artistic movement is thriving in China today!" Afterwards Guo Moruo, equally under the influence, drove him home, weaving through the streets in a terrifying manner.[17]

Two years later Tian Han founded his short-lived Nanguo Yishu Xueyuan ("l'Académie du Midi") with the aim of promoting Western drama and art.[18] He was more successful with drama than with art, but he did engage Chen Baoyi and Xu Beihong to teach oil painting, although the latter was only able to come down from his new post in Nanjing every two weeks. Although l'Académie du Midi ran out of funds and was forced to close after only a few months, Tian Han continued to take a very active part in China's cultural life throughout the war with Japan.

By the late 1920s the number of young artists returning from France was increasing. Among them was Pang Xunqin, who came home in 1930, anxious to be part of the cosmopolitan art circle of Shanghai. He joined a little group formed by Zhou Zhentai called the Taimeng Huahui, or Société des Deux Mondes (*taimeng* being an attempt to render *deux mondes* in Chinese; the "two worlds" were China and Europe, or perhaps Paris and Shanghai). Pang settled down to continue his oil painting, but before long he was confronted with the realities of Shanghai politics. His house in the French Concession was raided by the police and the members of the society meeting there arrested on suspicion of being subversives.[19] When he spoke to the officers in French and

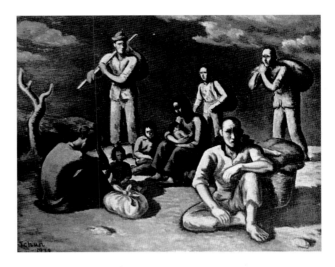

4.3
Chen Baoyi, *Exiles* (1939). Oils.

4.4
Tian Han (far left) and members of the Nanguo Academy, c. 1929: (left to right) Wu Zuoren, Jiang Zhaohe, Lü Xiaguang, Xu Beihong, Liu Yisi.

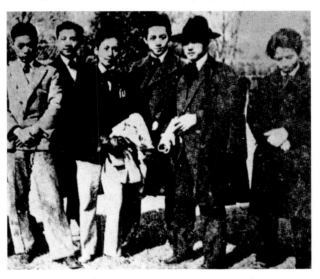

named a prominent Shanghai lawyer (whom he had never met), he was released. But he had had enough of Shanghai and returned to Changshu to establish a little base for Western art in his native city. Surprisingly, he had some success there, and by 1935 his Yuguang Art Society had held seven exhibitions. Back in Shanghai, the Société des Deux Mondes broke up, to be replaced in 1931 by Ni Yide's Storm Society (Juelan she), which would more truly reflect the somber mood of the city after the first Japanese attack.

Prosperous, cosmopolitan Shanghai became the natural center for modern graphic design in China. The de-

mands of advertising and the vast output of books and magazines during the 1920s and 1930s created a new demand for designers. A distinctive Shanghai style came into being, derived from many sources—chiefly ancient Chinese motifs, modern Japanese decorative art, and art deco, which had become the rage in Europe after the Paris Exposition des Arts Décoratifs in 1925.[20] Art deco's stylizations and distortions of form and space married well with the abstract elements of Chinese traditional design, stimulating bold experiments in typography and the creative manipulation of Chinese characters.

Among many serious artists who contributed to the movement, Tao Yuanqing was noted for his covers for the works of his close friend Lu Xun and for his skillful use of ancient motifs.[21] Other members of Lu Xun's circle who designed book and magazine covers included Qian Juntao, who had studied Japanese design and later the wall-paintings at Dunhuang, and Chen Zhifo, whose reputation now rests on his later bird and flower paintings in the *gongbi* style but who, after returning from Japan in 1923, had been a prolific designer in the eclectic Sino-European style that sums up so well the culture of Shanghai between the wars.

NANJING

Nanjing acquired a new cultural importance with the establishment of the national capital there in 1927, and particularly with Cai Yuanpei's presence as minister of education. The founding of the National Central University prompted a group of young artists to petition Cai Yuanpei to establish an art department there; the embryonic painting and handicraft department of the High Normal School became the obvious nucleus of it. This had been the first art department in China when it was set up in 1906; though it did not last, it was revived in 1915.[22]

Cai first invited the academic oil painter Li Yishi, who had been teaching for some years in Beijing, to head the new school, but in 1928 he was replaced by Xu Beihong, who directed its rising fortunes for the next ten years. Xu, always diplomatic and persuasive, managed to attract a good deal of talent. The romantic semi-modernist Pan Yuliang taught there from 1928 until she returned to Paris in 1935. Fu Baoshi joined the staff in 1935, Zhang Daqian (briefly) in 1936. Also in that year, Xu Beihong succeeded in luring a reluctant Gao Jianfu (see chapter 5) up from Canton. When Nanjing fell to the Japanese in 1937 Gao went home to Canton, but many of the staff, including Zhang Shuqi, Fu Baoshi, and the alumni Wu Zuoren and Lü Sibai, travelled with the school to its wartime home outside Chongqing. Xu Beihong's stress upon the *beaux arts* virtues of thorough training

and sound technique was just the recipe for an academy under the direct eye of the government. Years later, his stylistic conservatism and that of many of his staff and students were to serve the new China well in the first years after Liberation.

SUZHOU

Western art in Suzhou is bound up with the name of Yan Wenliang—indeed, without him it might never have developed.[23] Born in this city of gardens in 1893, Yan grew up in an artistic atmosphere, his father having been a student of Ren Bonian. While working in the art department of the Commercial Press in Shanghai, Yan Wenliang became interested in Western watercolor and oil painting. In 1919 he proposed that an art exhibition be held in Suzhou, and from that year until 1937 an exhibition of guohua and xihua was held in the city every year on January 1. After being a schoolteacher for nine years, Yan set up a little art school in the city with two friends in 1922.

In 1928, with Xu Beihong's encouragement, Yan Wenliang went to Paris, returning three years later to become president of what was then the Suzhou Art Training Institute (Suzhou yishu xuexiao). In 1931 he fulfilled his dream and the Suzhou Academy, as it came to be called, was well established. Visitors who penetrate far enough into Suzhou's famous gardens are often astonished, upon rounding a certain corner, to come upon his art school, an elegant classical building graced with a facade of fourteen Ionic columns. It consorts oddly with its surroundings, but the building forcefully symbolizes the completely Westernized outlook of its founder. The academy flourished until the war, when it was pillaged by the Japanese, the precious collection of casts and copies of masterpieces that Yan brought from Paris being completely destroyed. He was never able to revive the school.

As both painter and teacher Yan Wenliang took to heart the instruction for the national art curriculum given out by the Ministry of Education as far back as 1922: "For fixing models for specialization in art, make the practice of Western art the essential." He was a competent, conservative impressionist, lacking the technical range of Xu Beihong, the passion of Liu Haisu, the sophistication of Lin Fengmian, but his work at its best has a genial warmth sometimes lacking in theirs (plate 9). Pang Xunqin's daughter, Pang Tao, told me that she had seen some beautiful small landscapes Yan had done in Paris; they seem to have disappeared in the Cultural Revolution. Only during his last years did the quality of his work fall off, when he tended to indulge in thickly painted and rather crudely colored romantic sunsets. He died in May 1988, at the age of ninety-five.

Cai Yuanpei could have chosen no more ideal setting for an art school than Hangzhou, which still today preserves—in the area around the lake at any rate—the tranquility and charm that all the other big cities in China seem to have lost.[24] We have seen how Cai's meeting with Lin Fengmian in Paris prompted him, in the autumn of 1927, to offer Lin the opportunity to create the first national academy of art. Cai and Lin persuaded Jiang Menglin, president of Third Sun Yatsen University (now Zhejiang University), to rent them several buildings in his lakeside Le Yuan Garden, and the Hangzhou Academy was opened by Cai Yuanpei on March 28, 1928.

Lin Fengmian had assembled a staff of thirty, several of whom had been his fellow students in France and members of the Apollo Society. The school began with seventy students. There were departments of guohua, xihua, sculpture, design, and music; Lin wanted architecture as well but could not find the teachers. He established the Art Research Institute (Meishu yanjiu yuan) to attract the best graduate students from all over the country, and he made the bold decision to merge the guohua and xihua departments, so that whichever path the students eventually chose they would have a grounding in both. Founding faculty members included several who were to become well known: for guohua, Pan Tianshou; for xihua, Wu Dayu, Li Fengbai, Wang Yuezhi, and Cai Weilian, Cai Yuanpei's daughter; for sculpture, Li Jinfa and, later, Liu Kaiqu; for design, Sun Fuxi, Tao Yuanqing, Wang Ziyun, and, later, Lei Guiyuan. Chinese art history was taught by Jiang Danshu, Western art history by Lin Wenzheng, Cai Yuanpei's son-in-law. There were also several foreign staff members. For several years advanced oil painting was taught by André Claudot, sculpture by an Englishman ("Wei Da") from Shanghai, design by Yoshitoshi Saito, and music and foreign languages by European and Russian teachers.

While in France Lin Fengmian, Lin Wenzheng, Liu Jipiao, and Wu Dayu, responding to Cai Yuanpei's call to further education through art, had started the Overseas Art Movement Society. On returning home they launched the National Art Movement Society (Guoli yishu yundong she) from their base in the academy. The aims of the academy, they declared, were:

> To introduce Western art;
> To reform traditional art;
> To reconcile Chinese and Western art;
> To create contemporary art.[25]

Above all, they proclaimed, "It is the bounden duty of art to create!" In their dedication to "creating the art

of a new era," as they put it, they were more progressive than Liu Haisu and far ahead of the conservative Xu Beihong and Yan Wenliang.

On arriving in Hangzhou, Lin Fengmian addressed a long open letter to the art world of China. Although modern paintings have been produced in China for ten years, he writes, their quality is deplorable. He tells how he and his colleagues in the Beijing Academy tried to raise standards, and how their efforts were frustrated by politics and by personal attacks by opponents in Nanjing. He shares Cai Yuanpei's conviction that art can replace religion, giving meaning and value to life in the new society, instead of being merely a source of pleasure. As for China, the country is plagued by constant civil war; the poor suffer; few are educated; art has lost its power for good. To save society, art itself must be saved. Artists must forget themselves, to create a new art. "Friends in the art world of all China," he cries, "let us regroup our forces. For the art movement, the hour has come!"[26]

Zao Wou-ki, who joined the academy as a boy of fourteen in 1935, later recalled that his mornings were devoted to Western techniques and his afternoons to guohua and calligraphy, and that the six-year course included art history and English.[27] But to give the impression that the entire staff was fired with Lin Fengmian's progressive idealism would be misleading. The guohua classes, even those of Pan Tianshou, were devoted to endless copying of Ming and Qing paintings, while the xihua classes slavishly followed the system of the Ecoles des Beaux Arts in Paris and Brussels, where several of the teachers had been trained. Zao Wou-ki found the teaching, apart from that of the oil painter Wu Dayu and Lin Fengmian himself, "mediocre and artificial" and objected so strongly to the insistence on copying that he would have been thrown out if Lin and Wu had not interceded with Pan Tianshou on his behalf.

But the students did not waste their time. Zao Wou-ki remembered how peaceful it was in the studios, when the only sound that could be heard was the scrape of charcoal on paper. When the studios were locked in the afternoons one of them would climb in to open the doors for his friends so they could continue to work. In the evenings they put the day's paintings and drawings in glass frames, discussing and criticizing them far into the night.

In spite of the academy's problems, of which the influx of refugees from the Japanese attack on Shanghai of 1932 was not the least, it grew and prospered. In 1929 staff and students held their first exhibition in the Alliance Francaise in Shanghai; in 1930, when the school became known as the National Hangzhou Art College

4.5
Li Yishi, *Scene in the Tang Palace* (1933). One of *Changhen ge* series. Oils.

4.6
Cover of *Athéna*.

(Guoli Hangzhou meishu xuexiao), the members of the National Art Movement Association were sufficiently confident to send their work for a show in Tokyo. In 1931 they showed in Nanjing, and in 1934 again in Shanghai. It was here, in the big meeting hall of the Shanghai City Council, that Lin Fengmian's dark, tragic canvas mourning the dead of 1932 created a sensation. But by no means was all the work of the Hangzhou faculty even mildly modern. There was a good deal of conventional painting, both Chinese and Western; Li Yishi's series of thirty paintings illustrating the tragic poem *Changhen ge,* the story of the Tang emperor Minghuang's infatuation with Yang Guifei, would have been perfectly at home in a European salon exhibition of 1880 (fig. 4.5). Art was moving forward so fast that the pioneers were already left far behind, and the generation gap was widening.

The academy published several art journals, of which the chief were *Yishu xunkan, Athena* (fig. 4.6), and *Yapole* (Apollo), edited by the art historian Lin Wenzheng, who had gone to Paris with Lin Fengmian and returned in 1927. It also sponsored societies for art and music, while many more were created by the students themselves. Of

these the most important was the West Lake Eighteen Art Society, of which the radical students soon contrived to gain control.

As president of Beijing University at the time of the New Culture Movement, Cai Yuanpei had stressed learning for all, freedom of thought, and the unity of realism and idealism in culture and art. To educated youth at this time, all things seemed possible, and the Hangzhou Academy was launched on a note of high purpose. But it became harder and harder for these young idealists to feel altogether comfortable in their ivory tower beside the lake—though few were prepared to give it all up and throw themselves into the political struggle epitomized by the Woodcut Movement, of which I shall have more to say in chapter 8.

CANTON

Since the eighteenth century, artisan painters in Canton had been practicing oil painting. They produced portraits of foreigners and their ships, views of the Hongs, genre scenes (of Chinese daily life, customs, crafts), and

other subjects that appealed to visitors from the West, and they had applied this barbarian realism to the painting of ancestral portraits.

But Western art was not actually taught in Canton—except possibly around 1900 by the missionaries—until 1921, when the oil painter Ren Ruiyao returned from study in Japan, hoping to establish an art school. The best he could manage was to organize a study group, the Chishe ("Red Society"—red standing for the south of China), with other oil painters, most like himself trained in Japan. The Chishe held its first exhibition in that same year.[28] It was greatly strengthened by the arrival, also in 1921, of Feng Gangbai. Feng, from a poor Cantonese family, went to Mexico in 1904 at the age of twenty-one to find work, discovered art in the museums there, and then went on to San Francisco to study painting. There he met Li Tiefu, who later painted a fine portrait of him (see plate 6). Feng Gangbai, himself a competent portrait painter and an admirer of Rembrandt, became a key figure in the Chishe.[29] After World War II he went for several years to Hong Kong, but returned to Canton after Liberation to hold high posts in the cultural establishment.

The Chishe flourished, counting among its members Li Tiefu and Guan Liang as well as others whose fame never reached beyond Canton. But Ren Ruiyao's choice of its name was unfortunate. By 1930 the Guomindang authorities were crushing left-wing art movements in all the art schools, and although the Chishe's members were for the most part harmless portraitists and landscapists in oil and watercolor, the name "Red Society" was provocative. They changed the first character to another with the same sound but no meaning, but this was not enough to save them, and the society was closed down in 1931.

In 1926, the city government had established the Canton Municipal College of Art (Guangzhou sheli meishu zhuanmen xuexiao), appointing as its principal an old Chishe member, Hu Gentian, who had studied in Japan.[30] Hu Gentian recruited as his professor of Western painting another Tokyo graduate, Ding Yanyong, who was also invited to organize the municipal art mu-

seum. Guan Shanyue was one of its graduates, as was the famous cartoonist Liao Bingxiong.

A third center for art was established in Lingnan University (formerly Canton Christian College, and later Sun Yatsen University). Both Gao Jianfu and his brother Gao Qifeng taught there. The eclectic art of Canton continued to flourish until the Japanese occupation of 1937 drove artists into the Interior or to the temporary sanctuary of Hong Kong.

OTHER CENTERS

As the ripples spread outward from Beijing and Shanghai, many art schools were opened in the provinces, although few were staffed by properly qualified teachers.[31] The Wuchang College of Art (Wuchang yishu zhuanke xuexiao) was founded in 1920, the Wuxi Academy in 1926. In Fujian, an art department was opened in the Meiji Normal School in Xiamen; the staff there included (perhaps very briefly) Zhang Shuqi from the Shanghai Meizhuan, Mo Dayuan, trained in Japan, and Lin Xueda (Lim Hak-tai), who was later to open his own art school in Singapore. The Qiting Normal School art department, staffed by graduates from Shanghai University, lasted from 1923 to 1927.

As far away as Sichuan, an art department had been opened in the Provincial University in Chengdu, while in 1925 the Southwestern Academy was founded in Chongqing. By 1945—its fortunes greatly enhanced when Chongqing became the wartime capital—this school had produced twenty-eight hundred graduates.

While the number of new art schools that opened their doors between the wars is impressive—and I have only mentioned a few of them—they came into being chiefly to train art teachers for the local schools. For the most part the level of instruction was inevitably low, so they can hardly be said to have made a significant contribution to the development of the modern movement in Chinese art. In a small way, though, they must have helped to spread some awareness of it.

THE LINGNAN SCHOOL

So spectacularly successful had been Japan's modernization in the Meiji period that the Japanese were convinced that they had found the solution to the problem of how to adapt Western culture to east Asia, and they saw themselves as leading the way for the other cultures. Inspired by Fenollosa and his disciple Okakura Kakuzō, Japanese artists had combined traditional Japanese techniques—particularly those of the Kanō School, marked by a propensity for smooth surfaces and decorative effects—with Western realism and a more contemporary subject matter to create *nihonga,* or "Japanese painting." Though many of the Chinese pioneers of modern art studied in Japan, it was the brothers Gao Jianfu and Gao Qifeng, with Chen Shuren and their friends and pupils, all Cantonese, who brought the *nihonga* style to China and dedicated themselves to the creation of a New Chinese Painting (*xin guohua*).[1]

In 1892, as a boy of thirteen, Gao Jianfu entered the studio of the professional painter Ju Lian in Lishan, where he served his apprenticeship for the next seven years, painting chiefly birds and flowers, grasses and insects, in the careful, realistic, brightly colored style of his master. Chen Shuren as well was close to Ju Lian, eventually marrying his grandniece, and Gao Qifeng may also have studied briefly with him. It was in Ju Lian's studio that Chen Shuren met Gao Jianfu, sometime between 1902 and 1909, and they remained friends until Chen's death in 1948.

In 1903 Gao Jianfu went to Canton, where his horizons began to broaden under the patronage of the painter and collector Wu Deyi, who introduced him to

works in the great tradition. He entered the Canton Christian College (later Lingnan University and then National Sun Yatsen University), where he encountered a French teacher of painting known only by his Chinese name, Mai La. More important was his meeting with one of the many Japanese teachers then in China, Yamamoto Baigai, who fired him with the ambition to study in Japan and taught him the rudiments of the language. In the winter of 1906 he left for Tokyo. Cold, hungry, and almost destitute, he was rescued there and restored to health by his revolutionary friend Liao Zhongkai. After returning to Canton for the summer holiday, he went back to Tokyo in 1907, taking his nineteen-year-old brother Qifeng with him.

In the meantime Chen Shuren, more politically conscious, was working for an anti-Manchu newspaper in Hong Kong. When Sun Yatsen's revolutionary Tongmenghui was formed in 1905 he became a member and a close associate of leading Cantonese revolutionaries, including Liao Zhongkai and Wang Jingwei. He spent 1906–12 in Kyoto and 1913–16 in Tokyo, then devoted himself increasingly to politics. Sun Yatsen sent him to Canada in 1917 to head the Canadian branch of the Guomindang.

It is said that when Gao Jianfu first began to study in Tokyo it was Western art that attracted him, and that he joined societies formed to promote it.[2] His surviving works from the period, however, show little evidence of such enthusiasm. The most obvious and consistent influence in his early work is that of leading *nihonga* painters Kanō Hōgai, Hashimoto Gahō, and Takeuchi

Seihō, which he absorbed during two years of very intense study in Tokyo, although it is not clear whether he studied in the official Tokyo School of Fine Arts (Tōkyō bijutsu gakkō) in Ueno Park or in the independent Japan Fine Art Institute (Nihon bijutsu in), founded by Okakura Kakuzō. Croizier in his study of the Lingnan School thinks the latter more likely,[3] and in any case it would have been difficult for a Chinese, newly arrived, a stranger to the land and almost to the language, to gain admittance to the prestigious national academy. Gao Jianfu may also have spent some time in Kyoto, for his style shows that he was as much influenced by the masters of the Maruyama-Shijō School, Maruyama Ōkyō and Matsumura Goshun, as he was by the *nihonga* pioneers in Tokyo. Chen Shuren, who also studied in Kyoto for a time, felt that influence even more directly.

These artists believed passionately that they could create a new Chinese art through a synthesis of East and West. Here Gao Qifeng explains his purpose:

> I took up the study of Western art, paying particular attention to portrait painting, light and shade, perspective, etc. I then picked out the finest points of Western art and applied them to my Chinese techniques as to [*sic*] the masterful strokes of the pen, composition, inking, coloring, inspiring background, poetic romance, etc. In short, I tried to retain what was exquisite in the Chinese art of painting, and at the same time adopt the best methods of composition which the world's art schools had to offer, hereby blending the East and the West into a harmonious whole.[4]

Gao Jianfu was even more ambitious when he wrote, "I think we should not only take in elements of Western painting. If there are good points in Indian painting, Egyptian painting, Persian painting, or masterpieces of other countries, we should embrace all of them, too, as nourishment for our Chinese painting."[5] But the idealism of the Lingnan artists reached far beyond the mere creation of a new school of painting. Gao Qifeng again:

> The student of art must try to adopt a much loftier viewpoint and imagine himself charged with an altruistic mission which requires him to consider his fellows' miseries and affliction as his own. He will then work hard on the production of only such pictures as will effect a betterment of man's nature in particular and bring about an improvement of society in general, thereby presenting the new spirit of the art in all its glory and grandeur.[6]

Here Gao Qifeng echoes Fenollosa, who claimed that the *nihonga,* which he helped to create, would "dominate all Japan in the near future and . . . have a good influence over the world."[7]

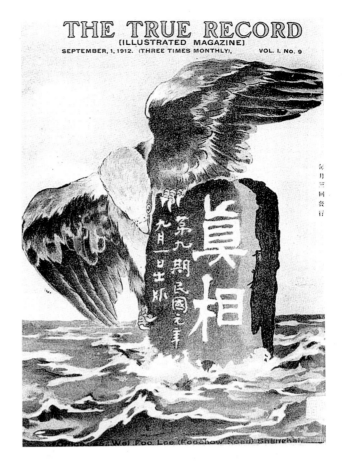

5.1
Cover of *Zhenxiang huabao* (1912).

Gao Jianfu returned from Japan in 1908. After a stay in Canton, where he held a one-man show, he went to Shanghai in 1912 and at once plunged into its cultural life. After starting a hand-decorated ceramics business—one of his pieces won a prize in 1912 at the Panama Exposition—he set up the Aesthetics Bookshop (Shenmei shuguan) and launched *Zhenxiang huabao* (The true record), a magazine that ranged over politics, industry, society, and art and was well illustrated with photographs and reproductions, many of them the Lingnan painters' own works (fig. 5.1). Although it ran for less than a year, *Zhenxiang huabao* broke new ground as the first of many journals to bring art to the literate public. Liu Haisu, in 1912 a sixteen year old just embarking on his life as a painter, later remembered that Shenmei Shuguan was the first place in Shanghai, other than traditional mounting shops, where paintings were publicly sold.

The Gao brothers continued to teach and paint in Shanghai until 1918, but Gao Jianfu always felt something of a stranger in this region, where the Shanghai school of painting was so firmly entrenched. When Sun Yatsen appealed to him to join the Canton government

5.2

Gao Jianfu, *Pumpkin* (1940s?). Ink and color on paper.

show a hint of Western realism, absorbed with apparent lack of conscious intent. He sketched constantly in the open air, in pencil or color, so his later landscapes based on his sketches are generally closer to nature, less contrived, than those of the Gao brothers. His easy, assured brushwork suggests the work of an amateur painting not to convey a message or demonstrate a theory but simply because he enjoyed it (plate 10). His poems are described by Lawrence Tam as "plain and straightforward, elegant and sincere"[8]—qualities that mark his later paintings as well, and qualities one seldom finds in the work of the Lingnan painters.

In 1923 the Gao brothers established their Spring Awakening Art Academy (Chunshui huayuan) in Canton. Now at last they were able to promote their own Chinese version of the *nihonga*. Among friends and compatriots, free of competition from the powerful Shanghai School, the Chunshui Academy flourished. Gao Jianfu was also tireless in organizing exhibitions and art associations. In 1930 he went on a long tour of India that took him to the Ajāñta caves, to Nepal, and to a meeting with Rabindranath Tagore in Calcutta. Although he later painted some pictures inspired by Indian themes—copies of the Ajāñta wall paintings, the Ganges at dusk, a conventionally melancholy (and very Japanese) view of ruined *stūpa*s—the effect of his Indian sojourn seems rather to have deepened his leaning towards Buddhism and things spiritual. Late in life he was a frequent visitor to a Buddhist temple in Guangxi, whose abbot dedicated a pavilion to him for his own use.

Gao Jianfu often painted flowers, plants, and grasses in his own version of the Chinese literary style, and occasionally—perhaps to establish his credentials with those who did not care for the Japanese element in his work—he painted landscapes in the orthodox tradition of Tang Yin and Lan Ying. After his early birds, flowers, and plants in the Ju Lian manner, though, most of his works are consistently synthetic, with a smooth finish and artificial sfumato effects (fig. 5.2). He loved sunsets and twilight moods, as shown in his painting of the Five Story Pavilion in Canton of 1936,[9] while his penchant for conventional Japanese themes appears in his monkeys and owls in the trees silhouetted against the moon. Even his rendering of so thoroughly Chinese a subject as the burning of Qin Shihuangdi's A-pang palace is based on a Japanese treatment of the theme. The influence of Takeuchi Seihō and other *nihonga* painters is also obvious in the lions and tigers as symbols of patriotic vigor that the Gao brothers and Chen Shuren liked to paint early in their careers.

Most consistent in his adherence to his *nihonga* background, and particularly to the style of his master Tanaka Raisho, was Gao Qifeng. In 1929 he moved into a house

as a member of the Guomindang Industrial Art Commission and head of the Provincial Art School, it was an opportunity he could not resist. Gao Qifeng also took up a teaching career in Canton.

Chen Shuren, by contrast, stayed at the center of political affairs after his return from Canada in 1922, holding a number of government posts, which eventually took him to Nanjing. As a painter he remained an amateur, less confined by style and doctrine than the Gao brothers. Consequently, after an initial "Japanese" phase, his later works are either traditional and conventional or

5.3
Gao Jianfu, *Flying in the Rain* (1932). Ink and color on paper.

in Canton which he called the Heavenly Wind Pavilion (Tianfeng lou), where he taught till his early death from tuberculosis in 1933. His favorite student, Zhang Kunyi, left her own husband to move in as his nurse and adopted daughter and perhaps also his mistress, an arrangement that caused some scandal at the time. She was herself a moderately talented painter and the devoted custodian of his memory, writing his funeral eulogy, it was said, in her own blood.

The Gao brothers were nothing if not patriotic—and modern, after their fashion. When flying was still a dangerous pastime in China, Gao Jianfu made sketches from an airplane; he used them in *Flying in the Rain* (fig. 5.3), a scroll showing a squadron of biplanes flying over a misty ink wash landscape with a pagoda, and in *Two Monsters of the Modern World,* a tank in a landscape with an airplane hovering overhead. A number of these airplane paintings were exhibited in Canton in 1927, accompanied by a banner bearing Sun Yatsen's slogan, "Aviation to Save the Country." When war came in 1937, Gao Jianfu and his former students, such as Seeto Ki (Situ Qi), were well prepared to depict the Japanese bombing and the ruin of cities.

Realism of a less contrived sort was practiced by Gao

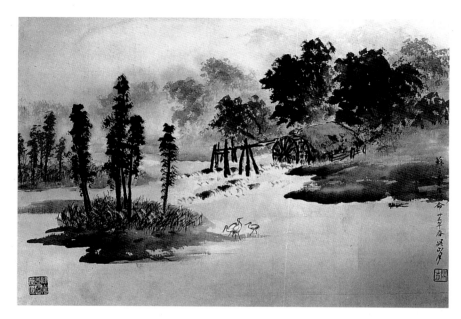

5.4
Guan Shanyue, *Waterwheel in Sichuan* (1946). Ink and color on paper.

5.5
Fang Rending, *Seated Woman with Rabbit* (c. 1935). Oils.

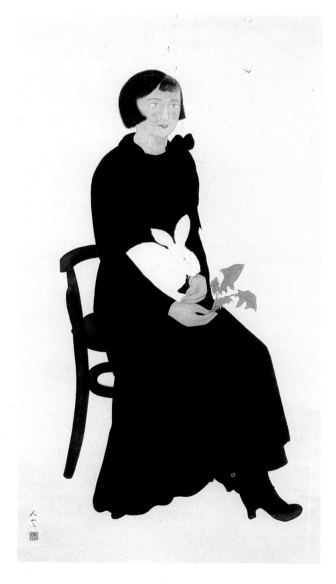

Jianfu's pupils Guan Shanyue, whose *Waterwheel in Sichuan* is reproduced here (fig. 5.4), and Fang Rending, who studied in Japan from 1929 to 1935. On his return Fang contributed to an exhibition over a hundred paintings, chiefly figure subjects. Croizier divides them into the realistic—"ordinary people in ordinary situations"—and the romantic—"sweet-faced Japanese farm girls, languorous nudes, and mythological scenes" (fig. 5.5).[10] He was praised by some critics for reviving figure painting and attacked by others for being too Japanese, one calling his work a hopeless mishmash of conflicting styles. When the People's Republic came to power he was able to make the necessary stylistic adjustments with little trouble.

A more forceful follower of Gao Jianfu is Li Xiongcai. He is above all a landscape painter, noted for often dramatic compositions marked by dense textures, strong chiaroscuro, and rather un-Chinese color effects. Richly realistic in detail, his style too adapted easily to the romantic realism of China after 1949.

The Chunshui Academy continued to flourish until the Japanese occupation of Canton in 1938 drove it to Macao, where Gao Jianfu kept the school barely alive until it could be reestablished in Canton in 1945. When "Liberation" closed all private art schools in 1949, Gao Jianfu took his academy back to Macao once more. He died there on May 22, 1951, not long after his big retrospective at the Zhongyang Hotel.

It may be wondered why Gao Jianfu's lead was not followed more widely than it was, given the thorough technical training he advocated and his sincerity and dedication to the creation of a new school of art for China based on a synthesis of the best from East and West. To begin with, at least, a number of critics and painters praised him. Xu Beihong saw him as the "forerunner of the revival of Chinese art." Wen Yuanning, the realist

Ni Yide, and even the fastidious Fu Baoshi lauded the courage with which he had thrown off the fetters of hackneyed styles and subject matter.[11] Whatever one might think of much of the work of the Lingnan painters—and I must honestly declare my antipathy—it at least focused the minds of many young Chinese artists on the problem of the East-West synthesis and showed one approach to a solution.

But there are reasons why the appeal of the Lingnan movement was always limited. To begin with, it was just getting under way when waves of anti-Japanese feeling were sparked by Japan's notorious Twenty-one Demands of 1915 and intensified by the May Fourth Movement, and later by Japanese aggression in China. This, we might say, was just Gao Jianfu's bad luck. Secondly, the *Lingnan pai,* as the name implies (*lingnan* means "south of the mountains," in reference to Guangdong Province and the city of Canton), was essentially a local school. It had little or no influence outside Guangdong.

The conservative inheritors of the literary tradition, dismissing the Lingnan School as "cheap imported Japanese goods," may well have looked on it as a more insidious threat to the purity of Chinese painting than was the outright challenge of Western art, while by the 1920s artists who wanted Western art wanted it pure and from Paris, not in Tokyo's diluted form. But perhaps the most cogent reason for the school's never catching on was that it was based on a misconception of the nature and purpose of art. Good art is produced not by lofty aims or fine technique, or even by a combination of the two, but by that passion for form which at the moment of painting excludes all other considerations. It is the lack of that passion, the utter impersonality of their work, that in the end robbed the Gao brothers and many of their followers of a dominant role in modern Chinese painting.

6

THE NEW ART MOVEMENT

To appreciate how difficult it was to establish a new art movement in China, one must have some idea of the obstacles Western-style painters had to face. Traditional painters had always been sustained by the system. Societies of painters and calligraphers showed their work to each other, while the public could often see paintings and calligraphy in picture mounting shops, which also acted as agents and accepted orders on commission. Western-style painters had no such ready audience for their work, no dealers, no mounting shops, and only a tiny handful of patrons. The idea of a public gallery was a Western one, imported by way of Japan; even in Shanghai, no independent commercial galleries for xihua were ever established. The system of exhibiting and selling oil paintings developed haphazardly indeed.

But the xihua artists forged ahead against all obstacles, and by the mid-1920s they had become a familiar part of the art world of Shanghai. It was in 1915 that the nudes in Liu Haisu's exhibition created something of a scandal. By 1922, however, the Ministry of Education had given the nude its official sanction, and in October of that year an exhibition of recent Western-style painting was held, including nudes and other oils by Wu Fading and Li Chaoshi. In July a group of Chinese artists who had set up the Art Society (Yishu she) in Tokyo, including Chen Baoyi, Yu Qifan, and Guan Liang, held an exhibition of their work in Shanghai that attracted considerable attention, partly, perhaps, because for the first time tickets were sold at the door. Liu Haisu's Heavenly Horse Society (Tianma huahui) held the first of its annual exhibitions in 1920;[1] a year later the Dawn Art Association, founded by Zhang Yuguang and his friends,

held its first show. In 1923, the Apollo Society that had been set up by Cai Yuanpei in Beijing mounted its second exhibition, remembered chiefly because Lu Xun attended and wrote encouragingly about it, although he cautioned against the unthinking aping of Western modernism.

The first attempt at a national exhibition showing guohua and xihua together took place in Shanghai in 1919. The second, held in Beijing in April 1926, was far more ambitious, at least in size. It included 150 Western-style works and no fewer than 464 works of Chinese painting and calligraphy, of which a considerable number were nothing more than copies of old masterpieces. If this depressing event demonstrated anything it was that, the work of a few major figures excepted, the guohua, dull and derivative, was a dying tradition, while xihua was still in its infancy.

After the Nationalist government was established in Nanjing, the first official National Art Exhibition, sponsored by the Ministry of Education and opened by Cai Yuanpei, was held in Shanghai in April 1929.[2] Ranging back to the beginning of the century, it embraced not only guohua and oil painting, but sculpture, architecture, design, and photography. The traditional paintings still included many copies and imitations of old masters. The Lingnan painters were prominent among the living artists, causing Huang Binhong to comment that the Gao brothers' reforms of traditional painting were "too Japanese," a damning indictment in the eyes of the conservative scholar painters. Among the oils, some were of more than passing interest: Situ Qiao's portrait of his wife, for example; Ding Yanyong's *Girl Reading* in the

manner of van Dongen, and figure compositions by Lin Fengmian showing the influence of Matisse; landscapes by Wang Yachen, Wang Jiyuan, and Zhu Qizhan; nudes by Li Chaoshi, Pan Yuliang, and Zhang Xian; He Sanfeng's *In the Studio* (fig. 6.1), a group of the artist, a male student, and an explicitly painted nude female model; and self-portraits by Wu Dayu and Feng Gangbai.

In an article published in the exhibition catalogue, Xu Beihong wrote that the best thing about it was the fact that "none of that brazen stuff by Cézanne, Matisse, or Bonnard" had been included—things that he said he could turn out himself at the rate of two an hour. If, he declared, the new national gallery packed ten rooms with paintings by Cézanne and Matisse, he'd have no choice but to shave his head and become a monk. The poet Xu Zhimo took the opposite line, declaring Cézanne to be the "uncrowned king" of modern art. Li Yishi sided with Xu Zhimo, but he felt that works by these masters should not be encouraged in China, "for if they become popular, they will have a great and, I fear, a deleterious impact on society." These positions taken toward modern Western art at the 1929 National Exhibition—total rejection, total acceptance, and qualified approval—have characterized Chinese attitudes to the problem throughout the rest of the century.[3]

A notable feature of the exhibition, and a tribute to the debt owed to Japan, was the inclusion of nudes and figure studies by a number of leading Japanese oil painters: Wada Eisaku, who had studied under Raphael Collin in Paris and Kuroda in Tokyo; Ishii Takutei, pupil of Asai Chū and Fujishima Takeji; Mitsutani Kunishirō, a follower of Matisse; the academic realist Terauchi Manjirō; and the great Umehara Ryūzaburō, who was on his first visit to China and attended the exhibition in person.[4] The presence of works by these Japanese artists made painfully clear how far the Chinese oil painters still had to go. In Japan, oil painting had been established for half a century. Their modernists painted with immense assurance and skill. But to the educated Chinese artist, mere skill carried with it the taint of professionalism. Art was much more than skill, it was the expression of thought and feeling. This devotion to personal expression rather than to craft may help to account for the relative reluctance to surrender completely to the discipline of oil painting that some Chinese Western-style painters showed.

But times were changing, and some works by artists recently back from Paris, such as Lin Fengmian, Wu Dayu, and Pan Yuliang, represented a great advance on anything Shanghai had seen before. As the modern movement gathered momentum, the number of exhibitions increased. In the summer of 1931, the bold young Hangzhou oil painter Hu Yichuan brought to Shang-

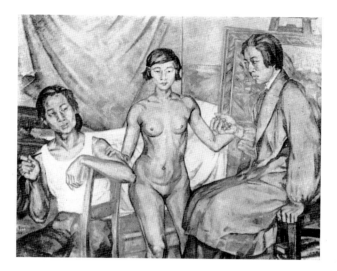

6.1
He Sanfeng, *In the Studio* (c. 1929). Oils.

hai (with Lu Xun's encouragement) a varied collection of 180 works that included guohua, oil painting, sculpture, and a few woodcuts. Lu Xun and his friend and protector Uchiyama Kanzō were able to rent a hall for only three days, and the exhibition attracted little public notice, but it was considered subversive enough for the authorities in Hangzhou to suppress Lu Xun's hardly inflammatory preface.[5] The annual exhibitions of the Storm Society (see page 63) in the early 1930s were also noteworthy.

Although the foreign settlements had not been affected by the fighting of early 1932, it took two years for the Shanghai art world to fully recover from the devastation of the Japanese attack. In 1934 the Art Wind Society (Yifeng she), which sponsored the influential art journal *Yifeng,* held an important exhibition in Shanghai that included works by many leading figures in the modern movement.[6] About half the pictures were for sale, at prices ranging from a modest twelve dollars for a Li Kuchan up to five hundred for a Lin Fengmian or Pan Yuliang. If these enormous prices were actually realized, and not just intended to attract attention (a stratagem sometimes used by Zhang Daqian and others), they suggest that there was at last in Shanghai a public for Western painting—although the collectors were still very few.

Much more sensational was the 1935 NOVA exhibition of the China Independent Art Association (Zhonghua duli meishu hui), composed chiefly of young artists under the spell of the Japanese "neo-fauves" and surrealists.[7] This first and sadly premature manifestation of the Chinese avant-garde included Li Dongping, Zhao Shou (plate 11), Liang Xihong, and Zeng Wu. No one, except the artists themselves, had any idea as to what it

meant, and the critics condemned it. What made the exhibition something of a landmark was the inclusion of works by the leading Japanese exponent of the avant-garde, Ai Mitsu, who also attended the show, and by a minor French Surrealist, André Bésein, who happened to be in Shanghai at the time; but the strongest influences were still Matisse, Picasso, Braque, Vlaminck.

The major part of the October issue of *Yifeng* was devoted to the exhibition, and particularly to surrealism. It included a translation of André Breton's *Manifesto of 1924* and reproductions of works by Ernst, Miró, Dalí, de Chirico, Tanguy, Klee, and others. The editor, Sun Fuxi, praised the young Chinese avant-garde as "daring and violent fighters deserving our respect," but thought that the movement stood on insecure foundations. His picturesque harangue is oddly noncommittal:

> These fighters engaged in desperate clashes have no need to plan for the future, to make sure that they have the talents of someone to pacify the people, to be appointed director of the Department of Education, to be generalissimo of the combined forces. Those engaged in hand-to-hand fighting only have to know how to fight; they shouldn't bother themselves with the question of whether or not they have a college diploma, whether or not their fathers stem from the aristocracy. For our fighting friends in the China Independent Art Association, it is enough that we show our admiration for their fighting spirit. After their campaign, how to secure their strategic position, how to supply it with provisions and weapons—that is a problem for the second step.[8]

There was to be no second step. The exhibition was savaged in the press, and that was the end of NOVA. But the fact that it could be held at all was a sign of how far the Shanghai intelligentsia—if not the rest of the country—had come towards the acceptance of foreign art.

Also in 1935 were held what must have been the largest exhibitions of original foreign works ever seen in China. Paintings by sixty-eight Belgian artists, ranging from Post-Impressionism to a portrait of King Albert on horseback, were shown under the auspices of the Belgian Ambassador and reviewed in *Yifeng* by Wu Zuoren, just back from Europe; while foreign residents in Shanghai put together a collection of two hundred works by Austrian and Hungarian artists. Some of them were offered as lottery prizes, suggesting that the quality can hardly have been very high.

The same must surely apply to the Yifeng She's third exhibition, which showed no fewer than 931 works![9] Many of the leading oil painters were represented, and far more guohua artists. A significant trend was the increasing number of oil painters, notable among them being Fang Rending, Xu Beihong, Fang Junbi, Wang Yachen (plate 12), and Sun Fuxi, who were doing at least some of their work in the Chinese medium. The same trend—or rather, the growing ability to work comfortably in both guohua and oils—could be seen in the first exhibition in Shanghai of the Silent Society (Mo she), founded in 1935.[10] At their exhibition in January 1936, some famous oil painters, including Xu Beihong, showed guohua paintings, although Chen Baoyi, Ni Yide, and Pan Yuliang were among those who continued to paint consistently in oils. The Mo She represented an unusually wide spectrum of contemporary painting, but the war killed it before it could become influential.

The first six months of 1937 were a period of even more intense artistic activity. There were at least forty-four exhibitions in Shanghai alone, including one-artist shows by Liu Haisu, Gao Jianfu, and Wang Jiyuan (fig. 6.2). The major event was the Second National Art Exhibition, held in Nanjing, Shanghai, and Canton. The Nanjing exhibition was held in the new Art Gallery and Concert Hall that was built with the proceeds from the 1935 Burlington House exhibition.[11] Perhaps inspired by the scope and success of the event in London, the Nanjing exhibition, mounted by the Ministry of Education, ranged from recent archaeological discoveries at Anyang, through ancient painting, calligraphy, architecture, and sculpture, and on to contemporary painting (both guohua and xihua) and photography. The guohua works included the usual copies as well as paintings by the Lingnan artists and Xu Beihong, while the oil painters included several of Xu Beihong's associates and pupils, such as Chang Shuhong, Wu Zuoren, and Lü Sibai, all of whom had studied in France. Artists suspected of radical sympathies, such as Ni Yide, were of course excluded. The selection was strongly influenced by the taste of Xu Beihong. Although it by no means represented the more adventurous trends, the standard of oil painting showed a considerable advance on that in the first National Exhibition of 1929.

In spite of the number of exhibitions around the country, Nanjing was the only city in China that could boast an art gallery. In Shanghai, exhibitions were held wherever room could be found. The Cishu Dalou in Nanjing Road housed company offices that could provide space: Yan Wenliang showed his paintings there. University halls offered room: Pang Xunqin had a show in 1946 in the auditorium of the Université Aurore. The Xinyue Shudian in Wangpinggai sold art books and had room for a few pictures. Other locales included the headquarters of the Li Clan Association and of the Ningpo Guild. Liu Haisu exhibited in the Sun Company Building; Zhang Daqian and his brother, the tiger painter Zhang Shanzi, in the New Asia Hotel; and Gao Jianfu

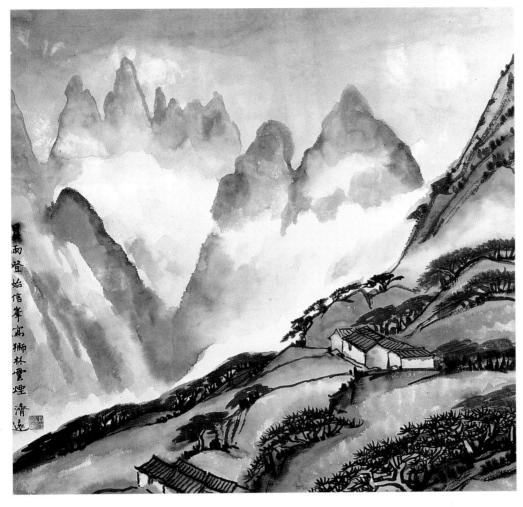

6.2
Wang Jiyuan, *Mountain in the Clouds* (1934). Ink on paper.

in the International Club. Hotels and department stores such as the Liangyu Shiyeshi were popular venues. The Daxin (Dai Sin) Department Store in Fuzhou Road in the International Settlement had one of the most famous galleries in Shanghai; the first to hold a show there was Gao Jianfu.

If more care had been taken with the display of the paintings, the lack of suitable galleries might have been less damaging. The critic Wen Yuanning wrote in 1936,

> The first point that strikes any visitor to most Chinese Exhibitions of Paintings is the atrocious way in which the pictures are displayed. Nothing is done to show a painting to its best advantage. The exhibits seem to be hung up on no principle that we can discover: short and long, big and small, they are thrown together pell-mell. The result is anything but artistic. Under such circumstances, many beautiful pictures stand precious little chance of catching one's attention. In this respect, we have plenty to learn from the Japanese. With them every picture, without sacrificing a jot of its claim on the spectator's attention, contributes to the harmonious effect of the whole exhibition. . . . In the West too, they order things better than we do here. What a difference, for instance, between the way we displayed our exhibits for the London Exhibition of Chinese Art at Shanghai last year and Nanjing a few months ago, and the way they were displayed at Burlington House! Our manner of displaying our exhibits is not even a good shopman's way of displaying his goods.[12]

Wen Yuanning notes how odd it is that "we Chinese should insist so much upon design and harmony in the drawing of a picture, and yet be so terribly negligent of them when we come to displaying a number of pictures at an Exhibition!" As for the places where they are

shown, he remarks, "To hold Art Exhibitions in them is about as appropriate as to hold a religious service in a gymnasium," and he looks forward to the time when galleries will be built in all the important cities in China—a hope that was not to be realized until well after Liberation.

ART ENTERS THE POLITICAL ARENA

By 1930 the Communists had been driven underground, and the struggle for the minds and the hearts of the educated class was intensifying. Two years later, the government set up the Chinese Art Association (Zhongguo meishu hui). With the backing of high Guomindang officials such as Zhang Daofan and the support of Xu Beihong, this body aimed to attract artists into its orbit and so counteract the left-wing movements that had grown considerably since the bloody purges of 1930.[13] The association held annual exhibitions, and though it inevitably got the support of the faculty of National Central University art department (Pan Yuliang, Chen Zhifo, Zhang Shuqi, and later Wu Zuoren and Lü Sibai), it attracted little attention outside Nanjing. Many of the Western-style artists were not pro-Communist, but neither were they prepared to support the Guomindang in its suppression of dissent.

The Guomindang philosophy of art was high in moral tone, but somewhat vague. In the words of one supporter of the government:

> I think that the artists of today must first know clearly the national character, then grasp the spirit of the age, before they proceed to create works of art which are an expression of these things. In other words, what we need today is the peaceful and great love of the Three People's Principles. We want to read poetry and prose that are stimulating and heroic. . . . We want to appreciate paintings that are solemn, holy and pure. At the same time, we hope the artists would focus their artistic activities on arousing our national consciousness and national spirit. . . . [14]

The launching of the New Life Movement in 1934 was another attempt by the Guomindang to counteract subversion by an appeal to morality and patriotism. At first, many liberals were seduced. In the conclusion of Lin Fengmian's *Art and the New Life Movement*, he wrote, "Artists are responsible for part of the leadership in our society; therefore, not only should they improve their own life, but [they] should also make use of the strength of their art to lead the people to improve their way of living. The new life style of the artists is not only a personal elevating process, but a helping force to advance the quality of living in the entire society."[15] These high-sounding sentiments did not touch on the real ills—social, economic, political—of contemporary Chinese society. But what was the artist with a conscience to do, short of the ultimate (and dangerous) step of throwing in their lot with the Communists? Was there no middle way?

THE STORM SOCIETY In the summer of 1931 Ni Yide met with Pang Xunqin and a band of artists trained in Tokyo and Paris to try to form a serious modern art movement. On September 23, 1931, they formed the Storm Society (Juelan she), holding their first exhibition in the following January in the French Concession.[16] By July they numbered twelve, including Zhuo Duo, Zeng Zhiliang, Zhou Bichu (a Fujianese oil painter who had studied in Paris), Zhang Xian, Liang Baibo, Yang Taiyang, Yang Qiuren, Wang Jiyuan, and Pang Xunqin's wife, Qiu Ti. We illustrate here Zhou Bichu's solidly painted nude (plate 13), bearing witness to his orthodox French training, and *Beauty Looking at a Picture* (plate 14), a rare surviving example of the more sensitive and imaginative work of Zhang Xian. Prominent artists who did not join the society but gave it their support included Chen Baoyi, Ding Yanyong, and Liu Haisu. Their *Manifesto* was a cry of despair about the present state of art, and of hope for the future:

> The air that surrounds us is too desolate. The commonplace and the vulgar enclose us on all sides, numberless feeble wriggling worms, endless hollow clamor!
>
> Whither has gone our ancient creative talent, our glorious history? Our whole art world today is decrepit and feeble.
>
> We can no longer be at ease in this atmosphere of compromise. We cannot tolerate this feeble breathing to await our death.
>
> Release the disturbing power of Realism!
>
> Let us arise! Summon up the passion of wild beasts, the will of steel, to create an integrated world with color, line and form!
>
> We recognize that art is certainly not the imitation of nature, nor is it the inflexible repetition of objective form. We must devote our whole lives to the undisguised expression of our fierce emotion!
>
> We do not take art to be the slave of religion, nor is it the explanation of a culture. We want freedom to build up pure creation!
>
> We hate the old forms, the old colors! We hate the commonplace, low-grade cleverness! We want to use the new art to express the spirit of a new era. . . . [17]

6.3
Pang Xunqin, *No Title* (c. 1933). Oils.

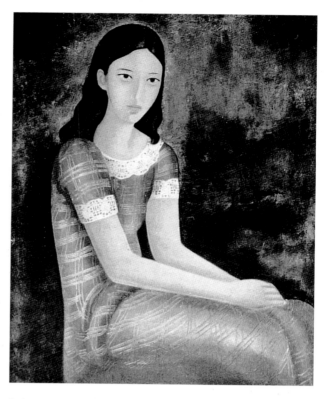

6.4
Pang Xunqin, *The Artist's Wife, Qiu Ti* (c. 1933). Oils.

Ni Yide wrote, about this time, "I deplore the praise handed out today to famous artists. . . . Most of them are without principle, while the nameless young artists seek their words of wisdom and precious message in vain. But it is they who are laying the foundations for the new art." Zhang Shuqi was more unrestrained: "To us, painting is life itself! . . . Have you seen the paintings hanging in the reception halls of our rich men and merchants—the famous works of the great masters [Cheng] Mantuo and [Xie] Zhiguang? [These were two popular painters of beautiful women in the early Republic.] Manto has finished off our four thousand years' legacy of art!" Pang Xunqin, more soberly, stressed the artists' freedom and the need to change one's painting in response to new experience.

After reading these stirring words, it is a little disappointing to find that the work of the Storm Society painters is quite restrained and conservative, at least in style. Photographs of the members taken at this time show a group of young men standing, hands in pockets, smartly dressed in Western suits (except Pang Xunqin, who wore a Chinese gown) as though they had just stepped off the boat from Marseilles. Their work showed no consistency of style or subject matter. Pang himself painted carefully composed, formalist works. His *Blind Man* and similar *No Title* (fig. 6.3), both of which owe much to the early Picasso, evoke man's helplessness, combining the formalism of a court playing card with a suggestion of loss, of the fickleness of human destiny. Pang was at his most sensitive and lyrical in the beautiful portrait of his wife Qiu Ti (fig. 6.4), painted about 1933, which was destroyed—either by Pang himself or by his students—during the Cultural Revolution. Paintings such as Pang's well reflect the predicament of the liberal Chinese intellectual and humanist of the early 1930s, but they were hardly a call to action.

Ni Yide's response to the challenge was rather different.[18] Born in Hangzhou in 1901, he had studied under Liu Haisu and in Japan (1927–28) under Fujishima Takeji. Although he was indirectly influenced by Cézanne, Derain, and Vlaminck and wrote extensively on modern Western art (it was he who translated André Breton's *Surrealist Manifesto*), he was never in Europe, and so did not have to free himself, as did Pang Xunqin,

6.5
Ni Yide, *Girl's Head* (c. 1935). Oils.

6.6
Qiu Ti, *Portrait of Pang Tao* (1944). Oils.

from that too seductive attachment. His portraits, nudes and landscapes are painted with uncompromising firmness and solidity (fig. 6.5). If they carry any message at all it is simply one of artistic seriousness and honesty.

Yang Qiuren, born in Guilin in 1907, had studied oil painting in the Shanghai Academy, and joined Pang Xunqin in the Storm Society almost as soon as he graduated.[19] He was a conventional, competent oil painter, as was Yang Taiyang, born two years later, also in Guilin, also a former pupil of Chen Baoyi. He was working in the editorial department of the Shanghai World Bookstore when he joined Pang. Many years later, having survived the vicissitudes of life under Mao Zedong, Yang Taiyang was to find himself again, this time as a lyrical watercolorist (plate 15).

For several years the Storm Society held annual exhibitions, but by 1935 rifts were appearing over the question of how far the artist should engage in the social and political struggle, and the group broke up. Pang Xunqin remained, like Lin Fengmian, politically uncommitted, seeking a middle way in his art. Zhang Shuqi soon abandoned oil painting and took up the Chinese brush. He later settled in America, where he became a popular painter of birds and flowers.[20] Ni Yide moved further to the Left, although not far enough to join the Communists in the long trek to the mountains of Jiangxi. We shall hear of him again, however. Qiu Ti, who had married Pang Xunqin after his return from Paris, was a competent oil painter and a sensitive one, as shown by her portrait of her little daughter, Pang Tao, painted in Chengdu in 1944 (fig. 6.6).

WESTERN ART IN TRANSLATION Returning from Paris and Tokyo intoxicated with their discovery of Picasso and Matisse, the Storm Society painters could not be expected to find a magic formula that would, within the space of a few years, fuse their own aesthetic tradition with the new art of Europe and somehow make it relevant to the contemporary scene in China. Their efforts were not simplified by the indiscriminate eagerness with which translators at that time seized on everything about Western aesthetics and art they could lay their hands on, from Plato to Herbert Read, from the ancient Greeks to the Surrealists.

A torrent of translations and interpretations appeared in the journals of the 1920s and early 1930s, and I can only give an impression of what was presented to eager and often utterly bewildered young readers. Part of Ruskin's *Modern Painters* was translated (from the Japanese) by the painter Feng Zikai in 1923, while in 1927 Liu Sixun attempted to set out Ruskin's theory of art.[21] The ideas of William Morris were outlined in an arti-

cle of 1920 in the influential journal *Dongfang zazhi,* which also published many articles on trends in modern painting in the Western world. Tolstoy's *What Is Art?* was translated in 1921. In his introduction, Zheng Zhenduo lauds Tolstoy's passionately ethical view of art as "a tool to remove violence and create a world of love" (a view that was to lead Tolstoy to condemn most of his own fiction). Although Zheng recognizes this as an impossible dream, he uses Tolstoy's vision as a stick to beat Chinese traditional painting, which he calls individualistic, mere entertainment, remote from life, with no aim but pleasure and the cultivation of refined feelings.

Neo-Confucianism could be said to have found a sympathetic echo in the thought of Benedetto Croce, which became accessible through translations in 1921. Croce's aesthetic and moral sensitivity, his belief in the beauty of all creations of the human spirit, and above all his profound sense of history appealed to the cultivated Chinese mind, acting as a counterbalance to the wilder dreams of the romantics and the protagonists of art for art's sake. Prince Kropotkin's benevolent anarchism also found its adherents, for it combined a Mencian belief in human goodness with revolutionary enthusiasm and the idea of the freedom of the individual.

In the heady atmosphere of the 1920s, artists were free to pick and choose among the plethora of ill-digested ideas and styles they were discovering, with little idea of how they came into being in the West, or why. Lu Xun wrote in 1927,

> A horrifying phenomenon in the world of literature and arts in China now is the importation of an "ism," but without introducing the meaning of this "ism." As a result, everyone uses his own interpretation. When he reads a work mainly on the author himself, he calls that "Expressionism." If it concerns other people more, then it is "Realism." To be moved by a girl's exposed legs to write poetry is "Romanticism," but to look at a girl's legs and not be allowed to write poetry is called "Classicism." A head falls down from the sky, on this head stands a cow, oh, love. . . . Such is "Futurism," etc., etc.[22]

Indeed, artists tended to call almost any modern Western movement that they did not understand "futurism."

And how could they possibly understand Western modernism? Few saw any examples of it. Cai Yuanpei had been an early enthusiast.[23] During his years in Europe (1907–15), he had come to know leading collectors in Berlin and Paris and had met Max Jacob, Juan Gris, and Picasso, whose studio he visited in June 1915. He thought that Picasso's idea of art as the "essence" and the creative distortion of nature was close to that of the Song poet-painter Su Dongpo. He brought back to China a small collection of early Picassos, which he later gave to his nephew, Chen Qinghua. For years they remained, almost unknown, in Chen's home in Suzhou. To whom had Cai shown them? And what impact had they had? These questions have yet to be answered. Artists and the intelligentsia generally knew modern Western art only through the magazines.

A glance at some of the art magazines that appeared in Shanghai about this time shows how totally dependent they were on Europe. Typical was *Meiyu zazhi* (Mi-yo magazine), published in 1930–31 by the sculptor, poet, and critic Li Jinfa, whose writings reflect the cosmopolitanism of the Nanguo movement (see page 47). Translations of Croce and Lamartine sit side by side with reproductions of the work of Bourdelle and Bouguereau, Li's own Symbolist poetry with photographs of D'Annunzio and film star Mary Philbin and barroom pin-ups of adagio dancers. Less catholic and perhaps more influential were *Yishu xunkan* and *Yifeng,* which did much to spread an understanding of modern trends, while *Yishu,* which appeared briefly in 1933, tried valiantly to put across to its readers the message of surrealism. The names of Cocteau, Aragon, and Breton are scattered through its pages, together with a serious study by the critic and art historian Teng Gu of Herbert Read's *The Meaning of Art.*

Apollo, published semimonthly from October 1928 by the Hangzhou Academy, began by welcoming André Claudot, "a famous artist from Paris," who had come down from Beijing with a little dog that he treated as a son. Successive issues carried translations of Baudelaire's poems, Elie Faure on Chinese art, and Clive Bell on Cézanne, as well as articles on Paleolithic art, Greek mythology, Leonardo, and the Pre-Raphaelites. The manifesto of the National Art Movement Association (see chapter 4) is printed, with supporting articles and a song to celebrate it. There is a "Letter from Paris" and a complete translation of Flaubert's *Temptation of St. Anthony.* Lin Fengmian and Lin Wenzheng also contributed extensively to *Athena* (Yadanna), published in Hangzhou through 1931, which reproduced several of Lin Fengmian's large oil compositions, now lost, works by Li Chaoshi and Li Kuchan, nudes by Wu Dayu, and a weekly chronicle of art events.

The climate that these journals helped to create was civilized, cosmopolitan, stimulating, and confused. They could do no more than speak to a small group endeavoring to stand apart from the political and ideological struggles that surrounded them. What would have happened to that group, which included most of the artists we have been discussing, if war had not come in 1937? Would they have been able to hold the center ground,

or would they have been crushed between Left and Right? The sudden Japanese attack outside Beijing on July 7, 1937, solved all these problems for a few years, as Left, Right, and the uncommitted Center sank their differences in the United Front.

THE FIRST TWENTY-FIVE YEARS

This is a good moment to pause in our narrative and to consider how much help Western art actually gave to the creation of new means of expression appropriate to the profound changes that were taking place in Chinese culture. The challenge was not merely one of how to acquire and adopt new techniques of pictorial representation; the whole world of art that had opened to the Chinese painter was something new. Cai Yuanpei's doctrine of the universality of artistic value came as a shock to some, a revelation to others. New and revolutionary also was the idea that art, at its higher levels, was not the exclusive province of the gentleman but could—indeed must—flourish by itself, unsupported by scholarship, poetry, and literary culture. The painter, cut loose from his traditional moorings, must chart his own course. The fact that many professional xihua painters attained some status as professors and teachers helped solve their social and economic problems, but it did not solve their aesthetic ones.

Equally unsettling to traditional views was the discovery that the subject matter of art was not confined to certain agreeable or symbolic themes. Virtually anything could be depicted. Even more disturbing was the related idea that the first aim of art was not to produce beautiful pictures or to give pleasure, but to reveal the world as seen and felt by the artist; to tell the truth, however ugly or tragic.

The influence of Western thought, moreover, challenged the integrated, holistic Chinese view of reality and the belief that it is the purpose of art to reflect, indeed to promote, that integrated view by producing works in which visual harmony reigns supreme. Western thought and art were more strenuous, more open-ended, more experimental, leaving it to the individual artist to stake out his own ground and reveal reality in his own way. For many young Chinese painters, this was too great a challenge for the poor means at their command. Many shrank from it into an artificial romanticism, or into feeble imitation of Western styles they barely understood.

To all but a fortunate few, training in the vision and techniques of the Western artist had been too short, or had been given by teachers who were themselves too little grounded in what they taught. Besides, the environment for Western art in China was hardly propitious,

and such support as there was was confined to tiny bridgeheads in a few major cities. "Western art in China is a tender plant," wrote Qin Xuanfu in 1937. "Unless it is nurtured, it will never grow. It has to rely on its own strength—on the puny strength of a very few people. Today's environment seems a bit better than before. At least the problem can be discussed." But the bridgeheads were still not secure, for he goes on, "Do we need Western art? . . . I hope everyone will ask themselves the question, and ask themselves whether on not, in the process of improving Chinese painting and creating a new painting, we need the help of Western art, and if we do, then we must make up our minds to do the utmost to develop it."[24]

The obstacles were many: the absence of all but a tiny handful of really gifted and competent teachers; an uninformed public, with no art galleries or permanent collections of modern art; the paucity of buyers for oil paintings; the almost total lack of competent critics. What sustained the Western-style painter was his belief that his was the art of the future, and the art that best expressed China's new vision. Besides, at the practical level, oil paints and canvas were far more expensive than Chinese ink and paper, and many young artists abandoned oils for that reason. Moreover, a guohua painter of even moderate gifts could, like an amateur pianist, produce through long practice a pleasing performance, if not an original one, while a less than accomplished oil painting gave no pleasure to anyone. But to paint well in oils was not easy. Perhaps Chinese students in Paris had heard the ditty that had once been popular at l'Académie Julian, when a student would suddenly break into song:

> La peinture à l'huile
> est très difficile!

at which the chorus would shout

> Mais c'est bien plus beau
> que la peinture à l'eau![25]

What made the challenge all the more difficult was the fact that the young artists were learning the fundamentals of the Western method (as taught, for instance, by Xu Beihong and Yan Wenliang) at the same time they were discovering that Western art was in violent rebellion against that very method. When academic art reached Japan in the 1870s, it was still the mainstream in Europe; when it reached China in the 1920s, it was already dead, or at least comatose. To follow Xu Beihong in a time of revolt was to be a reactionary; but to leap onto the crest of a wave, as the NOVA group did in joining with the Surrealists, was to be left high and dry

when the tide went out. Indeed, the artists' absolute freedom of choice, while exhilarating, often left them confused. As Mayching Kao put it, "The individual styles of Manet, Monet, Cézanne, van Gogh, Derain and Vlaminck were considered as a repertoire from which to pick and choose in the learning process. And a Western-style painter could become a Post-Impressionist or a Fauve anytime, depending upon his whim."[26]

During this critical period, a few artists and critics began to realize that while Chinese art was moving westwards, modern Western art was also moving eastwards, and that there might, after all, be common ground. Tao Lengyue wrote in 1932 that Post-Impressionism "pays attention to the tendency of strength and line . . . [and] emphasises exclusively subjectivity. It is moving away from the bondage of realistic representation towards the expression of an idea [xieyi]."[27] He thinks this is caused by the impact of Asian styles, though he does not mention Kandinsky, who for a time was deeply influenced by Chinese poetry and painting. Zong Baihua described the Chinese sense of space as something that Western art was discovering, while Pan Tianshou had noted in 1926 that European painting was "tending towards the spiritual taste of the Orient."

When war came in 1937, Chinese art seemed on the threshold of a major breakthrough into a mature modernism. But to some radical critics, all this theorizing was irrelevant. Writing early in 1937, Chen Yifan (Jack Chen) insisted that "only that art can be considered modern that is inspired by a revolutionary democratic nationalism. The test of a modern art is its value to the progress of China. . . . The final test of ideological content must be applied. . . . Can any but a realistic art for China be defended? This necessity for realism is basic. The very power of a truly national art makes any other content such as mysticism, futurism, a national dose of ideological poison. . . . In the creation of a realistic art the artist completely fulfills his social and political duties."[28] When the Communists came to power in 1949, this was to be the message that drowned out all others.

LEADING MASTERS
BETWEEN THE WARS

XU BEIHONG

Although one modern Chinese painter expressed to me the opinion that Xu Beihong had set back the development of Chinese art by forty years—a view shared by a number of radical young artists—it must be acknowledged that he was a key figure during his lifetime, and that his struggles, accomplishments, and failures illuminate the history of Chinese twentieth-century painting more, perhaps, than those of any other artist.

Xu Beihong was born in 1895 at Jitingqiao, a village in Yixing County to the west of Lake Tai, roughly halfway between Shanghai and Nanjing.[1] His father, Xu Dachang, a small farmer and largely self-taught artist who may also have studied with Ren Xiong, began to teach him as a child. When in his teens Beihong showed precocious talent, father and son together scraped a living as itinerant portrait painters. Beihong also did "ancestral portraits." By the time he was seventeen (and already married), he was supporting his ailing father by teaching art in the Yixing Girls' Normal School, and when his father died in 1914 he set off to seek his fortune in Shanghai.

The years that followed were hard. A momentary flash of success came when he took his painting of a horse to the Shenmei Shuguan to show to Gao Jianfu and his brother; but their extravagant praise of the painting led nowhere. By 1915 Xu had managed to enroll in the Université Aurore (Zhendan University), where he began to learn French, and may also have picked up some hints on Western drawing and painting from the Jesuit fathers at Siccawei. For nearly two years he studied in what would later become the Shanghai Meizhuan. Although he later acknowledged that he had worked there, he would never admit that he had once been a pupil of Liu Haisu.

By this time, Xu Beihong had been drawn into the circle of the Hardoons. Silas A. Hardoon, having worked his way up from night watchman in a Sassoon warehouse to property magnate, opium dealer, and city councillor, supported scholarly projects and hosted gatherings of Chinese artists and connoisseurs with his Eurasian wife, Luo Jialing, in their huge Ailing Park estate on Bubbling Well Road.[2] There Xu Beihong met Kang Youwei, who gave him entrée to his private art collection, and there too he met his future second wife, Jiang Biwei (Chang Pilwi). When Mrs. Hardoon sponsored a competition for a painting of the legendary Zang Jie for one of the buildings in the ephemeral "Mingzhi University" which she attempted to establish in their park, Xu Beihong was the winner. Clearly, he was a young man of promise.

Xu Beihong spent nearly two years in and around Ailing Park, dreaming of Paris. But the European war was raging, so with the help of Mrs. Hardoon and Ji Juemi, her majordomo and (said the scandalmongers) her lover, Xu set off for Tokyo with Jiang Biwei in May 1917. He spent most of his time in the art galleries and his allowance in the art bookshops, so he did not fall under the influence of any particular Japanese artist. By December his money had run out and they had to come home. In any case, his thoughts were already fixed on Paris.

In 1918 Cai Yuanpei appointed Xu Beihong as a teacher in the Painting Methods Research Society he had established in Beijing University. From that moment his

future was assured. This ardent young patriot inevitably became caught up in the revolutionary ferment of the university during the New Culture Movement and was one of the first to acknowledge that China's art, like her literature, needed to be rejuvenated. In an article he wrote for the first issue of the university's art journal on the reform of Chinese painting, he did not mince his words. Chinese painting, he declared, had reached the nadir of its decline—in fact, it had been declining for seven hundred years (a view he may have picked up from the Kanō·School painters in Tokyo). In order to modernize it, he urged artists to "preserve those traditional methods which are good, revive those which are moribund, change those which are bad, strengthen those which are weak, and amalgamate those elements of Western painting which can be adopted."[3] This sounds very like the program that Okakura Kakuzō had laid down for the *nihonga* movement thirty years earlier, which Xu Beihong must certainly have heard about during his stay in Japan.

In March 1919, with the blessing of Cai Yuanpei, a small stipend, and a promise of three hundred dollars a month from Ji Juemi, Xu Beihong and Jiang Biwei set off for Paris. After spending some months improving his French, he enrolled in the Académie Julian and later in the Ecole Nationale Supérieure des Beaux Arts, where he got a firm academic grounding, while in the Louvre and the Luxembourg he copied works of Prud'hon, Delacroix, Velázquez, and Rembrandt. He also spent several months in Geneva.

When his scholarship ran out (Ji Juemi's promised stipend never arrived at all) he was forced to go to Berlin, then in the depths of its postwar inflationary period, where his francs went further on the black market. There he worked under Arthur Kamph, head of the Hochschule für den Bildende Künste in Charlottenburg, and spent much time drawing the lions in the Berlin Zoo. Back in Paris in 1923 after twenty months in Berlin, his scholarship restored, he resumed his studies with the conservative painter and teacher Dagnan-Bouveret, with such success that in one year alone he exhibited no less than nine paintings in the official Salon exhibitions. In 1925 he returned home by way of Singapore, where he secured some lucrative portrait commissions. Arriving in Shanghai, he held a big one-man show. By now he was famous.

By June 1926, Xu Beihong was back in Europe, visiting Paris, Italy, and Switzerland, copying paintings in Brussels, so poor that to make ends meet Jiang Biwei had to make embroidery for the Magasins du Louvre at five francs a piece. When he returned home in the following year it was to join Tian Han's short-lived Académie du Midi (see page 47) as head of its art de-

7.1
Xu Beihong, study of French peasant with horse, in the manner of Dagnan-Bouveret (c. 1924). Charcoal.

partment. By the end of 1927, Cai Yuanpei had appointed him to head the art department of the newly established National Central University in Nanjing, which became his power base for the next ten years.

Xu Beihong had brought with him from Paris the firm belief of his master, Dagnan-Bouveret, in *dessin* (drawing) as the foundation of painting. (See fig. 7.1.) His drawing and oil painting techniques were solid, academic, and competent—standards he passed on to his many students.[4] He was much in demand as a portrait painter, and he liked to compose romantic groups of nudes in the moonlight or girls playing the flute under the moon. The maiden attended by pet lions which graces the first issue of Xu Zhimo's *Xin yue* (see page 34) is another example of a kind of painting that had a disastrous influence on students only too ready to mistake sentimentality for true feeling.

Xu's romanticism reflected the Parisian art world in which he had steeped himself (plate 16). "It was easy to see where he had been," wrote Dagney Carter at this time. "The long hair, velvet coat and flowing tie and his detached languid mannerisms, as well as his excellent French, suggested the Latin Quarter."[5] But Nanjing in

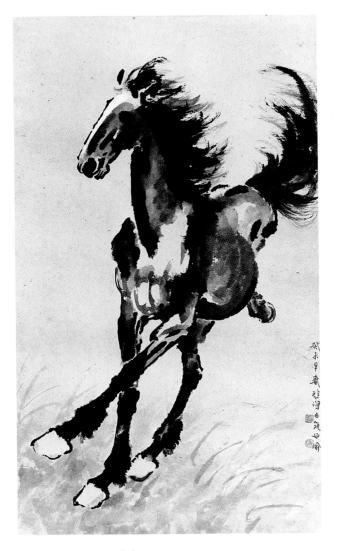

7 . 2
Xu Beihong, *Galloping Horse* (1943). Ink on paper.

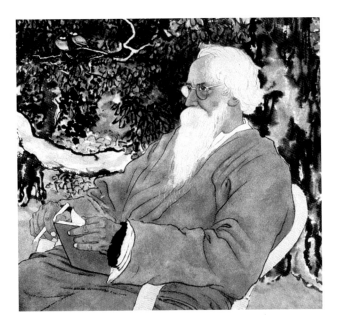

1928 was no place for a transplanted bohemian. Soon he had doffed his velvet coat and was painting elaborate figure compositions based on heroic Chinese themes, of which his most ambitious was *The Five Hundred Retainers of Tian Heng.* This large work, begun in Shanghai in 1928 and completed in Nanjing in 1930, illustrates a famous instance of loyalty in Chinese history. Tian Heng, who had fought against the Qin, was equally adamant in his refusal to serve Liu Bang, founder of the Han. Xu Beihong has chosen to illustrate the moment when he takes leave of his followers before cutting off his own head (after which they all commit suicide as well). Although the theme is Chinese, the handling is typical of the Salon painting of the late nineteenth century, well composed and utterly lacking in any true sense of the drama of the moment. The same atmosphere of conventional correctness and lack of dramatic feeling informs his later historical compositions, such as the equally admired *Awaiting the Deliverer* of 1933.[6]

By this time Xu Beihong had taken up his Chinese brush once more, and in addition to painting conventional guohua themes, he was experimenting in combining traditional brush technique with the realistic drawing of the human figure he had learned in Paris. His first important effort in this manner was *Giu fang gao* of 1930, which depicts the woodcutter of the Warring States period whose gift for judging horses was legendary. Xu is said to have chosen the theme as a protest against the government's refusal to recognize talent among the common people (although this may be the willful interpretation of his admirers: at this time he was still a loyal supporter of the Guomindang). Whatever his motives, this was his first major work to display his facility in painting horses. Here he was to develop a formula which, incessantly repeated, would become the cause of his worldwide fame.

About 1930, his marriage with Jiang Biwei began to fall apart. She was having an affair with Zhang Daofan, while he was becoming increasingly involved with his student Sun Duoci, of whose exceptional talent he alone seemed to be aware. Had he and Jiang Biwei divorced then, they would have been spared many years of tension and anxiety; but the marriage, such as it was, staggered on for another fifteen years. In Chongqing in 1943, shortly before they finally divorced, she held an exhibition, by way of revenge, of her collection, which included thirty-five of her husband's horse paintings (fig. 7.2).[7] Someone who had watched him paint his horses told me that they were produced by a kind of assembly-line method, with a dozen sheets of paper laid out on

7 . 3
Xu Beihong, *Rabindranath Tagore* (1940). Ink and color on paper.

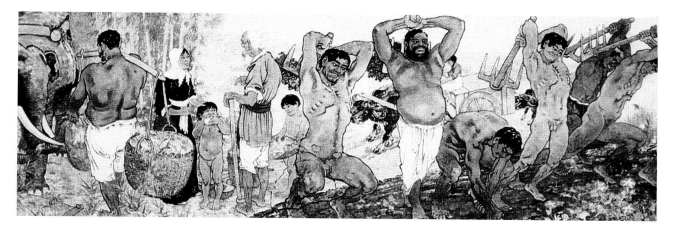

7.4
Xu Beihong, *Yu Gong Removes the Mountain* (1940). Ink and color on paper.

which he painted first the necks, then heads, then manes. The damage to his reputation caused by Jiang Biwei's exhibition, at least among serious artists, was severe.

Xu Beihong was back in Europe in 1933, bringing with him a collection of paintings by himself, the Gao brothers, Zhang Daqian, and Zhang Shanzi that was shown in Paris, Berlin, Rome, Moscow, Leningrad, and Kiev. He made many friends among Soviet painters and sculptors, and returned home by way of the Trans-Siberian Railway.

Back in China, Xu Beihong taught, painted with his students on Tianmushan and Huangshan, travelled to Guangxi—in 1937 he painted a large, well-known study of the Guilin scenery in ink wash—and met the constant demands for his work. By 1938 he was settled with the National Central University art department in the wartime capital in Chongqing. Early in the following year he took a collection of his paintings to Singapore for sale to aid China's refugee aid fund. He then set off for India, where he met Gandhi and Tagore, of whom he painted, in a Sino-Western style, one of his most successful portraits (fig. 7.3). While in Darjeeling he completed his large, patriotic composition, *Yu Gong Removes the Mountain* (fig. 7.4), the story of the old man who thought that by hacking away year after year he and his descendants could remove the mountain that blocked his view (though one wonders if it would not have been simpler to move his house). This parable of attempting the impossible appealed greatly to Mao Zedong, and helped to ensure Xu's exalted status after Liberation. The heroic nudes wielding mattocks have the appearance of posed models, which in fact they were, several of them Indians of whom he made studies in Darjeeling (fig. 7.5); it seems not to have occurred to him that there was any incongruity here. As a work of art, it is uncomfortable and tasteless. Yet Xu could be direct and unaffected in

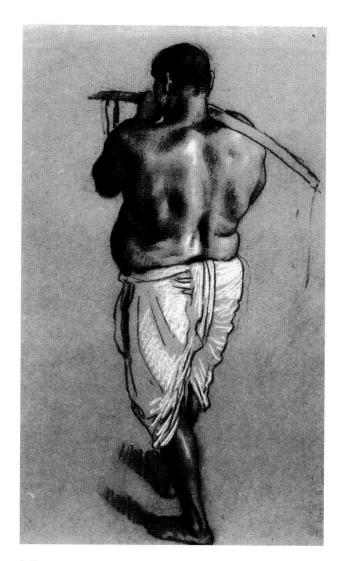

7.5
Xu Beihong, study for *Yu Gong Removes the Mountain* (1940). Charcoal and white chalk.

his oil landscapes and in a handful of his portraits, most notably in the thoughtful study of the twenty-year-old student Liao Jingwen, whom he married in 1943.

Having left India in December 1941, Xu just managed to escape to China ahead of the Japanese when their conquest of Malaya was completed early in 1942. He arrived in Chongqing in June 1942 to find that his former pupil Lü Sibai had been appointed to head the art department of National Central University in his place. He persuaded the British Boxer Indemnity Fund to establish him in his own Chinese Art Academy (Zhongguo meishu xueyuan), where he was joined by a small, loyal group that included the oil painters Feng Fasi and Wu Zuoren.

After a severe kidney illness in 1944, Xu Beihong returned to National Central University, and two years later he was installed as president of the Beijing Academy. Almost as soon as Beijing was liberated in the spring of 1949, he was sent with a Chinese cultural delegation to the International Congress on World Peace in Prague, and took a prominent part in the great meeting of cultural workers held in Beijing in July. He was by this time the acknowledged master among the Realists and the obvious person to appoint as president of the Central Academy of Fine Arts and chairman of the Artists Association, though the actual power, of course, was in the hands of the Party officials in these organizations. One of his last (and worst) oil paintings shows Mao Zedong being greeted by a crowd of smiling admirers, painted in the romantic, brightly colored, anonymous style so popular with his new patrons. Shortly after this, he had a stroke. By the early autumn of 1953 he was well enough to take the chair at the Second National Congress of Literature and Art Workers, but he suffered a cerebral hemorrhage during the meeting, and died on September 26.

In the course of his comparatively short career, Xu Beihong had travelled from painter of ancestral portraits under the Manchus to salon oil painter to model artist under the Communist regime. He was a man of principle, an idealist, a romantic, who gave his students a high example in artistic technique and seriousness of purpose. This having been said, it must also be said that he was by no means an artist of the first rank. Although his technical innovations were a contribution to the problem of the East-West dialogue, only rarely do his paintings, in ink or in oil, give one the sense of revelation, of intense inner vision, or even—except for some of his landscapes—of aesthetic pleasure. He may have been a passionate patriot and dedicated teacher, but he was not passionate or single-minded, as were Liu Haisu and Lin Fengmian, about the only thing that in the end matters to a painter—painting itself. As a result, his work is seldom more than merely competent.

Moreover, when he came to the West at the age of twenty-four his eyes were closed to all European painting after about 1880, and he never opened them again. Living in the Paris of Picasso and Matisse, he seemed totally indifferent to them, while to anything more avant-garde he was even more hostile. In 1929, he made the national art exhibition in Shanghai the occasion for a strong attack on Western modernism. In an article entitled "Doubt" he wrote, "Orientals only partly understand the true face of Western art; because Western art, and particularly that of France, is under the control of the picture dealers." The Chinese, he says with some truth, know only Picasso, Matisse, and Cézanne, and nothing of Constable and Turner. "Renoir is vulgar," he declared, "Cézanne is shallow, Matisse is inferior." The art that Xu calls "formalist" reflects the degeneracy of Western capitalism; the formalists separate art from life, holding that art is no more that "a reflection of the thought of the artist."[8]

Xu Zhimo took issue with him, pointing out that Xu Beihong equated beauty with realism, whereas beauty lies in the form itself. Xu Beihong's apparent blindness seems to have been deliberate, for he sincerely believed that what his students needed was not rootless modernism but a solid foundation in Western technique. That, to his credit, he provided. Perhaps it was enough.

LIU HAISU

Liu Haisu was born in comfortable circumstances in Wuxing, Jiangsu, in 1896, the youngest of nine children.[9] At six he was attending a private school. He acquired a classical education, at ten already had a leaning towards art, and at fourteen was enrolled in Zhou Xiang's little Ecole de Peinture de Shanghai in Baxianqiao. While his fellow students were learning to paint scenery and backdrops for photographers, he was discovering Velázquez and Goya in a bookshop. At the age of sixteen, having, he felt, learned enough of Western art to start out on his own, he opened his own little art school at Baxianqiao in Zhabei with his father's financial help—the germ of what was later to develop into the highly successful Shanghai Academy of Art. In 1915, as we have seen, he was already drawing the wrath of the conservatives by exhibiting the figure studies (albeit male ones) produced by himself and his students.

In 1918 Liu followed Xu Beihong to Tokyo, again with family help. He does not seem to have been formally enrolled in any art school, but he absorbed all he could and came to know a number of leading Japanese

oil painters, most notably Fujishima Takeji, who had spent the years 1905 to 1911 in France and Italy; Mitsutani Kunishirō, a follower of Matisse who had been in Europe in 1914; and Asai Chū's well-known pupil Ishii Takutei. He even managed to be present at the official opening of the National Academy of Art in 1919, after which he returned to China.

He held his first one-man show two years later in Beijing, and lectured on Impressionism and Post-Impressionism at Beijing University at the invitation of Cai Yuanpei. He became a close friend of the old reformer and philosopher Kang Youwei, who showed him copies of paintings by Michelangelo, Raphael, and Titian that he had brought back from Europe. The ever boastful Liu even claimed that it was he who introduced Hu Shi to Liang Qichao, and he took pride in the fact that while Hu Shi was called the Rebel in Literary Culture (Wenxue pantu), he was dubbed the Rebel in Art. By 1923, Liu Haisu had settled in Shanghai where he held a very successful five-day one-man show.

Liu Haisu was a natural oil painter. The earliest surviving canvases, dating from 1919, are already full of vigor and show a surprising technical confidence, considering that he was largely self-taught. His forms are solid, his color hot, crude, and laid on thick—he was never a subtle painter—revealing already a lifelong passion for van Gogh, of whom he said then (although he was not to see an original van Gogh until 1929), "His world is like a sort of raging fire; it is a world of the natural force of inner life."[10]

Until his second visit to Japan (1927–28), Liu Haisu divided his enormous energy between building up the Academy, promoting Western art, fighting warlords and officials over the exhibiting of nudes, and painting—chiefly landscapes, but also a few figure and still life subjects as well. Finally in 1929, with the help of Cai Yuanpei, he got to Paris, taking his twelve-year-old son with him. He travelled constantly in France, Italy, Germany, and Belgium, and also paid a short visit to London. He exhibited at the Salon, lectured in Frankfurt on the Six Principles of Xie He, earned an award in Brussels, and was back in Shanghai in 1932. He returned to Europe for a second visit in 1933–35. Although in the European exhibition that he staged in 1934–35 he showed only guohua paintings, he was steeping himself in modern Western art.[11] On returning to China in 1936, he wrote a vigorous defense of Cézanne, van Gogh, and Matisse, citing the writings of Clive Bell and Roger Fry, and attacking those—his chief target was of course Xu Beihong—who had condemned them.[12]

The rivalry between Liu Haisu and Xu Beihong stretched back to the early 1920s, when, after Liu founded the Heavenly Horse Painting Society in Shanghai, Xu Beihong in Paris launched the Heavenly Dog Painting Society in Paris, on the principle that Dog eats Horse. (It was short-lived.) In 1927, they competed for the directorship of the Beijing Academy, which Xu Beihong won. Their views on what kind of Western art was suitable for China were profoundly different: Liu believed in modernism (at least up to the Post-Impressionists) and in the freedom of the artist to find his or her own style, while Xu's philosophy was uncompromisingly academic.

By 1929, with Xu established in Nanjing and Liu in Shanghai, the rivalry extended to their students. Liu Haisu never tired of pointing out that whereas Xu Beihong went to Europe as a poor student, he himself had been sent on a tour of inspection as the principal of an art school. It was said that Liu Haisu brought his own exhibition to Europe only when he heard of Xu Beihong's project, and that Xu wouldn't take *his* to London because Liu was already there. And was it patriotism or merely rivalry that inspired them both to take collections of their work to sell in Southeast Asia in 1939, Liu to raise money for the Chinese Red Cross, Xu for the War Refugees? In 1953, when Xu Beihong was ill in hospital, Zhou Enlai appealed to Liu, for the sake of their long work together in promoting art education, to make allowances for Xu and patch up their differences. Liu Haisu, much moved, promised to do so.[13] But even after Xu's death that same year, the rivalry lived on. In the late 1980s the staff of the two academies in Nanjing, now run by the pupils of Xu and Liu, affected a total ignorance of each others' existence.

By the mid-1930s Liu Haisu's style and technique had advanced far beyond the crude oils of the early 1920s. His color is richer and warmer, his brushstrokes better controlled and more expressive. Most obviously derivative is his *Express Train* of 1929 (plate 17), his "hommage à van Gogh" (he also painted sunflowers). His view of *The West Front of Notre Dame* and his *Houses of Parliament* in a lurid sunset are equally obvious imitations of Monet. Yet he was too strong and energetic a personality to be content for long with mere imitation. Xu Zhimo, the champion of literary modernism, found in him a kindred spirit, while Guo Moruo in a poem of 1926 paid tribute to his courage. With the whole of Impressionism and Post-Impressionism to choose from, he chose what suited his temperament, and thereafter his style barely changed over the next fifty years.

We never find him casting about, looking for a corner of modern art that he could call his own. In this respect he stands out from many of his fellow modernists in Shanghai, whose individuality of style he interpreted

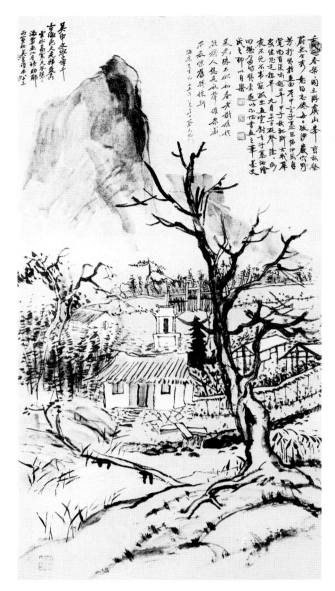

7.6
Liu Haisu, *The Grave of Yanzi* (1924). Ink on paper.

not as true originality but as a lack of clear purpose. He wrote of these artists in the early 1920s that while they had succeeded in opposing tradition and were no longer fettered by academicism, their freedom meant that each individual artist had his or her own style. Visitors to China in the late 1980's, a similar period of emancipation, have been struck by the same phenomenon—a plethora of styles, each reflecting the artist's attempt to create a style unique to him or her.

When Liu Haisu returned to Europe in 1933, it was no longer just to drink at the fountain of Post-Impressionism but as a kind of cultural ambassador. Before he returned home he had met Picasso and Matisse, the art historians William Cohn and Otto Kummel, and the Sinologist Otto Franke. It must have been painfully clear that, for all his individual success, the European public, unlike the Salon juries, was not ready for Chinese oil painting. What they wanted and expected was Chinese ink painting.

Like Xu Beihong, Liu Haisu had been painting with the Chinese brush even before he took up oil painting, and throughout his life he was a prolific painter of lively scrolls that show the influence of his two chief idols, Dong Qichang and Shitao. His vigorous, unsubtle brushwork is typical of the Shanghai School, yet he does not accept without question the traditional compositional conventions, sometimes articulating the "design" of his landscape (an expression one would never use of a correctly traditional work) with a Western rather than a Chinese sense of form: witness, for example, the conspicuous U-shaped element formed by the trees and linking bridge in *The Grave of Yanzi* (fig 7.6), or the awkward placement of trees in his *Trees in Frost.* In *Swiss Mountains,* painted in 1930 in collaboration with the woman flower painter He Xiangning, he draws the long straight trunks of the trees to either side with simple parallel lines, in defiance of the laws of good guohua. He was not a model for the orthodox to follow.

At the exhibition of contemporary guohua that he organized in Berlin in 1934, he showed, in addition to paintings by Xu Beihong, Lü Fengzi, Zhang Daqian, and others, six of his own ink landscapes. In his introduction to the catalogue, *Chinesische Malerei der Gegenwart,* he discusses traditional ink painting, making no mention of Chinese oil painting at all. He also held a one-man show of his own guohua in Paris, and another in London, for which Lawrence Binyon wrote the introduction.

In 1937 Liu Haisu's Shanghai Academy celebrated its twenty-fifth anniversary.[14] Although at the outbreak of war many of its staff and students left for the Interior, it managed to stay open until 1941. In 1939 Liu himself had set off for Southeast Asia with a collection of paintings for exhibition to raise money for the Chinese Red Cross among patriotic overseas Chinese. Published sources say that when the Japanese occupied Java in 1942 he changed his name and went into hiding in a Chinese laundry shop; that he was arrested and jailed for two months as a spy; and that he was repatriated by the Japanese to Shanghai. Throughout, we are told, he was "faithful and unyielding."[15] But the picture is somewhat

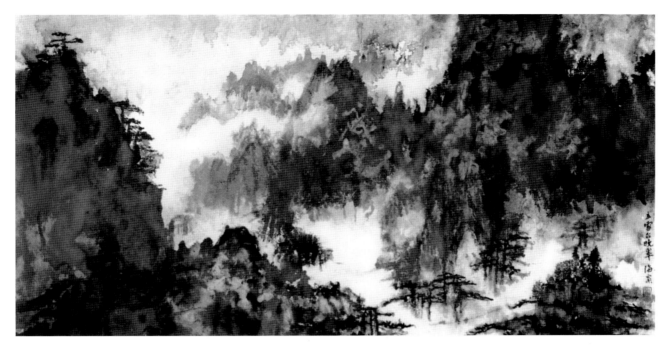

7.7
Liu Haisu, *Huangshan Landscape* (1979). Ink and color on paper.

confused at this point. Had he been accused of spying, the Japanese would almost certainly have shot him, and in any case not have allowed him to take back to Shanghai the canvases he had painted in Java and Bali in 1940, which are among his best works (plate 18). I was told in the late 1940s that he was in fact on good terms with the Japanese, and the emperor had acquired one of his pictures. Whatever the truth, in 1946 he was able to reestablish the Shanghai Academy, which struggled on during the difficult postwar years until it was closed by the Communists in 1949, at which time he was severely criticized for having cooperated with the Japanese. The stigma lingered on for some years, but in his old age all was forgiven and forgotten.

After Liberation, the Shanghai Academy was combined with Yan Wenliang's Suzhou Academy and the art department of Shandong University to form the East China College of Art (Huadong yishu zhuanke xuexiao), which was located at Tianxi until 1958, when it was moved to Nanjing. There, except for an adjunct professorship that he held in Shanghai and his frequent travels, Liu Haisu spent his old age, first as professor then as director of what is now the Nanjing Academy of Fine Arts (Nanjing yishu xueyuan).

Except for a period of painful anxiety during the Anti-Rightist movement of 1958, when Liu Haisu suffered what he described as "apoplexy," the 1950s and early 1960s were a period of intense activity, during which he produced a large number of vigorous post-impressionist canvases. When the Cultural Revolution was launched in 1966 he was spared at first, but, never cautious or discreet, he kept a hoard of old newspapers and cuttings about his turbulent and on the whole triumphant career. On the back of one of these, the Red Guard discovered a film review criticizing Jiang Qing from her days as a Shanghai starlet. He was accused of being an enemy of the Cultural Revolution and confined to his home, but because he suffered a stroke he was spared from having to write confessions.[16] Compared with what others endured his sentence was light, and by 1970 this irrepressible man was painting as vigorously as ever.

When I met him in 1980, Liu Haisu had just returned from Huangshan—his ninth visit, going back to 1922. In the 1950s and early 1960s he had painted a series of oil landscapes on the mountain, but the large paintings he produced in 1979 and 1980, however, were all in the Chinese medium (fig. 7.7). During his last trip, he told me, it had rained a good deal of the time; he saw nothing but clouds; so he poured water and ink on the paper, sometimes drenching it with brilliant reds and mineral blues, to produce, as if from memory, expressionistic works as full of energy as any in his long career, adding to his signature the words "I am only eighty-five!" Back on Huangshan in the following year, he painted (in three hours) a panorama in oils, six feet long, that he considered the best of his later works in that medium.

Liu Haisu had been experimenting with combining

Chinese and Western techniques since the 1930s. His painting of a kingfisher amid withered lotuses of 1935 is very Chinese in theme and composition, while he writes his inscription down the side in the traditional manner—but the medium is oil paint.[17] The picture is executed with such dash and confidence that it gives the viewer none of that uncomfortable feeling of a conscious, deliberate synthesis that deadens so much of the painting of the Lingnan School. Here, as in his late Huangshan paintings, the question of "Chinese" or "Western" does not arise. It is simply a Liu Haisu, which one must accept on its own terms.

Although Liu Haisu was a powerful artist, he was too individualistic to produce effective imitators, and too passionate a believer in the artist's total freedom to paint as he chooses, too little concerned perhaps with finding solutions to the aesthetic problems that beset his students, to found a school as did Lin Fengmian. Nevertheless, he has been a major figure in the modern movement.

LIN FENGMIAN

Xu Beihong and Liu Haisu were often in the limelight, but neither made that critical breakthrough in creating a contemporary school of Chinese painting that was achieved by Lin Fengmian.[18] Five years younger than Liu and three years younger than Xu, he was born in 1900 into a stonemason's family in Meixian, Guangdong. His grandfather wanted him to become not a scholar or an official or, like his father, a professional painter, but to follow in his footsteps as an artisan. But the boy showed aptitude for painting, and persisted. In old age he said, "Looking back, I daren't say that I ever equalled my grandfather's industry and frugality, but the painting brush in my hand and the chisel in his are just the same. I can work all day, and I love it. I cannot thank my grandfather enough for instilling that habit into me."[19]

After graduating from middle school, Lin Fengmian managed in 1918 to get to Shanghai, where by sheer chance he lodged in the hostel for students selected to be sent to France under Cai Yuanpei's work-study program. That winter he was on his way. At first he found a job as a sign painter; then, with the help of relatives, he enrolled in the Ecole Supérieure des Beaux Arts in Dijon. The principal, recognizing his talent, sent him up to the Ecole des Beaux Arts in Paris, where he entered the studio of Fernand Cormon.

His first teacher in Dijon, the sculptor Yencesse, had told him to get out of the studio and into the museums, and to study Oriental art, and particular cloisonné. So off he went to the Musée Guimet, with brush, paper, and enough hard bread to last him through the day. He thus learned far more about Chinese art than did most of the Chinese art students in Paris, who were only too ready to forget the heritage of which they were already deeply ignorant. Was it perhaps his encounter with traditional Chinese art in the free atmosphere of Paris, as he haunted the Louvre, the Luxembourg, and the museums and galleries of modern art, that gave Lin Fengmian his unique capacity to produce paintings that were both modern and Chinese?

Like Xu Beihong before him, Lin Fengmian was forced for financial reasons to spend some time in Germany. During his year in Berlin he met a young Austrian chemistry student; they were married and had a child. They returned to Paris where, within a year, mother and child were dead.[20] In 1925 he married Alice Vautieur, a French sculpture student, who returned with him to China. Before he left Paris, he showed at an International Fine Arts Exhibition some oil paintings, and the first of his owls in the Chinese medium. He also met Zhou Enlai, and had several long talks with him.

We have seen how, on returning to China in 1926, the twenty-five-year-old Lin Fengmian was appointed to head the new art academy in Beijing, and how he first launched the modern movement there. When he left in 1927 the life went out of it. But during his ten years as director of the Hangzhou Academy, he gave the movement firm foundations. In 1926 he had outlined his ideas about the future of Asian and Western art in an article in *Dongfang zazhi,* and in 1929 he published his *New Treatise on Chinese Painting.*[21] His friend and ally from Paris days, Lin Wenzheng, published in *Apollo* an "Outline for Art Education," in which he stressed not only the study of Western and Chinese techniques but freedom and self-expression. These were to be the guiding principles of the school.

Liu Haisu had stressed the same things, but Lin Fengmian was more responsive to contemporary trends in Western painting than was Liu. His model was Matisse, who not only expressed feeling through the rhythmic movement of the line, allied to harmonious color, but looked on painting as a source of pleasure to painter and viewer, as a "mental soother"—a very Chinese view. (There is, however, a dark side to Lin Fengmian's art that is quite absent in the work of the French master). When Lin Fengmian virtually abandoned oils for the Chinese brush and gouache, with which ideas and feelings could be expressed with so much more swiftness and spontaneity, he came still closer to the ideals of the Chinese scholar-painter, while his idiom was thoroughly contemporary. It is not to be wondered at that among his former pupils are some of the most distinguished modern Chinese artists, including Li Keran, Zao Wou-ki, Huang Yongyu, Wu Guanzhong, and Chu Teh-chun.

It has been suggested that Lin Fengmian went through

something of a crisis of confidence in the early 1930s. After returning from Europe he had painted two works, *Humanity* and *Sorrow*, which expressed his despair at the state of China, her weakness, her confusion, her fatal tendency to give in to circumstance. *Sorrow*, predominantly green in color (green is associated with tragedy in China), was painted as a memorial to the citizens of Shanghai killed in 1932.[22] People who could easily grasp Xu Beihong's superficial realism were disconcerted by these weird, tragic canvases. Lin Fengmian organized the Art Movement Society and published a ten-thousand-word exposition of his aims in *Apollo*, but the lack of response, combined with conservative political pressures, in the end defeated him, and he began to withdraw into a private world of his own. It could be said that he remained there until his death.

When assessing Lin Fengmian's oeuvre, one encounters problems. Nearly all of the early works of this immensely prolific artist are lost forever, or survive only in murky reproductions in old Chinese art magazines, so it is difficult to chart his early development. In a 1930s painting of *Mandarin Ducks*, which may or may not be typical of this period, the two birds are rendered in a curiously stylized semi-Western manner, the surrounding lotuses being more, but not entirely, Chinese.[23] It is an uncomfortable work, suggesting that the artist is still feeling around for a style. Small album-sized paintings of landscape and bamboo, dashed off with the apparent carelessness of Zhu Da, show in their spontaneity a hint of a synthesis not actively striven for but produced unconsciously, by an artist who had absorbed what he wanted from both East and West.

Apart from the obligatory genre scenes and views of dams and power stations that he produced on order in the 1950s, the bulk of Lin Fengmian's vast output consists of figures, flowers, birds, and landscapes. His nude women (never a male nude) are painted with a delicate, sweeping gesture with the brush, the flow of the line taking precedence over anatomical correctness, showing the influence of both Matisse and Modigliani. His robed girls, nearly always sitting on the floor, combing their hair or perhaps with a lute across their knees, have the same slightly luscious delicacy, with a hint of the feminine charm of Marie Laurençin. His flower paintings are more various, ranging from traditional free ink studies to compositions vibrant with life and color.

Lin Fengmian loved to paint birds, and was producing his mischievous owls more than forty years before his pupil Huang Yongyu aroused the wrath of Madame Mao with a very Lin Fengmianesque owl with one eye shut (see below, page 154). Some are sketched in ink, showing his debt to Zhu Da, others in transparent color. But it is in his landscapes (plate 20) that Lin Fengmian seems to have found fulfillment. These range from simple, swift sketches of reeds, perhaps with a fishing boat or a cormorant flying low over the misty water, to landscapes with white houses amid trees whose foliage is painted in such rich color that sometimes he seems to capture spring and autumn in the same picture. Never are his surfaces less than vibrant with life. Perhaps it was this urgency, this spontaneity, this need, as Gertrude Stein said of Picasso, to be constantly emptying himself, that caused him to abandon oil on canvas for the broader, swifter technique of gouache on paper.

In the spring of 1939, Lin Fengmian left Shanghai and travelled by way of Hong Kong and Hanoi to rejoin the academy in Kunming, having yielded his directorship to a succession of lesser painters. He left behind him piles of paintings, which the Japanese used to paper the walls of their latrines. The pictures he painted during his years in west China seldom reflect the drama and tragedy of the times, except possibly in a certain somberness in some of his landscapes, particularly in the river scenes that he painted almost obsessively after moving to Chongqing, where he lived in a cottage by the south bank of the Yangzi. There was always in Lin Fengmian a strain of melancholy, a longing to escape from the dirt and corruption of the world of men and hide himself in a quiet and lonely place, and in the opinion of his pupil Wu Guanzhong, that side of his character is reflected in the melancholy mood of some of these landscapes.[24]

When the war ended, he returned with the academy to Hangzhou as professor. But in the radical reorganization of the art schools in 1952, it seems there was no place for this most dedicated and independent of artists. He went to Shanghai, where he was given empty titles, including Vice President of the Artists Association and Municipal Councillor. He continued to paint as vigorously as ever, holding one-man shows in Hong Kong in 1962 and Beijing in 1963. His greatest trials were yet to come.

SOME LESSER MASTERS

DING YANYONG A Cantonese pioneer who by no means confined his career to Canton, Ding Yanyong was one of the first painters to move easily between guohua and xihua.[25] Born into a wealthy family near Mouming, Guangdong, in 1902, he was sent by his father in 1919 to study in Japan, first at the Kawabata Academy under Fujishima Takeji, and then at the Tokyo School of Fine Arts, where he graduated in 1925, returning to China an enthusiast for the Fauves and especially for Matisse. In Shanghai he taught in the Lida College of Art, where his colleagues were Feng Zikai, Chen Baoyi, Guan

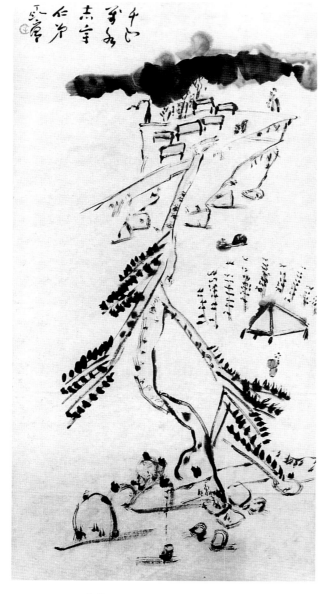

7.8

Ding Yanyong, *Landscape* (1973). Ink and color on paper.

munist cultural authorities, so on Liberation he slipped away to Hong Kong, where, after living in seclusion for a year on Castle Peak, he became more and more active as a teacher and painter, noted for his eccentric style with the Chinese brush.

So little of his work of the 1920s and 1930s survives, even in reproduction, that it is hard to say more than that he was strongly influenced at that time by Matisse and Derain. In his early Hong Kong years he continued to paint Fauvist oils and works showing the influence of Picasso, but in his last years he painted guohua almost exclusively (figs. 7.8, 7.9). Lively, quirky, humorous, he was too much of an individualist to found a school. Indeed, the critic Huang Mengtian wrote of him, "I find it dangerous for a beginner who does not have a foundation as good as Ting Yen-yung's to follow the path Ting took. Even for one who does possess a solid foundation and who chooses to follow Ting's path, I still think that it is unwise."[26] Like all the Chinese Eccentric painters, who refused to adhere to the language of pictorial conventions, Ding Yanyong stands outside the accepted canons, and so is not to be judged by them.

FANG JUNBI A more orthodox figure was Fang Junbi (Fan Tchun-pi), born in Fuzhou in 1898 and taken by her elder sister to Europe at the age of thirteen.[27] Their party of students included two key figures in revolutionary politics, Wang Jingwei and Zeng Zongming. The group settled in Paris and were able to keep house together by pooling their scholarship money. In 1922 Fang Junbi married Zeng Zongming, then acting as the chief secretary of the Franco-Chinese Institute in Lyon. In the meantime she had spent two years in art school in Bordeaux and three at the Ecole Supérieure des Beaux Arts in Paris, and was working also at the Académie Julian. Before they left Paris in 1925, she had exhibited briefly at the Salon.

After teaching in Canton, they were back in Paris from 1926 until 1930. In 1938 Zeng Zongming took the fatal step of joining the "arch-traitor" Wang Jingwei. Zheng was assassinated and Fang Junbi wounded by Guomindang agents. How she survived the reoccupation of Nanjing by the Central Government after the war is not clear, but by 1949 she was back in Paris, and seven years later she settled in the United States. Her long career as a painter was crowned in 1984 with a big retrospective at the Musée Cernuschi in Paris. She died two years later.

Fang Junbi was a competent oil painter with a romantic streak that only too often, as with her friend Pan Yuliang, strayed into sentimentality. Typical is her nude of 1933 reclining by a lotus pool, looking thoughtfully

Liang, and the then-modernist graphic artist Chen Zhifo, but he soon moved on to posts in the Shanghai Academy and the Xinhua Academy. In 1932 he joined the Storm Society. During World War II he went first to Canton, then joined Xu Beihong in the National Academy at Chongqing. When peace came he returned to Shanghai, where he joined the Society of Nine Artists (Jiuren huahui), but he was soon back in Canton, setting up the Provincial Art Academy and helping to lay the foundation for a museum of art.

Ding Yanyong had long been painting with great freedom in Chinese brush and ink, and was an admirer and collector of the work of Zhu Da. His brand of unfettered modernism, both Chinese and Western, was not of a sort that could adapt to the demands of the Com-

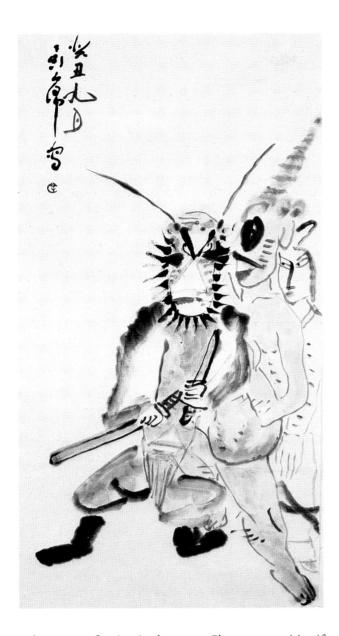

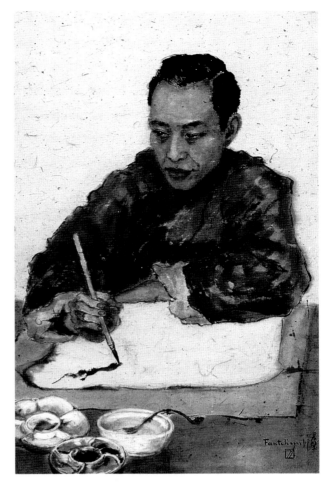

7.10
Fang Junbi, *Portrait of Zhao Shao'ang.* Ink and color on paper.

7.9
Ding Yanyong, *Figure 2* (1973). Ink and color on paper.

at her own reflection in the water. She was a sensitive if somewhat literal portrait painter, a typical example of her work being a portrait of the painter Zhao Shao'ang (fig. 7.10), her colleague in Canton in 1925 and again in 1930. She often seemed to hover a little uncertainly between East and West: her painting of the Tang poet Chen Yuanxiao reading an old inscription on a cliff, for example, is an attempt to carry out in oils a traditional subject more properly expressed in the Chinese medium, to which she turned increasingly in her later years. For some years, she was taken in some quarters as a model of how to blend guohua and xihua; *Vieille Cour à Pékin,*[28] painted during her return visit in 1973, is one of her more successful experiments in synthesis. She was one of a number of modern Chinese artists whose adventurous, at times tragic, lives were more interesting than their paintings.

THE WOODCUT MOVEMENT

Even the most dedicated members of the Storm Society recognized that their paintings spoke only to the educated class. They had before them the example of the revolutionary writers, who had acquired a mass audience for vernacular literature; but the salon art of the painters was bourgeois, cosmopolitan, and elitist, and would remain so until the artists could join in the progressive writers' vision of the social and reformist purposes of art. That this common ground was eventually reached was due, more than anything else, to the promotion of the Woodcut Movement by Lu Xun.[1]

LU XUN

Lu Xun (fig. 8.1) did not, as is often supposed, introduce the woodcut into China. Chinese book illustration from woodblocks goes back at least to the Tang Dynasty, while five-color printing was perfected early in the seventeenth century. The pioneer of the modern woodcut in China was not Lu Xun but Li Shutong, who by 1912 was already cutting and printing his own blocks, and before 1918 had exhibited European woodcuts in Shanghai.[2] But it was Lu Xun who saw the potential of the medium for mass education and propaganda. He had been fascinated by Chinese graphic art ever since 1913, when he joined Cai Yuanpei in the Ministry of Education, and until he left Beijing for Xiamen in 1926 he was a constant visitor to the antique shops in Liulichang, amassing a huge collection of ancient inscriptions, stone rubbings, and Ming and Qing books with woodcut illustrations, on which he became an authority.

Although the woodblock technique originated in China, the style of these traditional Chinese graphic works had never been realistic. Lu Xun wrote that as a child he had admired the fine quality and liveliness of the illustrations in English textbooks. In the 1920s he discovered Western wood-engraving, and came, partly through his translation of Kuriyagawa Hakuson's *Kumon no shōcho* (Symbols of suffering), to understand more clearly and passionately that art, like literature, could stem from "the suffering and remorse produced from the oppression of the life force."[3] In a society in which art was always seen as an expression of harmony and propriety, the idea that it should convey suffering was more novel than we can imagine.

With the aid of a monthly allowance of three hundred dollars, secured for him by Cai Yuanpei, from the Guomindang Ministry of Education from 1927 until 1933, Lu Xun began collecting examples of European, Russian, and American prints. In June 1928 he joined the writer Yu Dafu to found *Benliu* (Torrent), a magazine containing essays on Russian literary and art theory and translations of Russian stories, for which he carefully chose the illustrations.[4] In December of that year, with five young writers, he founded the Morning Flower Society (Chaohua she) to introduce foreign literature and woodcuts.[5] One of the group, his devoted follower Rou Shi, even wrote to Robert Gibbings in England and Käthe Kollwitz in Berlin begging for examples of their work.

Before it went bankrupt in 1930, the Morning Flower Society managed to produce five volumes of foreign

woodcuts, each with a preface by Lu Xun. The first comprised specimens from Europe and America; the second was devoted to Hikuya Geiji, a follower of Aubrey Beardsley; the third was a miscellany; the fourth was given entirely to Beardsley—not because Lu Xun wholly approved of this decadent artist but partly, at least, to put a stop to a spate of imitations of his work by a certain Ye Lingfen. The last volume was devoted to Soviet graphic art. This included Cubist and Futurist works of the pre-Stalin era, which, Lu Xun was at pains to point out, were appropriate to the era of the destruction of the old order; but what the phase of reconstruction required was Realism. It was these Soviet works, not so much "illustrated" as "decorated, designed, and visually created in a new spirit," that he thought pointed the way to a new kind of graphic art that would meet China's most urgent needs.[6]

It was this Soviet work that showed him how technical quality and political argument could be combined, but his appreciation of art was not confined to that which carried a revolutionary message. When he wanted to persuade his young friends that serial pictures and picture books should be taken seriously as an art form, he gave as supreme examples—both of the serial form and of propaganda through art—Michelangelo's fresco cycle in the Sistine Chapel, which he regretted that he knew only in reproduction. Does anyone doubt, he wrote, that Doré in illustrating the *Divine Comedy* was a serious artist? Besides, the serial form had respectable Asian antecedents in the ancient Ajāñta frescoes in central India of the story of the Buddha, and in Chinese scrolls illustrating the life of Confucius.

The birth of the Woodcut Movement took place against a background of violence that began in 1927, when Chiang Kaishek's troops occupied Shanghai, with the help of Du Yuesheng's Green Gang, and many radical workers were killed. This was the beginning of what the leftists called the White Terror. At the time Lu Xun was in Canton, chairman of the department of Chinese language and literature in the National Sun Yatsen University. The Guomindang, inevitably, turned on dissident students in Canton, executing forty (a mere handful, in comparison with the thousands of Communist supporters killed in Changsha and Wuhan at the same time). Lu Xun resigned in protest against this massacre of the young and took refuge in the Japanese Concession of Shanghai, which was to be his home until his death. He had many Japanese friends, one of the closest being Uchiyama Kanzō, whose bookshop in North Sichuan Road (see chapter 4) was a meeting place for the Shanghai literati. It was in Uchiyama's back sitting room that Lu Xun used to meet his student friends, while another,

8.1
Ding Cong, *Lu Xun* (1977). Ink on paper.

disguised room held his huge collection of subversive books and graphic art.[7]

In 1930, Lu Xun showed Uchiyama some of his foreign prints. His friend soon fell in love with them, and together they planned an exhibition. Uchiyama found a carpenter to make the frames, while Lu Xun wrote the labels, very beautifully, in Chinese, Japanese, and English. There were about seventy prints, all small. Most of the visitors were Japanese. A second show, of French and Belgian prints, was a flop; only ten people came. A third, for which they changed the name from *banhua* (prints) to *muke* (woodcuts), was more successful, as primary schoolteachers and their pupils poured in, so excited that they immediately wanted to make woodcuts too. But they had no tools, and no one to teach them. Uchiyama arranged for his shop to supply the tools, and from these modest beginnings the Woodcut Movement was born.

THE PROLETARIAN ART MOVEMENT

From the late 1920s, Lu Xun had been assiduously studying texts on aesthetics to establish a theoretical foundation for China's new art. In 1929 he had translated Itagaki

Takao's *Trends in the History of Modern Art,* a survey of Western art since the French Revolution. Itagaki based his interpretation on Alois Riegl's concept of art as "a continuous evolutionary and progressive process with the force of a binding law."[8] Lu Xun himself was too firm a believer in the freedom of the human spirit to embrace Riegl's historical determinism, but he did accept Riegl's idea that a work of art belonged to its era and could only be understood in terms of the historical conditions in which it was created. He even maintained that "the great artist, even the genius, is nothing but the executor, though the most perfect executor, the supreme fulfillment of the *Kunstwollen* [Riegl's 'will-to-form'] of his nation and age."[9] Lu Xun also translated the debates on art held by the Central Committee of the Soviet Communist Party during the relatively liberal pre-Stalin era, as well as the aesthetic writings of the Russian Marxist art theorists Anatoly Lunacharsky and Georgy Plekhanov, which stressed the need for struggle, for realism in art, for the unity of art and production.

Since it was Soviet Russia that had led the way in the creation of revolutionary art, it is not surprising that one of the first exhibitions in which Lu Xun was actively involved was a small show put on in June 1930 by the Epoch Art Club (Shidai meishu she) of Soviet revolutionary prints, cartoons, and posters, mostly from Lu's own collection.[10] Before this exhibition was held, however, the Proletarian Art Movement (Pulou yishu yundong) was already gathering momentum. Although the radical art groups were not, to begin with at least, all dedicated to the woodcut, it was this cheap, popular, powerful, and potentially subversive medium that attracted them most, and attracted also the relentless hostility of the authorities.

The years from 1929 to 1931 were a period of intense, feverish activity. Tensions were already building in the Hangzhou Academy between Lin Fengmian and his liberal staff and students, on the one side, and a small hard core of radicals on the other. In 1929, the eighteenth year of the Republic, the Academy founded the West Lake Eighteen Art Society (Xihu yiba yishe).[11] The radical students deplored the emphasis in the first exhibition of form over content, took over the society, and dropped the evocative "West Lake" from its name. This group included Li Chundan, Yao Fu (Xia Peng), Liu Mengbao, Shen Fuwen, Li Keran, Hu Yichuan, and a dozen more. At the same time, another group, of which the most talented was Li Qun, founded the Wooden Bell Woodcut Research Society (Muling muke yanjiu she). *Muling,* a wooden bell used to summon people together, also has the connotation of something silent that will one day ring out; it seems that both meanings should be read into the name.

When the radicals were finally expelled from the academy, a number of them went to Shanghai, where the radical "Eighteenists" had also set up a branch of their society, chiefly from among students at the Shanghai College of Art (Shanghai yida) and the Zhonghua Academy (Zhonghua yishu daxue). In 1929 the Hangzhou group sent Hu Yichuan to Shanghai to show their work to Lu Xun and Uchiyama, who put out an album, for which Lu Xun wrote the foreword. But when the radicals saw that the title on the cover, written by Lin Fengmian, still bore the hated words "West Lake," these young hotheads refused to distribute their own album.

The radicals failed to enlist the support either of Lin Fengmian in Hangzhou or of Wang Jiyuan, acting director of the Shanghai Academy (in the absence of Liu Haisu, who was in Paris), or to persuade more than a handful of art students to forget the beauties of West Lake and depict the suffering masses under capitalist exploitation. The first issue of the journal *Yapole* (Apollo), for example, contained a nude by Li Keran, a still life by Shen Fuwen, nude sculpture, and a lot of harmless academic works, among which the radical woodcuts were scattered. They were similarly distributed, for safety, in the Yiba Yishe exhibitions. The impression given by many Chinese writings since Liberation that most of the students were radicalized during these years is quite false; the great majority of both faculty and students were intensely patriotic and anti-Japanese but had no taste at all for Communism.[12]

Yet the Proletarian Art Movement continued to spread. In July 1930, an artists' section of the League of Left-Wing Writers was formed by staff and students of the art colleges in Hangzhou and Shanghai. At the League's summer session, Lu Xun gave two lectures to packed halls on basic aesthetic values, in one of them comparing the "beauty" of Millet's *Gleaners* with the "ugliness" of a girl in a Shanghai pin-up calendar. The beauty of the Millet, he said, was in its power to arouse our compassion; the work is "expressive, generous and beautiful."[13]

The chairman of the meeting was Xu Xinzhi, an oil painter who had returned in 1929 from studying in Japan and had joined the underground Communist Party in Shanghai. Xu had no use for the New Art Movement as represented by the cosmopolitan Storm Society, dismissing, in articles he wrote in 1930, the movement's "individualistic, fantastic, ridiculous, mysterious, pessimistic, and decadent tendencies." And he had no use either for those artists who "compromised with feudal culture" by reverting to the guohua style. In stark contrast to Lu Xun's humanity, Xu's recipe for art was doctrinaire and uncompromising:

8.2
Jiang Feng (Zhou Xi). *Disputing with the Landlord* (1931). Woodcut.

1. We must stand on a definite class basis, to fight the ruling class and the imperial artistic policy of this class.
2. We must grasp the theory of dialectical materialism, to overcome the artistic theory of the ruling class and to criticise their works of art.
3. We must strengthen our new art movement and perfect our works to surpass the works of art of the ruling class.
4. We must establish the relationship between art and social life, its inherent existence and value, and we must accomplish the movement for artistic enlightenment as yet to be completed by the ruling class.[14]

One after another, the Leftists took up and echoed these sentiments. Their slogan was "Out of the studios and onto the streets!" and their aim was to reveal the truth about the cruelty and corruption of the rulers and the suffering of the masses, in all its stark horror. Even more threatening to the government were the patriotic attacks on Chiang Kaishek's fear of offending the Japanese, who on September 18, 1931, had begun to annex Manchuria. Wherever the flame of protest started up, the Guomindang stamped it out; but no sooner had one group been crushed than another took its place.

THE PERSECUTION OF THE WOOD-ENGRAVERS

The young wood-engravers took appalling risks, though they tried to protect themselves by changing their names, not being seen together, meeting in secret. The story of

their betrayals, often for a few dollars or because of some petty sectarian rivalry, makes shocking reading. In 1931 the Eighteen Society was disbanded, its exhibitions banned, its prints confiscated. A number of wood-engravers were jailed, including Hu Yichuan's wife Yao Fu (Xia Peng), the first woman artist prominent in the movement. In January 1932 it was the turn of the Wooden Bell Society, as Guomindang police searched the Hangzhou Academy and discovered woodcuts of Soviet subjects, including Cao Bo's portrait of Lunacharsky (which the police claimed was that of a Soviet general). Cao Bo was lucky to be sentenced to two and a half years in prison; many of his friends were shot.

That summer, as the radicals shuttled back and forth between Hangzhou and Shanghai, stirring up students and workers, Hu Yichuan was sent from Hangzhou to help organize a mass meeting with members of the clandestine Spring Field Art Research Society (Chuntian [or Chundi] meishu yanjiu she) in the International Settlement. They managed to gather ninety students and workers in a hall, but before the meeting had even begun it was surrounded by the police. Hu Yichuan and a few of his companions escaped over a wall, but many others, including Li Chundan, Zhou Xi (later known as Jiang Feng; see fig. 8.2), Huang Liaohua, and the poet Ai Qing, were arrested and imprisoned. The Spring Field Society was almost immediately replaced by the Wild Wind Art Society (Yefeng huahui), for whose album Lu Xun got Cai Yuanpei, certainly no Communist, to write the title. In April 1933, the Yefeng Huahui was in turn

8.3
Rong Ge, copy of Käthe Kollwitz's self-portrait (c. 1933). Woodcut.

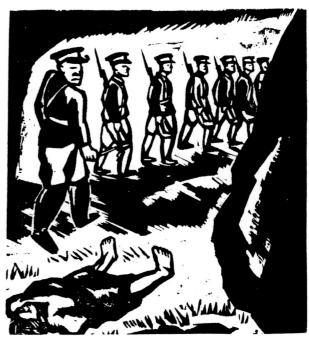

8.4
Chen Tiegeng, *The Meshes of the Law* (1933). Woodcut, in imitation of Masereel.

succeeded by the Great Earth Art Society (Dadi huahui). When that was broken up in June 1935, many of its members were arrested. In the following year, the young Xia Peng died in prison.

The Morning Flower Society, the group Lu Xun formed to introduce foreign woodcuts into China, came to a tragic end. On January 17, 1931, a secret meeting of Communist writers, artists, students, and workers was held in the Eastern Hotel on Avenue Edward VII. It was betrayed to the police in the International Settlement— almost certainly by a rival radical group who wanted them eliminated. They were handed over to the Chinese authorities, who sent them down to Longhua. In spite of agonizing efforts to save them, twenty-three young men and women were chained together and shot. Among the victims were three of the five founding members of the Morning Flower Society—the poet Hu Yebin (husband of the well-known writer Ding Ling), Yin Fu, and Rou Shi, to whom Lu Xun was particularly devoted. When eventually he could bring himself to mourn Rou Shi, Lu Xun in his memory published in *Beidou* (Big Dipper) Käthe Kollwitz's woodcut *Sacrifice* of 1922, showing a mother holding the body of her dead son.[15] Rong Ge's copy of Kollwitz's self-portrait (reversed) is illustrated in figure 8.3.

In an essay in memory of the young martyrs, Lu Xun lamented that it always seemed to be the old who wrote the obituaries of the young. "During the last thirty years," he wrote, "with my own eyes I have seen the blood of so many young people mounting up that now I am submerged and cannot breathe. All I can do is to take up my pen and write a few articles, as if to make a hole in the clotted blood through which I can draw a few more wretched breaths. What sort of world is this? The night is so long, the way is so long, that I had better forget or else remain silent."[16]

Yet nothing, it seemed, could crush the spirit of these young men and women. Magazines such as *Beidou, Yishu* (Art), and *Shalun* (Siren), often with striking "futuristic" covers, were born, lived a few months, and died. While the wood-engravers were hunted down in Shanghai, the movement flourished in Beijing and particularly in Canton. With the active support of the governor there, an opponent of Chiang Kaishek, the Modern Woodcut Society (Xiandai muke hui) was founded, led by Li Hua, a Cantonese painter and wood-engraver who had recently returned from Japan. Important exhibitions launched from Beijing in 1934 and from Canton in 1935 visited Tianjin, Taiyuan, Jinan, Hankou, and Shanghai, where the Canton show became a rallying point for Lu Xun and his devoted band of young followers. The Cantonese critic Huang Miaozi later remembered the 1935 exhibition as one of the formative influences on his life.

Meantime, in spite of the ban, more and more wood-

8.5

Li Hua, *Lu Xun and Uchiyama Kakechi Conduct a Woodcut Class in Shanghai* (1931). Woodcut.

engraving societies had sprung up: in 1932, in Beijing/Tianjin, Taiyuan, Canton, and Shanghai, where the MK (*muke* = woodcut) Research Society received Lu Xun's particular support; in 1933, in Canton, Shanghai, and Kaifeng; in 1934 in Shanghai (two more) and Nanchang; in 1935 in Hong Kong, and the large Wood-Engravers Association in Shanghai. Lu Xun himself organized three exhibitions of Soviet graphic art between 1930 and 1933. He published in 1933 Franz Masereel's series of twenty-five powerful woodcuts, *The Sufferings of a Man,* which immediately inspired Chen Tiegeng's series in imitation, *The Meshes of the Law* (fig. 8.4). In 1934 the MK Society, owing to an internal feud, was betrayed to the police and disbanded, as was the League of Left-Wing Artists. By the end of that year, almost all the radical woodcut societies in Shanghai and Hangzhou had been driven underground.

For their own safety, Lu Xun tried to curb the reckless young artists. When the Unnamed Woodcut Society put a portrait of Karl Marx on the cover of an album, he told them it was sheer folly. He saw, moreover, that for all their enthusiasm their prints were often technically crude, not to say incompetent, in comparison with the foreign works they were exhibiting and studying, and did not hesitate to tell them so. But he did not stop at criticism. In August 1931, with the help of his friend and protector Uchiyama Kanzō, he had organized a six-day woodcut workshop, conducted by Uchiyama's elder brother Uchiyama Kakechi, a primary-school art teacher who happened to be visiting Shanghai.[17] Lu Xun acted as interpreter and supplied the demonstration prints from his own collection. This momentous event—the first time the young enthusiasts had actually been

taught anything about technique—was later commemorated in a woodcut by Li Hua (fig. 8.5), who was to become one of modern China's most famous wood-engravers. Similar study groups and classes sprang up wherever teachers could be found.

Although at the end of his life Lu Xun was locked in the "Battle of the Two Slogans" (*liangge kouhao de zhenglun*) with radical writers and Communist Party ideologues, notably Zhou Yang, over how far the Left should compromise its revolutionary aims in the United Front against Japan, he never lost faith in his young friends in the Woodcut Movement. Eleven days before he died on October 19, 1936, though racked with pain from his tubercular lungs, he managed to attend the exhibition of the All-China Woodcut Association, where he was photographed, the inevitable cigarette in hand, surrounded by spellbound young artists. The last book on graphic art that he published, in May 1936, was *The Selected Prints of Käthe Kollwitz.* He chose twenty of her lithographs and etchings, including the famous self-portrait, because he wanted these media to be better known by the young artists who had hitherto only seen the etchings of Anders Zorn. He wrote that when he had received a volume of Kollwitz's work five years earlier, "In it I found poverty, sickness, hunger, death . . . also, of course, struggle and bloodshed. . . . As in the expression of the self-portrait of the artist, so in this book there was more of love and pity than hatred and wrath."[18] He recalled that five years had passed since he commemorated the murder of his beloved Rou Shi with a work of Käthe Kollwitz.

Lu Xun's attitude to art was never crudely political. Ten years earlier in Beijing, he had dropped in at the exhibition in Zhongshan Park of Situ Qiao, a poor young artist who had cut classes at Beijing University to spend his time sketching and drawing in the streets and the countryside. Lu Xun was particularly stuck by his *Jesus Christ,* which showed a woman kissing the crown of thorns. When in March 1928 Situ Qiao held an exhibition in Shanghai, not far from where Lu Xun was living, Lu asked him who the woman in that picture was. "An angel," Situ Qiao replied. "This answer did not satisfy me," Lu Xun noted in his diary on the night of March 14. "For I had just discovered that the artist sometimes makes his own sense of beauty shine through the yellow dust of the northern scene—a scene made up of men fighting the elements—as well as the struggle. At least he is making me aware of incipient Joy, for though blood is gushing from the wounds in Christ's side, an angel—or so the artist says—is kissing the crown of thorns. Look at it as you will, this is a victory."[19] Suffering, Lu Xun seems to be saying, is universal, whether it

8.6
Situ Qiao, *Lu Xun in His Open Coffin* (1936). Ink on paper.

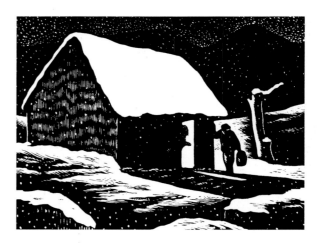

8.7
Huang Xinbo, *Northern Winter Night* (1942). Woodcut.

be that of Christ on the cross or of the young wood-engravers killed for their beliefs.

Situ Qiao, by now a devoted follower of the master, asked if he could paint his portrait in oils. Lu Xun agreed and said he'd tell him a suitable time. But the moment never came. When Situ Qiao did finally draw Lu Xun's portrait it was at the undertakers, where, fighting back tears, he made three swift ink sketches of his sunken features a few minutes before the coffin was closed (fig. 8.6).[20] A little later Huang Xinbo, another young wood-engraver very close to Lu Xun, sent Lu's volume of Kollwitz's lithographs to her in Germany, by way of the Japanese Embassy in Berlin.

Had Lu Xun lived another two months he would have learned of the kidnapping of Chiang Kaishek in Xi'an, which forced the reluctant dictator at last to agree to a united front against Japan. Within a few months, some of Lu Xun's young friends had been released from prison, and the Woodcut Movement took a new lease on life as a patriotic anti-Japanese crusade in the Guomindang-held areas. The rough first efforts of 1931, when young enthusiasts such as Li Yushi, Ni Huanzi, and Huang Shanding had fully justified Lu Xun's strictures, were by now forgotten; standards had risen quickly, as serious and patriotic artists trained in Western art, hitherto quite "nonpolitical," took up the medium in the service of the campaign against Japanese aggression. Many came from Canton, where the movement was less harried by the authorities than it was in Shanghai.

Huang Xinbo was one Cantonese artist who had left his native city for Shanghai and managed to survive there.[21] He joined the League of Left-Wing Artists, in 1935 visited Japan, and three years later secretly joined the Communist Party. As a wood-engraver his clean, emphatic compositions revealed his admiration for Rockwell Kent, while his paintings—many of them depicting solid, heavy figures with huge eyes, locked in compositions that recall Pang Xunqin's Symbolist works of his Storm Society days—also showed the influence of Diego Rivera. (See fig. 8.7.) Although Mexican influence appears in Chinese revolutionary painting before 1937, the similarity between Chinese and Mexican woodcuts seems to be due more to their common source in Soviet graphic art than to direct influence. The Mexican artists, and particularly those involved in the Taller de Gráfica Popular (Popular graphics workshop), founded in 1937 out of earlier revolutionary art organizations, were able to draw on far richer native sources of traditional and folk art than were the Chinese, who had not yet begun to explore their own popular art forms. Unlike Lu Xun himself, they were ignorant of their own art history. "Mexican artists," wrote Deborah Caplow recently, "were working within a unified cultural framework, whereas in China, the twentieth century was a time of rupture and upheaval in the cultural as well as political sphere."[22] But their revolutionary motives were very similar.

Other prominent Cantonese wood-engravers of the 1930s included Luo Qingzhen, whom Lu Xun told that his landscapes were good but that he should study human anatomy more; Chen Tiegeng; and Chen Yanqiao, whose work is full of images of the hungry, the imprisoned, the drowning, and the dead. Lu Xun singled out for special praise Zhang Wang's *Wounded Head* (fig. 8.8), a cleanly modelled and powerful close-up. At the MK Woodcut Research Society's exhibition of October 1933, Lu Xun had advised the young engraver to "use more white areas to clarify the silhouette of the figure and its facial expression"—advice which Zhang Wang seems to have taken to heart.[23]

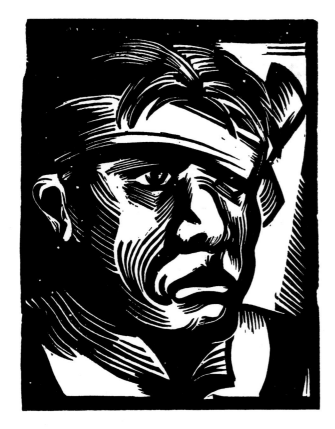

8.8
Zhang Wang, *Wounded Head* (1934). Woodcut.

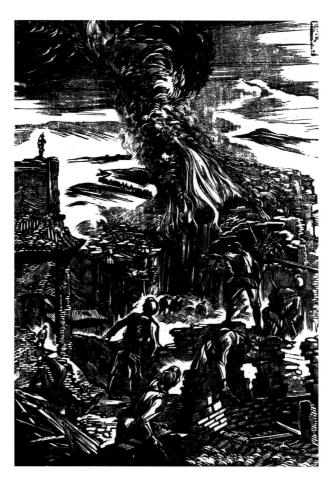

8.9
Huang Yan, *Mopping Up* (1942). Woodcut.

When we consider how much of their time the left-
ist Shanghai wood-engravers spent in prison or hiding
from the police, it is astonishing how many thousands
of prints they turned out. They never lost heart, nor did
their work ever lose its energy. Hu Yichuan's *Bringing
Up the Guns* of 1932 (plate 21) is a ringing call to arms
at the time of the Japanese attack on Shanghai. Li Qun,
a northerner from Shanxi who had helped to found the
Wooden Bell Society, was one of many former students
of the Hangzhou Academy who took shelter among the
clandestine groups in Shanghai. He produced in his *Sick-
ness* of 1935 a work showing the influence of both Koll-
witz and Masereel. By its very crudity it proclaims the
urgency of the message, as if in awakening the con-
science of China there is no time to be lost. By contrast,
a few wood-engravers, including Huang Yan (whose
Mopping Up is reproduced here), developed a fine crafts-
manlike technique influenced by Robert Gibbings and
the Soviet graphic artists Favorsky and Kravchenko.[24]

1937–1949: War

and Civil War

The twelve years of war and civil war that followed

the Japanese attack in 1937 faced Chinese artists with

a new and very different challenge. The dialectic between

Chinese and Western art was not resolved—indeed, it never

would be resolved. But now, as artists were uprooted from the

coastal cities and moved into the Interior, Paris was forgotten,

and modernism lost its momentum. If the art of these years

was less "contemporary" than that of the mid-1930s, and

often less accomplished, it became a truer expression of

Chinese feeling and experience.

THE FLIGHT TO THE WEST

Nineteen thirty-seven promised to be a good year for China. The Communists and the Guomindang government had established a United Front against Japan, stabilizing the political situation, and the economy was picking up. The Second National Exhibition of Art was held in Nanjing, and in the big coastal cities the art community was flourishing. Japan knew that if it did not conquer China now, it would soon be too late.

The blow fell swiftly. On July 7, fighting broke out at Lugouqiao, southwest of Beijing. Three weeks later the city was occupied by Japanese forces without any further resistance. On August 13, fierce fighting began in Shanghai. On September 1, Japanese bombers destroyed Tongji University. On November 5, Japanese troops landed in Hangzhou Bay. By December 12, they had taken over all of Shanghai except for the French Concession and the International Settlement. On the following day Nanjing was captured and the appalling atrocities to which its inhabitants were subjected began. On December 24, Hangzhou was occupied. The capital, meantime, had been moved far up river to Chongqing.

THE PROPAGANDA TEAMS

In the first weeks of the war, before the art schools closed and packed up for the long journey into the Interior, staff and students mobilized to produce propaganda paintings for the war effort. *Propagating Resistance against Japan, July 1937,* painted in 1940 by Tang Yihe, shows a group of eager young patriots setting out to do their

bit (fig. 9.2). Although unfinished, this is one of his best works.[1] In Hankou, artists recruited by the Central Publicity Bureau under Guo Moruo produced gigantic wall paintings depicting Chiang Kaishek on horseback, leading his united people against the enemy. One of the collaborating artists was Li Keran, then aged thirty.

On August 13, 1937, the first Cartoonists' Propaganda Corps was organized in the International Settlement in Shanghai.[2] Ye Qianyu, Hu Kao, the Cantonese woman artist Liang Baibo, and others made a series of striking posters under the direction of the political department of the Military Affairs Commission. A National Cartoonists Association was organized in Hangzhou, where leading academicians also did their part. Li Chaoshi, for instance, made a large oil painting on cloth of a man ripping a Japanese flag to shreds, while Wu Dayu, the Fauve, painted a huge bloodstained hand, with the legend "Our national defense is not in our northern mountains nor in our eastern seas, but in our own hands!" In the fervor of their patriotism, artists and art students were producing similar work all over China.

One of the leading exponents of the large propaganda picture was Liang Dingming, a Cantonese reared in Shanghai who had started as an untrained commercial artist, joined the army, and was sent in 1929 on an art study tour of Europe, returning to execute a series of paintings celebrating Chiang Kaishek's victories in the Northern Expedition for the Linggu Si, a temple in Nanjing dedicated to the war heroes.[3] A member of the Military Affairs Commission, he called himself "the master of war painting" (*zhanhua shishu*). In Chongqing in the

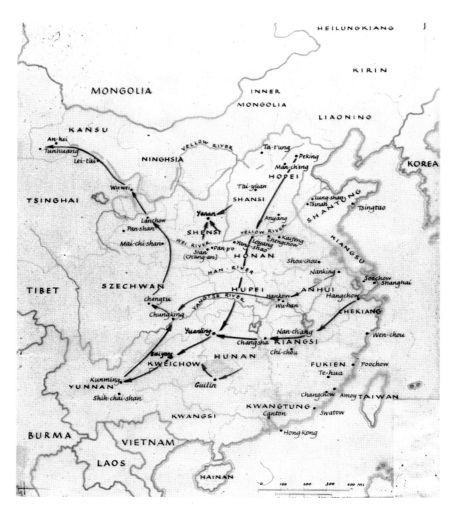

9.1
Routes taken by evacuated art academies, 1937–45.

9.2
Tang Yihe, *Propagating Resistance against Japan, July 1937* (1940). Oils, unfinished.

9.3
Zhang Leping, *Refugees* (1944). Watercolor.

9.4
Wen Yiduo, *Landscape in Guizhou* (1947). Pencil sketch on paper.

early 1940s, he made a series of seven huge paintings of the War of Resistance. His brothers, Liang Zhongming and Liang Yuming, also painted propaganda pictures. Dingming, a dedicated anti-Communist, went to Taiwan in 1947, where he continued to paint propaganda pictures, along with guohua paintings for his own pleasure. It is very unlikely that any of his large wall paintings survive in China.[4]

After the fall of Hankou, teams of cartoonists formed to stir up anti-Japanese feeling and spread out across China. One group led by Lu Zhixiang went to Jiangxi and Zhejiang to work behind enemy lines, another under Hu Kao went to Yan'an and the northwest, a third under Ye Qianyu to Guilin, a fourth under Yu Feng to northern Guangdong, yet another to distant Xinjiang.

THE JOURNEY TO THE INTERIOR

That summer, the universities and art schools emptied, as thousands of professors, teachers, and students set out for the West. Their migration was not only a flight to safety, an act of patriotism, and a means of preserving education, but an exciting adventure into the unknown. Men and women who had known only the comfort of the big cities and the ivory tower of the Hangzhou Academy found themselves travelling by bus or by sampan, and often on foot, in small groups, from one strange inland town and village to the next, sleeping wherever they could find shelter (fig. 9.3).[5] Wen Yiduo, with a small and dedicated band of students, walked for sixty-eight days across the breadth of China from Beijing to Kunming, making pencil sketches along the way (fig. 9.4).

A few who had private means, such as Wu Dayu, travelled in comparative comfort. Some gave up, turned back and went home. Others stayed behind. But those who stuck it out later looked on these as the most exciting and memorable years of their lives. The wild beauty of the western provinces and of their exotic inhabitants came as a revelation to the young men and women from the coast, giving them a new awareness of the beauty and vast size of China, and of themselves as Chinese. As their way of life and their outlook changed, their art evolved as well. Wang Jiyuan was one of many artists who now, for patriotic as much as practical reasons, gave up oil painting for the Chinese brush.

The experience of the staff and students of the Hangzhou Academy on their odyssey may be taken as typical of what many thousands of teachers and students endured. Wu Guanzhong, then a first-year student at the academy, wrote years later that when they got to Longhushan in Jiangxi they found an old Daoist temple, where they planned to settle down. But how could they set up an art school in a dilapidated temple, with no tables or chairs, no student dormitory, no kitchen? To add to their problems, a group out looking for scenery to paint was set upon by bandits. So they left that famous spot and went down to Guiqi, where they found refuge in a Catholic mission. But Guiqi was threatened, so the party—some seventy staff and students all told—went on to Changsha. Changsha was practically destroyed in the great fire set as part of a disastrous scorched earth policy, so they journeyed on further westwards, to Yuanling. When they reached the bank of the Yuan River and found no ferry, there was uproar; the students went on strike. More bad feeling came when a small group of them were sent funds to travel by car, leaving the rest to fend for themselves. Their furious classmates removed the valves from the tires, while the radical wood-engraver Yan Han locked the offenders up and lectured them severely before returning their car and instructing them to go ahead to the next stopping place to find accommodation for their companions.

In Yuanling, joined by some of the staff and students from the Beijing Academy, they formed the new National Academy of Art. But it was not a happy marriage. The Hangzhou Academy was more directly under Guomindang control than the Beijing Academy. Pang Xunqin, coming down from Beijing, later remembered how astonished he and his colleagues were when, at a joint meeting, all the Hangzhou contingent leaped to their feet when the names of Sun Yatsen and Chiang Kaishek were spoken. For a time feeling ran so high that the rival students armed themselves with sticks. The six-year Hangzhou students looked down on the three-year students from Beijing, while there was bitter conflict between them over who should head the amalgamated school.

When the Ministry of Education stepped in and appointed to the post Zhao Taiji, a nonentity who had been president of the Beijing Academy since 1934, a number of the Hangzhou professors, including Lin Fengmian, resigned, and the students protested by telephone to Chongqing. Peace of a sort was eventually restored when Zhao was replaced as president by Teng Gu, an art historian trained in Japan and Germany. He was not popular, for he was an aesthetician who understood nothing of the life and problems of artists, and his was a purely political appointment. Before the trouble was over, several secret Communist Party members, including Yan Han, Luo Gongliu, and Lu Hongji, had slipped away to join the Lu Xun Academy of Art in Yan'an.

In Yuanling work resumed, with propaganda teams turning out for the war effort pictures that some of the students did not think had anything to do with "art" as they understood it. But, as Wu Guanzhong wrote, they began to discover at last that there were other models than those provided in the studios: the life around them, the people going to market, the junk-crowded river with its forest of masts, the ancient city itself. They found a different world, no less beautiful than the one they had left behind. When the air-raid siren sounded most of them hid in a cleft in the hills, but Wu Guanzhong stayed in the "library" copying scrolls from the *Shina nanga taisei*. The fact that they had managed to transport this many-volume Japanese compendium of Chinese scholars' painting to so remote a place is some indication of the extraordinary efforts the schools and universities made to carry the lamp of learning far in the Interior.

The Japanese threat to Changsha made even Yuanling untenable, so the school moved on to Guiyang, capital of Guizhou, where again they found sanctuary in a Catholic mission. Guiyang was no refuge, though, and the academy moved even further west, settling in a village outside Kunming. There they were safe from bombs, but there were already sixty thousand refugees in and around Kunming, and accommodation was desperately scarce. Wen Yiduo's family lived in two rooms above a pack-horse station in a village ten miles from the city.

By now many of the students were destitute, though one enterprising group from the occupied areas made a little money by selling dumplings, noodles, and peanuts at their own "Apollo Shop." Though they began classes in an old temple and even managed to hold exhibitions in Kunming, some of the academy's faculty were ill qualified, and among the students were some who were not serious or were mere hangers-on. At one point Fu Lei,

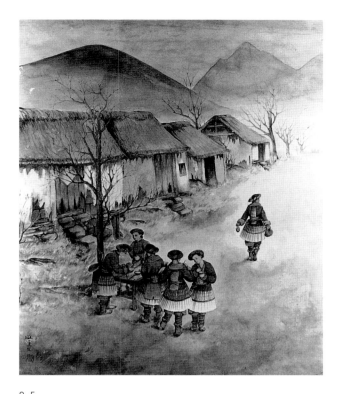

9.5
Pang Xunqin, *Miao Girls* (c. 1944). Ink and color on paper.

the much-admired Shanghai intellectual, patron of modern art, and father of the pianist Fu Tsong, was invited (very probably at the suggestion of Lin Fengmian) to come and lecture. After a long and difficult journey by way of Hong Kong he finally arrived, bringing with him a whiff of the civilized cosmopolitan world they had long since left behind. Fu Lei, always the outspoken critic, made it a condition for taking up teaching that the staff be screened for their competence, and the students sorted out into appropriate courses and departments. Teng Gu refused, and to the dismay of his old friends, Fu Lei departed again for Shanghai.

When, in 1978, Wu Guanzhong went back to the village where he had been an art student nearly forty years before, he was overjoyed to find some old people who still remembered the academy and the Apollo Shop, and how staff and students had made sketches and paintings of them. When the Japanese landed in Indo-China in 1940, the school had hastily packed up and left for Bishan in Sichuan, leaving behind boxes full of books and paintings. "Who has them now?" Wu eagerly asked. They told him that during the "Four Olds" movement (the campaign against old ideas, culture, customs, and habits that raised the curtain on the Cultural Revolution), the villagers, fearful of being found in possession of books and pictures, made a bonfire of the lot.

With the departure of the National Academy for

Sichuan, Kunming ceased to be an art center. But the Academia Sinica (the Chinese Academy of Sciences), in collaboration with the Central Museum, had established an institute for the study of the culture of the southwestern minorities. In 1939 the Central Museum commissioned Pang Xunqin to travel among the Miao and other tribes to study and record their costumes, textiles, and decorative arts. During a journey of many months through the hills of Guizhou, Pang collected over six hundred costumes and embroideries for the Academia Sinica and the Palace Museum. He wrote later that the Miao were hostile at first but welcomed him as soon as they saw that he was not a tax collector.[6] From his sojourn among them he brought back to Kunming a series of paintings and drawings (fig. 9.5) that was ostensibly an ethnographical record but is in fact much more than that, for these works combine accuracy with human appeal, a slightly romantic touch, and a concern for formal design that he had acquired in his Paris days. Thinking of Picasso, he later called this his "grey period."

GUILIN In the spring of 1936, while holding an exhibition there, Xu Beihong had proposed that an art school be established in Nanning, the capital of Guangxi, not far from the border with Indo-China. But Nanning was too close to the frontier for safety, so the provincial capital was moved to the beautiful city of Guilin, and there the academy was established under Xu's former student Zhang Anzhi (figs. 9.6, 9.7). Before long this had developed into the Provincial Arts Institute, which, under the benevolent eye of the provincial commissioner for education, Qiu Changwei, helped to make Guilin a flourishing center for the arts.[7] Among those who worked there during the early years of the war were playwrights Tian Han and Mao Dun, writers Xia Yan and Xiong Fuxi, and violinist Ma Sicong, while in the visual arts department under Zhang Anzhi studios were opened, lectures given, models provided.

By 1944 the new institute building had been finished and the third provincial art exhibition held. It was then, just as the tide of war seemed to be turning in the Allies' favor, that the Japanese army suddenly launched its Ichigō Offensive, aiming to create an overland route, safe from American submarines, to its sources of oil and other essential materials in Burma and Indonesia. The Japanese advance was swift, and the collapse of the Guomindang armies in Guangxi almost total. Guilin was occupied on September 10. In the general panic, the institute was evacuated to a small town across the border in Guizhou. Guilin was fired upon by the retreating army, shelled by the Japanese, and, during the Occupa-

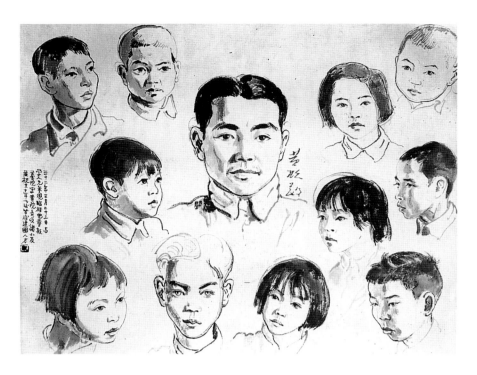

9.6 (above)
Zhang Anzhi, *Children and Teacher, Guilin School for War Orphans*
(c. 1943). Ink on paper.

9.7 (right)
Zhang Anzhi, *Chatting with a Daoist Monk under the Trees on Qingcheng-shan* (1944). Ink and color on paper.

9.8 (bottom)
Bombs falling on Chongqing (1940). Photograph by the author.

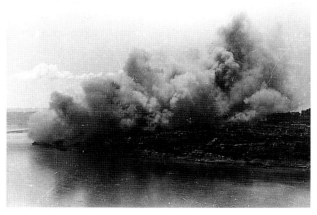

tion, bombed by the Americans. The Japanese finally retreated in July 1945, and the institute returned to the ruined city. Although a Provincial Art Academy was started under the musician Ma Weizi, the Occupation spelled the end of Guilin as a flourishing art center.

Before the blow fell, though, the cultural atmosphere of the city had been remarkably free and civilized. Remote from the eye of Chiang Kaishek, refuge of sophisticates from Hong Kong and Canton, a center for the activities of the banned Democratic League, Guilin became known as "The Paris of Free China" and the "City of Resistance Culture." After the U.S. Air Force arrived in 1943, American journalist Graham Peck called it "a party town, a picnic town." The number of artists who held exhibitions there gives us some idea of the artistic activity of the city between 1938 and 1944. They included many whose names we have already encountered: Xu Beihong, Li Hua, Liu Yuan, Guan Shanyue, Zhao Shao'ang, Li Xiongcai (plate 22), Ni Yide, Song Yinke, Teng Baiye, Yang Taiyang, Yang Qiuren, Li Tiefu, Shen Yiqian, Ma Wanli, Liang Dingming, Zhang Guangyu, Ye Qianyu, Yu Feng.

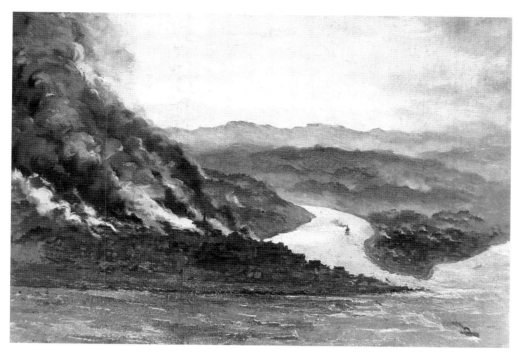

9.9
Wu Zuoren, *Chongqing Burning after an Air Raid* (1940). Oils.

CHONGQING The seven years (1938–45) during which Chongqing was the capital of "Free China" saw a surprising amount of artistic activity in that grey, muggy, bomb-shattered city. By 1940 the All-China Art Association (Zhongguo quanguo meishu hui) had been formed by the fusion of a local society with the old Zhongguo Meishu Hui that had been founded by the Guomindang in 1932. At their first exhibition, Dr. Wang Shijie, Minister of Information, exhorted artists to aim at realism, "to weave their art more closely into the lives of the people." While the exhibition contained almost two hundred xihua paintings (of which perhaps half might have been called realistic in the sense meant by Wang Shijie), there were more than six hundred traditional guohua paintings representing all the main schools—the Lingnan Pai, the academic Nanjing School (notably Chen Zhifo), the Shanghai and Hangzhou traditionalists, and the Beijing group dominated by Qi Baishi and Zheng Wuchang.

By this time the combined National Academy had settled at Bishan, with Lü Fengzi, a guohua painter of Buddhist subjects, as principal. In 1939, when Xu Beihong departed for Southeast Asia on his patriotic fundraising tour, his pupil Lü Sibai became the head of the art department at the National Central University (now at Shapingba, a suburb of Chongqing), where the art faculty included Li Ruinian, Xie Zhiliu, Fu Baoshi, Xu Shiqi, Chen Zhifo, and Ai Zhongxin.[8] When Xu

Beihong returned to Chongqing three years later, he was able to establish his own art research institute at Panxi (see page 72). Its members included the oil painter Li Ruinian and a number of Xu's former pupils: Fei Chengwu, Chen Xiaonan, Zhang Jingying, Sun Zongwei, Zhang Anzhi, and Feng Fasi. It is indicative of the somewhat unreal cultural atmosphere of Free China at the height of the war that Xu Beihong and his friends were able to spend two summer months painting at Qingchengshan, a mountain northwest of Chengdu famous for its Daoist temples.

For several years Chongqing was systematically pounded by Japanese bombers, but life went on amid the ruins. Artists painted, taught, planned what they would do when the war was over. Wu Guanzhong's heart was already set on Paris; he took French lessons at the university, and would rummage in the bookstores that were still standing for French novels and Chinese translations of them, which he compared word by word. Art exhibitions followed each other in rapid succession, particularly after the outbreak of the Pacific War on December 7, 1941, when the Japanese withdrew their bombers for their conquest of Southeast Asia and the Philippines, and the rebuilding of Chongqing could begin.

In the summer of 1942 the Third National Art Exhibition was held in Chongqing, under Government sponsorship. It was too conservative for some artists, so

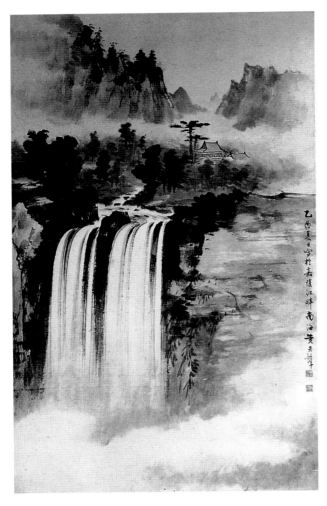

9.10
Huang Junbi, *Waterfall in Guizhou* (1945). Ink and color on paper.

9.11
Ye Qianyu, *Tibetan Lama with Mastiff* (c. 1944). Ink drawing.

9.12
Yu Feng, *Daoist Priest on Qingchengshan* (c. 1945). Ink and color on paper.

a group led by Zao Wou-ki, Ding Yanyong, and Guan Liang held their own "Salon des Indépendents." In December Huang Junbi (fig. 9.10) held an exhibition at the Sino-Soviet Cultural Association, a favorite venue, and Xu Beihong went south to hold exhibitions in Guiyang and Guilin.

Nineteen forty-three was even busier. In February, artists who had visited Dunhuang (see below, page 106) were invited to display their copies of the frescoes. In March Xu Beihong's exhibition at the National Central Library included *Yu Gong Removes the Mountain* and his largest oil, the famous *Five Hundred Retainers of Tian Heng* (see page 70). The exhibition drew enormous crowds. December saw a show of five hundred "ancient" paintings organized by the National Central Library and Palace Museum. (These could not have included important works, which were stored safely away in caves in Sichuan and Guizhou.) At about the same time, the Sino-Soviet Cultural Association held an exhibition of Russian paintings of the Czarist period.

The program of exhibitions continued unabated in Chongqing during the next two years, but by the winter of 1945–46 the artists and art schools began one by one to pack up and move downriver.

CHENGDU Almost out of range of Japanese bombers, home of six refugee universities and two local ones, Chengdu was the most peaceful and prosperous city in Free China. The modern theater was active against formidable odds, producing the plays of Cao Yu, Tian Han, Ibsen, and Shakespeare in a barnlike theater roofed with tin and thatch. The company worked, ate, and slept in the theater, prey to poverty, malnutrition, and tuberculosis, the eye of the censor, and the physical attacks of the secret police and of bands of soldiers, who would burst in demanding free seats. The lives of visual artists were less troubled, especially as many of them held some sort of teaching position, ill paid though it might be. Yet they too were undernourished and prey to disease.

There had been a small art school and an art society in Chengdu before the war. Now the huge influx of "downriver" talent helped to staff the Sichuan Provincial Academy of Art, founded in 1940 under the directorship of Li Youxing.[9] Among prominent artists who worked in Chengdu during the war years we find Chang Shuhong, Wu Zuoren, Pang Xunqin and his wife Qiu Ti, Zhang Shuqi, and Huang Junbi. Ye Qianyu (fig. 9.11), Yu Feng (fig. 9.12), Wu Zuoren, and Ding Cong made Chengdu the base from which they ventured out into the borderlands. It was in these middle years of the war that Ding Cong matured as a graphic artist. Illustrated here are his youthful self-portrait of 1943 (fig. 9.13), a drawing of an old peasant woman done with Chinese brush and ink that has the quality of an engraving (fig. 9.14), and one of his clear, firm pencil sketches of the Daoist monks of Qingchengshan (fig. 9.15).

Pang Xunqin in 1944 stayed for a while at Guanxian, the head of the ancient irrigation scheme for the Chengdu plain. There he painted two landscapes depicting the temple to its creator, Li Bing (fig. 9.16), and the huge boulder-filled bamboo baskets with which the dam was constructed. Liu Kaiqu, already well known for his statue of Sun Yatsen in Nanjing, enhanced his reputation with his memorial to the Unknown Soldier, erected outside the east gate of the city.

The first group exhibition of the Modern Art Society (Xiandai meishu hui) was held in March 1943, their more ambitious show a year later. It included guohua

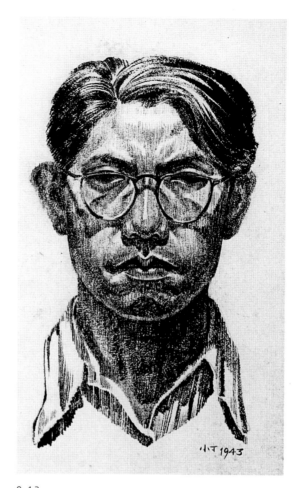

9.13
Ding Cong, *Self-Portrait* (1943). Ink on paper.

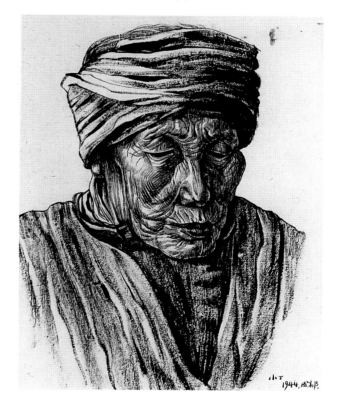

9.14
Ding Cong, *Old Lady, Chengdu* (1944). Chinese ink.

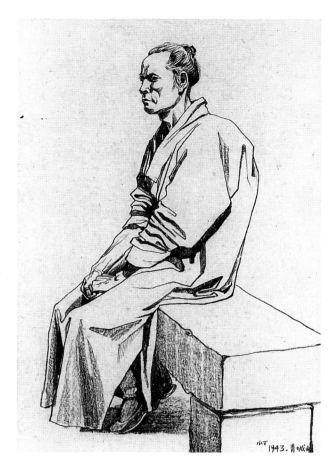

9.15
Ding Cong, *Daoist Priest on Qingchengshan* (1943). Pencil drawing.

9.16
Pang Xunqin, *The Li Bing Temple at Guanxian, Sichuan* (1944).
Ink and color on paper.

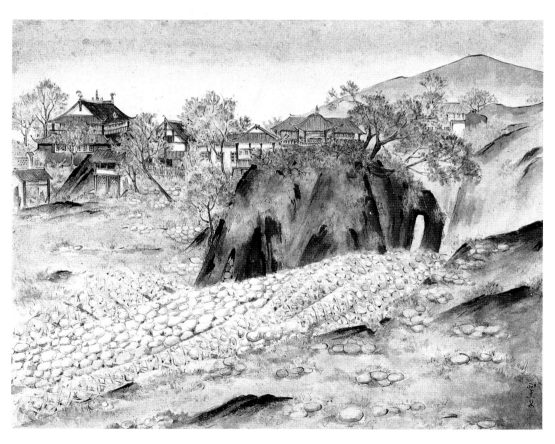

9.17
Su Hui, *View of Yan'an and the Lu Xun Academy* (c. 1939). Woodcut.

paintings by Guan Shanyue, Li Youxing, and Huang Junbi; Pang Xunqin's touching *The Letter* (plate 23), depicting a young peasant girl thinking of her distant husband, whose letter lies in the basket beside her; and xihua works—chiefly landscapes, portraits, studies of soldiers, refugees, peasants, Tibetans, by all the artists I have mentioned. Some of the works shown were undoubtedly subversive in intent. Zhang Guangyu's elaborate series *Xiyoumanji* (see chapter 11), painted in a decorative style derived from Han art and the Dunhuang frescoes, was a satire on the corrupt dictatorship of the Guomindang. But the sensation of the exhibition was undoubtedly Ding Cong's daring satirical handscroll *Xianxiang tu,* which is discussed below on page 122.

YAN'AN AND WARTIME PROPAGANDA

After enduring almost unbelievable hardships on the Long March, the remnants of the Eighth Route Army of the Communist Party reached Shaanxi in the winter of 1936. By the time war broke out, they were firmly established in Yan'an (fig. 9.17). Few artists made that incredible journey, and from their hands only a few rather crude sketches seem to have survived. But by 1938, when the coastal cities had all fallen to the Japanese, some talented artists had made their way to Yan'an, nearly all of whom had been members of the various radical woodcut groups before the war.

An exception was Shi Lu. He had only recently enrolled as a history student in West China Union Uni-

versity in Chengdu when he left suddenly for Yan'an, where he joined an art troupe, painted stage scenery, produced serial pictures and lantern slides and woodcuts, and taught in Yan'an University.[10] He was later to become a distinguished landscape painter and a highly unorthodox calligrapher. Another Yan'an artist was Wang Junchu, who had been fired from a teaching post at the Beijing Academy in 1930 for his leftist activities, was hounded by the secret police, and later went to Moscow. Liu Xian, a protégé of Lu Xun, had gone to Tokyo in 1934 to study wood-engraving and oil painting. As soon as he returned in 1937, he joined the New Fourth Army, and soon became an art administrator in Yan'an.

On October 1, 1938, the Lu Xun Academy of Arts and Literature ("Lu Yi") was opened in the former Catholic church in the center of the city, with departments of literature, music, drama, and art. The Party appointed as dean Zhou Yang, who later wrote of his work, "I put forth every effort to make myself an interpreter, propagandist, and practitioner of Mao Zedong's ideas and policies"[11]—although at this time Mao's cultural policies had not yet taken shape. Artists and wood-engravers who taught at the Lu Yi included Jiang Feng, Zhang Ding, Hu Yichuan, Chen Tiegeng, and the cartoonists Hua Junwu and Cai Ruohong, all of whom were to play key roles after Liberation, when the Communist Party took over total control of art and the art schools.

In the early war years, while communication between Yan'an and the government-held areas was still relatively

free and open, the Communist leaders took care not to alienate by too-tight controls the young intellectuals and artists flocking to the border region, and thereby to precipitate a mass exodus from Yan'an. For several years debate raged freely among artists, writers, and theorists about the new forms art and literature should take and about how foreign and traditional forms should be adapted, and how standards could be maintained while providing arts that the peasantry could understand. Zhou Yang, at this time in the internationalist camp, quoted Lenin: "The masses have the right to enjoy genuine, great art." The curriculum of the Lu Yi included, in addition to folk art, the study of "the world's famous paintings," although how this was done with their meager resources is hard to imagine.

In addition to putting on plays, concerts, and exhibitions, the Lu Yi trained young artists to produce woodcuts, propaganda wall paintings, and new year pictures, and to take their work out to the farms and villages.[12] Gu Yuan, who joined the wood-engraving workshop in 1938, tells how Mao Zedong visited the school shortly before his class graduated in 1940 and told them: "You will soon take your examinations and leave the Academy. But I urge you to continue your studies in a larger Academy—the great Academy of Life and the People, where your teachers will be the laboring masses." Gu Yuan went to live in a peasant family, making woodcuts which he spread out on the *kang* (a platform of heated bricks) for the peasants to see and criticize when they came home from the fields: "Isn't that Liu Qilai's great ox?" said one. "It's good and powerful!" And when they did not understand the woodcut style, they said so frankly: "Why is one side of that comrade's face black and the other white?" one of them asked. Gu Yuan also drew pictures of the things they used in their daily life and wrote the names underneath, so the peasants could learn to read at the same time.

Much of the work of the Yan'an artists was carried on in rural guerrilla areas, beyond the towns and main lines of communication controlled by the Japanese. To take a typical example, in the winter of 1938 the Lu Xun Woodcut Work Unit (Lu Yi muke gongzuo tuan), consisting of Hu Yichuan, Luo Gongliu, Yan Han, and Hua Shan, crossed the Yellow River and travelled into the Taihang mountain region on the Shanxi-Hebei border, where they stayed for over three years, holding woodcut exhibitions and discussion meetings with the peasants and villagers (as in Su Hui's woodcut, fig. 9.18).[13] They, like Gu Yuan, found that while a few of the peasants appreciated the black and white woodcuts, many did not understand them, finding them too foreign; they preferred the traditional new year pictures (*nianhua*) and paper gods (*zhima*), cheap paper icons that they could paste

about the house and farm. One of Gu Yuan's best-known color prints, adapted from the paper god form, is a portrait of a particularly successful farmer, bearing the legend "Emulate Wu Manyu!" (fig. 9.19).

Hu Yichuan's Unit returned to Yan'an in the spring of 1942 to find an ominous change in the atmosphere of the Communist capital. Some of the original dedication and willingness to submit to party directives had begun to wear off. The Communist-held areas were now tightly sealed off by the Guomindang armies, and Mao was beginning to impose an uncompromising radical policy. From now on, there would be no more debate. If the wood-engravers ever chafed at their new ideological bonds, they were silent; but not so the writers and poets. Ding Ling, Wang Shiwei, Ai Qing, He Qifang, and others were insisting that art and politics must be kept apart. Xiao Jun attacked the tyranny of overzealous cadres and claimed Marx and Lenin as "true poets," in the same category as Homer, Socrates, Byron, Beethoven, and Rodin. *Jiefang ribao* (Liberation daily) on February 15, 1942, issued a strong declaration on the freedom of the artist. Worst of all, Wang Shiwei declared that "many Communists had come to Yan'an in search of beauty and warmth, but saw only ugliness and coldness." He could not be tamed, and in 1944 Kang Sheng, head of public security, had him shot.[14]

It was the writers' claim to a degree of creative independence that prompted Mao Zedong to launch the first great Rectification campaign, orchestrated by a rapidly converted Zhou Yang and heralded by Mao's famous Talks on Art and Literature, delivered on May 2 and May 23, 1942. These talks set out in detail his philosophy of art, a compound of Marxism-Leninism with elements of traditional Chinese social morality.[15] In no uncertain terms, Mao directed artists and writers to toe the party line, to avoid "realism, sentimentalism, satire," to put politics before art always, and to respect only those writers and artists who put the interests of the masses first. The independents were forced to recant, many turning on each other to clear themselves. The all-embracing program Mao laid down in the Yan'an Talks left no room for ideological compromise and was to cast its long shadow over the arts for decades to come.

During the war years, however, not all the propaganda art teams were controlled from Yan'an. After the fall of Shanghai and Hangzhou in the autumn of 1937, some patriotic groups of artists and wood-engravers stayed on in the towns in Zhejiang not occupied by the Japanese to organize art propaganda meetings and exhibitions. Lishui was the headquarters of the Zhejiang Provincial Wartime Art Workers' Association (Zhejiang sheng zhanshi meishu gongzuozhe xiehui). A leading spirit in the movement was the painter and critic Sun Fuxi,

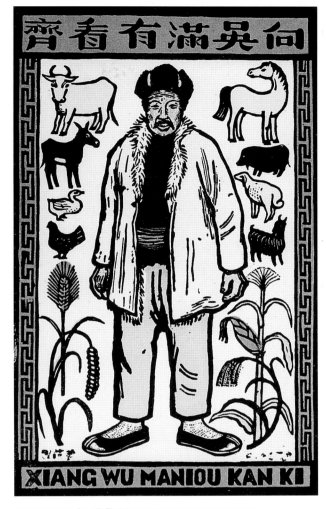

9.18 (above)
Su Hui, *Street Exhibition of Woodcuts in the Liberated Area* (c. 1939).
Woodcut.

9.19 (top right)
Gu Yuan, *"Emulate Wu Manyu!"* (c. 1950). Color woodcut.

9.20 (bottom right)
Zheng Yefu, *Early Dawn (Emptying Night Soil)* (c. 1932). Woodcut.

whose thoughts on the avant-garde NOVA exhibition were related in chapter 6. Sun trained in Paris from 1920 to 1925 and had been teaching watercolor at the Hangzhou Academy before coming up to Wuhan in 1938.[16] With him were Zheng Yefu (fig. 9.20), Zhang Min, Pan Ren, and many more. Other groups were the Mu Han Ban, Mu Yan She, and Mu He She, which in November 1940 held an exhibition of five hundred works in Lishui. Active centers also included Wenzhou, Shaoxing, and Ningpo. But all this activity came to an end in the summer of 1942 when the Japanese consolidated their hold over the Jiangnan region, the groups were disbanded, and most of the artists left for Free China. Sun Fuxi had already left for Kunming in 1940.

Although the Communists have always claimed the Woodcut Movement as their own, during the war there were more accomplished wood-engravers (most of them professional artists and teachers) in Guomindang China than in the "Liberated Areas" under the influence of Yan'an.[17] Some were clandestine party members, but the majority were not. The Chinese Wood-Engravers So-

9.21
Yang Jiachang, *A Song of Discontent (Street Performers)* (c. 1944).
Woodcut.

ciety for War Effort (1937–42) and its successor, the Chinese Wood-Engravers Research Association (1942–46) were based in Chongqing and had a number of regional branches. When the latter was launched on January 3, 1942, over forty wood-engravers, headed by Ye Fu, Wang Qi, and Liu Tianhua, met in the Sino-Soviet Cultural Association building to set up a program for exhibitions all over Free China. They began with a show in Chongqing in May which included 270 prints by 102 artists. This led to an exchange of exhibitions with Soviet artists in Moscow. Just how popular these wartime exhibitions were can be seen from figures published after the war: in 1942, if the statistics are to be believed, there were seventeen woodcut exhibitions, at which 5605 prints were seen by a total of 61,500 people, while in the following year fifteen exhibitions, showing 3075 works, attracted no less than 81,000 visitors.

The success of these shows was due not only to the appeal of the subject matter—for many of them showed the sufferings of the refugees, which must have struck a sympathetic chord in their viewers but would have been considered "negative" in Yan'an, where suffering was not acknowledged to exist except in Guomindang-held areas—but also to the talent of the artists, who included most of the leading members of the movement. Ye Fu, a former member of the Eighteen Society, was the organizer of the Third National Exhibition in Chongqing and the author of several books on the art. With the help of Pan Ren and Yang Jiachang (A Yang; fig. 9.21), he established a cooperative factory to produce wood-engraving tools. Liu Tiehua and Li Qun made powerful studies of peasants. Four Sichuanese were prominent in the movement: Wang Qi, trained in Shanghai, who had returned to Chongqing by way of Yan'an and was already a Communist; Huang Yongcan, who had a passion for railways; Liu Pingzhi, who made large, colorful prints of the life of the Miao people; and Zhang Yangxi, who, in addition to his prints exposing the corruption of wartime Sichuan, edited the *Chengdu ziyou huabao* (Chengdu independent illustrated), a paper that bravely published social and political satire.

For many years, a dominant figure in the movement was Li Hua, born in Guangdong in 1907. He had graduated in Western art from the Canton Academy in 1925 and went to Japan for further study.[18] He joined the Woodcut Movement in 1930, and two years later founded in his alma mater the Canton Modern Woodcut Society (Xiandai muke hui), which became one of the most powerful centers for the dissemination of the new art. Lu Xun thought his work was as good as any being done in Japan and encouraged him through letters. He could express the most powerful emotions through a single figure, such as his *Roar, China!,* a con-

torted, bound and blindfolded man reaching for a knife (1935), and his squatting beggar, *The Livelihood of the Distressed* of 1944.

Li Hua was also an official war artist, covering the south China fronts. His talents as a watercolorist and landscape painter were long smothered by the demands of war, civil war, and reconstruction, finally flowering in the 1980s. His figure paintings during the war years, like his woodcuts, show none of the crudeness of so much of the art of that time. Every curve and wrinkle of face and hands is explored for what it can reveal of human character. Like many revolutionaries, he became a violent opponent of modernism in all its forms, and in his last years before his retirement he was to be a stifling influence on the students and younger teachers in the Central Academy in Beijing who were trying to break new ground after the death of Mao.

Cantonese wood-engravers in Guomindang China included Liu Lun, who had studied in Japan; Huang Yan, a self-taught maker of large, realistic prints that show Soviet influence; Liang Yongtai, who worked up and down the Canton-Hankou railway with a dramatic troupe; and Li Zhigeng from Shanghai, who had joined the National Salvation Dramatic Troupe at the beginning of the War. His *Miserable Boyhood* (fig. 9.22), a grim little picture of a beggar-boy picking the lice from his tattered clothing, is one of the least pretentious and most compassionately felt of all the wood-engravings.

9.22
Li Zhigeng, *Miserable Boyhood* (c. 1946). Woodcut.

THE DISCOVERY OF THE BORDERLANDS

The early 1930s had seen the opening up of the west and southwest to the big coastal cities, as the Central Government extended its control, or more often formed alliances with local warlords to contain the Communists, in a huge area stretching from Yunnan to Mongolia. No Chinese artists visited the remoter border areas until 1937, when Shen Yiqian spent some months in Suiyuan and Mongolia, recording in hundreds of paintings and sketches the life of the peasants and the first skirmishes with roving Japanese army units (fig. 9.23).[19] When he returned to exhibit his work in Shanghai, the critic Chin Kum-wen (Chen Jinwen) wrote that he had captured the spirit of freedom and sense of unlimited space of Mongolia as well as its solitude and calm—aspects of the Borderlands that later were to make it a refuge for artists oppressed by the stifling ideological and bureaucratic atmosphere of the People's Republic.[20] But the climate of Guomindang China could be just as unhealthy for dissidents. Shen Yiqian, who in the course of his wartime journeys through unoccupied China had visited Yan'an, mysteriously vanished in October 1940 from his sister's house in Chongqing, where he had taken refuge after,

9.23
Shen Yiqian, *Machine Gunners* (c. 1940). Ink and wash.

he claimed, two attempts had been made to poison him. He was never seen again.

After the art schools had settled in the Interior, many artists travelled among the mountains and deserts of the west and northwest, drawn by the vast distances, the sharp, clear air, the free, dignified, and generally friendly inhabitants. Wu Zuoren was an indefatigable traveler by truck, horse, and yak caravan, in Xikang, Gansu, and Qinghai (plate 24). He even held a one-man show in Kangding, surely the first time anything of the sort had ever been seen in that remote borderland town. Xiao Ding, Ye Qianyu, and Yu Feng travelled in western Sichuan and what was then Xikang (later absorbed into Sichuan) among the independent Qiang and Luoluo. Many other artists, including Li Youxing and Zhang Anzhi, made forays beyond the Chengdu Plain, if only to Mount Emei and the hills beyond Guanxian.

A few went even further afield. In 1945, Ye Qianyu went with the dancer Dai Ailian to India, where she studied Indian dancing, while he drew and sketched (fig. 9.24). Later that year he returned to Chengdu to spend six months studying guohua technique with Zhang Daqian (who copied one of his sketches of Indian dancers)—an experience which, he said later, had turned him from a cartoonist into a painter.[21]

THE CALL OF DUNHUANG Nowhere was the enlarging of artists' horizons by the war shown more clearly than in their discovery of Dunhuang, and no artist did more to put this treasure-house of ancient Buddhist wall painting "on the map" than Zhang Daqian. He had left Beijing ten months after the city was occupied by the Japanese. After a long journey by way of Hong Kong, he was back in his native Sichuan in 1940 and almost at once started planning a journey to the caves at Dunhuang, in the far northwest of Gansu Province. He arrived in midwinter, expecting to spend a few weeks or months recording and copying the frescoes, but he soon saw that this would be a major undertaking. He went back to Chengdu, collected funds from his many friends and supporters, and returned, arriving at the caves with his family, a team of assistants, a military escort provided by the local Muslim warlord General Ma for protection against roving Khazaks, seventy-eight cartloads of equipment and provisions, and a cook—for, as this famous gourmet later explained, "We had to eat well. How else could we find the energy to work?"[22]

For two years and seven months Zhang Daqian and his assistants labored at the site, listing, cataloguing, describing, and making exact copies of the most important frescoes (see plate 25, for example), working from dawn to dusk in heat and freezing cold, standing on ladders or crouching on the floor, sometimes with a candle in one hand and a brush in the other. By the time they had produced 276 full-size copies on silk and paper, their resources and energies were exhausted, and in July 1943 Zhang Daqian returned to Chengdu, where he exhibited a selection of his copies to general acclaim.

Word of Zhang Daqian's work had stirred Chen Lifu, minister of education, to put the caves and their treasures under official care. In 1943 Chen Lifu set up the National Dunhuang Art Research Institute (Guoli Dunhuang yanjiu yuan), sending out as its first director the Paris-trained oil painter Chang Shuhong, who arrived with his wife and young daughter while Zhang Daqian was packing up. In 1945, the research institute was incorporated into the Academia Sinica. Just before Zhang Daqian left, he handed to Chang Shuhong, with a great air of secrecy, a small package which, he told him, he must on no account open until after he had left. Chang Shuhong was sure it must be the key to some secret caves or hoard of treasures. As soon as Zhang Daqian had gone, he eagerly opened the package and discovered that it contained a sketch-map of the Dunhuang area, marking the places where the most delicious wild mushrooms were to be found.[23]

Chang Shuhong settled down, did some oil paintings of the Dunhuang landscape (fig. 9.25), and with the help of a handful of assistants, chiefly art students sent to him for a year's training, set to work in the caves. Unlike Zhang Daqian, whose command of funds was legendary, he was very poor and life was hard, particularly during the civil war of 1947–49. His wife left him to go back to Paris. His daughter Chang Shana grew up to be his assistant (and years later to succeed Pang Xunqin as director of the Central Academy of Arts and Crafts in Beijing). Steadily the copies, photographs, and records accumulated. Then, one day in the summer of 1966, the Red Guard descended upon Chang Shuhong's remote and peaceable kingdom. They ransacked the library, studios, and storerooms, destroying everything they could lay their hands on—except, inexplicably, the original wall paintings and sculpture in the caves. Apart from a few of his own oils that he had been able to bury in the sand, Chang Shuhong lost all his paintings and sketches, in addition to the copies he had made of the wall paintings themselves. In the space of a few hours, the work of twenty-three years was lost.

Before the end of the war in 1945 drew most of the artists back to the coast, Chang Shuhong had had a number of artist visitors who came to look or to copy a few of the paintings. Among them were Wu Zuoren, Dong Xiwen, Guan Shanyue, and Zhao Wangyun. Several of them held their own exhibitions when they got back to Chongqing and Chengdu.[24]

9.24
Ye Qianyu, *Indian Youth* (1945). Charcoal.

9.25
Chang Shuhong, *Dunhuang Landscape* (c. 1945). Oils.

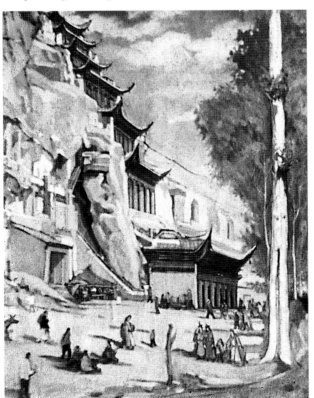

After Liberation the work at Dunhuang was stepped up, and it continues to this day. The frescoes have taken their place as the only considerable body of original Six Dynasties, Sui, and Tang painting in existence. Now extensively studied and published, the art of Dunhuang has had a great influence on figure painting in the meticulous *gongbi* style (by artists such as Song Zongwei and Pan Jiezhi) and supplied an inexhaustible repertory of techniques and motifs to the decorative artists and wall-painters.

THOSE WHO STAYED BEHIND: ART IN THE OCCUPIED AREAS

The story of the artists who spent the war years in Free China is so dramatic that it is easy to forget how many remained behind in the Occupied Areas. Some Communists stayed behind to organize underground resistance, though there was not much of it outside the northeast. For the rest, timidity or reluctance to leave their property unguarded or their aged parents uncared for were often sufficient reason to stay at home.[25]

BEIJING Many schools and colleges in the capital remained open or were reorganized. Furen University took the precaution of replacing its French professors with German ones, including Wolfram Eberhard and the art historian Max Loehr. The art department continued as usual, under Pu Jin as dean. He and his brother Pu Quan taught landscape, Chen Yuandu figure painting, Wang Rong birds and flowers; Pu Jin also taught the history of Chinese painting, while Gustav Ecke, who had first come to China in 1923 to teach at Amoy (Xiamen) University and was later to marry his talented student Tseng Yu-ho, lectured on the history of Western art.

In 1938 the puppet government took over the remains of the Beijing Academy and reorganized it as the Beiping Meishu Zhuanmen Xuexiao (Beijing College of Art) at No. 10 Dongzhongshe Hutong. They tried to induce Zhang Daqian to head it, but he prudently left for Sichuan, and they found a willing collaborator in a cartoonist named Wang Shizhi. The school remained active through the war, with a staff of forty that included Qi Baishi, Huang Binhong, and Yu Fei'an for guohua; Jiang Zhaohe and Wei Tianlin for oil painting; and Takami Jūichi, Itto Tetsu, and two other Japanese artists.

Several other Japanese artists settled in Beijing during the war. The guohua painter Jin Ye is said to have worked in the studio of a Japanese artist named Ōyama, while between 1939 and 1942 the great oil painter and sinophile Umehara Ryūzaburō spent several months in Beijing each year, painting some of his best-known land-

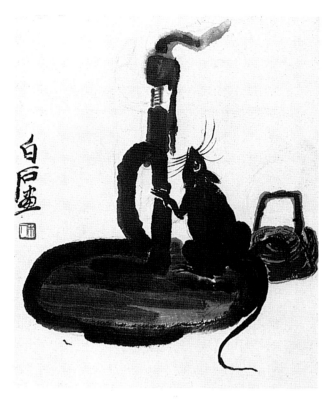

9.26
Qi Baishi, *Rat Steals the Lamp-oil* (1940s). Ink and color on paper.

wanted callers that he was not at home. When that was not enough, he put a notice on his door reading, "Old Man Baishi's heart has been acting up these days. No visitors!" During the Occupation, he altered it to read: "Distinguished Officials, Chinese and Foreign, if you want to buy Baishi's painting, please send delegates. It is not necessary for you to descend here yourselves. Since olden times officials must not enter a commoner's house; if that happens the host faces bad luck. You are respectfully informed and henceforth you will not be received here."[27]

Occasionally in his work Qi Baishi hinted at his feelings, as in this inscription on one of his many paintings of rats stealing the oil from a lamp (fig. 9.26), which could have been aimed at the Japanese, or the profiteers, or both:

> Groups of rats,
> Why so many?
> Why so noisy?
> You ate my fruit
> And you ate my grain
> The candles have burned short, and dawn
> is about breaking,
> The night watchman has struck his last
> report in the depth of winter.[28]

In 1944, Qi refused a monthly coal ration because it was granted by the Japanese-controlled Academy of Fine Arts, from which he had resigned at the outbreak of the war. On the whole, though, he continued to work as before, paying his staff with paintings and selling his work at so much per foot, which helps to account for his enormous output.

JIANG ZHAOHE'S *REFUGEES* Against this background of cautious conservatism, Jiang Zhaohe's huge handscroll *Liumin tu* (Refugees), painted secretly in occupied Beijing, stands out as a remarkable achievement. The son of a poor scholar and teacher, Jiang was born in 1904 in Luxian, Sichuan.[29] By the time he was eleven, his father was a jobless opium-smoker, his mother had committed suicide. With a knack for catching a likeness, the boy began making portraits in ink, charcoal, or even coal-dust, at two to five dollars each. When he had saved up eighty dollars he set off to seek his fortune in Shanghai. For years he struggled for a living, making portraits of the customers in the Sincere Department Store and picking up skills in oil painting and clay sculpture. His break came when he showed his *Rickshaw Coolie* at the National Art Exhibition of 1929. A popular print was made from it, and he was taken up by Xu Beihong. He taught for two years at the National Central University,

scapes there. He fell in love with the city and its people. "At one time," he later recalled, "such was my serenity that I was reprimanded by the occupying Japanese soldiers, and felt ashamed of myself."[26]

The Japanese authorities deliberately promoted conservative Confucian culture, which they claimed had been betrayed by the Guomindang and was threatened by the Communists; consequently, the guohua artists flourished. Among those who worked on in Beijing through the war were Xiao Sun, Hu Peiheng, He Haixia, Guo Weiqu, Wang Xuetao, Chen Nian, Wang Yun, and Li Kuchan. Many exhibitions, chiefly of guohua, were held in Beijing and other occupied cities—for example, the big group exhibitions of the work of Pu Quan and his students, held in 1944 in Beijing, Tianjin, and Shanghai.

To have survived in Beijing during these years without cooperating to some degree with the puppet regime would not have been possible, but these artists were at some pains later on to show that they had never done so willingly. Huang Binhong went into "hibernation," as he put it, although he kept his appointments with the Antiquities Office and fulfilled his duties at the academy. Qi Baishi had sought to avoid the attentions of the Japanese as far back as their occupation of Manchuria in 1931, when he had had his doorkeeper (one of the last surviving eunuchs from the Manchu court) tell un-

9.27
Jiang Zhaohe, *Rickshaw Boy* (1937). Ink on paper.

9.28
Jiang Zhaohe, *Poor Woman with Children* (c. 1943). Ink and slight color on paper.

and when that post vanished went back to Shanghai, where Liu Haisu invited him to teach drawing in his Salon. Portraits of well-known officials and military men, in ink, oils, or clay, established his reputation. He returned to Beijing in 1935, there to spend most of the rest of his career.

Already in the early 1930s, Jiang Zhaohe had found his style and subject matter. For the rest of his life he was a figure painter, finding his subjects (until Liberation) among the poor, the peddlers, the street craftsmen and musicians of Beijing, whom he depicted in the Chinese medium with a realism tempered by deep knowledge and compassion (figs. 9.27, 9.28). When war came to Beijing, he continued to work quietly, writing in the preface to his 1941 album of portraits: "Those who know me are not many, those who love me are few, those who understand my paintings are the poor, and those with whom I sympathise are the people who starve to death

on the streets. . . . Unfortunately, the victims of disaster are everywhere, roaming from place to place. The old and the weak, in particular, suffer most bitterly from poverty and sickness, but no one cares about them. Since they cannot earn a living, how can they know that there can be paradise and happiness on earth?"[30]

Jiang Zhaohe had had it in mind for a long time to record the sufferings of refugees and the poor in an ambitious work, and is said to have lived for a year and a half in the slums of Beijing, Shanghai, and Nanjing before embarking on the *Liumin tu* (fig. 9.29). This huge scroll, two meters high and twenty-six meters long, contained over a hundred figures. To avoid attracting attention, he worked on it section by section. Finally completed in the autumn of 1943, the scroll was put on show in the Imperial Ancestral Temple in Taimiao. Within a few hours, Japanese soldiers burst in to try to close the exhibition; so truthful a picture of life under the Occu-

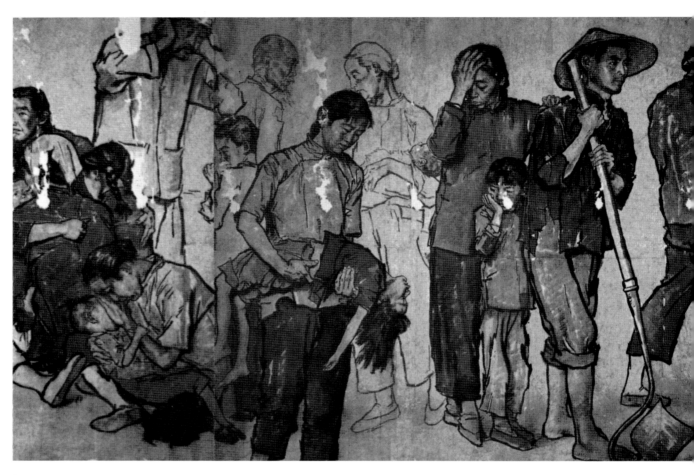

9.29
Jiang Zhaohe, *Refugees* (detail) (1943). Ink and color on paper.

pation was offensive to the occupying power. Later that afternoon, orders came from Japanese police headquarters to take the painting down, officially because of the "poor lighting" in the hall.

In the following summer, Jiang Zhaohe took the scroll to Shanghai for an exhibition in the French Concession. A week later, the Japanese "borrowed" it. It then disappeared until 1953, when it was discovered in a warehouse in Shanghai. By that time, the second half of the scroll was lost—destroyed, it was said, by a Japanese officer—and today exists only in photographs. The surviving half was badly damaged.

A Chinese critic has called the *Liumin tu* China's *Guernica*. But here is none of the screaming horror, the pitiless cruelty of Picasso's work. Suffering and despair, the dying and the dead, are here rendered with a quietness that is far more tragic, because it is more human. It is fortunate that it is the first half that has survived, for it has more variety and movement than the lost section, and the figures seem less posed. Taken as a whole, it is a deeply moving work.

Jiang Zhaohe continued to depict the life of the poor during the postwar period of civil war and inflation,

when conditions were if anything worse than they had been during the Occupation. Although most Chinese collectors shunned his painting, it found admirers and buyers among the foreigners working in Beijing during these turbulent years.

After Liberation, this gentle, frail old man at last received from his own people the recognition and honor due him. He continued to paint and to teach at the Central Academy almost until his death. During his last years, he produced some beautiful paintings, chiefly imaginary portraits of great figures out of China's past, such as the poets Qu Yuan and Li Qingzhao, and Cao Xueqin, author of *The Dream of the Red Chamber*. But no longer could he paint the victims of society—in theory, at least, there were none. His later work inevitably lacks the depth of feeling that makes his painting of the hard years before Liberation so memorable.

SHANGHAI AND ELSEWHERE The International Settlement in Shanghai remained outside Japanese control until December 1941, and the French Concession preserved a degree of independence even after the fall of France in

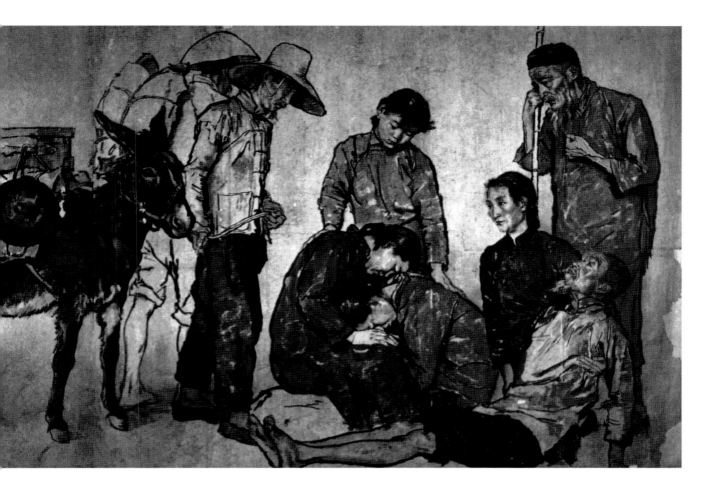

1940, so for several years, parts of the city were centers for anti-Japanese propaganda and art. Even after 1941, the arts flourished.[31] The theater was active, and a number of literary journals were published. Open anti-Japanese propaganda was of course not permitted, but there was little positive response to Japanese cultural initiatives. Some literary men, notably Lu Xun's brother Zhou Zuoren, came under strong Japanese pressure; he continued to write but kept a low profile, having to sell paintings to survive. A good deal of escapist literature and art was produced. Well-known traditional painters who continued to live and work in Shanghai included Chen Baoyi, Ye Gongchao, Chen Qiucao, He Tianjian, Tang Di, Tang Yun, Wu Hufan, Zhu Qizhan, and Qian Songyan, who made a living dealing in paintings. The newly rich could also acquire status as sophisticated collectors by buying oil paintings.

Among xihua artists, Yan Wenliang stayed in Shanghai during the war, although his beloved Suzhou Academy had been wrecked by the Japanese. Wu Dayu, after his abortive trip to Kunming, returned to live quietly at home. Zhou Bichu divided his time between Shanghai and his old home in Xiamen. Liu Haisu, as we saw in

chapter 7, was brought back from Java by the Japanese in 1943, and continued to work under their protection. Exhibitions continued much as usual, one of the largest being a show of oil paintings held in a department store in 1939. But by 1941 the art schools had closed down. The oil painter Xie Haiyan took his section of the Shanghai Meizhuan to Jinhua in southern Zhejiang, where it joined up with the new National United Southeastern University (Guoli dongnan lianhe daxue).

When war broke out in 1937, a few Cantonese artists took refuge in Macao and rather more in Hong Kong, which became for several years an active center of support for China's war effort, of anti-Japanese propaganda, and of relief to refugees. For the first time, Hong Kong also became the home of a number of important artists. Gao Jianfu, for example, exhibited in Hong Kong University in 1939, and two years later was lecturing on modern Chinese painting to the Chinese Cultural Promotion Society. He contributed his realistic paintings of the devastation of war and the bombing of Shanghai to an exhibition in aid of war sufferers from the East River region. Wang Jingwei, his old friend from early revolutionary times, had tried to entice him to collaborate

with the pro-Japanese authorities in Canton and Nan-jing, but Gao refused. He was no friend of Chiang Kaishek either, so he moved back and forth between Hong Kong and Macao. In 1938, Chen Baoyi spent some months in Hong Kong, held an exhibition of his oils, and probably painted the view of the harbor illustrated here (plate 26), before returning to Shanghai in November.[32] The cartoonists Zhang Guangyu, Ye Qianyu, and Ding Cong were among many who produced anti-Japanese cartoons in Hong Kong newspapers while earning a living working for film studios.

Other prominent artists who settled in the Colony included Feng Gangbai; He Xiangning, the well-known woman flower painter; and the oil painters Li Tiefu and Yu Ben. Yu Ben had arrived in Hong Kong from Canada in 1936. As a boy, he had been taken by his uncle from his peasant home near Canton to Winnipeg, where he worked in a laundry and a restaurant before studying art on a Canadian State Scholarship.[33] He worked as a professional painter in Hong Kong for twenty years before returning to China, where his accomplishment as an oil painter was finally recognized with a big retrospective that toured the country in 1980. At his best he was one of modern China's finest, and until recently least known, oil painters.

The ferment of cultural activity in Hong Kong came to an abrupt end when the Colony fell to the Japanese in January 1942. Most of the artists made their way to Free China. For the next three years, the light of culture and art in south China was all but extinguished.

Had the war not engulfed China, we may suppose that the modern movement would have continued to develop and to spread to inland cities. Ties with Europe and America would have strengthened; the followers of Matisse and Picasso, Dalí and Chagall, would have multiplied. But war brought the development of modernism to a halt. Ties with Paris were cut, and the cosmopolitan art world of Shanghai was destroyed. Art education was disrupted, and poverty and tuberculosis were the lot of painters and their families. During the war years, though, artists learned to find their models in the streets and the countryside rather than just in the studio. As oil paints became scarce, they took up the Chinese brush to find new ways to express what they saw and felt. Many who downriver were becoming *déraciné,* unsure of their place in Chinese society, found at last a use for their talents, discovered their own country, became involved in its destiny and shared in its sufferings, and in the process discovered themselves as Chinese.

FROM PEACE TO LIBERATION

As the war dragged on, men and women in the Interior dreamed of returning to their homes on the coast. When Japan at last surrendered, on August 15, 1945, the long trek downriver began. For some it took weeks, for others months. Some schools and universities were not back in place until the following summer. With the coming of peace after so many years, the time for reconstruction, Chinese artists and intellectuals believed, had begun.

But wartime dreams were soon shattered. In November 1945, Guomindang troops, with massive American help, advanced into Manchuria to take over the territory that the Japanese had surrendered to the Communists. Truces between the rival Chinese armies were made and broken, and for a year the Communists were on the defensive. By August 1947, however, the tide was turning, and the corruption and incompetence of the central government were beginning to tell. By April 1948 the Red armies had taken Luoyang, by June Kaifeng, by September Jinan. January 1949 saw the fall of Tianjin and the brief siege and bloodless surrender of Beijing. In April, the Communist armies crossed the Yangzi and turned east to capture Nanjing. Hangzhou, Wuhan, and Shanghai fell in May. In November the Communists were in control of the whole of the mainland, and the Nationalists had departed over the water to Taiwan and the protection of the American fleet. On October 1, the People's Republic was declared by Mao Zedong at the Tiananmen (plate 28), and Beijing once more became the capital. The liberation of rural China from oppressive landlords was depicted in many woodcuts, among

the best known of which was Yan Han's *Destroying Feudalism* (fig. 10.1), one of the few originals executed in color.

BEIJING

Before the end of 1945, the Beijing and Hangzhou academies had split apart again. In Beijing, Xu Beihong, president of the new National Academy, brought from Chongqing a strong team of professors that included Wu Zuoren, Dong Xiwen, Li Ruinian, Ai Zhongxin, and Feng Fasi, with Li Hua and Ye Qianyu for graphic art and Wang Linyi and (after his return from Paris in 1947) Hua Tianyou for sculpture. Xu was also appointed chairman of the new Chinese Artists Association (Zhonghua meishu xiehui), and for a short time it looked as if Beijing might recover its old position as an art center.

Inevitably, there were tensions between the "patriotic" teachers and students who had made the journey into the Interior, and those they unkindly called the "puppet" teachers and students who had remained in Beijing under the Japanese. These antagonisms were exacerbated by the greed and highhandedness of the Nationalist officials sent to take over the liberated areas, who seized as "puppet" property any institutions, factories, or materials they could lay hands on, and many innocent people were victimized. Those who had welcomed Chiang Kaishek's representatives as liberators soon came to hate them, and thus were sown the seeds that were to bear fruit in the Communists' triumph four years later.

Xu Beihong must have felt this resentment on taking

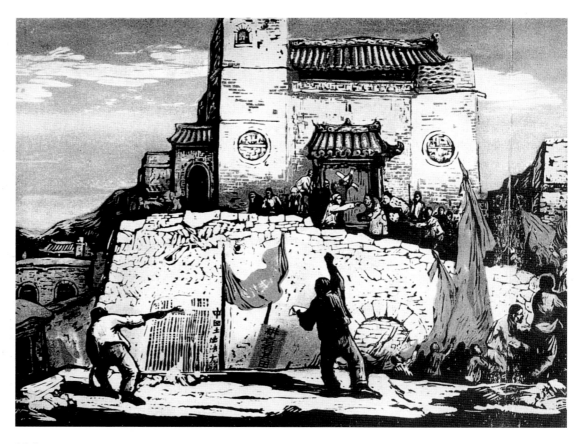

10.1

Yan Han, *Destroying Feudalism* (1948). Color woodcut.

over the Academy, particularly since he insisted on giving equal time and facilities to the xihua painters and students he had brought with him from Chongqing. The conservative old guohua specialists such as Li Qichao and Qin Zhongwen, who had remained in Beijing throughout the war, resented this outsider's power to hire and fire, his high-handed labelling of the guohua teachers he wanted to get rid of as "amateurs," and his insistence that all students spend their first two years in learning to draw.[1] Xu Beihong had other problems as well, as when he refused to allow the dean, supported by the Ministry of Education, to dismiss staff and students who had taken part in demonstrations against the Civil War.

For the art department of Furen University, the changeover was relatively painless. As a French institution with ties to the Vichy Government, it had not been taken over by the puppet regime, and the administration had collaborated with the Japanese authorities as much as was necessary to keep the university running. But at the same time Furen had become a center of underground pro-Chongqing activity, which led to the arrest and imprisonment of staff and students in 1942, 1943, and again in 1944. After the Japanese surrender the university was praised for its patriotic stand, which no doubt helped the

artists, such as Qi Baishi and Huang Binhong, who had continued to teach there during the Occupation.[2]

SHANGHAI

In Shanghai, the art world sprang to life again with astonishing speed, as if the artists could not wait to make up the lost years. Before the end of August 1945, original members of the Shanghai Industrial Arts Society, with other artists who had worked on propaganda during the war, created the Shanghai City Artists Society (Shanghai shi huaren xiehui); they selected their own teachers for guohua, xihua, and commercial art, and in two years had over 450 members. More selective was the Shanghai Society of Nine Artists (Jiuren huahui), which met monthly to discuss Chinese and Western art. Among the members were Ding Yanyong, Guan Liang, Ni Yide, Chen Shiwen, Zhou Bichu, and—a surprisingly conservative choice—Tang Yun.

In the following year, the Nationalist government set up the Shanghai Art Society (Shanghai meishu hui) under the patronage of Zhang Daofan. Graduate of the Slade School of Art in London and of the Ecole Supérieure des Beaux Arts in Paris, oil painter and high Guomin-

dang official, Zhang Daofan had been chairman since 1942 of the Central Cultural Movement Committee and wielded a heavy conservative influence in Nationalist art circles.[3] Consequently, most of the new society's founding members were traditionalists; they included Zhang Daqian and old masters such as Zheng Wuchang, Wang Yachen, He Tianjian, Wu Hufan, Feng Chaoran, and even Liu Haisu. (The government's treatment of "puppets," it seems, was highly selective, and Liu was also able to reestablish his Shanghai Academy of Art.) In 1947, the society began a bimonthly "tea party" (chahui), which proved a great attraction to local Shanghai artists anxious to acquire respectability. At one time there were over two thousand members. One cannot help wondering what kind of artists they were. In March 1946 a group of more progressive artists had formed their own Shanghai Artists Association (Shanghai meishu zuojia hui).[4]

I can give only an impression of some of the hectic artistic activity that took place in Shanghai after the war. Artists who had endured eight years of adventure and privation in the Interior brought back a wealth of paintings, drawings, and woodcuts, traditional and modern, and exhibitions followed each other in rapid succession. Many of these shows reflected experiences that had taken the artists far beyond the bounds of the studio, and they must have come as a revelation to the gallery-going public of Shanghai. In November 1946, for example, Zhang Daqian showed his wartime work, including his Dunhuang fresco copies, in the Zhongguo Huanyuan in Chengdu Road, selling for up to two million dollars apiece (the equivalent on the black market of US $1,000).[5] In January 1948 Wang Meng, the oil painter who had studied in Prague, showed his work in the Cathay Hotel. In May of that year the Chinese Wood-Engravers Association held a major exhibition of prints, following on the publication in 1946 of the important work Kangzhan banian muke xuanzhi (Woodcuts of wartime China, 1937–1945). Chang Shuhong exhibited in Nanjing and Shanghai his oil paintings and copies of the Dunhuang frescoes, together with photographs taken at the caves by journalist Luo Qimei.

The lack of a proper art gallery in Shanghai had long been a source of complaint. In 1947 a preparatory office was set up to plan for the establishment of the Shanghai Municipal Art Gallery, and in September of that year it held two successive exhibitions of guohua paintings of the last hundred years in the French School on Nanchang Road.[6] But in the mounting economic chaos, the Municipal Art Gallery was an impossibility, and it remained a dream until 1952, when the Communist authorities expropriated the former head office building of one of the British banks.

Hundreds of short-lived cultural journals appeared in

10.2
Ding Cong, *Flower Street, Chengdu* (c. 1944). Ink and color on paper.

Shanghai after the war. *Qingming* (Spring) caught very well the mood of thinking men and women as the clouds began to gather. Four issues, edited by playwright and Furen graduate Wu Zhuguang, with Ding Cong as art director, appeared in 1946; it was banned in October, although it was by no means a Communist organ. The first issue contained an article by Guo Moruo on the traditional drama and translations of a long piece on the young Tolstoy by Ernest Simmons, a short story by Saki, and a selection from V. I. Pudovkin's *Film Acting*. The cover bore a painting of a dancer done by Ye Qianyu during his Indian tour. Ding Cong's fine drawings of Luoluo tribesmen and Zhang Leping's *Refugees* were among the many illustrations that gave Shanghai readers a flavor of the far western regions. Other artists who contributed to *Qingming* included Pang Xunqin, Li Hua, Wang Qi, and Yu Feng.

Much of *Qingming* was politically harmless. But the journal also published Liao Bingxiong's savage woodcuts attacking the corruption of youth, Zhang Leping's powerful cartoon of a profiteer strangling a destitute man, Zhang Wenyuan's serial pictures showing the police brutally suppressing a demonstration against the Civil War, Zhang Guangyu's gorgeous yet subtly subversive *Cartoon Journey to the West* (discussed in chapter 11), and Ding Cong's *Flower Street, Chengdu* (fig. 10.2), his sardonic evocation of nightlife in the red-light district.

10.3
Huang Yongyu, *Self-Portrait* (1948).

HANGZHOU, CANTON, AND HONG KONG

The Hangzhou Academy reopened in unhappy mood.[7] The Ministry of Education refused to reappoint Lin Fengmian, whom they considered dangerously liberal. For some time the school drifted without any leadership, until finally the oil painter Wang Rizhang accepted the post early in 1947. Wang had been in the central government for years, and during the war he had headed the art section of the anti-Japanese propaganda organization formed under Guo Moruo. Earlier in his career he had studied in Paris and joined Pang Xunqin in the Société des Deux Mondes in Shanghai. Safely back in its ivory tower beside the lake, the Hangzhou Academy settled down at last, and was in a reasonably healthy state when the Communists took it over in May 1949.

Canton's artistic life was renewed in 1946, when Ding Yanyong returned from Shanghai to become president of the provincial art academy (Guangdong shengli yishu xuexiao). In the meantime, Gao Jianfu returned from Macao to reopen his Chunshui Academy, where he continued to take private pupils as before.[8] He also accepted the city's invitation to head the poorly financed Canton Municipal College of Art (Guangzhou shili meishu zhuanke xuexiao) in the hope of firing more young artists

with his own synthetic vision of the future of Chinese painting; Yang Taiyang, Guan Shanyue, and Liu Kang (who later went to Singapore) for a while taught there. In June 1948, the Lingnan group held its last exhibition, in which all the surviving members took part: they included Gao Jianfu, Chen Shuren, Yang Shanshen, Guan Shanyue, and Zhao Shao'ang, who was soon to move to Hong Kong, there to carry on the Lingnan tradition in bird and flower painting for another forty years.

Throughout the late 1940s, as the Civil War spread southward and inflation soared, conditions in Guomindang-held areas became more and more intolerable. Refugees poured into Taiwan and Hong Kong. Among them were wealthy merchants, businessmen, and art collectors from Shanghai, members of the banned Democratic League, and writers and scholars who were not yet prepared to throw in their lot with the Communists, such as Mao Dun and Zheng Zhenduo. They found Hong Kong a cultural desert island, and for a few years they caused the desert to flower.

The Colony had produced no artists of note, but now, with little help from local residents or the colonial government, art flourished once again, as it had briefly before 1942. In 1946 Fu Luofei, a Communist who had studied oil painting and sculpture in France and the United States and had spent the war years on Hainan, his birthplace, founded the Society for Art for the People (Renjian huahui) with the wood-engraver and oil painter Huang Xinbo.[9] Other wood-engravers who joined included Zhang Yangxi, Liu Jianan, and Wang Qi. The Renjian Huahui was very active in awakening Hong Kong's ignorant youth to conditions in China and to the power of propaganda, but support for it was by no means universal. The ideological conflict being fought out in China was reflected in the cultural life of Hong Kong. Conservatives and Guomindang supporters found the group's anti-American propaganda offensive, calling it a "Black Art Society" (*hei huahui*) and its members "monsters and demons."

A galaxy of cartoonists also gathered in the Colony, among them Liao Bingxiong, Ding Cong, Zhang Zhengyu, Mi Gu, Fang Cheng, and Chen Yutian, while the oil painters Yang Taiyang and Yang Qiuren also exhibited with the group. It was in Hong Kong that Ding Cong painted his second important satirical scroll, the *Xianshi tu* (described on page 123), and that Zhang Guangyu exhibited his *Xiyoumanji* (page 122), which had caused such a sensation when it was first shown in Chengdu. The young Huang Yongyu (fig. 10.3), who also exhibited with the Renjian Huahui and was employed as art editor of *Dagongbao,* the national newspaper, held a one-artist show in a restaurant gallery in January 1951, and, as a highly original portraitist, attracted

the patronage of leading members of the British community, including Sir John and Lady Keswick.

There were also a number of refugee artists in Hong Kong at this time who were not politically committed—oil painters such as Li Tiefu and Yu Ben, and Gao Jianfu's followers in the Lingnan Pai, notably Guan Shanyue and Zhao Shao'ang, who established a permanent base for the Lingnan tradition after most of the other artists left the Colony in 1949. For the next few years, very little happened in the art world of Hong Kong. The remarkable development of the modern movement, described in chapter 19, did not get under way until the 1960s.

AN ARTIST'S LIFE DURING THE CIVIL WAR

The growing chaos caused by the Civil War, the rampant inflation that enriched hoarders and impoverished the honest, the difficulty of finding a job and somewhere to live, are poignantly depicted in such woodcuts of this period as Yang Keyang's showing a scholar selling his books (fig. 10.4). A series of letters that Pang Xunqin wrote to me well capture those dark years. Arriving in Shanghai from Chongqing in the summer of 1946, Pang writes,

10.4
Yang Keyang, *The Professor Sells His Books* (1947). Woodcut.

> We imagined that we would surely find here a more tranquil life. But within a few hours of our arrival, our dreams were shattered. The country has become uninhabitable. I have been here two months, and even though I know many people, I cannot find even a small flat without paying three or four thousand American dollars in key money. . . . The city is flooded with American goods, and Chinese factories are closing one after another—for that we have to thank our government. Now, with American arms, the Guomindang think they can swallow up their enemy, like an idiot thinking he can grasp the moon in the water. All my plans for the future have burst like soap bubbles. What shall I do? I shall never abandon my art. All I want is to work for my art and for the people who live in such profound sorrow. . . . That is why modern Chinese art will never take the same road as French or British art. I hope that we can be more humane, and closer to the bruised and suffering heart of our people.

On March 25, 1947, there was an art festival in Shanghai, with two exhibitions, one organized by the Government—"plenty of pictures," Pang writes, "but neither one thing nor another"—and the other by Pang and his friends. His ten-year-old son Pang Jun fell gravely ill with pneumonia, spending three months in hospital, which further impoverished the family. Yet Pang

Xunqin continued to work. He, Fu Lei, and Stephen Soong took a villa for the summer in the north Jiangxi mountain resort of Guling, with the writer Chen Duxiu occupying the top floor.[10] Pang's delicate guohua landscapes (fig. 10.5), which capture the rich, shimmering foliage of the forest in summertime, were technically a new departure, combining traditional technique with his own brand of poetic realism. He called this his "green period." Back in Shanghai the exhibition, promoted by Fu Lei, was a great success, but the cost so far exceeded his receipts that he was even poorer at the end of it than he had been before. He hoped to sell some land left to him by an uncle who had died in the war, but in those parlous times no one would buy it. Faced with crippling taxes, he offered it to the peasants.

Hoping that the south would be better, Pang accepted an offer from Ding Yanyong and the violinist Ma Sicong to teach painting in the art department of National Sun Yatsen University in Canton, but conditions there were just as bad. "A family such as mine," he wrote on April 19, 1948, "has to spend every month, simply for food and absolute necessities, fifty million dollars, with nothing left for clothing or medicine." Yet the children con-

10.5
Pang Xunqin, *Guling Landscape* (1947). Ink and color on silk.

tinued to study art and music, and had just held a joint exhibition of their painting. Pang even asked how much it would cost to buy a violin for his son in London.

By May of that year, the Pang family was finding conditions hopeless and the climate unhealthy, so they returned to Shanghai. Many years later, Pang Tao told me that just when things were at their worst, her father received an almost unbelievable offer from a gallery in America: a five-year contract, with travel and living allowance and a sum in cash. He went home, told his wife and children of this fabulous offer, and asked them, "Do you want to sell your father for that sum of money?" With one voice the children shouted "No!" He did not go.

CARTOON AND CARICATURE

ORIGINS AND EARLY DEVELOPMENTS

Caricature has a long history in China, but with some rare exceptions the cartoon with a political or social message is a Western import, dating from the nineteenth century.[1] The Opium Wars and the Boxer Rebellion inspired thousands of crude caricatures of foreign imperialists and baby-devouring missionaries—though when we consider that European caricaturists had been ridiculing the "Heathen Chinese" for two hundred years, that was only fair.

The late nineteenth-century political cartoons were often overelaborate and ill-drawn. After 1900, though, they began to improve, as the anti-Manchu revolutionary movement spread, and with it patriotic outrage at the carving up of China by Japan and the Western powers. Zhang Yuguang, trained in guohua techniques, was the first competent artist-cartoonist whose work showed some economy of line (see fig. 11.1). Around 1910 his drawings began to appear in *Minhu huabao, Xinwenbao,* and other Shanghai journals, and he remained a dominant influence on the cartoon movement for many years.

Among those who turned their satire against President Yuan Shikai and Japanese encroachments in Shandong were Ma Xingchi and Qian Binghe. Cantonese cartoonist He Jianshi was a champion of Sun Yatsen's revolutionary movement. Shen Bochen, a young businessman from Tongxiang, turned to cartooning in Shanghai, one of his first works being a picture of the woman revolutionary martyr Qiu Jin, executed in 1908. Among the many cartoons he contributed during the May Fourth Movement to the satirical paper *Shanghai Puck* (*Shanghai puke,* founded September 1918) was *Warlords*

Fight over a Prostrate China (fig. 11.2). In another the giant fists of Chinese workers, students, and merchants threaten three political figures—Cao Rulin, Lu Congxing, and Chang Congxiang—who had collaborated in the surrender to Japanese demands on north China. Compared with the cartoons of the radical 1930s, this is a rather feeble work. At this time the best Western graphic and satirical art was still virtually unknown in China.

But that was soon to change. During the 1920s and 1930s, the thousands of magazines and books that poured from the Shanghai presses gave a vast range of opportunity to a new generation of graphic designers, and they learned fast—from the design of Japan, where several were trained; from Western modernist and art deco style; from Soviet experimental graphic design; and, increasingly, from the inexhaustible well of Chinese decorative motifs. The designs by Tao Yuanqing for covers of Lu Xun's writings were no less striking than those of journals such as *Shanghai manhua* (Shanghai sketch), *Zhongguo manhua* (China sketch), *Gongxian* (Contribution), *Xiandai xuesheng* (Modern student), *Chuangzao yuekan* (Creation monthly), and countless others.[2]

Among the leading graphic designers, Tao Yuanqing was noted for his use of motifs from Han art and for capturing (as Lu Xun described it) both an international spirit and China's national character. Qian Juntao, who had studied Japanese design, experimented in modernist typography and layout. Chen Zhifo, after studying for five years in Japan, acquired an encyclopedic knowledge of ancient Chinese motifs, on which he wrote a number

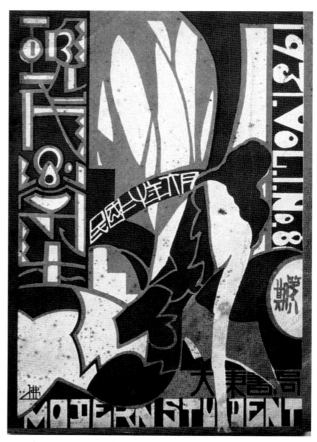

11.1
Zhang Yuguang, *One Step Higher* (1911). Foreigner and Chinese diplomat squeeze the common people. Ink on paper.

11.2
Shen Bochen, *Warlords Fight over a Prostrate China* (1918). From *Shanghai Puck*.

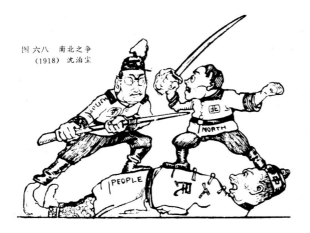

11.3
Chen Zhifo, cover to *Modern Student*, vol. 1, no. 8 (June 1931).

of books, though his covers for Lu Xun's journal *Wenxue* (Literature) or for *Modern Student* (fig. 11.3) are strikingly modern. He later retreated into academic flower painting in the traditional *gongbi* technique, for which he is best known today.

The years 1926 and 1927 saw the cartoonists attacking Western imperialism, the dumping of British goods, gunboat diplomacy, and an ironfisted Chiang Kaishek. It was at this time that they formed an organized movement, centered on the Cartoon Society (Manhua hui) and the journal *Shanghai manhua,* launched in April 1928 by Zhang Guangyu, Ye Qianyu, Lu Shaofei, and others. The journal's eight lithographed pages contained not only satire but news photos, pictures of movie stars, nudes, and notes on current art and literature.

The coming to maturity of the modern Chinese cartoon—using the word "cartoon" in a wide sense—went hand in hand with the Woodcut Movement (chapter 8), and suffered the same restraints. The government-con-

trolled national newspaper *Dagongbao,* for example, is said to have been the first newspaper to carry cartoons in color, but it allowed no social or political protest. So long as the foreign settlements in Shanghai were not under Chinese or Japanese control, though, the cartoon movement flourished there, and many societies for its promotion sprang up. Already in 1931 a group of young cartoonists that included Zhang Guangyu and his twin brother Zhang Zhengyu, with Lu Shaofei, Huang Wennong, Zhang Leping (fig. 11.4), and Ye Qianyu, had founded a progressive anti-Japanese group, publishing their caricatures and cartoons in such popular journals as *Shanghai manhua, Duli manhua* (Independent cartoons), *Shijie manhua* (World cartoons), and many more. The six years before the outbreak of war have been called by a Chinese critic the "first golden age" of the modern Chinese cartoon. Between 1934 and 1937, no fewer than nineteen cartoon and satirical magazines were published in Shanghai alone.

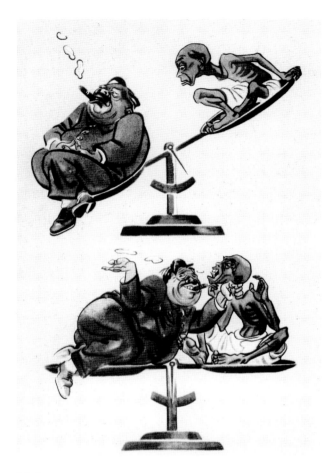

11.4
Zhang Leping, *The Lopsided Balance* (1946). From *Qingming*.

WARTIME ANTI-JAPANESE PROPAGANDA AND SOCIAL SATIRE

ZHANG GUANGYU AND DING CONG During the early months of the United Front in 1937, cartoonists left Shanghai for Nanjing and Hankou, organizing more than ten propaganda teams under the direction of Guo Moruo to stir the masses to resistance by exposing Japanese brutality.[3] They had an easy target. But as the war dragged on and conditions on the home front began to seem a greater menace than the Japanese, they turned their satire against the Guomindang and its supporters. In 1940, Guo Moruo was removed as too radical and his cartoon weekly *Manhua xuantuan* (Cartoon propaganda team) closed down. By now, open criticism of the authorities was extremely dangerous, although some brave artists took the risk. To avoid the censor, cartoonists would sometimes adopt a device popular with the dramatists: select from Chinese history or legend a theme of corruption, oppression, or heroic resistance that echoed the current situation.

It was their sense of outrage, combined with an awareness of the risks they ran, that inspired the cartoonists to produce their finest work in the 1940s. The dominant figure in the movement was Zhang Guangyu.[4] Born in 1900, he had painted theater sets in Zhang Yuguang's studio in Shanghai while in his teens. By 1920 he was making his living designing labels, posters, and calendars for a cigarette factory, and before he left Shanghai in 1928 was already publishing his cartoons in *Shanghai manhua* and in *Sanri huakan* ("Illustrated every three days"). He became a leader of the movement, which drew inspiration and stimulus from Western masters of the genre such as David Low of the London *Evening Standard,* whose work was well known in Shanghai. When the Mexican artist and cartoonist Miguel Covarrubias visited Shanghai in 1930, the two became friends, and in Zhang's work the influence of Covarrubias is clear. He and other artists in the movement were influenced also by seeing reproductions of the work of other Mexican revolutionary artists—Orozco, Siqueiros, Rivera.

When the International Settlements were taken over, Zhang Guangyu took refuge in Hong Kong, where he worked in film studios until the Colony fell early in 1942. He then spent three obscure years in the French concession of Zhanjiang (Guangzhouwan), west of Canton, until the Japanese Ichigō Offensive of 1944 drove him to Sichuan. It was in Chongqing that Zhang Guangyu produced his best-known work, the serial *Xiyoumanji* (Cartoon journey to the west). This satire on contemporary China is based on the famous Tang dynasty romance *Xiyouji,* which tells of the journey of Monkey, Pigsy, and the Monk in search of the Buddhist scriptures. In Zhang's series of sixty paintings, the scriptures are Democracy. The travelers pass through the Kingdom of Money, symbol of China's economic collapse; the Kingdom of Aiqin (fig. 11.5)—*ai* is Egyptian slave society, *qin* the tyranny of Qin Shihuangdi—referring to forced conscription and the reign of recruiting agents and spies; and the City of Happy Dreams, where one lives in the American style, caring only for one's material needs. At the end the travelers, in their search for the realm of Democracy, find instead fascism, in the person of Hitler, Mussolini, and Admiral Tōjō.

Xiyoumanji is a sumptuous work, rich in comic invention, highly decorative, drawing its style not only from early Chinese art but also from that of Mexico and ancient Egypt. With its barely concealed satire on the "four families" that controlled China, to publish it would have been out of the question, but Zhang Guangyu exhibited the series briefly in Chongqing late in 1945 and at the Modern Art Exhibition in Chengdu the following spring.

Ding Cong is another artist who stretched the mean-

毛尖鷹奉命，即斜集鴉鴉鳥們四出張羅
，抽調壯丁，設阱築牢，大事搜刮。一日邊
境探子報道：今有唐三藏等一行四人逼此，
藏戲要往西天探取天書，毛尖鷹道：把那兩個生得
像人樣子的拿下來問過明白，探子得令，便佈置陷
阱將唐僧沙和尚兩個提將官裡去。

第四章
第二頁

11.5
Zhang Guangyu, *Journey to the West* (detail) (1945).
Ink and color on paper.

11.6
Ding Cong, *Xianxiang tu* (1944). Ink and color on paper.

ing of the word "cartoon" to include ambitious satirical paintings that can be regarded as works of art in their own right. Born in Shanghai in 1916, he was the son of designer and cartoonist Ding Song, one of Zhang Yuguang's first pupils. By the early 1930s, Ding Cong—or Xiao Ding ("Little Ding"), as he signs himself—was studying in Liu Haisu's academy and already drawing cartoons, in company with Zhang Guangyu and Ye Qianyu. When war came, all three moved to Hong Kong, where Ding, like Zhang, worked for a film company. In 1942 he went to Sichuan, spending the rest of the war chiefly with art and theater friends in Chengdu; he also taught briefly in the Sichuan Provincial Academy of Art. In 1944 he travelled to the borderland of western Sichuan and Xikang and visited the Daoist temples on Qingchengshan, where he met Xu Beihong and his students. From these expeditions he brought back to Chengdu a striking series of sketches and drawings of the Luoluo tribespeople.[5]

It was in 1944 also that Xiao Ding painted what is probably his best-known work, the satirical handscroll *Xianxiang tu* (fig. 11.6)—literally, "looking at images."[6]

It opens with a student, forced to study volumes of useless old lore while his modern textbooks lie idle on the floor. Beside him stands the professor, nursemaid to his pregnant wife and children, who want food, not books. Partially screening the war profiteer counting his gains, two rascals close a secret deal by squeezing fingers hidden in their sleeves. The blindfolded artist has painted a dog when he intended a tiger, but five would-be buyers, unable to tell the difference, have attached their red tags to his scroll; the writer's every word, meanwhile, is measured and scrutinized by the huge eye of the censor. The rich man, member of many prestigious organizations, refuses to buy a coat from a refugee, while the painted woman on his arm holds her nose at the stink of the wounded soldier. Officials haggle over money pledged to feed the poor, while hoarded rice is eaten by rats and cloth rots. Soldiers and refugees crowd the road, while the rich in their limousine drive past unheeding. Finally, the journalist, his pen poised to expose the rot, can speak only through the official invitation stuffed in his mouth.

Xiao Ding's scroll attacks no individuals in particular,

11.7
Ding Cong, *Xianshi tu* (detail) (1946). Ink and color on paper.

but the picture it presents of life under Chiang Kaishek is devastating. In its sardonic exposure of the evils of society it owes much to Lu Xun, but stylistically the influence is chiefly that of the modern Mexicans. The debt to Rivera and Covarrubias is even stronger in the more carefully modelled but no less powerful figures on the scroll Xiao Ding painted a year later, when the war with Japan was over: *Xianshi tu,* "picture of reality" (fig. 11.7). Civil war was about to break out, profiteers were flooding the market with American goods, and peasants were pressed into the army, while weapons supplied by the Americans to fight the Japanese were being turned against the real enemy—the Communists. At the end an armed peasant is about to blow them all to smithereens.

Xiao Ding's work, not limited to cartoons, ranges from satire to landscape sketching, from woodcuts to book illustrations. His stylistic and technical range is remarkable, and always appropriate to the theme and the medium he employs. His woodcut illustrations to Lu Xun's *Ah Q,* published in Chongqing in 1944, have a crude dramatic power, while even his most bitterly satirical drawings, such as *Plunder* of 1945, combine fierce condemnation with a monumental solidity of form—a virtue for which he owes much to the Mexican revolutionary artists. By contrast, Te Wei (Sheng Song), active in Shanghai, Hong Kong, and Guilin in the late 1930s and early 1940s, was strongly influenced by David Low.

OTHER WARTIME CARTOONISTS Zhang Leping, creator of the much-loved little boy San Mao, or "Three Hairs," was born in 1910 into a poor teacher's family in Haiyangxian, Zhejiang. As a young man he came under the influence of Zhang Guangyu and Ye Qianyu, and with them contributed to the Shanghai cartoon magazines. The indomitable little San Mao first appeared in a Shanghai newspaper, the *Xiaozhenbao,* in November 1935.[7] When war came, Zhang Leping joined Guo Moruo's Third Propaganda Team, producing anti-Japanese cartoons, posters, even wall paintings; he worked in Nanjing, Wuhan, Changsha, and Guilin. His powerful watercolor of 1942, showing laborers building an airfield, shows that he was no mere caricaturist, while his mockery of the Japanese and of Chinese capitalist ex-

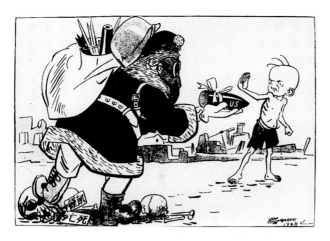

11.8

Zhang Leping, *San Mao Rejects Arms for the Civil War* (1948). Ink on paper.

11.9

Hua Junwu, two satires on modern art (c. 1980). The legends read: (*top*) "Traditional art taught. Guaranteed to turn the new old. Come as a tiger, graduate as a living fossil." (*bottom*) "Keep on painting, my dear, and when you're good at it you can go on TV. Then they'll make films about you, and when you win first prize in an international competition, you'll get your dad abroad for a look round."

ploiters of the poor was both savage and accomplished.

When Zhang Leping returned to Shanghai in 1946, the comic strip saga of San Mao was published in *Dagongbao,* appearing weekly throughout the country for 234 installments (fig. 11.8). To many, San Mao was a real child, and when the little urchin for some reason did not appear, an eight-year-old reader wrote to the newspaper: "Mr. Zhang, I haven't seen San Mao for three days and I miss him terribly. Where has he been? Has he starved or frozen to death, or has he gone to school?"[8] After Liberation, San Mao continued to appear—by this time, of course, a happy child, diligent student, and Young Pioneer, and a godsend to the moral propagandists of the Mao era. Several popular films based on the series were produced.

Among the other leading cartoonists of the 1930s and 1940s was Liao Bingxiong, born in Canton in 1915. He studied in Shanghai, early becoming known as a satirical writer and member of the Shanghai cartoonists' circle. He too joined Guo Moruo's cartoon propaganda team on the outbreak of war. Some of his most powerful work was produced in the years before Liberation, when he attacked not only the usual targets but those who were corrupting China's youth.[9] A particularly savage cartoon (plate 29) shows mahjong gamblers staking not cash but the bound and naked bodies of men and women.

Cai Ruohong, born in Jiangxi in 1910, was a founding member of the League of Left-Wing Artists. Before he went to Yan'an, around 1938, he made satirical and often derivative drawings and cartoons of Shanghai; his *Avenue Joffre* of 1937, for example, might be a copy of one of Georg Grosz's cartoons of Weimar-period Berlin.[10] Cai Ruohong was later to become deeply involved in the cultural politics of the People's Republic, a relentless enemy of ideological waverers.

Hua Junwu was born in Suzhou in 1915, studied in Shanghai, became a bank clerk for two years, and went to Yan'an in 1938.[11] He later said that when he began his career in Shanghai he was influenced by the German cartoonist E. O. Plauen, whose strip cartoon *Vater und Sohn* was widely appreciated by Chinese cartoonists, and by "Sapajou" (the former czarist officer Georgi Sapojnikov), who worked for the *North China Daily News* from 1925 until he left China for Hawaii in 1949. Hua Junwu said he even imitated the way Sapajou wrote his signature. He is a witty cartoonist who expresses his politically orthodox sentiments with simplicity and economy (fig. 11.9).

One of the very few woman cartoonists of the time was the Cantonese Liang Baibo. An early student of oil painting at the Hangzhou Academy, she had been an active member of the Storm Society (see chapter 6).

Feng Zikai defies classification.[12] He was not purely a cartoonist or a painter but something in between, caring too passionately for the individual to ally himself to any movement. Born in 1898 in Shimenwan, north of Hangzhou, son of a scholar who became a *juren* too late to enjoy the fruits of office, by the time he was sixteen he was learning to be an art teacher in the Hangzhou First Normal College, struggling to draw Homer, Venus, and the Laocoön. Under the inspiring influence of Li Shutong, he studied Western art and music before spending ten critical months in 1921 in Japan, where he discovered the Japanese *manga* (cartoon) tradition, from which the Chinese term *manhua* is derived.

By 1924, back in Shanghai, Feng Zikai was making such a reputation with his illustrations to single lines from well-known poems that Chinese readers were speaking of "Zikai manhua." At about this time he turned to depicting the world about him. He became a writer, teacher, and widely popular lecturer on art, fascinating his audience with his transparent honesty and a deep understanding of things that went with the strong Buddhist leanings that he had developed under the influence of Li Shutong. He almost succeeded in becoming a vegetarian, but, as Christoph Harbsmeier noted in his sympathetic study of him, "he had considerable problems with the Buddhist injunction to abstain from wine"—although he never drank too much.

Though Feng has been called a social realist, the label does not fit; in fact, he was criticized by the Leftists in 1930 for his "spineless attitude" on ideological questions. Rather, his simple brush drawings catch the essence of a place, a person, a moment in everyday life. His innocent eye invests with feeling even common objects—a teapot and teacups, for example, on a deserted terrace in the moonlight—while his men or (more often) young women and girls gazing out of windows convey a sense of loneliness and longing (as in fig. 11.10). During the war and after, the social comment in his work became a little sharper, but he was more often moved to sympathy than to anger. Throughout his life, he made drawings of the children he loved. Indeed, he often seemed to see the world through their eyes.

After Liberation, Feng Zikai seemed happy with the new order. In his paintings of the 1950s and early 1960s, more carefully drawn and colored, he depicts men and women peacefully calling on each other at new year, enjoying the spring, visiting a temple. His orderly, well-dressed children do their lessons under the trees and are altogether more serious. In these paintings houses and figures are drawn with the same economy and feeling for character that we find in the work of the Ming master Shen Zhou. Inevitably, his innocent enthusiasm for

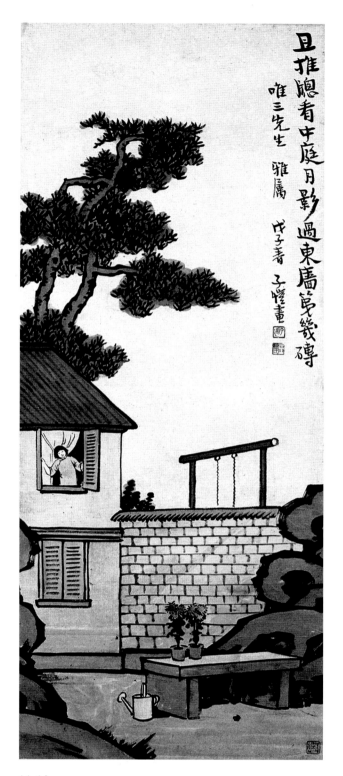

11.10
Feng Zikai, *Looking at the Moon* (1940s). Ink and color on paper.

the new order was made use of, but he was eventually moved to protest the abuse of the dignity of the individual, with dire results. His last years, during the Cultural Revolution, were tragic.

1949–1976: Art in

The Era of Mao Zedong

The years during which Mao Zedong exerted total control over cultural life in China were, for creative men and women, at first a period of commitment and hope, then of uncertainty as the reins were alternately tightened and loosened, and finally of growing despair and frustration, culminating in the nightmare of the Cultural Revolution. Artists were required to "serve the people." The dialectical struggle between tradition and revolution, Chinese and Western art, continued, with Western modernism replaced by Soviet socialist realism. The theoretical debate was carried on over the artists' heads by Party ideologues, who enforced Mao's directives to "make the past serve the present" and "make foreign things serve China." Within strict ideological limits, many new answers to that challenge were found. If for the professional artist Party control was often stifling, and at times severe punishment was meted out to deviants, the encouragement given to workers and peasants to take up the brush would enormously broaden the human base from which creative art could spring.

LIBERATION

RESTRUCTURING THE ART WORLD

The greatest upheaval in modern Chinese history ended with the restoration of order and the birth of hope. The mood of excitement and expectation of Liberation shared by many, if not all, is well expressed in Huang Xinbo's oil painting of 1948, *"They're Coming!"* (fig. 12.1). As the straw-sandalled Red Army marched into Beijing, carrying their food and bedding, people lining the streets stood silent, wondering at their discipline and restraint. For most, apprehension gave way to an enormous sense of relief that the years of strife and economic chaos were over. The Red tide swept outward from Beijing, until the whole of mainland China was engulfed. The price of order and stability was spelled out from the start. There were to be no hidden corners into which the tide would not reach; no institutions, no individual that did not come under the control of the Party; no private education of any kind; no thought not controlled by Party ideology.

With the Soviet model before them and ten years of planning and preparation in Yan'an, the Communists moved quickly to put their cultural policies into effect. Artists from both Communist and Guomindang areas were summoned to the first National Congress of Literature and Art Workers, convened in July 1949, to hear the official policy towards the arts.[1] This event was so important that it was addressed not only by Lu Dingyi, the propaganda chief, but also by Zhu De, Zhou Enlai, and Mao Zedong himself. The Artists Association was set up under the aegis of the Ministry of Culture to recruit, organize, reeducate, and support artists, "mental workers" toward whom the government "must adopt policies that will protect them and make use of them to serve the People's Republic to the best of their ability." As registered members of the provincial and local branches of the association, provided with regular salaries and free accommodation for their families, artists now enjoyed a security such as they had never known before. It is hardly surprising that most of them at first welcomed their new masters.

Although the constitution of the heavily subsidized Artists Association was not promulgated until 1954, its aims were enforced from the start: to organize artists for national reconstruction; to produce art of a high ideological level and artistic quality; to organize the study of art theory on the basis of Marxism-Leninism and the principles laid down by Mao in the Yan'an Talks, using the method of criticism and self-criticism; to organize art exhibitions, publish art journals, promote the study of the Chinese cultural heritage, help young artists, and encourage the masses to take up art, partly by sending professional artists to decorate the walls in their villages; and to stimulate international art exchanges with the USSR, Eastern Europe, and "people's artists" in other countries. No aspect of artistic activity was to be allowed to slip through the net of Party control.

As titular chairman of the association, Xu Beihong sent out an appeal to artists who had taken refuge from the Civil War in Hong Kong to return home. Zhang Guangyu, Ding Cong, Ye Qianyu, and many others answered the call. By June 1949 they were meeting with Party cultural officials in Beijing and learning what was expected of them. Not all responded, however. The in-

12.1
Huang Xinbo, *"They're Coming!"* (c. 1948). Oils.

vitation of Guan Shanyue, who had seen the light, to his old teacher Gao Jianfu was not exactly cordial: his failure to return, Guan wrote, would make him "an enemy of the people." Gao Jianfu, not surprisingly, decided to stay in Macao.[2] Xu Beihong himself had been an object of contention between the Communists and the Guomindang. In October 1948 the government in Nanjing, which had set up a special fund to help important people to come south, had sent Xu two air tickets, but he was watched over by his friend and former student, the oil painter Feng Fasi, who had been a member of the Communist underground in the academy. Another friend, the dramatist Tian Han, came secretly with messages from Mao Zedong and Zhou Enlai wishing him well and urging him to stay in Beijing, and the effort was successful.[3] Most of the staff and students of the Beijing Academy had refused to leave as well.

The Party propaganda machine lost no time in exploiting China's artistic talents to create a favorable impression in the Communist world. At the First International Conference on World Peace, held in Belgrade and Prague in April 1949—six months before the People's Republic was founded—the large Chinese delegation included a group of artists headed by Xu Beihong. An exhibition of Chinese applied art (decorative design applied to lacquer, textiles, etc.) visited Moscow and Leningrad in 1950, followed in 1954 by ceramics and in 1957 by guohua. Ding Cong was among the delegates sent to a youth conference in Hungary and then on to Moscow. Through the 1950s, Chinese art exhibitions regularly toured the Soviet bloc and Third World countries. A new and very different era was opening in China's cultural relations.

ART UNDER POLITICAL CONTROL

From the moment Beijing became the capital, art and art education felt the full weight of Party control. In 1946 Huabei United Revolutionary University, an outgrowth of Yan'an University, had been founded at Zhangjiakou. Its cultural institute (*wenyi xueyuan*) was headed by Sha Kefu, with the poet Ai Qing as vice president and Jiang

Feng as head of the art section. When Beijing was liberated they moved in and took over the academy, confirming Xu Beihong as president, "assisted" by three radical professors—Feng Fasi, Ai Zhongxin, and Zhou Lingzhao—and a group of Communists from Yan'an that included Hu Yichuan, Yan Han, and Mo Bu. In October the Wenyi Xueyuan was fused with the academy, and in July 1950 it acquired the name by which it is still known today: the Central Academy of Fine Arts (Zhongyang meishu xueyuan). Xu Beihong remained the titular head, although control was in the hands of a Communist group of five: Hu Yichuan, Wang Chaowen, Luo Gongliu, Jiang Feng, and Jiang Ding.

The Central Academy, under the all-seeing eye of the Ministry of Culture, thus became the model for art schools across the country, the arena in which new policies were inaugurated and new teaching methods tested, the center to which art teachers were summoned for conferences and "discussions"—that is, for receiving their instructions—and for mobilization in support of each successive Party campaign or propaganda onslaught.

After a year of relative tolerance, the authorities ceased to conciliate "bourgeois elements," and the honeymoon was over. The political reeducation campaign intensified, undoubtedly helped by the wave of patriotic anti-American fervor roused by the Korean War.[4] In September 1951, Zhou Enlai lectured the academy on the evils of individualism; later that same year "austerity inspiration committees" initiated mass criticism of teachers, leading to humiliation and public confessions. In 1952 the faculty was orchestrated to support the Three Antis and Five Antis campaigns. In 1953, when the government needed support for the launching of the first Five Year Plan, there was a slight relaxation, lasting until late 1954. That autumn, the Party made a strenuous attack on wayward intellectuals, notably on Feng Xuefeng, editor of the *Literary Gazette*.

Even more severe was the campaign of the following year, directed personally by Mao, against Lu Xun's disciple Hu Feng, who had dared to challenge Mao's doctrine of the total subservience of art to politics.[5] In July 1955 the Ministry of Culture held an art education meeting at the Academy, attended by fifty professors from twenty-two art schools, and the propaganda chief, Hu Qiaomu, used the occasion to mobilize them for a concerted attack on Hu Feng. Among those obliged to denounce him in statements published in *Meishu*, the official journal of the Party's cultural affairs bureau, were Yu Fei'an, Liu Kiaqu, Hu Yichuan, and Ni Yide, while Pang Xunqin, hitherto completely apolitical and now a naive and apparently enthusiastic convert, declared that Hu Feng's "eccentric thinking" deserved to be punished.

The constant stresses and tensions generated from the start by ideological struggle in the Central Academy created an oppressive atmosphere that has persisted ever since. The pattern of reforms and campaigns, carrots and sticks, that characterized the Central Academy was followed in other art schools across the country. It would be tedious to attempt to describe it all, but a few comments are in order.

For some months before Hangzhou was "liberated," the Hangzhou Academy had been run by an underground progressive group, which set up a provisional committee to take over as soon as the Guomindang had departed.[6] They included Liu Kaiqu, Ni Yide and his wife Lu Wei, Li Hua, and Wei Mengke. On Liberation, Jiang Feng took control, aided by Mo Bu, who had been with the Communist New Fourth Army. They put up Liu Kaiqu as president, with Ni Yide and Jiang Feng as his deputies, and appointed Pang Xunqin to head the painting section. The real power in the academy, as in all institutions, was wielded by a succession of Party secretaries, beginning in 1952 with Gao Shan. A similar pattern was followed in all the public art schools, so that within a few months, although the president and many of the staff were the same as before, control was completely in the hands of the Yan'an men. Private art schools were simply abolished. The staff and students of Wang Yachen's Xinhua Academy were distributed between Nanjing and Hangzhou. In 1952 those from Liu Haisu's and Yan Wenliang's academies and from Shandong University's art department were amalgamated at Tianxi, and in 1958 this combined school moved to Nanjing to become the Nanjing Academy of Art, over which Liu Haisu continued, nominally, to preside.[7]

ART AND ARTISTS REFORMED

In his keynote address to the National Congress of Literature and Art Workers in July 1949, Zhou Yang was specific about the kind of art that would be given high priority: works considered part of the folk tradition, for example, and cartoons. "The Liberated Area woodcuts, New Year's pictures, picture story books, etc., are all rich in Chinese style and flavor. We all know the woodcuts of Gu Yuan, Yan Han, Li Chun [Li Qun], and the cartoons of Hua Junwu and Cai Ruohong"—all, of course, Party men. But that was not to say that no other kinds of art would be tolerated: "We highly respect and wish to learn from what is useful from the fine heritage of all native and foreign traditional forms, especially from Soviet socialist literature and art."[8] This emphasis on "traditional" forms clearly excluded Western modernism. Cosmopolitan, Western-trained artists soon came under heavy pressure to reform. Wu Guanzhong, returning from Paris to teach at the Beijing Academy in 1950,

found his students eager to learn about the Post-Impressionists and more modern movements in the West, but he was soon told that discussion of the subject was forbidden. He himself was severely criticized as a bourgeois formalist.

Had Wu Guanzhong studied the Yan'an Talks on Art and Literature he would have known what to expect, for Mao had insisted that writers and artists must undergo "a long and even painful process of steeling." Just how this steeling was to be accomplished was spelled out in no uncertain terms by the propaganda chief, Hu Qiaomu:

> First, they should, in accordance with the instructions of Comrade Mao Zedong, engage themselves earnestly in ideological reform, study Marxism, and identify themselves with the workers, peasants and soldiers. . . .
>
> Second, Marxist ideology in regard to art and literature should be widely taught . . . so that everyone may realise that art and literature play an important part in the class struggle. . . . Writers and artists must maintain close contact with the labouring masses, finding sources for creative work in their life and struggles. . . .
>
> Third, the leadership of our art and literature should be reorganised. . . . We must enlarge and strengthen the leadership of creative production and criticism. . . .
>
> Fourth . . . every really necessary literary and art organisation should become a combat unit which will effectively help writers and artists to identify themselves with the working people. . . . Organisations which cannot do so should be dissolved and "writers and artists" who cannot actually carry out literary and art work should be dismissed by the organisations concerned. . . .
>
> Fifth, all literary and art publications . . . should be reorganised. . . .
>
> Sixth, we demand that writers and artists who are Party members should become models in the aforementioned activities, i.e. models in the study of Marxism, models in uniting with the workers, peasants and soldiers, models in the practice of criticism and self-criticism, and models in their literary and art work. We oppose any lack of discipline on the part of Party members who are literary or art workers.[9]

Under great moral and psychological pressure, Lin Fengmian and Pang Xunqin both made statements repudiating the error of their "formalist" ways, and many lesser artists followed suit. Yet the Party realized that art could not be reformed overnight, and that in the meantime it was necessary, as Zhou Yang had said, to win the artists over to their side. Accordingly, the National Congress was made the occasion for a huge exhibition that filled seventeen rooms of the Central Academy, ranging across the whole of Chinese modern art, from traditional guohua through oils, watercolors, and sculpture, as well as woodcuts, cartoons, and *nianhua*. Derk Bodde, who visited the exhibition, noted how derivative the professional works were by comparison with the crude vigor of the paintings and drawings by peasants, soldiers, and laborers. He singled out also Liu Kaiqu's sculpture group of a woman and child in an air raid and a violently anti-American cartoon, and went on:

> Most interesting, however, were the less sophisticated works prepared by Communist propagandists for use among the peasants. There were colored lantern slides illustrating the powers of the Liberation Army or its cooperation with the people; lithographed wall newspapers in which the news of the day was presented in the form of brightly coloured pictures arranged like American comic strips; colored New Year pictures . . . in which the traditional God of Wealth and the Eight Immortals are replaced by such up-to-date themes as peasants working together in the field or participating in a "bean election" (voting for village officials by casting beans into jars beneath the names and pictures of candidates); "scissor pictures" (designs cut with scissors from red paper—a traditional art of peasant women), likewise modernised to show Liberation Army soldiers or peasants at work. . . . The entire exhibition left two dominant impressions. One was the dynamic force that graphic art can give when it is harnessed with conviction and skill to certain guiding ideas. The other was the extent to which the Communists, as no other group in Chinese history, have succeeded in conveying their message to China's rural millions.[10]

This exhibition was to be a model for many more of its kind in the years to come.

Similar developments took place in Shanghai, where in 1950 Party leaders set up the Shanghai Municipality New Chinese Painting Research Society (Shanghai shi xinguohua yanjiu hui) to promote realism in the traditional style, along the lines pioneered by Xu Beihong. At their first major exhibition in 1951, works ranged from the pure landscape of the Lingnan artist Li Xiongcai to a propagandist scroll by Pan Yun depicting the southward march of the Liberation armies, in which the grouping of the figures and even the style owe something to the Dunhuang frescoes.

In May 1950, Zhou Enlai, addressing the staff and students of the Beijing Academy, had urged them to get out of their studios, take their art to the countryside, and teach the peasants while learning from them. The effect of this injunction is well illustrated by the following piece written by a journalist on the staff of *China Weekly Review.* Entitled "Art Education in the New China," I quote

it at length not only because it is a lively piece of writing, but because although the picture it gives of teaching in the Academy before Liberation is deliberately distorted—in suggesting, for example, that the students had not drawn clothed models, or gone out to the countryside to paint—it shows in graphic detail how the new policy was carried into effect, while well capturing the buoyant mood that perhaps the majority of teachers and students felt in the first years after Liberation.

"Mao Zedong has said that 'Life is the fountain of creation.' The National College of Fine Arts in Hangzhou now follows this theory in its teaching methods.

"On a typical morning, April 16, the students were awakened by the ringing of bells.

"They rose, tied their quilts and clothing into bundles and after eating their bowl of rice, went to the playground to wait for the trucks that were to take them to the farms and factories.

"While they waited, a group of students began to dance the *Yangge* to the accompaniment of some Chinese instruments:

> Zhang, zhang, ji, ji, zhang.
> Zhang, zhang, ji, ji, zhang.

Others sang as follows:

> Why should we go to the farms?
> Why should we go to the factories?
> We educated people want to reform ourselves,
> We must live and work with the working class.
> Hey!
> We must live and work with the working class.

The students were accompanied by their professors, who included Lin Fengmian and Guan Liang, some of China's most famous painters. Professor Lin won fame in Paris years ago. His paintings are still highly valued by the French connoisseurs. But, now, he no longer paints for the rich. He wants to reform himself with the other artists in China. He sat this morning on his baggage, talking with his friend Professor Guan. . . .

"To understand why they were going to the farms and factories it is necessary to look back on the past history of art education in the old liberated areas.

"The first revolutionary art school in China was the Lu Xun Art Academy in Yan'an. Most of the famous artists in north China, such as Gu Yuan, Hua Junwu, Mi Ke [Mi Gu], came from that school. But as Comrade Jiang Feng explained to me, the Lu Xun Academy also made mistakes.

"'The teachers and students in that school were enthusiastic about revolution,' he said, 'but their associa-

tion with the working class was not strong enough. Like the students in any other art school, the Lu Xun students studied art in classrooms and studios. They did not really understand the people. The characters whom they created in their pictures were fictitious. Later, at Yan'an's Cultural Meeting, Chairman Mao Zedong pointed out these mistakes and asked them to change.

"'From that time on, the Lu Xun Academy began to undergo a great transformation. All the teachers and students went to the farms, living and working with the peasants. They described the lives of the peasants. They came to understand the true feelings of the peasants. This is the reason why the art in north China has been so vivid and true to life. . . . '

"In the past, art education in the Guomindang areas was deeply influenced by the Paris school. The students did not like to draw pictures of what they actually saw. They liked to distort the figures in their paintings. 'Exactitude is not truth,' said Henri Matisse.

"The students blindly followed the doctrines of these French artists. They knew nothing except how to paint willow trees, peachblossoms, and female nudes. They were unable to master a large composition.

"In order to cultivate the students' ability in 'creative painting,' the professors in the National College of Fine Arts use a new method of teaching. The first-year and second-year students have to draw the portraits of the 'living men' besides studies of Greek sculptures. Likewise, the third-year and fourth-year students have to draw 'models in clothes' in addition to studies of nudes.

"In the past, the first-year and second-year students studied only Greek sculptures. They were so familiar with these things that they could draw the figure of Venus or the torso of Laocoon from memory. But if they were asked to paint a portrait, they could only draw a Chinese with a Greek nose. The same was the case with the more advanced students. Most of them were unable to draw the drapery of a man in clothes because they had only studied nudes in their classrooms.

"In the past, the poses of 'models' were adopted from Greek sculptures. They were usually reclining figures. They expressed the Greek idea of the 'sleeping Venus.' Now, the models have to stand up, with tools in their hands. They express the beauty of the working class. . . .

"It was a hard task at first to reform some of the students who were worshippers of Matisse and other modern French artists. They refused to go to the farms and factories. They wanted to study art in classrooms. They imitated the lines of Matisse in their drawings and paintings.

"But other forces were at work. At meetings of small discussion groups and in the classrooms the paintings of Matisse and other famous artists of the Paris school were

critically analysed. The Dramatic Club presented a four-act play called 'Direction,' which was written by the students themselves. In that play, they told the audience how meaningless the paintings of the capitalist world were! Gradually, these 'Matisse-worshippers' changed. Now, they are as happy as the other students, because they no longer hesitate. They understand that realism is the only truth in art.

"Under the new system the students have improved both in political understanding and technique. Last term, they held an exhibition after returning from the factories and farms. The spectators—most of them workers and farmers—looked at their paintings and exclaimed, 'They are too good! The persons in these pictures really look like us.'

"All of these pictures are realistic. But this does not mean that they are 'photo-like.' Everyone shows his own character in his creative painting. Within the realm of realism, the development of personality will not be limited.

"No professor is able to teach if he does not go to the farms and factories with his students. The students like to ask such questions as these:

"'Sir, how does a rope go through the nose of an ox?'

"'Sir, what does a windmill in west Zhejiang look like?'

"Well, the professor has to blush if he does not know how to answer. So all of the professors go to the farms and factories.

"At the end of term, the students put their drawings and paintings on the walls of the Art Gallery. Then the professors and students hold a meeting and discuss the pictures. They grade them according to the opinion of the majority.

"In the past, some of the professors in the Guomindang areas were not interested in teaching. They came to school once or twice a month, letting the students themselves grope for methods of drawing and painting. Some of them were so lazy that they refused to paint pictures without 'inspiration.' Some did not paint a single picture for ten years, because 'inspiration' did not come.

"Since the liberation of mainland China, this has changed. Unlike the world of capitalism, the new society lets no one be lazy. The artists, too, study the works of such great thinkers as Marx, Engels, Lenin, Stalin, and Mao Zedong. They hold meetings from time to time. They attend the public lectures of famous men. This is the only way for an artist in a society of New Democracy to understand his time and surroundings thoroughly.

"The professors at the National College of Fine Arts have a 'special studio' in which they can work. So they also have a chance to improve their technique. In addition to this, the college provides a 'special schedule' for its professors. Every artist is expected to finish one or two paintings each term.

"The exhibition of the professors in April was most successful. Most of the pictures were oil paintings describing what the professors saw and found in the factories and farms."

This buoyant mood was to be sustained until 1957, when the wilting of the "Hundred Flowers," and the Anti-Rightist Campaign, in which artists were among the principal victims, introduced a new note of cynicism and disillusionment.

13

ART FOR SOCIETY

OIL PAINTING:
THE DECADE OF SOVIET INFLUENCE

By the summer of 1950 the doors to the West had been shut by the Korean War, and they were to remain shut for more than twenty years. Now China's political and cultural partners were the Soviet Union, her Eastern Bloc satellites, Cuba, and Albania. Selected art students were sent to study in the USSR. Li Tianxiang and Qian Shaowu were at the Leningrad Academy from 1953 to 1955; Lin Gang was sent to Leningrad in 1954 and did not return until 1960; Luo Gongliu went in 1955. Among many others who travelled in the Soviet Union and Eastern Europe on art tours or as members of cultural delegations we may mention Xiao Feng, Dong Xiwen, Ai Zhongxin, Yang Taiyang, Liu Kaiqu, Yan Han, and Guan Liang.

In April 1951 an exhibition of Soviet propaganda and satirical art was mounted in the Central Academy. Books on Russian art began to replace those on the Post-Impressionists in the libraries and bookshops—books not only on the work of Soviet artists but also on earlier anti-academic realists of the czarist period, notably the group known from its traveling exhibitions as the Wanderers, which had seceded from the Academy in 1863.[1] Among its leading members were Ivan Kramskoy, Ilya Repin, Vassily Surikov (see fig. 13.1), and Valentin Serov. Wu Guanzhong later recalled his humiliation when his students at the Academy discovered that he had never heard of Repin, and his relief when he discovered an article on that artist in a magazine.

Although art students continued to study Renaissance and nineteenth-century European art (particularly Courbet and Millet), the impact of the Russian realists

on the younger generation of Chinese oil painters at this time was considerable. Feng Fasi, a pupil of Xu Beihong, had been painting realistic oils after World War II in Chongqing, where he had seen the exhibitions put on at the Sino-Soviet Cultural Centre; in 1949 he exhibited a large oil denouncing the Civil War. In the following year he was appointed professor in the Central Academy. His impressive work of 1957, *The Heroic Death of Liu Hulan* (fig. 13.2), shows the heroic defiance of a peasant girl of seventeen, tortured and executed by the troops of the warlord Yan Xishan because she refused to reveal the hideout of her fellow Communists, and demonstrates how much he had learned from the naturalism of the Russian realists, particularly Surikov.[2] Dong Xiwen's huge painting of Mao Zedong proclaiming the birth of the People's Republic from the Tiananmen (see plate 28), much admired by Mao himself, is a typical propaganda painting of the period. The original of 1950 showed the figures of Liu Shaoqi and general Gao Gang. When Mao destroyed these former allies, they were painted out. After Mao died they were painted in again, as in this version of about 1980.

Tunnel Warfare (plate 30), painted in 1951 by Luo Gongliu, is an early example of dramatic realism; his *Jinggangshan Landscape* of ten years later shows how much his technique had improved during his years in the Soviet Union. Among hundreds of competent works of this period we may also mention Wang Shikuo's *The Bloody Shirt* (fig. 13.3), an elaborate composition depicting peasants holding up the tattered garment of a tor-

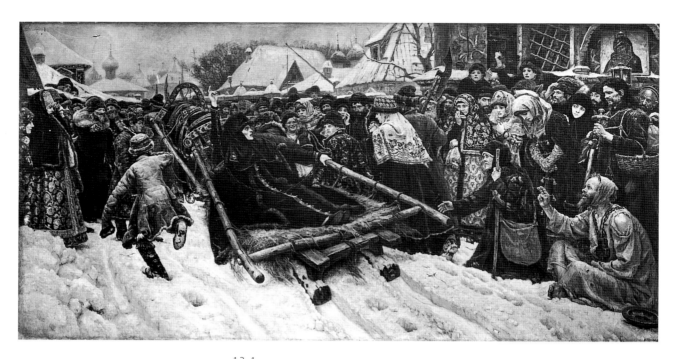

13.1
Vassily Surikov, *The Boyarina Morozova* (1887). Oils.

13.2
Feng Fasi, *The Heroic Death of Liu Hulan* (detail) (1957). Oils.

13.3
Wang Shikuo, *The Bloody Shirt* (c. 1959). Preparatory drawing for an oil painting.

tured and murdered friend before a cowering landlord. Wang's unfinished oil painting of 1972 was based on a series of sketches and cartoons begun in the 1950s.[3] In 1961 Hou Yimin painted Mao with the Anyuan miners, and in 1962 Liu Shaoqi leading the strikers out of the pits. By contrast with the bad old days, the cheerful optimism of these early years of the People's Republic is expressed in Dong Xiwen's idyllic landscapes of Tibet and the borderlands (as in fig. 13.4), full of sunlight and blossoms, and in the smiling faces of his peasants and herdsmen, which show the influence of Serov and Isaac Levitan.

By the time Konstantin Maksimov arrived at the Academy from Moscow in February 1955, there can have been few who had not heard of Repin. Maksimov, a Stalin Prize winner whose works had been shown in Beijing in the Soviet art exhibition of 1951, became a dominant influence.[4] In 1956 he painted a portrait of Wu Zuoren (by now vice president of the Academy, under Jiang Feng), and in 1957 he met Qi Baishi shortly before the old master died. Maksimov's own style was comparatively loose and free, but he insisted, following the doctrines of the Soviet theorist Chistyakov, that every picture should tell a story, or at least that the subject matter should be immediately apparent to the viewer. However, the almost photographic realism that is so evident in the work of Hou Yimin and some other Chinese oil painters at this time owes less to Maksimov than to a close study of the technique of earlier Russian artists such as Surikov and Repin.

The standards in realistic oil painting established by Jiang Feng at the Central Academy in the 1950s were taken up in all the art schools, notably in the Hangzhou Academy, where the Romanian artist Babov taught for several years beginning in 1960.[5] It has persisted with little change into the 1990s—indeed, it is a politically useful style in which "development" has little place. The ambitious compositions by painters such as Wang Shikuo and Wen Lipeng (Wen Yiduo's son) demonstrate great technical competence and little or no individuality. As late as 1977, Chen Yifei and Wei Jingshan showed in their dramatic painting of the capture of Nanjing in 1949

13.4
Dong Xiwen, *Landscape of the Long March* (1955). Watercolor.

13.5
Chen Yifei and Wei Jingshan, *Overturning the Dynasty of Chiang Kaishek* (1977). Oils.

(fig. 13.5) that the style still had its skillful exponents—and that there was still an official demand for this kind of painting. By this time Chinese oil painters could well have seen, at least in reproduction, the works produced by Russian, German, Japanese, and American war artists, which are remarkably similar to theirs in style.

The Soviet influence, however, was by no means all-pervasive. Most of the older Paris- and Tokyo-trained artists continued to paint as they had before. Wu Zuoren, in spite of his close association with Maksimov, seldom painted "socialist realist" pictures, while Lü Sibai, Chang Shuhong, Yan Wenliang, and Ni Yide seem from published works to have been little affected. Liu Haisu remained an ebullient, unrepentant post-impressionist, revealing in his Huangshan landscapes of 1953–54 and his Shanghai snow scenes of 1957 his undying debt to van Gogh. Wu Guanzhong, condemned for his inability to paint smiling peasants, abandoned the figure altogether for landscapes. Pang Xunqin too painted landscapes, flowers, and still lifes in his own Ecole de Paris style, which did not betray his ideological shortcomings. Lin Fengmian virtually abandoned oils for gouache, which allowed this prolific artist to work extremely fast. Although he sometimes painted peasants in the fields, he was never able to give them the solid heroic glamour the Party required.

13.6
Pan Tianshou, *Unloading Rice* (1950). Ink on paper.

GUOHUA: A CONTROLLED REVIVAL

Revolutionary China, one might expect, would have had no use for traditional painting. It was an inheritance from feudal culture, identified with the old scholar class. Jiang Feng, supported by the wood-engraver Li Hua, declared that it was unscientific, useless, and had no future in depicting revolutionary society. When he became acting president of the Central Academy after the death of Xu Beihong in 1953, he created a new department to promote a synthesis of Western color and Chinese ink, which he called *caimohua*, color and ink painting. The synthesis was not in itself revolutionary: Lin Fengmian had been doing it for twenty years. Coming from Jiang Feng, though, it was a threat to the integrity of the guohua, and the traditionalists were up in arms. But they had their supporters too. With the destruction of the bourgeois intelligentsia, guohua was cleansed of its elitist associations and no longer thought of (at least by some) as an elitist art; besides, it was uniquely Chinese, with a long tradition, and it remained in the eyes of many far superior to Western art. Armed with Mao's exhortation to "make the past serve the present," the Party set out to woo the leading traditionalists and began an attack on Jiang Feng that was to lead eventually to his downfall.

The guohua painters had to accommodate the new artistic order, of course. They were told to forget about landscapes, bamboo, and birds and flowers, and to paint figures instead. They bitterly resented being forced to draw the model from life. Huang Binhong was told that he must lecture on the history of figure painting, an art he had never practiced. Pan Tianshou, criticized for not conforming, made a few halfhearted attempts at genre subjects (fig. 13.6). The scholar Zheng Zhenduo, in an article on Dunhuang art, obligingly insisted that the ancient painters always made the human figure their main theme, and that landscape was not the criterion for judging the quality of an artist. He even went so far as to say that when the Tang poet and landscape painter Wang Wei introduced the antirealist and intellectually elitist *wenren* (literatus) concept into painting he brought about its degeneration; that this led to the painting of birds, flowers, and fishes; and that consequently the main tradition came to an end.[6]

One solution to the problem of how to make guohua relevant in a revolutionary society was to stress the symbolic meaning of traditional motifs. During the World Peace Movement of 1951, Qi Baishi and the academic flower painter Chen Zhifo painted peace doves.

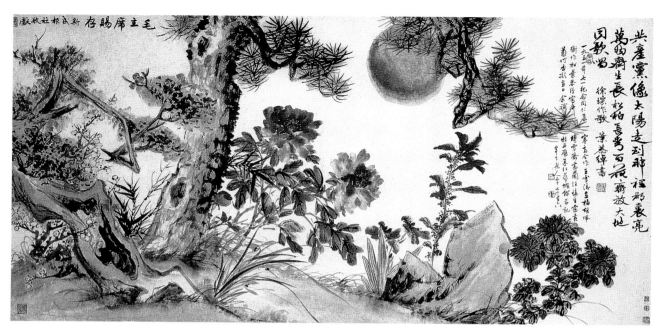

13.7

He Xiangning, Pu Xuezhai, Ye Gongchao, Hu Peiheng, Wang Xuetao, Wang Zhensheng, and Chen Nian, *"Let a Hundred Flowers Bloom!"* (1951). Collaborative painting for Mao Zedong. Ink and color on paper.

Many guohua artists painted traditional themes symbolic of spring's awakening, such as red plum blossoms against the snow, or of strength and endurance, such as great gnarled pine trees. Red stood for the Communist victory, or for the blood of martyrs. Even a "pure" landscape became politically respectable if it purported to illustrate a line from one of Mao's poems.[7] Collaborative pictures, not in themselves new, were created by as many as ten specialists in pines, landscape, birds and flowers, to heap cumulative praise on the new regime—as in fig. 13.7, a large composition on which He Xiangning, who had by this time abandoned the Westernisms of her earlier years, collaborated with Pu Xuezhai, Ye Gongchao, Hu Peiheng, Wang Xuetao, Wang Zhensheng, and Chen Nian. Other collaborative pictures were painted anonymously by "The Graduates of the Central Academy," "Beijing Chinese Painting Academy, Bird and Flower Group," "Shanghai First Steel Plant Workers' Art Group," and so on.

THE PROBLEM OF REVISING TRADITIONAL PAINTING During a lively debate on the merits of guohua carried on in 1954 in the art academies and in *Meishu,* some, led by Jiang Feng and Yan Han, still argued that it was "unscientific" and should be abandoned. Even Li Keran declared that the problem with guohua was that it was too much concerned with "self-expression" and that it overemphasized "likeness in spirit" (*shensi*) at the expense of "likeness in form" (*xingsi*).[8] But the reformists won the day. Zhou Yang urged painters to modernize their style and to put figures in their landscapes—not idle scholars and fishermen, but modern men and women doing useful things.[9] For stylistic models, they were told to reject the abstract manner of the discredited literati of Yuan, Ming, and Qing and go back instead to the realism of Northern Song and the craftsmanlike technique of the academic and Zhe School masters.

Up to this point, the guohua reform presented few difficulties. Before Liberation, modern guohua artists such as Xu Beihong had been free to select their subject matter, excluding anything demanding accurate rendition—a truck, for example, or a power station. But now, with the new subjects obligatory, artists were faced with reconciling the irreconcilable: on the one hand the generalized language of conventional "type forms" for the elements of nature, as learned out of handbooks such as *The Mustard-Seed Garden,* and on the other the "scientific" rendering of individual figures and forms drawn from life. In many of these new guohua works—see, for example, figure 15.1, Pu Quan's *Building the Red Flag Canal*—the landscape is conventionalized while peasants and workers, buses and dams, are drawn realistically. They look, a critic complained, like paper cutouts stuck on a traditional landscape, and the effect is uncomfortable and unpleasing.[10]

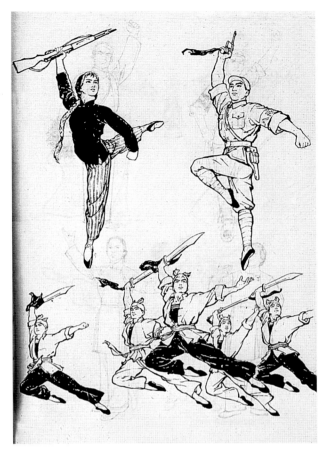

13.8 (*above*)
Figures from model book (1979).

13.9 (*right*)
Drapery from model book (1979).

Realism demanded that artists abandon their conventional vocabulary of texture strokes (*cun*) appropriate to different kinds of rocks and terrain and paint instead directly from nature; but this they did not find easy. In the 1920s, students assigned to draw a street scene had asked their teacher for photographs of people that they could copy into their pictures, for the camera had already produced two-dimensional images for them. Forty years later, Qian Songyan was describing how he went to Huangshan not to draw what he actually saw before his eyes but to "check his *cun*" against the rock faces of the mountain. Having "corrected" them, he continued to paint as before.[11] Thus the conventional language was not rejected but rather adjusted. Although trained to draw from life, students often use model books, not only for typical idealized workers and soldiers, rapacious landlords and wicked imperialists, but even for clothing and drapery folds (figs. 13.8 and 13.9). The lazy artist could slip back into the old habit of learning forms out of books rather than painting what he or she saw.

Also incompatible were the rendering of solid form in light and shade, as taught by the Soviet and western-

ized realists, and the traditional Chinese rendering of form through modulations of the line. The pro-Soviet teachers stressed *ti* (form) while the traditionalists spoke of *xian* (line). Even apparently realistic modern guohua makes very little use of shading, and often there is no single light source and so no cast shadows at all.

Finally, the two traditions use space in fundamentally different ways. Western art organizes form within the frame, governed by a constant viewpoint and single perspective. In guohua painting, space goes beyond its edges, while perspective is continuously changing (as in Zhang Daqian's *Ten Thousand Miles of the Yangzi*, fig. 1.19). The new guohua, therefore, was based on a series of compromises. Often the two kinds of perspective are reconciled so skillfully that we are not aware of the inconsistency.

But in making these compromises, how could the new guohua fulfill the requirement for realism? It couldn't, of course, but the reformed artists' answer was delightfully simple: call it realistic anyway. "The greatest painters of the past," wrote Qian Songyan, "express a certain mood, a philosophical concept. Yet most classical Chinese landscapes are highly realistic in that they are a synthesis of nature and the artist's feelings and ideas."[12] Cong Baihua, writing in 1961, spoke of "wholeness"—by which he meant faithfulness to appearance—and "essentiality," the distilling from the individual form of its typical, timeless character. Too much wholeness, he says, leads to naturalism (that is, to literalism), and too much essentiality to abstract formalism. In painting a dragon, "the expressive power of art lies in the fact that one scale or claw can symbolise the whole without in any way detracting from the richness of its content." He quotes William Blake:

> To see a world in a grain of sand
> And heaven in a wild flower,
> Hold infinity in the palm of your hand
> And eternity in an hour

This, Cong says, is "the essence of the realist creative method of the classical Chinese artistic tradition." As examples of this realism, he cites the paintings of Gu Kaizhi, Yan Liben, Bada Shanren, and Qi Baishi.[13] It is hardly surprising that so metaphysical a definition of pictorial realism was demolished by Maoist critics during the Cultural Revolution.

Through the late 1950s and early 1960s, the guohua movement, no longer the private preserve of the elite, grew and flourished under official patronage, particularly after the Ministry of Culture founded the Beijing Painting Academy (Beijing huayuan), which opened on May 14, 1957.[14] Both Zhou Enlai and Shen Yanping, the minister of culture, spoke at the opening, which coincided with the launching of the Hundred Flowers Movement (discussed below). An encomium on guohua published in *People's China* in June noted that "certain people holding leading positions in the world of art [meaning Jiang Feng and his group] had scant respect for our national heritage and took a very supercilious and high-handed attitude in regard to traditional Chinese painting. They described it as a product of feudal society. . . . They held forth on the fact that Chinese painting by its very nature cannot serve the interests of the working people and should therefore be replaced by Western methods of painting. This sectarian approach has seriously hampered the development not of Chinese traditional painting alone but of Chinese pictorial art as a whole."[15]

Now all that would change. Before Liberation, Mao and Zhou had planned to set up the Wenshi Guan (Institute for culture and history) to secure the participation of old scholars and cultivated gentry in the new regime.[16] They were told to write their "memoirs" for private circulation, as a gentle way of persuading them to reform their thinking. In 1952, the Ministry of Culture established the first institute in Beijing, and thereafter every major city had its own Wenshi Guan to which elderly artists were elected. Some of the branches acquired large collections of paintings and calligraphy. During the Cultural Revolution the Wenshi Guan was almost completely suppressed, to emerge again, with much diminished membership, after the Third Plenum of 1979.

Supported by the Wenshi Guan and by local branches of the Artists Association, guohua artists produced a vast number of new traditional paintings during the 1950s and early 1960s. Many carried no ideological message at all, and birds, flowers, and bamboo were very popular. Pan Tianshou produced some of his best landscapes at this time, not infrequently choosing to illustrate a line from a Mao poem in his own powerful, uninhibited way (fig. 13.10). His talented pupil Lai Chusheng flourished in Shanghai. Li Keran also seemed full of confidence, and even Fu Baoshi managed on occasion—when he was not obliged to collaborate with Guan Shanyue—to recapture some of the poetry of his pre-Liberation work.

Gao Xishun, who was born in Hunan in 1895 and studied in Changsha with Mao Zedong, was another notable guohua painter of the time.[17] He had settled in Beijing in 1919 to become a bird and flower painter in the circle of Qi Baishi and Chen Hengke, and on a visit to Japan in 1927 he had studied the work of Ido Reizan, Masamoto Naohiko, and Yokoyama Taikan. After Liberation, he was briefly president of the Beijing Painting Academy. During the 1950s his paintings became realistic, showing the influence of Giuseppe Castiglione, but

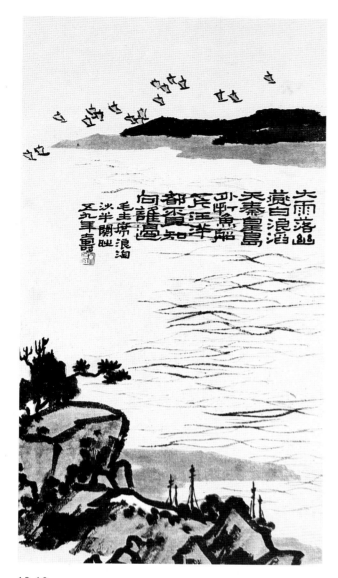

13.10

Pan Tianshou, landscape illustrating a poem by Mao Zedong (1959). Ink and color on paper.

in his last years he returned to the free, expressive *xieyi* manner he had acquired in the 1920s.

More typical of the guohua revival were the orthodox figure subjects of Liu Wenxi. Also in demand were landscapes peopled with workers, peasant, and soldiers, busy with construction projects, commerce, the Socialist transformation of the Chinese countryside. In such works Song Wenzhi, Qian Songyan, Guan Shanyue, and Wei Zixi excelled, and their popularity was assured.

THE HUNDRED FLOWERS
AND THE ANTI-RIGHTIST MOVEMENT

The point of highest hope for the development of guohua, and indeed of culture generally, was reached in the brief, intoxicating months of the Hundred Flowers

Movement. It began with Zhou Enlai's secret report of January 1956, upgrading the status of intellectuals, writers, and artists, whose talents were needed for China's reconstruction.[18] In May Mao uttered his famous dictum, "Let a hundred flowers blossom! Let a hundred schools of thought contend!" What this meant was then spelled out by Lu Dingyi, chief of the propaganda department of the Central Party Committee:

> With regard to works of art and literature the Party has only one point to make, that is that they should "serve the workers, peasants and soldiers," or, in terms of today, serve the working people as a whole, *intellectuals included*. Socialist realism, in our view, is the most fruitful creative method, but it is not the only method. . . . As to subject-matter, the Party has never set limits to this . . . the choice of subject-matter is extremely wide. Creative writing deals not only with things that really exist, or that once existed, but also with things than never existed—the gods in the heavens, animals and birds who talk, and so on. One can write about positive people and the new society, and also about negative elements and the old. Furthermore, it is difficult to show the new society to advantage if we fail to describe the old, hard to show the positive to advantage if we leave out what is negative. Taboos and commandments about choice of subject-matter can only hamstring art. . . . They can only do harm. [Emphasis added.][19]

Lu Dingyi also exhorted artists: "Learn from abroad and not exclusively from the Soviet Union; don't neglect the great tradition of Chinese painting [as the socialist realists and some wood-engravers insisted they should], but carefully select, cherish and foster all that is good in it while criticizing its faults and shortcomings in a serious way." Zhou Yang, vice-minister for cultural affairs and another sudden convert to *glasnost,* also criticized the tendency of the Party to "belittle, reject or deal roughly with our national tradition."[20] Guohua painters had long been unhappy at the downgrading of their art in the academies—an extreme example of which was when Wang Jingfang had his scrolls torn up in front of his face, an act of cruelty that is thought to have hastened his death soon after.

The painters demanded more exhibitions and more reproductions of their work, and the authorities responded positively. Another result of the new policy was a new openness to foreign art: British, Japanese, Greek, Italian, Vietnamese, and Mexican exhibitions appeared in Beijing, while a small touring collection brought Beijing viewers their first taste of Picasso, Matisse, Bonnard, Rouault, Marquet, Léger, and Utrillo, whose *Moulin de la Galette* delighted many viewers who found the Picasso still lifes "difficult."

By the spring of 1957, the direction of the Hundred Flowers campaign was changing to a rectification of the Party itself. People were invited to expose and criticize corrupt, lazy, and bureaucratic cadres. For the intellectuals, artists, and students, it was as if the May Fourth era had come again, and they attacked the establishment with a will, thinking they were doing Mao's work. Pang Xunqin was one of many artists who presented their complaints; he was soon to pay dearly for it. Meantime, as Merle Goldman has observed, the Hundred Flowers had developed a momentum of its own far beyond what the Party had intended.

Hardliners in the Party became alarmed. If a halt was not called, China would go the way of Hungary, whose revolt of the previous year had been crushed with Soviet tanks. On June 8, the Party counterattacked. Mao was forced to abandon the intellectuals and artists. In every work unit, a wholly arbitrary five percent had to be designated as "bourgeois rightists." Even in units with few intellectuals, and where no one had spoken out, the quota had to be fulfilled. Selected victims were denounced by their friends and colleagues, forced to make endless self-criticisms. One of the most ruthless opponents of the movement he had backed a month earlier was Zhou Yang himself.[21]

To save themselves, friend turned on friend. The designer Lei Guiyuan denounced his old colleagues, among them Pang Xunqin, his particular crimes being that he had resisted official attempts to turn his Central Academy of Arts and Crafts into a center for the production of export and tourist goods such as ivory carving, and—worse still—that he had proposed that it be governed by an independent council elected by the academy itself. When Pang's wife, the painter Qiu Ti, who was in hospital, heard that he had been branded a Rightist, she died of a heart attack. And the sins of the fathers were visited upon the children: their daughter Pang Tao was sent for a year of reeducation in the countryside. The young oil painter Zhu Naizheng, branded a Rightist, was banished to remote Qinghai and not called back to the Academy until 1980, a span of *twenty-three years.*

The casualties were many. Artists who had studied in the West, such as Wu Dayu, Wu Guanzhong, and Lin Fengmian, were obvious targets. *Meishu* carried a long list of charges by Wu Jun against Liu Haisu, among them that he had opposed a direction of 1956 that the Huadong Art Academy should move from Tianxi to Xi'an; that he hated the cadres, had said they understood nothing and only joined the Party to eat rice; that he had used the airing of views in the Hundred Flowers to "loose off guns"; that he had said the Party leadership was lacking in culture, and that the painting produced since Liberation had no style, no life, no feeling; that he

had opposed the study of Soviet art, which he claimed was not the world's best, while in the history of world art Repin was only of the second or third rank . . . and many more such allegations, not the least serious being that he was luring students into his camp.[22]

In one night's "struggle session" at the Central Academy, forty-four artists and students were branded "enemies of the people." They included even devoted Communists who had been with Mao in Yan'an—Jiang Feng, now labelled "The Number One Rightist in the Art World," and his close allies Li Hua, Yan Han, and Feng Fasi. The ostensible reason for the persecution of Jiang Feng, in which even Li Keran and Jiang Zhaohe joined (how willingly is not known), was that he had denigrated traditional painting; in fact it was the end result of a long and bitter feud with the unscrupulous Cai Ruohong, his rival from Yan'an days.[23]

Those artists who were not sent down to the country (such as Li Hua, a "Rightist Leaner" rather than a "Rightist") were required to continue to teach and to paint what the authorities demanded: decorations for public buildings and embassies, or paintings to be sent abroad as gifts or offered for sale to earn valuable foreign exchange. They were nonpersons, forbidden to paint for themselves or to exhibit their work. Estimates of the number of individuals from all areas of artistic and intellectual endeavor who were labelled as Rightists range from three to four hundred thousand.

In some ways, the Anti-Rightist persecution orchestrated by Deng Xiaoping, Zhou Yang, and the moral watchdogs of the Party was more unbearable even than the Cultural Revolution ten years later. Then, artists could take some comfort from knowing that they were the innocent and often random victims of uncontrollable hooliganism. The Rightists of 1957 were condemned, on ethical grounds, by an inquisition that searched out their innermost thoughts and feelings, and found them wanting. Against such an attack there was no defense.

THE GREAT LEAP FORWARD

As if the Anti-Rightist campaign were not enough to cripple creative art, it was immediately followed by the Great Leap Forward, the mass mobilization to create People's Communes and generate rural industry.[24] Artists by the thousands were sent into the countryside to share in the hard life of the peasants, there to take part in their unwilling hosts' futile efforts to smelt iron or to tend their pigs. When they were allowed to paint, the artists were expected to help rouse enthusiasm for the great upheaval by painting propaganda pictures on the walls of houses. This was the real beginning of the "peasant art movements" described in the next chapter. Some artists were

PLATES

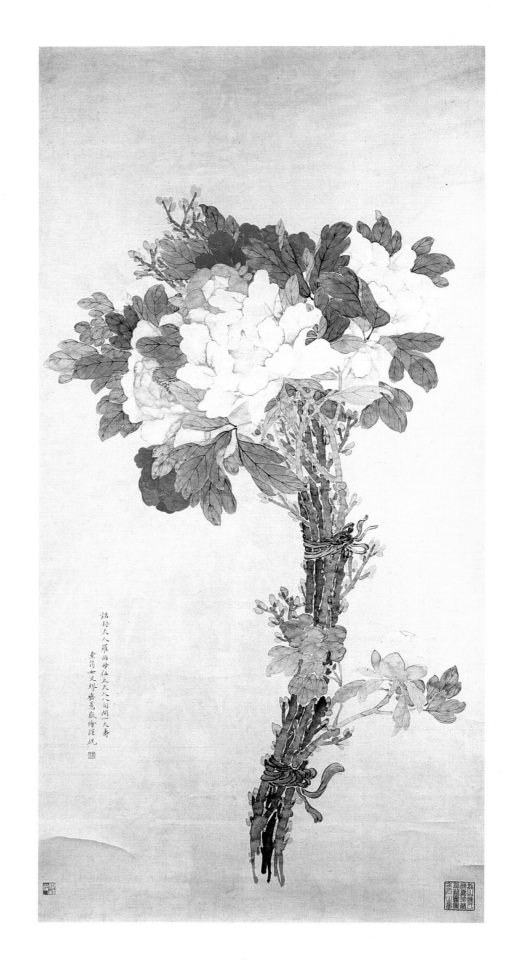

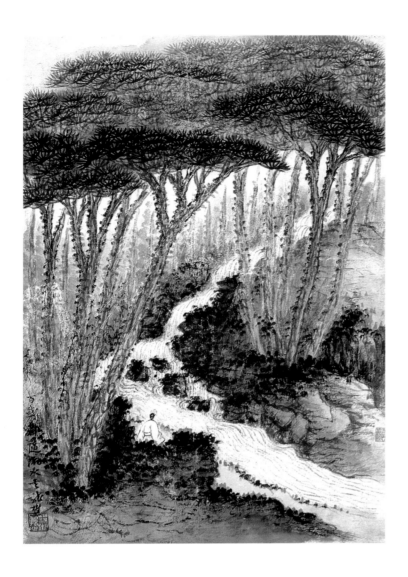

PLATE 1 (*opposite*)
Miao Jiahui, *Bouquet of Peonies* (c. 1900–1905). Ink and color on silk.

PLATE 2 (*left*)
Xiao Sun, *Landscape* in the style of Shitao. Ink and color on paper.

PLATE 3 (*below*)
Wang Geyi, *Pomegranate*. Ink and color on alum paper.

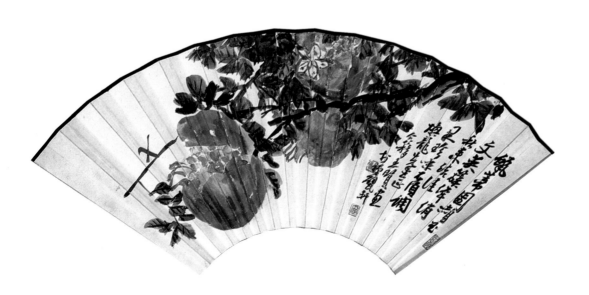

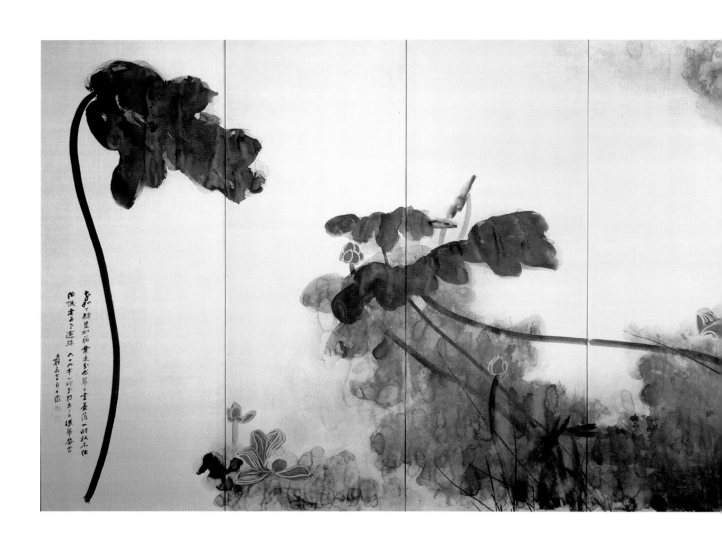

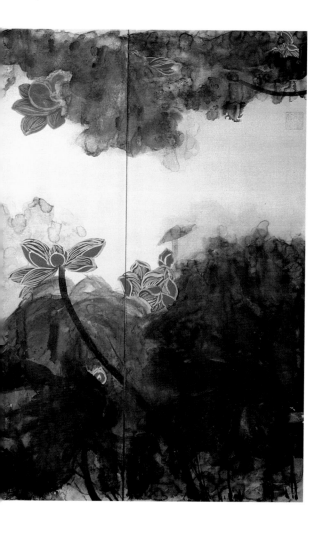

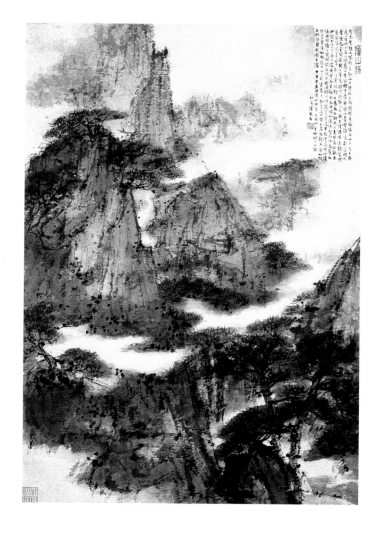

PLATE 4 (*above*)
Zhang Daqian, *Crimson Lotus on Gold Screen* (1975). Ink and color on silk.

PLATE 5 (*right*)
Fu Baoshi, *The Song of Mount Lu* (1944). Ink and color on paper.

PLATE 6 (*above*)
Li Tiefu, *Portrait of the Painter Feng Gangbai* (1934). Oils.

PLATE 7 (*right*)
Wen Yiduo, *Feng Xiaoqing* (1927). Pencil and wash.

PLATE 8 (*opposite, top*)
Pang Xunqin, *Portrait Painted in Paris* (1929). Oils.

PLATE 9 (*opposite, bottom*)
Yan Wenliang, *Street on Putoushan* (1935). Oils.

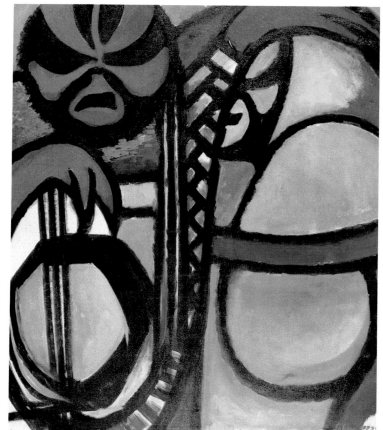

PLATE 10 (*above*)
Chen Shuren, *Shadows on a Snowy Lake* (1931). Ink and color on paper.

PLATE 11 (*right*)
Zhao Shou, *Faces* (1934). Oils.

PLATE 12 (*opposite, top*)
Wang Yachen, *Mountain Village* (1935). Oils.

PLATE 13 (*opposite, bottom*)
Zhou Bichu, *Nude* (c. 1932). Oils.

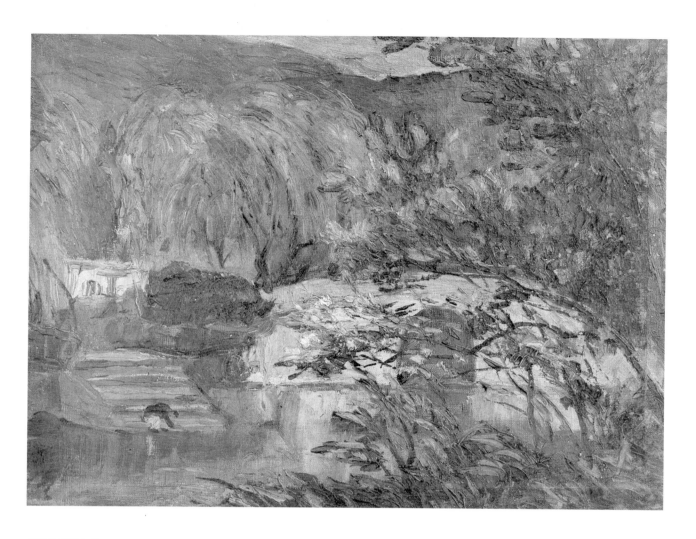

PLATE 14 (*above*)
Zhang Xian, *Beauty Looking at a Picture* (1935). Oils.

PLATE 15 (*opposite, top*)
Yang Taiyang, *Landscape along the Yangzi River* (c. 1981). Watercolor.

PLATE 16 (*opposite, bottom*)
Xu Beihong, *Self-Portrait* (1931). Oils.

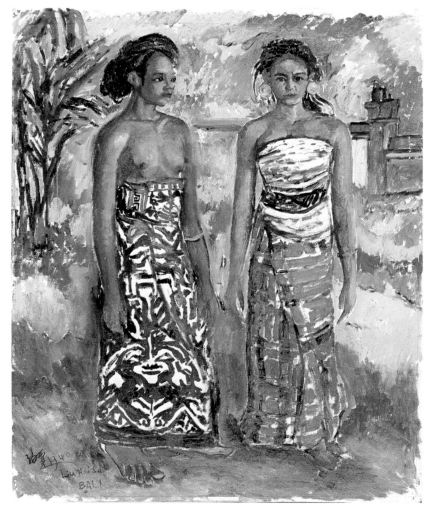

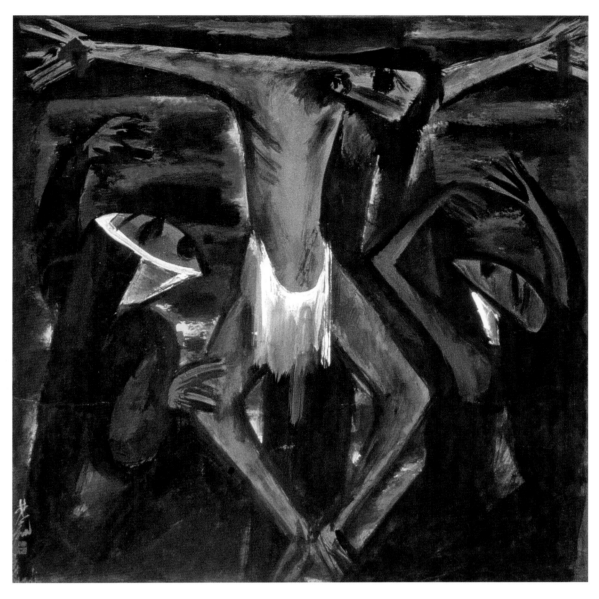

PLATE 17 (*opposite, top*)
Liu Haisu, *Express Train* (1929). Oils.

PLATE 18 (*opposite, bottom*)
Liu Haisu, *Balinese Girls* (1940). Oils.

PLATE 19 (*above*)
Lin Fengmian, *Crucifixion* (late 1980s). Gouache.

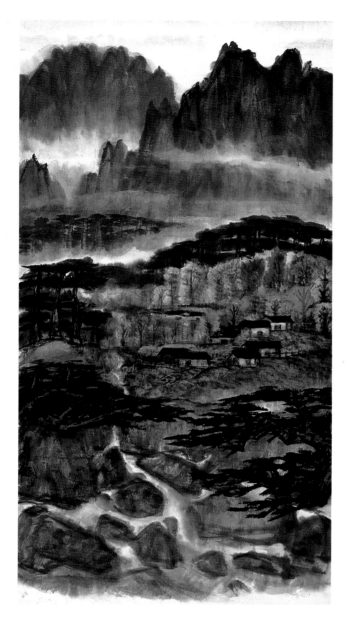

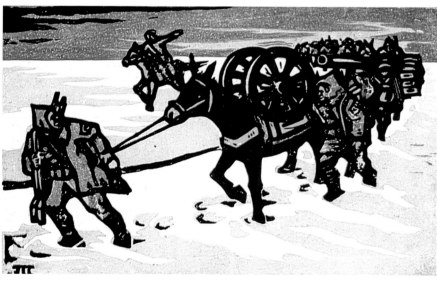

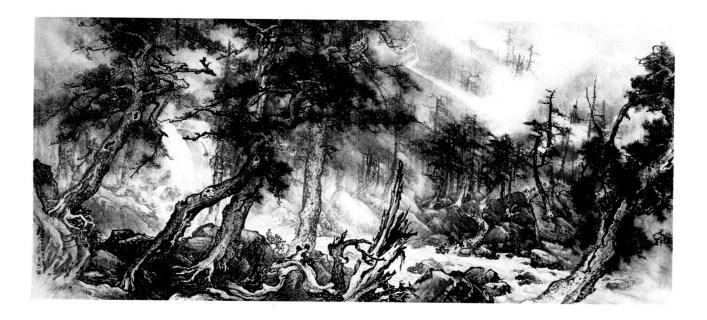

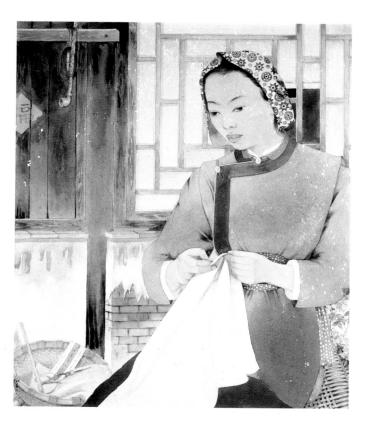

PLATE 20 (*opposite, top*)
Lin Fengmian, *Landscape* (1980s?). Gouache.

PLATE 21 (*opposite, bottom*)
Hu Yichuan, *Bringing Up the Guns* (1932). Colored woodcut.

PLATE 22 (*above*)
Li Xiongcai, *The Forest* (early 1950s). Ink and color on paper.

PLATE 23 (*left*)
Pang Xunqin, *The Letter* (c. 1945). Light ink and color on paper.

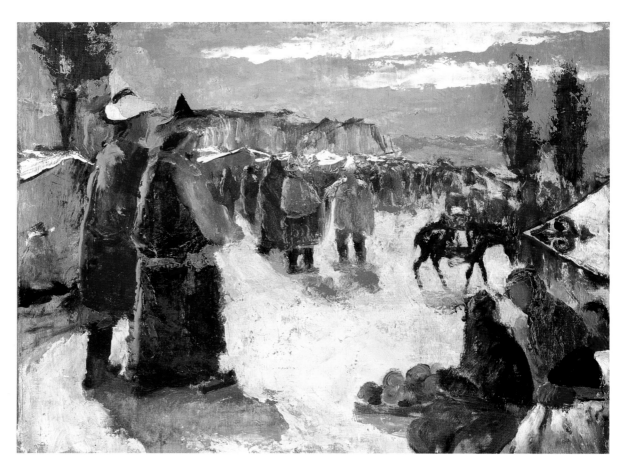

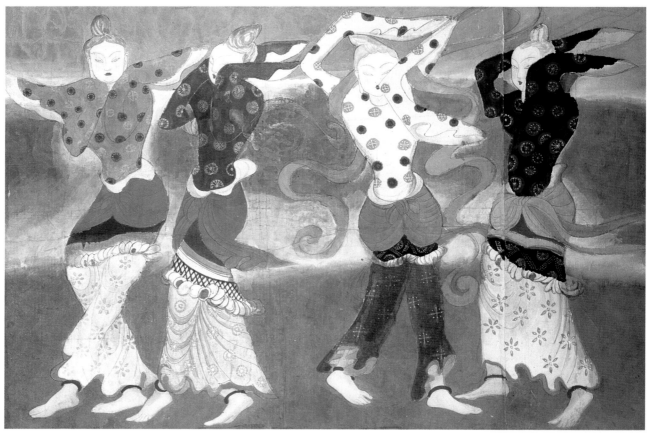

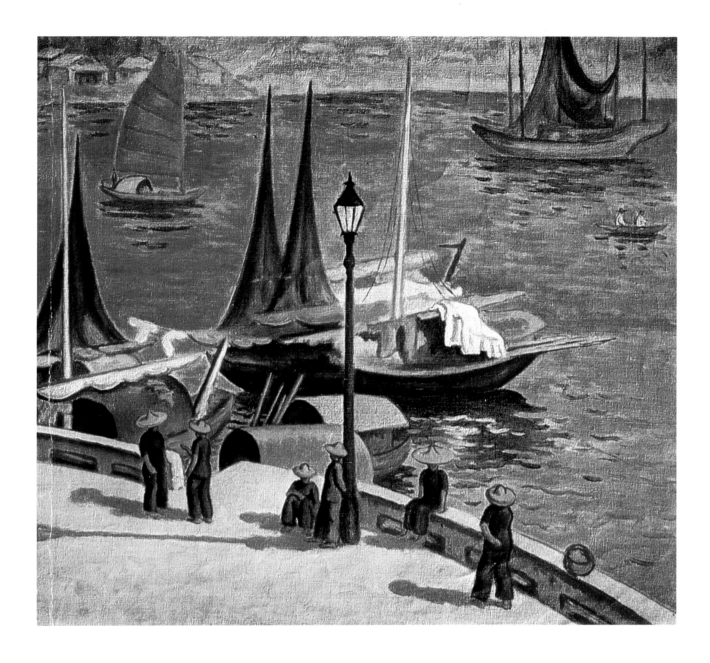

PLATE 24 (*opposite, top*)
Wu Zuoren, *Market in Qinghai* (1944). Oils.

PLATE 25 (*opposite, bottom*)
Zhang Daqian, *Dancers* (1943). Copy of Tang dynasty wall painting at
Dunhuang. Gouache on paper.

PLATE 26 (*above*)
Chen Baoyi, *Hong Kong Harbor* (detail) (1938). Oils.

PLATE 27 (*above*)
Yu Ben, *Rural Scene in Hong Kong* (c. 1938). Oils.

PLATE 28 (*opposite, top*)
Dong Xiwen, *Mao Zedong Declaring the People's Republic from Tiananmen*
(revised version, c. 1980). Oils.

PLATE 29 (*opposite, bottom*)
Liao Bingxiong, *Gambling with Human Beings* (c. 1945). Ink on paper.

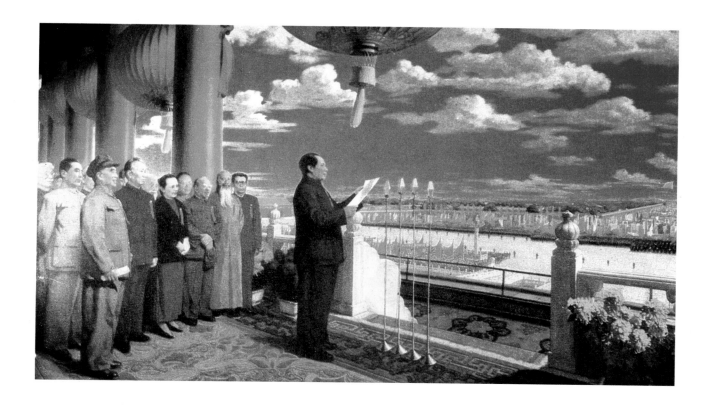

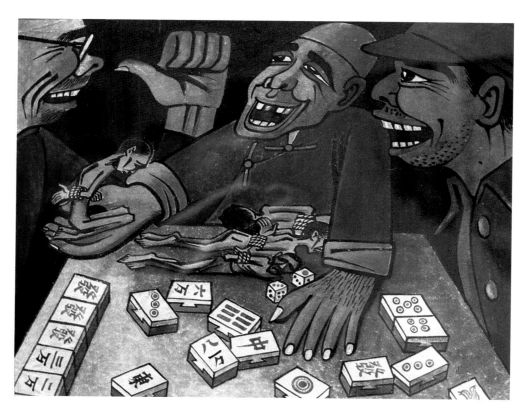

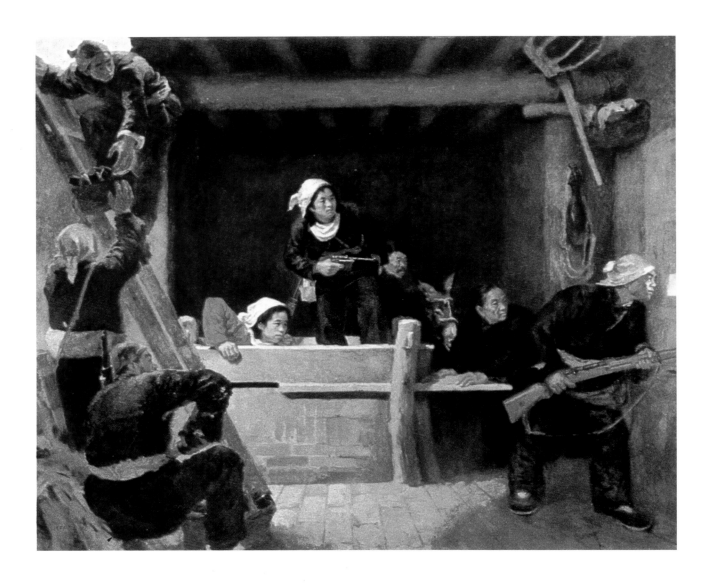

PLATE 30 (*above*)
Luo Gongliu, *Tunnel Warfare* (1951). Oils.

PLATE 31 (*opposite, top*)
Fu Baoshi and Guan Shanyue, *Such Is the Beauty of Our Mountains and Streams* (1959). Wall painting in the Great Hall of the People, Beijing.

PLATE 32 (*opposite, bottom*)
Bai Tianxue, *Learning to Sing Revolutionary Songs* (c. 1950). Gouache on paper.

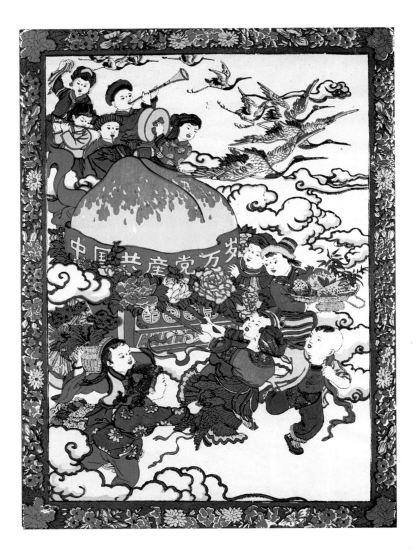

PLATE 33 (*opposite, top*)
Hua Shuang (Jiaxing peasant painter), *Fisherman* (c. 1987). Gouache on paper.

PLATE 34 (*opposite, bottom*)
New year picture (*nianhua*) by an anonymous Suzhou artist (1950s). Hand-colored woodblock print.

PLATE 35 (*above*)
Huang Xuanzhi, *The Island in the Lake* (1980). *Shuiyin* print.

PLATE 36 (*left*)
Li Quanwu and Xu Yongmin, illustration to Lao She's *Yue Ya'er* (Crescent moon) (1983). Ink and color on paper.

PLATE 37 (*right*)
Chen Jin, *Old Instrument* (1982). Chinese ink and color.

PLATE 38 (*opposite, top*)
Liu Kuo-sung, *Landscape* (1966). Ink and color on paper.

PLATE 39 (*opposite, bottom*)
Chen Tingshi, *Day and Night #25* (1981). Block print on rice paper.

PLATE 40 (*opposite, top*)
Liao Xiuping, *Future Life* (1972). Embossed serigraph.

PLATE 41 (*opposite, bottom*)
Chu Ge, *Life Is a Ritual of Offering* (1988). Ink and color on paper.

PLATE 42 (*left*)
Yu Peng, *Father and Son* (1990). Ink and color on paper.

PLATE 43 (*above*)
Chen Laixing, *No. 94* (1984). Oils.

PLATE 44 (*right*)
Chen Qikuan, *Vertigo* (1967). Ink and color on paper.

PLATE 45 (*opposite*)
Chen Qikuan, *Peaceful Coexistence* (1988). Ink and color on paper.

PLATE 46 (*opposite*)
Yu Chengyao, *Rocky Mountains with Gurgling Streams* (1984).
Ink and color on paper.

PLATE 47 (*above*)
Ju Ming, *Single Dip Whip* (1985). Bronze.

PLATE 48 (*left*)
Ju Ming, *Fish* (1984). Glazed pottery.

PLATE 49 (*opposite, top*)
Ng Yiu-chung, leaf from an album (1971). Ink and color on paper.

PLATE 50 (*opposite, bottom*)
Irene Chou, leaf from an album (1971). Ink and color on paper.

PLATE 51 (*above, left*)
Kwok Hon Sum, *Enlightenment* (1989). Oils.

PLATE 52 (*above, right*)
Wucius Wong, *Purification No. 2* (1979). Chinese ink and gouache on paper.

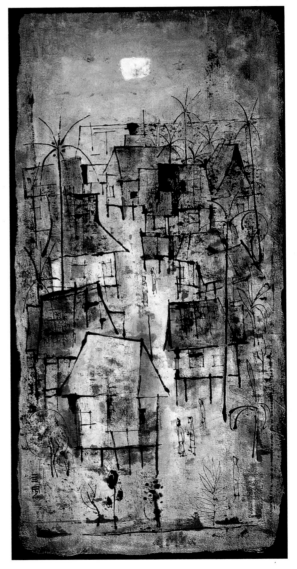

PLATE 53 (*above*)
Cheung Yee, *Tortoise Shells for Divination* (1968). Oils on paper.

PLATE 54 (*right*)
Cheong Soo-pieng, *Kampong, Evening* (1959). Ink and color on paper.

PLATE 55 (*opposite, left*)
Cheong Soo-pieng, *Portrait of K. S.* (1959). Ink and color on paper.

PLATE 56 (*opposite, right*)
Chhuah Thean Teng, *Opening the Curtains* (c. 1960s). Batik painting.

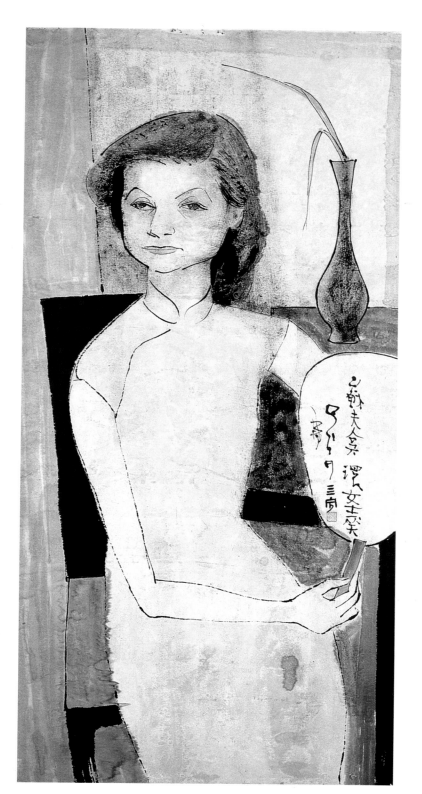

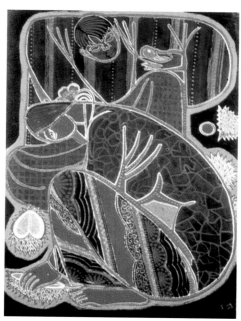

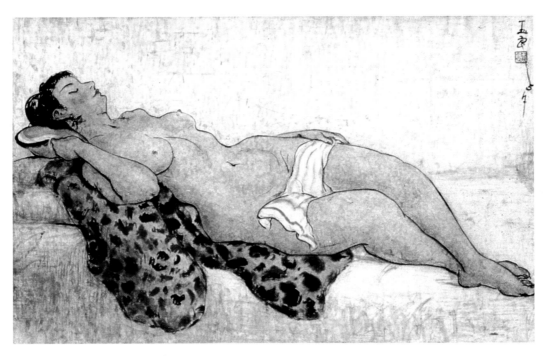

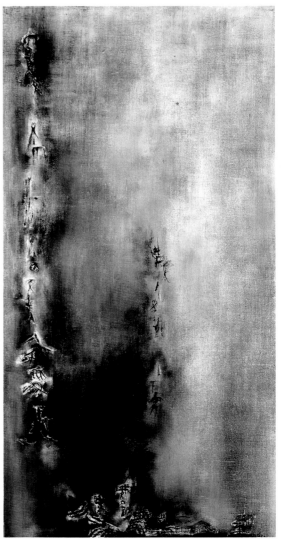

PLATE 57 (*above*)
Pan Yuliang, *Nude Study* (1957). Ink and color on paper.

PLATE 58 (*right*)
Zao Wou-ki, *Wind* (1954). Oils.

PLATE 59 (*opposite, top*)
Zao Wou-ki, *27–1–86* (1986). Oils.

PLATE 60 (*opposite, bottom*)
Chu Teh-Chun, *Amplitude* (1986). Acrylic on canvas.

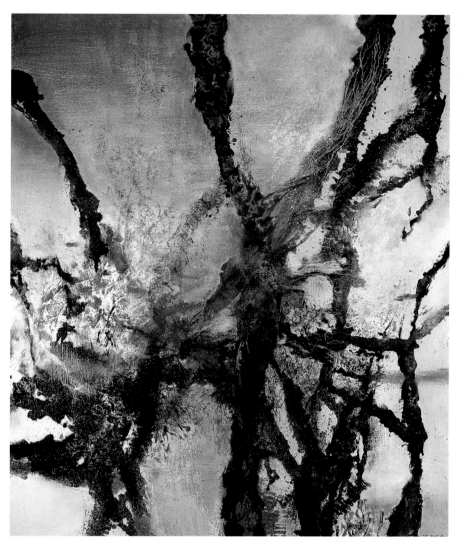

PLATE 61 (*opposite, top*)
C. C. Wang, *Landscape* (1967). Ink and color on paper.

PLATE 62 (*opposite, bottom left*)
Anonymous, *The Gang of Four* (c. 1977). Ink and color on paper. Exhibited at China Art Gallery, Beijing, 1977.

PLATE 63 (*opposite, bottom right*)
Liao Bingxiong, *Himself Liberated after Nineteen Years* (1979). Ink and color on paper.

PLATE 64 (*left*)
Huang Guanyu, *July* (c. 1978). Oils.

PLATE 65 (*below*)
Yuan Yunfu, *Rivers and Mountains of Sichuan* (detail) (1979). Acrylics on panels; Beijing International Airport. Photo by Joan Lebold Cohen.

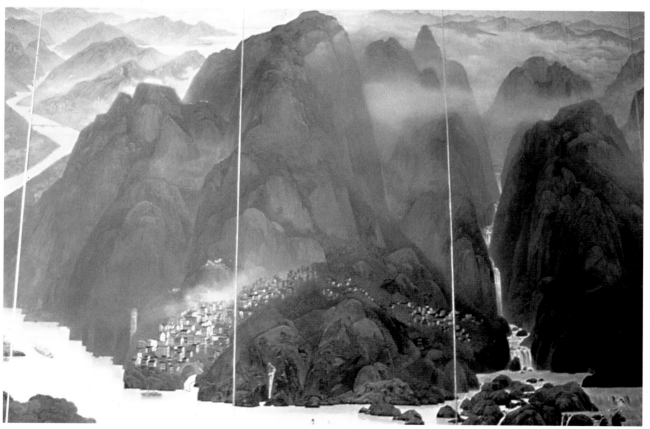

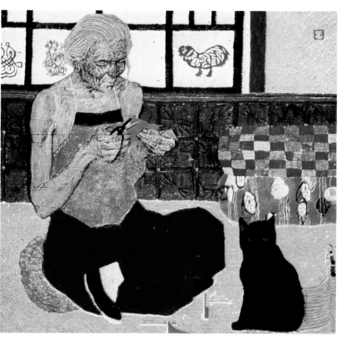

PLATE 66 (*opposite, top*)
Yuan Yunsheng, *Song of Life* (detail) (1979). Acrylics on canvas on plaster;
restaurant of Beijing International Airport. Photo by Joan Lebold Cohen.

PLATE 67 (*opposite, bottom*)
Liu Bingjiang and Zhou Ling, *Creativity Reaping Happiness* (1980–82).
Acrylic on canvas on plaster; restaurant of the Beijing Hotel.
Photo by Joan Lebold Cohen.

PLATE 68 (*top*)
Feng Guodong, *Self-Portrait* (1979). Oils. Photo by Joan Lebold Cohen.

PLATE 69 (*above left*)
Wang Huaiqing, *Papercut* (c. 1979). Oils.

PLATE 70 (*above right*)
Ge Pengren, *Water* (1986). Oils.

PLATE 71 (*opposite, top*)
Pang Tao, composition inspired by archaic bronze motif. Oils.

PLATE 72 (*opposite, bottom*)
Wang Yidong, *Shandong Peasant Girl* (c. 1983). Oils.

PLATE 73 (*left*)
Zhan Jianjun, *Portrait of Xiao Mi* (c. 1980). Oils.

PLATE 74 (*below*)
Luo Erchun, *Old Town* (c. 1984). Oils.

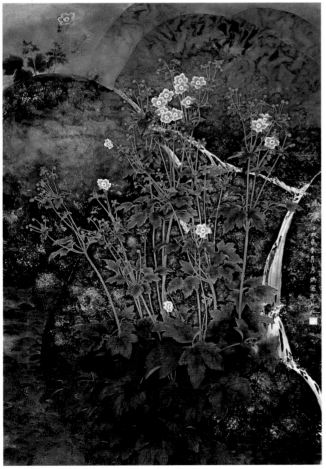

PLATE 75 (*opposite*)
Luo Zhongli, *Father* (1980). Oils.

PLATE 76 (*above*)
Ai Xuan, *Stranger* (1984). Oils.

PLATE 77 (*left*)
Zhao Xiuhuan, *Mountain Stream* (1982). Ink, color, and gold on paper.

PLATE 78 (*opposite, top*)
Wu Guanzhong, *The Lakeside at Wuxi* (1972). Oils.

PLATE 79 (*opposite, bottom*)
Wu Guanzhong, *Spring and Autumn* (1986). Ink, color, and gouache on paper.

PLATE 80 (*above*)
Yang Yanping, *Rocky Mountain with Snow* (1990). Ink and color on paper.

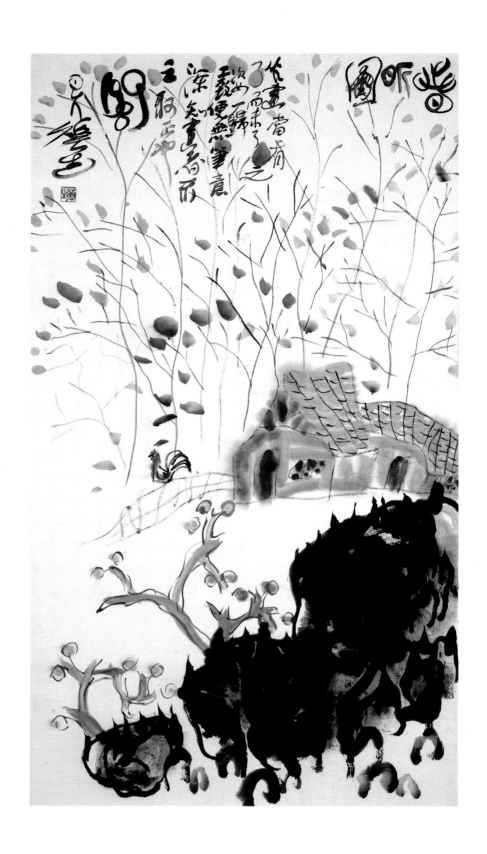

PLATE 81 (*opposite*)
Li Huasheng, *Cock-Crow at Dawn* (1989). Ink and color on paper.

PLATE 82 (*above*)
Du Jiansen, *Frame of Mind* (1982). Oils.

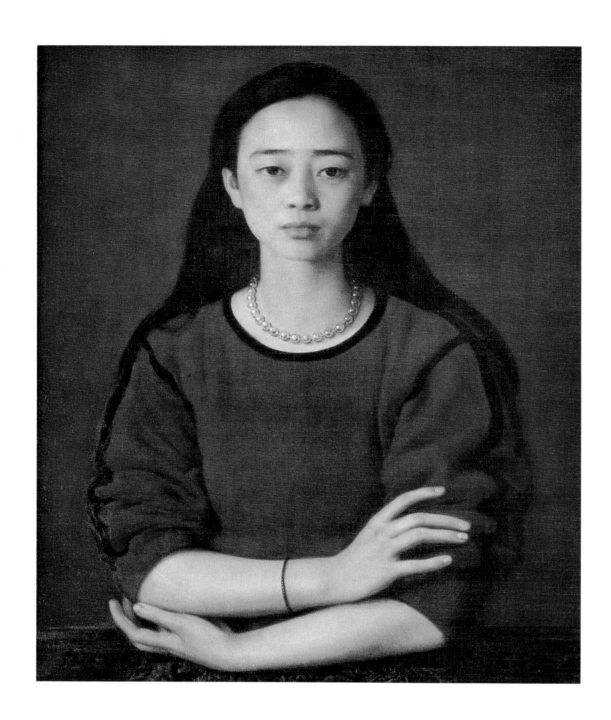

PLATE 83 (*above*)
Yang Feiyun, *Pengpeng* (1985). Oils.

PLATE 84 (*opposite, top*)
Wei Ershen, *Mongolian Bride: Praying for Good Fortune* (1988). Oils.

PLATE 85 (*opposite, bottom*)
Mao Lizhi, *Old House with New Life* (1988). Oils.

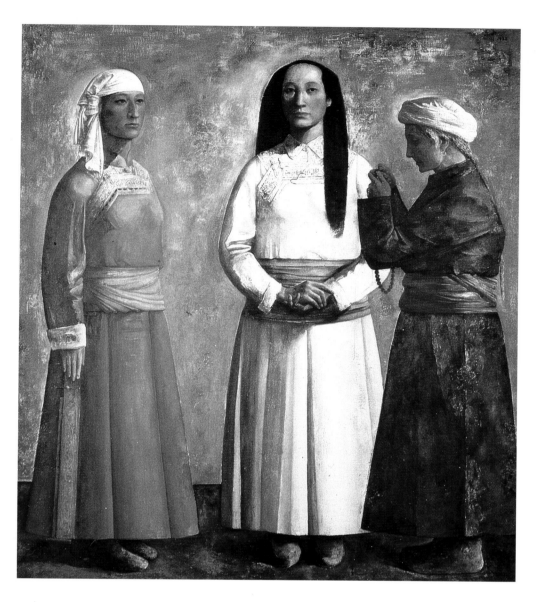

PLATE 86 (*opposite, top*)
Zhang Ding, *Cock* (c. 1981). Tapestry. Made by the Beijing Institute of Research for Carpets.

PLATE 87 (*opposite, bottom*)
Zhu Wei, *Upwards* (detail) (c. 1986–87). Hemp, wool, and silk.

PLATE 88 (*above*)
Yu Feng, *The Spectre of the Middle Ages III: Lash Marks* (1987). Ink and color on paper.

PLATE 89 (*top*)
Ai Weiwei, *Untitled* (1986). Oils.

PLATE 90 (*above*)
Li Shuang, *Collage* (1985). Chinese watercolor and ink on rice paper.

PLATE 91 (*opposite, top*)
Xu Mangyao, *My Dream* (1988). Oils.

PLATE 92 (*opposite, bottom*)
Chen Yiqing, *Out of Qinghai* (1989). Oils.

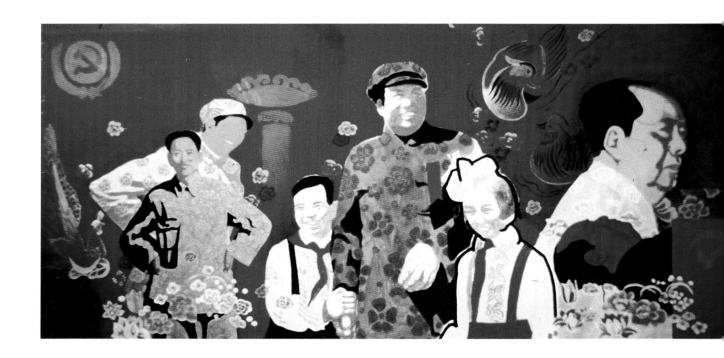

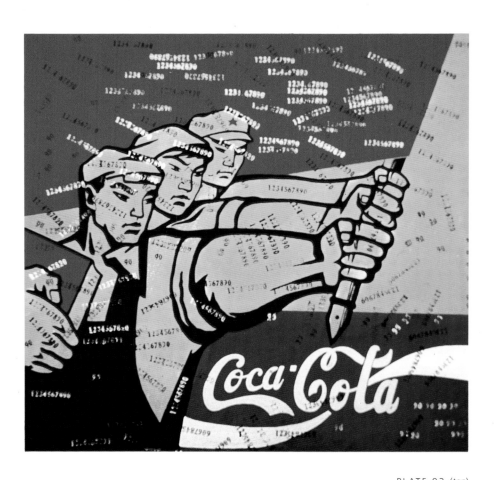

PLATE 93 (*top*)
Yu Youhan, *Mao Zedong Age* (1991). Oil on canvas.

PLATE 94 (*above*)
Wang Guangyi, *Workers, Peasants, Soldiers, and Coca Cola* (1992). Poster color on paper.

sent to take part in, and record, such giant construction projects as the Ming Tombs Reservoir dam, aiming to combine realistic techniques with an idealized vision of heroic achievement in the face of the nearly impossible. Party theorists, borrowing a phrase from the Soviet ideologue A. S. Zhdanov, called this kind of art "revolutionary romanticism."

The years 1960–62 were among the darkest in the history of the People's Republic. The Great Leap had caused economic chaos and brought famine to the countryside. In 1960, the year of the worst drought in modern Chinese history, Soviet aid abruptly terminated, all Soviet experts were withdrawn, cultural exchanges with the Soviet Union and Eastern Bloc ceased, and China became politically and culturally isolated. She saw herself as (apart from Albania) the only truly Communist country left.

But like all nightmares, this one came to an end. The Party acknowledged that the Great Leap had been a mistake. The chaos subsided, some degree of normalcy returned, and 1962–63 was a period of relative ease for most artists. Among the seven million victims who were rehabilitated were a number of artists, but many others were to bear the brand of "Rightist" until after the death of Mao. At the July 1960 Congress of Literature and Art Workers, Zhou Yang had declared, "Our principle is integration and uniformity in political orientation and variety in artistic styles. . . . Our artists in traditional painting, employing traditional methods of expression, depict truthfully and with natural ease the life of the new age and the natural scenery of our motherland, endowing traditional painting with a new lease of life." Now these words, for a short time at least, came to have real meaning.

The artists, so long as they did not subvert socialism, had a powerful protector in Zhou Enlai, who in a remarkable speech of June 19, 1961, encouraged them to participate in open discussions, to "dare to think, speak, and act."[25] He attacked the indiscriminate victimization of individuals such as took place in the Anti-Rightist Movement. "Mental work cannot be uniform. . . . Too high quotas and too strict demands sometimes hamper the production of mental work." Besides, "The political criterion is not everything: there must also be artistic criteria and the question of how to serve. The service performed by art and literature is done by means of many artistic forms, and no restrictions can be imposed on these. . . . Slogans are not art." Flesh was put on these words by a document drafted in 1961–62 by the propaganda department of the Central Committee, which appeared as ten points (later reduced to eight) setting out more liberal conditions for art workers and more flexible demands upon them, although the artist's social and political responsibility is still insisted upon.

It should be remembered, however, that the vast majority of artists were, as always in China, middle-of-the-roaders who had no politics, made no demands, and only wanted to go on painting. They did not ask for total freedom and would not have known what to do with it if it had been granted to them. They had learned how to avoid taking risks with their style and their subject matter, and they were now kept busy with official commissions. In 1959, the Great Hall of the People and nine other public buildings had been completed in Beijing, all decorated with huge guohua paintings in the approved conservative style. The most famous is the red sun rising to bathe the benighted landscape with its warm radiance (plate 31), painted in the Great Hall by Fu Baoshi and Guan Shanyue to illustrate a line from Mao's poem *Snow*: "Such is the beauty of our mountains and streams." In this vast painting, the artists manage to bring together, with somewhat laborious skill, the snow mountains, the deserts, the lush green of the south, the Great Wall, and the Yellow River.

In 1963–64 Zhou Enlai secured commissions for a number of guohua painters who had been victims of the Great Leap Forward, including Li Keran and Dong Shouping. The latter was a polished elderly scholar who had turned professional painter and served on the staff of the Rongbaozhai publishing house. A constant visitor to Huangshan, his paintings of the mountain show little variation but have an air of easy sincerity that gives them great appeal. At this time, traditionalists such as Pan Tianshou, Zhu Qizhan, Guo Weiqu, and Shi Lu were producing some of their best work, but the "safest" and most popular artists were, as before, Wei Zixi, Song Wenzhi, Guan Shanyue, Qian Songyan, and their like, who had become adept in combining revolutionary realism with revolutionary romanticism.

Pure landscape was now acceptable too, for, wrote Deng Wen, "when people admire the sublimity of mountains, the breadth of the ocean, the enduring quality of the pine, the loftiness of the stork, they are admiring qualities of man which coincide with these qualities in nature"[26]—a view that exactly accords with that of the great masters of the past. Of bird and flower paintings, the conservative guohua artist Cui Zifan now said that "through them the artist arouses in his audience a love of beauty, of life, and of the land of their birth."[27] One might think that such an attitude to traditional painting was politically unassailable, but it was to be utterly condemned in the Cultural Revolution only a few years later.

Nor was oil painting in decline. Ni Yide, Chang Shuhong, and Yan Wenliang were still near the top of their powers. In the slight thaw of 1962, *Meishu* published a painting by Huang Yongyu, an article by Ni Yide on Shitao, another on Rodin. In 1963, Lin Fengmian's

13.11
Fu Baoshi, *Abundance on the Way* (1961). Ink and color on paper.

major exhibition in Beijing was praised in *Meishu* by, of all people, the Yan'an cartoonist Mi Gu, and by a Dr. Shen Fangxiao, who wrote, "He sees forms that others do not see, perceives colors others do not perceive, discovers interests others do not discover."[28] Wu Zuoren's early nudes were reproduced, while the monthly *Xinjianshe* published the daring contention of Zhou Gucheng, a professor at Fudan University, that the spirit of each age, including the present, is reflected through different classes and individuals, and that this consciousness is the unified expression of various coexisting ideologies. The idea that there could be more than one truth was a dangerous heresy.

Artists in this relatively relaxed period were able to forget politics and the demands of the Party from time to time, when a few friends could get together for a painting session, or, better still, escape from the stifling atmosphere of Beijing altogether, on tours planned and financed by the Artists Association. In 1961, for example, Wu Guanzhong and Dong Xiwen were painting in Tibet, Yu Feng for the first time travelled in the northwest, while Zhang Anzhi, Bai Xueshi, Song Wenzhi, and Chen Dayu were in Jiangsu painting landscapes which the Chinese press described as "a warm response to Socialist reality."[29] Together, Zhang Anzhi and Song Wenzhi visited Mao's birthplace and other sacred sites. For four months in 1961–62 Fu Baoshi and Guan Shanyue (Fu's "minder," perhaps?) travelled and painted in the northeast, although Fu Baoshi's effort to come to grips with electric power has a rather desperate air (fig. 13.11).[30] Wu Zuoren was a constant traveler in the borderlands, more at home with the Tibetans, yaks, and pandas than with the cultural apparatchiks in the capital.

ART FROM THE PEOPLE:
PEASANTS AND WORKERS

THE RURAL ART MOVEMENT

For some years after Liberation, the Chinese cultural authorities deliberately cultivated the idea that China had a vigorous tradition of peasant art that could become the basis for a mass movement. In fact, such a tradition hardly existed. Although the Miao and Yao minority people of Yunnan, Guangxi, and Guizhou had a rich tradition of arts and crafts (though not of pictorial art), some of which is recorded in the wartime paintings of Pang Xunqin, the peasant art of the Han Chinese was chiefly confined to conventional new year pictures, door gods, and papercuts. The peasant painting movement was a deliberate creation of the cultural arm of the Communist Party.

During World War II, peasants in the guerrilla areas had made crude imitations of the woodcuts and anti-Japanese propaganda pictures produced in the Lu Xun Academy in Yan'an. (It was these naive paintings that made such an impression on Derk Bodde at the exhibition described in chapter 12.) Peasant painting developed into an organized movement during the Great Leap Forward of 1958, when once again art teachers and students were sent to the country (fig. 14.1)—this time to mobilize the peasants for the great experiment of the rural communes, which would, as Maurice Meisner put it, "eliminate the differences between town and countryside, between peasants and workers, between manual and mental labour."[1] Mao had declared that anyone could be an artist; it was not a matter of talent, but simply of the will. To Mao, the peasants were the greatest source of revolutionary power. Accordingly, they were encouraged to depict, however crudely, the new world of

superabundance and prosperity into which the miracle of the Great Leap would transport them. However much encouragement the cadres gave them to stress political themes, though, the peasants always preferred traditional subjects—fat babies, symbols of wealth, figures from legends and fairy tales.

The first peasant paintings to attract wide public attention were produced in Pixian, in the extreme northern part of Jiangsu.[2] There, in the summer of 1958, fifteen thousand "peasant artists"—all but three self-taught—produced 183,000 paintings, drawings, and murals on the whitewashed walls of their houses and barns, depicting gigantic fishes and ears of corn, pigs as big as elephants, and pictures that bear an astonishing resemblance to scenes of rural life in the Dunhuang caves and in fourth-century tombs—none of which these peasants could possibly have seen. The critic Ge Lu was frank about their limitations: "Technically, much of this art may leave much to be desired [but] its mass appeal is undoubted. . . . They have an immediacy of impact. . . . Exuberant in mood and emancipated in their way of thinking, the Pixian artists show remarkable originality and boldness."[3]

HUXIAN

Peasants in many other rural communes took up painting in a big way, helped by local art teachers.[4] In Huxian, southwest of Xi'an, for example, the County Party Committee started an art class for peasants working on an irrigation project, sending out teachers from the

14.1
Wu Tongchang conducting art class for peasants in Jinshan (1960s)

14.2
Shao Yu, Ye Qianyu, Wu Zuoren, and Jiang Zhaohe paint murals on a village wall in Hebei. Photo from *China Reconstructs* (November 1958).

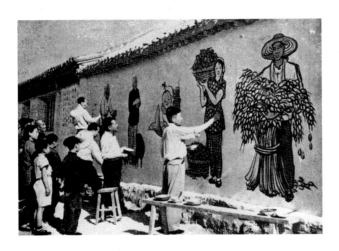

County Hall of Culture and the Shaanxi Academy of Art to teach them to paint peasant pictures.[5] Art students from the Hangzhou Academy went to live with the country folk and offered to paint them some pictures. The farmers were delighted to see their lives portrayed, were critical of inaccuracies, and soon decided that they would like to have a go themselves. A group from the Central Academy, in a village in Hebei to help the people with their harvest, spent their spare time "turning the mud walls of the village into a virtual open-air art gallery."[6] A photograph published in 1972 shows Shao Yu, Ye Qianyu, Wu Zuoren, and Jiang Zhaohe painting figures of happy peasants on the wall of a house while the villagers admiringly look on (fig. 14.2).

The rural art movement collapsed in the chaos and demoralization that accompanied the failure of the Great Leap Forward, when peasants were too bitterly disillu-

sioned—often too hungry—to think about painting, and the fading wall paintings of the coming millennium on the walls of their houses must have seemed to mock their poverty.[7] But here and there it survived or was revived, notably in Huxian, which was deliberately selected by Jiang Qing in 1972 as her model art commune, to go with Daqing, the model oilfield, and Dazhai, the model agricultural production brigade. In 1966, Huxian peasant art had been singled out for praise in the national press, and in 1970 Huxian, now called "Picture Land," earned the glory of an exhibition in the China Art Gallery, from which a selection was later sent abroad. By 1973, the Huxian peasants had produced over forty thousand paintings and woodcuts.

The Party gave the impression that the Huxian paintings were the spontaneous creation of untutored peasants. If this had once been the case, though, it was true no longer. The peasant painters were now being trained by many professional artists whose names have never been divulged, although it has emerged that the wood-engraver and watercolorist Gu Yuan was one of them. As a result, the Huxian paintings of the 1970s are technically far more accomplished than those of the Great Leap, but they are often dull and lack the spontaneity of the crude early efforts. Out of hundreds of would-be artists, Huxian inevitably produced a few who had genuine talent. They included Dong Zhengyi, whose famous *Commune Fishpond* is painted with astonishing skill; Liu Zhide, whose *Old Party Secretary* (fig. 14.3)—a study of a peasant cadre resting from work, lighting his pipe and reading Karl Marx's *Anti-Dühring*—was a great favorite; and Li Fenglan, a worker and mother of four who became a full-time painter, and something of a star. Her autobiography was published in 1972, and in the following year she was a member of a cultural delegation to Vietnam.

The better Huxian paintings range from the very professional and relatively realistic work of the artists I have mentioned to the flatter, more colorful compositions of artists like the commune accountant Bai Tianxue (plate 32), which often look like hand-colored woodcuts and preserve more of the instinctive decorative quality of a true peasant art. In all of these pictures the color is bright, the tone cheerful and optimistic; much of their appeal lies in the fact that they so obviously reflect the life the peasants led, or dreamed of leading in the not too distant future.

When a selection of 179 Huxian paintings was shown in the China Art Gallery in October 1973, it attracted over two million people—although it must be said that in those bleak years there was not much else for gallery-goers to look at, and attendance was highly organized and often compulsory. Exhibitions toured the country

and were sent all over the world. A special peasant art gallery was built at Huxian, to which artists and art students were obliged to make pilgrimage to learn how a truly mass art could be created by men and women to whom a few years earlier painting would have been unthinkable.

By the mid-1980s the cult of Huxian, like those of Daqing and Dazhai, had become a memory. Visitors to the art gallery reported it deserted, the paintings gathering dust. In many areas, peasant painting, like new year painting, was being kept artificially alive in the art schools. That the peasant art movement was not completely dead, however, was demonstrated to me in 1988. After I had spent some time looking at work in the Zhejiang Academy by students who seemed to be completely at sea, casting about and imitating modernist and postmodernist styles they barely understood, two senior representatives of the Zhejiang Provincial Popular Art Center (Zhejiang sheng qunzhong yishu guan) courteously insisted that I visit their institute, to which they took me in an official car. They showed me recent paintings by peasants in Chenshi County that were marked by a striking vigor, directness, and natural feeling for color and design, demonstrating that these men and women knew very well what they were about (plate 33). The political element in their work was barely discernible; they were painting the world they knew. My host told me that after the peasants have been painting for some time they want to learn more about technique, become self-conscious and dissatisfied with their work, and often stop painting altogether. "What happens then?" I asked. "There are always plenty more coming along," he replied.

The life of the peasant art movement has always depended on encouragement from cultural bodies and art schools. The results have been very uneven, but taken as a whole, it has spread the *idea* of art into areas of Chinese society where it had never penetrated before, and thus greatly broadened the base from which creativity could spring.

Although the peasants were the spearhead of revolution, the urban proletariat shared in China's cultural reforms. Every city established its Hall of Culture, while many factories and work units had their own art clubs. Teachers came from the academies to hold evening and weekend classes, and exhibitions of members' work were frequent. Painting clubs also became a feature of the armed services.

There was of course no tradition of urban workers' painting to be recreated on the model of Huxian peasant art, so the range of subjects was much wider than would be found in the rural communes: not only propaganda, woodcuts, and paintings of factory life, but

14.3
Liu Zhide, *Old Party Secretary* (c. 1974). Gouache on paper.

thoroughly traditional landscapes, bamboo, and birds and flowers, painted in imitation of the teachers' work—as well as fat babies, kittens with pink bows round their necks, and the worst influences from commercial art. The general level of these works was inevitably low, but it opened up new horizons for the city workers, and provided them with some relief from the appalling ugliness that surrounded them.

OTHER POPULAR ART FORMS

If there is some doubt about the antiquity of Chinese peasant painting, there is none about *nianhua,* the pictures and prints hung up on house doors at new year (plate 34).[8] Writing in 1308, the Yuan poet and connoisseur Zhou Mi had noted that "from the tenth Lunar month, the market was filled with new calendars of brocade binding, all sizes of door gods, Zhong Kui [the 'Demon Queller'], lions, tigers, charms and paper-cut blessings in gold and colored papers." Almost every province produced its own *nianhua,* the most famous being those from Suzhou, Yangliuqing in Hebei, and Weifang in Shandong.

The Communist Party deplored the "feudal," super-

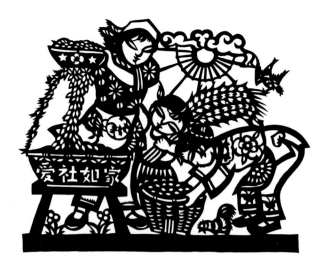

14.4
Anonymous, *Love Society Like Your Own Family*. Papercut.

14.5
Hua Sanchuan, *The White-Haired Girl* (detail) (1964). Serial picture.

stitious element in traditional *nianhua* and resolved to re-form it. Already in November 1949, Mao had approved a directive to cultural and educational institutions to introduce new themes: the rebirth of China, the great victory of the people's war of liberation, and the lives and struggles of the ordinary working people.[9] The provincial cultural departments began to collect and study traditional *nianhua,* which depicted good fortune and abundance; what was more natural than that they should celebrate socialist reconstruction and the coming rural utopia? The range of subjects and variety of techniques was enormous, from the flat, crude, decorative work of untutored peasants to the sophisticated "decorative realism" of pictures obviously produced by artists and art teachers. Well-known professionals who produced *nianhua* included Wang Shikuo, Zhang Feng, Huang Xinbo, Hu Yichuan and Dong Xiwen.

Since the death of Mao, the tradition has increasingly been sustained by the folk art departments of the art schools. Although the upbeat mood is preserved, the content is often anything but rural; *nianhua* of the 1980s, for example, show school children attending science classes. One, called *New Stocks Are in Every Day,* shows a shop interior with broadly smiling young people eagerly unpacking not the collected works of Mao Zedong—once a favorite theme—but new television sets.

The papercut was another traditional craft which could easily be adapted to depict modern themes in a stylized way (fig. 14.4).[10] It has a long history: a papercut of the Six Dynasties period was unearthed in Xin-

jiang, and in the Tang and Song they were used for decoration in a great variety of ways. In the modern world the variety of subjects is endless, from tiny flowers, dragons, and tigers to huge portraits of Mao Zedong.

Yet another old art form with a long history is the serial picture, *lianhuanhua.*[11] It could be said that the sixth-century wall paintings at Dunhuang depicting successive incidents in the life of the Buddha were an early form of *lianhuanhua,* while Chinese children have for centuries loved reading the serial or strip-picture books illustrating *The Romance of the Three Kingdoms, The Water Margin,* and other stirring tales. New *lianhuanhua* tell the epic story of the Long March, the lives of heroes such as Lu Xun, Wang Jingshan, the "Iron Man" of Daqing who mixed the concrete slurry by jumping into the tank, and of course the incomparable Lei Feng, the "great ordinary soldier" whose Maoist ideals and selfless devotion became a model for all. Among those who have drawn these strip and serial pictures are many accomplished artists, including Cheng Shifa, who has also produced fine illustrations for early novels. Popular as they are, the modern *lianhuanhua* often reach a remarkably high standard.

During the Cultural Revolution, the *lianhuanhua* was one form that was not abused. Indeed, some of the best serial pictures were produced during these years, a fine example being Hua Sanchuan's illustrations to *The White-Haired Girl* (fig. 14.5), one of Jiang Qing's widely promoted revolutionary ballets. We shall see in chapter 17 how the *lianhuanhua* developed after Mao, introducing new techniques and a far wider range of subject matter.

THE CULTURAL REVOLUTION

The breathing space for art that followed the chaos of the Great Leap Forward was not to last, and soon the storm clouds were gathering once more. In May 1963, when the Lei Feng campaign was at its height, a national conference was called to mobilize artists and writers for the fight against revisionism and harmful "bourgeois" elements. It was at this meeting that Jiang Qing began to play a key role.[1] Further danger signs appeared when Yao Wenyuan, who would become one of the Gang of Four, attacked Zhou Gucheng's heretical view of the coexistence of various ideologies that I referred to in chapter 13. In *Meishu* Lin Fengmian's exhibition was heavily criticized and Yu Feng's praise of it condemned. The same journal publicly apologized for having published Mi Gu's article "I love Lin Fengmian's Paintings."

In June 1964, Mao gave the writers and artists a warning. "In the past fifteen years," he declared, "the literary and art circles for the most part . . . had not carried out policies of the Party and had acted as high and mighty bureaucrats. . . . In recent years they have even slid to the verge of revisionism. If serious steps were not taken to remould them, they were bound at some future date to become groups like the Hungarian Petöfi Club"[2]—a reference to the society that helped to bring about the 1956 revolt against Hungary's Communist government. He demanded reform in art circles, while Lin Biao was instructing artists and writers to extol Mao thought and the class struggle. In the meantime, Kang Sheng and Jiang Qing had launched the nationwide Socialist Education Movement, using the Central Academy as the testing ground for art.

Through 1965 the anti-liberal campaign gathered force. Hu Feng, in spite of an abject confession, was denounced as a counterrevolutionary, while a series of articles in *Meishu* showed that the PLA cultural arm, under Lin Biao and Jiang Qing, was in full control of the arts. Issue after issue extolled the army. Landscapes were crowded off the pages by relentless propaganda and portraits of the Great Leader. By September, Mao was in Shanghai establishing a base for his assault on the Party. Although the new China Art Gallery opened in Beijing in October, it showed nothing but propaganda pictures and woodcuts. Now artists were being told to spend a third or a half of their time among workers, peasants, or soldiers—not to gather material for their painting, but to remold themselves and take part in actual struggle. Before the end of the year there were already references in the press to a "great socialist cultural revolution." Artists were now being subjected to unbearable pressures. An early victim was Fu Baoshi, who died on September 29 of an internal hemorrhage brought on by excessive drinking.

In May 1966, the first student Red Guards announced themselves in a secondary school attached to Qinghua University, and on June 1 big character posters were displayed at Beijing University, proclaiming the Great Proletarian Cultural Revolution. By July Mao was back in Beijing and the attacks on his enemies in the Party began. Zhou Yang, his loyal art theorist, was one of his first victims.

The original Red Guard Manifesto vowed to "turn the old world upside down, smash it to pieces, pulver-

ize it, create chaos and make a tremendous mess, the bigger the better!" In June, all the art and archaeology journals ceased publication. In August, the Red Guard changed place and street names and ransacked bookshops and private homes, destroying or carting off pictures and books, pianos and gramophone records. All Christian churches were closed. On August 23, the writer Lao She was summoned to a "struggle session," at which he was severely beaten. He went home and said goodbye to his beloved little granddaughter. The next morning his body was found in shallow water at the lakeside. Mao called on the students to denounce their professors and teachers who held bourgeois ideas. Liu Shaoqi's opposition was crushed, and on November 28 a mass rally of over twenty thousand literary and art workers in Beijing repudiated the "bourgeois line" and confirmed Jiang Qing as cultural advisor to the PLA.

Not until the summer of 1967 did the PLA attempt to control the chaos, and their efforts had little effect. Institutions of higher learning were split into rival factions which, when they were not actually fighting each other, waged an incessant loudspeaker war that deafened the neighborhood. By the summer of 1968, although the strife in the universities continued to be intense, the violent stage of the Cultural Revolution was over. In the following year, revolutionary committees of workers, peasants, and soldiers were sufficiently in control for the persecution of intellectuals and artists to be put on a more systematic basis, and now those "bourgeois elements" who had survived the chaos were dealt with. In 1970 nearly all the teachers in the Central Academy were sent down to two small villages in Cixian, near the Henan border, to integrate their lives with the peasants. The Hangzhou staff were sent up the Fuchun River to lodge with a production brigade near Tonglu. A similar pattern was followed in all the art schools. Artistic life had all but come to a standstill.

The new order, or rather disorder, allowed the artist little freedom. Except briefly in 1972–73, traditional landscapes, birds and flowers, and impressionist oil paintings were alike forbidden. Art became completely politicized and Mao a deity, his image everywhere. Huge exhibitions were held on such themes as "Long Live the Victory of Chairman Mao's Revolutionary Line," which ran in Beijing through October and November of 1967, while the Shanghai public were treated to "Long Live Mao Zedong's Thought!" and similar shows. The immaculate Mao became the central figure in innumerable paintings, the most famous being *Chairman Mao Goes to Anyuan* by Liu Chunhua, which shows the resolute young Communist, long-gowned with umbrella in hand, striding over the hills on his way to take charge of the miners' strikes.[3] This was the Maoists' counterblast to an ear-

15.1
Pu Quan, *Building the Red Flag Canal* (1971). Ink and color on paper.

lier work by Hou Yimin which had shown Mao's archrival Liu Shaoqi, whom Mao was soon to destroy, as leader of the Anyuan miners, with Mao nowhere in sight. Liu Chunhua, of course, gave credit for the success of his work to "Mao Zedong's thinking" and Jiang Qing's "great care and warm support."

A faint glimmer of light appeared in April 1971 with the visit of an American table tennis team to China, followed in July by Henry Kissinger's secret talks with Zhou Enlai and the announcement of Zhou's invitation to President Nixon to visit China. Later that year, Li Keran was brought back from exile in the countryside to decorate official buildings in preparation for Nixon's arrival in February 1972.[4] This heralded, briefly, a more liberal policy, as the talents of conservative, established artists were made use of, and through 1973 and early 1974 the number of such artists returning to work greatly increased. New works that were published included landscapes by Li Keran, Qian Songyan, Bai Xueshi, Tao Yiqing, and others, and a "pure" flower painting by the traditionalist Tang Yun. Even Pu Quan, the scion of the old imperial family who had stayed on in Beijing after Liberation, celebrated the building of the Red Flag Canal in a thoroughly academic landscape (fig. 15.1).

In 1973, a number of leading artists were recalled from farm labor to make decorations for the new wing of the Beijing Hotel on the initiative of Zhou Enlai, who saw this as a way of rewarding them and alleviating their suffering. Zhou said that because these paintings were for the eyes of foreigners and were therefore "outer" art, they need have none of the political content that was almost obligatory for "inner" art—that is, art for the Chinese. But before the end of 1974 Zhou Enlai, seriously ill with cancer, was no longer able to protect and support the artists, and Jiang Qing seized her opportunity. She collected paintings, chiefly from the hotels, and mounted in Beijing and Shanghai two exhibitions of "Black Art," reminiscent of Hitler's exhibitions of "Degenerate Art" in the 1930s.[5] In these shows she held up to vilification and mockery most of the leading painters of the day, denouncing their works as "wild, strange, black and reckless." The hapless painters, whom the ailing Zhou Enlai could no longer protect, were thus even worse off than they had been before. From this moment night descended, and no relief came until the death of Mao Zedong and the arrest of Jiang Qing, two years later.

JIANG QING AND THE ARTISTS

For the ten years of the Cultural Revolution, no deviation was permitted from the line laid down by Jiang Qing. At a forum held in February 1966, she had spelled out her aim: "We, too, should create what is new and original: new, in the sense that it is socialist, and original in the sense that it is proletarian."[6] In October 1973, a group of reliable staff members left behind to take care of the Central Academy had proposed to the State Council Cultural Group to set up a "May Seventh Art University" on the lines of the May Seventh cadre schools. The teachers, who included Gu Yuan, were the politically pure, those who had not been branded as Rightists; the students were selected for their purity from the families of workers, peasants, and soldiers. The principal was directly responsible to Jiang Qing. For several years this rump institution set the tone for a uniform revolutionary style of art. Landscapes, unless they celebrated socialist reconstruction or reforestation or heroic achievements, were of no significance, and (as Li Xiongcai, one of Jiang Qing's victims, put it) were even regarded by the Gang of Four as dangerous "soft daggers." Of his own landscapes, Qian Songyan wrote in 1972 how, when he studied Mao's Yan'an Talks, he discovered that for thirty years he had been serving the landlord class and the bourgeoisie, but that "now I should act on Chairman Mao's instructions and serve the workers, peasants and soldiers. . . . The problem was that my

ideology needed to be remoulded: I must gradually establish a proletarian world outlook. . . . In the course of study I also realised that political content was the first thing to consider in any work of art."[7]

I do not need to weary the reader with further quotations from those who so willingly trod the correct path, and it would be uncharitable to condemn them now. As Tang Tsou has pointed out, many writers (and, one assumes, artists) were at this time "torn by self-doubt and the gnawing feeling that the regime's overall policies might be correct,"[8] and the penalties for resistance were extremely severe. Rather should we trace the dire effects of the Cultural Revolution on those artists who attempted to maintain their integrity. Perhaps no complete history of their sufferings will ever be written; many prefer to forget, thinking only of the precious years of work still left to them. The information that follows is fragmentary, and can give no more than an impression of what they endured.

For the more fortunate, the new regimen meant spending weeks or months in the *niupeng* (cattle pen), a place or room to which they were taken every day to study the thoughts of Mao and "wash out their minds" through endlessly rewritten confessions. At best they could make a joke of the ignorance and stupidity of their warders behind their backs. Always, they suffered soul-destroying boredom and humiliation, and they were often subjected to gratuitous cruelty. When Xiao Feng dared to criticize the Red Guards, they beat him and forced him to crawl with a heavy stone on his head. Zhang Ding's son recalled how his father, "with paint on his face, a dunce cap and paper clothes . . . was dragged through the streets to be criticised at struggle meetings. He was compelled to kneel on a high bench, and, even after falling off several times, he was forced to climb on it again. . . . Hundreds of father's paintings were completely destroyed. . . . Father was later banished to a cowshed and forced to wear a black sign around his neck, clean latrines, and weed the garden"[9]—which last must have come as a blessed relief.

Many artists were forced to become factory or farm laborers, forbidden to write or even speak to their husbands or wives, who might be toiling nearby. Wu Guanzhong, who shared these privations on a collective farm in southern Hebei with Zhang Ding and Yuan Yunfu, later remarked that, because he was able to do a little painting in secret during his last year of exile, he belonged to the Dung Basket School of painting. For those sent to more remote areas, the conditions were extremely harsh. Huang Yongyu, Ya Ming, and Huang Zhou spent the years from 1966 to 1972 working as peasants in the far north. Wu Zuoren and his wife, the flower painter Xiao Shufang, were separated and sent to the

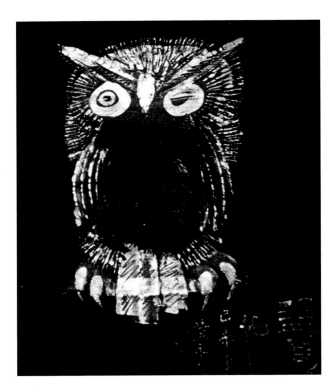

15.2
Huang Yongyu, *The Owl with One Eye Shut* (1979). Batik on cotton cloth.

country, where he became a swineherd and was often beaten. Shi Lu, persecuted because in his celebrated painting of Mao standing on a Shaanxi loess terrace he had showed him "separated from the masses and hoping he would fall off the cliff," was sent to a labor camp and suffered a mental and physical collapse, from which he never fully recovered. Pan Tianshou, denounced by Yao Wenyuan as "personifying the secret agent," died in 1971 as the result of his persecution. Persecution drove Ni Yide to his death in 1970, Guo Weiqu to his in 1971. In 1973, Lü Sibai committed suicide. Lin Fengmian, Zhao Dan, and Liu Haisu were imprisoned. Lin was not released until 1972, and then only, he believed, because three months earlier Zao Wou-ki on his trip to China had asked repeatedly and in vain to be allowed to see his old teacher. Li Keran was denounced for "wanting to restore capitalism"; he was sent to work in the fields, his family dispersed. Much the same happened to the sculptor Liu Kaiqu. The oil painter Dong Xiwen, who had extolled Mao's achievements (in plate 28, for example, the famous painting of the declaration of the People's Republic), became a factory hand, forced in 1972 to work barefoot. He suffered a hemorrhage and died in the following year.[10]

Jiang Qing revenged herself personally on many whom in her paranoia she thought were undermining her cultural work, or whom she saw as rivals in the the-

ater world. In October 1968, Zhou Enlai's adopted daughter Sun Weizhi, who had eclipsed her in the Lu Xun Academy in Yan'an, died in prison after being tortured. Huang Zhou, whose popular donkey paintings she took as a satire on her group, was condemned to pull donkey-carts every day before dawn. Liu Xun, an outspoken opponent, broke stones for nine years. Huang Yongyu was imprisoned for his famous painting of a winking owl (a later batik version of which is reproduced as fig. 15.2), which Jiang Qing took—rightly, perhaps—as an ironic comment on her cultural activities.[11] Liu Haisu was denounced by a group of artists and actors around Jiang Qing because the Red Guard had found among his collection of press clippings an old, uncomplimentary review of one of Jiang Qing's film performances. He Zi was branded for an illustration of Dai Yu, the heroine of *The Dream of Red Mansions,* burying withered flowers, which Jiang Qing took as an attack on the "flowers" of the Cultural Revolution, just as Li Kuchan's eight lotus flowers in black ink were held to be a condemnation of her eight model operas, now performed to the exclusion of all else.

For the historian of modern Chinese art, hardly less painful is the record of lost works of art. In the name of the "Four Cleanups," the Red Guard entered the homes of artists (who were forbidden to lock their doors), destroying or carrying off all they could lay their hands on. Sometimes they left nothing higher than an inch above floor level, such as a thin mattress or a blanket. How this process looked to the activists is graphically, if crudely, depicted in "Clean Out the Filth!" (fig. 15.3), an oil painting of 1974 by Shi Qiren (a transport worker in No. 1 Printing and Dyeing Works) and Chen Guo (a carpenter in No. 2 Alcohol Factory)—artists now consigned to oblivion. It shows a neighbor denouncing to an investigating team a young man whose degeneracy is symbolized by the overturned wine bottle, the gramophone record, the oil painting on the wall, and other evidence of spiritual corruption.

Pang Xunqin, hearing the mob on the stairs, hastily thrust a roll of paintings under the bed; a few others he retrieved from the garbage can into which the rampaging youths had thrown them. The rest were lost forever. Chang Shuhong saved some of his oils at Dunhuang (see chapter 9) by burying them in the sand. In 1967, Ya Ming's home in Nanjing was ransacked by Red Guards, students, and robbers. They left only what they could not easily sell, taking over 150 paintings, some of which later turned up on the art market in Hong Kong. Several years after the Cultural Revolution came to an end, Li Keran was likewise shocked to learn that a number of his stolen paintings were on sale in Hong Kong.[12]

Wei Tianlin, professor of oil painting at the Beijing

15.3
Shi Qiren and Chen Guo, *Clean Out the Filth!* (c. 1974). Oils.

Normal College of Arts and Crafts, was forced by Red Guards to cover his flower pictures with white paint.[13] Other artists preferred to destroy their own work rather than let the Red Guards get their hands on it. Wu Guanzhong destroyed all his nude paintings and drawings. Pang Xunqin, or his students, destroyed his beautiful portrait of his wife Qiu Ti. One of Lin Fengmian's students re-members watching him tear up hundreds of his paintings and stuff them down the toilet, where, because of the glue in the paper, they formed a solid mass. Hardly a single artist avoided destruction of some work, while in some cases the loss was almost total. When the expressionist oil painter Wu Dayu died in Shanghai in 1988, of his life's work, only six oil paintings survived.

PART FOUR

Other Currents

After the Mao era, sculpture, printmaking, graphics,

and other art forms began to emerge far beyond the narrow

confines dictated by Communist ideology. Sculpture, no

longer limited to the monumental and the official, at last

became an art form expressive of the sculptor's own creative

vision, while printmaking and book illustration extended

their range of subject matter and techniques in response to

the impact of modern Western culture, now flowing

relatively freely into China.

At the same time, Chinese artists working in the more

open atmosphere beyond the borders of the People's Repub-

lic, neither sustained by tradition nor confined by ideology,

were free to experiment and to respond to the infinite range

and complexity of international modernism. Thus the first

truly modern Chinese artists after midcentury appeared in

Taiwan and Hong Kong. They in turn were to stimulate the

developments in mainland art that are discussed in Part Five.

SCULPTURE

PIONEERS

In traditional China, sculpture was never regarded as one of the fine arts, which were the monopoly of the educated class. The Chinese elite did not lack a feeling for plastic beauty, but that feeling was satisfied by contemplating archaic bronzes, ceramics, carved jade, and the fancy rocks in the scholar's garden and sitting on his desk. The reason for sculpture's low place in Chinese cultural life was a social one. Not since the fifth century—and not often before then—had it been acceptable for a Chinese gentleman to soil his hands with manual labor, except perhaps to tend his chrysanthemums or to carve seals. He might appreciate bamboo or ivory carving, but he would be unlikely to practice these crafts himself. The gulf between the unlettered artisan who performed manual work and the literatus was scarcely bridgeable. No Chinese scholar ever wrote about sculpture, and no critical vocabulary was ever created to evaluate it.

The crafts, moreover, were subordinate to the arts of the brush. The great stylistic change that came over imported Buddhist sculpture in the fifth and sixth centuries, making it more "Chinese" in feeling, was brought about by the influence of Chinese figure painting. The celebrated stone reliefs of horses that decorated the tomb-shrines of Tang Taizong are said to be based on paintings by the court artist Yan Liben. The sculpture which most eloquently expresses Chinese aesthetic ideals is modelled in clay or cast in bronze from clay models, which, unlike hewn stone, derive their beauty from the free movement of the modeller's hands. As the noted English critic Roger Fry recognized, the aesthetic basis of Chinese sculpture is more linear than plastic. Chinese

painting, poetry, and chamber music depend for their effect upon subtlety and refinement of expression. For the cultivated man, a mere hint is enough. Sculpture can have no place in these rarefied regions; it is too solid, too completely realized, leaving too little to the imagination.

So sculpture had no status among the fine arts in China at the beginning of the twentieth century. If art students took it up—and few did—that was generally because it was Western, and modern, and there was a new civic use for it. But until the mid-1920s there was no one to teach the subject, for no one had learned it, and before Liberation it was never a popular art form. As late as 1937, the Shanghai Academy had no full-time professor of sculpture, and only 0.6 percent of its students enrolled for sculpture.[1]

Early in the 1920s, the far-seeing Cai Yuanpei spotted the potential of Li Jinfa, born in 1900 in Guangdong and already showing promise as a writer and painter. Cai sent him to Paris, whence he returned in 1924 to take up a career as a professional sculptor and teacher; almost his first commission was a portrait bust of Cai Yuanpei. He was soon much in demand for statues in bronze of prominent men, among his best known being those in Nanjing and Canton of Sun Yatsen, Deng Zhongyuan, and the diplomat Wu Jianfang, all completed between 1932 and 1934.[2]

Another isolated pioneer was Jiang Xin (Jiang Xiaojian), born in 1893. In the 1920s he was a close friend of Wang Jiyuan and Xu Zhimo, and he was active in Beijing and Shanghai in the circle of the Tianma

16.1
Li Jinfa, *Huang Xiaochang* (c. 1932). Bronze. In Second National Art Exhibition, 1937.

16.2
Zhang Chongren, *Wu Hufan* (c. 1948). Clay.

Huahui. A painter as well as a sculptor, he designed covers for several of Xu Zhimo's works.[3] After two years studying sculpture in Paris, he returned to Shanghai before 1930. Zhang Chongren, born in Suzhou in 1907, went to Belgium in the early 1930s, travelled widely in Europe and earned a gold medal at the Brussels Salon before returning in 1935 to Shanghai, where he remained through the war and after. His lively portrait in clay of the painter Wu Hufan (fig. 16.2), made about 1947, shows something of his quality. Hardly any of the work of these pioneers, or others such as Wang Linyi, Jin Xuecheng, and Wang Zhijiang, survives.

All these men were competent, conservative Salon sculptors. Hua Tianyou and Liao Xinxue were something more. Hua Tianyou, a native of Huaiyin in Jiangsu, was born in 1902 into a family of carpenters.[4] He became a primary school teacher, spending his holidays studying Western art at the Xinhua Academy in Shanghai. In 1930, he sent Xu Beihong a photograph of a small bust of his three-year-old son that he had carved in wood. Xu was impressed, even more so when Hua brought the bust to show him in Nanjing. Xu sent the photograph and an article he had written about Hua to Jiang Xiaojian in Shanghai, who (according to Hua) was impressed in turn, so much so that he flew to Nanjing to meet him and brought him back to Shanghai to work on statues of Sun Yatsen and Chiang Kaishek. Hua then spent two years restoring the partially ruined Tang dynasty Buddhist sculpture that had been rediscovered by some Japanese scholars in the Yanghuisi near Xuzhou, an experience that he later said gave him a valuable insight into the Chinese sculptural tradition. In 1932, his portrait bust of the Hunanese poet and essayist Chen Sanli, father of the painter Chen Hengke, was chosen by Xu Beihong and Wang Yachen over one by Jiang Xiaojian; this broke their friendship, but it greatly increased Hua Tianyou's reputation.

When Xu Beihong went with his exhibition to Europe in 1933, he took Hua Tianyou with him. Hua was to spend fourteen years in Paris. He studied first under Bouchard and lived in great poverty on four francs a day. Recognition came in 1936 when his bronze figure, *Meditation,* was purchased by the University of Lyon and earned him a three-year scholarship from the Franco-Chinese Institute in that city. Thereafter, though often hungry and working half the day in the studio of Despiau, Rodin's former assistant, Hua produced a number of fine pieces, including a nude female torso, *After the Bath,* that won him a silver medal at the Salon in 1941. In the following year, by working for four months with a lacquer artist, he earned enough to subsist on while he made his finest work, the standing male nude in bronze, also called *Meditation* (fig. 16.3), which brought him the

gold medal in the 1943 Salon and put him in the first rank of mainstream sculptors in France.

When one day a French sculptor friend said to Hua, "Why do you come to us to learn? We should be learning from you," he began to feel more aware of his Chinese origins. He must have thought often of what his own people were suffering during the war years, because the works he produced in Paris before returning home in 1947 include three that are Chinese not only in subject but in feeling also: a woman with her children fleeing from an air raid, a farmer with a hoe, and *Mother and Child,* all showing a rhythmic flow of the line that is Chinese rather than Western.

Liao Xinxue, the sculptor who forgot to attend his own wedding party (see above, page 41), was born in 1901 into a poor peasant family in Yunnan.[5] He started his career at eighteen as an assistant in a painting shop in Kunming. The next ten years are obscure, but 1933 finds him in Paris, studying at the Ecole des Beaux Arts, always, like Hua Tianyou, struggling with poverty, copying Rubens, Ingres, Delacroix, and Millet in the galleries—Millet's *The Angelus* was a special favorite of his. He was a gifted oil painter in the impressionist manner and a watercolorist, while he managed to earn some money from his Chinese paintings, for which there was always a demand. By the time he returned home in 1948 he had won a number of prizes, among his best works being his standing male athlete with a discus (fig. 16.4), which won a gold medal at the Salon, and an equally accomplished standing draped female figure of 1947.

The best-known Chinese sculptor of his generation, although by no means the most creative, was Liu Kaiqu, who as a young man acquired some reputation as a painter, writer, and calligrapher.[6] He was born of illiterate peasant parents in 1904 in Xiaoxian, Anhui. By the happiest chance, the art teacher at his primary school was Wang Ziyun, a sculptor and oil painter who later studied in Paris. Wang raised the money to send the boy to Beijing, where, in September 1920, he entered the Academy, graduating four years later. Life became very hard, but again rescue was at hand: the woman writer Ling Shuhua gave him the royalties from short stories she had published in the literary journal *Xiandai pinglun* and an introduction to the physicist-dramatist Ding Xilin, who took him to Shanghai. There he boldly told Cai Yuanpei that he wanted to go to France to study sculpture. By the autumn of 1928, with a scholarship of eighty dollars a month, he was established at the Ecole des Beaux Arts, studying under Bouchard. An ardent patriot, he was drawn home in 1932 by the first Japanese invasion and the loss of the northern provinces, having spent too short a time in France to accumulate prizes at the Salon like Hua Tianyou and Liao Xinxue. But he

16.3
Hua Tianyou, *Meditation* (1943). Bronze.

more than made up for this by the dominant position he was now to occupy among sculptors in his own country.

Soon after Liu Kaiqu returned to Shanghai in 1932 he called on Lu Xun, who told him, "In the past, one did bodhisattvas. Now one should do portraits," and it was almost exclusively with portraits and monuments that the sculptors returning from France were able to find work. It was chiefly with nudes that they had achieved their reputations in Paris, but the idea of commissioning or exhibiting a nude statue was unthinkable. The hard realities of the art world of China in the 1930s and 1940s

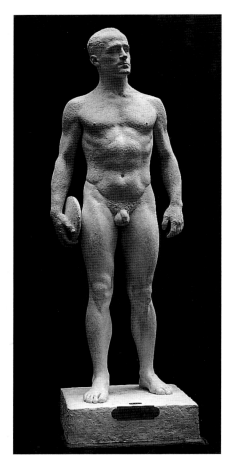

16.4
Liao Xinxue, *Athlete* (1946). Bronze.

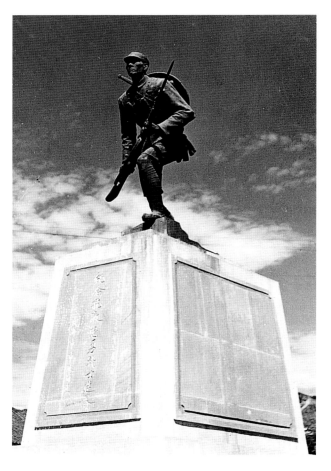

16.5
Liu Kaiqu, *Unknown Hero* (1943). Bronze. Formerly in Chengdu.

16.6
Wang Linyi, *President Lin Sen* (c. 1945). Bronze.

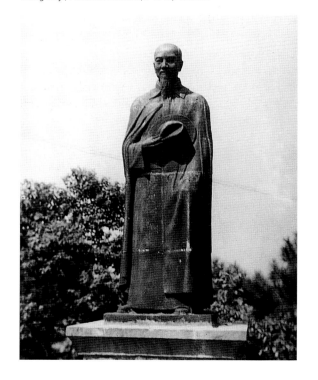

imposed their own restraints and challenges, and commissions could not be turned down. In 1932–33, Li Jinfa made a ten-foot-high seated figure in bronze of the diplomat Wu Jianfang for the Guanyinshan in Canton, while in 1935 he produced for a park in Hangzhou a memorial to those who fell in the clash with Japan. These are both competent, conventional works.

When war came, the leading sculptors moved to Free China to make their own contribution to resistance— although it may be questioned whether the life-size equestrian statue in Chengdu of the Guomindang general Wang Mingchang, in precious bronze, that was commissioned from Liu Kaiqu in 1939 did much for the war effort.[7] More inspiring was Liu Kaiqu's *Unknown Hero* (fig. 16.5) of 1943, a strong, realistically modelled figure of a soldier advancing with fixed bayonet that stood on a high plinth at the east gate of Chengdu. Wang Linyi, before he left Chongqing in 1946, executed a simple, dignified bronze of President Lin Sen, standing hat in hand and wearing a long cloak (fig. 16.6).

When peace came, the sculptors struggled on. Liao

Xinxue returned to relative obscurity in Kunming, where he died in 1958, while Wang Ziyun remained in Sichuan. Wang Linyi became the head of the sculpture department at the Beijing Academy under Xu Beihong. Hua Tianyou joined him in 1947, straight from Paris, and held a one-man show at the Academy that created a sensation, particularly when a writer noted that Hua was the only Chinese sculptor included in an encyclopedia of world art that had recently been published in Paris. Liu Kaiqu, meantime, returned to Shanghai with no job and no studio; he survived on commissions for portrait heads of Cai Yuanpei, Lu Xun, Fan Xudong, and other notables. As the political and economic crisis deepened, though, the commissions dried up. By the time Shanghai was liberated in 1949, the situation for artists, and for sculptors in particular, was desperate.

The reader will not have failed to notice that every one of the sculptors I have discussed was, in terms of Western art, thoroughly conservative. Chinese sculptors did not experiment; there was no influence from European sculptors such as Rodin or Maillol, long accepted in Japan. The work of Archipenko or Lipschitz would have been even less comprehensible. An art world that accepted Käthe Kollwitz and Covarrubias seemed unaware of Barlach. This suggests that there was as yet no conception in China of sculpture as an *expressive* art form, and if Chinese sculptors abroad had acquired such a sense, they had little chance to display it once they got home.

SCULPTURE SINCE LIBERATION

If the place of sculpture in modern China had been uncertain or even peripheral, "Liberation" brought it suddenly to center stage. Not only were all social barriers to the profession gone, but reconstruction, the planning of new towns, parks, and open spaces, and the need for vast numbers of monuments and memorials created a huge demand, which at first the handful of competent sculptors in the academies could scarcely meet. Jiang Feng appointed Liu Kaiqu president of the Hangzhou Academy, but the main center for sculpture was the Central Academy in Beijing, where Wang Linyi headed the department, aided by Hua Tianyou and Wang Neizhao. It was they and their students, among them Liu Xiaoling, Liu Shiming, and Yu Jianyuan, who were to produce or direct many of the sculptural projects of the 1950s and early 1960s.[8]

Their themes were chiefly reconstruction, land reform, world peace, the unity of the Chinese peoples, the Great Leader, and military and labor heroes. In 1950, after the National Model Heroes meeting, Xu Beihong invited four of these paragons of labor and the military to the Academy as models for inspirational portraits, while Wang Linyi made a large relief panel entitled *Great Gathering of the Nationalities*.[9] Western modernism, and particularly the style of which Hua Tianyou had become a master in Paris, was totally rejected in sculpture as in painting, and Soviet influence became overpowering. Huge sculptural figures and groups were modelled on the work of sculptors such as Vera Mukhina and Insif Chaikov. By 1952 sculpture students were being sent to Moscow and Leningrad, while sculptors were coming to teach and exhibit from the USSR, Czechoslovakia, Poland, and Albania.

On September 29, 1949, the day before Mao declared the establishment of the Peoples' Republic, it was decided to erect in Tiananmen Square a monument to Chinese heroes from the time of the Opium War hero Lin Zixu to the Communist victory. The tall stela would bear an inscription composed by Mao Zedong and written by Zhou Enlai, and a plan for a series of reliefs running round the base was drawn up by the Party historian Fan Wenlan. To head the project, Liu Kaiqu was brought up to Beijing, where he put together a team from the Central Academy under Wang Linyi and Hua Tianyou, aided by a group of sculptors from the Historical Museum that included Fu Tianqiu and Situ Jian, with the painter Feng Fasi to advise on composition. These men worked for seven years to create a series of four panels, six feet high and totalling 130 feet in length. Liu Kaiqu's panel showing the Red Army crossing the Yangzi and Fu Tianqiu's of the Wuchang Uprising are typical in their careful skill and crowded detail. But even Hua Tianyou's relief of the May Fourth Movement (fig. 16.7) suffers from a stiffness and lack of individuality, inevitable given the ideological restraints to which the sculptors were subjected from the start.

Later, the painter Zhang Anzhi complained that Hua Tianyou had once had a personal style but now these panels all looked pretty much the same.[10] Indeed, the criticism can be leveled at Chinese sculpture in general at this time. How much the Chinese sculptors resented the Soviet influence is hard to say now; many of them, and particularly those who had studied in France, later said that they had disliked it. With the withdrawal of Soviet aid in 1960 the sculptors were happy to find other models and influences, partly through a search for the roots of the native Chinese sculptural tradition. Thus, in the sculpture research department of the Beijing Academy (which by now boasted five senior sculptors and twenty-three assistants) we find Wang Linyi being assigned to study Han sculpture, Hua Tianyou that of the Tang, Zeng Zhushao that of the Song. Others travelled in search of vernacular styles: Fu Tianqiu, for instance, to Wutaishan and to Yunnan, Situ Jian to study Qiaozhou wood sculpture and the carving of the minorities. For popular ap-

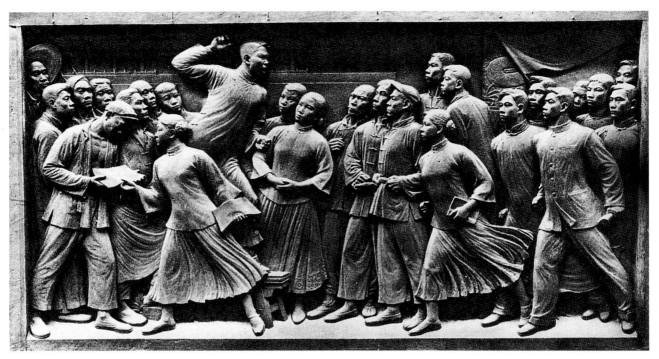

16.7
Hua Tianyou, *The May Fourth Movement* (1958). Panel for Heroes' Memorial, Tiananmen Square. Stone.

16.8
Guo Qixiang, *Tibetan Woman* (1963). Granite.

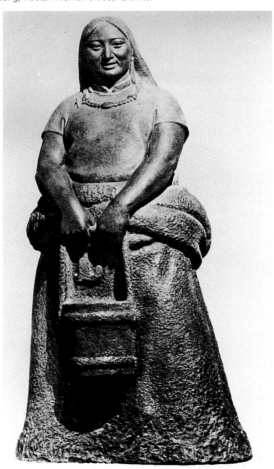

peal, the Academy invited up from Canton a well-known modeller of the ceramic figures for which the Shekwan kilns had long been famous.

Although the Soviet manner remained in vogue for monumental projects all over China, one of the last of these being the huge groups set up before the Mao Mausoleum in 1977, the early 1960s saw a far greater range of styles emerge. In Sichuan, a regional style of sculpture was beginning to develop, as it later did in painting. Although Guo Qixiang's subjects of this period were chiefly fashioned in the conventional Soviet heroic mold, when he carved a Tibetan woman in stone (fig. 16.8) he achieved a work which, like that of the later oil painters such as Luo Zhongli, is massive and monumental in form yet lively and natural in effect.

In general, however, sculpture for public places was becoming more decorative, more romantic (even sentimental), and certainly more Chinese in feeling, while individual sculptors were now producing many smaller works for exhibition and for their own pleasure. Of the new names, Liu Huanzhang was perhaps the first post-Liberation sculptor to achieve wide reputation and popularity.[11] Though born in Inner Mongolia, he grew up near Beidahe on coastal Hebei. The boy's middle school teacher caught him carving in class and chose to send him off to be apprenticed to a seal-carver instead of scolding him. By 1954 he had graduated from the Central Academy in Beijing and had set up as a professional sculptor. From now on—except for the three Cultural Rev-

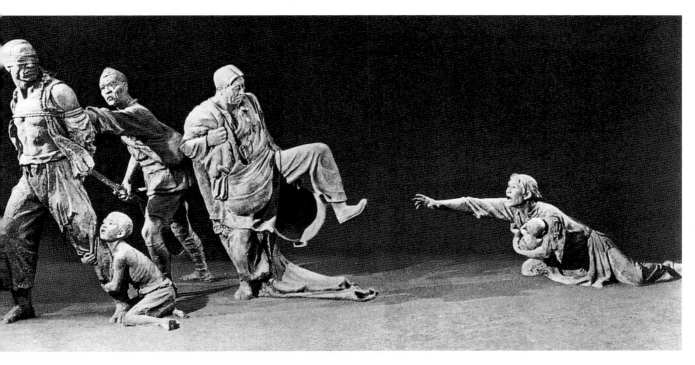

16.9
Ye Yushan and a team of sculptors from the Sichuan Academy of Fine Arts, Chongqing,
The Rent Collection Courtyard (detail) (1965). Clay. The figures are life-size. Dayi, Sichuan.

olution years when he was in the countryside with Huang Yongyu and other artists—a steady stream of carvings of figures, animals, and birds, in clay, wood, and stone, issued from his studio. When in January 1981 he was given what was said to be the first one-sculptor show at the China Art Gallery it drew crowds, along with appreciative articles by Wu Guanzhong, Huang Yongyu, and the young sculptor Situ Yaoguang. His style, which shows instinctive feeling for form and for the nature of the material he is working with, is straightforward, unaffected, and appealing.

In the meantime, however, the masses still had to be educated, or reminded, about the iniquities of the recent past. The most famous artistic enterprise of this kind was *The Rent Collection Courtyard* (fig. 16.9), a tableau of over one hundred life-size clay figures set up in the former mansion of Sichuan landlord and warlord Liu Wencai in Dayi.[12] Although like all such projects it was anonymous, "created collectively by eighteen amateur and professional sculptors of Sichuan," it was in fact carried out by a team at the Sichuan Academy, one of the leaders of which was Ye Yushan, who had trained in Chongqing and under Wang Linyi and Hua Tianyou at the Central Academy. He was later to be honored with the commission for the Abraham Lincoln–like marble figure of Mao Zedong in the mausoleum on Tiananmen Square.

Although *The Rent Collection Courtyard* is often ridiculed as crude propaganda, the figures of this tableau recreate with vivid detail and some truth an operation that had taken place every year in this courtyard. Peasants would bring their pitiful harvest to pay the rent, often leaving nothing for themselves; some of them had mortgaged their crop for sixty years in advance. They were cheated by the landlord, sold their children, or were condemned to the landlord's own prison for debt, to die of starvation. The original version of 1965 ended with their revolt. The tableau, which closely parallels in spirit and intent the revolutionary operas and ballets that Jiang Qing was promoting at this time, was widely discussed, imitated, and revised under her direction to "raise it to a still higher ideological and artistic level." Thus in the final version of 1968 it ends with figures holding aloft a political placard and the writings of Chairman Mao, additions which quite destroy the emotional impact of the original. In 1973–76, Ye Yushan and his team were assigned to smarten it up and make duplicate sets for distribution. When I visited the Sichuan Academy in 1980, some of these unwanted replicas were locked away in a storeroom, gathering dust like the original in Dayi.

In Tibet the serfs were likewise exploited and oppressed by their landowners, but while the Chinese occupation of 1951 did indeed liberate Tibetan serfs from Tibetan masters, the Tibetans so hated their liberators that in 1959 they rose in revolt. The savage punitive response of the Chinese armies, the flight of the Dalai Lama and many thousands of Tibetans to India, and the even greater destruction carried out during the Cultural Revolution

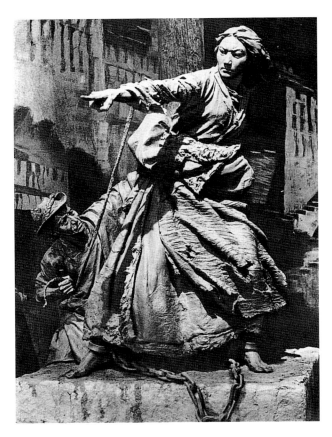

16.10
Nine sculptors from the Central May Seventh Academy of Arts and Lu Xun Art College, Shenyang, *The Wrath of the Serfs* (detail) (1975–76). Clay. The figures are life-size. Lhasa, Tibet.

16.11
Wang Keping, *Idol* (1980). Wood.

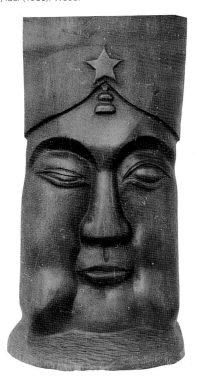

make bitterly ironical the message of *The Wrath of the Serfs* (fig. 16.10), a vividly realistic tableau of 106 figures against a painted background.[13] It tells of the suffering of the serfs under their old masters, their revolt, and their longing for the arrival of the Communists. Created over a period of eighteen months in 1975–76 by a team of sculptors from Jiang Qing's May Seventh Academy of Arts and the Lu Xun Art College in Shenyang, this tableau is full of sharp detail and violent movement and is even more theatrical than *The Rent Collection Courtyard*.

AFTER MAO

During the Peking Spring, sculpture flowered as did painting, and in a special way. There had always been individualists, eccentrics, and dissidents among Chinese painters, but never before had there been dissident or eccentric sculptors. When at the first Stars exhibition in September 1979 (see chapter 21) Wang Keping hung his satirical carvings on the railing of the China Art Gallery, he was attacking not only the iniquities of the Gang of Four but the bureaucracy and censorship that had been part of Chinese life since Liberation. *The Backbone of Society* is a head without a brain, a mouth without lips, a nose but no nostrils: "That's the way," he explained later, "I visualised incompetent bureaucrats who were always screwing things up."[14] The mouth of his mask-like *The Silent One* (see fig. 16.11) is stuffed with a wooden stopper, one eye hatched as if covered with tape. Did Wang Keping know Xiao Ding's famous satirical scroll of 1944 (discussed in chapter 11), in which the mouth of the journalist is stuffed with an official invitation, the eyes of the painter blindfolded? Nothing had changed. Wang's best-known piece in the second Stars exhibition was a massively carved head resembling Mao (fig. 16.11), which in itself was daring. Even more so was the title: *Idol*. The point was driven home when for my benefit he turned an abject kneeling figure on an adjacent stand to face his idol.

The Stars exhibitions were small, without precedent or sequel, and dissident sculpture hardly became a feature of the art scene of China in the 1980s. But the work of Wang Keping shook Chinese sculpture once and for all free of the conventions it had labored under since it had first become a recognized art form in China. This new freedom stimulated young sculptors, liberated some of the established ones, and opened the way to a vast enlarging of the range of style and expression.

Already in 1981 Liu Huanzhang was freeing his style, carving heads, birds, and animals with expressive energy. He gave the raw strokes of chisel on wood almost the quality of brushstrokes, while his works in stone and bronze suggest the influence of Maillol and Henry

16.12 (*left*)
Yang Dongbai, *Bear Drinking* (1983). Marble.

16.13 (*above*)
Cheng Ya'nan, *Evening Wind* (1983). Wood.

16.14 (*below*)
Sun Shaoqun, *Nine Women of the Taiping Rebellion* (1984). Bronze.

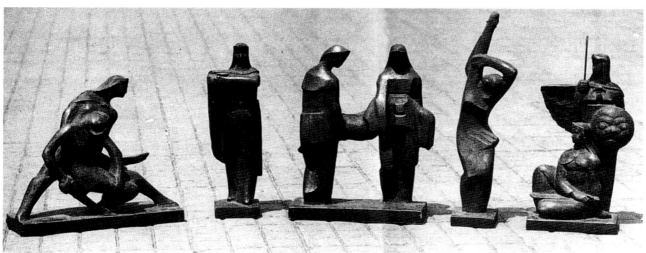

Moore, whose art was widely featured in Chinese art journals in the 1980s. Although he is admired, Liu Huanzhang has never courted fame; his models were often rejected, and he refused to take part in the ambitious assigned group projects that were the sure path to favor.

The Sixth National Art Exhibition, in the summer of 1984, showed how much sculpture had advanced in the five years since the Peking Spring.[15] A sure sign that politics were not wholly in command was the awarding of the gold medal for sculpture to Yang Dongbai's beautifully conceived and fashioned *Bear Drinking* in white marble (fig. 16.12) while Qian Shaowu's lifelike and sympathetic head of Jiang Feng (who had died in 1982) only earned a silver. A bronze medal went to *Evening Wind* (fig. 16.13), a playful yet firmly modelled mother and child in wood by Cheng Ya'nan. Fu Zhongwang's head

of a surgeon, only her eyes and nose emerging from the stylized mask, showed great subtlety and sophistication in the modelling. Collaborative projects were dominated by the model by Liu Zhengde, Li Zhengwen, and Sun Shaoqun of a group of free forms to be erected at the Gezhuo Dam site in Hubei, of which the largest, a geometric tower reminiscent of Archipenko, was to stand twenty-two meters high. The effect is awkward, and it is as well that nothing came of it. In quite different style, and far less pretentious, was Sun Shaoqun's other work, *Nine Women of the Taiping Kingdom* (fig. 16.14), a memorial group of five single and four paired figures modelled in bronze with massive power and dignity, suggesting that Sun had studied the work of some Western sculptors, such as Barlach and Meštrović.

In the 1980s civic sculpture became less obviously po-

16.15
Anonymous, *Girl of Zhuhai* (1980s). Stone.

litical in content. The urge for sheer bigness, sign of China's new confidence in herself, showed in an interest in colossal sculpture abroad. A writer in *Meishu* discussed the colossal Buddha figures at Yungang, Longmen, and Leshan as possible precedents; described the Statue of Liberty; and illustrated Gutzon Borglum's huge presidential heads on Mount Rushmore, pointing out that nothing of that sort has yet been attempted in modern China.[16] The largest new Chinese work of its kind is the stone figure of the patriot Zheng Chengkong, towering from a rock off the island of Gulangyu in Xiamen harbor, which was his base in his long struggle against the Manchus. Another colossus, standing on a rock in the water near Canton, is the graceful figure of a Pearl River fisher-girl holding a monstrous pearl above her head (fig. 16.15).

Among the most successful of the civic pieces of the 1980s are the four figures, two male and two female, that decorate the approaches to the Yangzi Bridge at Chongqing.[17] Representing the four seasons, they were made in cast aluminum alloy by a team of sculptors at the Sichuan Academy under the direction of Ye Yushan, who was responsible for the most graceful and popular figure, *Spring* (fig. 16.16). When the clay models were completed they were nude, but Authority insisted they be at least partly clothed.

As we might expect of a fine art so new to China, Western influences are everywhere present, in spite of the search for the roots of Chinese style in Han, Tang, and Song. It is hard to imagine, for instance, that when Yang Dongbai carved his *Bear Drinking* he did not know the work of Henry Moore, as featured in *Meishu*. The influence of Rodin, particularly in the partial freeing of a figure or a head from the uncarved stone, is pervasive. Liu Huanzhang and his contemporaries must surely have been well aware of the work of Maillol. There are echoes of Marino Marini in *Winter on the Grasslands* (fig. 16.17), a horseman with a lance by the young Hangzhou sculptor Zhang Keduan.

Through the 1980s these borrowings increased, as younger sculptors became ever more eager to be part of the international modern movement. To take a positive view, they vastly extended the Chinese sculptor's range of expression. For the time being, at least, the question of the creation of a contemporary Chinese style in sculpture (as opposed to Chinese subject matter) seemed to be in abeyance. But in the 1980s some sculptors, rejecting the West, were finding inspiration nearer home—not, fortunately, in the Buddhist sculpture of Yungang and Longmen, but deeper in the native culture and in the art of the minorities.

16.16
Ye Yushan with Huang Caizhi and Xiang Jinguo, *Spring* (1980). Cast aluminum alloy. One of four figures for Yangzi Bridge, Chongqing.

16.17
Zhang Keduan, *Winter on the Grasslands* (1985). Bronze.

MODERN GRAPHICS

NEW VENTURES IN PRINTMAKING

When the Communists came out of the wilderness and took over control of the arts, they set up print departments in the art schools. The first was opened in 1955 in the Central Academy under Li Hua, aided by his colleagues from Yan'an days Gu Yuan, Yan Han and Wang Qi. Soviet prints were of course a major influence, and between 1951 and 1965 the radical Chilean graphic artist José Venturelli lived in China (chiefly in Beijing), teaching and exhibiting.[1]

Although the revolutionary styles and themes of the 1930s and 1940s continued to be useful and popular, techniques became more sophisticated. Gu Yuan, Li Qun, and many more began to use color; the range was limited at first, but confidence increased as more and more young graphic artists appeared. Color prints—some collaborative, some anonymous, many by amateurs in factory art clubs—celebrated such projects as the building of the Chengdu-Kunming railway, the Daqing oil field, and the steel and shipbuilding industry of Luda.[2] The most popular of all modern Chinese prints, Wu Fan's charming *Dandelion Girl* of 1958 (fig. 17.1), which won a gold medal at an international print exhibition, was unusually lyrical for its day, presaging the nonpolitical prints that were to appear after the death of Mao.

While workers always liked to look at pictures of the life they knew, by the late 1970s people had become sick of propaganda and of the constant reminders of the evils of the old society. When in 1983 Zhou Ruijuan, who had lived for fifty years in Japan, held an exhibition of her heartrending images of destitution and suffering, full of pleading hands and haunted, large-eyed women and children reminiscent of those of Edvard Munch, they

were thought depressing and old-fashioned, and few people came to see them. The public had long wanted new themes, the printmakers new styles and techniques. By the 1980s even some of the old masters felt liberated. Wang Qi's new landscape prints, for example, contained no hint of propaganda, while Yan Han's compositions had become almost abstract. Gu Yuan had gone back to his old love—painting lyrical landscapes in watercolor.

Many young artists took up the challenge to create something new, and regional schools of printmaking began to develop. In Sichuan, Dai Jialin, Luo Nengjian, Liu Shitong, and Xu Kuang created powerful images of Tibetans and nomads that paralleled in black and white the oil paintings of Luo Zhongli, Chen Danqing, and Ai Xuan. One of the most gifted printmakers of this region is Dong Kejun, born in Chongqing in 1939, who labored as a construction worker for many years, eventually managed to study art in Chongqing, joined the local Wuyue Woodcut Research Society (Wuyue muke yanjiu hui), and settled in Guiyang.[3] He finds his subjects among the rural life of the Miao people of Guizhou, their customs and beliefs, sorcerers' masks and dances, bullfights and sacrifices. His early prints are in black and white, but more recently he has worked in strong primary colors that well convey the wild vitality of Miao culture (fig. 17.2). A kindred spirit working in black and white is the Sichuanese printmaker Bu Weiqin.

In recent years, printmakers in Yunnan such as Li Zhongnian, Zheng Xu, and Zeng Xiaofeng have developed a strong colorful style, many of their works being inspired by the customs and culture of the Va people. Indeed, for print artists with a sense of pattern and

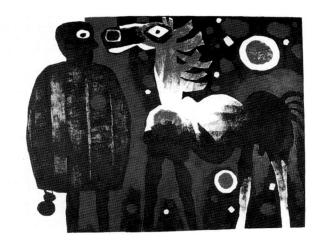

17.2
Dong Kejun, *Dialogue* (c. 1988). Woodblock print.

17.1
Wu Fan, *Dandelion Girl* (1958). *Shuiyin* print.

color, the arts of the southwestern minorities are a far richer source than the somewhat meager repertory of the Han Chinese peasantry.

Another regional school developed under the patronage of the military in the northeastern provinces of Liaoning and Heilongjiang during the period of reconstruction, and after the Cultural Revolution, the movement developed a life of its own. Artists of this Northern Wilderness (Beidahuang) School, including Hao Baiyi, Chen Yuping, Zhang Shanmin, Liu Bao, Song Yuanwen, Liang Dong, and Li Jianfu, were encouraged to attract settlers to their inhospitable world by depicting it as appealingly as possible, creating colorful compositions of ice-breaking, snow-covered trees, spring flowers, and laughing children.[4]

Many of the Beidahuang prints are produced by the uniquely Chinese *shuiyin* or *taoyin* (water-based printing) method, a technique perfected early in the seventeenth century in southern Anhui and Nanjing, where the famous *Painting Manual of the Ten Bamboo Hall* (*Shizhuzhai huapu*), a handbook of models for students, was published between 1622 and 1643. In this technique the blocks are hand-colored with watercolor and printed on multilayer sprayed paper to produce subtle gradations

of tone and atmosphere, the aim being to create the effect of a painting.[5] With the fall of the Ming, the tradition in Nanjing declined and was not revived until the early 1960s, when the Jiangsu branch of the Chinese Artists Association held training sessions in the technique. In 1963 the Jiangsu CAA mounted the first exhibition of modern *shuiyin* prints in Beijing. Well-known Nanjing masters of the *shuiyin* print today include Wu Junfa, Huang Jinyu, Weng Chenghao, Lai Shaoqi (also a guohua painter), the woman artist Zhu Qinbao, and Ding Lisong. Suzhou, also a center of fine printing in the late Ming, has become known for romantically pretty prints of the city's picturesque houses, gardens, and canals, paralleling the paintings of such artists as the ever popular Xu Xi. Sichuan also produced its own school of printmaking. The lyrical landscape prints of Huang Xuanzhi (plate 35), working in the Artists Association in Chongqing, are typical of this genre of *shuiyin* printing. Wu Fan's *Dandelion Girl* was also produced in Chongqing.

The famous Rongbaozhai studio had been established in Beijing in 1894, originally to produce high-quality writing paper decorated with designs reproduced from the work of leading modern painters, notably Chen Hengke, and later Qi Baishi, Zhang Daqian, and others.

17.3
Zhao Zongzao, *Huangshan Rocks* (1982). *Shuiyin* print.

17.4
Wang Weixin, *Temple of Heaven,* from *Ancient Capital—Beijing* (1981). Etching and embossing.

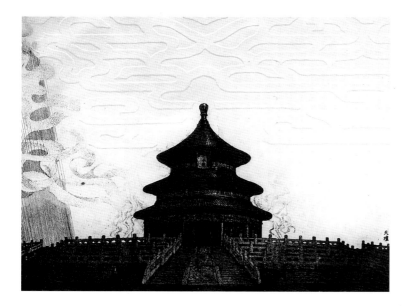

The studio had closed down during the 1940s but was reorganized after Liberation, chiefly to make reproductions of famous paintings, ancient and modern, that are almost indistinguishable from the originals. During the Cultural Revolution the Rongbaozhai studio turned out millions of reproductions of the best-known icon of all, Liu Chunhua's *Chairman Mao Goes to Anyuan* (discussed in chapter 15). The Rongbaozhai undoubtedly set a standard for *shuiyin* printing throughout the country, and young printmakers have been sent there from many art schools to perfect their technique.

The Hangzhou Academy suffered severely from being downgraded by Mao, and its printmaking department was somewhat unfocused and eclectic, but it does boast several accomplished artists. Notable is Zhao Zongzao. His early work, which included the inevitable illustrations to Lu Xun, was conventional. He stopped printmaking in 1963 and only began to work again, cautiously, in 1972. It was after a visit to Japan that he made, in 1983, his print of a famous group of rocks on Huangshan (fig. 17.3), in which he combines the subtlety of a wash painting with a feeling for the block itself—using the grain of the wood very appropriately to suggest the texture of the rocks. This must be one of the first truly modern prints produced in the People's Republic.

The range of techniques used today by Chinese printmakers is as wide as it is in the West, going far beyond water- and oil-based block printing. Wu Changjiang's powerful studies of Tibetans show a masterly use of fine-line wood engraving. Wang Weixin (fig. 17.4) in his series "Ancient Capital—Beijing" combines copper-plate etching with embossing, while Liang Dong combines embossing with the *shuiyin* technique. Chen Qiang evokes in mezzotint the harsh life, and death, of the northern nomads. Among lithographers, Li Hongren creates elaborate compositions in color (fig. 17.5), while Zhang Zhiyou, who opened China's first independent print workshop in 1984 in Zhuoxian, south of Beijing, aims in some of his lithographs at an almost photographic effect. Chen Wenji produces very original pictures of household things such as chairs and kitchen stoves by collagraphy—that is, printing in intaglio or relief from a surface built up with various collage materials (fig. 17.6).[6]

Screen printing was introduced into China in the 1980s, but its development has been hampered by the difficulty of obtaining the right inks and solvents; printmakers have been forced to fall back on oil color thinned with turpentine. In general the Chinese printmakers suffer, like the oil painters, from working with poor materials. In the early 1980s, for example, lithographers in Hangzhou worked on high-quality imported German

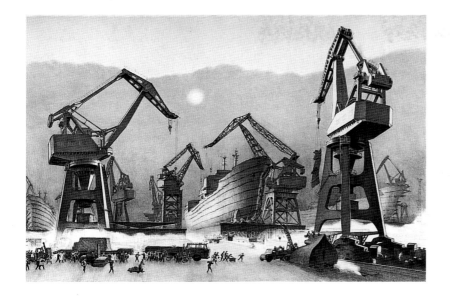

17.5
Li Hongren, *The Sun Rising in the Eastern Sky* (1984). Lithograph.

17.6
Chen Wenji, *Stove and Chair* (1983). Collagraph.

stones, while those in Chongqing had to make do with inferior local ones.

The quality of the work in the Ninth National Print Exhibition in 1986 showed not only that the range of techniques had expanded enormously in less than a decade but that what had once been a generally mono-chrome art at one extreme and a means of reproducing paintings at the other, with nothing much in between, had been elevated from a craft to a fine art, and the range of pictorial sources on which the Chinese printmakers could draw had become enormous.[7] From Western art, they study not only Masereel, Grosz, and Kollwitz but Beardsley, Toulouse-Lautrec, Gibbings, Rockwell Kent,

and the full range of Western modernists. In the 1970s Hokusai was already being exhibited and imitated in China. The modern Japanese print has had considerable influence not only on the Beidahuang School of the northeast and on Beijing printmakers such as Shi Jihong (fig. 17.7) but also in Sichuan, where echoes of the very different styles of Munakata and Saitō Kiyoshi are evident in some of the work of members of the Wuyue Society. The modern Japanese influence can also be seen in the work of two woman printmakers—Zhang Shuang in Canton and Li Xiu from Guangxi.

But it is the Chinese pictorial tradition that furnishes the richest source, beginning with the bronzes of Shang

17.7
Shi Jihong, *Storytelling* (1980). *Shuiyin* print.

17.8
Anonymous, from *Forward Guard Post of the Southern Sea* (1963–64).
Serial picture series. Ink and color on paper.

17.9
Cheng Shifa, illustration to the Ming novel *Rulin waishi* (1957). Ink on paper.

and Zhou, continuing with rubbings from Han stone reliefs (in the work of Lang Kai, for example), the apparently inexhaustible Dunhuang material (Yan Han), the great tradition of landscape and flower painting, old book illustrations, the decorative arts of the southwestern minorities (Wang Jianguo), peasant art (Ma Gang, Zhou Zhiyu, Yang Xianrang), and new year pictures. With such technical and stylistic resources at their command, there seems to be nothing, given the freedom to create, that the Chinese printmakers cannot accomplish.

BOOK ILLUSTRATION AND SERIAL PICTURES

Chinese pictorial skills are shown at their best in book illustration and *lianhuanhua* (serial pictures). This is a very ancient art in China: some Han reliefs tell stories in serial form, and the sixth-century wall paintings at Dunhuang illustrating successive incidents in the life of the Buddha are an early form of *lianhuanhua*. For centuries

children have loved to pore over the strip picture-books of *The Romance of the Three Kingdoms, Outlaws of the Marshes,* and other stirring tales. In Mao's China, popular themes were the Long March, model PLA units (as in fig. 17.8), and the lives of such heroes as Lu Xun, Wang Jingshan (who mixed the concrete slurry by jumping into the tank), and the immaculate Lei Feng.[8]

Between 1949 and 1966, 600 million picture books were sold. In recent years about 700 million have been sold *every year.* To train artists for this insatiable market, the Central Academy somewhat belatedly opened a *lianhuanhua* and *nianhua* (new year picture) department in 1980. A Serial Picture Research Society was set up in 1983, with many branches, and in 1983 the Chinese Comics Publishing House was established in Beijing. With so huge an output, naturally the number of artists and the range of styles has vastly increased, and the *lianhuanhua* is no longer regarded, as it once was, as a low form of art. From the start, serial books, including many for children, were illustrated by the best artists, a fine example being Hua Sanchuan's brilliant illustrations for the original version of *The White-Haired Girl,* published by the Youth Press in 1964 (see fig. 14.5).

17.11
Dai Dunbang, illustration to the Song novel *Shuihu zhuan* (1980s). Ink and color on paper

17.10
He Youzhi, illustration to Lu Xun's *The White Light* (1980s).

A few of the examples given below are individual book illustrations, but many are serial pictures meant to be viewed either separately or sequentially. Cheng Shifa's brush-line illustrations to the Ming novel *The Scholars* (fig. 17.9), published by the Foreign Languages Press in 1957, set a standard which many of his successors have hoped to meet. Huang Yongyu also excelled as an illustrator, notable being his delightful woodcuts of 1953 for the *Fables* of Feng Xuefeng, a revolutionary writer and propagandist who had used the style of Aesop for veiled attacks on the Guomindang.[9]

Many artists work in ink-line, which marries well with the printed text. Ye Qianyu and in particular Ding Cong are masters of this style, while among other excellent examples we may cite Zhao Hongbian's 1964 illustrations to *Monkey* and sets by Huang Chuanchang, Shi Shengchen, and Wang Huaiqi. A freer ink line is displayed in Fang Zengxian's illustrations to Lu Xun's *Kongyiji,* while many artists use traditional ink and wash in a realistic modern way, among them Zhao Qi and Zhang Wanli. He Youzhi's pictures in this manner for Lu Xun's *The White Light* (fig. 17.10), the story of a failed examination candidate, are particularly effective. A versatile artist who also works in a *gongbi* technique, he is the head of the "comics department" at the Central Academy.

In illustrating ancient texts, poems, and stories, many artists have turned to the style of the period in question.

Gao Yun, for example, illustrates a Qing story about the Tang court in a monochrome *gongbi* style, while Wu Sheng and Yu Shui appropriately treat Bai Juyi's *Song of Unending Sorrow* in the manner of the Tang masters of figure painting Zhou Fang and Zhang Xuan. *Gongbi* techniques are also used effectively for modern themes, such as the moving series by Li Quanwu and Xu Yongmin for *Crescent Moon* (plate 36), Lao She's tragic story of a girl forced to follow her mother into prostitution. For his illustrations to the Song historical romance *All Men Are Brothers* (fig. 17.11), Dai Dunbang brilliantly adapts the realism of the well-known panoramic handscroll *Qingming shanghe tu* by the twelfth-century master Zhang Zeduan. Qin Long, who had helped Huang Yongyu with his landscape for the Mao Mausoleum, effectively illustrates *The Thousand and One Nights* in a *gongbi* style partly influenced by a famous twelfth-century Japanese scroll of *The Tale of Genji.*

Some artists have adopted an even more decorative, artificial style: Qu Lingjun's designs, for example, give an effect of mosaic in treating a folktale. More successful are Han Shuli's richly composed illustrations to the Tibetan legend *Bangjin Flower.* Huang Peizhong's pictures for the folktale *The Gold-Edged Peony* playfully and very successfully borrow the style of village new year prints.[10]

Western techniques are always used for Western themes. Oil painting would not seem to be the natural

17.12
Li Shaowen, illustration to Dante's *Inferno* (1984). Ink and color on paper.

medium for serial pictures, but He Duoling uses it for the Chinese translation of Paul Gallico's *The Snow Goose.* Bai Jingzhou's pictures for Alphonse Daudet's *The Last Lesson* are drawn in ink (they look like etchings). Li Shaowen's brilliant illustrations to Dante's *Inferno* are carried out in watercolor (fig. 17.12). And Russian influence continues to be important: *Meishu yanjiu* for April 1984 carried an article by Gao Mang on the art of O. Veleisky, with particular reference to his illustrations to *Anna Karenina*.

You Jingdong's fifty-three pictures of various shapes and sizes telling the story of Stendhal's *Fanina Fanini* show

many Western influences, including that of Klimt. This artist stretches the serial picture well beyond conventional limits in his best-known work, *Ren dao zhongnian* (The middle years of life) (fig. 17.13), the story of a patriotic young woman doctor returning from abroad to serve her country. With skill and imagination, he assembles almost photographically realistic pictures in a variety of ways, some suggesting a series of movie stills, or family snapshots pinned on the wall.

In the early and mid-1980s, there seemed to be no end to the styles, forms, and techniques that the *lianhuanhua* artists used and experimented with. China's vast

17.13
You Jingdong, illustration to *Ren dao zhongnian* (1981).

book-devouring public, as well the incredibly rich pic-
torial tradition, suggested that the possibilities for this
form, as for the modern print, were limitless. Yet a vis-
itor to publishing houses and bookshops in the late 1980s
reported that the market had collapsed. Few people were
buying *lianhuanhua* any more, while the best illustrators
had retired and were not being replaced. Television, it
seems, had dealt this great tradition a mortal blow.

ART IN TAIWAN

ART UNDER THE JAPANESE OCCUPATION, 1895–1945

It would have been hard to imagine in the 1950s that Taipei would very soon become one of the key centers of the development of modern Chinese art. In the nineteenth century, when Taiwan was a prefecture of Fujian province, Taiwan's cultural contacts were chiefly with Fujian and Guangdong, both outside the mainstream of Chinese painting.[1] Her arts were old-fashioned and very provincial. Just when China was stirring to life at the end of the nineteenth century, Taiwan was conquered by Japan.[2] For the first ten years after the Japanese occupation of 1895 the island was dominated by the Japanese military presence, although local guohua painters continued to meet and exhibit and the governor-general was a patron of traditional painting. After 1905 art was taught in secondary schools, and the teachers' training colleges had Japanese instructors. By 1922, over two thousand Taiwanese were studying in Japan, although only a tiny handful—chiefly the sons of wealthy parents—were art students. One of the first was the sculptor Huang Tushui, who in 1919 distinguished himself at the official Teiten exhibition in Tokyo with a feeble clay figure of a country boy playing a flute. His later sculpture, particularly his buffaloes in the round and in relief that show the influence of Takamura Kōun and his son Kōtarō, were somewhat more accomplished. He died of overwork in Tokyo without ever returning to Taiwan.

Interest in Western art in Taiwan had first been sparked by the arrival in 1910 of Ishikawa Kin'ichirō (1871–1945). Long a member of the Meiji Art Association, Ishikawa was a Christian who was fluent in English and had acted as interpreter for the English watercolorist Alfred East on his visit to Japan in 1889.[3] He

was appointed part-time lecturer in painting in the Taipei Normal College, a post he held—apart from a return to Japan from 1916 to 1923—until his final homecoming in 1932. He also travelled in China and Europe. His watercolors, conventional and competent, showing his admiration for Turner, had a considerable influence on his many Taiwanese pupils, some of whom he sent to Japan for further study. They later named a society in his honor.

The Taiwan gentry had always painted as a hobby, stimulated from time to time by painters (though hardly distinguished ones) arriving from the mainland. In Taipei, Kaohsiung, and Chiai, guohua societies flourished: the Sandalwood Society (Zhantan she), for example, and the New Sprouts Painting Society (Chunming huahui), and the Elegant Society (Ya she). But the Japanese influence was even stronger, and in Chiai particularly there were plenty of Chinese artists who had fallen under the spell of *nihonga* masters such as Takeuchi Seihō, Yokoyama Taikan, and Hishida Shunsō. Among the Taiwanese exponents of this technically demanding but impersonal style (for which, see chapter 5), we should mention Lin Yushan and Chen Jin in Chiai and Guo Xuehu in Taipei. Not surprisingly, *nihonga* ceased very suddenly to be fashionable in Taiwan in 1945. Forty years later, however, it had become respectable again, and long-neglected artists like Chen Jin (who had spent the years 1925 to 1945 in Tokyo) were admired once more; her *Old Instrument* (plate 37) was painted in 1982.

During the 1920s and 1930s Western-style painting, with a strong Japanese flavor, continued to develop in Taiwan. Oil painters in Tokyo came under the influence

of Okada Saburosuke, Yamashita Shintarō, Fujishima Takeji, Umehara Ryūzaburō, and Hishida Shunsō. An official annual Taiten exhibition, modelled on the Tokyo Teiten, was established in Taipei. In 1934 the Taiyang Art Society (Taiyang meishu xiehui) was organized to give local artists more facilities for exhibitions than the official salon provided. Four years later a group of young modernists, dissatisfied with the society's conservatism, formed a breakaway movement called Cercle MOUVE. Although the name suggests direct contact with the Fauves and their successors in Paris, the secessionists were merely following current trends in Japan, with which they were anxious to establish their credentials. These would-be modernists were almost cut off from the West, even more so when in the late 1930s Japanese militarism turned Taiwan into a fortress, subject to relentless anti-Western propaganda and thought control. During World War II, in Taipei as in Tokyo, all art not dedicated to the war effort was discouraged and modernism forbidden. The avant-garde, suppressed in Japan, had no chance at all in Taiwan.

A typical Western-style artist of the prewar period was Li Shijiao, born in 1908, who after studying under Ishikawa entered the Kawabata Academy of Painting in Tokyo in 1929 and then the Tokyo Academy in 1931.[4] He exhibited regularly in the Teiten, sent paintings to the Taiwan Taiten, and finally returned to Taipei in 1944. There, after an initial period in disfavor, he became a prolific painter of colorful nude compositions and figure groups in a cheerful salon style (as in fig. 18.1). Others more directly affected by modern European painting included Liao Jichun, who was much influenced by Umehara Ryūzaburō. Although he never managed to get to Paris, late in life he did go to the United States, where he spent the years 1962 to 1972. He felt then the pressure of abstraction, but later returned to realism. More fortunate was Yang Sanlang, who spent seven years in the Kyoto Academy before going to France in 1932 with Liu Qixiang. They were met in Marseilles by another Taiwanese, Yan Shuilong, and together they studied and copied paintings in Paris for several years. Yang and Yan returned to Taiwan, where the latter became a dominating influence on oil painting; but Liu Qixiang, who seemed most at home with modern French painting, went back to Tokyo in 1935, married a Japanese woman, and only returned home in 1946.[5] Strongly influenced by Picasso and Derain, he was probably the most talented Taiwanese oil painter of his generation, as suggested by his *Woman in a Chinese Chair* of 1974 (fig. 18.2). After World War II this group of conservatives, modernists in their day, had a repressive influence on the younger generation of Western-style painters.

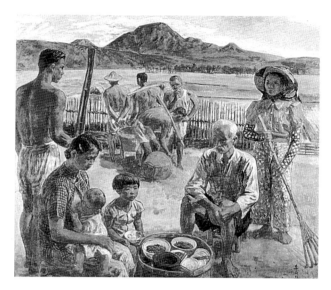

18.1
Li Shijiao, *Happy Farmers* (1946). Oils.

18.2
Liu Qixiang, *Woman in a Chinese Chair* (1974). Oils.

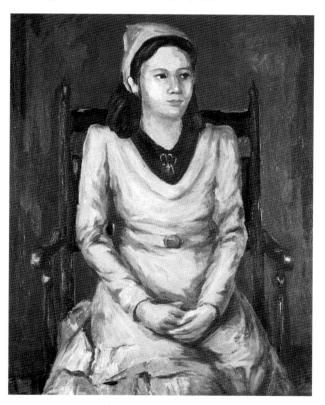

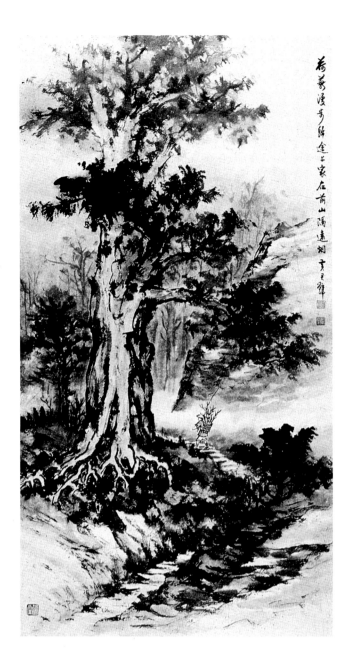

18.3
Huang Junbi, *Returning from the Woods* (1970s). Ink and color on paper.

POSTWAR CONSERVATISM

For the Taiwanese, the joy of liberation from the Japanese in 1945 was not unmixed with apprehension, as the new provincial government imposed a dictatorship that the Taiwanese found all the more intolerable because it was Chinese. In 1947, their demands for reform denied, they rose in revolt. Among the thousands of Japanese-educated Taiwanese killed in the savage punitive measures that followed was the pioneer oil painter Chen Chengbo.

Taiwan's new masters were convinced that China's traditional values must be preserved at all costs against the Communist threat. To prevent unrest after the bloody uprising of 1947, martial law was imposed. It remained in force until 1988, paralyzing the free development of cultural life.[6] As the mainland government crumbled, local artists and professionals were pushed aside by the refugees from the mainland, who took the best jobs. To add to their confusion, Taiwanese artists were suddenly confronted not only with all the developments that had taken place in Chinese art since the Japanese had seized the island but also with contemporary international movements—and particularly the postwar New York School, which they began to encounter in 1950 when the U.S. Seventh Fleet arrived to protect Taiwan from Communism. We can see one effect of this sudden dislocation in the work of Li Shiqiao, who in the 1950s briefly experimented with abstraction before settling down again as a mildly fauvist figure painter.

The Guomindang brought almost the whole of the imperial art collection to Taiwan when they fled Beijing, a symbol of their claim to legitimacy as the rulers of all China. A huge museum was eventually built in Taipei as a shrine of traditional culture. The Taiwan government saw itself as the custodian of the Chinese heritage. Through its network of security organizations it hunted out dissent in the arts as in ideology, promoting all that was conservative and traditional. Writing in an art journal in 1967, a Guomindang apologist declared, "What we must recognize today is that the essence of an anti-communist war is that it is a cultural war. Therefore we must first have a deep and penetrating conception of the spirit of Chinese culture." He attempts to link Chinese aesthetics with the doctrines of Sun Yatsen: "Speaking frankly, if we wish to establish China's burgeoning art, to depart from the philosophical and academic system of the Three Principles of the People which has grandly brought together both ancient and modern, both Chinese and foreign thought, would be to depart from a nationalism that represents the Chinese 'people's spirit,' which otherwise there would be no way of establishing."[7]

In this sterile climate the guohua artists who had fled the mainland flourished, patronized by officials and the wealthy. Pu Ru, cousin of the last Manchu emperor, and the Cantonese artist Huang Junbi (fig. 18.3) had enormously successful careers as teachers of traditional painting, while to Huang Junbi came the additional cachet of instructing Madame Chiang Kaishek herself. Among the many established guohua painters, amateur and professional, who settled in Taiwan we may mention Fu Chuanfu, the connoisseur and politician Ye Gongchao (George Yeh), and the Fujianese individualist Shen Yaochu (fig. 18.4), who paints as Wu Changshuo might have painted had he lived into the era of expressionism. It is worth noting, however, that among the many guohua painters who came to Taiwan most were amateurs, and there were few of any exceptional talent. The masters had preferred to remain in China. The Nationalists were only able to lure Zhang Daqian to Taiwan at the end of his life by declaring him a "national treasure" and building a house for him near the Palace Museum. Had he been able to return to his beloved Sichuan, he would certainly have done so. More than anything else, it was homesickness that inspired the greatest of his late works, *Ten Thousand Miles of the Yangzi* (see fig. 1.15).

THE FIFTH MOON GROUP

By the 1950s, young artists were feeling stifled by the atmosphere of preservation rather than creation in which they worked.[8] The first exhibition hinting at new trends

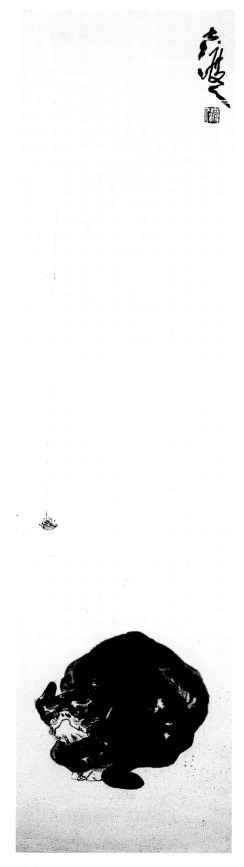

18.4
Shen Yaochu, *Cat Regarding a Spider* (1970s). Ink and color on paper.

18.5
Liu Kuo-sung, *Which Is Earth? No. 9* (1969). Ink, collage, and color on paper.

soon emerged as the dominant personality. They held their first exhibition in the Taipei City Hall in the following May, and thereafter exhibited every May for the next fourteen years.[9]

The founders of the Fifth Moon Group believed that Chinese painting, frozen into conformity on the mainland and hidebound by conservatism in Taiwan, was at a standstill and that it was their mission to bring it to life, to create a new Chinese painting responsive to the challenge of Western modernism. They were not restricted by medium or technique. They used oils, oils mixed with sand, collage, Chinese ink; they screwed up the paper or painted on both sides of it; they printed with fiberboard—any means was acceptable so long as it expressed the artists' feeling and vision. There is no doubt that it was abstract expressionism that helped these artists to discover in their own traditional art the essence of form and the vital line, and to fuse these with a feeling for nature that is also intensely Chinese. A particularly beautiful example of this new synthesis is Liu Kuo-sung's semiabstract landscape of 1966 illustrated in plate 38. The importance of this Taipei movement (matched by similar developments by pioneer modernists in Hong Kong) cannot be exaggerated, for it has become one of the cornerstones of contemporary Chinese art and since the Peking Spring has had an impact on art in the People's Republic, particularly after Liu Kuo-sung's exhibition in February 1983 in the China Art Gallery.

Liu's breakthrough had come in 1958–59, when he experimented with a number of Chinese and Western styles, feeling the influence of Cézanne, Klee, and Picasso. At that time he was painting on plaster laid over canvas, scratching the surface, dripping ink like Pollock. It was the exhibition in 1962 of paintings from the Palace Museum, returned to Taiwan from their triumphant tour of the States, that gave him his first sustained encounter with ancient Chinese masterpieces and persuaded him to abandon oils for Chinese ink and brush. As his mastery of the medium developed, he would screw up the coarse many-layered paper, or strip off the top layer to expose the rougher surface beneath and pull out the fibers to leave lines and streaks. He combined paint with collage and the calligraphic brushstroke with subtle effects of tone and atmosphere to create his own vision of the natural world.

When it seemed that he had exhausted the abstract expressionist vein, suddenly he took it in a new direction with the "Which Is Earth?" series (fig. 18.5), which was to occupy him for the next five years. The Apollo missions and the wondrous discovery of the Earth from space clearly inspired him; a less obvious inspiration was said to be the huge globular lanterns that hang from the roofs of Chinese temples. These paintings were spec-

was mounted in 1951 by three refugee artists who had been associated with the Hangzhou Academy: Li Zhongsheng, who had exhibited with the Storm Society in Shanghai in 1932 and later visited Japan; Chu Teh-chun, who in 1955 settled in Paris; and Zhao Chunxiang (Chao Chung-hsiang), who in 1956 went to Spain and on to New York, where he fell under the spell of Kline and Rauschenberg. Scarcely any record survives of this show, but their work at this time seems to have been a medley of modern styles as they cast about for a way out of the artistic doldrums. Little more happened until 1956, when a group of young artists, several of whom were students of Liao Jichun in the Taipei Normal College, came together to form the Fifth Moon Group (Wuyue pai). Among these ardent young spirits, Liu Kuo-sung

18.6
Liu Kuo-sung, *One atop the Other* (1983). Ink on paper.

tacularly successful, generally saved from any taint of self-consciousness by Liu's brilliant handling of the style he had created. With that vein worked out, he came back to earth, and his later paintings (such as fig. 18.6) are undeniably landscapes. His *Landscape of the Four Seasons* (1983) is a work of great energy and changing moods, ranging from the lyrical opening through the almost too tempestuous summer and autumn to the glacial silence and grandeur of winter. The scroll ends with such chilling finality that one is tempted to join the ends in a complete circle, or to search in the snow for the red plum blossom that is the first herald of the coming spring.[10]

In 1957 two serving officers in the Marine Corps, Hu Qizhong and Fong Chung-ray (Feng Zhongrui), had founded the Four Seas Artists Association to promote modern art. (Feng had encountered Western modernism in 1954 when he attended a national pistol championship in San Francisco.) They painted chiefly in oils, or in oils mixed with sand. But when at the 1961 Fifth Moon exhibition they heard Liu Kuo-sung announce that henceforward he would abandon oils and paint with Chinese ink and brush, they joined his group, and exhibited with it for a number of years. Other early Fifth Moon members included Han Xiangning and Zhuang Zhe (fig. 18.7), whose Kline-like gestures with Chinese ink were particularly powerful and expressive.

Ch'en T'ing-shih (Chen Tingshi), who first exhibited with the Fifth Moon painters in 1965, was born in 1915 into a scholarly family in Fuzhou, became stone deaf as a result of a childhood accident, and learned traditional

18.7
Zhuang Zhe, *Hiding Buddha* (1967).

18.8
Qin Song, *Yuan zhi* (1967). Gouache.

painting from his father.[11] He spent the war years making propaganda paintings and woodcuts, then came to Taiwan in 1949 to take a job as a library assistant. Once there he was finally free to discover his own medium: he made impressions from irregular cutout pieces of building board made from compressed sugarcane and printed them on paper to create compositions, sometimes in color, more often in monochrome, as large as five feet by seven feet (plate 39). The effect is bold and monumental, if not obviously Chinese. But Ch'en T'ing-shih's abstract compositions draw not only on Western abstraction but also on the Chinese tradition of rubbings from carved stelae and stone reliefs.

In the eyes of the Taipei establishment, the Fifth Moon Group was not only an outrageous assault on traditional Chinese art but actually subversive. Because Picasso was an abstract painter, and Picasso was a Communist, these Chinese abstractionists must be Communists too. The group was attacked in the press; Liu Kuo-sung was threatened with arrest when in 1960 he tried to found a modern art center; it was impossible for any of these artists to find posts as art teachers. What saved and sustained them until authority gave them grudging recognition was the support of foreign residents in Taipei and the attention their exhibitions attracted abroad.

Liu Kuo-sung and his friends were not the only Taipei rebels at the time. Also in 1956 another group of modernists came together, calling themselves Ton Fan, or Dongfang Huazhan (Eastern painting exhibition).[12] Forbidden by the police to form a society, they could exist only as an organization for holding exhibitions. They too were almost all mainlanders, including Li Yuan-jia, Xiao Qin, Wu Hao, Ouyang Wenyuan, Xia Yang, and Huo Gang (Ho Kang). They were later joined by many more, also chiefly from Nanjing, including Zhu Weibai, Li Wenhan, who had been a pupil of Liu Haisu, and Qin Song, who exhibited conventional guohua landscapes in the first Free China Artists Exhibition in 1952 but by the end of the decade had become an abstract painter, influenced by Klee but incorporating, as did so many others, formalized ideographs in his powerful compositions (fig. 18.8).

From the start the Ton Fan group was international, holding its first exhibitions simultaneously in Taipei and Barcelona and showing in company with Spanish and West German painters. Later they exhibited often in West Germany, Spain, the United States, and Italy. Few of the Ton Fan artists claimed to be searching for the roots of a new Chinese painting; on the contrary, their aim was to be part of the world movement of modern art. In 1961 Li Yuanjia and Xiao Qin, the latter by this time living in Spain (he later became an Italian citizen), broke away to found the "Punto" movement, in which the

18.9
Swallow Lin, *Sister* (1969). Woodcut.

Chinese connections were even more tenuous. While the Ton Fan group played an important role in bringing Taiwan onto the international scene, its roots in Chinese art were not deep enough to sustain it in the complex swings of fashion that beset Western modernism, and its influence was far less than that of the Fifth Moon Group.

Among the pioneer modernists of the 1950s and 1960s were several printmakers, members of the Ton Fan group, who quickly established an international reputation. Qin Song won a prize at the 1959 São Paulo Biennial with a powerful abstract print.[13] Swallow Lin (Lin Yan), born in Zhejiang in 1946, was already exhibiting her work in Taipei at the age of twenty, and by 1970 she was producing prints of great charm, strength, and originality, inspired partly by old woodblock illustration and partly by Taiwanese aboriginal carvings (fig. 18.9).

Shiou-ping Liao (Liao Xiuping), born in Taiwan in 1936, was almost the only major artist of his generation who had not come over from the mainland as a child. He studied for three years in Tokyo and three in Paris under S. W. Hayter in Atelier 17 before returning to Taiwan, where in 1974 he published an encyclopedic manual on the art of printmaking.[14] His technically brilliant prints draw upon a vast range of sources, of which the Chinese elements—yin-yang symbolism, ancient mirror and coin designs, archaic characters, and so on—are so perfectly integrated with other elements in his compo-

sitions that their Chinese origin is not always apparent (plate 40). Although Liao settled permanently in the United States in 1970, he has continued to stimulate printmakers in Taiwan through his visits to teach and exhibit there. He is also a sensitive and accomplished watercolorist.

THE MODERN MOVEMENT

Once modernism was established in Taipei, the range of movements and styles expanded rapidly through the 1970s. There were surrealists (Chen Jingrong), photorealists (Xie Xiaode), and minimalists (Lai Chunchun), while some artists, following the Native Soil Literature and Art Movement (Xiangtu wenyi yundong), looked closer to home for inspiration. Zhuang Zhe, for example, fired by the antitraditional ideas of pop art, for a time chose his subjects from the popular arts of the temples, domestic shrines, and street stalls. In this heavily censored culture, in which any criticism of the government was forbidden, pop art became for a time a form of protest against the establishment and its values. Others found a new source of subject matter among the minority tribes in the mountains.

The second exhibition of the Chinese Ink Painting Association (Zhongguo shuimo huashui hui), held in 1970, showed works still very much in the spirit of the Fifth Moon Group, some of whom were members. Eleven years later, the first exhibition of the Taipei Art Club (Taibei yishu lianyi hui) demonstrated that far more choices were now open to artists, ranging from Luo Fang's orthodox guohua through Li Shiqiao's postimpressionism to the abstract expressionism of Chen Zhengxiong. Sun Mide's work shows the influence of Andrew Wyeth, while Li Qimao, more surprisingly, seems to have studied the pretty herd-girls of Cheng Shifa—one of many signs that Taiwan artists were no longer shielded from any knowledge of what was happening on the mainland.

Once abstract expressionism was no longer the mark of the modernist, artists were free to express themselves as they chose. Luo Qing (Lo Ch'ing, or Lo Ch'ing-che) is typical of the new spirit.[15] He was born in Qingdao of a Hunanese family in 1948, but they soon left for Taipei. By the time he received his M.A. from the University of Washington in 1974, he had already made his mark with his volumes of poetry, notably *Chi xigua de fangfa* (Ways of eating watermelon) and *Zhuozeji* (How to catch a thief), for which he won Taiwan's First Crown for Modern Poetry in 1974. As a painter of night scenes, luxurious plants (especially palm trees, as in fig. 18.10), and winding roads seen from above, his images are warm in color, clear and strong, lively and playful,

18.10
Luo Qing, *The Fifth Gentleman* (1980s). Ink and color on paper.

18.11
Qiu Yacai, *Number 12* (1980s). Oils.

with a little of the flavor of the Ming painter Shen Zhou. At peace with himself, not troubled by the need to take up abstraction, he is very much at the center of intellectual life in Taipei. A companion spirit is Yuan Dexing, best known by his pen name, Chu Ge (or Ch'u Ko). A poet-painter on the staff of the National Palace Museum, his images are even bolder than Luo Qing's, his imagination more wide ranging, while in his "character painting" he reaches deep into the origins of writing. His *Offering* (plate 41) incorporates the graph for a bronze tripod (*ding,* in the lower left) with others suggesting sacrifice. Like Luo Qing, he is one of the Taiwanese artists who have given new meaning to the term *wenrenhua* and set a challenge to their less well-educated brethren on the mainland.

The confidence with which artists developed new styles and techniques gave a wonderful freshness to the Taipei art scene in the 1980s. Typical is Yu Peng (plate 42), who brings together animals, birds, rocks, people, and pieces of furniture in a playful free association, held together by the viewer's eye as it darts from object to object. An artist whose creative energy and inventiveness often run ahead of his technical skill (or does he cunningly conceal it?), Yu Peng is equally happy carving in stone or making crude figures in glazed earthenware.[16]

By contrast, anything but playful is the work of the young painters who have dared to introduce a new, disturbing element into Taiwanese painting. The innocent men and women of Qiu Yacai (Ch'iu Ya-ts'ai), who has moved from a Modiglianesque elegance to a more expressionistic manner, have an air of loneliness and helplessness (fig. 18.11), while Zheng Zaidong (Cheng Tsaitung), and Chen Laixing (Ch'en Lai-hsing; plate 43) create strained images of human suffering that recall Edvard Munch and Georg Grosz, expressing the pain, sadness, and alienation of artists living in an ever more prosperous and materialistic society.[17]

Not all Taiwanese artists are haunted by doubts about the human condition, however. Although Chen Qikuan (Ch'en Ch'i-k'uan) has lived and worked in Taiwan for thirty years, his art is by no means a product of the Taipei avant-garde. He was born in Beijing in 1921 and began to study architecture in Chongqing during the war, completing his degree at the University of Illinois. He worked under Walter Gropius at Harvard, taught briefly at M.I.T., and in 1954 began his association with I. M. Pei, which led to their collaboration on the design of Donghai University in Taichung, where he became dean of the department of architecture. Later he moved his practice to Taipei.[18]

While still in Boston Chen Qikuan was already developing his themes and styles as a painter, making free

ink sketches of his mischievous monkeys and painting tall, narrow landscapes in which he records, with the precision of an architect and the eye of an artist, the city steps, streets, canals, and bridges he remembered from his youth in Beijing and Chongqing. He was always experimenting; one of his most famous and original paintings is his *Football* of 1953, a scroll in which the movement of the ball down the field, as the invisible players dart about, dodge, and tackle, is expressed with two or three uninterrupted brushstrokes, reminiscent of the "wild cursive script" that he admires but says he is unable to practice. Here he achieves a synthesis of movement, space, and time, developed with greater subtlety in some of his landscapes, notably in those panoramas in which the mountains at top and bottom of a vertical scroll tilt up to the horizon (plate 44)—a vision that came to him when, flying with the United States Air Force as an interpreter, his pilot swung the plane through the mountains of the Burmese border with such abandon that at moments the world seemed to be upside down.

Chen Qikuan's paintings are miracles of exact observation, of which I wrote in 1977: "What does he see, from his nest high in the treetops? Birds, animals, insects, going about their business with no thought to man; eating, playing, huddling, protecting, scratching themselves and each other. He really loves them. Every now and then he leaves his nest and like a hawk soars up to wheel though the sky, until the mountains tilt over his head and the rivers seem to flow upwards. Drifting in the upper air, he peers down, his hawk's sharp eye picking out villages, rooftops, boats, and if we look close enough, people, creeping like parasites among the houses and rice fields. Ch'i-k'uan clearly prefers the monkeys."[19] His paintings are so clear and exact an expression of his vision that they need no commentary. Seldom does he provide more than a signature, and perhaps a whimsical title. His *Peaceful Coexistence* (plate 45), a landscape of rich, unaffected serenity, is perhaps a little unusual in containing none of the mischievous visual tricks that so often entertain the viewer.

In the mid-1960s, rumors were heard in Taipei of a retired general who on his own was developing a highly original style of landscape painting. This was Yu Chengyao, born in 1898 in the Yongchun district of south-central Fujian.[20] He studied economics in Japan, where he joined the Cadet Academy, and by 1925 he was in Canton as instructor in tactics in the Whampoa Military Academy. After a long career as a fighting soldier with the Nationalist army, he retired in 1946 with the rank of major-general, engaged briefly in business, which he disliked, then settled in obscurity in Taipei to cultivate his passion for calligraphy and Nanguan music.

In 1954, Yu Chengyao decided he would like to take up painting. On his visits to the Palace Museum his innocent eye found flaws even in the masterpieces of Fan Kuan and Wang Yuanqi, whose mountains, he concluded, bore no resemblance to those he had seen and loved on his travels all over China. He began by making tiny sketches of mountain outlines. He had no training, and did not even own a copy of *The Mustard-Seed Garden*. Practicing several hours a day, he gradually enlarged his pictures until he was completing large compositions, his most ambitious being the long scroll *Ten Thousand Miles of the Yangzi,* completed in 1973.

His method of painting is peculiar, for he uses a dense network of short strokes having no calligraphic character of their own to build up his rocks and mountains into masses of great solidity that heave and thrust against each other, piling up into compositions of monumental power (plate 46). I quote from an exhibition catalogue of 1987:

> Inevitably there are awkward passages, even what an orthodox Chinese landscape painter would consider elementary mistakes in technique or composition, and areas where we are not sure just what Yu's close-knit textures are meant to represent: are they rock surfaces, or trees, or grasses? But these ambiguities are unimportant compared with what he has accomplished. For as our eye moves over the surface of his paintings, we are continually astonished and fascinated by the richness and variety of texture, the dramatic chiaroscuro, the sheer strength of his compositions which are bound together by a passion for pure form that seems to be untutored, and quite instinctive. . . . Yu Chengyao's sense of colour is also his own. Sometimes he leaves his landscapes in monochrome, sometimes he colours them, sometimes he waits for months or years before overlaying them with transparent washes of poster-colours rubbed so thoroughly into the surface that colour and ink take character from each other. . . . He uses colour like the Impressionists, to give his landscapes a Spring-like effect of glowing warmth and sunlight that is surprising, often beautiful, and quite without precedent in Chinese painting.[21]

For years Yu Chengyao's talent remained hidden, and when it emerged orthodox painters were quick to spot his faults of brushwork and composition. But soon even they came to see in him a Northern Song classical master reborn. He is a far more original and powerful painter than many trained artists, and eventually he was accepted for the sheer force of his artistic personality.

The acceptance of Yu Chengyao was a sign that local critical opinion was growing up and freeing itself of old prejudices, as well as a mark of the new self-confidence that came with Taiwan's economic prosperity in the 1980s. Another sign of the new maturity was the interest that critics and historians began to show in the

artists from the period of the Japanese occupation, who had for decades been stigmatized as collaborators. Now at last their works were studied without prejudice, published, and accepted as one of the sources of contemporary Taiwanese art.

Yet by the late 1980s, the art world of Taipei was not altogether in a healthy state. In this intensely materialistic society, works of art were seen by the new class of entrepreneurs as marks of status, commodities, safe investments. These people, emulating the rich Japanese industrialists, were prepared to pay ridiculously high prices for indifferent works, sold at so much per *hao* (an area about the size of a postcard). Oil painters such as Li Shiqiao and Liu Qixiang who had once been poverty stricken suddenly found themselves millionaires, while galleries dealing in their works multiplied and compliers of guides to art investment prospered.[22] As for the artists themselves, with few exceptions the search for a national identity through art seems to have been forgotten in the crude scramble for wealth and fame. In no other society in East Asia was art so debased.

Meantime, as the old generation of Guomindang officials died or were pensioned off, proud, confident, and independent young Taiwanese began to see Taiwan as the progressive part of China and—insofar as they thought about the mainland at all—as a model for the People's Republic. Xiao Qin, a member of the Ton Fan group living in Italy, visited Beijing in 1981 to see his relative Xiao Shufang, the wife of Wu Zuoren; he noted how important it was that Taiwan artists should give a lead to those on the mainland.[23] Partly as a result of his visit, no doubt, between March 1981 and July 1982 *Meishu* featured the work of a number of overseas Chinese artists, including Liu Kuo-sung, Li Shiqiao, Zao Wou-ki, Qin Song, and Chu Teh-chun. In August 1980, the Taiwan art journal *Hsiung-shih* had already run a feature article on mainland art, in which the works of Li Keran, Huang Yongyu, Huang Zhou, and others are discussed with reasonable objectivity, though the writer gives many well-known instances of Communist Party tyranny and intolerance towards artists. At least it could be said that Taiwan and the People's Republic were no longer ignoring each other's art, as they had for thirty years. By the early 1990s, the barriers had almost disappeared, and traffic was flowing freely in both directions, with frequent exhibitions of Taiwanese artists in the P.R.C. and exhibitions (less frequent, but still permitted) of the work of mainland artists in Taiwan.

THE NEW SCULPTURE

Sculptors of any distinction were not to be found in Taiwan before the 1970s. Typical of the earlier era is Chen

Xiayu, born in 1917, who in 1933 went to Tokyo and studied and exhibited until returning to Taipei in 1942. After some hard years, he became well established as a successful sculptor of portrait and salon-style figures. In 1960, Yuyu Yang (Yang Yingfeng) was a conventional sculptor as well, though he has since acquired a high profile in Taiwan as a town planner and environmental designer.[24] Though born in Taiwan he grew up in Beijing, where he received art lessons in middle school from Japanese teachers, and during the war he studied architecture and sculpture in Japan. Back in Taiwan he took a job as art editor of a magazine, supplementing his income with teaching and lecturing, and soon he was exhibiting his sculpture not only in Taiwan but in Tokyo, Seoul, Manila, and Chicago. He spent the years 1961–64 on an art scholarship in Rome, returning to be appointed a research scholar in the Chinese Academy.

Yuyu Yang's first major work was the striking iron *Phoenix* that stood before the Taiwan pavilion designed by I. M. Pei for Osaka Expo 1970 (fig. 18.12). The variety of his projects is reminiscent of the wide-ranging oeuvre of Isamu Noguchi: the Chinese gate of the International Park in Beirut (1972), *Marble City* for the Taroko Gorge and Dalian Airport on Taiwan, the *Q. E. II Gate* in polished steel on a pavement in downtown New York for the shipping magnate H. Y. Tung, the *Phoenix Screen* for the 1974 Spokane Expo, a major environmental project for Saudi Arabia (1976), and many more. During these years he had moved away from representation into pure formal abstraction, although his *Little Flying Phoenix* of 1986 in the Taipei Fine Arts Museum (fig. 18.13) still suggests the soaring movement of the mythical bird.

In 1977, Yuyu Yang encountered laser art in Kyoto for the first time. He was, as he remembered, "transfixed" by the intensity and purity of its color. "I find in it," he wrote, "a noble quality which is elevating for modern life. It is rich in rhythm, inspiring in the viewer a sense of the pulse of the cosmos. . . . Laser art is essentially abstract. This quality brings to mind the aesthetics of Zen art. . . ."[25] In 1980, Yuyu Yang founded his Chinese Laser Institute of Science and Arts. For several years the experiments and demonstrations carried out by his team attracted a good deal of attention, but he continued to work in more orthodox materials, and some of his finest abstract sculptures are of highly polished stainless steel, a material with which he has a special affinity.

Ju Ming (Zhu Ming), born of a peasant family in 1938, was apprenticed as a youth to Li Jinchuan, a famous wood-carver in the local Taiwanese folk art tradition; Ju carved folk heroes, flowers, and animals for him, developing a deep feeling for the medium.[26] In 1968 he joined the studio of Yuyu Yang, who taught him mastery of a

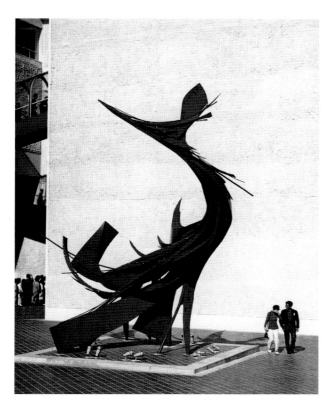

18.12
Yuyu Yang, *Phoenix* (1970). Steel. Created for the Taiwan pavilion of Osaka Expo.

18.13
Yuyu Yang, *Little Flying Phoenix* (1986). Steel.

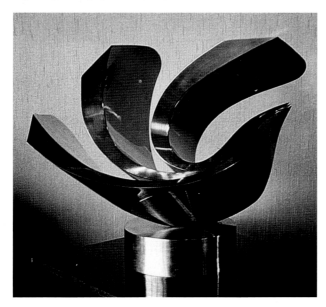

wider range of materials and urged him, because of his frail physique, to take up *taiji* (*t'ai chi,* or "shadow boxing"). When in 1976 he held his first one-man show at the National Historical Museum, his *taiji* figures created a sensation. Hacked out of the wood with axe or chisel

or torn out with his bare hands, and then often, but not always, cast in bronze, they are tense with life, the movement dramatically arrested; they seem rooted in Chinese culture yet utterly spontaneous. In these striking figures Ju Ming brings modern Chinese sculpture to life, much as the Fifth Moon Group, at about the same time, were revitalizing Chinese painting. He continued to create this powerful series through the 1980s (plate 47).

While the *taiji* series was attracting widespread admiration, Ju Ming was already exploring in new directions. As he said to an interviewer, "My friends often . . . say I am unpredictable. They come and see my new work and before any conclusion is reached I have gone on to something else. . . . I believe change comes naturally."[27] Perhaps the key to his art is the word "naturally." "I try to live naturally," he said. "You must pay attention to the order of things. Treat life with an open heart. . . . When the heart is pure, the mind becomes clear and you begin to see your own nature"—a surprisingly profound observation for so apparently restless and impatient an artist.

Less heroic, more human and vulnerable, are the small wooden figures of his first Living World series, begun about 1980. These men and women of city or beach are hacked out of the wood and colored so crudely that it seems Ju Ming's hand could scarcely keep pace with his creative energy. Some of them are sad, some alienated, some vulgar, herded together like crowds on Coney Island or in a bus queue—these are Ju Ming's response to his sojourn in New York in 1980–81. Just as full of life are his colored ceramic figures and fishes, in which the vital spirit (*qi*) flows, without the agency of any tool, direct from his fingertips into the clay to bring it to life (plate 48).

Perhaps Ju Ming's most outrageous defiance of technical orthodoxy appears in his second Living World series, in the mid-1980s (fig. 18.14). These figures are fashioned swiftly in styrofoam, folded and bound with thongs, then cast in bronze, and they simply burst with *qi*. By the end of the decade they were no longer earthbound, for like a circus master he was making them do somersaults, ride bicycles, pole-vault, or descend to earth by gaily colored parachute. For all his inner seriousness, there is something in Ju Ming of the inventive wit of Picasso, of whom Gertrude Stein once said that he had constantly to empty himself of his overflowing creative energy.

Many younger sculptors are less independent of current Western trends than is Ju Ming. They explore with enthusiasm the space inhabited by the forms that define that space and invite us to move within it, creating constructions in angle steel. At the 1985 Contemporary Sculpture Exhibition in the Taipei Fine Arts Museum,

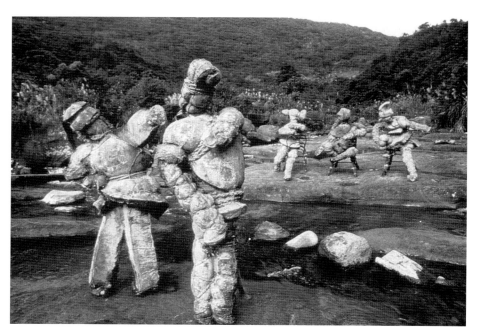

18.14
Ju Ming, styrofoam/bronze figures (1986).

18.15
Lai Jun, *Happiness* (c. 1985). Steel and cement.

18.16
Xu Yangcong (Onion Shyu). *Terms of Endearment* (c. 1985). Painted wood.

the influence of David Smith was obvious in the large painted steel *Steps* of Wang Yuren, in Lai Jun's *Happiness* in cement and steel (fig. 18.15), in *The Love of End* in painted wood by Paul Men (Chen Xianhui), in the striking geometric steel forms of Richard Lin (Lin Shouyu).[28]

In creating a new kind of beauty, these sculptors inevitably sacrifice the sensuous appeal of the carved or cast single form enjoyed for its mass and the subtlety of its contours. Such qualities are present in the marble sculptures of Lai Chi-man (Li Zhiwen) and Liu Tsunghui (Liu Conghui), the wood constructions of Huang Huei-shyong (Huang Huixiong), and the bronze forms of Dawn Chen-ping (Dong Zhenping) and Tsay Shoei-lin (Cai Shuilin). Chen Fangming's stretching figure in the 1985 exhibition, part muscle and part skeleton, is a bravura technical piece of a high order, while *Terms of Endearment* by Onion Shyu (Xu Yangcong)—two black chairs embedded in a table—is ambiguous, leaving the viewer wondering whether the message is of communication or its opposite (fig. 18.16). Little of this new sculpture is obviously Chinese in form. Only when we read what these young sculptors say about their own work do we find that they are often seeking to invest a foreign style or form with Chinese meaning.

ART IN HONG KONG
AND SOUTHEAST ASIA

HONG KONG: EARLY TRENDS

Before World War II, Hong Kong was an artistic back-water into which random, shallow eddies drifted from Europe and Canton. In 1924 Wong Po Yeh (Huang Bore) moved to Hong Kong and established a branch of the Guangdong Association for the Study of Chinese Painting (Guangdong hua yanjiuhui), which became a bridgehead for the spread of Lingnan School painting in the Colony. Wong settled down as an art teacher in a middle school and became an influential figure through his travels in China and his friendship with Zhang Daqian and Huang Binhong, which for the first time put Hong Kong artists in direct contact with the mainstream of Chinese painting.[1]

By the 1930s, artistic activity in Hong Kong was beginning to heat up.[2] There had always been a handful of amateur artists among the cultivated Chinese and the British residents. In 1936, no less than twelve exhibitions were reported: six of Western-style painting, three of guohua, two mixed, and one devoted to Japanese painting. The most important were those of the Canton Chinese Fine Arts Club, composed of six students of Gao Jianfu, and the Hong Kong Art Club, founded in 1925, of which the most active members were now Mrs. MacFadyen, a painter of portraits in oils, and Luis Chan (Chen Fushan), who had joined the club in 1934. Luis Chan, born in Panama in 1905, was at this time a real-ist watercolor painter and an admirer of the work of William Russell Flint. He was later to change his style completely and become a central figure in the artistic life of the Colony.

There were then no art galleries in Hong Kong. Art shows were put up, under far from ideal conditions, in

the Hong Kong Working Artists Guild in the Glouces-ter Building, the Hotel Cecil on Icehouse Street, the China Building, and the Kowloon YWCA. But by 1937 there were at least eight other art organizations in Hong Kong, including the Chinese Art Promotion Society, the Kowloon School of Fine Arts, and the Lai Ching Insti-tute, founded by Tokyo-trained Pau Shiu-yau (Bao Shaoyou) in 1928. At the National Art Exhibition held in Nanjing, Shanghai, and Canton in 1937 (see chapter 6), nearly all the works sent from Hong Kong were painted by Pau and his students.

Apart from the strongly Cantonese flavor of most of the traditional painting before World War II, Hong Kong art had no real local character, for the people of the Colony had no sense of cultural identity. The arrival in 1937 and 1938 of a number of refugee artists from cities occupied by the Japanese (described in chapter 9) briefly brought new talent to Hong Kong, but their thoughts and energies were directed towards the propaganda war against Japan, and in any case they were all gone by Feb-ruary 1942. For over three and a half years, artistic life in Hong Kong was at a standstill.

When peace came in August 1945, the awakening at first was slow. As the trickle of refugees from the Civil War became a flood, however, Hong Kong art flourished. Of the traditional artists active there in the first decade after 1945, nearly all were Cantonese. Zhao Shao'ang, well known for his brilliant technique and his long ca-reer as a teacher, simply continued to develop the style he had inherited from his master, Gao Jianfu, becom-ing ever more skillful in his handling of ink and color. Flowers, insects, and bamboo were his subjects. He was

19.1
Wong Po Yeh, *Village by the Sea* (1966–67). Ink and color on paper.

19.2
Jao Tsung-i, *Pagoda among the Trees* (1980s). Ink and color on paper.

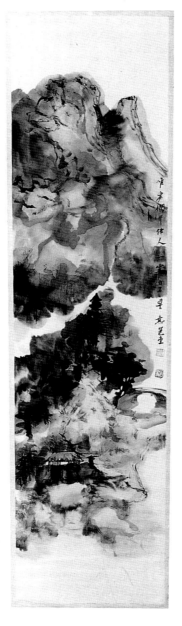

no landscape painter, and nowhere in his work do we find him responding to the remarkable environment in which he worked. Yang Shanshen, who had studied in Tokyo and in 1940 had painted with Xu Beihong in Singapore, is a rather similar artist, though with a wider range of subjects that do not exclude nudes and erotic subject matter. He settled in Vancouver in 1988.

Wong Po Yeh, although he came from the same background, developed very differently after returning to Hong Kong in 1948. By the mid-1950s he was already painting the mountains, islands, harbors, and fishing-boats that make Hong Kong so fascinating. Through the 1960s his style matured, full of easy spontaneity and a masterly handling of wet ink that reveals the depth of his training and is totally free from the stylistic and technical mannerisms of the Lingnan School. Nor was he ever diverted by the fashionable seductions of abstract expressionism. He died in 1968, when the balance of freshness and maturity in his painting was at its height (fig. 19.1).

Other traditionalists working in Hong Kong whose painting goes beyond the bounds of the Lingnan School include Pang Si-ming (Peng Ximing), Koo Tsin-yau (Gu Qingyao), Zhang Bihan, and Jao Tsung-i (Rao Zongyi), a distinguished scholar and student of Chinese culture whose painting ranges from figures inspired by his study of the Dunhuang frescoes to free, playful, and spontaneous landscapes evocative of Shitao and Zhu Da (fig. 19.2).

When Ding Yanyong settled in Hong Kong in 1949 he had a long career behind him as a modernist trained in Japan who had fallen in love with Matisse.[3] After an initial period of retirement, he became an active teacher of traditional painting in New Asia College. His work shows an exhilarating interplay of East and West, the color and line of Matisse happily fusing with the vital brushwork of a Chinese individualist who, for a few years, was so under the spell of Zhu Da that he found it hard to break free. Although the critic Huang Mengtian rightly said of him that he was a dangerous example to follow (see chapter 7), he was a liberating influence on many young Hong Kong artists.

THE MODERN MOVEMENT Neither Lingnan School painting nor socialist realism could provide the stimulus that artists needed, so their eyes turned westwards. The Korean War, as later the war with Vietnam, greatly increased the American presence in the city. The influence of abstract expressionism, born in New York in the 1950s, began to be felt in Hong Kong before the end of the 1960s. Far from cutting the artists' ties with the Chinese tradition, this import actually strengthened them, be-

cause it brought about both a complete break with the art of the recent past and a search into the calligraphic roots of Chinese pictorial art. Abstract expressionism also stimulated artists to experiment with the very language of Chinese painting itself, while at the same time it made them feel that they were becoming part of a worldwide movement in contemporary art. This awareness of possibilities opening up, combined with a new dynamism in the economic life of the Colony, brought about a remarkable flowering of Hong Kong art.

By the 1950s, new art schools and programs were coming into being—the art department of New Asia College (now part of the Chinese University), the arts and crafts section of the Colony's Education Department, and a special art course in Grantham Teachers' Training College, to name a few. Art students were becoming well aware of contemporary movements in the West. The first clear signs of a Hong Kong art movement appeared in the first exhibition of the Society of Hong Kong Artists in 1957, in which Chinese, British, and American artists exhibited together.

The 1960s, which Wucius Wong has described as "a heroic period in Hong Kong art,"[4] were ushered in by the Sixth Hong Kong Arts Festival Exhibition and the first exhibition of the Hong Kong International Salon of Paintings. The international element in these exhibitions was provided by Chen T'ing-shih, Fong Chung-ray, and Liu Kuo-sung from Taipei, Cheong Soo Pieng (Zhong Sibin) from Singapore, and paintings by Zao Wou-ki (by now settled in Paris) and Xavier Longobardi in Hong Kong private collections. The emphasis, in the works of Pansy Ng (Wu Puhui) and Lui Show Kwan (Lü Shoukun), for example, was abstract expressionist, showing the strong influence of Pollock, Kline, the Tachistes, and Zao Wou-ki, who had spent six months in Hong Kong in 1958. Among the British residents who made a significant contribution at this time to the growth of the modern art movement in Hong Kong were Douglas Bland (1923–75) and Dorothy Kirkbride (b. 1924).

The Modern Literature and Art Association, founded in 1958, staged a number of shows, exhibiting, among others, Pansy Ng, Raymond Kong (Jiang Congxin), King Chia-lun (Jin Jialun; see fig. 19.3), Lui Show Kwan, and the sculptors Cheung Yee (Zhang Yi) and Van Lau (Wen Lou). Feeling the need for a body more sharply focussed on contemporary art, these artists and some of their friends founded the Circle Group in 1964. For several years this group included most of the progressive painters and sculptors in Hong Kong. The range of forms and styles they displayed was almost as wide as that of contemporary Western art, so the Circle Group can hardly be said to have helped to create a uniquely Hong

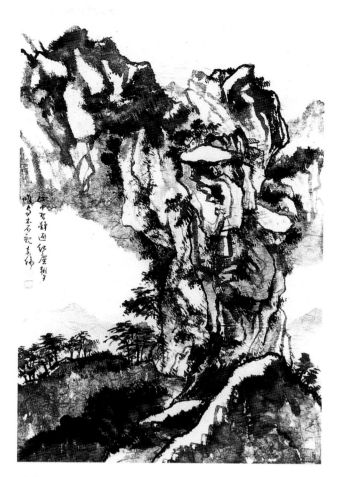

19.3
King Chia-lun, *Mountain Dwelling* (1986). Ink and color on paper.

Kong mode of expression; but it did bear witness to Hong Kong's contribution to international modernism, and with the opening of the museum and art gallery in the city hall in 1962 it did much to educate the new gallery-going public in the mysteries of modern art.[5]

It was in the late 1960s that Lui Show Kwan began to take a leading place in the art world of Hong Kong.[6] Born in Canton in 1919, a graduate in economics from Canton University in 1943, by 1948 he had settled in the Colony, where he worked for several years as inspector for the Yaumati Ferry Company. In the meantime he was studying the history of Chinese painting, acquiring a repertory of styles and techniques, and contributing articles and reviews to local newspapers. He also studied Western art, imitating Turner, John Piper, and Graham Sutherland. In 1954 he joined the Hong Kong Art Club, and soon he showed his power to organize and attract other artists by establishing the Chinese Art Club (with Li Yanshan and Zhao Shao'ang) and then the Seven Artists Club, with Ding Yanyong, Li Xipeng, Li Yanshan, Wong Po Yeh, Yang Shanshen, and Zhao Shao'ang — all guohua painters. In later years his devoted students formed various art societies under Lui's inspiration. In

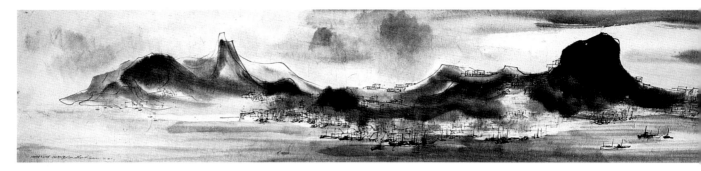

19.4
Lui Show Kwan, *Hong Kong* (1961). Ink on paper.

19.5
Lui Show Kwan, *Semiabstract Landscape* (1960s).

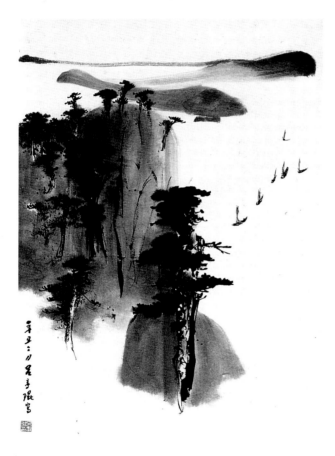

nical repertory. In the second—roughly through the 1960s—he painted the landscape of Hong Kong in a style that became ever freer and more experimental (fig. 19.4). Finally, in the third, he made experiments with the calligraphic gesture, inspired both by the Chan ideal of the expression of sudden enlightenment and by the influence of Franz Kline. Unlike Kline's, Lui Show Kwan's works are seldom entirely divorced from nature, while his Chinese ink is always more transparent and luminous than Kline's solid opacity (fig. 19.5). Sometimes his touch was a little crude and harsh, and he could be careless, but he had an exhilarating and liberating effect on his many students and left a permanent mark on Hong Kong art. He was also the first modern Hong Kong painter to attract notice abroad, holding a one-man show in the Atherton Gallery in Menlo Park, California, as early as 1959.

Luis Chan, by contrast, was far too original a character and painter ever to be an effective teacher. By the 1960s, he had freed himself from orthodoxy and was creating his own surrealist world of dreamlike landscapes, strange open-mouthed men and women, fishes that fly. Echoes of Chagall, the Ukiyo-e, Brueghel, and Hieronymous Bosch seem almost accidental.[7] What makes his paintings remarkable is not just their content, or even their composition, but Luis Chan's extraordinary gift for color, which makes even the weirdest of his later paintings a joy to the eye (fig. 19.6). He is indeed one of a kind.

Through the 1970s and 1980s the modern movements flourished in Hong Kong, unchecked by anything like the conservative establishment that Taiwanese artists had to contend with. Indeed, every form of modernism was supported, while some artists moved back and forth between East and West. Jackson Yu (You Shaozeng), for example, once a traditional artist, became a powerful abstract expressionist, reverted to guohua, and later still fell under the spell of the German expressionists Nolde, Beckmann, and Schmidt-Rotluff.[8] Such a wayward and impulsive artist defies classification.

1966, already a successful painter and art teacher, Lui gave up his job with the ferry company, and he devoted himself to art until his early death in 1975. In 1968 his devoted students in the extramural department of the Chinese University formed the In Tao (Yuan Dao) Art Association; two years later another group of his students organized the Painting in the Chinese Tradition exhibition, and later the One Art Society (Yihua hui)—all inspired by his example.

Lui's work divides into three periods. In the first he assiduously studied the old masters and built up his tech-

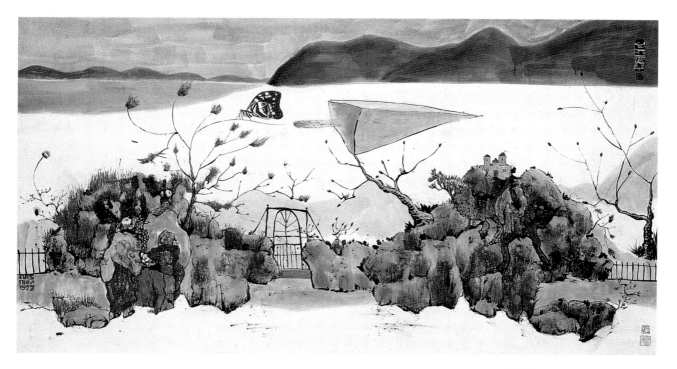

19.6
Luis Chan, *Butterfly and a Net* (1977).
Ink and color on paper.

19.7
Leung Kui-ting, *Consolidation* (1980). Relief print.

The Hong Kong Arts Festival became an international event. In 1976 the Hong Kong Arts Center was opened and the city became host to the first Festival of Asian Arts. Between 1970 and 1979 the City Hall Museum and Art Gallery mounted five contemporary art biennials, and Hong Kong art was now seen in international exhibitions across the world. New groups appeared, among them the Visual Arts Society, founded by graduates in art and design from Hong Kong University's extramural studies department; they were more concerned with modernism than with coming to terms with traditional techniques, although King Chia-lun, who became a senior tutor there, remained deeply committed to the development of a contemporary language of Chinese ink painting.

In spite of Lui Shou Kwan, abstract expressionism was not the only path the young artists took. Hon Chi-fun (Han Zhixun), briefly a pop artist, later became an abstract painter and printmaker. Leung Kui-ting (Liang Ju-ting) and Kan Tai-keung (Jin Daiqiang) played briefly with minimalism before turning to a richer and more tonal and sophisticated form of abstraction (fig. 19.7).

19.8
Lawrence Tam, leaf from an album (1971). Ink on paper.

19.9
Beatrice Ts'o, *Tree Roots* (1971). Ink and color on paper.

More significantly, Kwong Yeu-ting (Kuang Yaoding), Yeung Yick-chung (Yang Yichong), and Ng Yiu-chung (Wu Yaozhong), discarding the traditional vocabulary of texture-strokes (*cun*), built up their mountains with short, even, straight strokes, layer upon layer, as if they were bricks (plate 49). Their pictures lack calligraphic vitality, but they are solid and monumental. Kwong Yeu-ting later moved on to create in oils powerful semiabstract landscapes based on elements in Chinese garden design'that he had studied during his years (1947–59) in the United States. As a printmaker, he has won many international awards.[9]

At this time Tan Zhicheng (Lawrence C. S. Tam) was creating in ink wash somber landscapes of mountains, caves, and stalactites (fig. 19.8). He was to play an important part in promoting modern art in Hong Kong in his dual role as critic and curator in the City Hall Museum and Art Gallery. Beatrice Ts'o (Zhang Jiahui) painted intricate tree-roots and plants which came to resemble human organs as well as the compositions of Pavel Tchelichew (fig. 19.9). For a while Irene Chou (Zhou Lüyun) shared her predilection for writhing figures. Born in Shanghai in 1924, she was just embarking on a career as a journalist when she had to flee to Hong Kong. There she took up painting, studying for many years under Zhao Shao'ang. In the late 1960s, partly under the influence of Lui Show Kwan, she broke free, drawing trees and tree-roots endlessly until, like Li Cheng, she had them in her heart. In the 1970s and 1980s she produced, in addition to finely crafted and infinitely complex studies of trees and roots, symbolic and even metaphysical compositions in which these or wavelike forms often provide the setting for spheres suggestive of astral bodies or atomic particles drifting in space (plate 50). To these haunting compositions she gives such titles as *My Inner World, The Story of Time and Space, Infinity Landscape* (fig. 19.10), and so on. Not the least intriguing thing about Irene Chou is the contrast between the profound, unearthly concepts of her paintings and the cheerful serenity of her comments on them, and on life in general. "Looking back over my past thirty years as a painter," she wrote, "I cannot help smiling. I want to thank God for making me a minor painter!"[10]

Another Hong Kong artist whose work shows a spiritual sensibility is Kwok Hon Sum (Guo Hanshen), a former student of Liu Kuo-sung who has gone in a very different direction from his teacher. In some of his richly textured canvases Kwok Hon Sum calls up the iconology of Tibet, the "thousand Buddhas," the sacred texts of Buddhism and Daoism, to convey by symbolic suggestion metaphysical ideas that verge on the inexpressible (plate 51). His finely crafted paintings are mandalas, objects of contemplation.

19.10
Irene Chou, *Infinity Landscape* (1989). Hanart II.

The synthesis of East and West appears strongly in the work of Fang Chao-ling (Fang Zhaolin). Born in Wuxi in 1914, she studied in China and Britain and lived in the United States before settling in Hong Kong, since when she has travelled frequently in China and exhibited there with éclat.[11] As she has grown older the style of her painting and calligraphy has become ever more emphatic—sometimes excessively so. Her well-known paintings of the Vietnamese boat people are too cheerful to suggest the tragedy of the theme. But in the best of her landscapes, such as her Stonehenge series of 1981 (fig. 19.11)—a subject well suited to her artistic temperament—she is a powerful and impressive painter.

Wucius Wong (Wang Wuxie) was born in Guangdong in 1936 and came to Hong Kong as a boy of ten. At fourteen he began to study classical painting with Lui Show Kwan. By the time he was nineteen he was co-

19.11
Fang Chao-ling, *Stonehenge No. 1* (1981). Ink and color on paper.

19.12
Wucius Wong, *Agitated Waters No. 7* (1989). Chinese ink, gouache, and acrylic on paper. One of a series painted in response to the massacre in Beijing on June 4, 1989.

publisher of an avant-garde poetry magazine; by twenty-two he was one of the founders of the Modern Literature and Art Association. In 1960, still only twenty-four, he was a chief organizer of the First Hong Kong International Salon of Painters. He set off for America in that year, returning in 1965 with bachelor's and master's degrees. On his return to Hong Kong he taught design, then joined Lawrence Tam on the staff of the City Hall

Museum and Art Gallery, where he was in charge of modern art and exhibitions until 1974. After teaching for a while at the Polytechnic, he left permanently for the United States in 1984.

As he developed as a painter, Wucius Wong had moved from Song-style landscapes to experiments in abstraction. His encounter in the U.S. with the best modern art greatly enlarged his vision and technical skill, while

he became an authority on design and design education. In Hong Kong he gradually found his way back to the Chinese tradition, as Lawrence Tam put it, as his work became closer to nature, his brushwork (inspired by his study of Fan Kuan and Juran) denser and more closely worked, his ink tone and color richer and more atmospheric.[12] His compositions became extremely subtle and sophisticated as he broke up the surface of the picture into flattened planes and facets, presenting a spatial ambiguity through a network of lines originally inspired by the crackle on Chinese porcelain. (See fig 19.12 and plate 52.) "These landscapes," in the words of one catalogue foreword, "tread the uncertain ground between the real and the unreal: seemingly natural; yet the eye is arrested by the delicate trellis of lines so disposed—and here is the art—that they do not violate nature, but seem rather to cause the landscape to fold in on itself, and so to draw us after it, until we are lost in its mysterious silence."[13] Wucius Wong is also a calligrapher and has collaborated with Pat Hui Suet-bik (Xu Xuebi), poet and former student of philosophy, in creating elegant compositions in which the "three perfections"—poetry, calligraphy, and painting—are brought subtly together.

At a conference on modern Chinese art held in Hong Kong in 1984, Wucius Wong spoke of the "hesitation, confusion, frustration and failure" felt by Hong Kong artists, who "lacked any sense of national identity and represented neither China nor any aspect of British art" and who, unlike their counterparts in Taiwan, "could not be benefited by being precursors of a new direction in Chinese painting."[14] Yet in many respects the Hong Kong artists were far better off than their colleagues across the border. They had a ready market, enlightened public and private patrons, and reasonable if not very well informed critics, while many art galleries came into being to promote their works. Notable among these have been Alice King's Alisan Gallery, Hanart I, run by the painter Harold Wong, and Hanart TZ, where Wong's former partner, Johnson Chang (Chang Tsong-zung), gives generous and enlightened support to a wide range of artists in Hong Kong, Taiwan, Singapore, and the People's Republic.

Even if some Hong Kong artists suffered from a lack of national identity, working in an atmosphere of greater freedom they developed a creative energy quite as remarkable as that of Taiwanese artists. They played as well a crucial role as the chief transmitters of Chinese modernism to the People's Republic, where their influence was considerable. It may even be that their creativity was given an especially sharp edge by the very fact that they were *not* sustained by any sense of national identity, and that they consequently felt the challenge to create an individual identity through their art.

19.13

Van Lau, *Abstraction* (1971). Painted copperplate etching mounted on album leaf.

SCULPTURE Enlightened public patronage has been more evident in sculpture than anywhere else in Hong Kong art.[15] The birth of a strong movement is linked to the names of two men, both trained in the fine arts department of Taiwan Normal University: Cheung Yee (Zhang Yi, born in Canton in 1936), who arrived in Hong Kong in 1958, and Van Lau (Wen Lou, born in Vietnam in 1933), who came two years later. Both held their first solo exhibitions in the City Hall Museum and Art Gallery in 1964.

Of the two, Cheung Yee is the more scholarly. His deeper roots in Chinese culture show in the album leaf illustrated here (plate 53) as well as in his bronze reliefs, for which he finds his inspiration in the script on ancient oracle bones and bronze inscriptions, although recently he has made a number of striking crabs in bronze for outdoor display. Van Lau's work, less "Chinese," often has a more purely visual appeal. The album leaf here—actually an etched and painted copperplate pasted in the album (fig. 19.13)—and his monumental works in steel and brass such as *Static Kite* display a combination of elegance, power, and fine craftsmanship that reflects a more international aspect of modernism.

Since 1982 Cheung Yee has been chairman and Van Lau president of the Hong Kong Sculptors Association. Their influence on the next generation has been considerable. Ha Bik-chuen (Xia Biquan) first made his reputation as a printmaker before turning to sculpture. Chu Hon-sun (Zhu Hanxin) studied in Hong Kong and spent four years in Italy, much of the time at the marble quarries at Carrara, before returning to Hong Kong. His work, chiefly in white marble or granite, has great beauty of form and texture (fig. 19.14).

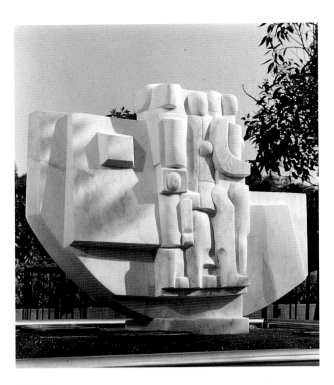

19.14
Chu Hon-sun, *Floating* (1980s). Marble.

19.15
Aries Lee, *Light* (1984). Brass.

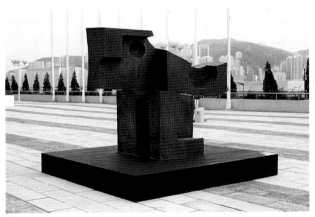

The Contemporary Open-Air Sculpture Exhibition, sponsored by the Urban Council and the Hong Kong Museum of Art in 1984, was an impressive illustration of the Hong Kong government's encouragement of sculpture for public places, giving local sculptors far greater scope for creative experiment than they enjoyed in Taiwan, to say nothing of the People's Republic. Among younger men and women who exhibited there we might mention Lai Chi-man (Li Zhiwen), who worked in granite; Aries Lee (Li Fuhua), trained in Germany, who showed a powerful piece in brass (fig. 19.15); and Tong Kim-sum (Tang Jingsen), who makes massive elemental shapes in granite.

These and other young sculptors have carried out many commissions for public buildings, parks, and open spaces. The Sculpture Walk in Kowloon Park, a joint project of the Hong Kong Royal Jockey Club and the Urban Council, was laid out in 1989 to display the work of young sculptors and pieces for sale by established workers in metal and stone. Another event that gave enormous encouragement to artists and sculptors was the opening of the Hong Kong Cultural Center by Prince Charles in November 1989. Among the works commissioned for this building were sculptures by Van Lau, Cheung Yee, and Chu Hon-sun, a ceramic mural by Lau Wai-kee, and tapestries based on paintings by Luis Chan and Gaylord Chan (Chen Yusheng).

CHINESE ARTISTS IN SINGAPORE AND MALAYSIA

Even more than Hong Kong artists, Chinese artists in Southeast Asia felt cut off from their cultural roots. To paint Malayan villages and palm trees in the Chinese manner, as did Ch'en Chong Swee (Chen Zongrui), who had studied in Shanghai, might produce charming pictures (fig. 19.16); but in this alien tropical world the Chinese tradition, with its long-established vocabulary of pictorial conventions inspired by the Chinese landscape, was no guide, while for the oil painter to imitate Gauguin was too easy a solution. It says much for the leading Chinese artists in Singapore and Malaysia that they resisted those temptations and created a genuine local school.

Organized art teaching in Singapore began as early as 1923, when Richard Walker was put in charge of the art program in the schools. Before he retired in 1950 he had trained a number of watercolorists, notably Lim Cheng-hoe (Lin Qinghe), and the tradition of conventional English-style watercolor painting has always remained strong in Singapore. Art in Singapore began to develop with Xu Beihong's arrival in 1938 on his patriotic painting and fundraising tour of Southeast Asia. His coming was a great stimulus to Lim Hak-tai (Lin Xueda), a Western-style painter who had trained in Xiamen. In 1938 Lim founded the Nanyang Academy of Art, which today remains the only art school in the region.[16]

At that time, Singapore could boast one artist actually trained in Europe: Liu Kang, born near Xiamen and raised in Malaya, who had been taken by Liu Haisu in 1929 to Paris. There he worked at La Grande Chaumière and exhibited at the Salon, returning in 1934 to teach in the Shanghai Academy. The war brought him back to Malaya, where he lived in great poverty and witnessed Japanese atrocities that he later recorded in a series of drawings. He lost almost all his life's work but survived

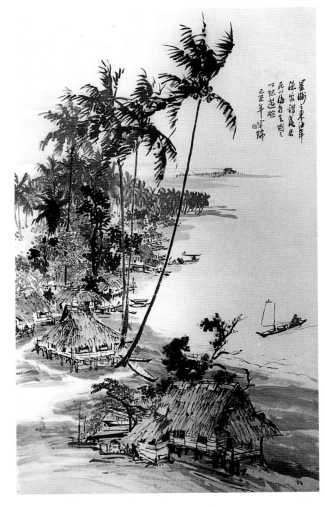

19.16
Ch'en Chong Swee, *Landscape with Palm Trees* (c. 1955). Ink and color on paper.

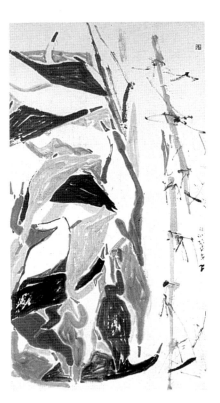

19.17
Chen Wenxi, *Swans* (1987). Ink and color on paper.

to become an established oil painter of figure subjects in a solid, colorful, and somewhat emphatic style.

Zhang Liying (Mme Georgette Liying Chen), widow of the revolutionary leader Eugene Chen, had studied in Paris and at the Art Students' League in New York before her arrival in 1953 in Singapore, where she had a long career as a competent portrait and landscape painter in oils. Cheong Soo Pieng (Zhong Sibin), who had trained in Xiamen and at the Xinhua Academy in Shanghai, arrived in Singapore in 1946. Until his death in 1983 he was prominent both as a teacher in the Nanyang Academy and as an independent artist. His early work was undistinguished, but by the mid-1950s he was beginning to evolve his unmistakable (though much imitated) style of figure and landscape painting (plate 54). In his paintings of Malayan houses and villages, as in his decorative figure subjects, he achieved a highly effective stylization, rearranging elements into almost abstract compositions that still retain a feeling for the subject and

a warm lyrical appeal. His rare portraits in the Chinese medium are admirable for their elegance and sensitivity (plate 55). Late in life his figure compositions became more decorative and highly finished, while he also created abstract metal relief sculpture reminiscent of the work of Cheung Yee.

Ch'en Wen-hsi (Chen Wenxi), born in Guangdong in 1908, studied at the Xinhua Academy in Shanghai with such success that his work was represented in the collection of modern Chinese paintings that Xu Beihong took to Europe for exhibition in 1934. He arrived in Singapore in 1949 and taught for many years in the Nanyang Academy and the Singapore Chinese High School. Although he painted vigorously in oils, he was the most "Chinese" of this group of Singapore artists, at his happiest painting, in free ink wash, attenuated herons and the gibbons in his Singapore garden (fig. 19.17). Among his most sensitively felt works are his drawings, which include both nudes and the beautiful studies of women that he made on a tour of Bali in 1953.

Singapore and Malaysia became separate independent states in 1957. Thereafter, as they grew in prosperity, the number of artists multiplied enormously, and by 1970 Kuala Lumpur was a flourishing art center. A survey completed by Dolores Wharton in 1971 lists sixty-eight Chinese artists working in Malaysia, twenty-six Malays, three Tamils, and half a dozen others.[17] By that time the

19.18
Lee Joo For, *Scorched Antiquity* (1964). Etching.

work of the Chinese artists, both in Malaysia and in Singapore, had little that was identifiably Chinese about it, as they responded with increasing confidence and sophistication to the Malaysian scene. Lai Foong-moi (Lai Fengmei) studied in London and Chia Yu Chian (Xie Yuqian) in Paris, both returning to paint local scenes in oils. Lee Joo For spent seven years studying art in England before returning to Kuala Lumpur to teach and to attempt as painter, poet, and playwright to create there an "intellectual art colony" as a forum for debate and for the promotion of his views. Although his claims for art, and for his own work in particular, verge on the pretentious, this ambitious, dynamic, and culturally omnivorous artist and designer shows a genuine creative talent. In his etching *Scorched Antiquity* (fig. 19.18), he powerfully combines echoes of ancient Chinese ritual vessels with decorative motifs that seem to be derived from the indigenous art of Malaysia.

Next to Cheong Soo Pieng, the best-known Chinese artist in the region was Chhuah Thean Teng (Cai Tianding), or "Teng," as he signed himself.[18] Born in Xiamen in 1914, he came to Penang in 1932. For years he eked out a miserable existence as a hawker, tapioca farmer, maker of umbrellas and sarongs, textile designer, and amateur artist, until in 1953 he conceived the idea of using the batik technique not just to dye textiles but to make pictures (plate 56). Describing this moment, he said, "Suddenly I thought to myself, as an artist I can paint like this [gesturing with his left hand], as a batik craftsman I can do good work like that [gesturing with his

right]. Then I suddenly asked myself: why can't I do them both at once?" Within two years he had achieved his synthesis and was displaying his batik paintings at a one-man show presented by the Singapore Art Society. Four years later he exhibited in London and executed a large mural in oils for the Malaysian High Commission in Canberra. Although neither his subjects, his technique, nor his strong feeling for formal design are Chinese, it is perhaps his Chinese feeling for line and rhythm, combined with a typically Chinese enterprise and endurance, that have made him a leading figure in the art world of Southeast Asia.

Since those pioneering days, the Singapore art world has flourished in a fairly modest way. Faced with local apathy or even hostility to experimental art, serious young painters in 1964 founded the Modern Art Society, dedicated to establishing a foothold for international modernism in Singapore. Among its leaders have been Wee Beng-chong (Huang Mingzong), Thang Kiang-how (Tang Jinhao), and Ho Ho-ying (He Heying), all abstract painters. Thomas Yeo (Yao Hongzhao) and Anthony Poon (Fang Jinshun), both of whom studied in England, have also played a prominent part in the modern movement. One of the most eclectic and inventive of the now middle-aged modernists is Chen Ruixian, writer and artist, admirer of D. H. Lawrence and M. C. Escher, whose work includes oils, guohua, scraperboard graphics, and seal-carving in a wide range of styles.

To counteract the dangerous tendencies represented by these modernists, Ch'en Chong Swee in 1970 founded the Singapore Watercolor Society; Ong Kimseng (Wang Jincheng) and Ling Yunhuang (Leng Joon-wong) are among those who excel in this more conventional art. The Ministry of Culture popularizes art through its "Art for Everyone" program, the laudable aim being, as in the People's Republic, to build art at the grassroots level. Little encouragement has been given to more modern trends, however.

Since the National Museum of Art was established in August 1976 an eclectic modernism has begun to develop, although the modernists are still largely dependent on overseas patrons. To the extent that contemporary Singaporean art has successfully entered the mainstream of the international modern movement it has ceased—and this is the dilemma of many of these artists—to have any particular Singaporean character.

EXPATRIATE ARTISTS: WORLD WAR II AND AFTER

PARIS

When he was a student at the Hangzhou Academy during the war, Zao Wou-ki once asked his teacher, Lin Fengmian, "Will we ever be able to get to Paris and make our living as painters there?" Lin replied, "That is only a dream." And for most Chinese artists, going abroad remained a dream. In the late 1940s, a few scholarships were to be had; in 1947, for example, the British Council sent Zhang Anzhi, Chen Xiaonan, Zhang Jingying, and Fei Chengwu, all then working with Xu Beihong in Nanjing, to study in London. Zhang Anzhi returned to China after a year to resume his career, while Chen Xiaonan went home to oblivion. The other two, who had come to study oil painting, married and settled in London to make a living as professional guohua painters.

Paris had always attracted the best artists, and a handful survived the occupation. One was Zhang Yu, born in Sichuan in 1900, who had come to France in the early 1920s and apart from a short return visit to China in the 1930s made his home in Paris, where his highly individual figure subjects (showing the influence of Matisse and van Dongen), flowers, birds, and lonely animals earned him some success before World War II (fig. 20.1). As his friend and fellow painter Xi Dejin put it, "Chang Yu almost became famous in his early years."[1] Being casual and undisciplined, he fell on hard times after the war. Hoping to recoup his fortunes by selling paintings and promoting "ping-tennis," an indoor game he had invented, he paid a disastrous visit to New York, living for months on hot dogs and selling nothing.[2] Returning to his Paris studio, he gradually sank into poverty, and died alone in his studio in 1965—after which his canvases were

exhibited in two Paris galleries and caught the attention of collectors, and their prices soared.

Pan Yuliang had returned from her earlier years in Europe (see chapter 3) to teach in Shanghai and later in Nanjing under the ultraconservative Xu Beihong. Life in China was not easy for this modern young woman with a questionable past, however, and by 1935 she was back in Paris and her studio in the rue Vercingétorix, where she was to live until her death.[3] She was a sculptor and a gifted oil painter. Among her best works in oils were a striking self-portrait (fig. 20.2) and a *Still Life* of 1944, which combines the solidity of a Cézanne with a Chinese linear expressiveness enhanced by the manner in which she places her signature. Best known, however, are her nudes painted with Chinese brush and ink on paper, studies that express a thoroughly Western understanding of the human body by means of a sensitive, expressive, and very Chinese line (plate 57). In her later years she was tempted into creating more elaborate and decorative figure groups that exude too sweet a charm, especially in the faces, which her many friends and admirers, on whom she relied increasingly for support, found somewhat disconcerting. She was a frequent exhibitor and prizewinner at the Salons, the honor of which she was most proud being the Gold Medal of the City of Paris, awarded to her in 1959. Several years after her death in 1983, most of her unsold works were taken back to Hefei, her ancestral home, with the intention of building a gallery in her memory.

As the art world in Paris revived after the war, a number of exhibitions of modern Chinese art were given.

20.1
Zhang Yu, *Tiger* (c. 1946). Oils.

20.2
Pan Yuliang, *Self-Portrait* (c. 1945). Oils.

June 1946 saw a major presentation at the Musée Cernuschi under the patronage of the great sinologue René Grousset, who wrote a long historical introduction to the catalogue.[4] Most of the Chinese artists in Paris were represented, together with others who had once studied there: Xu Beihong, Lin Fengmian, Pang Xunqin, Wu Zuoren and his wife Xiao Shufang, and others who had never set foot in Europe, among them Fu Baoshi, Chen Zhifo, and Zhang Daqian. Vadime Elisséeff, formal cultural attaché in Chongqing, had also brought back with him seventeen paintings and drawings by a young artist unknown in Paris—Zao Wou-ki. In October 1946, Zhou Ling's Association des Artistes Chinois en France held its own exhibition, which included works by the oil painters Li Fengbai and Fang Yong and the guohua artist Liao Xinxue, all of whom were soon to return to a China rapidly sinking into chaos.

One of the first Chinese artists to reach France after the war was Xiong Bingming. His father had taught mathematics at Beijing University, where the young painter came to know Qi Baishi, Xu Beihong, and Chang Shuhong.[5] He came to Paris in 1947 on a government scholarship to study sculpture under Zadkine and others, and he became there a close friend of Wu Guanzhong. Once he had settled in Switzerland he painted mountain landscapes in the Chinese manner, but he is chiefly known as a sculptor of birds and animals in bronze. In his solid yet attenuated forms we see the influence of Giacometti, but he often works in open wire mesh or strips of metal, which he handles as if they were strokes of the Chinese brush, giving his birds a feeling of movement and life.

Zao Wou-ki (Zhao Wuji) arrived in Paris in 1948. The son of a rich banker, he was born in Beijing in 1921 and grew up in the liberal and humane atmosphere of the family home in Nantong, near Shanghai.[6] The influence of his scholarly grandfather, coupled with the collection of art postcards brought back from Europe by an uncle, helped to form his love of art. When he was fourteen, after passing an examination that required drawing from a cast of a Greek statue, he was admitted to the Hangzhou Academy, where he studied Western drawing and painting under Wu Dayu. He was in his third year, still only sixteen, when he joined the great exodus to the far western provinces (described in chapter 9). Graduating in Chongqing in 1941, he was taken on by Lin Fengmian as a teacher.

Zao Wou-ki showed remarkable initiative when, in 1942, he mounted in the Sino-Soviet Cultural Association an exhibition of the work of Lin Fengmian, Wu Dayu, Guan Liang, Ding Yanyong, and himself—the first group exhibition ever held of these leaders of Chinese modernism. Returning to Shanghai, he held his own

20.3
Zao Wou-ki, *Young Woman* (1945). Oils on wood.

one-man show in the Daxin department store. His painting of the mid-1940s was quite unlike that of his teachers, with none of the bravura of Wu Dayu's abstractions, none of Lin Fengmian's facility. Rather, he seems in his landscapes, portraits, and still lifes to be making his first hesitant, tentative steps toward the creation of a new pictorial language (fig. 20.3). The words of this language are few, but they are his own.

Zao Wou-ki set off for Europe with his wife, Lanlan, his little son, and the blessing and support of his parents. Arriving in Paris on April 1, 1948, they went straight to the Louvre. They found lodgings near Giacometti's house in Montparnasse, a district Zao Wou-ki has never left. He studied French, drew from the nude under Othon-Friesz at La Grande Chaumière, and soon had many friends, not only among leading Paris artists such as Leger, Soulages, Giacometti, and Dubuffet, but also among Americans who came to Paris (some under the G.I. Bill)—Sam Francis, Hans Hartung, Nicolas de Staël, and others. His circle of friends grew rapidly, and unlike many of his compatriots he felt completely at home in Paris from the start. By 1949, he had won his first prize, for drawing. In 1950 he signed his first contract, with Pierre Loeb.

In his early Paris years the influences on this extremely receptive young artist came from all directions. "From Picasso," he said, "I learned to draw—like Picasso. . . .

I already admired Modigliani, Renoir and Matisse, but it was Cézanne who helped me to find myself, to discover myself as a Chinese painter." Among the artists he never ceased to admire were Rembrandt, Courbet, Goya, Poussin. Of Corot's *Woman with a Pearl* he said, "one feels that this painting must have brewed for millions of years." But the most beautiful painting in the Louvre was Cimabue's *Madonna with Child and Angels*: "What serenity!" he wrote. "The whole of the picture is on about the same plane, but the gold halos create a strange perspective, a feeling of depth"—which made him think of classical Chinese landscapes![7]

In 1951, Zao Wou-ki visited Geneva and found himself for the first time face to face with the work of Paul Klee, who, he knew, had for a time been steeped in Chinese poetry and thought. For hours he was absorbed in Klee's paintings, in "those little signs traced on a ground of multiple spaces from which arose a world which dazzled me." "How," he asked, "could I have ignored this painter in whom the knowledge and love of Chinese painting is so evident?" For the next three years Klee was a dominant influence in Zao Wou-ki's sensitive, dreamlike paintings and drawings. By 1954, though, it was as if the "signs" he discovered through Klee were transforming themselves into the signs of the archaic Chinese pictographs. It was a natural path back into the roots of his own culture.

Zao Wou-ki's *Wind* of 1954 (plate 58) marks the beginning of his transition to apparent abstraction—apparent, because these pictures are in fact landscapes. But they are landscapes, as the poet Henri Michaux noted, without hills or rivers, rocks or trees.[8] Zao Wou-ki, who prefers the word *nature* for these canvases, ceased at about this time to give them titles, merely noting the date of their completion. In his mature style, the calligraphic gesture, color and tone, form and the void, space and movement, unite in a work of almost cosmic purity and energy, one that both delights the senses and liberates the spirit (plate 59). If there are changes in the style and mood of the paintings—from the lyrical and serene, for instance, to the dark and tempestuous—these are an expression of some crisis in the personal life of this most sensitive and warm-hearted of artists. For a year after the tragic death of his second wife, May, in May 1972, he abandoned color and painted only in monochrome ink, a medium to which he has since returned from time to time.

In 1972 and again in 1975, he went home to see his family and toured China, and in 1982 he was the guest of the Chinese Artists Association. In the following year, he was invited to exhibit simultaneously in the China Art Gallery and the Hangzhou Academy. The Beijing exhibition was received with hostility by the Artists Association, who made no attempt to interpret it to the public, and Yu Feng was criticized for her defense (in *Meishujia,* published in Hong Kong) of the abstract panels Zao had painted for the Xiangshan Hotel, designed by his friend I. M. Pei. He was glad to escape to his alma mater in Hangzhou, where he was rapturously received by the students, although some of the older professors stood outside the hall beforehand warning them not to applaud or write favorable comments. Nevertheless, he was invited to return with his wife, Françoise Marquet, in the following year (as described in chapter 22).[9]

Conscious though he is of his Chinese roots, Zao Wou-ki has no urge to return to China as it is today. He left China before his style was fully formed and was thrown as a young man into the art world of Paris, where the challenge to find himself as a person and as an artist was far more urgent than any conscious desire to bring East and West together. Because that reconciliation took place intuitively, deep within his own psyche, he came, once he had mastered the influences to which he responded so readily, to create an art of impressive purity and consistency. A Parisian but not a member of the School of Paris (if indeed such a thing still exists), Chinese and yet not an exile from China, he denies, or rather resolves, any conflicts in his position in the very act of painting, and thus, in his creative imagination, brings East and West together.

Chu Teh-chun (Zhu Dequn) had been a contemporary of Zao Wou-ki in the Hangzhou Academy and had also graduated in Chongqing in 1941.[10] He taught for three years under Xu Beihong at the National Central University before departing for Taiwan in 1949. In 1955 he arrived in Paris, an accomplished salon-style portraitist in oils and a painter of post-impressionist landscapes. His response to the modernism he encountered was a series of canvases that display an almost violent repudiation of figurative art. Powerful strokes of the brush in black seem to destroy representation in a manner reminiscent of Kandinsky's breakthrough around 1910, when he would "cross out" in his compositions any form that might be read as a rock, a mountain, or a tree. Having thus purged himself, Chu Teh-chun was free to create, in oils or acrylics, an abstract style of luminous transparency, which has established his position among leading abstract expressionists in Paris (plate 60).

The Tang critic Sikong Tu, in speaking of the quality of grandeur in poetry, wrote: "Leap beyond the external appearance [*xiang wai*] to reach the circle's center." He even speaks of *xiang wai zhi xiang*—"the image beyond the image." We may read Chu Teh-chun's gestures with the brush as mountains, clouds, or waves, or

as the cosmic swirl of Chaos at the birth of the universe, visionary forms forever appearing and dissolving before our eyes. Like the painting of the Chan masters, his visions seem to occupy some mysterious realm between form and the formless, the temporal and the eternal. Ask him what they mean, and he replies, like a true artist, "I'm no good at analyzing my work. What I want to say comes out in my painting." Such work is indeed beyond analysis. "Looking at a painting," he says, "is like listening to music."

Many Western modernists have sooner or later rejected or moved on from abstract expressionism because to them it was a style, a moment in the evolution of contemporary art. For Chu Teh-chun, and in a different way for Zao Wou-ki, it was—though they might not put it this way—a door opening on a vision of reality that has deep roots in Chinese metaphysics, leading towards the "image beyond the image," which can never be fixed or defined but only hinted at, sought by each artist in his or her own way. Why should a Chinese abstract expressionist, once embarked on this journey, return to base and accept the limitations of representational art (unless out of social commitment or for some more practical reason)? Taking the path of abstract expressionism, with its links to Daoist metaphysics on one level and to calligraphy on another, seems natural for the modern Chinese painter.

Nevertheless, many younger Chinese artists, whether from conviction, impatience, or a desire to catch hold of the coattails of Western modernism, have rejected abstraction. When in 1983 Les Amis du VIe Arrondissement mounted an exhibition of the work of Chinese artists in Paris, the abstract expressionist works of Zao Wou-ki and Chu Teh-chun were far outnumbered by works that reflected, in most cases rather feebly, not so much the state of Chinese art as that of the Western styles then current.[11] By this time the scores of artists who had arrived from China, Hong Kong, Taiwan, and Singapore included many realists, among them Dai Haiying, who came to Paris in 1970, Le Karsiu (Li Jiazhao), who arrived in 1976, Lee Kwok-hon (Li Guohan, 1970), and Peng Wants (Peng Wanchi, 1965). Among the photo-realists were Lai Kit-cheung (Li Jiexiang, 1976), Huang Mingchang (1977), and Chan Kin-chung (Chen Jianzhong), who after his arrival in 1969 acquired an international reputation for his hyperrealist paintings of doors, windows, and piles of boarding. Indeed, the works of almost all the younger artists in this exhibition had scarcely any identifiable Chinese—or French—character at all. They might as well have been created in Tokyo or New York, and the fact that the artists were Chinese is hardly significant.

NORTH AMERICA

While the United States attracted hundreds of Chinese scholars, scientists, doctors, and engineers after World War II, to very few artists was the New World a magnet. Even if they had been aware that the center of modern art was shifting across the Atlantic, the art of Pollock, Rothko, and Kline would still have been quite beyond their comprehension. The Chinese painters who made their mark in the States in the 1950s and 1960s were few, isolated from one another and generally from American modernism.

When Tseng Yu-ho (Zeng Youhe) arrived in Hawaii in 1949 at the age of twenty-six, she came not as an artist or art student but as the young bride of the German scholar Gustav Ecke.[12] Ecke had been teaching in Chinese universities since 1923 but was driven from China by the Communists, and he accepted the post of curator of Asian art in the Honolulu Academy of Art. Tseng Yu-ho, while still in her teens, had been a student-apprentice of Pu Quan, who was teaching painting and connoisseurship at Furen University. She had also studied painting and literature under Qi Gong, a descendant of the emperor Qianlong. Graduating in the art department in 1942, she became assistant to Pu Quan and to Dr. Ecke, whom she married three years later. To her solid grounding in classical painting she added knowledge of Chinese poetry and antiquities through her classes with the great scholars Gu Jiegang and Rong Geng.

Tseng Yu-ho's success as a painter came early, with exhibitions not only in Honolulu but also in San Francisco, Zürich, Rome, and Paris, and she could have made a good living as a competent guohua artist, as did Zhang Shuqi in New York and Zhang Jingying in London. But she was not content with that. Young enough to be receptive to new influences, she attended the lectures of Max Ernst in Honolulu, and on her travels with her husband in Europe met a number of modern painters, including Georges Braque, André Masson (both of whom confessed to her their love of Chinese painting), Soulages, Chagall, Hartung, Miró, and many more. By 1956 she was responding in her own very original way to the Hawaiian landscape, as in the painting illustrated here, a brilliant adaptation of the style of the seventeenth-century master Gong Xian to the texture of the mountains of the islands (fig. 20.4). She was also designing sets and costumes for the Juilliard School opera productions. In 1958 she came under contract with the Downtown Gallery in New York.

This rich combination of influences and stimuli—Chinese classical culture and art, Western modernism, security and humanistic inspiration from her highly cultivated husband—produced the ideal conditions for her

talent to flower. She began to create her own formal language, founded on her study of the structure of Chinese landscape paintings but clothed in a texture of her own making: a combination of paper collage (a skill she had acquired when learning to mount her paintings in China) with Chinese ink and color, sometimes adding to them *tapa* cloth, torn seaweed, or gold or metallic leaf, often mounting her compositions on canvas or Masonite. In a notable series of paintings of 1958 and 1959 she paid homage to Shitao, Zhu Da, Wu Li, and other masters, evoking the essential character of their styles in contemporary terms, thus keeping the tradition alive in the only way possible—by creatively interpreting it, in the spirit of the Ming painter and critic Dong Qichang. In her later work—apart from a phase, happily brief, when she fashioned three-dimensional Han mirror designs and other ancient motifs in plastic—Tseng Yu-ho created works, some of impressive size, that stop just short of abstraction by reason of the trees, rocks, and mountains, or suggestions of them, that emerge from a pictorial surface admirable for the subtle beauty of its color and texture (fig. 20.5).

By contrast with Tseng Yu-ho's youthful rise to fame, C. C. Wang (Wang Jiqian) was not taken seriously as a painter until he was in his sixties.[13] Born in Suzhou in 1907, he became a lawyer in Shanghai, sometimes supporting himself by dealing in real estate. In his ample spare time he studied painting and connoisseurship,

chiefly under the well-known and very conservative Shanghai artist Wu Hufan. He acquired a thorough knowledge not only of the palace collection but of all the important private collections in China, and by 1935 he was recognized as a leading expert on Chinese painting, leading to an appointment in 1935 to the executive committee of the great exhibition of Chinese art at Burlington House in London. He spent the war years in Shanghai, supporting himself by dealing in property.

By this time Wang had acquired an encyclopedic knowledge of the styles and techniques of the old masters. As a painter, he was skillful, orthodox, conservative, and deservedly unregarded, and might have remained so had he stayed on in China. But in 1947, on the recommendation of the dealer Alice Boney, he was appointed consultant to Alan Priest, curator of Chinese art at the Metropolitan Museum. Thereafter, except for a return to Shanghai in 1948 and two years as chairman of the art department of the Chinese University of Hong Kong in the early 1960s, he made his home in New York, where he supported himself by teaching Chinese painting privately and dealing once again in real estate. He attended life drawing, oil painting, and other classes at the Art Students' League, one product of his studies being a still life in the manner of Braque that he painted in 1956.

In 1954 Cho Fulai (Frank Cho) opened his Mi Chou Gallery in the back of C. C. Wang's house. (It was later

20.5

Tseng Yu-ho, *Joyance of Limitation* (1990). Ink, acrylic, aluminum, and paper on canvas.

to move to more roomy quarters at 801 Madison Avenue.) Here, in the first gallery in New York to be devoted to modern Chinese art, the works of Zhang Daqian and Chen Qikuan were shown. Wang told his biographer, Jerome Silbergeld, that Zhang Daqian sold very few paintings at his show in 1957, and those at a very low price. "We began to discuss this," Wang remembered, "and Chang wondered what he should do next. He had no confidence in himself, and I didn't know what to do either." How many Chinese artists arriving in the West have escaped that moment of doubt?

For C. C. Wang, a way forward in his art suddenly opened up. He thinks that the catalyst was "something he had seen in a magazine." Had he suddenly become aware of the breakthrough into semiabstraction that had been made by Liu Kuo-sung and the Fifth Moon Group in Taipei, by Lui Show Kwan in Hong Kong, and, several years earlier, by Zao Wou-ki in Paris—events that had at last made the expressive gestures of the New York School meaningful to Chinese artists? Like Liu Kuo-sung,

Wang began to crumple the paper before painting, sometimes applying color on both sides of it, and to use impressed textures, to exploit the "controlled accident." But while Zhang Daqian in his new paintings seemed to let himself go with joyful abandon, C. C. Wang is almost always firmly in control. He is anything but a natural expressionist, and his least successful paintings are those in which the effects are least carefully managed. He might say of himself, with Degas, "No art was ever less spontaneous than mine."

When C. C. Wang's talent finally flowered in the late 1960s, everything seemed to come together: his skill with the brush; his understanding of the great masters, so deeply ingrained that his references to Fan Kuan, Dong Yuan, Ni Zan, and Hongren seem quite uncontrived; the feeling for composition, formal structure, and color that he had acquired from Western as much as from Chinese art. His best paintings have an air of somewhat static perfection that is due, at least in part, to the subjection of the expressive brushstroke to the demands of the

20.6
Hung Hsien, *Rocks and Trees* (1976). Ink and color on paper.

composition as a whole, which gives them something of the monumental calm of the Northern Song landscapes that he so much admires (plate 61).

Hung Hsien (Hong Xian, known to her friends as Margaret Chang), born in Yangzhou in 1933, spent her childhood in Chongqing and later left with her family for Taipei, where she studied painting in the Normal College under the academic master Pu Ru.[14] She settled in Evanston, Illinois, in 1958 with her husband, architect T. C. Chang, through whom she came into contact with the modern movements in American painting. Her break away from academicism towards semiabstract expressionism was stimulated by her encounter with Liu Kuo-sung, who visited the States in 1966. Sensing a kindred spirit, he invited her to exhibit with the Fifth Moon Group in Taipei, which she did for several years in the 1970s.

By this time, Hung Hsien's rather tempestuous landscapes had gone through a process of refinement and purification, emerging as a style that more truly expressed her temperament. In her mature paintings shapes that suggest rocks, water, or clouds meet, flowing together or apart in a swirl of endless movement. Surfaces become smooth; the effect is lively, lyrical, and soothing. Hung Hsien might have gone on producing these fluent, harmonious paintings indefinitely, but during a summer spent on an island off the coast of Vancouver she be-

came fascinated by the strange shapes of rocks, driftwood, and dead trees on the shore, of which she made many careful drawings. Their forms accorded well with the near-abstraction she had been practicing and are sometimes recognizable, subtly transformed, in her later paintings (fig. 20.6).

Abstract expressionism had been so vital and congenial a stimulus to arriving Chinese artists that for a time few could escape from it. Zhao Chunxiang (Chunghsiang Chao), once a pupil of Lin Fengmian and Pan Tianshou in Hangzhou, had come to the U.S. in 1958 by way of Taiwan and Spain, where he had worked for three years. In New York he met Franz Kline, and was under his spell until Kline's death in 1962. His own abstract expressionist paintings, pulsating with calligraphic gestures, masses of ink, and bold blobs of color, gave him a secure place in the movement.[15]

By the 1980s, however, abstraction had given way to realism of many kinds. In 1984 Koo Mei (Gu Mei), who had been a singer and actress in Hong Kong and studied there under Zhao Shao'ang and Lui Show Kwan, settled in Vancouver. There she became known for her impressive winter landscapes of the Rockies, which are for the most part refreshingly free from the technical mannerisms of the Lingnan School.[16]

Amateur artists and calligraphers in the scholarly tradition continued to paint for the sheer pleasure of it.

20.7
Wang Fangyu, *Mo wu* (Dancing ink) (c. 1980). Ink on paper.

20.8
Y. J. Cho, *Mottled* (1987). Oils on linen.

Among them are Wang Dawen, Fu Shen, Li Shan, Hu Nianzu, Zhang Hong (Arnold Chang at Sotheby's), Huang Junshi (Kwan S. Wong at Christie's), and the scholar-teacher Wang Fangyu, living in New Haven, who in 1971 began to explore the relationship between calligraphy and forms in nature (fig. 20.7). Their work was brought together for the 1989 Beyond the Magic Mountains exhibition at New York's Hanart Gallery, founded by Harold Wong to stimulate interest in contemporary guohua at a time when so many Chinese artists were becoming, as Gu Wenda put it, "prisoners of Western art."

Chinese modernists arriving in the West in the late 1970s and 1980s were faced with a difficult choice: to continue to paint in the manner that had brought them recognition or even notoriety in Beijing, Taipei, or Hong Kong, even though it might already be old-fashioned in New York, or simply to follow the fashion of the mo-ment. Lü Wujiu (Lucy Lu Wu-chiu), who came to the U.S. in 1959 and settled in Oakland in 1970, remained faithful to abstract expressionism. By contrast, Zhuo You-rui (Y. J. Cho), who came to New York in 1977, changed her style completely. In her oils of the late 1980s, based on projected slides, she depicts New England barns, odd corners of Beijing, streets of New York, doors, windows, steps, peeling walls, all the shabbiness of decaying cities, with a realism that comes close to poetry (fig. 20.8).[17] Situ Qiang (Szeto Keung) came to New York in 1975 to become a master of trompe-l'oeil painting; his semiabstract compositions skillfully reproduce the texture of wood, paper and fiberboard.[18] Yang Qian, who left Beijing for Florida in 1984, is another realist whose painting has become completely American. In the work of none of this group is there any discernible Chinese quality.

After Mao: Art

Enters a New Era

With the death of Mao Zedong, a new era dawned

for Chinese art. So complete had been the Party's control

over the minds and hearts of creative people that several years

passed before their powers could stir to life again. Not until

1979 were all the artists once branded as "Rightists" finally

rehabilitated, and that year saw an astonishing outburst of

creativity that came to be known as the Peking Spring.

During the 1980s, in spite of sharp attacks and periodic

persecutions carried out by an increasingly nervous Party

apparatus, Chinese art became ever richer, more complex and

adventurous, drawing inspiration from China's past, from the

West, from Japan, and from the artists' own experience. The

old debates—past versus present, Chinese versus Western—

were not resolved, but they were now carried on at a new

level of depth and sophistication, while the development of

new forms and styles was stimulated by the work of

Chinese modernists in Taiwan and Hong Kong.

Yet the atmosphere of uncertainty, tension, and insecurity

never cleared away. During the late 1980s many younger

artists sought greater freedom abroad, notably in America,

where they faced a different challenge—the loss of

their identity as Chinese artists.

WINTER GIVES WAY TO SPRING

NINETEEN SEVENTY-SIX

As if the turmoil and suffering of the previous ten years had not been enough, 1976 began on a tragic note with the death, on January 8, of Zhou Enlai, last hope of the artists and writers. Although his illness had for some time made him powerless to protect them, the out-pouring of grief for him, at least among the well edu-cated, was far greater than that for Mao later in the year. Mourning was forbidden by the Gang of Four, but when word got about that his catafalque would be coming down Chang'an Road, thousands lined the streets—a moment that was to produce a striking painting once Jiang Qing had passed from the scene.

This was a year also of portents and disasters. In March a tremendous meteor shower—traditionally the sign of the fall of a dynasty—descended upon Jilin Province. In August an earthquake at the coal-mining city of Tang-shan left nearly half a million dead. On April 4, the day for remembering the souls of the dead, a huge crowd gathered to place wreaths and recite poems at the He-roes' Memorial at Tiananmen Square, to mourn Zhou Enlai and protest the tyranny of the Gang. When the police tore down the banners and wreaths a passionate demonstration of anger was brutally put down. The Tiananmen Incident, as it came to be known, was to pro-duce some of the most memorable painting, poetry, and literature to come out of modern China.[1]

Mao Zedong died on September 9. Three weeks later Jiang Qing and the rest of the Gang were arrested. When news of their fall spread across the county, ecstatic crowds poured into the streets; smiling strangers shook hands; the wine shops were emptied, I was told in Chengdu, "even of their sweet wine." The nightmare

was over, but had the dawn really come? Mao and his successor Hua Guofeng were still revered. Tens of thou-sands of leftist cadres still controlled cultural life. The Gang, I was told by an artist friend, had not suddenly dropped out of Heaven: they were the culmination of a historical process that had begun with the wilting of the Hundred Flowers in 1957. Artists and writers were so beaten down, so cautious, that for some months there was very little movement on the cultural front.

The first task was to bury Mao. A national competi-tion had produced a number of rather ponderous de-signs for his mausoleum, all more or less inspired by the Lincoln Memorial, which were homogenized into a building which makes up in dignity for what it suffers in poverty of detail. The marble seated figure of Mao—also inspired by the Lincoln Memorial—was executed by a team of sculptors led by Liu Kaiqu, Hua Tianyou, and Wang Linyi.[2]

The walls of the hall in which the embalmed body of Mao lies carry huge landscapes by leading guohua artists—Qian Songyan (fig. 21.1), Guan Shanyue, Li Xiongcai, Wei Zixi, Li Keran, and several collaborative paintings. Clearly done by artists on their best behavior, these works are of competent and imposing dullness.

When it came to the huge tapestry to hang behind the figure of Mao, I was told that none of the established artists would dare undertake it; so, on the initiative of Hua Junwu, the commission went, almost by default, to the painter and wood-engraver Huang Yongyu, who, his enemies pointed out, was not even a Party member, and had achieved some notoriety with his subversive painting of the winking owl (see chapter 15). In a few

21.1
Qian Songyan, *Dawn in the Date Garden, Yan'an* (1977). Ink and color on paper.

21.2
Huang Yongyu, tapestry in the Mao Zedong Mausoleum, Beijing (1977).

weeks, working with assistants under constant official supervision, Huang Yongyu produced a cartoon in oils, ninety feet long, for a panoramic landscape of China's mountains and rivers. It was woven as a tapestry in record time (fig. 21.2). Serene, vast, and tranquil, this work contains no hint of propaganda, no glorification of the leader, suggesting that when the Chinese feel the need to express their noblest and most enduring sentiments they turn, now as always, to the landscape. But Huang Yongyu was to gain no credit for this achievement. The jealousy of the artistic establishment ensured that when the mausoleum decorations were eventually published in *Meishu* the names of Huang Yongyu and his assistants (one of whom was his pupil Qin Long, later to make his name as a book illustrator) were never mentioned. His huge oil cartoon was never shown, and at the time of writing is believed to languish rolled up in the basement of the Mausoleum.

THE THAW OF 1977-79

Not until the Eleventh Party Congress in August 1977 was the Cultural Revolution officially declared to be at an end, and an era of "great unity" inaugurated. In March of that year the Central Academy was back on track, with Zhu Dan as president and a senior staff that included Liu Kaiqu, Gu Yuan, Luo Gongliu, Ai Zhongxin, and Wu Zuoren. In September the Ministry of Culture abolished the "May Seventh Art University" that had been set up by Jiang Qing in 1973. With the art schools opening their doors, the flood of applicants became a torrent. The Canton Academy for its first class selected forty out of four thousand young hopefuls; at Hangzhou, sixty-eight were chosen from sixteen thousand who applied.

The slow and seemingly haphazard process of rehabilitation of "Rightists" in the art world began with Party ideologue Zhou Yang, cleared in October 1977—a year after the fall of the Gang. Others took longer. When Ye Qianyu's "misjudged case" was rectified in 1978, he was given a scholarship by way of compensation. In the same year Zhang Ding was cleared and eventually became president of the Central Academy. Jiang Feng was rewarded with the chairmanship of the Artists Association. His vice-chairmen were Guan Shanyue, Hua Junwu, Cai Ruohong, Li Shaoyan, Liu Kaiqu, and Wu Zuoren, every one of whom had cooperated in bringing about his downfall twenty years before!

All those branded in the Great Leap Forward were officially freed and their professional and social status restored in December 1978, though some artists had to wait longer still—Liu Haisu was not cleared until March 1979, having borne the stigma for twenty-two years. But absolution was not enough to heal their wounds. Many

would carry the scars for the rest of their lives. Teachers found themselves working beside colleagues and students who had only recently denounced and persecuted them, and not all were in a forgiving mood: a correspondent in Beijing wrote to me that a now famous and successful artist and his friends beat up a wood-engraver who had informed against him. Most, though, felt that the time left to them was too precious to waste on revenge and recriminations. As Jiang Feng put it, "Let's not settle old scores again. . . . My idea is to look forward to the future."[3] "If only," Pang Xunqin said to me in 1979, "I were ten years younger!" The urge to make up for lost time—in some cases, for a lifetime's lost work—kept a number of these indomitable artists working well into their eighties and nineties. But for some, the experience had been too traumatic. Shi Lu suffered a breakdown from which he never recovered. Lin Fengmian, granted leave in 1977 to visit relatives in Hong Kong, never returned; he went into deep seclusion in the Colony, from which he only gradually emerged. In the somber expressionist renderings of the *Crucifixion* that he created during these last years (plate 19), he seemed to find a universal symbol for the suffering that the Chinese people, and he himself, had endured under Mao.

Although *Meishu* reproduced little but propaganda works through 1977, the artists did not wait to express their sense of release. Liu Haisu chose cinnabar red, the color of celebration, to paint three sturdy pine trees, symbolizing China's new leaders Hua Guofeng, Ye Qianying, and Deng Xiaoping. Pictures of flowers and trees bursting into blossom became fashionable—although it should be said that, except during the worst years of the Cultural Revolution, such subjects had not been forbidden; Liu Haisu, for example, had continued to paint his boisterous flowers and lotuses all through the 1970s. But now they could be exhibited and published.

Every artist with a name poured out tributes to the memory of Zhou Enlai and denunciations of "the white-boned demon," Jiang Qing, in the pages of *Meishu*.[4] Her notorious exhibitions of 1974 were described as the work of her "black line dictatorship." She had "seen everything with black eyes," hated flower and landscape painting, and disapproved even of that most correct of works, the landscape by Fu Baoshi and Guan Shanyue in the Great Hall of the People, of which she is alleged to have said that after looking at it for half a day she still couldn't make it out, and demanded to know what was good about it. Her hatred of the painting was clearly motivated by jealousy: she had not commissioned it herself.

For the most part, the huge National Art Exhibition held in February 1977 in Beijing was heavily orthodox, but the cartoonists had sprung to life, turning their satire

on the Gang, whom they depict strutting with swastika banners and armbands (plate 62). In one cartoon, Hitler's propaganda chief Joseph Goebbels proudly holds up his infant son and pupil—Yao Wenyuan. Several show Jiang Qing confiding to Roxanne Witke, her American biographer, her ambition to succeed Mao Zedong as "empress." Although these cartoons created something of a sensation in Beijing, they are not mentioned or reproduced in *Meishu,* the editors no doubt fearing that they might set a dangerous precedent. Less subversive but equally telling was Liao Bingxiong's cartoon of himself (plate 63), so paralyzed by years of censorship that even when his shell is broken he cannot move.

The cultural thaw continued through 1978, hand in hand with the Four Modernizations campaign. May saw the first enlarged meeting of the Federation of Literary and Art Circles since the smashing of the Gang, and on June 15, Seiji Ozawa performed in Beijing, the first foreigner to conduct a Chinese orchestra since Liberation. *Meishu* for March reproduced two engravings by Piranesi, while the April issue carried paintings by the realists Courbet and Bastien-Lepage, modern Japanese art, and classical landscapes of the Song and Yuan dynasties. October saw an exhibition in the China Art Gallery of paintings by Fang Junbi, who had settled in the United States in 1956.

Late in the year, the liberalizing process speeded up. The Writers Union in Anhui allowed an author to attack the persecution of writers who told the truth and to appeal to the authorities to stop blaming everything on the Gang of Four. Elsewhere, students were attacking local leaders who "trampled on human rights and respect for intellectual growth." In November, the first posters had appeared on what was to become known as Democracy Wall at Xidan, the market area in the west of Beijing, accusing Mao of having supported the Gang. Finally, in December 1978, the Third Plenum of the Eleventh Central Committee of the Party put the official seal on a more liberal cultural policy.[5] In February 1979, *Meishu* announced the publication of Zhou Enlai's secret Beijing speech of June 1961, in which he had urged a more flexible treatment of art and artists. As the clouds parted, people began to speak not only of a new Hundred Flowers (a term that hardly carried happy memories) but, putting the past behind them, of the year 2000 and the coming millennium, when the Four Modernizations would bring China freedom, stability, and prosperity.

The Fourth National Congress of Literature and Art Workers, the first for nineteen years, was held in Beijing from October 30 to November 16, 1979, beginning with a reminder that Lenin had said that "greater scope must undoubtedly be allowed for personal initiative, individual inclination, thought and fantasy, form and content." The rehabilitated Zhou Yang, after declaring in his address that "there should be no forbidden zones in literature," then went on to edge away from the hard line of the past. "We must not regard Marxism–Leninism–Mao Zedong Thought as a dogma immutable for all ages, but as a guide to action. We are confronted by many new circumstances and new problems unknown to the writers of the Marxist classics, Mao included. We cannot expect to find ready and complete answers to all the problems in the writings of the revolutionary teachers. As to some of [Mao's] directives and statements on specific questions, we should have the courage to revise and supplement those which do not conform . . . with the actual situation." When he went on to say, "We should integrate Marxist theory with the practice of the literary and art movement of China, with the long cultural tradition of our country," he was opening the door to a dismemberment of the whole structure on which art had stood for the previous thirty years.[6]

All through that year the floodgates of feeling and emotion had been swinging open across China. A hot stream of stories and poems poured from the presses, exposing not only the tyranny of the Gang of Four but the evils in the system itself. Mang Ke's brief and poignant *Frozen Land* takes the death of Zhou Enlai as the darkest hour:

> The funeral cloud floats past, a white cloud,
> Rivers slowly drag the sun.
> The long, long surface of the water, dyed golden.
> How silent
> How vast
> How pitiful
> That stretch of withered flowers.[7]

But Huang Yongyu's sardonic poem about the ever present informer strikes at the poison that ran through the whole system:

> If you feel good
> He is happy for you;
> If you are down
> He shares your grief.
> Once he has you in his sights
> An honest comrade is defenceless.
> When you're confused, he'll enlighten you;
> If you forget, he'll jog your memory.
> Gently, patiently he leads you
> Across the bridge of no return
> To the place of execution.[8]

The release of pent-up feeling was everywhere apparent in art between 1979 and 1981. In the National

21.3
Lin Gang and Ge Pengren, *Funeral of Zhou Enlai* (1977). Oils.

Art Exhibition of October 1979, a whole gallery was devoted to the events of 1976, beginning with the death and funeral of Zhou Enlai. A particularly striking work, without any precedent in Maoist China, was the large oil painting by Lin Gang and Ge Pengren (fig. 21.3), showing the catafalque approaching a group of mourners who express their grief with restrained intensity. (The model for the girl just to the left of Zhou's photograph was the painter Pang Tao, Lin's wife and the daughter of Pang Xunqin.) Many of the works in that exhibition depicted the seething crowds in Tiananmen Square, the sea of white wreaths, the young poets declaiming their verses. What we might call the "Mulan syndrome" (after the folk heroine who took her father's place and fought in the frontier wars) appears everywhere in the art of these years. Lovely girls lie dead or injured in these pictures, as in Luo Zhongli's *Song of the Constant Soul,* depicting Zhang Zhixin, a young martyr to Jiang Qing's torturers, carried in the arms of a companion, as it seems, up to heaven.[9] Many of these girls falling beneath the clubs of the not-too-clearly defined militia clutch white roses (symbols both of purity and of mourning) in their hands.

Ai Xuan's *Defending the Wreaths* (fig. 21.4) shows a girl with outspread arms at the foot of the Heroes' Memorial, her attitude identical with that of the Spirit of the Commune on Vauthier's memorial wall to the executed Communards of 1871 in the Père-Lachaise Cemetery in Paris. Ai Xuan told me he did not know Vauthier's work, which was published in *Meishu* at about that time, as was a lithograph of 1978, based on an old photograph, of the young Zhou Enlai with his revolutionary companions, standing before Vauthier's relief.[10] Ai Xuan later

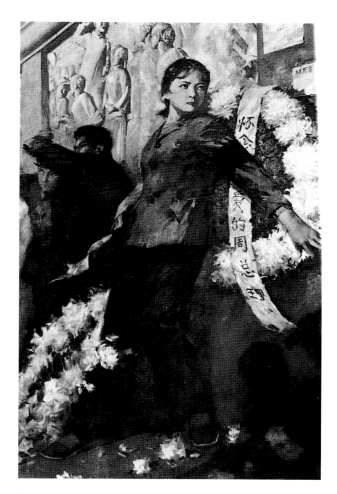

21.4
Ai Xuan, *Defending the Wreaths* (1978). Oils.

21.5
Wang Tong, *Youth* (detail) (c. 1980). Oils.

21.6
Gao Yi, *I Love the Oilfield* (c. 1980). Oils.

thought his painting crude, which it certainly is when compared with his later work, but it was a vivid expression of the drama of that day.

The apotheosis of Zhou Enlai became one of those necessary myths by which a culture sustains itself. Was he really a champion of artistic liberty? By no means. He was a dedicated Communist. Did he really protect the artists? He would not, or could not, prevent many of the atrocities of the Cultural Revolution—he was Mao's right-hand man, after all. But I was told that a quiet word from him led to the protection of an artist here, a temple or historic monument there. For Zhou to have opposed the Cultural Revolution would have been to ensure his own destruction; all he could do without exposing himself was to mitigate the lot of some unfortunate artists and writers. What is significant for post-Mao China is not what he achieved, but what he is believed to have stood for. His tragedy, and China's, was that Mao survived him.

As the reverberations of the Tiananmen Incident faded, artists began to recall the terrible decade that ended in October 1976. One popular oil painting, *The Orphan* by Luo Zhongli, showed a child kneeling on her bed, a broken violin beside her, gazing sorrowfully at a photograph of her father, obviously a musician who had fallen victim to the Gang.[11] If the events and emotions portrayed were not so real, this would be an example of kitsch at its worst. A haunting oil by Wang Tong (fig. 21.5) shows a little girl sitting alone amid the chaos of her home. Her parents are in jail, her elder brothers and sisters on the rampage, while with the keys around her neck she is mistress of what is no home any more. The look of utter desolation on this child's face would move all but the most stony-hearted. Much later, Wang Tong, studying in Connecticut, to her astonishment saw this painting reproduced in a Western magazine; she wrote to me that the child was herself.

The message of Gao Yi's *I Love the Oilfield* (fig. 21.6) is equivocal. Clearly, from the suggestion of sudden awareness of each other that passes between the man and woman, it is not the oilfield that this rather forlorn "sent down" city girl will be falling in love with. Nor is the maiden in a diaphanous dress in Huang Guanyu's *July* (plate 64) likely to be reading *The Thoughts of Mao*. The most popular picture in 1980 was Wang Hai's *Spring* (fig. 21.7), of which reproductions were sold by the thousand. It shows a girl standing at her cottage door combing her long hair (itself suggestive of freedom), while the swallows build their nest and her miserable cactus, having barely survived the long winter, puts out its first blossom. Mulan has taken off her armor, and stands dreaming of the future.

21.7
Wang Hai, *Spring* (c. 1978). Oils.

THE BIRTH OF DISSIDENT ART

The "art of the wounded," as it came to be called, was cathartic, but it did not end with dramatic pictures of the Cultural Revolution and the Tiananmen Incident.[12] The evils it exposed went to the very root of modern Chinese society, and dissidence, open or underground, from now on became a permanent feature of Chinese cultural life. In the spring of 1978, a daring group of young abstract painters who called themselves the Nameless (Wuming huahui) held a brief show in Beihai Park. Practically no one went to see it, and it was quickly forgotten. Another dissident group that flowered briefly called itself the Grass Society (Caocao). A far more daring group, the Stars (Xingxing), were already planning their first exhibition.

Through that never-to-be-forgotten summer, the bolder spirits among the young Beijing writers and artists

were meeting to press for artistic freedom. Geremie Barmé wrote at the time of a small courtyard near premier-turned-warlord Duan Qirui's Beijing residence on Dongshi Shitiao that had become the scene for the burgeoning unofficial culture of the city.

> Each Sunday afternoon anything from a dozen to forty young people would gather to talk, drink and sometimes dance. Everyone brought their own drink and victuals. It was one of the first independent cultural and political salons the city had seen for decades. . . . Apart from many members of the Stars, other people who were often in attendance were the editors and writers of *Today,* Bei Dao, Mang Ke, Chen Maiping. . . . Participants recall that during the gatherings the various groups tended to keep fairly much to themselves; people did not necessarily mix across the invisible lines drawn by background, affiliation and friendship. The members of the Stars and *Today* were often together, and the writers gave the first public readings of some of their works there. Bei Dao read *Waves* . . . and Ma Desheng (one of the leading Stars) performed "Maspeak" (*Mayu*), an incomprehensible one-man comedy routine for which Bo Yun [the painter Li Yongcun] acted as interpreter.[13]

The progressive artists and writers did not by any means have it all their own way. The first ominous signs that the Party was hunting down dissidents appeared in March 1979 with the arrest of Wei Jingsheng, who had insisted that the Four Modernizations could not be achieved without a fifth—democracy. In October, Wei was sentenced to fifteen years' hard labor. Before the end of March the Beijing Municipal Party Committee had ordered that public gatherings obey the police and had banned photographs, publications, and big-character posters that "opposed socialism." In July a Hebei journal called for the restoration of the essentials of Maoist literary dogma. Yet the writers and artists did not lose heart. Those who were sufficiently naive may have been somewhat reassured when, in his address to the congress of writers and artists, Zhou Yang publicly apologized to those he had unjustly persecuted, an adroit move which helped ensure his election as chairman of the All-China Federation of Writers and Artists.

THE STARS On September 28, 1979, the Stars, frustrated by the authorities' refusal to give them exhibition space, hung their paintings and sculptures on the railing outside the China Art Gallery.[14] None of them were registered artists, although several, including Yan Li and Ai Weiwei, son of the poet Ai Qing, had managed to get some training. Of the leaders, Huang Rui worked in a

21.8
The first Stars exhibition, Beihai Park, Beijing (1979). Wang Keping discusses his work with Liu Xun of the Beijing Artists Association.

21.9
Wang Keping, *The Silent One* (1978). Wood.

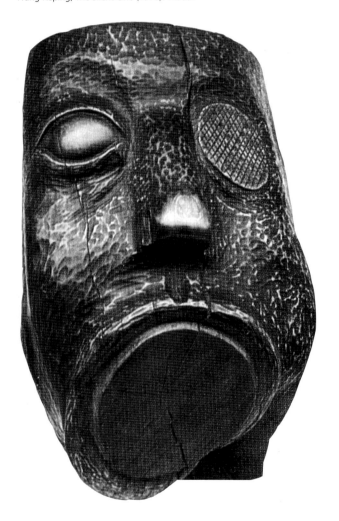

leather goods factory; Wang Keping wrote scripts for Beijing Television; Ma Desheng designed printed circuits in a research center. When the police came to order their works taken down, Wang Keping and Huang Rui challenged their right to do so. A small crowd gathered. An officer rashly suggested that the masses would have "some reaction," whereupon several bystanders called out, "We're the masses, and we think this exhibition is great!" When the artists were eventually forced to remove their work, the staff of the China Art Gallery gave it shelter.

On October 1, the courageous young Stars staged a march of protest to the offices of the Beijing Municipal Party Committee, headed by Ma Desheng under the banner "We demand democracy and artistic freedom!" They then moved on to Democracy Wall, where Ma addressed the crowd. To their delight and surprise, the Artists Association then arranged for them to hold an exhibition in four rather dark rooms of the Shufang Studio in Beihai Park (fig. 21.8). Although the *Beijing Daily* refused to carry their announcement, during the days that the exhibition ran (November 23 to December 2) it was seen by forty thousand people. When Huang Zhen, minister of culture and himself an amateur painter, was asked in reference to the Stars if art must still serve the workers and peasants, as Mao had insisted, he reportedly said that there was nothing wrong with art for art's sake, and added "I think you can produce just about anything today."

In the introduction to their show, the Stars wrote: "The shadows of the past and the brightness of the future are entwined to create the reality of our life today. It is our responsibility to be steadfast in our determination to survive, to remember every lesson."[15] It was the spirit that moved the twenty-three exhibitors, even more than the content of the show itself, that stirred the imaginations of those who saw the exhibition. Among the 170 paintings, graphics, and works of sculpture shown by the Stars, many were hardly avant-garde, although in the climate of the time anything less than orthodox was startling. There were a few nudes, abstractions, and semi-abstractions by Huang Rui, Li Shuang, and others, and imitations of avant-garde Western art, which puzzled their viewers and represented not so much a new movement as an urge to do *anything* that was different from the general run of accepted art. Far more telling was Wang Keping's powerful "absurd sculpture," as he called it, in wood, which fearlessly attacked censorship and the corrupt dictatorship of the Party. *The Backbone of Society* was a head with a nose but no nostrils, a mouth but no lips. *The Silent One* (fig. 21.9) was a mask of a man twisted and choking, with a cylinder stuffed in his mouth. *The Art Judge,* wearing his heart on his cheek, was a somewhat ungrateful satire on the very establish-

ment that had sanctioned the show. A head swathed in chains was entitled *Love.*

In August 1980, the Stars were given a room for their second official exhibition on the top floor of the China Art Gallery. So great were the crowds that they were soon allotted a second room. This time they had had more time to prepare, and the 130 paintings, graphics, and works of sculpture by thirty-one artists represented an altogether more substantial show. There were fewer nudes than in 1979, more abstract paintings, an almost surrealist collage by Qu Leilei. The note of oppression and of struggle for freedom was sounded in paintings and graphics by Li Shuang, Yan Li, and Ma Desheng (fig. 21.10), while Huang Rui's figure compositions and semiabstract townscapes (fig. 21.11) suggest an artistic rather than a political revolt. There were several paintings of the ruins of the Yuanmingyuan, the rococo buildings destroyed by Europeans in 1861, which had acquired a new association as a symbol of a desolate past and hope for the future. This peaceful spot, long popular as a meeting place for students, intellectuals, and lovers, was the setting for a memorable poetry reading organized by Bei Dao, who, with Huang Rui, had founded *Jintian* (Today), the literary journal which first appeared in Beijing as a wall poster on December 23, 1978.

Many of the paintings in this and less provocative exhibitions of the Peking Spring were full of hidden meanings, not simply to dodge the censor but because by obscurity the artists could express their sense that reality itself was dissolving, taking new shapes not yet fully understood—a counterpart in the visual arts to the trend of *menglongshi* (obscure or misty poetry).[16] But although the images and the symbolism might be obscure, the message was plain. Bei Dao's poem *Our Every Morning Sun,* inscribed on a painting by Huang Rui in the second Stars exhibition, sounds a note of hope:

> . . . Fear and pain that tremble in the wrinkles'
> folds
> Hearts no longer hide behind curtains
> Books open windows, and let birds fly out freely
> Ancient trees no longer snore, no longer bind
> The children's nimble legs with withered vines
> Young women return from bathing
> Trailing stars and a broad moonbeam
> All of us have our own names
> Our own voices, loves and longings
> The iceberg in a nightmare
> Melts in the early morn, while from the linger-
> ing night
> We lead out our shadows
> May the heavy memories underfoot
> Gradually fade as we walk
> On the horizon of hands joined to hands
> Every story has a new beginning
> So let's begin[17]

21.10
Ma Desheng, *Landscape* (1980). Ink on paper.

21.11
Huang Rui, *Listening to Music* (1980). Oils.

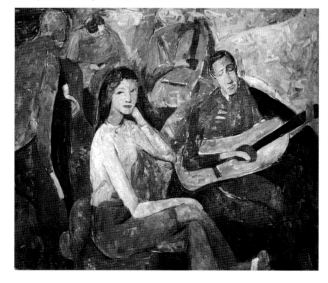

But other poems strike a very different note. Jiang He's *Unfinished Poem,* printed in the second Stars catalogue, seems to presage the terrible events of June 4, 1989:

> I am dead.
> Bullets left in my body holes like empty sockets.
> I am dead,
> Not to leave behind whimpering or weeping to
> impress people,
> Not to let a lone flower bloom upon a tomb.
> National emotion is already too full, too rich.
> The grasslands are drenched with dewdrops.
> Rivers flow, every day, towards the big ocean,
> Like old, old wet emotions.
> Can we really say that we lack emotion and have
> not yet been moved enough?
> I am nailed to this prison wall.
> The hem of my clothes rises to the winds
> Like a flag about to be raised.[18]

The organizers of the second Stars exhibition kept a "Golden Book" for visitors to express their views. Not all were complimentary. "You shouldn't be too abstract," wrote one. "You should be more careful, and take the masses into consideration." Another, more contemptuously: "If you want to understand this, go to a lunatic asylum." But even *Meishu* reported that seventy percent of the comments were favorable. One note read: "Wang Keping, we congratulate you on your daring. Compared with you, the professional sculptors of China are like walking corpses." Another asked, "Have the Chinese people really gone dumb? No, I have seen that the Chinese people's spirit is still alive. This is the best exhibition since 1949."[19] For many viewers, young people who knew nothing about art, it was not the quality of the works to which they responded but the message of freedom and defiance of authority. Later, in Chengdu, an older, conservative painter remarked to me that what was important was not whether the works were good or bad but that the authorities had allowed the exhibition to take place at all. Another conservative artist in Nanjing thought it was good that these young artists expressed themselves, but few had had any training, and "we older painters wish that they had more tradition behind them."

When I asked Jiang Feng why the Artists Association had permitted an exhibition which so blatantly violated the official line on art, he replied, "When the artists discover that no one wants to see their work, they will admit their error, and change their ways."[20] In fact the tremendous success of the event, together with the hardening of the Party line that took place that autumn, ensured that there would be no more Stars exhibitions. By 1981, in any case, the group was dissolving. Within a few years Wang Keping and Li Shuang would be in Paris, Ma Desheng in Switzerland, Huang Rui in Tokyo, Ai Weiwei and Yan Li in New York, Qu Leilei in London. But despite the severe setbacks to come, something irreversible had happened: art had found a new role in China, and for the first time since Liberation artists had acted spontaneously. The French poet Julien Blaine, who met many of the Stars and writers for *Today* at the 1979 exhibition, put it well when he wrote, "It is important to understand the wild energy that enabled them to create or recreate the history of art in five years. Cut off from their ancestral roots by the Cultural Revolution, they looked to the West and in a few months reinvented everything: fauvism, cubism, impressionism, surrealism, Dada, expressionism, pop-art and hyper-realism. And through this reconstruction, which will doubtless be repeatedly criticised, banned and suppressed, they are on the way to finding an identity. This identity is for the future, truly for the future, whatever may happen."[21]

The Stars and the dissident writers of *Today* caught the attention of the world, but they represented only a tiny minority, on the fringes or perhaps at the very narrow cutting edge of contemporary Chinese culture, and their importance should not be exaggerated. Indeed, the attention they received from foreign observers and critics with a nose for trouble was unfortunate, as it inspired many lesser artists in the 1980s to do and make outrageous things simply in order to catch the attention of foreigners. In the meantime the mainstream of Chinese painting flowed on, less defiant—and more accomplished—artists blossoming in the warmer climate after the chaos of the Cultural Revolution. There were to be icy gusts to warn them of winter, and the certainty remained that winter would one day come again, but, as one painter remarked to me in Chengdu in 1980, "We live from day to day. All we can think of is that we feel freer now. What tomorrow will bring, no one can tell."

THE 1980s:
NEW DIRECTIONS

CONFLICTING SIGNALS FROM AUTHORITY

From Liberation until 1979, there was to all intents and purposes one artistic mainstream in China, positive and inspirational in content and conventional in style. It embraced all art that was approved or tolerated, while freer forms of artistic expression were so rare as to be hardly significant. But from 1979 what Hua Junwu disparagingly called "undirected art" became a band in the spectrum that, though never very wide, shone with a special (if erratic) brilliance and could no longer be ignored. For the first time since Liberation, a handful of artists were acting publicly outside the established artistic order. It soon became clear that the Party was deeply divided about how to deal with this new phenomenon. The vacillations of official policy over the next ten years would make tedious reading were it not that they created the shifting climate in which artists were forced to work.

At the Third National Meeting of the Artists Association in November 1979, Jiang Feng had insisted that art must have "collective leadership" and that the tradition of revolutionary art that serves the people must not be forgotten, and he deplored the lack of respect for paintings done by peasants and workers. But another speaker at that meeting said that artists' rights should be respected, even that they should have lawyers to guarantee their rights and freedoms.[1] The issue of *Meishu* that reported the meeting also carried an article by Wu Guanzhong urging that outdated restrictions on artists be abandoned and welcoming an exhibition by young artists that had to do with "the liberation of people's minds."

Subsequent numbers of *Meishu* kept up the liberal tone, and aesthetic issues were freely debated. In March 1980, Xiao Daqian upheld the nude. In the ancient Greek Olympics, he says, men and women ran naked. "They could do this because their culture was very advanced and the political system free and open." Wu Guanzhong pleads that the study of the nude is "scientific" and cunningly suggests that young Chinese painters who have never worked from nude models produce, by default, a kind of abstract art, "which people unreasonably object to." But, he says, "Don't exhibit everything in public places. People won't understand it and will think it low and cheap." Moreover, "Don't be *conscious* that you are painting a naked woman: that way harms art." Ye Qianyu, who may be regarded as a moderate orthodox artist, reminds his readers how in the 1950s paintings had been divided into three kinds: beneficial, harmful, and not harmful. Landscapes and birds and flowers were "not harmful," but one shouldn't paint too many of them. Abstract or expressionist works were of course harmful. Now, he says, all that must change: "Whether beneficial, harmful, or not harmful—what does it matter? In our time we should try some 'unlawful' things to know why they are called harmful."

With the open expression of such opinions, it was clear that a momentous change was coming. Obviously worried about this, Xu Yang in the same issue of *Meishu* warns that the painter must not just express what he or she feels but must be with, and feel with, the people. He sees danger ahead: "We are running towards the crossroads."[2]

Deng Xiaoping, in his speech to the January 1980 meeting of the Eleventh Central Committee, had justified the purge of artists and intellectuals in the Great Leap Forward. He maintained that the right to speak out freely, hold debates, and write wall newspapers guaranteed by Article 45 of the Constitution "had never functioned effectively" and recommended therefore that this article be struck out![3] At a September meeting of the People's Congress, thirty-two hundred out of thirty-four hundred delegates obediently voted to abolish it.

February 1981 saw further directives from Deng Xiaoping curbing dissent, and advice to writers to stop producing the "literature of the wounded." In June, the Sixth Plenum of the Eleventh Central Committee officially put an end to the liberal policy of the Third Plenum, and the Democracy Movement was crushed.[4] In August, a long speech to propaganda officials, "workers in art theory," and the press by Hu Qiaomu (now president of the Academy of Social Sciences) spelled out the limits of free expression, insisting that the "New Hundred Flowers" should not be interpreted as including embracing "bourgeois liberalisation."[5] In September, the editor in chief and deputy editor of the *People's Daily,* who had supported the liberal policy, were dismissed, and many who had demanded human rights were arrested and given long prison sentences. In October, Bai Hua, producer of the never-released film *Unrequited Love,* the story of a patriotic painter who had returned from the United States at Liberation only to be horribly mistreated in the Anti-Rightist Campaign of 1957, was forced to confess his errors.[6]

Through 1982 and much of 1983, the signals from the top continued to be contradictory. While Hu Qiaomu was taking a very hard line, Zhou Yang in June 1982 was reaffirming the role of the arts in strengthening China's "spiritual culture," urging a moderate course, and even going so far as to defend disco as a part of popular culture. Party Secretary Hu Yaobang said that "in no way should we call a defective work of art counter-revolutionary" (though he does not say what he means by "defective") and appealed to artists, who by now must have been utterly at sea about what was permissible and what was not, to rid themselves of any "unjustified sense of insecurity."[7] It was Hu Yaobang's essential humanity and (within Party ideological limits) reasonableness that brought about his downfall five years later. His successor, Zhao Ziyang, was to be disgraced for the same failings in June 1989.

In the same month that Hu Yaobang was extending his protective arm over the artists, Deng Liqun, director of the propaganda department of the Central Committee, launched a harsh attack upon "spiritual pollution." During the next six months, writers and artists came under heavy fire, being singled out by name in the press; Yu Feng was thrown into a panic early one morning when she heard herself denounced on Beijing Radio for having published an article in Hong Kong in praise of Zao Wou-ki, who was holding an exhibition in Beijing. By May of 1983, artists and writers began to fear that the "struggle session" methods of the Cultural Revolution were coming back again, and for several months the cutting edge of creative life was severely blunted.[8]

After lengthy debate in the Party, the Anti–Spiritual Pollution campaign was sharply curtailed in January 1984—partly because it had been carried to such absurd lengths that it had become a joke. Some artists felt that the atmosphere remained less free than it had been before the campaign started. And how long would the thaw last? In the meantime, however, independent art acquired a momentum of its own, and 1984 saw some remarkable developments, among them the appearance of performance art, neo-Dada, and a one-man show of surrealist paintings. These activities went hand-in-hand with student demonstrations demanding more freedom.

Predictably, though, the pendulum continued to swing back and forth. In December 1986, the government launched a new anti-liberal campaign, and for a while all artistic exchanges with foreign countries were stopped. Nineteen eighty-seven began with huge student demonstrations. Hu Yaobang, who would neither support the students nor suppress them, was dismissed as Party Secretary and forced by Deng Xiaoping to write a confession; but then again the reins were slackened. The arts flowered through 1987 and 1988, putting out some exotic blossoms, notably the highly controversial exhibition of the nude staged by the Central Academy in December and the even more sensational exhibition of avant-garde art mounted in Beijing in February 1989 (discussed in chapter 25). Late in 1988, a strongly antiliberal document on the arts was adopted by the Central Committee of the Party.[9] Before it could be put fully into effect, though, the surging tide of student protest and the call for artistic freedom and democracy swept forward, reaching a tragic climax on the night of June 4, 1989, in the slaughter on the streets of Beijing.

OFFICIAL EXHIBITIONS

While independent art became an increasingly tolerated part of cultural life, the Artists Association continued to promote the orthodox mainstream through its exhibitions. The pages of *Meishu,* the official organ of the art establishment, often reflected current political priorities. When in February-March 1979 China rashly embarked on a short, sharp war with Vietnam, suffering twenty thousand killed, *Meishu* responded by carrying articles

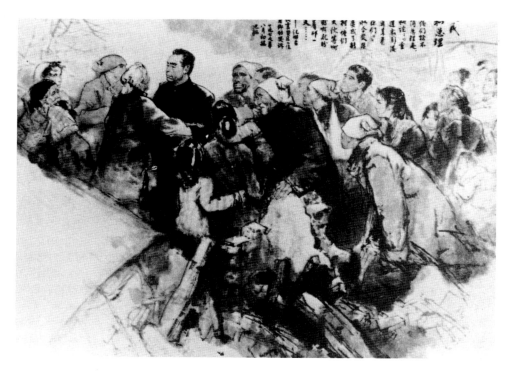

22.1
Zhou Sicong, *Zhou Enlai among the People* (1979). Ink and color on paper. Prizewinning picture at the Thirtieth Anniversary Exhibition of the People's Republic.

and paintings extolling military heroism, the army and the people, art and war.

In the autumn of that year the Artists Association staged a huge exhibition to mark the thirtieth anniversary of the People's Republic. Over 2,400 artists submitted work; 615 pieces were selected, by 470 artists, professional and amateur. Seven issues of *Meishu* featured the exhibition, concluding in May 1980 with reproductions of the eighty-two prizewinning works, almost all of which were orthodox oils, guohua, sculpture, woodcuts, and other graphics. First prize went to Zhou Sicong's painting of Zhou Enlai among the people (fig. 22.1), second to a collaborative picture of two young characters in the popular serial *Maple,* in poses and style borrowed from Norman Rockwell.[10] Among the prizewinners were several works inspired by the Tiananmen Incident—almost the last time that paintings on this unsettling subject were given the stamp of Party approval. Officially, the period of catharsis was over.

The purpose of official exhibitions was to accentuate the positive. In December 1980, the second National Youth Exhibition featured 554 works, of which 153 won prizes, a popular choice being Ai Xuan's *With High Aspiration,* a study of a girl on crutches standing reading by the bookshelves in her college library.[11] The sensation of the show was undoubtedly Luo Zhongli's gigantic,

meticulously painted head of a worker, *Father* (discussed below), which launched the new Sichuanese school of superrealism with great éclat. This exhibition was notable for its richness and variety of style and subject matter.

In November 1981 the China Art Gallery staged the first exhibition of the newly refounded Chinese Painting Research Society (Zhongguo guohua yanjiu hui). Many old masters attended a meeting at which the venerable Marshal Ye Jianying exhorted them to uphold tradition. The three hundred works shown included, for the first time, paintings from Taiwan and Hong Kong. Meantime, the National Minorities Institute in Beijing continued to foster, to "guide," and even to create the art of the national minorities, sponsoring a huge exhibition in February 1982. Peasant art, also supported and guided by the art academies, was the focus of a show in October of works by 306 artists, one hundred of whom were given prizes. Exhibitions such as these were largely ignored by serious young artists of the "New Wave," discussed below.

The Anti–Spiritual Pollution campaign launched by Deng Liqun in June 1983 led to a major exhibition that autumn of historical and propaganda art, which must have been hastily organized, as it was not previously announced in *Meishu.* Prizewinning pictures predictably extolled patriotism, support for the army, science, health,

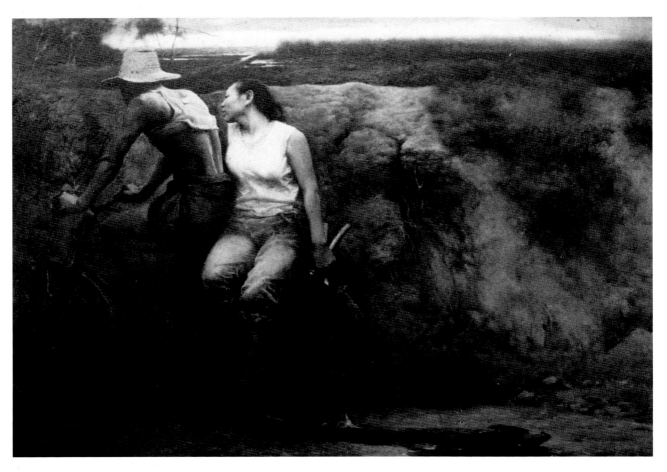

22.2
Wang Yuqi, *In the Fields* (1984). Oils.

the one-child family, and even the protection of antiq-
uities—a sure indication that that was something that
could no longer be taken for granted as it had been in
the early years after Liberation.[12]

Far more ambitious was the Sixth National Art Ex-
hibition of October 1984, in celebration of the thirty-
fifth anniversary of the founding of the People's Re-
public.[13] A large selection committee was headed by Wu
Zuoren (though he was a mere figurehead) and Hua
Junwu. The range of works exhibited was far wider than
in any previous exhibition, and although the subjects of
the prizewinning pictures were predictable, the standard
was much higher than before. Of the nineteen gold
medals the first went to a heavy, impressive study of sol-
diers by Yang Lizhou and Wang Yingchun, the second
to an elaborate guohua composition inspired by the Dun-
huang banners, the fourth to an oil of a small boy gaz-
ing at a notice board covered with drawings of space-
ships, in the manner of Norman Rockwell. A series of
illustrations to Lao She's *Crescent Moon* (see plate 36)
earned Li Quanwu and Xu Yongmin a well-deserved
gold medal, while another, in the sculpture section, went
to Yang Dongbai's ingenious and beautifully fashioned

polar bear and its reflection carved in white marble (see
fig. 16.12). *Spring Snow* by Wu Guanzhong was high on
the list of silver medals, but Wang Yuqi's moving, Mil-
letesque *In the Fields* (fig. 22.2), showing workers bicy-
cling home dirty and exhausted from a day's work in the
fields, only merited a bronze. Seven special awards were
given to artists from Hong Kong and Taiwan, including
Liu Guosong and the sculptor Van Lau (Wen Lou).

Although this exhibition was a great advance on what
had gone before, it left few artists happy. Indeed, the
whole unwieldy apparatus of official exhibitions, under
the all-seeing eye of Hua Junwu, did more to stifle art
than to encourage it. Selection committees were huge,
cliquish, and divided between the cultural apparatchiks,
who insisted on political and ideological criteria, and the
professional artists, who were concerned with aesthetic
standards. In the Sixth National Exhibition, for exam-
ple, a series of dreadful equestrian portraits of military
men, painted as *nianhua,* earned its several perpetrators
gold medals, while the artists among the jury had their
say with the medals for Wu Guanzhong and Wang Yuqi.

Serious artists might dislike these shows, but they could
not afford to ignore them. Private galleries were forbid-

den, so the official exhibitions gave them their only chance of exposure. Having lost so much of their work in the Cultural Revolution, however, they were reluctant to send in their best. To be sure of acceptance they had to play it safe with works that were bland, positive, and uncontroversial. Experiment was out of the question. I called on Cheng Shifa when he was trying to complete a large composition for the national exhibition of 1984. It showed an Overseas Chinese gentleman with his granddaughter, a local peasant, and his children, standing side by side looking up at an ancient tree. It was entitled *Ten Thousand Generations from One Root.* Cheng Shifa's heart clearly was not in it, and he was stuck. Years later he told me that he had finally managed to finish it and it had ended up in a government building in Fuzhou.

The art academies put on regular shows of the work of staff and students. In October 1985, for example, the Central Academy held the annual exhibitions of the oil painting and wall painting research departments; in November it was the turn of the guohua artists, and in December came the annual general exhibition. The academies also celebrated anniversaries, real or imaginary, with special exhibitions, but they were ceremonial occasions, of no artistic significance whatever.

PUBLIC WORKS: WALL PAINTING

In China, as in other Communist countries, the state has been the chief and often the only patron of the arts. To be honored with a commission, especially for a large wall painting in a public place, was a step toward the recognition, even fame, that artists so desperately desired, although they had little or no freedom in style or subject matter. We have seen how Huang Yongyu took on the design for the tapestry in the Mao Mausoleum when none of the established artists would risk their reputations with it. Even in less sacred projects, the risk of failure was great.

While the new Beijing International Airport was under construction in 1979, Zhang Ding, who had only recently returned from the disciplinary rigors of a May Seventh Cadre School, was asked by the airport authority to put together a team of artists to decorate the public halls and restaurants. There was to be no propaganda, just landscapes and scenes from mythology and daily life. Although none of the artists chosen had attempted anything so ambitious before, on the whole the results were successful.[14] Zhang Ding himself took as his theme the legend of the boy hero Nezha, who defeats the Dragon King of the waters and saves China from flood. His panel, painted on dry plaster, draws upon traditional figure painting, while from the Dunhuang frescoes he borrows both the archaic landscape style and the symmetrical composition. Zhang Ding has made a successful animated film, and his admiration for Walt Disney shows in the lively movement and humor of his painting.

A panorama of the mountains and rivers of Sichuan, painted in acrylics on panels and decorating a wall of one of the restaurants (plate 65), is the work of Yuan Yunfu, who had studied in Hangzhou and later joined the staff of the Central Academy of Arts and Crafts. During the Cultural Revolution he spent three years in the countryside with Wu Guanzhong, and in 1973 he had been one of the artists recalled in Zhou Enlai's ill-fated initiative to decorate the Beijing Hotel. Now, in 1979, he was at last given a free hand. He brilliantly combined traditional technique with realism in the details. The panels can be viewed as a whole as a satisfying, if very formal, composition. When in 1981 he painted for the lobby of the Jianguo Hotel a very long panel depicting the time-honored *Ten Thousand Miles of the Yangzi,* he treated it appropriately as handscroll, which should properly be viewed a little at a time.[15]

The Dunhuang frescoes, with their attenuated maidens and flying Apsarases (godlings), were also the inspiration for *The Tale of the White Snake,* painted in oil on canvas by Li Huaji and his wife, Quan Zhenghuan, both trained in Beijing. The composition is weak, and Li Huaji at least is capable of more accomplished work. Of the same quality is Xiao Huixiang's *The Springtime of Science,* executed in glazed tiles, in which figures representing the arts and sciences disport themselves playfully amid orbs symbolic of atomic nuclei and the heavenly bodies.

The most successful—not only because it was the most controversial—of the airport decorations is *Song of Life* (plate 66) by Yuan Yunsheng, Yuan Yunfu's brother. It depicts the water-splashing festival of the Dai people of Xishuangbanna, an autonomous district of Yunnan that has long been a mecca for Chinese artists, drawn there by the tropical luxuriance of the landscape, the picturesque villages, and the beautiful women. Yuan Yunsheng's composition is richly conceived, full of action and incident, yet revealing a true sense of design. Of the slender girls splashing each other in the purification ceremony, two are nude. This was the first time nudes had been permanently displayed in a public place (even if only for the eyes of foreigners), and it caused a furor. Party officials in Xishuangbanna alleged that the Dai people had objected to them, although they had not. The offending section of the wall was curtained off, and in the Socialist Morality campaign of March 1981 paneled over.

Authorship of the mural is somewhat controversial as well. During Yuan Yunsheng's long exile in the northeast, he had been taken care of by an old friend, the decorative artist Ding Shaoguang. According to Ding, it was he who first brought Yuan to Yunnan, where he had

22.3
Ding Shaoguang, *Village Scene in Xishuangbanna* (1970s). Ink on paper.

been accumulating a mass of drawings and sketches of the Dai people, and when Yuan was given the airport commission he drew heavily on Ding's material: some details of his fresco seem to correspond to drawings that Ding published shortly before leaving for the States in 1980 (fig. 22.3). But Ding Shaoguang later claimed that Yuan had never given him any credit for his help, and was very bitter about it.[16] By 1983, Yuan Yunsheng was artist in residence at Tufts University, where he painted a huge mural based on the Nugua myth in a rather crude manner, inspired partly by Michelangelo and Blake, and by 1984 he was working on another for Radcliffe College.[17]

Another ambitious project of this fruitful period was the mural painted in 1980–82 on the end wall of the main dining room of the Beijing Hotel by Liu Bingjiang and his wife, Zhou Ling, both on the staff of the National Minorities Institute. At the Central Academy Liu Bingjiang had been a student of Dong Xiwen, with whom he had visited Dunhuang. He later travelled extensively in the southwest, Tibet, and Xinjiang, collecting a vast number of drawings and sketches. The huge mural in the Beijing Hotel, *Creativity Reaping Happiness* (plate 67), presents in encyclopedic wealth of detail the whole world, it seems, of the Han Chinese and the national minorities, traditional and modern, rural and urban. The fresco is perhaps a little too overloaded to be completely successful as decoration, but it is a major achievement nonetheless.

These were by no means the only decorative projects carried out in the Peking Spring and after. Wei Jingshan decorated the Hall of Physical Education in Shanghai with appropriate figures. Yuan Yunfu designed a huge symbolic landscape in ceramic tiles for the Academy of Social Sciences in Beijing. The debt to Dunhuang is nowhere more obvious than in the two wall paintings on the theme of the fertile earth and how it enriches our lives, by Li Tanke, Li Jianqun, and others, in the Gansu Hall of the Great Hall of the People, but the artists nevertheless manage to give these panels a modern feeling, with great charm and elegance. Li Huaji and Quan Zhenghuan did a mural in 1981 for the Yuyuantan Park in Beijing, and in the following year Li created a series for the new Beijing Library on the highlights of Chinese culture. Together they also made a pretty mural for the Chinese Cultural Center in New York.

Many local municipalities took their cue from Beijing, decorating public buildings with the aid of local talent. A successful example is the waiting hall of the bus station in Hefei, Anhui, which Bao Jia and his students adorned with a huge panorama of—inevitably—Huangshan (fig. 22.4), while on the opposite wall they put that most hackneyed theme, the Huangshan Guest-

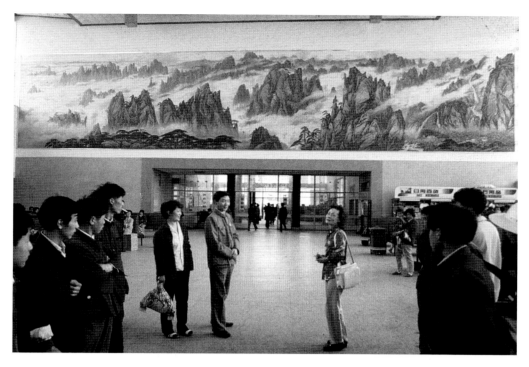

22.4
Bao Jia, *Panorama of Huangshan* (c. 1982). Wall painting in bus station in Hefei. In the foreground, Pang Tao, Bao Jia, and Khoan Sullivan.

Greeting Pine. The treatment may be conventional, but such decorations came as a very welcome change from the propaganda paintings that people had hitherto had to put up with.

NEW GROUPS AND MOVEMENTS, 1979–83

Although the Chinese Artists Association would have preferred to initiate all art exhibitions, by the end of the 1970s the number of artists of all sorts who wanted exposure was causing the stream of art to overflow its official banks. For some time Hua Junwu was able to contain the flood by granting exhibitions to independent artists who came together linked by a common aim, ideal, or background and petitioned the association to be allowed a show. These groups and movements came and went with bewildering rapidity. There was of course the Scar Wave (*shanghen chao*), visual counterpart of the Scar Literature inspired by the Cultural Revolution. There were the Life Stream (*shenghuo liu*), the Bitter Past Trend (*kujiu feng*), the Cherish the Moment Trend (*huaisi feng*), and the Romantic Craze (*fengqing re*), while art-for-art's-sake had its advocates also. To express their exhilaration, young artists seized upon any and every Western art style and movement they could discover in books and magazines, from Impressionism to Dada and Surrealism. It mattered not whether these styles were understood; what mattered

was that they vastly enlarged the Chinese artists' expressive language and enabled them to say things that had been forbidden for thirty years, to be up-to-date, to catch the attention of foreign visitors, and to feel themselves in some way a part of the stream of international modern art.

Among the first signs of this new creative impetus in Beijing was the New Spring Art Exhibition (Xinchun huazhan), sponsored by the Artists Association and the Zhongshan Park authority in February 1979, in which over forty oil painters showed landscapes and still lifes. The participants—young, old, and middle-aged—ranged from Liu Haisu (eighty-two years old), Pang Xunqin (seventy-two), and Wu Zuoren (seventy) to recent graduates, including Cao Dali and Feng Guodong. So successful was this event that by the summer the group had consolidated as the Beijing Oil Painting Research Association (Beijing youhua yanjiu hui), or OPRA for short.[18]

OPRA's big October exhibition in Beihai Park subsequently went on tour to Canton, Wuhan, Changsha, Hefei, Hangzhou, and Shanghai. Although stylistically it was hardly avant-garde—there were no pure abstractions, and of course no direct protest art—the inclusion of a few nudes and expressionist and semisurrealist paintings, such as Feng Guodong's tortured self-portrait (plate 68), made the show controversial enough. Jiang Feng,

the newly appointed chairman of the Artists Association and an ideological and artistic conservative, at first opposed the New Spring group, but he swung around to support them and wrote an encouraging foreword to their show. This exhibition was significant not for its content but for the fact that, after thirty years during which no "undirected" artistic activity had taken place, a group of artists, by no means dissidents, had staged an artistic event on their own initiative and won official approval for it.

This was the signal the artists had been waiting for, although in fact the first stirrings had already been seen in Shanghai a few months earlier. Late in 1978, a cultural center had put on small show of work by former "black" artists, including Liu Haisu, Lin Fengmian, and Huang Yongyu—the first time their work had been seen in public for more than twelve years. Out of this little show grew a group of young graduates from Shanghai and Hangzhou calling themselves the Twelve, who mounted their own exhibition in the Shanghai Youth Palace early in 1979.[19] Out of the Twelve came the Grasses (Caocao), whose show, "Painting for the Eighties," was held in the Shanghai Luwan Cultural Palace in February 1980. The exhibition, dominated by the work of Qiu Deshu and Guo Runlin, included cubist and expressionist works, Pollock-like abstractions, symbolism, play with archaic calligraphy, and a nude, which was withdrawn to head off trouble from the authorities. The range of works showed no clear aim or direction, but the insatiable hunger to tear down walls and to explore new ways of painting was evident. No official body in Shanghai was prepared to sponsor this highly controversial show, and when it closed the group dissolved. Meantime, far away in Quanzhou, the Southern Fujian Art Group flourished briefly at this time, more in touch through their Overseas Chinese contacts with art in Hong Kong, Southeast Asia, and the Philippines than with trends in Beijing and Shanghai. Other modern groups were formed in Xi'an and the northwest.

In 1980 the Contemporaries (Tongdairen) persuaded the Artists Association to sponsor their first exhibition in Beijing.[20] Most of these young men and women had been classmates in the middle school of the Central Academy. Unable to study at the Academy in the mid-1970s, they stayed together, studying Western art, particularly Matisse and Klimt, from books and old magazines. They included a number of artists who became well known in the 1980s: Zhang Hongnian, Wang Huaiqing (plate 69), Sun Weimin, Li Zhongliang, and Zhang Hongtu. They went their several ways in 1982.

Another group founded in 1980 that also had a short life was the Monkey Year Society (Shen she), so named because 1980 was the year of the monkey. It was formed in remote Kunming by artists whose work often featured the minority people of the southwest.[21] In the following year ten artists from the southwest, prominent among them Liu Ziming and Yao Zhonghua, earned national recognition by being granted a show at the China Art Gallery, although the Artists Association, presumably reluctant to acknowledge their independent origin, did not mention the name Shen She. Several of these Yunnanese painters, among them Jiang Tiefeng and Ding Shaoguang, followed Huang Yongyu in painting thickly on both sides of tough Korean paper (gaolizi), which gave their color added depth and brilliance. These "Modern Heavy Color Painters," as they called themselves, were inspired not only by contemporary Western art but also by the tradition of Chinese decorative art, by the Dunhuang wall paintings, and by the batik designs and rich embroideries and jewelry of the southwestern minorities.

SOME LEADING OIL PAINTERS

In 1959, an oil-painting studio had been opened in the Central Academy under Wu Zuoren.[22] At first it bore his name, but it became known as the First Studio in the 1960s when the Second and Third studios opened. They were closed in the Cultural Revolution and not reopened until 1980, when Wu Zuoren had retired and the teaching at the First Studio was in the hands of Ai Zhongxin, Feng Fasi, and Wei Qimei, who, like Wu, stressed the more orthodox European and Soviet techniques. The Fourth Studio, which claims to be more responsive to modern trends, was not opened until 1986; its teachers include Ge Pengren (plate 70) and Lin Gang, who had collaborated on the Zhou Enlai funeral picture; Wen Yidou's son, Wen Lipeng; and Lin's wife, Pang Tao (plate 71), the most original, experimental, and unpredictable of this group. With few exceptions (Pang Tao was one), the products of these four studios could be said to represent the acceptable range of styles in the 1980s.

Indeed, few of them broke new ground. Many socialist realists continued to work in a style unchanged—indeed, incapable of change—for there was always a demand for propaganda paintings. Others blossomed. Hu Yichuan began to develop a new freedom in his technique. Feng Fasi, once an impressionist and later a realist, became a (cautious) impressionist once again. Lin Gang tried combining new techniques with old ideas—heroic workers and memories of the Long March, for example—though he only achieved any real individuality in his guohua paintings. Wu Zuoren, seventy-two when his studio reopened in 1980, still painted the occasional picture in oils, as did the seventy-three-year-old Pang Xunqin, whose flower paintings recovered their old warmth and serenity.

Among middle-aged painters, the Tianjin artist Hou Yimin, who had established himself as a painter of propaganda pictures, now lightened his touch and turned out attractive and very skillful portraits and figure studies, chiefly of the minority peoples. Jin Shangyi, born in Henan in 1934 and a student of Maksimov, never ventured beyond a solid academicism. His nudes, figure subjects, and portraits, such as his characteristic study of his friend Huang Yongyu with pipe in hand (fig. 22.5), are both conventional and accomplished.

Much of the oil painting of this first phase of the modern era has been described as experimental—but it was experimental only by comparison with what had gone before. Little of it was daring or avant-garde.[23] It was rather as if these artists, having been in uniform for thirty years, were putting on their first "civvies," trying on a number of styles and fashions in front of the mirror to see what suited them best. Some found what they wanted, and their styles became unaffected expressions of their personalities: the early work of Wang Yidong, for example, is admirably direct. In his *Shandong Peasant Girl* of about 1983 (plate 72), we find no smiling labor heroine but a poor, plain country girl, painted with a feeling and tenderness worthy of Millet, that is lacking in his later and more technically accomplished paintings. Others seemed to cast about, to assume a style or series of styles less from conviction than from a desire to be in fashion, or to establish some kind of identity in a world that was becoming rapidly overcrowded.

Of the artists who exhibited with OPRA we should mention Chen Yifei and Zhan Jianjun, who was born in Liaoning in 1931, had been a pupil of Maksimov, and was now a professor at the Central Academy. He travelled widely, notably in Xinjiang, and in 1982 he had even been sent by the Artists Association on a painting tour, in company with Wu Guanzhong, to Mali. ("Why Mali?" I asked Wu Guanzhong. "Because it was cheap," he replied.) Zhan Jianjun's work of the 1980s, heavy in color and somewhat labored in technique, seems to be striving for something striking and substantial that has no clear aesthetic purpose behind it. His portraits, by contrast, notably that of Xiao Mi (plate 73), are admirably honest and direct. Huang Guanyu, born in 1949, was another artist who tended to load his canvases with thick paint. Much of his work is decorative. His best-known and most popular painting, perhaps because it is so evocative of the warmth of the new era, is *July,* a richly painted study of a slim girl in a white dress reading against a background of flowers in the manner of Gustav Klimt, whose work had been featured in *Meishu* in May 1980.

The challenge for artists at this time to attempt everything, to be officially accepted and yet be different, can be seen in the work of Zhang Hongnian, born in Nan-

22.5
Jin Shangyi, *Portrait of Huang Yongyu* (1981). Oils.

jing in 1947. In the early 1980s he was painting skillful portraits; ambitious orthodox compositions such as *Deep Feeling for the Land,* which expresses no feeling at all; heavy Tibetans, then much in vogue; and pictures that strove to be deep and meaningful, such as his autobiographical *Thinking of the Source* of 1981. He told me in 1984 that he admired Chagall more than any other Western artist, but that one could not exhibit that sort of picture in Beijing.

Li Zhongliang was another Beijing artist who was painting heavy Tibetans in the early 1980s, but he also painted nudes, and an alluring girl in caminickers—acceptable, he told me, because she was a well-known dancer. More impressive were his small illustrations in oil to stories by Lu Xun (fig. 22.6), pictures so intense, so accomplished, so close to the spirit of *Ah Q* and *The New Year Sacrifice,* that one is left wondering how an artist who could paint with such honesty and lack of pretension could also be so slick and superficial.

Liu Bingjiang, born in Beijing in 1937, had studied under Dong Xiwen at the Central Academy before being sent to Sichuan in 1964 to do propaganda work for the central government. He met and married Zhou Ling when both were members of the art department of the Central Nationalities Institute. During the Cultural Revolution, they were separated for many years. In 1979 Liu Bingjiang was a founding member of OPRA; in their first exhibition he showed a kneeling nude, inspired, it has been suggested, by a calendar pinup from Southeast

22.6
Li Zhongliang, *The New Year Sacrifice* (c. 1982). Oils.

Asia. By the early 1980s he too was working in several styles. Perhaps in his strongly painted *Little Girl* with her teddy bear we may find an echo of Kishida Ryūsei's famous series of portraits of his daughter Reiko.

Yuan Yunfu was one of the younger artists trained in Hangzhou in the European rather than Soviet style, although he made his home in Beijing.[24] In the 1970s, banished among the peasants of Hubei, he was painting village scenes full of sunlight with a sure sense of design and color. In the mid-1980s he even experimented with abstraction, cautiously naming a composition of flat rectangular patches of color *Flags*. He later became an important figure in the wall painting program and a powerful designer of tapestries.

Cao Dali was born in Beijing but grew up mostly in Indonesia, returning to China in 1955.[25] By the time he graduated from the painting division of the Central Academy in 1961 his early devotion to Gauguin had given way to the orthodoxy of his teacher Wu Zuoren. For years little was heard of him, but published works of the post-Mao era, such as his *Bali Spirit* (1979) and a Gauguinesque landscape of 1980, suggest that his heart was still in the South Seas. His symbolist, slightly Dalíesque *The Other Shore* (fig. 22.7) of 1983 shows the head of a dark-haired girl appearing over the ocean, separated from the painter, it seems, by a frame suspended in midair beside her; was she the girl he left behind, perhaps? An oil painting of lotus flowers in the New Spring show of 1979, however, already pays tribute to Chinese tradition. His work of the late 1980s is heavily symbolic, "futuristic," and fragmented, showing a confusion of influences ranging from Paul Klee to Francis Bacon.

Echoes of post-impressionism appear also in the work of Luo Erchun, one of Yan Wenliang's last pupils in the Suzhou Academy.[26] For a time after he graduated in 1951 he made little mark, although he was painting in the beautiful Xishuangbanna region of Guangxi, which often has a liberating influence on Chinese artists. Perhaps his declared admiration for Gauguin and van Gogh kept him out of the mainstream. By the early 1980s, however, he was painting canvases of rural life that seem to sweep away the dust of decades of conventional Chinese oil painting. They are vibrant with color, with the figures often stylized or distorted in a very natural way (plate 74). Although Yan Wenliang gave him a firm basis in technique, he had found his style, and it was very much his own.

While these younger artists were forging ahead, exploring new styles and techniques, the gulf between them and their elders rapidly grew wider. The really old oil painters knew modern Western art; many had studied it at first hand in Paris and Tokyo. Young artists utterly

22.7
Cao Dali, *The Other Shore* (1983). Oils.

repudiated the art of the Mao years, reaching out hungrily for anything Western and contemporary. Between them were those in their thirties to fifties, whose model had been Soviet art. They were becoming a lost generation, increasingly isolated from new trends. In an effort to establish their credentials in a fast-moving artistic world, a group of these artists, calling themselves the Banjiezi, the "halfway through," mounted a big exhibition in the early winter of 1985.[27] Among the oil painters were Wen Guochang, who submitted a portrait of two children in the German expressionist manner; Zhan Hongchang; and Wu Xiaochang, who showed a portrait of Zao Wou-ki's wife, Françoise Marquet. There were conventional guohua paintings by Shang Tao and more expressionist ones by Yang Lidan and Shi Hu, as well as sculpture by Cheng Ya'nan and Sun Jiaban.

Their exhibition had first been canceled in the Anti–Spiritual Pollution drive, after which, they wrote, they had kept "as silent as a cicada in cold weather" out of fear. When they finally showed, they wryly noted in their manifesto: "People feel sorry for us. Those who came before us say we are chicks that haven't yet come out of the shell. Those who come after us aren't satisfied either: they say we are just preserved eggs."[28] It is even more true of the Banjiezi than it was of the Twelve and the Painting for the Eighties group that their eclecticism stemmed from eagerness to be accepted in the new stream rather than from any real understanding of the styles they adopted. This brave show did little to help their cause.

THE SCHOOL OF SICHUAN

The Sichuan Academy in Chongqing emerged from the Cultural Revolution solidly orthodox and academic. Typical products were Liu Guoshu's *For the Happiness of the Border People,* showing smiling PLA men building a mountain road in a snowstorm, and Gao Xiaohua's *Running for the Train,* a scene of bustle in a crowded station almost worthy of the popular Victorian artist W. P. Frith. The post-Mao perestroika introduced a new and very different note.

Some of the worst fighting of the Cultural Revolution took place in Sichuan, where thousands were killed. In the winter of 1967–68, pitched battles were fought in Chongqing between rival Red Guard bands armed with rifles and bayonets, along with such improvised weapons as clubs, crowbars, and vials of sulphuric acid. At one time they even used artillery. Cheng Conglin's *Snow on X Month X Day, 1968* (fig. 22.8) depicts an incident during the long conflict in Sichuan when rival Red Guard factions had inflicted terrible suffering on each other; Soviet realism is here used to great dramatic effect. Hardly less effective is Zhu Yiyong's *Father and Son* (fig. 22.9). In this large painting the penitent son kneels at the feet of the father (is the striking resemblance to Boris Pasternak intentional, one wonders?) he has betrayed during the Cultural Revolution, who is about to be taken to prison. A crowd of young people outside the courthouse, presumably the professor's former students, look on, thoughtful, moved, ashamed.

At this time many artists were sent to remote country farms and villages. If life for the older ones was barely

22.8
Cheng Conglin, *Snow on X Month X Day, 1968* (1979). Oils.

22.9
Zhu Yiyong, *Father and Son* (1980). Oils.

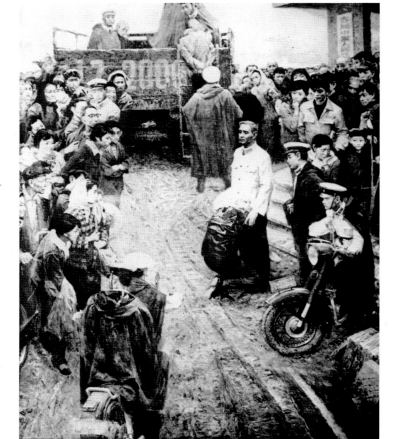

22.10
He Duoling, *Spring Breezes Have Arrived* (1980). Oils.

tolerable, some tough and resilient young painters were able to use that experience as a source of inspiration— none more effectively than Luo Zhongli.[29] Born in Bishan in 1948, he entered the Sichuan Academy preparatory middle school in 1964. On graduating in 1968, at the height of the Cultural Revolution, this dedicated young revolutionary went deep into the remote Daba mountain area on the Sichuan-Shaanxi border and lived there for ten years, sharing the hard life of the peasants. In 1978 he came down to Chongqing, where, after graduating from the academy, he joined the staff as an instructor in oil painting.

By 1980, he was using the accumulated sketches from his years in Dabashan to create an impressive series of paintings of the peasants he had come to know so intimately. The idea for his most famous picture, *Father* (plate 75), a gigantic canvas filled with the sweating, turbaned head of a peasant holding a bowl, is said to have come from seeing in a Chinese art magazine a reproduction of a photo-realist painting by American artist Chuck Close. Luo Zhongli himself described how he had come upon the peasant in 1975, watching the nightsoil pit that manured his meager plot, and was spellbound by "his immobile figure—silent, staring, anesthetized."[30] The painting won first prize in the 1980 National Youth Exhibition in Beijing and sent shock waves through the art world; its uncompromising honesty and realism directly challenged the principles of Revolutionary Romanticism. It was on the insistence of Li Shaoyan, chairman of the Sichuan Artists Association, that Luo Zhongli added the ballpoint pen behind the peasant's ear, to show that he was modern, educated, and prosperous.

Between 1980 and 1982 Luo Zhongli produced an impressive series of canvases, massive in conception, meticulous in recorded detail, deeply human. *Years,* for example, depicts a white-haired old lady sunning herself in the doorway of her cottage. In *Water from the Eaves,* a peasant girl washes her feet at the end of the day's work. *Spring Silkworms, Weighing the Baby, Napping*—in these pictures a new kind of Chinese realism has emerged, owing far less to the American photo-realists than it does to Luo Zhongli's own experience, and to his admiration for Millet.

Such was the reception of *Father* that Luo Zhongli was tempted to try to repeat its success three years later with *Father II.* Here another old peasant, eyes shut, blows his traditional *suona* horn—in celebration, critics claimed, of the new prosperity and hope for the future, although the somber mood of the painting rather suggests a rustic funeral. Impressive as the painting is, greater technical smoothness and a more calculated effect of light and shade rob it of the visual impact of its famous predecessor. By this time, Luo Zhongli had achieved international fame. He was invited as visiting artist by the Belgian Academy in Antwerp, and in the following year held a one-man show at Harvard University.

Realism of a more subjective kind, along with a fascination with oil technique, drew a number of Chinese artists at this time to the work of Andrew Wyeth, whose meticulous rendering of the visible world seemed unclouded by any ideology. He Duoling, born in Chengdu in 1948, frankly acknowledges his debt to Wyeth's *Christina's World* in *Spring Breezes Have Arrived* (fig. 22.10), in which a young peasant girl sits pensive on the

grass, every blade accurately rendered, accompanied by her dog and resting buffalo.

Two of the more noted artists of the "Sichuan School" are not Sichuanese at all. Chen Danqing, born in Shanghai in 1953, spent some time in rural Jiangxi before graduating from the Central Academy, but in the 1970s he joined his artist wife, Huang Suning, in Tibet, and the years he spent there inspired a series of impressive paintings of Tibetan men and women, monumental in conception and richly realistic in technique, which put him, at this stage of his career at least, in the company of Luo Zhongli and other Sichuan realists such as Zhou Chunya and Yuan Min. Ai Xuan was born in Zhejiang in 1947, and he also graduated from the Central Academy in Beijing. We have already noted *Defending the Wreaths,* his contribution to commemorating the Tiananmen Incident. His travel to Sichuan was a turning point in his career, for from Chengdu he set out on long journeys onto the Tibetan tableland, creating then and later a series of memorable canvases in which he found his style, capturing perfectly the mood of this sparse region and its inhabitants (plate 76). Chen Danqing's heroic Tibetans toil, embrace, strip to wash themselves; so strong is their physical presence that we can almost smell them, almost hear them laugh and chatter. Ai Xuan's Tibetans live in a desolate, cold, empty, world in which the only sound that breaks the silence is the moan of the unceasing wind. He achieved instant and deserved acclaim when his paintings were shown in New York—with the unhappy result that what began as the expression of intense personal experience declined after the mid-1980s into the expert repetition of a successful formula. But by the early 1990s he was painting close-up studies of young Tibetan women and children that have a haunting beauty not easily forgotten.

THE SLOW AWAKENING OF SHANGHAI

For several years after the death of Mao, Shanghai remained artistically sterile. The academies of music and drama had a vigorous life, as musicians gladly abandoned *The Red Detachment* and the *Yellow River Concerto* for Bach and Mozart, Beethoven and Schubert, and in fact it was in the theater design department of the Academy of Drama that several of the younger and more adventurous painters got their first training. But Mao's deliberate destruction of Shanghai's artistic world was harder to repair. After the closing of the private art schools and the departure of leading artists, including Liu Haisu, to Nanjing and Hangzhou, the rump Shanghai College of Fine Arts (Shanghai meishu zhuanke xuexiao) under Mao Luoyang did little to revive art. A handful of old mas-

ters of oil painting—all born in or before 1903—survived, though their energies were almost exhausted. Zhou Bichu, a frail eighty-two when I called on him in 1985, only dimly remembered his life in Paris, Xiamen, and Hong Kong before his return to China and to great travail in 1959. Normal life had long since come to an end for him, although in the early 1980s he painted a few landscapes in his conservative impressionist style.

Wu Dayu (fig. 22.11) had rejoined the Hangzhou Academy after the war, but Liberation drove him into seclusion in Shanghai. He continued to paint, although the almost total destruction of his life's work by the Red Guard would have been enough to kill the spirit of any artist. When Liu Haisu came to Paris in 1980, he brought news of Wu Dayu to his former student, Chu Teh-chun, reporting that the old painter was still talking of Cézanne; Chu sent him a big box of oil paints. Recognition of a sort came in 1981, when *Meishu* reproduced one of his abstractions in color—upside down, to which Wu remarked that it didn't matter, it would look right way up from the moon. Before he died in 1988 he had painted six more abstract expressionist paintings. It seems that these are all that survive of his life's work, apart from some "gestures with the brush" that he made when his hands were so crippled with arthritis that he could no longer control it.

Both Zhou Bichu and Wu Dayu had been elected to membership of the Shanghai Oil Painting and Sculpture Research Institute (Shanghai youhua diaosu yuan), which had been founded under another name in 1965.[31] This curious body consisted largely of orthodox realist oil painters and sculptors, a company into which Wu Dayu, at least, seems not to fit at all. It is hard to see the raison-d'être of this institute, as its members do no teaching, and since state patronage declined there has been little demand for their work and little stimulus or competition among them. Most remained isolated from the new trends of the 1980s, or made halfhearted attempts to imitate them. Among its better-known members were Wang Yongqiang, who painted heroic military pictures and later conventional oil portraits; Wei Jingshan; and Chen Yifei, who was to find fame and fortune in New York with his photographic portraits and endlessly repeated views of the waterways of Suzhou.

In 1983 Shanghai University established an art department, and it has since become the focus of mainstream art in the city.[32] Among its competent if unadventurous members active in the mid-1980s we would put Han Heping, Hu Li, Yu Shaofu, and Tang Muli, a skillful painter of luscious nudes who spent the years 1981–84 on a British Council scholarship at the Royal College of Art in London. He has since settled in Montreal.

22.11
Wu Dayu, *Beijing Opera* (c.1980). Oils.

Why was Shanghai so slow to recover? A local artist told me that the city had never felt the shock and excitement of the Peking Spring. Shanghai, as he put it, was much more "level." There was only a slow, sluggish thaw; consequently, people were hardly aware of the change. Moreover—and this was a key factor—Shanghai's foreign community was almost nonexistent. In Beijing, even when the cultural establishment was indifferent or positively hostile to new trends, young artists worked under the eye of foreign visitors, diplomats, collectors, and journalists eager to discover any new thing. Their presence, patronage, and power to get recognition abroad for these artists were powerful encouragements that were entirely lacking in Shanghai, where, as late as 1989, the avant-garde painter Yuan Shun said to me, "Perhaps three hundred people like what we are doing, another three hundred hate it. The rest couldn't care less."

NANJING AND HANGZHOU

Nanjing and Hangzhou were also slow to wake from their slumbers, and for the same reasons. The two rival art schools in Nanjing—the Normal University Art De-partment, sacred to the memory of Xu Beihong, and the Academy of Art, dominated by the vigorous figure of Liu Haisu and the gentler presence of the venerable Yan Wenliang—resumed much where they had left off in the Cultural Revolution. The Hangzhou Academy in the early 1980s was still under heavy political control, so remote as to feel only faintly the fresh breeze of the Peking Spring. Soviet influence (in the work, for example, of the oil painter Quan Shanshi) was dominant, while the teaching faculty seemed to be generally ignorant of, or hostile to, modern Western art. Few had heard of Zao Wou-ki or wanted to talk about him. The art library was wretched, and most of it in any case was inaccessible to students. The president, Mo Bu, was a wood-engraver from the Lu Xun Academy in Yan'an; among the other faculty, Zang Zongyang made decorative paintings of minority girls, while Wang Dewei was a facile oil painter who visited France and Italy in 1983.

In May 1985 Zao Wou-ki, now a successful abstract expressionist in Paris, was invited back to teach in his alma mater after an absence of thirty-seven years. He found the school little touched by the changes that were going on in Beijing.[33] Twenty-six teachers and students gathered for his course, some from as far afield as Xi'an, Chongqing, and Canton (fig. 22.12). He found Hangzhou still painting in the Soviet method. His hopes were raised when one fifty-one-year-old teacher from the northeast asked him whether he was too old to become his student, but when the teacher went on to say, "But we have learned painting differently from you—putting down then adding the colors one by one, more and more," he realized that it would be a hard task to get him to change his ways. Zao Wou-ki almost gave up. "If you find more in what you have learned already," he replied, "then you have no business here, and nor have I." Another student, set by Zao to draw from the model for two days, challenged him: "You are an abstract painter. Why don't you make us do abstractions? Are you afraid you'll run into political trouble?" Zao Wou-ki was already discouraged, as he wrote in his autobiography, at the long road he'd have to tread just to explain to them that his presence there had nothing to do with politics.

Zao Wou-ki's effort to instill a new approach to painting left him drained and depressed. "I was the object," he wrote, "rather of their veneration—for reasons that are obscure and not necessarily connected with my painting—than of the attention one pays to someone one is trying to understand." But it must have been some reward for his efforts that before he left Hangzhou his students, on the initiative of Wu Xiaochang, founded a society dedicated to the new approach to painting with which he had fired them. They wanted to name it after

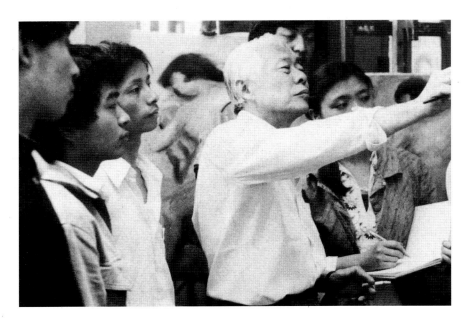

22.12
Zao Wou-ki teaching in Hangzhou (1985).

him, and when he would not consent, they called it the
Twenty-eight Painting Society (after the number of
members). From the works they painted together, Zao
Wou-ki selected fifty-eight for exhibition in China and
Paris. But nothing came of it, and the Twenty-eight went
the way of all the other ephemeral societies.

GUOHUA REBORN AGAIN

The post-Mao thaw dissolved the restrictions that had hampered traditional painting since "Liberation." Now the old masters were free to summon their energies to paint as they chose, and to exhibit paintings that they once would have been afraid to hang on their walls at home. The Wenshi Guan (see above, p. 142) was revived, although its elderly membership was much diminished. In Beijing the Beijing Painting Academy (see chapter 13) came to life again, and similar bodies arose in other cities; the magazine *Zhongguohua* was launched; and traditionalists were exhorted to contribute in their own way to the Four Modernizations, the latest campaign to bring China up to date in agriculture, industry, national defense, and science and technology.

GONGBIHUA

Fine line painting (*gongbihua*) had always been looked on with favor by the authorities. It was craftsmanlike, with no elitist associations, and it was accurate, impersonal, rooted in tradition. There were many painters skilled in decorative flower painting in the tradition of Chen Zhifo and Yu Fei'an, among them Wang Qingsheng and Dong Shouping, while Chen Baiyi specialized in historical and mythological scenes, fairies, and beauties (*meiren*), which came as a welcome change from the Red Detachment of Women and such themes of the Mao years.

Some of the post-Mao *gongbihua* artists showed a surprising receptivity to the influence of *nihonga* painting. In July 1979 an exhibition of conservative Japanese art came to Beijing as part of a cultural exchange program that included recent *nihonga* paintings by Katayama Nampu, Nakamura Teji, Morita Sai, and others. These were featured in the August issue of *Meishu,* together with Hirayama Ikuo's two-panel screen *The Introduction of Buddhism to Japan* (1954), inspired by the early Dunhuang frescoes.[1]

Japanese influence is very evident in the richly decorative flower and rock paintings by the Beijing woman artist Zhao Xiuhuan (plate 77), whose affinity with Japanese art was already present when in 1979 she took part in the joint exhibition of paintings from Tokyo and the Beijing Academy. Another who responded to the influence was Pan Jiezi. Born in Zhejiang in 1915, he studied painting in Beijing and Shanghai, spent the war years in west China, and after Liberation became art curator for the Historical Museum in Beijing.[2] In 1945 he had visited Chang Shuhong at Dunhuang and had copied the murals there—an experience that led to his best-known work, *The Creators of the Murals* (1955). He was already leaning towards Japanese decoration when he painted *The Heart of the Lute* in 1977, but after 1979 he went even further, painting mythological scenes in the Japanese manner and Japanese beauties in kimonos. His *Lilies in a Secluded Valley* (fig. 23.1) of 1981 has no Chinese features at all. One cannot but wonder what inspired Pan Jiezhi to surrender so completely to an alien aesthetic. In spite of the technical skill of these and many other *gongbi* artists and the popularity of the style for propaganda, calendars, and serial pictures, the *gongbi* has always remained a very conservative trend in modern Chinese painting.

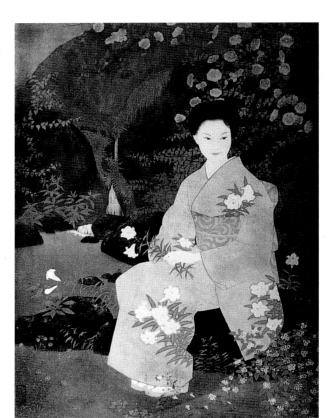

23.1
Pan Jiezhi, *Lilies in a Secluded Valley* (1981). Ink and color on paper.

23.2
Cui Zifan, *Lotus Pond, Autumn Color* (1980). Ink and color on paper.

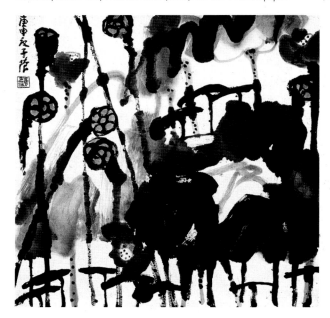

BEIJING In Beijing, bird and flower specialists such as Wang Xuetao, Gao Xishun, and Tao Yiqing, to name a few out of hundreds, continued to paint much as before in the expressive *xieyi* manner. Cui Zifan (fig. 23.2), having spent the war years in Yan'an, was holding Party administrative and secretarial posts when, about 1955, he showed some of his amateur flower paintings to friends in Hangzhou. They introduced him to Qi Baishi, who took him on as his student, and eventually he became director of the Beijing Painting Academy. He is a bold painter of flowers in ink, boneless wash, and strong color, but an indifferent calligrapher. Li Kuchan (fig. 23.3) was another venerable pupil of Qi Baishi, eighty in the year of the Peking Spring, whose work burst out with a new and triumphant energy. He lived to be eighty-five, painting almost to the end. Both he and Cui grew to be the equals of their teacher—indeed, they often surpassed him, for they were seldom as careless and repetitive as Qi Baishi.

Soon after he was allowed to return to Beijing in 1972, Huang Yongyu was back at work. In 1973 he painted a series of flowers and landscapes in his favorite medium, Chinese ink and strong body color on heavy paper; many were painted secretly, in the dead of night. The brilliant decorative effect of these paintings is a mark of his defiance, concealing the bitterness in his heart. By 1975 he was creating bold landscapes and lotuses, often in red against a dark background, the most famous being the *Red Lotus* that he painted as a tribute to Zhou Enlai during the night after the leader's death.[3] When he chose to he could also paint with great care—in his *gongbi* flower studies, for example, but nowhere more successfully than in the paintings he made on returning after a long absence to his native town in western Hunan. His views of the riverside, houses, and gardens of Fenghuang, done with close attention to detail, show none of that facility that led him later, as he became more and more successful, into carelessness and decorative bravura effects. These Fenghuang landscapes, few and now scattered in private collections, are among his finest works (fig. 23.4). In 1986 Huang went on a painting tour of Italy, and the paintings and sketches he made in Florence and Perugia, Assisi and Milan, show that none of his old skill as a draftsman had deserted him.[4]

Probably the most famous survivor in Beijing was Li Keran.[5] Born in 1907 in Xuzhou, Jiangsu, he graduated in 1925 from the Shanghai Meizhuan, where he had studied oil painting under Liu Haisu. In 1931 he joined the radical Eighteen Society in Shanghai and attended study sessions on art and literature run by Lu Xun. He taught in schools in Hangzhou and Xuzhou until the outbreak

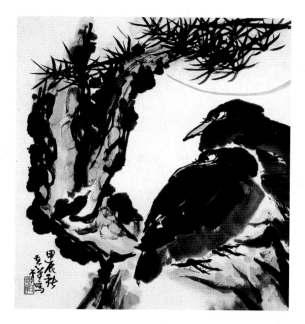

23.3
Li Kuchan, *Two Birds under a Pine Tree* (1979). Ink and color on paper.

23.4
Huang Yongyu, *The Town of Fenghuang* (c. 1979). Gouache on paper.

of war, when he joined Guo Moruo's patriotic Union of Artists and Writers. By 1943, teaching painting in Chongqing, he had given up oil painting for the Chinese medium.

His meeting with Qi Baishi and Huang Binhong after the war had an enormous and liberating influence on his brushwork. After Liberation, his career flourished at the Central Academy. During the Cultural Revolution he was denounced and sent to the country for a year,

recalled in 1973 to decorate the new wing of the Beijing Hotel, and pilloried by Jiang Qing in the Black Art exhibitions of 1974 for his dark gloomy landscapes. He emerged into fame, his spirit unbroken and his energy restored, in the late 1970s.

Li's work since Liberation has been very uneven. Many of his landscapes of the 1950s and 1960s depict compulsory subjects—the most compulsory of all being Mao Zedong's birthplace in Hunan, to which all artists made

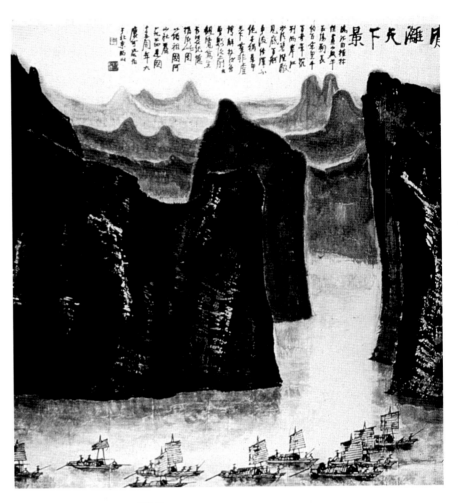

23.5
Li Keran, *Landscape on the Li River* (detail) (1964). Ink and color on paper.

pilgrimage—and his treatment of such subjects is inevitably leaden. Left to himself, though, his spirit emerged: in his "pure" landscapes (fig. 23.5) inspired by Huang Binhong and Shitao; in his pictures of Tao Yuanming by his chrysanthemum fence; in his drunken monks and eccentrics, to which he returned again and again with gaiety and abandon; in his paintings of water buffaloes and the little boys who tend them (fig. 23.6). I asked him in 1980 why he was so fond of painting water buffaloes. "They are so beautiful," he replied, "so tame that a small child can control them. I am moved by their melancholy eyes, by the patience with which they bear their endless burdens for men."

Wu Guanzhong is one of the handful of modern Chinese artists who, in the spirit of Lin Fengmian, have created a new, contemporary style of guohua painting.[6] We have seen how he suffered after his return from France, how he abandoned figure painting and retreated into landscape, although he never ceased to champion modern art and the nude, or to prepare the minds of his apprehensive students and readers for abstraction. His oil landscapes (as plate 78) are lyrical, light in touch, combining echoes of Utrillo and Dufy with a Chinese sense of space, which brings them halfway towards Chinese painting. Indeed, he moves more easily between the two media than any other modern Chinese artist.

One reason Wu Guanzhong gave for painting more in the Chinese medium is a purely practical one: his flat was small, and canvases take up a lot of room, while guohua paintings can be rolled up and put away. Also, although he did not say this, oil painting takes much longer, and good quality oil paints are very expensive. Much more important, however, is the feeling that has grown in him of his "Chineseness." Only through the Chinese brush can the essential qualities of *qi* (vitality) and *xing* (exhilaration) be expressed with complete freedom and spontaneity. Even his most loosely painted oils cannot fully convey those uniquely Chinese qualities. Yet guohua too has its expressive limitations, which perhaps is what caused him to say, "Whenever I feel frustrated I

23.6
Li Keran, *Playfulness in the Autumn* (1982). Ink and color on paper.

will resort to oils again." Equally expressive is his line when, as he often does, he draws with pen and ink.

Wu Guanzhong's guohua is no retreat into the past; on the contrary, it is far more experimental than his oil painting. In the early 1970s he was still painting very realistically, limited by the acceptable conventions of the time. But in the 1980s he broke free, creating new techniques to express a wide range of ideas and feelings. Writhing wisteria or pine branches such as his *Pine Spirit* of 1984 evoke one kind of abstraction, while the broad, sweeping washes in *Snowy Mountains in Spring* (1982) create another, and the heaving hills of *Fishing Village* (1983) yet another. *The Great Wall* of 1986 moves further towards abstraction, yet powerfully suggests the strength of the wall itself, while in the striking simplicity of *Grand Residence* (fig. 23.7) he wonderfully captures the beauty of the houses of the Jiangnan region. Suzhou has become his Montmartre, the white-walled mansion his Sacré-Coeur. To illustrate the poetic variety with which he manipulates the Chinese medium, we need

only compare this painting with his *Spring and Autumn* (plate 79), in which the birth and decay of nature are evoked in the same picture, with poignant delicacy.

One of the most sensitive Beijing artists to emerge in the early 1980s was Yang Yanping. Born in Nanjing in 1934, she graduated in architecture from Qinghua University, then took up painting with the support and encouragement of Xiao Ding (her godfather) and her close friends Yu Feng and Huang Miaozi.[7] In their search for the roots of Chinese painting, some Chinese modernists, beginning with Zao Wou-ki after his arrival in Paris, have explored and exploited the connection between drawing and writing, which they trace back to the ancient ideographs and pictographs. Yang Yanping, in the calligraphic works she produced in the 1980s, sought to reinforce and intensify the import of the ideographs by the way in which they are presented. Some of her works in this genre are suggestive in a purely visual way, a simple example being *Rice Paddy*, composed of the archaic graph *dao* superimposed on the graph for a field, *tian*. Here the

23.7 (above)
Wu Guanzhong, *Grand Residence* (1981). Ink and color on paper.

23.8 (left)
Yang Yanping, *Wang chuan qiu shui* (c. 1985). Ink and color on paper.

23.9 (below)
Zeng Shanqing, *Head of a North China Peasant* (c. 1983). Watercolor on paper.

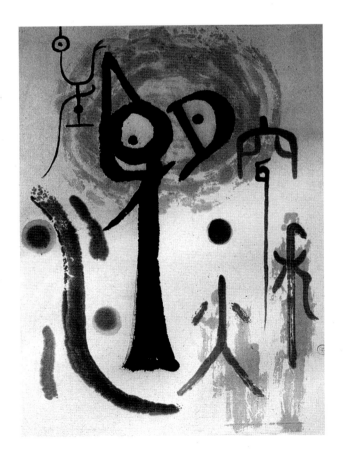

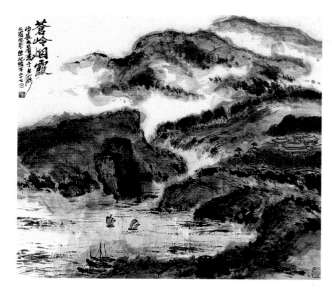

23.10
Zhu Qizhan, *Landscape* (1977). Ink and color on paper.

ancient graphs are given a new lease of life in a work of undemanding charm.[8]

But Yang Yanping did not simply use the pictograph to express feelings about nature. Her most intense emotions were about her own predicament in a closed society, about her feelings of frustration, insecurity, and hope for a better future that might be snatched away at any moment. In her *Wang chuan qiu shui* (fig. 23.8), a design of great beauty, the character for hope dominates, surrounded by the graphs for water, autumn, and "to bore through" or "penetrate." The phrase may be loosely translated as "Anxiously straining one's eyes"—towards a better life. It was her sense of frustration in China that in 1986 led to her settling with her husband on Long Island.

Yang Yanping does not confine herself to calligraphic abstraction. Her earlier work included some distinguished figure paintings, while she made particularly her own a series of evocations of the natural world, full of poetic undertones. Especially notable are her paintings of Taihu rocks and of lotuses, very different from the bravura creations of Zhang Daqian and Huang Yongyu. A typical work is the scroll *Lotus Plants in Winter,* painted in 1985, which breathes an air of exquisite melancholy reminiscent of the famous scroll *Early Autumn* in the Art Institute in Detroit, once attributed to the Yuan artist Qian Xuan.[9] More recently, she has found inspiration in her adopted country. *Rocky Mountain with Snow* (plate 80) blends grandeur of conception with great refinement of feeling. By the late 1980s, when success came at last and confidence with it, she had truly found herself.

Yang Yanping's husband is Zeng Shanqing, a somewhat conventional oil painter who is best known for his monumental studies in watercolor of workers' and peasants' heads (fig. 23.9) that express the same crude power as the north China peasants depicted in Zhang Yimou's film *Red Sorghum*.

SHANGHAI In Shanghai, as the surviving old masters stepped once more onto the stage, full of vigor and confidence, the Shanghai Chinese Painting Academy (Shanghai zhongguo huayuan), which was founded in 1956 on the initiative of Zhou Enlai but had long been in the doldrums, came to life again. Some familiar faces were missing: Feng Zikai, Lai Chusheng, Xie Zhiguang, Wu Hufan, and Pan Tianshou were dead. But others, some of great age, kept the spirit of Wu Changshuo alive—none more so than Zhu Qizhan (fig. 23.10).[10] Born in 1892 into a merchant family in Jiangsu, Zhu Qizhan had begun as a post-impressionist at the same time as Liu Haisu. Later he studied at the Hashigawa Art Academy and under Fujishima Takeji in the Tokyo Academy, where he became a devotee of van Gogh and Matisse. Returning to China, he taught for many years in the Xinhua and Hangzhou academies, gradually giving up oil painting for the Chinese brush—or rather, absorbing into his Chinese painting elements of strong color and emphatic composition he had acquired from Western art. As I write these words, he is painting his strong, colorful landscapes, bamboo, and flowers, vigorous still at the age of a hundred and two.

Xie Zhiliu too is still painting flowers and landscapes that display his enormous technical skill, his eclecticism, and his deep knowledge of the tradition. For so dominant a personality, some of his flower paintings are surprisingly subtle and delicate in texture (fig. 23.11). Among other Shanghai guohua painters who survived the long winter to blossom in the warm climate of the post-Mao era, we may mention also Zhang Dazhuang (fig. 23.12); Chen Qiucao, who, fifty years before, had founded the White Goose Painting Society in Shanghai; and Tang Yun, an active member of the Shanghai art world before and after Liberation whose admiration for Shitao and Bada Shanren shows in his vigorous brushwork.

Cheng Shifa, born in Jiangsu in 1921, came of a family of traditional doctors.[11] After studying painting on his own, he entered the traditional painting department of the Shanghai Academy and then worked in a bank, from which he was fired when he contracted tuberculosis. Thereafter he kept alive by doing serial illustrations, calendars, and new year pictures. He first found security

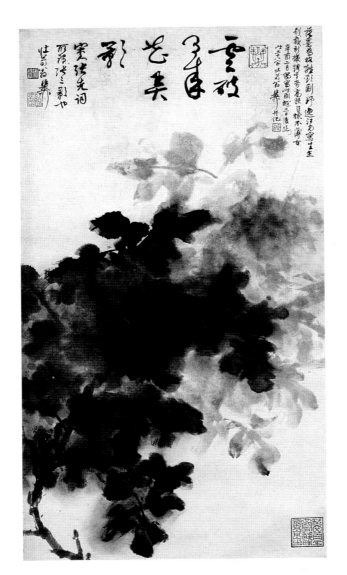

after Liberation, when he joined the East China People's Publishing House in Shanghai. With the publication in 1957 of his illustrations to *The Scholars,* the English translation of *Rulin waishi* (see chapter 17), he began to acquire a reputation as an accomplished book illustrator, which led to a lectureship at the Shanghai Chinese Painting Academy.

Today, however, Cheng Shifa is best known as a guohua painter (fig. 23.13). Although he paints flowers and occasionally landscapes, his true métier is figures, his favorites being the demon-queller Zhong Kui marrying off his daughter and charming pictures of Tibetan children and minority girls herding their goats. When I asked him why he painted these girls so often, he replied simply, "Because they are so beautiful." His brushwork is lively, sensitive, often with a pleasingly staccato rhythm, but the constant repetition of these very popular themes has tempted Cheng Shifa into a too-cloying charm. He has many imitators, among them Liu Han and Zhou Sicong.

Of the Shanghai landscape painters who flourished in the post-Mao era, none had a more distinctive style than Lu Yanshao, who was born in the Jiading district of Shanghai in 1909.[12] As an amateur painter and seal carver he was drawn into the circle of Wu Hufan and Feng Chaoran, whose pupil he became. Before the war he had

23.11
Xie Zhiliu, *Peony* (1981). Ink and color on paper.

23.12
Zhang Dazhuang, *Watermelons* (1963). Ink and color on alum paper.

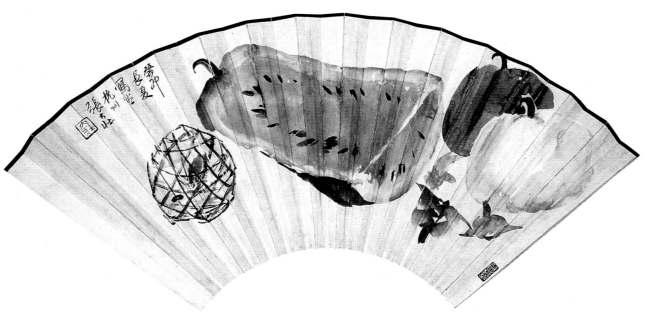

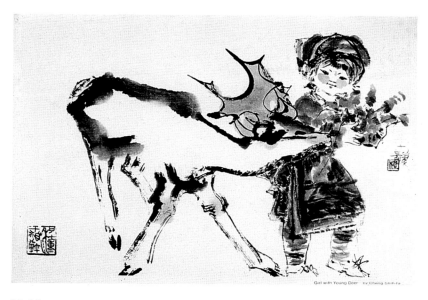

23.13
Cheng Shifa, *Minority Girls with Young Deer*. Ink and color on paper.

23.14
Lu Yanshao, *Journey Down the Yangzi River* (1981). Ink and color on paper.

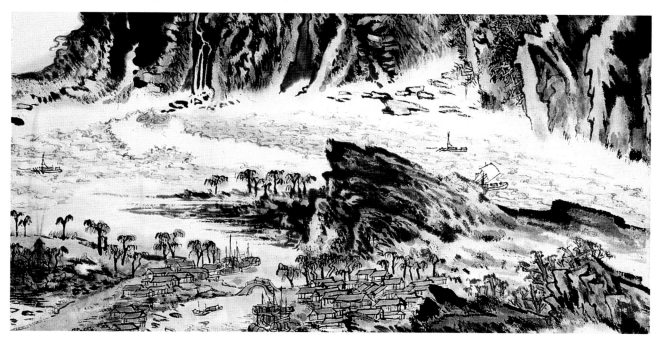

made several painting expeditions, to the Great Wall, Huangshan, and elsewhere. He spent the war years in Sichuan. Liberation at first found no place for his elitist art, so he drew comic strips and cartoons, but by 1953 he was a member of the Shanghai branch of the Artists Association, and in 1962 he joined the staff of the Hangzhou Academy at the invitation of Pan Tianshou.

Lu Yanshao's landscapes draw upon many sources: Northern Song, the Yuan master Wang Meng, and most of all Shitao and his older painting companion Mei Qing, from whom Lu derives his restless, trembling brushwork. This brushwork gives to his rocks, mountains, and water a shimmering life and movement that sometimes, as in the work of Mei Qing, verges on mannerism, but it is saved from artificiality by the rich consistency of the style (fig. 23.14).

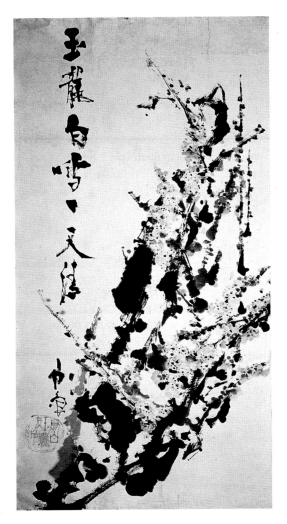

23.15
Shi Lu, *Jade Dragon in White Snow* (c. 1980?). Ink and color on paper.

SHAANXI Chinese critics have spoken of a distinct Shaanxi School of landscape painting based at the Xi'an Academy, citing as typical examples Zhao Wangyun, Fang Jizhong, and Shi Lu. But the Xi'an tradition—of landscape painting at any rate—died with the Tang Dynasty, and although Zhao Wangyun paints northern landscapes with a feeling for the peasant life he knows so well, his style has no regional character. The same can be said of Fang Jizhong, but by no means of Jia Youfu, a native of Hebei and pupil of Li Keran at the Central Academy who developed a deep attachment to the Taihang Mountains of Shaanxi, which he visited on painting expeditions no less than nineteen times. His heaving, distorted masses, created in wet ink or close-textured brushstrokes, are among the most successful efforts of guohua artists to escape from convention to evoke subjectively, even passionately, the true character of the northern landscape.

Shi Lu was born Feng Yaheng in 1919 into a landlord's family in Renshouxian, Sichuan.[13] After studying art at the Dongfang Art College in Chengdu he entered West China Union University, but left in 1939 for the border region. As a member of the Northwest Cultural Working Group, he painted stage scenery and serial pictures, made woodcuts, and taught in the Lu Xun Academy—where, out of his admiration for Shitao and Lu Xun, he changed his name to Shi Lu. Shortly after arriving in Yan'an he fashioned from a photograph a two-foot-high copy of Rodin's *Age of Bronze,* an indication of the relative freedom that Yan'an artists enjoyed before Mao's fateful Talks of 1942.

After Liberation, he taught in the Academy of Fine Arts in Xi'an, visiting India and Egypt in 1955–56. During the Cultural Revolution he was persecuted almost to the point of death, one of his many crimes being that in his famous *Shifting to Fight in North Shaanxi* he showed Mao "separated from the masses and hoping he would fall off the cliff." He was imprisoned, escaped, caught again, and severely punished. Although he later took up painting again, he never fully recovered from his ill treatment, became tubercular and schizophrenic, and died in a Beijing hospital in August 1982 at the age of sixty-two.

Shi Lu's paintings of the 1950s and 1960s, chiefly landscapes, show the clear influence of Shitao, while for his flowers he found inspiration in Wu Changshuo. His style is rich, direct, and powerful. In his last years, the painting and calligraphy of this great spirit, who blended in his character the eccentricity of Bada Shanren and the passion of van Gogh, acquired an extraordinary intensity. He painted and wrote in very black ink, with the side of the brush; his brushstrokes acquired a jerky, nervous rhythm, as if his pent-up feelings were too strong to be contained. (See figs. 23.15 and 23.16.) Although it was said that his mental and emotional state made him unable to paint after 1979, he had the gratification of a big one-artist show in December of that year, which confirmed his place as a leader among modern guohua artists in north China.

NANJING Nanjing, by contrast with Shaanxi, inherited a strong local tradition that went back to the Anhui masters of the seventeenth century—to Xiao Yuncong, Hongren, Mei Qing, and Shitao—and found in Fu Baoshi a modern leader who raised Nanjing landscape painting to a level it had not seen for two hundred years. Furthermore, the Nanjing painters have all found inspiration in Huangshan, the very quintessence of the mountain landscape, to which they return again and again. (And not only the Nanjing artists: Dong Shou-

23.16
Shi Lu, *Writing with Style* (c. 1980?). Ink on paper.

23.17
Ya Ming, *The Yangzi Gorges* (1978). Ink and color on paper.

ping is one of many painters from other regions—he was born in Shanxi—whose best landscapes depict Huang-shan.) So strong are these influences that none of the leading followers of Fu Baoshi, with the possible exception of Ya Ming, have been able to create a distinct style of their own.[14]

Xie Haiyan is identified with Nanjing, where he spent his last years in close association with Liu Haisu, but he was Cantonese by birth, had studied Western painting in Shanghai and Japan, and had taught guohua in Shanghai and Chongqing before becoming vice president of the Nanjing Academy. He is an accomplished but conventional artist, as are Qian Songyan and Song Wenzhi, whose early career was spent in Shanghai in company with Wu Hufan, Lu Yanshao, and other traditionalists before he joined the Nanjing Academy in 1957.

The dominant figure among the middle generation of Nanjing artists is Ya Ming. Born in Hefei in 1924, he became a successful landscapist in the 1950s. During the Cultural Revolution he was sent to the country to labor for four years in company with Huang Yongyu, Huang Zhou, and Shi Lu. By 1980 he was once again prosperous and in favor, chairman of the Jiangsu Artists Association, owner of a motorcycle and an air conditioner, and his work was selling well abroad. He is a vigorous painter of expressionistic landscapes, rich in dramatic contrasts of rhythm and ink tone and highly effective as large-scale decoration (fig. 23.17).

CANTON In Canton, the Lingnan School established by Gao Jianfu was in what might at best be called a steady state in the 1950s. When in 1978 the Canton Academy was revived the Japanese flavor had almost disappeared, and if Western influence appears at all, as for instance in the work of Chen Dongting and Wang Weibao, it is less self-conscious than in the earlier Lingnan painters.[15] Guan Shanyue (fig. 23.18), who remained a dominant figure, returned to pure landscape after decades of turning out obliging propaganda paintings. In his late work he shares with others of the school, notably Cai Dizhi, Wang Li, and Liu Lun, formerly a wood-engraver, a warmth and luxuriance that seems, at last, to be a true expression of the character of the lush southern landscape. Guan Shanyue held a major retrospective in Canton in 1980. Yet Canton, for all its cosmopolitan history and proximity to Hong Kong, remained, like Shanghai, something of an artistic backwater.

THE ECCENTRICS

It was natural that expressionists and eccentrics should once again flourish in the freer atmosphere of the 1980s.

23.18
Guan Shanyue, *In the Shade of the Banyan Tree* (1962). Ink and color on paper.

Many of the major artists, including such old masters as Liu Haisu, Li Kuchan, and Li Keran, let themselves go from time to time, while many younger artists, impatient with convention, stretched guohua almost to its limits. They are scattered about China, owing allegiance to no particular place. Li Keran's son, Li Geng, a child prodigy who spent seven years in the grasslands of the northwest and later visited Japan, became a strong painter of eccentric landscapes and whimsical pictures of Su Dongpo and other kindred spirits. Huang Yongyu's brother, Huang Yongyuan, is an amateur painter of huge wild landscapes and a member of the Anhui Painting Academy (Anhui guohuayuan) in Hefei. Yang Guanghua in Beijing paints both orthodox figures at the National Minorities Institute and very free landscapes in ink wash and splashed ink. Yang Yanwen abandoned oil painting, in which he had been tutored by Wu Guanzhong, for a spontaneous *xieyi* style, evocative of the lush landscape of the Jiangnan region.

A more considerable figure and a true eccentric was Chen Zizhuang (fig. 23.19). Born into a farming family in Sichuan, he had a tempestuous career as a *gongfu* master, bodyguard to a warlord, member of a secret society, and amateur painter. In spite of his background, he found a niche after Liberation in Chengdu as a member of the local Wenshi Guan, which gave him the security to paint, teach, and exhibit until he was overtaken by the Cultural Revolution. In his character as in his painting he resembled Zhu Da—difficult, abusive, often drunk. Unacceptable for membership in the Artists Association, hounded by the woman painter Zhu Peijun (an ally of Jiang Qing and director of the Chengdu Painting Academy), he was revered by his students and by other young painters who were too terrified to approach him. After enduring horrendous suffering and humiliation during the Cultural Revolution he died in poverty, quite forgotten, three months before the death of Mao and the fall of his tormentors. He was "discovered" through a major exhibition of his work in Beijing in 1988, and lives on in the work of his followers and students in Sichuan, among the most gifted of whom is Li Huasheng.[16]

Li Huasheng, son of a boatman, was born in Yibin in 1944. He got his first art training, in both guohua and xihua, in one of Chongqing's Culture Halls. He met Chen Zizhuang in 1972 and within four years had absorbed his style and even gone beyond it, with such success that in 1980 he was invited to demonstrate his art before Deng Xiaoping. By this time he was painting wild landscapes, quaint vignettes of country cottages, fishermen, and birds, flouting artistic and calligraphic conventions with the same reckless abandon that he flouted the social ones. His meteoric rise to fame, coupled with his fearless and uncompromising arrogance, brought him into headlong collision with conservative forces in Sichuan, led by the hard-line wood-engraver and cultural apparatchik Li Shaoyan, of whom Li Huasheng said that he "had the power of life or death over Sichuan artists." Victim of an outrageous campaign of slander, Li Huasheng was lucky not to be arrested, or shot. By the time he painted his *Birds Returning to the Trees at Sunset* (fig. 23.20) in 1981, he had by sheer courage weathered the worst of the storms and was beginning to be reluctantly accepted by the establishment. But something of past stresses seems to linger in this powerful work. In its use of heavy black ink it is, for so tranquil a subject, surprisingly restless and intense.

In October 1985, his cultivated eccentricity by now recognized and admired—even by Li Shaoyan—Li Huasheng was made an honorary member of the Sichuan Fine Arts Academy in Chongqing. In the following January he was finally accepted into the Sichuan Academy of Poetry, Calligraphy, and Painting, from which he had

23.19 (above)
Chen Zizhuang, *Evening Colors*. Ink and color on paper.

23.20 (left)
Li Huasheng, *Birds Returning to the Trees at Sunset* (1981). Ink and color on paper.

been so long excluded. His final triumph came in 1986 when, on his own insistence, he was awarded the rank of First Grade Master in the academy—he would accept nothing less. In his *Cock-Crow at Dawn* of 1989 (plate 81) is all the vigor of the earlier work, married now to a playfulness, a simplicity, a joy in color, that is a distillation of all he had learned from his masters. It was through such paintings that he was able to rise into purer air above the tensions and jealousies of the art world of modern China. On a brief visit to the United States in 1987, he was astonished and bewildered by the air of freedom and independence he found all around him. "Only those Chinese who have travelled abroad," he said on his return, "can understand Chinese life well enough to care profoundly for the nation's future and the powerlessness of our people."

In the 1920s the Beijing scholar, critic, and amateur painter Wang Senran, friend of Chen Hengke, Wu Changshuo, and especially of Qi Baishi, had coined the terms *hou wenrenhua* (postliterati painting), and *xianjin wenrenhua* (new, progressive literati painting) in his discourses on their work. In the great revival of the post-Mao era, the aesthetics of the literati once more became the topic of serious critical discussion. A writer in

Meishu said that the term *xin* (new) *wenrenhua* had been first used for an exhibition of Shi Lu's paintings in Nanjing in 1979 and had gradually gained currency since. The writer noted that it could mean many things: some said it was the art of scholars, others of amateurs, others of eccentrics, or that it was the art of those who opposed tradition, or Western realism. Some said it was a matter of technique, others of style. It clearly has elements of all of these, but can be summed up as free, uninhibited painting in ink and wash, with some literary or poetic flavor—although it is surely stretching the term *xin wenrenhua* beyond the point of usefulness to include, for example, the work of the Central Academy teacher Tian Liming, whose ink paintings, according to a Chinese critic, "blend nudes with misty landscapes in such a way that at first glance the nudes are indistinguishable from the landscapes."

In the spontaneous outpourings of the truly gifted artists such as Li Huasheng, the new *wenrenhua* is, as it always has been, full of life, wit, and invention. For hundreds of lesser talents it is an easy short cut, in which shallow thought can be hailed as spontaneity, untrained brushwork and incompetent calligraphy passed off as eccentricity. Whatever name it is known by, it is clear that in the 1980s the *wenrenhua,* in its many forms, was restored to its rightful place at the very center of Chinese painting.

24

THE NEW WAVE

Many Chinese artists would come to look on the mid-1980s as the high summer of the forward movement in Chinese art that began with the Peking Spring. Although the political winds changed direction with shocking suddenness from time to time, the general trend was toward a steady expanding and enriching of all the arts. This was the time of the *xin chao* (New Tide, or New Wave)—an apt name, describing no single movement but rather a surge in many different directions, as artists seemed to reach out to anything new, and particularly to anything that would forge links with the long-forbidden world of modern Western culture.

And not only the artists. Through 1985 and 1986, students and intellectuals were avidly reading every work of fashionable Western thought they could lay their hands on, often paying what they could ill afford for inaccurate or incomprehensible translations of the writings of Nietzsche, Schopenhauer, Freud, Heidegger, and Sartre. Circles and "salons" sprang up; in lectures and discussions, young people sought the meaning of life and of their own individual existence. Freud's theories of the subconscious and Sartre's doctrine that only the individual's situation, actions, and choices had meaning appealed to people who had rejected all authority—who had indeed been encouraged during the Cultural Revolution to attack the Communist Party itself. Their hunger for Western ideas, however ill-digested, was matched by the hunger of artists for any new style or theory. To act spontaneously, to paint as impulse or instinct dictated without reference to any order outside oneself, was to assert one's absolute freedom of choice.[1]

During this brief high summer of freedom the cultural establishment sponsored, or at least tolerated, an ever larger number of exhibitions displaying this catholicity of style.[2] Nineteen eighty-five, for example, saw the Advancing Chinese Youth Art Exhibition, which demonstrated the creative energy of recent graduates and young teachers in the academies. A Hangzhou group calling itself New Space (Xin kongjian), composed of Xu Jin, Geng Jianyi (fig. 24.1), Zhang Peili, and others, held an exhibition chiefly of abstractions and realistic yet stylized figures and groups notable for their stylish stillness and cool colors, some showing the influence perhaps of Edward Hopper and Charles Sheeler.[3] This was one of the few exhibitions that seemed to present a consistent stylistic character.

Nineteen eighty-six was the year of the joint show of oil painting by members of the staffs of the Central Academy and the Lu Xun Academy, and of exhibitions mounted by the Contemporaries (Dangdai),[4] the Beijing New Fauves, and many groups of young artists and students around the country. Among those that flourished briefly were the Zero Artists Organization in Hunan, the Ants Painting Society in Hebei, the Red-Yellow-Blue Painting Society in Chengdu, the Southern Artists Salon in Guangdong, and other ephemeral groups in Taiyuan, Lanzhou, Wuhan, even Baotou.

A major event of 1987 was the National Oil Painting Exhibition held in Shanghai, a huge show in which almost every artist tried desperately to be represented.[5] In the same year, an exhibition to mark the sixtieth anniversary of the founding of the People's Liberation

24.1
Geng Jianyi, *Barber Series No. 3* (1985). Oils.

24.2
Nie Ou, *Three Figures and Bird's Nest* (1985). Ink and color on paper.

Army was notable for including pictures not only of heroes and heroic deeds but of the pain and horror of war, a mood already evident in a show the previous year of paintings inspired by the short and disastrous border war with Vietnam.[6] In February was held the Nine Women's Exhibition. Here the moving spirit was Yu Feng, who, in addition to exhibiting her new landscape fantasies, wrote a poem for the occasion. Among artists exhibiting were Pang Tao, Zhou Sicong, Nie Ou (fig. 24.2), Xiao Xiuhuang (one of the artists of the Beijing Airport frescoes), and Shao Fei, a former member of the Stars and wife of the dissident poet Bei Dao, whose 1988 composition *Flight* is illustrated in figure 24.3.[7]

Images and symbols popular at this time were youthful beauty, new growth, the window opening from a dark room onto a sunlit sea, the frames that imprison the artist, and the frame shattered or broken through—if only in the artist's dreams. A popular, much-discussed work in the 1985 Advancing Chinese Youth exhibition caught the mood. *A New Era: Revelation from Adam and Eve* (fig. 24.4), by the young Beijing artists Zhang Qun and Meng Luding, shows a beautiful girl bursting through the successive frames that enclose her as she strides into the future, flanked by Adam and Eve (symbolizing pristine cleanliness and innocence) bearing on a dish the fruits of knowledge, while below, his plate empty, sits the new man, his hands outstretched in expectation. The borrowings from Botticelli and Dalí are only too obvious to the Western viewer, but the picture is technically accomplished, and a rather charming expression of the collective optimism of the post-Mao era. By contrast, Du Jiansen's *Frame of Mind* (plate 82), in which the artist's haunted face is reflected from frames within frames, is a stark reminder that, in spite of the glasnost of the 1980s, many artists still felt imprisoned and were desperate to escape.[8]

Exhibitions of the work of graduating students, particularly those in the Central, Zhejiang, and Sichuan academies, showed that art students were now even less willing to follow in their professors' footsteps. Bursting with energy and avid for knowledge of new trends in the West, they were leaving their teachers behind. At the Central Academy, the old revolutionary wood-engraver Li Hua was one of many old-timers who fought a bitter rearguard action against every new trend. But the students were learning to ignore him.

For young artists there was little of the political commitment that had illuminated the Stars. When in 1984 I asked Wang Keping the reason for this, he shrugged his shoulders: the young generation, he said, realizing that they were powerless to change anything, had become disillusioned and politically cynical. Except for the Stars themselves, few artists took any interest in politics. For

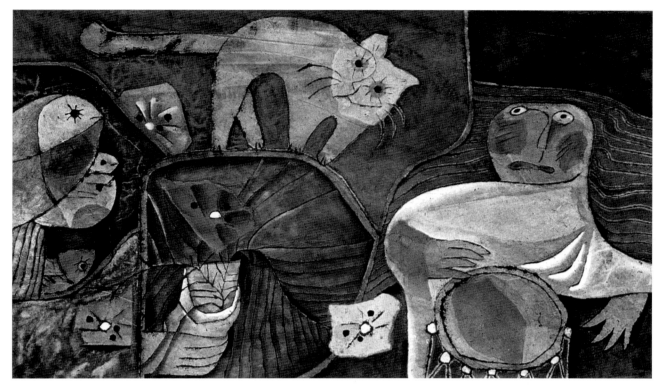

24.3
Shao Fei, *Flight* (1988). Oils.

24.4
Zhang Qun and Meng Luding, *A New Era: Revelation from Adam and Eve* (1985). Oils.

24.5
Chang Xiaoming, *Peasants in a Landscape* (1980s). Oils.

24.6
He Datian, *Grandmother's Kitchen* (1988). Oils.

most, the aim now was to become true professionals and to perfect their technique—particularly when they discovered that in the West realism was once more an acceptable form of modernism. When the Museum of Fine Arts in Boston sent paintings from its collection to China in 1981, Copley, Sargent, and Homer attracted more attention than Kline or Pollock. The Brooklyn Museum's exhibition Three Hundred Years of American Art, sent to Beijing in 1984, met with a similar reaction. On the day I visited the show, the biggest crowd—which included art students—had gathered around a painting by Norman Rockwell. A clever imitation of that winsome realist by Wang Xiaoming, showing a small boy looking at drawings of spacecraft, was featured in *Meishu* in November of that year.

The fruits of this new attention to technique can be seen in many highly finished portraits painted in the mid-1980s.[9] Jin Shangyi, who had visited Germany in 1979 and made, he claimed, a close study of Leonardo, Michelangelo, Raphael, Rembrandt, and Ingres, five years later painted a meditative portrait of the popular folksinger Peng Liyuan, seated before a Song landscape, that has a little of the flavor also of Annigoni.[10] Other excellent examples of high finish in oil painting include Wang Yidong's *Manchu Woman,* Yang Feiyun's beautiful *Pengpeng* (plate 83), shown in the Central Academy's Biennial of 1987, and another *Seated Girl* painted by the Shanghai artist Dong Qiyu in the manner of Ingres and exhibited in the national oil painting show of 1987. Such

accomplished Salon paintings provide a piquant and sophisticated contrast to the rough peasants and heroic Tibetans painted in the early 1980s by Sichuan artists such as He Duoling and Ai Xuan.

Artists in this stream were increasingly studying Renaissance, Flemish, and Dutch art and the works of Holbein. A group of peasants in a landscape by Chang Xiaoming suggests in its color and composition Piero della Francesca (fig. 24.5). Wei Ershen's monumental *Mongolian Bride* has more than a hint of Masaccio (plate 84). The handling of light in Gao Min's *Red Candles* is indebted to Caravaggio or to Georges de la Tour. The influence of modern Western classicists is no less strong: in *The Olive Tree,* painted in the late 1980s by PLA artist Zhang Zhenggang, not only the composition and color but the languid pose of the reclining woman staring at the viewer are taken straight from Balthus.

In the work of He Datian, by contrast, it is hard to see any Western inspiration at all, although his technique is foreign enough.[11] Born in Changsha in 1950, he made his national reputation with a one-man show at the China Art Gallery in 1988, and his paintings have since drawn much attention in the United States. He makes wooden panels, painted in warm, rather somber colors, that open to frame a narrow lane or a courtyard with accurate perspective and meticulous realism. This in itself is not remarkable, but his interiors have an air of mystery that makes the viewer want to pause on the threshold, hesitating to step across. Although his old houses are ob-

viously inhabited, there is no one about. All is stillness and silence (fig. 24.6).

When the Stars mounted their heroic exhibitions in 1979 and 1980 they knew very little about contemporary Western art. Five years later, everything had changed. *Meishu* was regularly translating articles on Western modernism from *Art News* and other journals. Art books and journals were coming in from Hong Kong; Westerners in China were spreading the word; Chinese artists and students abroad were sending back reports and impressions. In 1985, letters from Pang Tao, Zhang Song-nan, and Wang Dewei in Paris—the latter writing on the "Trans–Avant-Garde"—were published in *Zhongguo meishu bao,* the first lively, up-to-date, semi-independent art journal to appear in China since Liberation. Moreover, Beijing (and to a lesser extent Shanghai) saw a steady stream of foreign exhibitions: Picasso,[12] Edvard Munch, and Zao Wou-ki in 1983; a Moscow-Beijing exchange in 1984; Canadian art, French twentieth-century impressionism, and modern *nihonga* in 1985; and in 1986 exhibitions of Danish, Dutch, Belgian, British, American, Japanese, and West German art—and many more. The work of modern Chinese artists in Hong Kong and Taiwan, notably Liu Kuo-sung and Wucius Wong, also made a strong impression.

In this atmosphere of intense and often indiscriminate enthusiasm for anything new, it is hardly surprising that the art scene in China became more and more confused. The range of styles was enormous: one might see in the same exhibition realism, abstraction, abstract expressionism, symbolism, symbolic expressionism, photorealism, and hyperrealism. Or one might see Mao Lizhi's witty, skillful, and acutely observed trompe-l'oeil paintings of subjects that, however "foreign" their technique, are intimately Chinese (plate 85).

But there were limits to what the young Chinese artists seemed willing to try. With a few exceptions, they showed little interest in the more reductionist Western forms—minimal art, op art, hard-edge, "primary structures" such as Carl André's arrangements of bricks and tiles, the soft sculptures of Claes Oldenburg. (On the other hand, the superrealist fiberglass sculptures of Duane Hanson were published in *Meishu,* and he had at least one imitator.) One explanation is that some of these manifestations of Western modernism were simply too expensive: how, for instance, could a poor young sculptor get sheets of polished steel? Even if materials had been available, though, these forms of expression were too remote from the gesture with the brush that is at the heart of Chinese painting, or too unsettling, or too poor in intellectual or philosophical content to be taken seriously by these very serious young Chinese artists.

24.7
Tian Shixin, *Sima Qian* (1988). Clay.

OTHER MEDIA

The new spirit of stylistic and technical experiment was not confined to painting. Most of the old wood-engravers must have watched these developments with horror, but even Yan'an veteran Yan Han, once one of the most orthodox, revealed that he was not beyond striking out in new directions: his late prints, although still figurative, show more concern with abstract form than with content.[13] The Guizhou wood-engraver Dong Kejun gave his powerful prints a new gaiety by adding rich color. In Hangzhou, Chen Yujiang invented "watercolor silk-screen printing," in which Chinese water-based ink and color are mixed with glue and applied through a silk screen to a dampened sheet of paper. Several artists, including Pu Guochang and Zhang Xu, no longer printed from the block but simply carved it and painted on it.[14] Many artists made increasing use of mixed media, undoubtedly aided by Liao Xiuping's manual of printing techniques.

Sculpture as an expressive art form also took off in the later 1980s. Sculptors began to employ every conceivable medium and technique, reaching out into the international scene, back into their own past, and into the rich culture of the minorities. This sense that new worlds of experience were opening up gave the new Chinese sculpture a richness and variety not seen before. Tian Shixin's *Sima Qian* (fig. 24.7), a ceramic figure of crude and memorable power, is clearly inspired by the warriors

24.8
Wang Ping, *Sacred Column* (c. 1986). Free ceramic sculpture.

from the tomb-pits of Qin Shihuangdi. Hong Shiqing, a professor at the Hangzhou Academy, reaches still further back: he began in 1986, for the sheer fun of it, to cover rocks and boulders on Dalu Island, some hours away by boat, with crude and lively carvings of fishes, crabs, and other creatures that seem to be inspired by prehistoric rock carvings.[15]

Free-form ceramic sculpture became popular—not surprising when we consider how natural a Chinese mode of expression is the ceramic art, in which form is born from the touch of the craftsman's fingers, rather than carved out of solid stone or wood. Wang Ping, like the printmaker Dong Kejun, found her themes in the arts, beliefs, and customs of the Miao people of Guizhou. In earthenware and wood, she created powerful, freely fashioned forms from heads, bodies, and masks, sometimes superimposed on each other like those on a totem pole (fig. 24.8).[16] Zhao Yunchuan and the Cantonese artist Liu Yong have drawn on the same rich sources, with here and there a nod in the direction of Picasso. Tribal art also inspires the wall-masks of Li Shaowen (fig. 24.9), hitherto best known as an illustrator,[17] and the masklike gourd carvings of Miu Zhihui. In spite of their enormous debt to Western modernism, these young artists were finding inspiration deep in the roots of their own culture.

New, or almost new, to China were tapestry, wall hangings, macramé, and soft sculpture in woven textiles.[18] The work of the French tapestry designer Jean Lurçat had been introduced into China in the early 1950s, but his art was far too advanced for Mao's China and its impact was minimal. Tapestry was chosen for the huge landscape in the Mao Mausoleum, but that was merely a copy of a painting. The art came into its own at last in the 1980s. Wisely avoiding the elaborate prettiness of traditional Chinese decorative style, the best of the new tapestry artists—among them Zhang Ding (already well known as a muralist), Yuan Yunfu, veteran designer Lei Guiyuan, and younger talents such as Xiao Huixiang—found their themes in the art of Shang and Zhou and among the peasant arts: door gods, tigers and dragons, peasant embroideries, and other simple, brightly colored motifs that lend themselves admirably to tapestry. The semiabstract designs of Han Meilin are particularly successful, while Zhang Ding's *Cock* shows that Lurçat's example was being successfully emulated (plate 86).

In 1985, the Bulgarian artist and craftsman Maryn Varbanov (1932–89), who had taught in Beijing from 1952 to 1959, returned with his French wife, she to work for Pierre Cardin in Beijing and he to set up in the Zhejiang Academy what became known as the Varbanov Institute of Art Tapestry (IATV) or the Varbanov Wall Hanging

24.9
Li Shaowen, *Wall Mask* (1986).

24.10
Maryn Varbanov with his wife and students in the Zhejiang Academy of Art (1987).

Art Research Department (Wanman bigua yishu yanjiu suo).[19] He made soft sculptures and macramé, and inspired his students Shi Hui and Zhu Wei (plate 87) to make a huge wall hanging for the Zhejiang Academy. Zhao Bowei, Lin Dongcheng, and Gu Wenda were much influenced by him, and Sun Liang's "soft cloak art" was also inspired by the Varbanovs. A Soft Sculpture Research Society had been established in Shanghai by the end of 1987, but this new art form had not found wide acceptance in China at the time of Varbanov's death.

Another medium that was new to Chinese professional artists was batik. Although for centuries the Miao people had dyed their cotton cloth in floral patterns using this technique, it was Ma Zhengrong, stimulated by an American textile designer who demonstrated at the Central Academy of Arts and Crafts, who made the first batik pictures in China.[20] It would be surprising if he had not also been inspired by the work of Chhuah Thean Teng, the Malaysian Chinese artist and craftsman who had invented batik painting in Penang in the 1950s and whose work had become widely known (see chapter 19).

Peasant art, too, underwent a change and something of a revival, as peasants became prosperous and their tastes (in some districts at least) more sophisticated. Art schools, beginning with the Central Academy, set up departments of folk art. Organizations such as the Nantong Arts and Crafts Institute in Jiangsu became centers where traditional peasant subjects and motifs met and mingled with new media and techniques, some of them imported from the West. To take but one example of this new trend from Nantong, in 1988 Guo Chengyi created *Door God*, in which the semiabstract central motif, carried out in Tang-style polychrome glazed pottery, is set in a scroll-like wall hanging made from textiles and bamboo (fig. 24.11). Media could hardly be more mixed.

In Zhejiang, the well-funded Popular Art Investigation Bureau (Zhejiang sheng qunzhong yishu guan) not only helped the peasants with artistic advice (not all of it good) but arranged in 1988 for an exhibition of their work to be sent to Montana and on to Australia and Europe. When they come into contact with the work of professionals, many peasant artists become dissatisfied with the crudity of their own and stop painting. Those who continue become more self-conscious. Their new awareness of the power of art is charmingly illustrated in a painting by Miao Huixin, a star peasant artist in Jiaxing County, that shows a group of cats dancing ecstatically before a large stylized painting of a fish (fig. 24.12). Ten years earlier, such a painting would have been called *Harvest of the Sea* or some such title. Miao Huixin called his delightful work *Art's Enchantment*.[21] Peasant painting had come a long way from Huxian.

24.11
Guo Chengyi, *Door God* (c. 1985). Mixed media.

24.12
Miao Huixin, *Art's Enchantment* (c. 1986). Gouache on paper.

THE BIRTH OF THE AVANT-GARDE

While the peasant painters were becoming more sophisticated, young artists in the cities were pushing art to its limits and beyond. They had heard of "performances" and "events" in America, Europe, and Japan, and that was enough to prompt them to attempt their own, even though these had long gone out of fashion abroad. Between 1984 and 1986 performances had been staged in Canton, Xiamen, Nanjing, and elsewhere by spontaneously formed groups, but they were frowned on by authority and hardly reported. Even Taiyuan, not generally thought of as being at the cutting edge of Chinese modernism, got into the act with an exhibition on the theme of life and death in October–November 1987 that included, in Caroline Blunden's description,

> A performance piece which took place amidst a series of large trunks of wood, about 4–5 feet high, balanced against each other and tied at the top to form teepee-like shapes, placed on a red ground against a red wall. Two figures appeared, one dressed in white with hair, face, arms etc completely painted in white, symbolising death or sorrow and the other draped in and painted from top to toe in red, symbolising life and joy. They did not say a word, but wandered through their sculpture, occasionally picking up a black ceramic pot or brandishing a red painted hose pipe, or wheeling a red painted iron wheel and replacing all these objects carefully where they had come from.[22]

The meanings of these performances were often even more obscure than this. In December 1986, Zhu Qingxian and Kong Chang'an, who were teaching modern art at Beida, organized a performance they called Concept 21.[23] Some participants were wrapped in cloth and had ink and colors poured over their bodies; another stripped and dripped ink over himself. The purpose, Zhu Qingxian told me, was deliberately to shock the audience, to force them to think about artistic creation and their involvement in it. Spontaneity was the key. And the significance? I asked him. "We can see the significance of our performance," was his existentialist reply, "because we did it." But the mystified student audience quite failed to enter into the spirit of the thing. "They should have received it and reacted more strongly," Zhu said rather sadly.

The cultural apparatchiks viewed these goings-on with predictable unease, or with outright hostility. In May 1985, the Fourth Plenary Meeting of the Chinese Artists Association, attended by 221 artists, art historians, and critics, was subjected to a long lecture by Hua Junwu. Although he acknowledged that art must modernize, in tune with the Four Modernizations, he stressed that the

artists' first duty was to raise the level of art and of the masses' appreciation of art, and to oppose the harm that "capitalist filth and feudalism's evil legacy" wreak upon bodily and mental health.[24] Articles in *Meishu* in 1985 and 1986, hammering away on the Marxist line that art is not self-expression but a reflection (*fanying*) of real life, attacked the "ugly and unsightly" in modern art, mocking its more extreme forms, such as Cristo's projects.

The pseudonymous Fei Wei, writing in *Meishu*, deplored the number of paintings that show figures in back view, facing away from the viewer towards a vast, level empty space. Here, he says, is no intense, stimulating mood, no longing, heartrending sentiment, no agonizing deep thought (although the artists themselves would certainly have challenged that); the principal effect is of vanishing, disappearing, everything enshrouded in a murky, ambiguous atmosphere. "Idealism has been transformed into mysticism; crying out has been changed to 'anti-thought.' More and more young artists have sunk into the bosom of a hesitant, indefinite, speculative cast of mind." He regrets the passing of the powerful oil painting of the Sichuan Realists, even of the Stars, who were "blazing hot, advancing on the enemy, showing a heroic spirit that is hard to find today."[25]

Lang Shaojun took a more forward-looking view, and his defense of Chinese modernism is worth quoting. Since Mao, he writes, the economic egalitarianism that had been taken for the perfect society has been dispelled. "The eyes and ears of aesthetics should respond to the changing positions and relationship of subject and object in the world. . . . Painters must address themselves to the new topic of how Chinese painting is to be baptized by science, adapt itself to an ever increasing number of connoisseurs whose brains are armed with modern technology, and borrow from modern psychology, chromatology, and the various new media offered by a mechanized culture."

Lang notes, almost in passing, that "there is of course a duty to guide the young," but the main question is how to reconcile older viewers to the art of a younger generation "emerging from historical transformation with for the most part a structure of knowledge, interests in life, and aesthetic ideals very different from those of their elders. . . . With a public ever more weary of expository pictures entering a contest with photography, with whose realism they cannot contend, subjective awarenesses (including significant latent awarenesses), hard to verbalize or put across by lifelike simulation, demand new graphic forms and languages." Lang cites the controversy over Shi Chenghu's painting *Old World Inscription,* of which he offers this robust defense:

This work smashes the classical harmony of Chinese painting to make a feature of dissonance. The excitement it conveys by unorthodox ink-and-wash imagery charged with astringency and close to Western expressionism, its nightmarish recollection of a past age and its complex mood of the pain, hatred, and fascination of that recollection, strike a sympathetic chord in those who can neither turn back to nor dismiss the past. Not only does it make one feel one is face to face with that long-departed unfortunate historical shadow, it brings one face to face with the artist's mind in the here and now, a state inexpressible by realistic methods and difficult to convey via the clean, elegant, charming aesthetic of traditional ink painting.[26]

In the same gallant spirit, critics in the progressive *Zhongguo meishu bao* praised Robert Rauschenberg (whose strange exhibition came to Beijing in 1985) for giving Chinese artists "a window through which to look out of China and get to know the world and modern Western art." They appealed to China to be tolerant, and not to look at things from the conventional Chinese standpoint. Rauschenberg, wrote one, "breaks some rigid laws and makes a new style"; he uses common materials and so "shortens the distance between art and life. . . . The line between art and non-art is becoming vague." Rauschenberg's works "give viewers the space to imagine."[27] Doors were opening that could never be closed again.

GUOHUA TAKES NEW DIRECTIONS

Once almost every conceivable Western style and medium had been tried, young artists put the revitalized guohua back at center stage. Prominent among artists who emerged at the Advancing Chinese Youth Art Exhibition in 1985 were several who carried guohua into a new world of often violent emotion.[28] Among them was Li Shinan, who showed his powerful *Dream of Zuoshan;* an equally compelling work is his memorial to the rape of Nanjing forty-eight years earlier. The Japanese atrocity is also the theme of a guohua triptych painted with unsparing realism by Cai Yushui (fig. 24.13), suggesting that he might have seen, at least in reproduction, the horrific 1950–54 series of paintings of Hiroshima by the Japanese artist Maruki Iri.[29]

Remembered horrors could also be captured symbolically. After her tour of Germany in 1986, Yu Feng completed a series of paintings (plate 88 is one) of which she wrote to me, "I was deeply moved by the perfect art of architecture, but when I walked along in the dark path

24.13
Cai Yushui, *The Rape of Nanjing, 1937* (1985). Chinese ink on paper.

with stone steps and big halls with small windows, I felt chilled with dreadful terror. That reminded me of the mystery and cruelty of the history of the Middle Ages. . . . I should say the conception included the reality in China I used to know, especially the Cultural Revolution"—and, we might add, the China she was to know again, in June 1989. A week after that terrible event, she and her husband, Huang Miaozi, sought refuge in Australia.

At the opposite extreme from the realists were those who used guohua to explore in new ways the interaction between pictorial form and ideographic symbol that is at the heart of Chinese visual communication. We have already seen Yang Yanping's experiments in this direction (in chapter 23); now it was carried to dramatic extremes. A leader in this movement was Gu Wenda. Born in Shanghai in 1955, grandson of a playwright and brother of a musician, he became a Red Guard as a youth. After a spell in the country he was sent to study woodcarving in Shanghai, but he disliked it and took up painting, imitating the style of Li Keran.[30] Soon he was enrolled under Lu Yanshao in the Zhejiang Academy, where, like Zao Wou-ki before him, he became impatient with the endless copying of old paintings. He turned to the study of Western art, philosophy, and religion, reading voraciously, declaring himself a disciple of Nietzsche. Yet so assiduous a student had he been of orthodox Chinese painting that he was appointed to teach guo-

hua in the Zhejiang Academy, while continuing to paint in oils. He came to feel that too many young Chinese artists had been "taken prisoner," as he put it, by Western art, and although he remained an intense student of Western art and thought, he gave up oils and returned to the Chinese medium. His landscapes are full of hidden meanings and ambiguous images: in *Sky and Ocean* a white pillar of cloud rises from the sea, resembling, as Fan Jingzhong noted, "the frozen phantom of an ancient Greek statue."[31] Other landscapes carry heavy sexual imagery, which shocked not only the officials but many of his fellow students. During the Anti–Spiritual Pollution campaign he was violently attacked and demoted to teaching in the high school attached to the academy.

Gu Wenda's most striking and original works of 1985 and 1986 are a series of large paintings, some in several panels, dominated by Chinese characters that are often reversed, crossed out, or mutilated in red. "This treatment of Chinese characters," wrote Jason Kuo, "seems to be the artist's reaction toward the abuses of language by the writers of the 'Big-Character poster' (*dazibao*) during the Cultural Revolution"—and since, one might add. "A related mutilation of the written language can be seen in his series of paintings in which enlarged seals bearing reversed and almost indecipherable legends serve as the foci of the paintings."[32] His most powerful works of this kind include *A World of Purity* (a

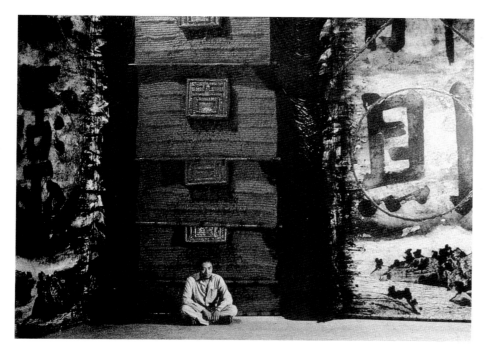

24.14
Gu Wenda, *Inspiration Comes from Tranquility* (1987). Tapestry and mixed media installation.

set of five panels), *The Door God of Insanity,* and *The Door God of Silence. The Characters Zheng and Fan* ("correct" and "opposed") created a sensation in the National Youth Exhibition in 1986. These questioning, symbolic works, by violating orthodox doctrine of artistic value, represented a direct challenge to authority, provoking Xiao Feng, director of the Zhejiang Academy, to describe Gu Wenda's art as "pornographic, vulgar, obscene, and superstitious." In 1987 Gu went into voluntary exile in Canada.

In the short time before he quit China, Gu Wenda's work developed beyond painting on a flat surface. Working with Varbanov on several of the latter's soft sculpture projects stimulated him to create his own large-scale multimedia installations, notably *Jingzhe shengling,* which might be translated "from tranquility comes inspiration" (fig. 24.14). The four characters (the first and third crossed out, the second and fourth circled) flank a series of superimposed hanging woven panels bearing indecipherable seals in relief. Predictably, because the artist's name appeared several times in large format, Xiao Feng attacked Gu for "individualistic self-expression." In another work with the same Chinese title (fig. 24.15), the monumental characters are simply written on the flat surface of the silk panels.

Although Gu Wenda was perhaps the most daring and creative serious artist in China between 1985 and 1988, he was not the only one to explore the formal, seman-

24.15
Gu Wenda, *Wisdom Comes from Tranquility* (1983–86).
Four panels. Ink and acrylic on silk mounted on paper panels.

tic, symbolic, and expressive power of the Chinese ideograph. Xu Bing was born in Chongqing in 1955.[33] Before he graduated from the Central Academy in 1985 his prints had been exhibited in France and West Germany, and he was already rapidly developing from straightforward printmaking toward a new form of conceptual art, which he made his own. Like Gu Wenda, he was deeply concerned with meaning and the distortion of meaning.

24.16
Xu Bing, sheet of imaginary characters, from
Tian shu (A book from the sky) (1988).

24.17
Xu Bing, *Tian shu* (1988). Installation.

24.18
Xu Bing, *Tian shu* (1988). Installation.

Xu Bing's project *Five Series of Repetitions* (1987) explored the carving, printing, and wearing away of wood blocks, inspired by the plants in the rice fields he remembered from his youth. In October 1988, his *Tian shu* (A book from the sky) was the sole exhibit in his show at the China Art Gallery in Beijing (figs. 24.16–18). Of this remarkable work, Britta Erikson wrote when it was later installed at Madison, Wisconsin, "The somber orderliness of thousands of characters printed in black on white enshrouds the room, masking the walls, draping down from the ceiling, and covering part of the floor. It is a very formal arrangement. The prints on the floor are bound together in the form of traditional Chinese books. . . . The prints draped from the ceiling follow the more ancient format of sutras, or religious texts. On the walls, the prints recall the newspapers which in China are pasted on walls daily for the public to read." Of the thousands upon thousands of characters, all but ten are meaningless, invented by Xu Bing himself. Thus does the artist, by seeming to mock the sacred texts of antiquity, mock those of contemporary China. The viewer becomes enveloped in the verbiage that passes for truth.

When a Party critic in *Wenyibao* condemned this work, and the New Wave generally, as "ghosts-pounding-the-wall art . . . opposing the laws of art and of society," Xu Bing, in a splendid gesture, embarked with his students at the Central Academy on an even vaster project: to take rubbings from the rough surfaces of the Great Wall, symbol of China's isolation, and mount them in an enor-

mous installation. Here, through the very futility of the tremendous labor involved, Xu Bing once again expressed the meaninglessness of human endeavor in modern China.

CHINESE ARTISTS SEEK FAME AND FORTUNE ABROAD

As artists' horizons expanded through the 1980s, they became restless and dissatisfied with the conditions under which they lived and worked—particularly so after 1986, when the *xin chao* was suppressed. The vagaries of official patronage and neglect, encouragement and censure, contributed to the crisis in the mind of artists such as Gu Wenda, as did the lack of facilities for exhibition, of any permanent collections of contemporary Chinese art, of intelligent critics and collectors. Chinese artists also could not avoid the sense that as they advanced they drew further and further away from the public they should be communicating with, and that for support and intelligent criticism they had to rely on foreigners and exhibitions of their work abroad.

The choice that faced them was stark. They could stay on in China and endure these conditions, or they could go abroad to be absolutely free, cut off from China, allowed to sink or swim as chance or fortune determined. The choice was made the more difficult by alluring reports of the freedom and infinite possibilities of the European and American art world and by rumors of the huge sums that Chen Yifei, a technically brilliant oil painter and graduate of the Shanghai Academy, was being paid for his portraits in New York.[34]

By May 1987, when Odile Pierquin-Tian mounted in the lobby of the Maison des Sciences de l'Homme in the Boulevard Raspail an exhibition of the work of Chinese artists, most of whom were living in France, there had been a major exodus of frustrated and embittered young modernists from the People's Republic.[35] Among the exhibitors were three of the original Stars: Wang Keping and Li Shuang, who had married French citizens and settled in Paris, and Ma Desheng, who was struggling to establish himself in Lausanne. Ma was a man of passion, speaking no French, whose pride aroused as much resentment as his single-minded devotion to art won him admiration. "We can never surpass the Ancients, but neither have we any choice but to risk taking new paths," he said.[36] At this time he was creating tumultuous compositions in Chinese ink, some of which emerge as figures or mountain landscapes (fig. 24.19), and he seemed, against all odds, to be winning the struggle for recognition.

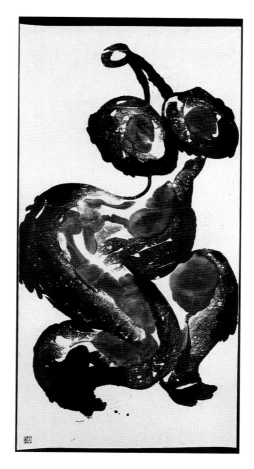

24.19
Ma Desheng, *Nude* (1988). Ink on paper.

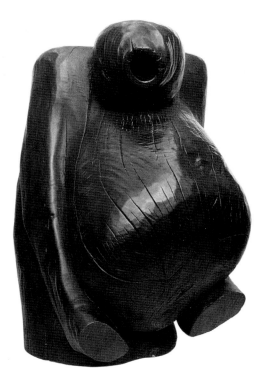

24.20
Wang Keping, *Big Belly* (1988). Wood.

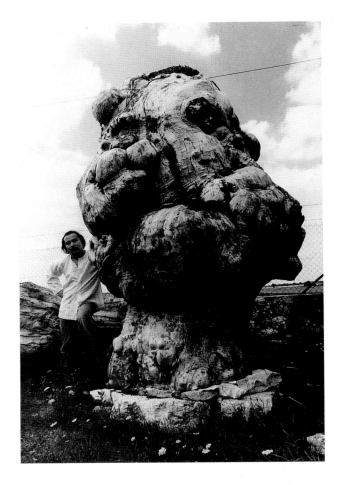

24.21
Wang Keping, sculpted tree trunk (1988). Olympic Park, Seoul.

Nor had Wang Keping compromised. From the time of his arrival in 1984, this fecund self-taught sculptor worked ceaselessly, regardless of fashion or the demands of the art market.[37] His pieces, generally in wood and occasionally in bronze—now no longer limited in size to what he could scrounge in Beijing—were anthropomorphic, exploiting and accentuating natural bosses, projections, and holes, giving them powerful sexual overtones (fig. 24.20). "I am a male," he wrote in a letter to me, "Anyone who looks at my work will know that!" A huge work of 1984 was bought by the Korean government in 1988 to stand in the Olympic Park in Seoul: a tree-trunk, 3.4 meters high and weighing four thousand kilos, of which the upper part—carved and uncarved masses indistinguishable, writhing and twisting—seems to burst outwards with barely contained power (fig. 24.21).

In the letter quoted above, Wang Keping vividly describes the problems that face the Chinese artist coming to the West. The first is language. The artists unable to communicate in French cannot make contact with the galleries or catch the critics' attention, no matter how good they are. Many who cannot adapt want to go back to China, or to quit painting and go into business. Before leaving China, artists thought they would have an easy life in the West; they heard the good news and turned a deaf ear to the stories of failure. "If you want to sustain yourself," writes Wang Keping, "don't have too big a dream. Accept that you will be very lonely. That is the only way to become successful. This applies just as much to the Western artists: they have the same problem." Wang well describes the emptiness and disappointment that many Chinese arrivals feel: "Some artists, famous in China, came to the West to find they were unknown, and had to start all over again. Some just got lost. Many of them, back in Beijing, had been like actors performing on the stage. But when they come abroad they become the audience, watching the play. By leaving China, they have lost much."

Some artists, thinking that their art would not suit Western tastes, started to change their style, to their great loss. The majority feel a terrific stimulus from Western art, but it robs others of their self-confidence. As Wang Keping writes, clinging to "Chineseness" is no solution: "If you purposely add on Chinese characteristics, that shows you are a second-rate artist and have no real creativeness in you." And he underlines the point: "Lots of Chinese artists from the PRC like to put some traditional elements in their work as a substitute for their own creation. This is only to deceive those who don't under-

stand art." He says, in effect, be true to yourself, "and you will be Chinese in whatever you produce. Anyone in the West, when they look at your work, will feel that."

By 1987, contemporary Chinese art had become popular with U.S. collectors, always eager for any new thing. There were frequent special exhibitions, and no fewer than four galleries in Manhattan were selling current Chinese work, with a heavy though not exclusive emphasis on various kinds of realism: the Hammer Gallery (which did very well with Chen Yifei), the Hefner Gallery (specializing for a time in the Sichuan School), the less specialized Grand Central, and Ethan Cohen's Art Waves, which promoted the avant-garde. Some young artists who innocently accepted a gallery contract became disgusted when they understood the restrictions it imposed on them and returned to China. A handful prospered. Many, at last given the absolute freedom they had longed for in China but cut off from the culture that had sustained them even as they fought against it, felt isolated and bewildered, hoping only to gain a foothold in the art jungle of New York, relying less on conviction or inner necessity than on their intelligence, technical skill, and adaptability. As the number of talented refugees increased, so was the art world in China impoverished by their departure.

Bai Jingzhou, a conventional realist who had graduated from the Central Academy in 1980, spent two years in Southern Illinois University before settling in New York in 1985. Ai Weiwei, one of the original Stars, arrived in 1981; after studying at the Parsons School of Design and the Art Students' League, he established his own studio and became well known in New York for his surrealist and satirical works in a variety of media (plate 89).[38] In 1982 Yuan Yunsheng came from Beijing, and in 1983 he was appointed artist in residence at Tufts University. His *Grapevine* of 1987 (fig. 24.22) shows a violent yet ambiguous eroticism that is a very long way from his stylish Beijing Airport wall paintings. In 1984, Zhao Gang, another of the Stars, came to New York after a year's study in Holland. From a very different background came Wang Jida, who had spent many years painting and sculpting in Mongolia, and his wife Jin Gao. Both had also played a prominent part in promoting Mongolian art.

Xing Fei, born in Beijing in 1958, came to New York in 1984, trained in traditional painting. After a year she had abandoned guohua for conceptual and structural art, one of her better known pieces being *Window with Wall,* a lattice window through which visitors to the Beijing/New York Avant-Garde Chinese Art exhibition, held in the City Gallery in July-August 1986, could see a room filled with the assorted styles of Chinese modernism. Her *Garden Installation,* featured at Art Waves,

24.22
Yuan Yunsheng, *Grapevine* (1987). Ink on paper.

was described by Alisa Joyce in *New York* as combining "the symbols and clichés of traditional Chinese composition with Western materials of mixed media and collage on canvas." Other artists who arrived in 1985 included Wei Jia, a subtle painter of landscapes and abstractions, who settled in Bloomsburg, Pennsylvania; Zhang Hongnian; and Zhou Xiqin, a gifted wood engraver and painter of animals and birds, who was a visiting artist at the Los Angeles County Museum of Natural History.[39] Li Shuang, another of the original Stars, had started to make collages long before she settled in New York, and the panel illustration here (plate 90) is typical of her work, which makes up in decorative charm what it lacks in depth and passion.

One artist who clung closer to his Chinese roots was Zhang Wei, who had been denied admission to the Central Academy on account of his bourgeois background, worked as a garbage collector during the Cultural Revolution, and in 1981 had exhibited with the Nameless in Beihai Park. A sensitive and poetic landscape painter, he was briefly influenced by Pollock and Kline after his arrival in New York in 1986, but he soon returned to the deeper, more poetic and elusive qualities that Western abstract expressionism shares with Chinese calligraphy and landscape painting.

Yan Li, one of the brightest of the Stars, a self-taught and rather playful surrealist artist and poet, had been allowed a solo exhibition in Shanghai in 1984. But this rare privilege was not enough to dissuade him from leaving in the following year for New York, where he soon found his feet. "Your environment changes," he told a reporter with disarming frankness, "and your art

24.23
Gu Wenda, *The Dangerous Chessboard Leaves the Ground* (1987). Installation.

changes." By 1986, his paintings were showing the be-
lated influence of Lichtenstein and Warhol. "Maybe by
next year," he said, "I'll choose another style to express
myself with."[40] Such cynical opportunism was not yet
typical, although the temptations were great.

Many of these artists (as well as Gu Wenda and Wang
Keping) were featured in the first exhibition of the Chi-
nese United Overseas Artists Association, founded in
1986 by Yuan Yunsheng and Bai Jingzhou to bring ex-
patriate artists together and give them a feeling of soli-
darity. In his foreword to their first *Annual,* Yuan
Yunsheng wrote, "We have finally arrived at the time of
an important turn in the course of events. China's an-
cient culture has been a burden we have carried for a
long time. Now, here is our time to speak out to history
and to the people of the world. We can no longer en-
dure the consistently blank space representing China in
the books of so-called 'international' modern art. . . .
Chinese artists are determined to fill in that blank space.
We need not be intoxicated with the past glories of our
culture, and should not console ourselves with 'the
beauty of the blank space.' Chinese modern art exists,
and we shall go our own way."[41]

These are brave words. But the problems of commu-
nication between artists scattered across the world, and,
more seriously, the rivalries and jealousies created by the
commercial competitiveness of the Western art world,
defeated them. Within two years, the association was
falling apart.

The challenges and temptations of the Chinese ex-
patriate artist are vividly illustrated by the activities of
Gu Wenda after he went to Ontario on a Canada Coun-
cil Grant in 1987. At York University he was given the
freedom, the space, and the resources to create a suc-
cession of huge installations, such as *The Dangerous
Chessboard Leaves the Ground* (fig. 24.23), which, in the
words of Bruce Parsons, "makes an articulate statement
about the life of a young artist dealing with the contra-
dictions facing him today."[42] The floating chessboard fills
the gallery with panels suspended above the floor. Thirty
players dressed in red robes are the chess players; the walls
are covered with huge abstract calligraphic paintings,
while the audience standing in the center of the room
is an integral part of the work. To other installations Gu
created in 1987 he gave such titles as *Closet for the View-
ers' Red Costumes, Coming Out,* and *Don't Touch.* The

24.24
Gu Xiong, *Barricade of Bicycles: June 4, 1989* (detail) (1989). Acrylic on paper.

summit of sensationalism was achieved in his *Two Thousand Natural Deaths,* in which the artist sits flanked by screens bearing on one side a thousand clean sanitary napkins and on the other a thousand soiled ones. One cannot but deplore the manner in which critics and interviewers feed the ego of a confirmed egotist and, in concert with him, grossly inflate the value of his work. If Chinese artists at home suffered from a lack of critical response, those in the West, eager for media attention, can be corrupted by too much of it.

For some exiled Chinese artists, the solution to the problem of personal identity in an alien and rapidly changing world might be to ignore cultural frontiers and national styles altogether, and even the reconciliation of East and West, and instead reach down into the inner world of one's own psyche to find the images that are a true expression of one's self. Wang Keping is convinced that this is the only path for the Chinese artist in the West, and it is the path he courageously treads himself. Few of the expatriates can forget their "Chineseness" and say, with the Taiwanese painter Yang Chihong, who settled in New York in 1980, that he has "neither an Eastern nor a Western consciousness. . . . Before being a Chinese, or a New Yorker, or even a painter," he declared, "I'm a man."[43] For most, their identity is inescapable, and the source of their strength.

The memory of June 4, 1989, is still fresh for these artists, inspiring them to produce in Canada and the United States works that they could not exhibit in China: Han Xin's *Crucifixion,* for example, a mixed media painting of a bicycle flattened by a tank at Tiananmen; Gu Xiong's ambitious compositions and installations on the same theme, exhibited in Vancouver (fig. 24.24); and Chen Danqing's *Expressions,* a photo-realist work based on a press photograph of the slaughter on the square. These artists keep alive memories that the authorities in China are only too eager to suppress.

But exile has also made Chinese artists aware of their identity at a deeper level, breeding a more detached and reflective attitude toward their culture, drawing upon Chinese philosophical concepts now well understood by sophisticated Westerners. Zhang Hongtu, in his gutted *Chinese Book 2* and his negative, hollowed-out concrete silhouette of Mao Zedong, both comments on the loss of power of recognizable symbols and invites Daoist thoughts about the meaning of the void. Gu Wenda, Zhang Jianjun, and Hou Wenyi, working in North America and Japan, explain their new creations in terms of the philosophy of Zhuang Zi, *The Book of Changes,* the yin-yang dialectic, even the Five Elements system.[44] Thus do the expatriates add a richer dimension to the art of China as it approaches the end of the century.

25

TIANANMEN AND BEYOND

SHANGHAI MODERNISM

In November 1986, the students of Anhui University of Science and Technology in Hefei, buoyed on the wave of hope and optimism that characterized the second Peking Spring, staged a demonstration demanding democracy.[1] The mood quickly spread to other cities, and in January 1987 the call was answered by an even bigger demonstration in Tiananmen Square. The official response was swift and harsh. The movement was crushed in the campaign against "bourgeois liberalization" that lasted until May 1987. There were many arrests in those dark months, and three leading dissidents—physicist Fang Lizhi and writers Wang Ruowang and Liu Binyan—who had supported the students were dismissed from the Party. For much of that year, the momentum went out of the modern art movement. But the struggle for creative freedom was not yet over, finding expression in such striking works as Xu Mangyao's *My Dream,* painted in 1988 (plate 91).

In the meantime, the art world of Shanghai had at last begun to stir from its long sleep. As early as 1983, the art department of the University of Shanghai had held an exhibition of "experimental" painting, which was little noticed. The movement began to take form and purpose two years later with the founding of the Shanghai Youth Artists Association.[2] About three hundred strong, these artists had ambitious goals: to hold biennial exhibitions, promote international exchanges, sponsor new talent, and arrange symposia and lectures. When they held their first exhibition in 1986, it was reportedly visited by ten thousand people, although it only lasted four days. Shanghai had seen nothing like this since Liberation.

For many years Shanghai, its artistic life sterilized by

Mao, had boasted no art school worthy of the name, though a few artists were trained in the theater design department of the Shanghai Academy of Drama, among them three men prominent in the new art movement: Zhao Baokang, Zhang Jianjun, and Wang Jingguo. Shanghai artists had been little involved in the dissident movement of the Peking Spring, and their art of the mid-1980s was less obviously political than that of the Stars, more subjective, perhaps—a subjectivity that became more pronounced as the anti-liberalization campaign gathered strength through late 1988 and early 1989. Yuan Shun's *House and Man* series of ink paintings conveys a sense of desolation and imprisonment (fig. 25.1). Wu Liang, writing in *Zhongguo meishu bao,* claimed that Yuan's striking series of lohans reflected the serenity and quietude of Eastern people: "The nine lohans that look like rocks reflect the pure condition of returning to the primeval state of the universe"[3]—a curious statement about figures that seem a parody of the crude lohan type (itself a caricature of the Indian ascetic) and are charged with an almost desperate intensity of emotion that is the very reverse of quietude. Even Qiu Deshu's semiabstract paintings, which seem so beautiful to the eye, convey tension, a sense of something flawed (fig. 25.2). Of these, the artist writes, "One can see cracks everywhere—on the earth's crust, in mountains and rivers. These cracks are the epitome of nature and also my own soul. They represent life's wounds and scars . . . a broken heart. . . . My images of cracks are at once beautiful, painful and alive."

More painfully expressive of such feelings are Zhao Baokang's oils, notably his *Crown with Brambles* series of 1988–89. To Zhao this represents the cost in inner suffer-

25.1
Yuan Shun, *House and Man* (1989). Ink and color on paper.

25.2
Qiu Deshu in his Shanghai studio (May 1989).

ing to the artist and intellectual who accepts the "crown" of Party approval, status, and privilege, surrendering his independence. Vitality and almost unbearable tension come through also in the work of Yu Youhan, Xu Hong, and Wang Jingguo.

The blossoming of the Shanghai school of modernism in the space of four or five years was remarkable, but we should be careful not to overemphasize its importance. Most of the new Shanghai painters reflected the general tendencies of eclectic Westernized modernism discussed in chapter 24, and the public cared nothing for painting that was not easy to understand at first glance. It was this colossal public indifference, as well as erratic official hostility, that drove many of these artists to seek recognition abroad and some to settle permanently in Europe or the United States.

THE AVANT-GARDE ASSAULT

The Shanghai movement was startling in that it seemed to come from nowhere, but it was by no means the only bridgehead of defiant, subjective modernism in the late 1980s. The critics responded predictably to the outbreak, some bewildered, some afraid to attack the young, some praising the new "pluralism." Party cultural apparatchiks became increasingly uneasy. The Fifth National Congress of the Federation of Literary and Art Circles, which opened in Beijing on November 5, 1988, was considered important enough for Deng Xiaoping to attend in person, there to deliver a lecture and a warning.[4] Propaganda chief Hu Qili, who three years earlier had encouraged creative freedom, now insisted that art and literature must be subservient to the four basic principles: socialism, party leadership, proletarian dictatorship, and the primacy of Marxism.

But even while the congress was sitting, final preparations were being made for the exhibition of nude paintings organized by the Teachers' Society of the Central

Academy with the support of Ying Ruocheng, who was vice-minister of culture and a noted actor. The Guangxi People's Publishing House produced, purely for profit, a lavishly illustrated catalogue that sold for forty-five yuan, the equivalent of half the average worker's monthly salary.[5] In his foreword Wu Guanzhong, one of the moving spirits behind the show, appealed to viewers not to be afraid of the nude, which "had been hiding in the dark shelter of the art college studio, dragging out an ignoble existence."[6] He compares Goya's *Maja Clothed* and *Maja Naked,* noting that the sexual component in the perception of beauty is not salacious, while many salacious pictures are not completely naked. He says of this first exhibition of nude painting in China that it is a milestone, showing the development of the Chinese social consciousness and of the open-door policy in the arts.

As for the works themselves, they ranged from the beautifully painted salon-style oils of Jin Shangyi (fig. 25.3) and Yang Feiyun—including a very frank frontal nude, the head of which is that of his wife and the body that of an unnamed model—through the merely competent to the outright awful. Meng Luding showed his abstractions, very different from his surrealist-symbolist *Revelation from Adam and Eve.* Artists and art students took the show in their stride. One said, in an opinion echoed by others, "It's perfectly normal. Most students are entirely behind this exhibition because it shows the influence of the West. . . . It shows we are opening up."[7] But many of those who queued for hours, paying the huge sum of two yuan (instead of the usual three fen) for a ticket, came out of mere curiosity, or from more prurient motives: they largely ignored the abstractions while giving the realistic paintings close scrutiny.

The effect of the exhibition on some of the models was unfortunate. Some were furious with the Ministry of Culture for not keeping their names secret and were outraged at the sale of postcards and picture albums

25.3
Jin Shangyi, *Seated Nude* (1988). Oils.

(which did not stop some of them from claiming a share of the proceeds). A newspaper reported that one model was so terrified of her husband's reaction that she kept him out of the house when the opening of the exhibition was shown on TV news. Another asked her husband if he too would model—whereupon he divorced her.[8] The value of an exhibition devoted entirely to the nude would have been questionable in any society, however advanced; in the Beijing of 1988, it was a brave mistake. Public opinion about the nude had advanced a little from Liu Haisu's daring exhibitions of sixty years earlier, but not much.

As if the nude show were not provocative enough, artists were now resolved, it seems, to test the limits of Party tolerance. In 1987, a group of artists and art editors and critics had planned an exhibition of avant-garde art. The prime movers in this audacious enterprise were Li Xianting, a progressive art editor; Liu Shaochun, editor of *Zhongguo meishu bao;* Gao Minglu, its most authoritative contributor on contemporary art; and Zhou Yan from the art history department of the Central Academy.[9] But the timing was unfortunate, for the Anti-–

Bourgeois Liberalization campaign was at its height, and the Artists Association prohibited the exhibition. The project was revived in the warmer climate of May-June 1988, when over a hundred artists and critics gathered for a preparatory meeting at Huangshan. The artists brought slides of their work, and a preliminary selection was made. Among the avant-garde artists who took a leading part were Xu Bing, the Xiamen dadaist Huang Yongping, Wu Shanzhuan, and Feng Guodong.

The organizers were by no means of one mind about the aims of the show. Li Xianting, who insisted that it should be an instrument to "pound society," actually came to blows with Gao Minglu, who wanted to present the strands of Chinese modernism in a logical historical sequence. The exhibitors included the North China Art Group (Beifang yishu tuanti), which promoted a cool, reasoning kind of painting; the New Wild Group (Xinyexing pai), composed chiefly of expressionists from southwest China; Huang Yongping's Xiamen Dada; and the City Artists Group (Dushi huajia qun), artists living in the big cities, whose work tended to be more abstract, advanced, and sophisticated.

In the atmosphere of feverish tension and excitement that often heralds a storm, the Avant-Garde Exhibition opened in the China Art Gallery on February 5, 1989. The shocked and bewildered public was treated to constructions, installations, performances (one artist threw seven thousand condoms on the floor as his comment on China's population problem), dada, symbolism, surrealism, and indeed almost every conceivable manifestation of ill-digested Western modernism and postmodernism.[10]

Meng Luding's mixed media panel, originally called *Family,* was a complicated metaphor for the tensions and stifling pressures of modern city life, a feeling expressed also by Zhang Peili with a pair of rubber gloves pressed between two sheets of glass. Geng Jianyi's *Second State* (fig. 25.4) showed a man's face twisted in agony—or is it mocking laughter? Or a vast yawn of sheer boredom? *Suicide,* a performance by Wei Guangqing and others, and *Speaking, Communication, Mankind,* by Hou Hanru and others, both spoke of isolation and despair. Gu Dexin's human organs in colored plastics evoked, intentionally, revulsion (fig. 25.5). Just as striking were the works that expressed the artist's mockery of accepted interpretations of history—even of the history of art itself. Huang Yongping's dadaist box of printed books reduced to pulp in a washing machine, obviously influenced by Joseph Beuys, is entitled *A Comprehensive History of Chinese Art and A Concise History of Modern Painting*—the former a reference to Wang Bomin's well-known work, the latter to the book by the English champion of modernism, Herbert Read. The printed word and the

25.4
Geng Jianyi, *Second State* (1987). Oils.

25.5
Gu Dexin, *No Title* (1988). Plastics.

received versions of history, Huang Yongping is saying, are a load of rubbish. So also is art itself, said the Xiamen Dadaists, who after their notorious show of 1986, the first such event in China, had publicly burned all the exhibits.

Perhaps the most memorable exhibits in the avant-garde show were the huge installations by Xu Bing and Gu Wenda described in chapter 24. But the most sensational was undoubtedly *Dialogue* (fig. 25.6), an installation showing telephone booths separated by a stand, the phone in the center dangling from the hook before a mirror: the man and woman in the booths are clearly not communicating with each other at all. One of its creators, Xiao Lu—feeling, as she later explained, that her work was incomplete, that it "lacked destructive energy"—walked in on the first day, drew a pistol, and shattered the mirror with two shots, claiming that only by this act of destruction could the work be said to be "complete." Perhaps she also had in mind this definition of art in Bei Dao's *Notes from the City of the Sun:*

> Art:
> A million scintillating suns
> appear in a shattered mirror.[11]

Xiao Lu, daughter of the extremely embarrassed director of the Zhejiang Academy, was held in police custody for two days and then released, although the authorities refused to allow any more performances. The exhibition was allowed to continue but closed down after a few days.

Some critics gave the avant-garde show, without attempting to interpret it, their cautious approval, although they noted that some artists had abandoned their natural style in order to draw attention to themselves with some

25.6
Tang Song and Xiao Lu, *Dialogue* (1989). Installation.

outrageous work. Others were predictably hostile. *China Daily* quoted one unnamed critic who wrote of these artists: "They never admit that their works have any external purpose. They have no intention to enlighten someone or to search for the meaning of human existence. What they are doing is just to keep painting in their heart: an upset, depressed and frenzied heart."[12] If the writer did not go on to enquire why, he or she at least was aware that the painters' hearts were upset, depressed, and frenzied. More typical was the Party cadre who wrote in the comments book, "My general feeling is that this exhibition is incomprehensible, a confused hodgepodge that has everything in it but works of real artistic value. It reflects ideological emptiness . . . primarily sexual liberation, lust that will drive people into promiscuity. Disgusting, naked filth!"[13] Clearly the gulf that Mao Zedong had once closed between the educated and the masses had widened to the point that it was now almost unbridgeable.

With the avant-garde exhibition, the young artists had clearly gone beyond what even the most liberal cultural officials could tolerate. The counterattack began to gather pace. The Ministry of Culture ruled that hence-forward all exhibitions were to be vetted and nothing shown that had not been approved beforehand. But the artists were not to be silenced—not yet, at least. They were to make one more magnificent gesture.

THE SLAUGHTER AND ITS AFTERMATH

Shortly after April 15, 1989, the day that Hu Yaobang died, artists, writers, teachers, students, and many others began to gather on Tiananmen Square to mourn him and to demand freedom and democracy.[14] Students at the Central Academy of Fine Arts took a prominent part in the events that followed. They turned out banners and posters and a huge portrait of Hu Yaobang that was paraded in the square bearing the legend, "Where can we find his soul?" Support poured in. Established artists, including the veteran Li Keran, gave them paintings to sell. Over the next six weeks, as the numbers on the square multiplied, the tension and excitement grew.

The students planned a great demonstration to take place on May 30. Five days earlier, students in Shanghai had carried a replica of the Statue of Liberty through the streets; their friends in Beijing wanted something both

more original and more Chinese. The Federation of Beijing University Students gave eight thousand yuan (about two thousand dollars) to the art students in the Central Academy to make a figure of the Goddess of Democracy. Working night and day, a group of about fifteen young men and women in the academy sculpture studios fashioned a figure ten meters high in styrofoam (fig. 25.7). When the time came to move it to Tiananmen, the security police threatened that any truck driver who carried it would lose his license, so the students linked hands to form a protective escort and brought the statue in sections on flat-bed trolleys to the square, where they erected it at a point midway between the Heroes' Memorial and the portrait of Mao on the palace gate. On the night of May 29 it was assembled and at noon on the 30th it was unveiled, to the sound of cheers from a huge crowd, patriotic songs, and the "Ode to Joy" from Beethoven's Ninth Symphony (fig. 25.8). A dedicatory statement demanding freedom and democracy was signed by the central academies of arts, crafts, drama, and music, the Beijing film and dance academies, the Academy of Chinese Local Stage Arts, and the Academy of Chinese Music.

Five nights later, amid the indiscriminate killing of students, workers, and citizens ordered by Premier Li Peng, the Goddess of Democracy was overturned and crushed by a tank. The next day its fragments, with all traces of the month-long occupation of the square and the slaughter in the surrounding streets, were swept away. In the following days, the police several times visited the Academy, paying particular attention to the wall painting department. But virtually all the staff and students had been involved: the president had donated money, and the vice president had taken part in the demonstrations. They closed ranks, and control was gradually relaxed.

With the crushing of the Tiananmen demonstration, night descended. On July 10, the propaganda department of the Central Committee launched the first of a mounting series of attacks on bourgeois liberalization. A week later book banning intensified. On July 20 there were mass arrests. In December, the Central Committee denounced the New Wave in Chinese art as "dead, negative, anti-socialist." A planned exhibition by young Beijing artists was banned.

In the meantime, however, the Ministry of Culture had gone ahead with the Seventh National Art Exhibition, which opened in Beijing on July 17, while the memory of the slaughter on the night of June 4 was still horrifyingly fresh. The selection had taken place in May and June, when the leading Beijing artists were so deeply involved in Tiananmen that they did not bother to submit works.[15] For the artists in the provinces, however, this was their great opportunity to get their work

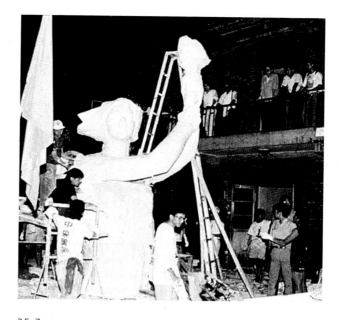

25.7
Central Academy sculpture students making the Goddess of Democracy (May 29/30, 1989).

25.8
The Goddess of Democracy unveiled on Tiananmen Square (May 30, 1989). Styrofoam.

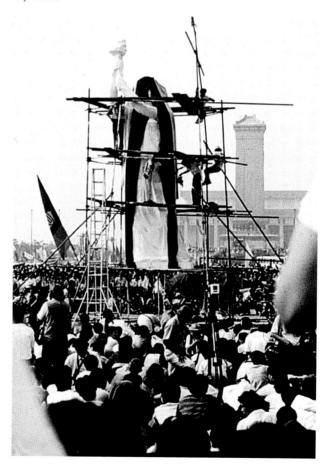

known in the capital and to win prizes and honor for their local art academies. Artists in the northeast, and particularly those in the Lu Xun Academy in Shenyang, had been encouraged by the local leadership to produce paintings extolling the pleasures of life in that bleak region. Such upbeat paintings were natural prizewinners.[16]

But paintings that won prizes also included several notable works that had been previously shown and published, such as Wei Ershen's *Mongolian Bride* (see plate 84), Chen Yiqing's very assured *Out of Qinghai* (plate 92), Wang Guangyi's *Madonna and Christ,* and a lively series of illustrations to *The Western Chamber* by Peng Xiaocheng, pupil of the eccentric Sichuan master Chen Zizhuang. The sculpture and prints represented a real advance on earlier work. On the whole, the standard of oil painting was higher than that of guohua. Many of the oil painters were activists, or were at least enthusiastic about painting, while most of the guohua painters, politically uncommitted, had a purely commercial attitude to their work. Of course, nothing remotely "negative" was rewarded, so the exhibition was by no means representative of the state of art in the summer of 1989.

The curtain seemed at that time to be descending on the most productive period in the modern history of Chinese art. The old hard-liners pushed aside the middle-aged liberals. Hua Jia replaced Shao Dajun as chief editor of *Zhongguo meishu bao.* Gao Minglu was told that if he wanted to stay on in the editorial office he must submit his work to censorship; he promptly resigned. By December 1989, the Party had established almost complete control over art publications and exhibitions and had dismissed or muzzled progressive critics, such as Lang Shaojun, who had supported the various forms of modernism. Politics was once more in command. In June 1990 the official organ *Wenyibao* carried an article by Yang Chengyin denouncing the New Wave of the 1980s, which he claimed had reached a dead end. The July 1991 issue of *Meishu,* exhorting artists to uphold socialism, ran a lead article on Mao's long-forgotten Yan'an Talks of 1942.

But young artists had long ceased to read *Meishu.* They were busy creating a new art world outside the established order.[17] A new phenomenon appeared—the totally unattached young artist who led a bohemian life, moving easily from city to city and creating with writers and poets a confraternity of free spirits such as modern China had not seen before. These worldly-wise young men and women were learning how to promote their work. They formed useful contacts with officials, with businessmen Chinese and foreign, with factory and hotel managers; for the more fortunate artists, lucrative commissions for wall paintings, decorations, and commercial

art followed, giving them the freedom to paint works of a very different kind in the privacy of their studios.

For the majority of these new artists, however, the search for patronage was a constant struggle. They were lucky if they could show their work in hastily arranged "salons," private viewings, and cocktail parties in the hotel rooms or apartments of foreign diplomats and journalists. So desperate was their scramble for notice that some would not only bribe TV stations and magazines to feature their work but pay critics to attack them. Any attention was better than none.

Art dealers from abroad were beginning to arrive in Beijing. The Japanese in particular were buying oil paintings, at the Beijing International Art Palace (opened in August 1991), the Beijing International Oil Painting Gallery, and an increasing number of privately run commercial galleries. Oil painters could expect to earn three thousand yuan for a "middle-grade" canvas, far more for a major work. Even with sixty percent deducted for income tax, a successful painter could become rich in Chinese terms. It was even reported that art teachers in the academies were forcing their students to paint pictures that could be sold abroad. Little wonder that the temptations of the foreign art market became irresistible, and that the work of even so accomplished an artist as Ai Xuan became facile and repetitive as he reworked again and again a style that had been successful abroad.

By 1992, the art market was flourishing. In October, for the first time since Liberation, antiques were sold at auction in Beijing. Buyers came chiefly from Hong Kong and Taiwan, but casual visitors driven by mere curiosity were deliberately put off by the price of admission: 2,517 yuan. A second auction, sponsored by a Chinese-American consortium, followed later in the month in Shanghai. Here many of the buyers were not foreign art dealers but Chinese state-owned companies. As a Shenzhen newspaper reported, "Investment in art will become a new trend following the craze for real estate and stocks."

Art as investment was not confined to antiques. The aim of the first Guangzhou Biennial, held in October 1992, was, according to young Sichuanese entrepreneur Lu Peng, to establish China's first contemporary art market, supported by about a hundred organizations of various sorts. The Shenzhen Dong Hui Industrial Share Co. paid one million yuan for the top twenty-seven prizewinning paintings, which they proposed to use as the opening inventory of Shenzhen's first private auction house.

THE REVIVAL OF THE 1990s

From this time forward, modern Chinese art was to be bound ever closer to the art market in a way familiar in

the West and Japan but unprecedented in China itself. Against this background, the innocence and idealism of the 1980s, the impulse to struggle against authority, became harder and harder to maintain.

But the vitality of the post-1989 revival, once it had gained momentum, was astonishing. It began to attract worldwide attention with the "China New Art: Post-1989" exhibition, organized by the Hanart TZ Gallery in Hong Kong, that opened at the City Hall Art Gallery and the Hong Kong Arts Centre in February 1993.[18] (It later travelled to Sydney, while a similar but smaller show visited Berlin and Oxford.) This show had originally been conceived four years earlier, when Chang Tsong-zung (Johnson Chang), proprietor of Hanart TZ Gallery, met the critic Li Xianting at the notorious Beijing avant-garde exhibition. The events of June 4, and the paralysis that followed it, put an end to the scheme, until the revival that followed what Li Xianting has called a "period of gestation" in 1990 showed that, in the privacy of the artists' studios, the modern movement had quietly been gaining strength and was indeed very much alive. The works selected could not be publicly shown in China, but the authorities, with a variety of motives that certainly included future profits, permitted them to be exhibited in Hong Kong.

Not everything in this exhibition broke new ground. The current of malaise, disillusionment, and cynicism that had followed the New Wave ran as deep as ever. Works characterized by the organizers as "Emotional Bondage" and "Cynical Realism" reflected a society in which, wrote Chang Tsong-zung, "people are physically and mentally so closely herded that their repressed desires are forced to find expression in perverted attitudes and behaviours."[19] Zhang Peili was one who seemed totally unreconciled, retreating into a private world where his feeling of anger and rejection burned as hot as ever. Zeng Fanzhi, in a huge triptych ironically entitled *Harmony Hospital* (fig. 25.9), portrayed, in the style of the German expressionists, doctors, patients, and nurses with empty, staring eyes—all mentally deficient, come there to die. These lost souls, he said, were the people around him in life. Although the title of Fang Lijun's satirical work illustrated here—*Series II, No. 6* (fig. 25.10)—is deliberately enigmatic, there is little doubt that these shaven-headed, small-eyed bullies are cadres.

In the work of Song Yonghong and others, Chang Tsong-zung found a "sick voyeurism, contained in strange tableaux in which his protagonists seem to partake in erotic suspense dramas."[20] Other works in this group revealed private obsessions or evoked a feeling of disgust. This is a far cry from the elegiac chord struck by the monumental works of the mid-1980s, such as Cheng Conglin's unforgettable *Snow on X Month X Day,*

1968 (see fig. 22.8), painted at a time when many felt that the worst was behind them and they could look forward to the future with hope.

Some vestiges of the old idealism remained. A group of realistic paintings labelled by Chang Tsong-zung "The Wounded Romantic Spirit" celebrated the endurance and heroism of the Tibetan nomads and the harsh world of the north China peasantry. Works in this vein, by Ding Fang, Zhou Chunya, and Zhang Xiaogang, among others, failed to impress the young cynics of the new generation, whose mood was one of mockery and irreverence; but their merits are perhaps more enduring.

The school Chang called "Political Pop" struck an altogether more positive note and attracted instant attention abroad. The huge canvases of Wang Guangyi, Li Shan, Yu Youhan, and others drew their images from the propaganda art of the Mao era. Now robbed of their oppressive power, these images are treated almost affectionately as part of Chinese folk culture, and at the same time mocked into meaninglessness in the manner of Andy Warhol's famous Campbell's soup cans. A curious revival of the Mao cult was taking place at this time, part mockery but part nostalgia for those strenuous times. Pop versions of revolutionary songs were suddenly popular; to hunt out a long-discarded Mao badge and sport it became the fashion. Yu Youhan's *Mao Zedong Age* series makes decorative play with the icon of a tyrant who could terrorize the artist no longer (plate 93). Wang Guangyi juxtaposes potent images of the Red Guard days with corporate logos, both reducing the images of China's revolutionary past to the level of commercial art and paying tribute to China's new popular god—consumerism (plate 94).

Pure abstraction, because of its apparent lack of subject matter, has had little appeal in modern China, and post-1989 abstractionists such as Shang Yang and Wang Chuan tended to express a tension, an inwardness, a sense of mystery or spiritual apartness, that is in itself a comment on the times. At the opposite extreme were the installations of Gu Wenda and Xu Bing, both already famous, to which Chang Tsong-zung gave the trendy label "Endgame Art," although that was hardly adequate for the extremely complex sources of their works. These include an element of social comment and deconstruction for Gu Wenda and a deeper sense of futility and the absurd in the installations of Xu Bing, evoked with such immense and exhausting labor that the act of creating—even of creating something ultimately futile—becomes not only a kind of ritual but a search beyond illusion for an inexpressible reality that has its roots in Buddhist thought.

Hanart TZ's post-1989 exhibition made it abundantly clear that modernism had emerged from the shad-

25.9
Zeng Fanzhi, *Harmony Hospital* (1991). Triptych. Oil on canvas.

ows to take its place beside the more traditional move-
ments in Chinese art in a tapestry of ever increasing com-
plexity. Already the Chinese art world, under "capital-
ism with socialist characteristics," was beginning to look
more and more like that of the free countries of the West,
as prosperity grew and more people had more leisure time
and the means to enjoy and support the arts. In the tur-
bulent years since the Peking Spring of 1979, the world
of Chinese art had changed utterly.

By the beginning of the 1990s, artists had grasped their
opportunities with such energy and imagination that it
seemed that all options had been explored, and that all
that remained to cope with was the increasingly ineffec-
tive (yet still erratically tyrannical) cultural bureaucracy.
By this time, the artists' problems were essentially those
of the international community of modern art across the
world. But this new art, for all its acknowledged debt to
Wyeth and Rauschenberg, Warhol and Lichtenstein, is
Chinese, and it is from Chinese culture that it draws its
strength—if not always its form. One finds constant ref-
erence to ancient Chinese art and ritual, to Chinese folk
art, to the many levels of meaning of the ideograph, to
the power of the pictorial symbol. The sense of the so-
cial responsibility of the artist, however radical (and in-
deed the more radical the more committed), the holis-
tic, deeply ethical view of the relationship of art and the

artist to all other human activity—all these aspects of cre-
ativity are essentially Chinese.

It is not the imported Western elements in themselves,
crucially important and necessary as they have been, that
have provided the dynamic of modern Chinese art.
Rather, the artists' struggle to break free from the
tyranny of tradition while still being nourished and sus-
tained by it, and the creative dialectic between Chinese
and Western artistic aims and values, have fueled the cen-
tury's art. Long after all technical and stylistic barriers
have been removed and every possible option declared
open—and it seemed that by the early 1990s that mo-
ment had already been reached—the tension will remain
between the appeal of the Western concept of total cre-
ative freedom and the Chinese sense, rooted in Confu-
cianism, of the artist's responsibility to society. Perhaps
it is this tension, deeply felt and often expressed by in-
dividual artists, that gives to the art of late twentieth-
century China its extraordinary richness and power.

As we approach the end of the century, it becomes
ever clearer that this has been an age of crisis and change
in China's art and culture without precedent in its his-
tory. In the decade after 1900, awareness that the great
tradition had become sterile was just beginning to dawn.
By the 1990s, we have seen the birth and spread of the

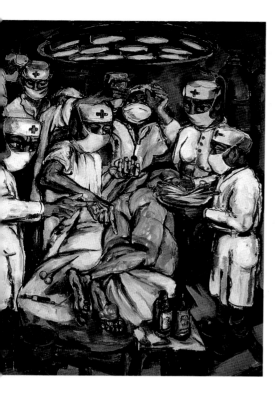

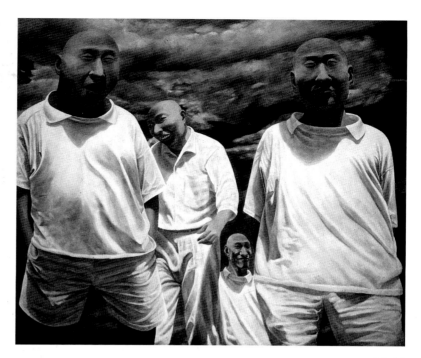

idea that something drastic must be done to save it, and that the cure must come from an injection of ideas and forms from the West; the intense debate between the traditionalists and the reformers; the creation of the first art schools and art museum; the birth of the idea, shocking in ethnocentric China, that art was a world language that obliterates all frontiers; the introduction of the concept of art as a social activity and an instrument of reform and revolution; the undermining of the Chinese belief in fine art as the prerogative of an elite; the struggle to understand, absorb, and adapt a plethora of traditions and styles that had evolved historically in the West but were imported into China more or less simultaneously; the crisis in personal identity felt by artists torn between East and West; and, not least, the existence, from the middle of the century, of a cultural tyranny that made the free exploitation of these ideas, forms, and institutions virtually impossible.

Can it be said that, by the early 1990s, artists had met and solved these problems? That they had engaged with them all, and found many solutions, must be obvious from some of the illustrations in this book. But late in the century, just when Western art seemed to have been successfully absorbed and traditional art reborn, there came from the West the wholly new question of the nature of art itself. Conceptual art, performance art, mul-

timedia presentations of an infinite variety arrived to make some Chinese artists question the validity of all that had been achieved since 1900. The last decade of the century, therefore, introduced a new challenge. At the time of writing, it is too soon to say how far these new concepts of the nature and purpose of art will take root in China, or how enduring they will be. But that they will be a destabilizing factor seems certain.

The responses to these questions, and the answers to the challenges they present, will not be found by the critics and art historians, but in the creative imagination of the artists themselves, who have, throughout the century, shown courage and great resource in confronting bureaucratic ignorance and intolerance. There is no reason to think that these virtues will not carry them forward into the next century.

CHAPTER 1. TRADITIONAL PAINTING

1. The reader will note that throughout this book the artist is often referred to as "he." There were many women painters, but their gifts were seldom celebrated in a world that, before the twentieth century, was almost exclusively male. The best introduction to the subject is Marsha Weidner, ed., *Views from Jade Terrace: Chinese Women Artists, 1300–1912* (Indianapolis, 1988).

2. For a glimpse of these court artists, see Katherine Carl, *With the Empress Dowager of China* (London, 1906), 173–74. For a good survey of late Qing and early modern traditional artists, see Tsuruta Takeyoshi, *Kindai Chūgoku no kaiga* (Modern Chinese painting) (Tokyo, 1974).

3. On Miao Jiahui, see Weidner, *Views from Jade Terrace*, 164–66.

4. For the collected works of Pu Ru, see Lin Lu, ed., *Pu Xinyu shuhua chuanji* (The complete paintings and calligraphy of Pu Xinyu), 4 vols. (Taipei, 1978). The chronology states that he went to Germany in 1915, entered the University of Berlin, returned to China in 1918, and in 1922 received doctorate degrees in astronomy and biology in Germany.

5. On Jin Cheng and the Hushe, see Chu-tsing Li, *Trends in Modern Chinese Painting* (Ascona, Switzerland, 1979), 12, 14.

6. Ibid., 14.

7. On Chen Hengke, see ibid., 18, 84, 85.

8. On Qi Baishi, see especially *Qi Baishi zuopinji* (Collected works of Qi Baishi), 3 vols. (Beijing, 1963), and Catherine Yi-yu Cho Woo, *Chinese Aesthetics and Ch'i Pai-shih* (Hong Kong, 1986), which includes a ten-page bibliography on the artist. For his early career, see Huang Miaozi, "From Carpenter to Painter: Recalling Qi Baishi," *Orientations* (April 1989): 85–87.

9. On Li Kuchan, see Wang Jingxian and Ling Hubiao, eds., *Xiandai guohuajia bairen zhuan* (Biographies of one hundred contemporary traditional painters) (Hong Kong, 1986), 51–52.

10. For Ren Bonian and the Shanghai School, see James Han-hsi Soong, *A Visual Experience in Nineteenth-Century China: Jen Po-nien (1840–1895) and the Shanghai School of Painting* (Ph.D. diss., Stanford University, 1977); James Cahill, "The Shanghai School in Later Chinese Painting," in *Twentieth-Century Chinese Painting,* ed. Mayching Kao (Hong Kong, Oxford, and New York, 1988), 54–77; and Li, *Trends in Modern Chinese Painting,* 31–44.

11. Li, *Trends in Modern Chinese Painting,* 64.

12. See *Wu Changshuo zuopinji* (Collected works of Wu Changshuo), 2 vols. (Shanghai, 1984).

13. The Xiling Society was named after a group of eighteenth-century Hangzhou seal-carvers known as the Eight Great Artists of Xiling. See Robert van Gulik, *Chinese Pictorial Art as Viewed by the Connoisseur* (Rome, 1958), 434.

14. For the Shanghai literary and art circles of this period, see Tsuruta, *Kindai Chūgoku no kaiga.*

15. See Wang Geyi, *Wang Geyi suixianglu* (Recollections of Wang Geyi) (Shanghai, 1982), 60.

16. Ibid., 60–61.

17. See Zhejiang People's Art Publishing House, *Pan Tianshou huihauce* (Paintings of Pan Tianshou) (Hangzhou, 1979).

18. For a recent study of this artist, see Jason C. S. Kuo, *Innovation with Tradition: The Painting of Huang Pin-hung,* with contributions by Richard Edwards and Tao Ho (Hong Kong, 1989).

19. For Huang Binhong's collected writings and thoughts on art, see Chen Fan, ed., *Huang Binhong huayulu* (The thoughts on art of Huang Binhong) (Hong Kong, 1961), and Sun Qi, ed., *Huang Binhong di huihua sixiang* (Huang Binhong's thoughts about painting) (Taipei, 1979).

20. The story is told in Jeffrey Mindich, "More Tales of China's Late, Great Master Artist," *Free China Review* (April 1985): 38–40.

21. Van Gulik, *Chinese Pictorial Art,* 396.

22. Ibid., 286 n. 1.

23. See Wang Bomin, "Huang Binhong di huaniao-hua" (Huang Binhong's bird and flower paintings), *Meishu congkan* 23 (1983).

24. The most up-to-date and comprehensive of many studies of this artist is Shen C. Y. Fu and Jan Stuart, *Challenging the Past: The Paintings of Chang Dai-chien* (Washington, 1991). See also Xie Jiaxiao, *Zhang Daqian di shijie* (The world of Zhang Daqian) (Taipei, 1968).

25. See Shen C. Y. Fu, "A Brief Discussion of Japanese Influence on the Development of Traditional Chinese Painting in the Modern Era," in *China: Modernity and Art*, ed. Huang Kuang-nan (Taipei, 1990), 31–56.

26. On the founding of the Dunhuang Research Institute, see Cheng Te-k'un, introduction to *Chinese Inscriptions in the Caves of Tun-huang,* by Shi Yai (Chengdu, 1947), 4–5.

27. The lithograph illustrated here is from the second set, published by Editions Press in San Francisco in 1974, with a foreword by the author.

28. No full study of Fu Baoshi has yet appeared, although an important selection of his works in the Nanjing Museum has been published. See *Fu Baoshi huaji* (Nanjing, 1981).

29. See James Cahill, *Gō Shōseki, Sai Hakuseki* (Wu Changshuo and Qi Baishi) (Tokyo, 1977). English tr. 60.

30. Quoted in Li, *Trends in Modern Chinese Painting,* 131.

31. See Ellen Laing's discussion of this painting in *The Winking Owl: Art in the People's Republic of China* (Berkeley and Los Angeles, 1988), 36.

32. On Yu Fei'an and other guohua artists discussed in this section, see Robert Hatfield Ellsworth, *Later Chinese Painting and Calligraphy: 1800–1950,* 3 vols. (New York, 1987).

33. Wang Geyi, *Wang Geyi xuexianglu,* 35 ff.

34. See Mayching Kao, *China's Response to the West in Art, 1898–1937* (Ph.D. diss., Stanford University, 1972), 203.

35. Pan Tianshou, *Zhongguo huihua shi* (History of Chinese painting) (Shanghai, 1936), 294–95, trans. in Mayching Kao, *China's Response,* 203.

36. Wen Yuanning, "Art Chronicle," *T'ien Hsia Monthly* 3, no. 1 (May/August 1936): 163.

37. Nelson I. Wu, "The Ideogram in the Modern Chinese Dilemma," *Art News* 57, no. 7 (November 1957): 34–37.

CHAPTER 2. THE REVOLUTION IN CHINESE ART

1. The best account of this early period is Mayching Kao, "The Beginning of the Western-style Painting Movement in Relationship to Reforms of Education in Early Twentieth-Century China," *New Asia Academic Bulletin* 4 (1983): 373–400.

2. The six-volume *Xihua chuxue* (Primer of Western painting), attributed to him by Mayching Kao (ibid.), is not, however, listed among his translations and books in the Scientific Book Depot of the Jiangnan Arsenal on sale in 1896.

3. Kao, "Beginning of the Western-style Painting Movement," 379.

4. Xue Fucheng, *Diary of an Envoy in Four Countries;* quoted in Lawrence Wu, "Kang Youwei and the Westerni-sation of Modern Chinese Art," *Orientations* (March 1990): 47.

5. From Kang Youwei, *Travels in Eleven European Countries;* quoted in Wu, ibid., 47–48.

6. See Chi Ke, ed., *Li Tiefu* (Canton, 1985).

7. See Bi Keguan, "Jindai meishu de xianqu Li Shutong" (Li Shutong, a pioneer of Chinese modern art), *Meishu yanjiu* (1984.4): 68–75, and Kao, "Beginning of the Western-style Painting Movement," 386–87.

8. For Feng Zikai's relationship with Li Shutong, see Liu Xinhuang, *Hongyi Fashi xinzhuan* (New biography of Li Shutong) (Taipei, 1965).

9. C. E. Darwent, *Shanghai: A Handbook for Travellers and Residents,* 2d ed. (Shanghai, 1920), 79.

10. See Chen Ruilin, "Chen Baoyi he zaoqi de youhua yundong" (Chen Baoyi and the early oil painting movement in China), *Meishu yanjiu* (1986.2): 29.

11. For a vivid but highly unreliable study of the life of Liu Haisu, see Ke Wenhui, *Yishu dashi Liu Haisu zhuan* (Biography of the master of art Liu Haisu) (Jinan, 1986).

12. See Pan Tianshou, *Zhonggou huihua shi* (History of Chinese painting) (Shanghai, 1936), 295–301.

13. Quoted in Zhang Shaoxia and Li Xiaoshan, *Zhongguo xiandai huihua shi* (History of modern Chinese painting) (Nanjing, 1986), 68.

14. On Chen Baoyi, see especially articles by Liu Haisu, Chen Ruilin, and Yang Taiyang in *Meishujia* 59 (1987.12).

15. See Kao, "Beginning of the Western-style Painting Movement," 381.

16. Ibid.

17. For Cai's philosophy of art, see particularly William J. Duiker, *Ts'ai Yüan-p'ei: Educator of Modern China* (Philadelphia, 1977), 15–52.

18. Ibid., 24.

19. See Hans van der Meyden, "Early Picassos in the Collection of Mr. Chen Qinghua in Suzhou," *Apollo* (December 1986): 555–56.

20. See Vera Schwarz, *The Chinese Enlightenment* (Berkeley and Los Angeles, 1986), 80–81.

21. Hu Shih, *The Chinese Renaissance* (Chicago, 1933), 54. On Chen Duxiu, see Chow Tse-tsung, ed., *The May Fourth Movement: Intellectual Revolution in Modern China* (Cambridge, Mass., 1960), 276. For another translation of Chen Duxiu's broadside, see Ch'en Shou-i, *Chinese Literature: An Historical Introduction* (New York, 1961), 632–33.

22. See William R. Schultz, "Kuo Mo-jo and the Romantic Aesthetic: 1918–1925," *Journal of Oriental Literature* 6, no. 2 (April 1955): 49–81.

23. On the Japanese I-novel, see Ching-mao Cheng, "The Impact of Japanese Literary Trends," in *Modern Chinese Literature in the May Fourth Era,* ed. Merle Goldman (Cambridge, Mass., 1977), 76–88.

24. Zhou Zuoren's views were repeated in several essays. See his "Notes for a New Literature," in Chow, ed., *The May Fourth Movement,* 442, 442nn.53,54.

25. On the literary revolution and its effects, see especially Chow, ed., *The May Fourth Movement,* 269–88.

26. For the manifesto, see appendix to *Wenxue yanjiuhui xuanyan xiaoshuo yuehao* (Literary Research Society novel monthly) 12.1 (January 10, 1921).

27. This phase of Guo Moruo's career is well covered in David Roy, *Kuo Mo-jo: The Early Years* (Cambridge, Mass., 1971), 72–96.

28. On Cheng Fangwu, see Leo Ou-fan Lee, *The Romantic Generation of Modern Chinese Writers* (Cambridge, Mass., 1973), 21.

29. See Roy, *Kuo Mo-jo,* esp. 148–61.

30. Lee, *The Romantic Generation,* 277.

31. For Xu Zhimo, see Lee, *The Romantic Generation,* and Jiang Fucong and Liang Shiqiu, eds., *Xu Zhimo quanji* (Collected works of Xu Zhimo), 6 vols. (Taipei, 1969).

32. Translated by Wen Yiduo and Robert Payne, from *Contemporary Chinese Poetry,* ed. Robert Payne (London, 1947), 52–53.

CHAPTER 3. THE CALL OF THE WEST

1. On Li Yishi, see article by Chen Boping in *Meishu* (1986.4): 65–67.

2. See Y. C. Wang, *Chinese Intellectuals and the West, 1872–1949* (Chapel Hill, N.C., 1966), 105–11.

3. See Marie-Thérèse Bobot, *Fan Tchun-pi: Artiste chinoise contemporaine* (Paris, 1980).

4. *Zhenxiang huabao* (1912.1): 1–16.

5. See Ralph Croizier, "The Japanese Connection," in his *Art and Revolution in Modern China: The Lingnan (Cantonese) School of Painting, 1906–1951* (Berkeley and Los Angeles, 1988), 24–72.

6. See Hong Kong Arts Centre, *A Retrospective Exhibition of the Works of Ting Yen-yung* (Hong Kong, [1979]).

7. The fullest study of this remarkable man is K'ai-yü Hsü, *Wen I-to* (Boston, 1980).

8. Ibid., 71.

9. A number of Wen Yiduo's early graphic designs and illustrations were published by his son Wen Lipeng in "Yishujia Wen Yiduo" (The artist Wen Yiduo), *Meishu yanjiu* (1986.4): 39–55.

10. Quoted in K'ai-yü Hsü, *Wen I-to,* 88.

11. The literature on the Chinese artists in France is growing rapidly. See, for example, Huang Kuang-nan and others, *China-Paris: Seven Chinese Painters Who Studied in France, 1918–1960* (Taipei, 1988).

12. For Pan Yuliang's story see Xie Lifa, "Qinglou huahun: Pan Yuliang di yishu shengya" (The painting spirit of Qinglou: The art life of Pan Yuliang), *Xiongshi meishu* 157 (March 1984): 30–37.

13. For a brief biography, with reproductions, see Zhang Daofan, *Zhang Daofan xiansheng huaxuan* (Selected paintings of Mr. Zhang Daofan) (Taipei, 1969).

14. William Rothenstein, "Paris and Julian's," in *Men and Memories,* vol. 1 (London, 1931). See also Raymond Nacenta, *The Painters and Artistic Climate of Paris since 1910* (New York, 1981).

15. For information on Chinese artists in France in the 1920s and activities in Lyon, see l'Institut Franco-chinois de l'Université de Lyon, *Annales Franco-chinois* 1 (March 1927) and subsequent issues.

16. See Craig Clunas, "Chinese Art and Chinese Artists in France, 1924–25," *Arts Asiatiques* 44 (1989): 100–106.

17. Sun Fuxi, quoted by Mayching Kao, "The Spread of Western Art in China, 1919–1929," in *China: Development and Challenge,* ed. Lee Ngoc and Leung Chi-keung (Hong Kong, 1981), 91.

18. Clunas, "Chinese Art and Chinese Artists," 101.

19. The full roster is given in *Yifeng* 1, no. 8 (August 1933): 67–68.

20. For Chang Shuhong's account of the activities of Chinese artists in France in the early 1930s, see his "Bali Zhongguo huazhan yu Zhongguohua qiantu" (The Paris exhibition of Chinese painting and the prospects for Chinese painting), *Yifeng* 1, no. 8 (August 1933): 9–15.

21. Hu Shih, *The Chinese Renaissance,* 10.

22. See Wu Guanzhong, "Wodi yishu shengya" (My artistic career), *Meishujia* 30 (February 1983): 4–15.

23. See the rather highly colored life of Xu by his widow Liao Jingwen, *Xu Beihong: Life of a Master Painter* (Beijing, 1987), 52.

24. Told to the author by Hua Tianyou in Paris in 1946.

25. On Liao Xinxue, see memoir by Chen Ji in *Meishu* (1978.8): 46.

26. On Pang's life in Paris, see his *Jiushi zheyang zuoguo-lai de* (That is the way it happened) (Beijing, 1988), chapters 19–55.

27. Kohara Hironobu, "The Reform Movement in Chinese Painting of the Early 20th Century," *Proceedings of the International Conference on Sinology,* ed. Academia Sinica (Taipei, 1981), 450.

CHAPTER 4. CENTERS OF MODERN ART

1. For Wang Yuezhi, see his *nianbiao* (chronological biography) in *Meishu* (1982.12).

2. Lin almost certainly met Xu Beihong in France, and travelled with him on the last stage of their voyage home. On the boat, Lin had asked Xu to help him find a job in Shanghai. Xu Beihong's chagrin on finding Lin welcomed as "President" is easy to imagine. They were never friends after that. See Bao Limin, "Xu Beihong, Lin Fengmian shouci huimian kaoyi" (Research on the first meeting of Xu Beihong and Lin Fengmian), *Duoyun* (1990.4): 112–15. On Lin Fengmian in Beijing, see Zhu Boxiong and Chen Ruilin, *Zhongguo xihua wushinian* (Fifty years of Western art in China) (Beijing, 1989), 66–67.

3. On Claudot, see also I. Joseph, *L'Art et les artistes* 23 (1931–32): 69, 92–98; and *Beaux Arts* (October 1931): 23.

4. See "Chinese Painter Will Show Slavic Work," *North China Daily News* (January 26, 1948).

5. See *Meishu* (1986.4): 64n.2

6. See *Bulletin of the Association Amicale Sino-française* 1 (November 1933) and 2 (March 1934).

7. The history of the Shanghai Academy is given in the 25th anniversary volume prepared by the Ministry of Education, *Shanghai Meishu Zhuanke Xuexiao* (Shanghai, 1937).

8. It is not altogether clear what was exhibited. It has generally been assumed that the pictures that caused the uproar were nudes, but the expression *renti* merely means the human figure. The term was often used for both undraped and partially clothed figures. In 1915, even partly clothed models would have caused offence.

9. The story of this episode is recorded in Ke, *Yishu dashi Liu Haisu zhuan,* 73–81.

10. See Ministry of Education, *Shanghai Meishu Zhuanke Xuexiao,* statistical chart after p. 100.

11. On Chen Baoyi and Lu Xun, see article by Chen Ruilin in *Meishujia* 59 (1987.12): 18–21.

12. See Kao, "Spread of Western Art," 92.

13. Ibid., 93, and Tsuruta, *Chūgoku no kaiga,* 13–14.

14. Kao, "Spread of Western Art," 93.

15. For the origins of the Xinhua Academy, see Zhu and Chen, *Zhongguo xihua wushinian,* 93–95.

16. On Uchiyama, see chapter 8, p. 85.

17. *Tanizaki Jun'ichirō zenshu* 10 (1969): 581–82, quoted in Joshua A. Fogel, "Japanese Literary Travellers in Prewar China," *Harvard Journal of Asiatic Studies* 49, no. 2 (December 1989): 593.

18. On Tian Han's academy, see Tian Han, "Nanguo she shilue" (A brief history of the Nanguo Academy), in *Zhongguo wenxue daxi* (Chinese culture series) 10 (1962): 435–41.

19. For Pang and the Taimeng Huahui, see his *Jiushi zheyang zuoguolai de,* 154–57.

20. See Scott Minick and Jiao Ping, *Chinese Graphic Design in the Twentieth Century* (London, 1990), esp. 35–65.

21. See *Meishu* (1979.9): 12–13.

22. See Kao, "Spread of Western Art," 75ff.

23. On Yan Wenliang and the Suzhou Academy, see Liu Qijun, "Zhongguo youhua jiaoyu de dianjizhe—Yan Wenliang" (The founder of Chinese oil painting education), *Yishujia* 125 (October 1985): 115–25) and Lin Wenxia, "Oil Painter Yan Wenliang," *Chinese Literature* (July 1983): 61–64.

24. For the history of the academy and reminiscences of staff and former students, see Song Zhongyuan, *Yishu yaolan* (The cradle of art) (Hangzhou, 1988), and *Xin meishu* (1983.4), 28–32, 73–75. Liu Haisu claims in Ke Wenhui's biography of him (*Yishu dashi Liu Haisu zhuan,* 144–45) that it was he who persuaded Cai Yuanpei to create the academy at Hangzhou, by resisting Cai's pressure to convert his own private academy in Shanghai into a government-controlled institution. Needless to say, this is not mentioned in *Yishu yaolan,* the official history.

25. Song, *Yishu yaolan,* 9.

26. Lin Fengmian, "Zhi quanguo yishujie," *Gongxian* (1928.5): 2–16.

27. Conversation with the author, Paris, December 1989.

28. For the story of the Chishe and Ren Ruiyao, see Yu Yuan, "Huiyi chi she" (Recollections of the Chishe), *Meishujia* 62 (1988.6): 40–42.

29. See Zhu and Chen, *Zhongguo xihua wushinian,* 231.

30. *Meishujia* 62 (1988.6): 40.

31. See Kao, "Spread of Western Art," 95–96.

CHAPTER 5. THE LINGNAN SCHOOL

1. For a good general survey on the Lingnan School, see Croizier, *Art and Revolution.*

2. Ibid., 29.

3. Ibid., 32.

4. Quoted in Hong Kong Museum of Art, *The Art of Gao Qifeng* (Hong Kong, 1981), 7.

5. From "My Ideas on Chinese Painting," quoted by Lawrence C. S. Tam, "The Lingnan School of Painting," in *Twentieth-Century Chinese Painting,* ed. Mayching Kao (Hong Kong, Oxford, and New York, 1988), 121.

6. Hong Kong Museum of Art, *The Art of Gao Qifeng,* 9.

7. Lawrence Chisholm, *Fenollosa: The Far East and American Culture* (New Haven, 1963), 81.

8. Tam, "Lingnan School of Painting," 121.

9. Reproduced in Croizier, *Art and Revolution,* color plate 4.

10. Ibid., 138.

11. For Wen Yuanning's extravagant praise of Gao Qifeng's work ("modern in every sense of the word"), see his "Art Chronicle," 164.

CHAPTER 6. THE NEW ART MOVEMENT

1. See Zhu and Chen, *Zhongguo xihua wushinian,* 209–12.

2. See the Ministry of Education's catalogue *Meizhan Tekan* (Nanjing, 1929), with prefaces by Cai Yuanpei and Jiang Menglin.

3. See Lang Shaojun, *Lun Zhongguo xiandai meishu* (On modern Chinese art) (Nanjing, 1988), 25–29, and Li Xianting, "Notes and Illustrations to *Major Trends in the Development of Modern Chinese Art,*" in Valerie Doran, ed., *China's New Art, Post-1989, with a Retrospective from 1979–1989* (Hong Kong, 1983).

4. For a convenient survey of the Japanese art of this time, see Tanaka Kazumatsu, *Nihon kaiga-kan* (Gallery of Japanese painting), vol. 10 (1969–71).

5. On Lu Xun's relations with Hu Yichuan, see Song Zhongyuan, *Yishu yaolan,* 115.

6. For a full list of the exhibits, with prices, see "Yifeng zhanlanhui chupin mulu" (Catalogue of the exhibits in the Yifeng exhibition), *Yifeng* (1934.6): 117–27.

7. See Sun Fuxi, "Zhonghua Duli Meishuhui lan" (Exhibition of the China Independent Art Association) and other contributions, *Yifeng* (1935.4): 61–71.

8. Ibid.

9. See Sun Fuxi, "Yifengshe disanjie zhanlanhui zai Guangzhou" (The Yifeng Society's third exhibition in Guangzhou), *Yifeng* (1936.5): 13–19.

10. See Zhu and Chen, *Zhongguo xihua wushinian,* 382.

11. See Ministry of Education, *A Special Collection of the Second National Exhibition of Chinese Art,* vol. 2, Modern Chinese Painting and Calligraphy (Nanjing, 1937).

12. Wen Yuanning, "Art Chronicle," 161–67.

13. See Tsuruta, *Kindai Chūgoku no kaiga,* 16.

14. Quoted in Mayching Kao, *China's Response,* 182.

15. Lin Fengmian, *Yishu yu xin shenghuo yundong* (Art and the New Life Movement) (Nanjing, 1934), 67–68; quoted in Kao, *China's Response,* 183.

16. For Ni Yide and the founding of the Storm Society, see Yang Qiuren, "Huiyi Ni Yide he Juelan she" (Memoirs of Ni Yide and the Juelan Art Club), *Meishujia* 31 (1983.4): 18–25, and Pang Xunqin, *Jiushi zheyang zuoguolai di,* 171–75.

17. This quotation and the two that follow are from Yang Qiuren, "Huiyi Ni Yide."

18. Ibid., 24.

19. See Chi Ke, "The Life and Surviving Oil Paintings of Yang Qiuren," *Meishujia* 42 (1985.2): 18–35.

20. For sources on Zhang Shuqi, see Ellen Laing, *An Index to Reproductions of Paintings by Twentieth-Century Chinese Artists* (Portland, 1984), 15.

21. See Liu Sixun, *Lesijin zhi yishu lun* (Ruskin's theory of art) (Shanghai, 1927). For a list of these and other translations, see Kao, "Spread of Western Art," 97–98.

22. See Kao, "Spread of Western Art," 98–99.

23. See van der Meyden, "Early Picassos in the Collection."

24. See Teng Gu, ed., *Zhongguo yishu luncong* (Shanghai, 1937), 21–23.

25. See Rothenstein, "Paris and Julian's," 1:36–40.

26. Kao, "Spread of Western Art," 99.

27. Kao, *China's Response,* 203.

28. Ch'en I-fan, "The Modern Trend in Contemporary Chinese Art," *T'ien Hsia Monthly* (January 1937): 47.

CHAPTER 7. LEADING MASTERS BETWEEN THE WARS

1. Important sources on the life and work of Xu Beihong are Liao Jingwen's biography of her husband, *Xu Beihong: Life of a Master Painter,* trans. Zhang Peiji (Beijing, 1987); Hong Kong Museum of Art, *The Art of Xu Beihong* (Hong Kong, 1988); and Ai Zhongxin, *Xu Beihong yanjiu* (Researches on Xu Beihong) (Shanghai, 1981). Liao Jingwen's biography, with its novelettish style and invented and reconstructed conversations, was tied in with a popular TV serial on the life of Xu. Throughout the book, the names of Liu Haisu and Lin Fengmian are never mentioned, and the portrait of Jiang Biwei is, predictably, very unflattering.

2. For a vignette of the Hardoons, see Pan Ling, *In Search of Old Shanghai* (Hong Kong, 1982), 72–74.

3. See Zhu and Chen, *Zhongguo xihua wushinian,* 169.

4. On Xu's doctrine of *dessin,* see Chang Shuhong, "Bali Zhongguo huazhan," 13–14.

5. See Dagney Carter, "Modern Chinese Painting," *Asia* 34, no. 4 (April 1934): 228.

6. Reproduced in *Meishujia* 7 (1979.4): 76–77.

7. A copy of the brief catalogue of this show is in the author's possession. No doubt Jiang Biwei was also anxious to sell as many of her husband's paintings as possible, to support their children and her own (allegedly extravagant) lifestyle.

8. See Liao Jingwen, *Xu Beihong,* 86.

9. On Liu's life and work, see particularly Ke Wenhui, *Yishu dashi Liu Haisu zhuan.* The first issue of *Nanyi xuebao* (Southern art journal) (Nanjing, 1980) is chiefly devoted to Liu.

10. From Zhu Jinlou's introduction to Liu Haisu, *Liu Haisu youhua xuanji* (Selected oil paintings of Liu Haisu) (Shanghai, 1981), 9.

11. Liu Haisu, *Chinesische Malerei der Gegenwart* (Berlin, 1934).

12. Liu, *Liu Haisu youhua xuanji.*

13. See *Zhongguo meishu bao* (1987.11): 3, quoting *Zhejiang jibao* for August 28, 1985.

14. See Ministry of Education, *Shanghai Meishu Zhuanke Xuexiao.*

15. See his biography in Li Runxin and others, eds., *Zhongguo yishujia cidian* (Biographical dictionary of Chinese artists) (Changsha, 1984), 4:451.

16. This story was told to the author by Liu Haisu in Nanjing in 1980.

17. Reproduced in color in Liu, *Liu Haisu youhua xuanji,* pl. 14.

18. It is surprising that no substantial work on Lin Fengmian has yet appeared in China. One of the most useful, because it includes reprints of his early writings and a detailed *nianpu* (chronology), is Zhu Pu, *Lin Fengmian* (Shanghai, 1988). See also Cheng Chao and Jin Shangyi, *Lin Fengmian lun* (Writings on Lin Fengmian) (Hangzhou, 1990), which includes an article by his pupil and admirer Wu Guanzhong. For a well illustrated, though very incomplete, volume with a chronology, see Chen Guimiao, ed., *Lin Fengmian huaji* (Collected works of Lin Fengmian) (Taipei, 1989).

19. For reminiscences of his childhood, see Jian Chai, "Lin Fengmian," *Meishujia* 33 (1983.8), 30–32. Other articles in this issue are also devoted to the artist. Particularly interesting are the illustrations of the work of his last years in Hong Kong.

20. See Huang Kuang-nan and others, *China-Paris.*

21. For Lin's writings on art, see his *Yishu conglun* (Collected writings on art) (Nanjing, 1936), and *Dongfang zazhi* 25, no. 7 (April 10, 1928).

22. Cheng Chao and Jin Shangyi, *Lin Fengmian lun,* plate 11, lower.

23. Reproduced in *Meishujia* 33 (1983.1), 30.

24. See *Meishujia* 33, no. 7 (1983), a special edition devoted to Lin Fengmian, with articles by Wu Guanzhong, Huang Mengtian, and others.

25. See essays by T. C. Lai and Huang Mengtian in Hong Kong Arts Centre, *Works of Ting Yen-yung.*

26. Huang Mengtian, ibid.

27. See Bobot, *Fan Tchun-pi,* and Zeng Zonglu, "Jinian Fang Junbi" (Recollections of Fang Junbi), *Meishujia* 57 (1987.8): 40–41.

28. Reproduced as fig. 38 in Bobot, *Fan Tchun-pi.*

CHAPTER 8. THE WOODCUT MOVEMENT

1. The history of the Woodcut Movement is fully documented in Li Hua, Li Shusheng, and Ma Ke, eds., *Zhongguo xinxing banhua yundong wushinian 1931–1981* (On the fifty years' development of the Chinese Woodcut Movement, 1931–1981) (Liaoning, 1981). For Lu Xun's role in the movement, see especially Chen Yanqiao, *Lu Xun yu muke* (Lu Xun and the woodcut) (Beijing, 1949), and Shirley Hsiao-ling Sun, *Lu Hsün and the Chinese Woodcut Movement, 1929–1936* (Ph.D. diss., Stanford University, 1974).

2. See Bi Keguan, "Jindai meishu de xianqu Li Shutong," *Meishu yanjiu* (1984.4): 69.

3. Sun, *Lu Hsün,* 38.

4. For an appreciation of Yu Dafu, see Liu Haisu, *Qilu tanyilu* (Qilu discussions on art) (Jinan, 1985), 156–65.

5. On Lu Xun and the Morning Flower Society, see Li and others, *Zhongguo xinxing banhua yundong,* 144–46.

6. See Sun, *Lu Hsün,* 55–56. The quotation is from *Vladimir Favorsky,* ed. Yuri Molok (Moscow, 1967), 78.

7. Sun, *Lu Hsün,* 79–80.

8. Ibid., 61.

9. Ibid., 62.

10. "The Exhibition of Graphic Art" (1930) in *Selected Works of Lu Xun* (Beijing, 1960), ed. Yang Hsien-yi (Xianyi) and Gladys Yang, vol. 4, 143–45.

11. See Hu Yichuan, "Shoudao Lu Xun Xiansheng guanhuai di 'Yiba Yishe'" (Lu Xun's deep concern for the Eighteen Art Society), in Song Zhongyuan, *Yishu yaolan,* 114–17.

12. Shirley Sun even suggests that the opponents of the Yishe formed a "bogus organisation." *Lu Hsün,* 89–90.

13. Ibid., 78–79.

14. "The Mission of the Newly-Arisen Art Movement," *Yishu* 1, no. 1 (March 15, 1930): 24; translated in Kao, *China's Response,* 117.

15. See Lu Xun, "Written in Deep Night: 1. Introducing Kaethe Kollwitz to China" (1935), in *Selected Works* 4:253–55. *Sacrifice* appeared in *Bei dou* for September 1931.

16. "In Memory of the Forgotten," *Selected Works* 4:213.

17. Uchiyama Kakechi, who in 1956 paid a return visit to China, recorded his memories of Lu Xun in Li and others, *Zhongguo xinxing banhua yundong,* 253–57.

18. "Written in Deep Night," 223–24.

19. See Lu Xun, *Selected Works* 4:18–19.

20. For a more finished version, see People's Art Publishing House, *Situ Qiao huaji* (Oil paintings of Situ Qiao), 2d ed. (Beijing, 1980).

21. See Huang Mengtian, "Huiyi Xinbo" (Remembering Huang Xinbo), *Meishujia* 43 (1985.4): 46–55; *Meishujia* 55 (1987.4): 72–79; *Meishujia* 56 (1987.6): 46–53.

22. Deborah Caplow, "Some Thoughts on the Chinese Woodcut Movement" (paper presented at symposium on modern Chinese art, University of Washington, Seattle, 1990).

23. Sun, *Lu Hsün,* 100.

24. On Soviet influence, see Pearl Buck, *China in Black and White* (New York, 1944), and Laing, *The Winking Owl,* 12.

CHAPTER 9. THE FLIGHT TO THE WEST

1. See Liu Yiceng, "The Art of Tang Yihe," *Meishu yanjiu* (1982.3): 29–34, 84.

2. On cartoons produced for the United Front, see Chun Kumwen, "Art Chronicle," *T'ien Hsia Monthly* 8, no. 1 (August 1938): 207–10, and Bi Keguan and Huang Yuanlin, *Zhongguo manhua shi* (History of Chinese cartoons) (Beijing, 1986), especially 149–84.

3. See *Zhongguo meishu bao* 21 (1985), and Li, *Trends in Modern Chinese Painting,* 50–55.

4. See Chun Kumwen, "Art Chronicle," *T'ien Hsia Monthly* 9, no. 1 (August 1939): 84.

5. For reminiscences of these times, from which much of the following is taken, see Song Zhongyuan, *Yishu yaolan,* 16–24, with contributions by Wu Guanzhong, Yan Han, Yang Dewei, Fu Tianqiu, and others.

6. See "Deep among the Miao," in Pang's autobiography, *Jiushi zheyang zuoguolai di,* 225–29.

7. Much of this material on Guilin comes from conversations with Zhang Anzhi during his stay in London in 1947. See also Graham Hutchings, "A Province at War: Guangxi during the Sino-Japanese Conflict, 1937–1945," *China Quarterly* 108 (1986): 657–61, and Graham Peck, *Two Kinds of Time* (Boston, 1950), 426–550.

8. Valuable information on who was who in the Chongqing art world at this time is given in *Guoli Zhongyang Daxue Yishu Xuexi xixun* (National Central University Art Department news) (Chongqing, 1944). This booklet, printed on coarse brownish paper, has a foreword by Xu Beihong, articles by Lü Sibai, Chen Zhifo, Fu Baoshi, Fei Chengwu, and others, and a list of teachers, past and present, in the academy.

9. For an account of the arts in wartime Chengdu, see Liu Mingyang, *Hongyiji* (Record of the arts) (Chengdu, 1946).

10. See Ellsworth, *Later Chinese Painting,* 1:31–32, and Primerose Gigliese in *China Reconstructs* (June 1980).

11. Merle Goldman, *Literary Dissent in Communist China* (Cambridge, Mass., 1967), 48.

12. On the arts in Yan'an, see Zhang Wang, "Yan'an meishu huodong huiqu" (Looking back on artistic activity in Yan'an), *Meishu yanjiu* 4 (1954): 54–58; Li and others, *Zhongguo xinxing banhua yundong,* 268–314.

13. Described in articles by Hu Yichuan, Luo Gongliu, and Yan Han in Li and others, *Zhongguo xinxing banhua yundong.*

14. Merle Goldman, *Literary Dissent in Communist China,* 46–47.

15. For an analysis of the talks, see Bonnie S. McDougall, *Mao Zedong's "Talks at the Yan'an Conference on Literature and Art": A Translation of the 1943 Text with Commentary* (Ann Arbor, 1980).

16. On Sun Fuxi, see Li and others, *Zhongguo yishujia cidian* 4:455–56.

17. See Chinese Woodcutters Association, *Woodcuts of Wartime China 1937–1945* (Shanghai, 1946).

18. See his *nianpu* in *Meishu yanjiu* (1980.3).

19. See Lan Zhai, "Shen Yiqian yu zhandi xiesheng" (Shen Yiqian's sketches on the battlefront), *Meishujia* 35 (1983.12): 74–79, and "Shen Yiqian bashi dan zhan" (Shen Yiqian's eightieth birthday exhibition), *Meishujia* 60 (1988.2): 22–25.

20. See Chun Kum-wen, "Art Chronicle," *T'ien Hsia Monthly* 8, no. 1 (August 1938): 207–8.

21. See *Meishu* (1985.5): 54 for illustration of both works.

22. For a lively account of Zhang's life and work at Dunhuang, see Xie Jiaxiao, *Zhang Daqian di shijie,* 61–73.

23. This story and what follows was told to me by Chang Shuhong in Hangzhou in 1988.

24. Cheng Te-k'un lists the following: Wang Ziyuan, who worked at the same time as Zhang Daqian, coloring his copies on the spot (as Zhang apparently did not always do, so they are more accurate than Zhang's); Guan Shanyue, who made eighty copies; Wu Zuoren, who made twenty-eight; and the lacquer artist Shen Fuwen and his wife Li Dehui, whose sixty copies were chiefly of decorative designs. See introduction to Shi Yai, *Chinese Inscriptions,* 5–6.

25. No study, to my knowledge, has yet appeared of the activities of artists in Occupied China during the war. What follows is pieced together from biographical information on individual artists.

26. See Asano Kiyoshi and others, eds., *Genshoku gendai Nippon no Bijutsu,* vol. 7, *Kindai Yōga no Tenkai* (Development of modern European-style painting) (Tokyo, 1979), plates 66 and 67, p. 115.

27. For another version of this announcement, see T. C. Lai, *Ch'i Pai Shih* (Seattle, 1973), 94.

28. Quoted in Woo, *Chinese Aesthetics and Ch'i Pai-shih,* 38–39.

29. The fullest study of this artist is Liu Xilin, *Yihai chunqiu: Jiang Zhaohe zhuan* (Annals of Art: Biography of Jiang Zhaohe) (Shanghai, 1981).

30. Quoted in Liu Xilin, "Artist Jiang Zhaohe's Wartime Epic 'Refugees,'" *Chinese Literature* (Winter 1984): 151–52.

31. For a view of the literary scene, see Edward Gunn, *Unwelcome Muse: Chinese Literature in Shanghai and Peking, 1937–45.* Some of the information here is from a letter to the author from Irene Chou in Hong Kong, dated August 18, 1988.

32. See Chen Ruilin, "Chen Baoyi," and Liu Haisu, "Huainian Chen Baoyi," *Meishujia* 59 (1987.12): 18–24.

33. See his biography in Li and others, *Zhongguo yishujia cidian* 1:476–77. See also Huang Mengtian, "Yu Ben huajicun" (Preface to Yu Ben's painting collection), *Meishujia* 27 (1982.8): 13–28; and Wang Li, "Yu Ben, the Oil Painter," *Chinese Literature* (November 1981): 77–80.

CHAPTER 10. FROM PEACE TO LIBERATION

1. See Liao Jingwen and Xu Fangfang, "Life of Xu Beihong," *Oriental Art,* n.s., 28, no. 1 (Spring 1982): 85.

2. See Derk Bodde, *Peking Diary* (New York, 1950), 182–83.

3. See *Biographical Dictionary of Republican China* (New York, 1967), 1:112–14.

4. Some of the information in this section was given to me in 1947–48 in private correspondence with Geoffrey Hedley of the British Council (then in Shanghai), Pang Xunqin, Stephen Soong, Fu Lei, Fu Baoshi, and others.

5. See *North China Daily News,* January 26, 1948.

6. See leaflet, *Painting Exhibition of the Last Hundred Years* (Shanghai, 1947).

7. See article by Wang Richang in Song Zhongyuan, *Yishu yaolan,* 143–44.

8. See Croizier, *Art and Revolution,* ch. 5.

9. For the activities of the Renjian Huahui, see Huang Mengtian, "Xinbo yu Renjian Huahui" (Xinbo and the Renjian Art Society), *Meishujia* 61, no. 4 (1988): 48–56.

10. See Pang's *Jiushi zheyang zuoguolai di,* 270.

CHAPTER 11. CARTOON AND CARICATURE

1. For a comprehensive study, from which much of the material in this chapter is taken, see Bi and Huang, *Zhongguo manhua shi,* and Wang Bomin, *Zhongguo meishu tongshi* (Comprehensive history of Chinese Art) (Jinan, 1988), 7:257–300.

2. See Minick and Jiao, *Chinese Graphic Design,* 21–87.

3. See Roy, *Kuo Mo-jo,* and Bi and Huang, *Zhongguo manhua shi,* 158, 159, 163, 164, 167, 189.

4. On Zhang Guangyu, see P. Destenay, "Zhang Guangyu: caricaturiste et imagier," *Cahiers de linguistique, d'orientalisme et de slavistique* 1, no. 1/2 (1973): 85–106, and articles by Lan Zhai in *Meishujia* 39 (1984.8): 64–67, and Huang Miaozi in *Meishujia* 69 (1989.8): 38–49.

5. On Ding Cong's wartime work, see Michael Sullivan, *Chinese Art in the Twentieth Century,* 54, 55, 56, 80; Huang Miaozi in *Meishujia* 29 (1982.12): 36–42; and Huang Miaozi in *Meishujia* 56 (1987.6): 28–31. See also Huang Mengtian, ed., *Ding Cong: Manhua, chatu, suxie* (Ding Cong: Cartoons, illustrations, sketches) (Hong Kong, 1983).

6. Sullivan, *Chinese Art in the Twentieth Century,* plate 69 (with commentary).

7. See Zeng Kaixun, ed., *Zhang Leping huaji* (Collected works of Zhang Leping) (Shanghai, 1982), and Huang Yuanlin, "Cartoonist Zhang Leping," *Chinese Literature* (Summer 1984): 101–6.

8. Huang Yuanlin, "Cartoonist Zhang Leping," 105.

9. See Xu Soya (pseudonym), "Lun Bingxiong de manhua" (Discussion of Bingxiong's cartoons), *Qingming* 1 (1946): 32–33.

10. See Cai Ruohong, "Avenue Joffre," *T'ien Hsia Monthly* 8 (September 1937).

11. See *Chinese Satire and Humour: Selected Cartoons of Hua Junwu, 1955–1982,* trans. W. J. F. Jenner (Beijing, 1984). For the influence of Grosz, see article by the editor, *Meishujia* 65 (1988.12): 56–59, and Lan Zhai, "Waiguo manhua dui Zhongguo manhuajia di yinxiang" (The influence of foreign caricatures on Chinese caricaturists), *Meishujia* 67 (1989.4): 44–49.

12. See Christoph Harbsmeier, *The Cartoonist Feng Zikai: Social Realism with a Buddhist Face* (Oslo, 1984).

CHAPTER 12. LIBERATION

1. See Xinhua Book Co., *Zhonghua chuanguo wenxue yishu gongzuozhe diabiao dahui jinian wenji* (Record and proceedings of the great meeting of national representatives of Chinese cultural and art workers) (Beijing, 1950), which reprints the speeches and resolutions of the conference. In view of the fact that Zhou Enlai was later regarded as the artists' champion and protector, it is well to remember that he was never anything but a committed Communist, dedicated to carrying out Mao's policies. On July 6, 1949, he delivered an important "Report to Political and Art Workers" in which he stressed that writers and artists must serve the people, get to know the workers and peasants, publicize art, and raise standards. Parts of the old literature and art would die out, but "those which are desirable and fit to develop will improve and advance and gradually become part of the new art."

2. Ralph Croizier, interview with Gao's daughter, Gao Lihua. See *Art and Revolution,* 166.

3. See Liao and Xu, "Life of Xu Beihong," 85.

4. For a detailed study of this period, see Maria Galikowski, *Art and Politics in China, 1949–1986* (Ph.D. diss., University of Leeds, 1990); Laing, *The Winking Owl,* 19–23; and Arnold Chang, *Painting in the People's Republic of China: The Politics of Style* (Boulder, Colo., 1980), 10–17.

5. Goldman, *Literary Dissent in Communist China,* ch. 6 and 7.

6. See Song Zhongyuan, *Yishu yaolan,* 22–24, and, on Ni Yide, Zhu Boxiong and Chen Ruilin, "Ni Yide di youhua yu Quelan she" (Ni Yide's oil paintings and the Storm Society), *Meishu* (1981.6): 59–62.

7. See Ke, *Yishu dashi Liu Haisu zhuan,* 326–30.

8. Chang, *Painting in the People's Republic,* 11.

9. Hu Qiaomu, "On the Ideological Remoulding of Writers and Artists," *Chinese Literature* 1 (Spring 1953): 5 ff.

10. Bodde, *Peking Diary,* 182–83.

CHAPTER 13. ART FOR SOCIETY

1. Typical of the many books on Russian and Soviet art published in these years was Yang Chengyin, *Shehuizhuyi*

xianshizhuyi shi shehuizhuyi shehui shenghuo di fanying (Socialist realism is the reflection of the life of socialist society) (Shanghai, 1954). Chinese theorists constantly reiterated the Soviet doctrine that art is the "reflection" of life.

2. On Feng Fasi, see Li and others, *Zhongguo yishujia cidian* 2:478.

3. See People's Art Publishing House, *Wang Shikuo huaji* (Beijing, 1982), plates 54–115.

4. On Maksimov and his influence, see Bi Keguan and Li Shaoshan, *Zhongguo xiandai meishu shi*, 260, and article welcoming him to China by the editor, *Meishu* (1955.3): 39. On his career in the Soviet Union, see article by Bandarenko, *Meishu yanjiu* (1986.2): 59–61.

5. On Babov, see *Meishu* (1962.5): 31–32.

6. See *Xinhua yuebao* 4, no. 1 (May 1951): 224–25.

7. For pictorial symbolism in this period, see Chuang Shen, "Art and Politics: Study of a Special Relationship in Contemporary Chinese Painting," in *Twentieth-Century Chinese Painting,* ed. Mayching Kao (Hong Kong, Oxford, and New York, 1988), 178–94.

8. See Galikowski, *Art and Politics in China,* 30.

9. For Zhou Yang's exhortation to artists in the early 1950s, see Laing, *The Winking Owl,* 20–22.

10. A review of the first National Exhibition of guohua, held in Beijing in 1953, complained of the traditional landscapes onto which the figures seemed to be stuck like cutouts. See *Meishu* (1958.2): 46, and Galikowski, *Art and Politics in China,* 35.

11. See Zhang Anzhi, "The Painter Ch'ien Sung-yen," *Chinese Literature* (1964.9): 117.

12. Ibid., 103.

13. Cong Baihua, in *Chinese Literature* (1961.12).

14. For the history of the institute, see Beijing Painting Academy, *Beijing Huayuan zhongguohua xuanji* (Selected traditional paintings from the Beijing Painting Academy) (Beijing, 1982).

15. See "A New Day for Chinese Painting," *People's China* 12 (June 1957): 36–37.

16. On the Wenshi Guan, see Jerome Silbergeld with Gong Jisui, *Contradictions: Artistic Life, the Socialist State, and the Chinese Painter Li Huasheng* (Seattle, 1993).

17. See Li and others, *Zhongguo yishujia cidian,* 5:485–86.

18. See Roderick MacFarquhar, *The Origins of the Cultural Revolution,* vol. 1, *Contradictions among the People* (New York, 1974), 53–56.

19. For a report on and quotations from Lu's speech, see *Chinese Literature* (1957.3) and Laing, *The Winking Owl,* 23–24.

20. Zhou Yang, "The Important Role of Art and Literature in the Building of Socialism," *Chinese Literature* (1957.1): 184.

21. For Zhou Yang's volte-face, see "Peking Writers and Artists Discuss Chou Yang's Report," *Chinese Literature* (1958.3): 103–35, and (1958.5): 139–40.

22. *Meishu* (1957.11): 40–41.

23. The whole sorry story of Jiang Feng's persecution, and the reasons for it, are set out in Julia F. Andrews, "Traditional Painting in New China: *Guohua* and the Anti-Rightist Campaign," *Journal of Asian Studies* 49, no. 3 (August 1990): 555–86.

24. For a study of the Great Leap Forward and its disastrous consequences, see MacFarquhar, *The Origins of the Cultural Revolution,* vol. 1. See especially chapter 5, "Mao Against the Planners," and chapter 16, "Blooming and Contending."

25. This speech was carried in *Wenyibao* and *People's Daily.* See *Chinese Literature* (1979.6): 83–95.

26. See Laing, *The Winking Owl,* 36.

27. Quoted in ibid., 35.

28. Ibid., 52.

29. See *Meishu* (1963.5): 50–52 and *Chinese Literature* (1963.1): 101–8.

30. Some of the paintings done by Guan Shanyue on this tour clearly show Fu Baoshi's beneficial influence, loosening up Guan's brushwork. See *Fu Baoshi Guan Shanyue dongbei xiesheng huaxuan* (Collection of paintings done in the northeast by Fu Baoshi and Guan Shanyue) (Liaoning, 1964). During the Cultural Revolution, Cai Ruohong and Hua Junwu, who had sanctioned the tour, were attacked for "squandering the people's hard-earned wealth to satisfy the luxurious tastes of bourgeois 'authorities'" (Laing, *The Winking Owl,* 65).

CHAPTER 14. ART FROM THE PEOPLE: PEASANTS AND WORKERS

1. Maurice Meisner, *Mao's China: A History of the People's Republic* (New York, 1977).

2. Almost the whole of *Meishu* (1958.9) is devoted to Pixian and its painters. See also Ellen Laing, "Chinese Peasant Painting, 1958–76: Amateur and Professional," *Art International* 27, no. 1 (January–March 1984): 2–12.

3. "New Peasant Painting," *Peking Review* 23 (September 1958): 18, quoting from his article in *Meishu* (1958.9): 22.

4. See *Chinese Literature* (1958.6): 165–67.

5. Several pages of photographs in Song Zhongyuan, *Yishu yaolan,* show staff and students working and apparently enjoying themselves with the peasants.

6. See Liu Yifang, "Artists Go to the People," *China Reconstructs* (November 1958): 16–18.

7. A good account of the art of the Great Leap Forward is given by Ellen Laing in *The Winking Owl,* 29–31.

8. A thorough study of *nianhua* old and new is Else Unterreider, *Glück ein Ganzes Mondjahr Lang* (Happiness the whole year long) (Klagenfurt, Austria, 1984).

9. Galikowski, *Art and Politics in China,* 25.

10. John Warner, *Chinese Papercuts* (Hong Kong, 1978), contains many contemporary examples.

11. For information on *lianhuanhua,* see Ho Yung, "Illustrations of Serial Picture Books," *Chinese Literature* (1964.12): 105–11. He notes that in the serial picture department of the Shanghai People's Publishing House more than forty artists were at work, and that print runs of these picture books could run to several hundred thousand. For later developments, see Jiang Weipu, ed., *Chinese Comics* (China Exhibition Agency, n.d.). The editor notes that in recent years (that is, the 1980s) about *two million* picture books have been published annually.

CHAPTER 15. THE CULTURAL REVOLUTION

1. See MacFarquhar, *Origins of the Cultural Revolution,* 222, 384n. 32.

2. Quoted in Tang Tsou, *The Cultural Revolution and Post-Mao Reforms* (Chicago, 1986), 92.

3. See Laing, *The Winking Owl,* 67–70, and Galikowski, *Art and Politics in China.*

4. Laing, *The Winking Owl,* 85.

5. See Galikowski, *Art and Politics in China,* 145.

6. See *Peking Review* 23 (June 2, 1967): 13.

7. Qian Songyan, "Creating New Paintings in the Traditional Style," *Chinese Literature* (1972.11): 111–14.

8. Tang Tsou, *The Cultural Revolution,* 150.

9. Unpublished manuscript quoted by Joan Cohen, *The New Chinese Painting, 1949–1976* (New York, 1987), 31.

10. For further tragic details of persecution, see Laing, *The Winking Owl,* 63–64 ("Artists in Disgrace").

11. For comments on the significance of the owl, see Laing, *The Winking Owl,* 186, which stresses the bird's ominous connotations; Galikowski, *Art and Politics in China,* 147–148, notes its ambiguity. The very fact that Huang's painting was open to many interpretations made it subversive.

12. These stories were told to me by the victims themselves.

13. For a moving account of Wei being ordered to destroy his own paintings, see his obituary in Wu Guanzhong's collected essays, *Dongxun xizhao ji* (Searching here and there) (Chengdu, 1982), reprinted from *Guangming ribao* (1980.7.13).

CHAPTER 16. SCULPTURE

1. In Ministry of Education, *Shanghai Meishu Zhuanke Xuexiao,* section on statistics.

2. For an illustration of Li Jinfa's bust of Wu Jianfang, see *Yifeng* 1, no. 2 (February 1933).

3. See ibid., and Xu Zhimo's *nianpu* in Jiang Fucong and Liang Shiqiu, eds., *Xu Zhimo quanji,* 1:635.

4. See Wang Bomin, *Zhongguo meishu tongshi* 7:309.

5. See brief article by Chen Ji in *Meishu* (1987.8): 47–49.

6. See Wang Bomin, *Zhongguo meishu tongshi* 7:304–6.

7. A photograph of this work, now probably destroyed, is in the author's possession.

8. Post-Liberation sculptural projects are noted in (for example) *Meishu* 1955.12, 1962.3, 1965.3.

9. See *Meishu* (1987.6): 32.

10. Cited in Laing, *The Winking Owl,* 24.

11. See Chen Peng, "A Diligent Man with a Natural and Forthright Style," in *Sculpture by Liu Huanzhang* (Beijing, 1984). This book claims that the first one-sculptor show ever held in China was devoted to his work.

12. See Foreign Languages Press, *The Rent Collection Courtyard: Sculptures of Oppression and Revolt* (Beijing, 1968).

13. See Foreign Languages Press, *Wrath of the Serfs: A Group of Life-size Clay Sculptures* (Beijing, 1976).

14. Quoted in Li Xianting, "The Stars Talk about Their Work," in *The Stars: 10 Years,* ed. Chang Tsong-zung, 85.

15. For new trends in sculpture after Mao, reflected in the Sixth National Exhibition, see article by Wang Chaojian in *Meishu* (1985.1), 26–31, with illustrations following p. 44.

16. See *Meishu* (1981.7 and 1986.3), both largely devoted to modern sculpture for open spaces, Chinese and foreign, including Mount Rushmore.

17. Color plate in *Meishu* (1981.7) shows all four figures.

CHAPTER 17. MODERN GRAPHICS

1. See Yu Feng, "In Memory: Chilean Painter José Venturelli," *China Reconstructs* (March 1989): 29–31.

2. See Gesellschaft für Verständigung und Freundschaft mit China, *Holzschnitt im Neuen China* (Berlin, 1976).

3. On Dong Kejun, see Qi Lin, "Dong Kejun and his Art," *Chinese Literature* (Summer 1989): 93–97, and Tang Qingnian, "Cai hei yu bai zhong ningju di" (A condensation in black and white), *Meishu* (1985.8): 22–27.

4. For examples of the Beidahuang prints, see *Meishujia* 54 (1987.2): 56–60.

5. See Michael Sullivan, "The Chinese Art of 'Water-Printing,' *Shui-yin*," *Art International* 27, no. 4 (September-November 1984): 26–33.

6. See Richard Riley, *Modern Chinese Prints from the Central Academy of Fine Art, Peking* (Preston, England, 1986).

7. For the Ninth Print Exhibition, see *Meishu* (1987.1): 10–14 and color plates.

8. The literature on *lianhuanhua* in China is very extensive. Works by the seventy-two prizewinners in the Second National Exhibition in Beijing (February 1981) are illustrated in *Meishu* (1981.3): 4–23. See also the popular monthly *Lianhua huahao,* published in Beijing, and China Exhibition Agency, *Chinese Comics* (n.d.), catalogue of an exhibition held in London c. 1985. Serial pictures are discussed in *Meishu* 1981.9, 1983.12, 1985.4, 1985.5, 1985.9, 1986.10, etc.

9. See *Feng Hsueh-feng Fables,* trans. Gladys Yang (Beijing, 1953).

10. For these and other examples, see China Exhibition Agency, *Chinese Comics.*

CHAPTER 18. ART IN TAIWAN

1. For a useful survey of the early modern period, see Xie Lifa, ed., *Taiwan meishu yundong shi* (The history of the Taiwan art movement), vol. 2 of *Yishujia congkan* (Taipei, [1988]).

2. The volume of literature on the Japanese period in Taiwanese art has increased considerably in recent years. In addition to the above, see important articles by Hsiu-hsiung Wang and Lin P'o-ting in Huang Kuang-nan, ed., *China: Modernity and Art* (Taipei, 1991), and John Clark, "Taiwanese Painting and Europe: Direct and Indirect Relations," in *China and Europe in the Twentieth Century,* ed. Yu-ming Shaw (Taipei, 1968).

3. See Ni Chiang-huai and others, *Early Twentieth-Century Watercolours of Ishikawa Kin'ichirō* (Taipei, 1986).

4. See Taipei Fine Arts Museum, *The Art of Li Shih-ch'iao* (Taipei, 1988).

5. See Taipei Fine Arts Museum, *A Retrospective Exhibition of Liu Ch'i-hsiang* (Taipei, 1988).

6. For an overview of the situation for art after the Japanese withdrawal, see John Clark, "La peinture à Taipei

après 1945: le contexte politique et économique," *Etudes chinoises* 7, no. 1 (Spring 1988): 29–63.

7. Quoted in ibid.

8. For the early years of the modern movement in Taiwan, see Guo Jisheng (Jason Kuo), ed., *Dangdai Taiwan huihua wenxuan 1945–1990* (Anthology of writings on modern painting in Taiwan) (Taipei, 1991), and Martha Su Fu, "Chinese Painting in Taiwan," in *Twentieth-Century Chinese Painting,* ed. Mayching Kao, 196–209.

9. Particularly informative on the Fifth Moon Group is National Museum of History, Taipei, *Five Chinese Painters* (Taipei, 1970), with essays by Chu-tsing Li, Yu Kwang-ching, and Thomas Lawton.

10. See the author's essay reprinted in Taipei Fine Arts Museum, *Paintings by Liu Kuo-sung* (Taipei, 1990).

11. See National Taiwan Arts Center, *Graphic Art by the Contemporary Chinese Artist Chen Ting-shih* (Taipei, 1967).

12. See Ton-Fan Painting Association, *Ton-Fan Painting Exhibition: Chinese and Italian Modern Painters* (Taipei, 1968).

13. See Jerrow C. H. Chung, ed., *The Contemporary Chinese Artist Chin Sung: Paintings and Poems Primitive Black* (Taipei, 1967).

14. Liao Xiuping, *Banhua yishu* (The art of printmaking) (Taipei, 1974).

15. Much has been written by, and about, this poet-painter. See, for example, *Luo Qing shi hua* (Paintings and poems by Luo Qing), with introduction by Roderick Whitfield (Taipei, 1990).

16. For a collection of Yu Peng's delightful paintings, poems, and sketches, see *Sanbu di shanlu* (Wandering in the hills) (Taipei, 1984).

17. See Chang Tsong-zung, *Apparitions: Paintings by Cheng Tsai Tung* (Hong Kong, 1990), and Hanart II Gallery, *Cheng Tsai-tung and Chiu Ya-tsai* (Hong Kong, 1988).

18. See Art Book Company, *Chen Chi Kuan Paintings 1940–1980* (Taipei, 1981), with contributions by Nelson Wu, James Cahill, Richard Edwards, Tao Ho, Chu-tsing Li, Michael Sullivan, and Joan Stanley-Baker.

19. Ibid., 34.

20. See Michael Sullivan, *The Art of Yu Ch'eng-yao* (Hong Kong, 1987).

21. Ibid.

22. For an account of the naked commercialism of the Taipei art world, see "A New Focus on Old Painters—Art Movement Heats Up!" *Sinorama* (July 1990): 31–39, and interview with the art dealer Pai Hsingjan, 40–43.

23. See Clark, "Taiwanese Painting and Europe."

24. See catalogue of Yuyu Yang's sculpture from 1969 to 1988, published in Taipei, 1988.

25. See Hong Kong Arts Centre and Hanart Gallery, *Laser and Lifescape Sculpture by Yuyu Yang* (Hong Kong, 1986).

26. The range of work of this remarkable sculptor is illustrated in a number of catalogues put out by the Hanart Gallery in Hong Kong and Taipei. See, for example, Chang Tsong-zung, ed., *Ju Ming: Sculpture* (Hong Kong, 1986), and *Ju Ming: Taiji Sculpture,* with essay by the author (London, 1991).

27. Ju Ming, *The Living World* (Taipei, 1989), 15.

28. See Taipei Fine Arts Museum, *An Exhibition of Contemporary Chinese Sculpture in the Republic of China* (Taipei, 1985).

CHAPTER 19. HONG KONG AND SOUTHEAST ASIA

1. See J. C. Y. Watt, *Wong Po Yeh* (Hong Kong, n.d.).

2. For an overview of Hong Kong art, see Wucius Wong, "Chinese Painting in Hong Kong," in *Twentieth-Century Chinese Painting,* ed. Mayching Kao, 210–23, and Lawrence C. S. Tam, *1970–1980 Hong Kong Art* (Hong Kong, 1981).

3. Hong Kong Arts Centre, *A Retrospective Exhibition of the Works of Ting Yen-yung* (Hong Kong, n.d.).

4. Wong, "Chinese Painting in Hong Kong," 215.

5. The groups and societies mentioned held regular exhibitions, publishing brochures and catalogues too numerous to list here.

6. Among many publications that feature this seminal artist, the most thorough is Wucius Wong and others, eds., *Lui Shou-kwan 1919–1975* (Hong Kong, 1979).

7. See Chang Tsong-zung, *The World of Luis Chan* (Singapore, 1987).

8. See Chang Tsong-zung, *Jackson Yu: New Vision* (Hong Kong, 1990) and *Jackson Yu: New Vision 2* (Hong Kong, 1991).

9. See Mayching Kao, *Kwong Yeu Ting* (Hong Kong, 1982).

10. See Michael Lau, ed., *Chinese Painting by Irene Chou* (Hong Kong, 1986), 28.

11. See *Fang Zhaoling: Portfolio* (Hong Kong, 1983).

12. See Robert D. Jacobsen, *Mountain Thoughts: Landscape Paintings by Wucius Wong* (Minneapolis, 1987).

13. Michael Sullivan, foreword to Gerald Godfrey Gallery, *River Dreams: Recent Paintings by Wucius Wong* (London, 1989).

14. Wong, "Chinese Painting in Hong Kong," 210.

15. No single work, to my knowledge, has been devoted to Hong Kong sculpture, but the work of Cheung Yee, Van Lau, and others is featured in Fung Ping Shan Museum, *Art '84* (Hong Kong, 1984); Hong Kong Museum of Art, *Art Now: Hong Kong Painting and Sculpture* (Hong Kong, 1971); and Hong Kong Museum of Art, *The Sculpture Walk: Kowloon Park* (Hong Kong, 1989).

16. For Chinese artists in Singapore and Malaysia, see Michael Sullivan, *Chinese Art in the Twentieth Century,* 59–60; Dolores Wharton, *Contemporary Artists of Malaysia: A Biographic Survey* (Petaling Jaya, Malaysia, 1971); and Hong Kong Museum of Art, *Contemporary Singapore Painting* (Hong Kong, 1980).

17. Wharton, *Contemporary Artists of Malaysia.*

18. See Frank Sullivan, *Teng—Master of Batik* (Kuala Lumpur, 1963).

CHAPTER 20. EXPATRIATE ARTISTS

1. Quoted by Huang Kuang-nan in *China-Paris,* 105.

2. Letter to the author from New York, September 29, 1948.

3. See *China-Paris,* 97–101.

4. Musée Cernuschi, *Exposition de peintures chinoises contemporaines* (Paris, 1946).

5. See article on Xiong by Wu Guanzhong in *Meishu* (1982.6).

6. This important artist has been the subject of many books, notably Claude Roy, *Zao Wou-ki* (Paris, 1988).

7. Quotations from Jean Leymarie, *Zao Wou-ki* (Paris, 1986), 17. Translated from the French.

8. Ibid., 41.

9. See Zao's *Autoportrait*, 174–79.

10. See National Museum of History, *Chu Teh-chun* (Taipei, 1987), with an introduction by the author, and Hubert Juin, *Chu Teh-Chun* (Paris, 1979).

11. Les Amis du VIe Arrondisement, *Artistes chinois de Paris* (Paris, 1983).

12. See Tseng Yuho and Howard Link, *The Art of Tseng Yuho* (Honolulu, 1987).

13. See Jerome Silbergeld, *Mind Landscapes: The Paintings of C. C. Wang* (Seattle and London, 1987).

14. See Chu-tsing Li, *Rocks, Trees, Clouds and Water: The Art of Hung Hsien* (Lawrence, Kansas, 1978).

15. See Alice King, ed., *Chao Chung-hsiang* (Hong Kong, 1992).

16. For a typical work of Gu Mei, see Urban Council of Hong Kong, *1970–1980: Hong Kong Art,* pl. 17.

17. See Hong Kong Institute for the Promotion of Chinese Culture, *Y. J. Cho* (Hong Kong, 1988).

18. See Hong Kong Institute for the Promotion of Chinese Culture, *Szeto Keung* (Hong Kong, 1981).

CHAPTER 21. WINTER GIVES WAY TO SPRING

1. For the art of this first Tiananmen Incident, see *Meishu* (1979), nos. 8–12.

2. For the creation of the square, see Liang Sicheng, "T'ien An Men Square," *Chinese Literature* (1960.2): 114–15, and "The Great Hall of the People," *Chinese Literature* (1960.3): 121. For the planning and decoration of the Mao memorial hall, see Laing, *The Winking Owl,* 90–96, and Wu Hung, "Tiananmen Square: A Political History of Monuments," *Representations* 35 (Summer 1991): 84–117.

3. See Jiang Feng, "Zhongguohua wenti de yi fongxin" (A letter on the problem of Chinese painting), *Meishu* (1979.11): 10–11.

4. Almost the whole of *Meishu* (1977.2) is devoted to attacks on Jiang Qing and the Gang of Four.

5. For a good account of the events of 1978–79, see W. J. F. Jenner, "1979: A New Start for Literature in China?" *China Quarterly* 86 (June 1981): 274–303. On the Third Plenum, see Galikowski, *Art and Politics in China,* 173.

6. Zhou Yang's speech (on November 3) was not reported in the press, but Xia Yan's of November 16, very similar in content, was published in *Red Flag* on November 17.

7. Translation by Susan Cooke and David Goodman, *Renditions* 19/20 (Spring/Autumn 1983): 235.

8. "The Informer," *Shikan* 9 (September 1979); translation by W. J. F. Jenner in "1979: A New Start," 298.

9. Reproduced in *Meishu* (1980.2), inside back cover.

10. *Meishu* (1979.1), inside back cover, and 22.

11. Reproduced in *Meishu* (1980.2), inside back cover.

12. For a positive view of "wound" literature and art, see Lang Shaojun, "An Evaluation of Innovation in Chinese Painting," trans. Simon Johnstone, *Chinese Literature* (Summer 1986): 173–88.

13. Geremie Barmé, "*Arrière-pensée* on an Avant-Garde:

The Stars in Retrospect," in *The Stars: 10 Years,* ed. Chang Tsong-zung (Hong Kong, 1989), 79–80.

14. The story of the Stars and their exhibitions is best told in Chang, ed., *The Stars: 10 Years,* and the fuller French version, *Les Etoiles: 10 Ans;* both include Barmé's "*Arrière-pensée* on an Avant-Garde." See also Robin Munro, "Unofficial Art in China: How Artists Like the 'Stars' have fared since 1978," *Index on Censorship* (June 1982): 36–39.

15. Quoted in Barmé, "*Arrière-pensée.*"

16. See William Tay, "Obscure Poetry': A Controversy in Post-Mao China," in Jeffrey C. Kinkley, ed., *After Mao: Chinese Literature and Society, 1979–81* (Cambridge, Mass., 1985), 133–37.

17. Translation by Bonnie S. McDougall, from *Notes from the City of the Sun: Poems by Bei Dao* (Ithaca, N.Y., 1984), 104.

18. Translation by Wai-lim Yip, *Renditions* 19/20 (Spring/Autumn 1983): 226.

19. *Meishu* (1980.3): 9 records both positive and negative comments on the Stars.

20. For an orthodox party view, see Gao Yan in *Meishu* (1980.12): 33–36. He writes, "Young friends, it is all very well to express your feelings, but if you exhibit your pictures you must paint pictures that people understand. If very few understand them, what kind of an impression are you making?" Wang Keping himself, Gao writes, cannot explain his own work.

21. Julien Blaine, *Wild Lilies, Poisonous Weeds: Dissident Voices in People's China* (London, 1982).

CHAPTER 22. THE 1980S: NEW DIRECTIONS

1. See *Meishu* (1980.1): 3–15.

2. All of the above quotations are from *Meishu* (1980.4).

3. For Deng's speech, see *China Quarterly* 82 (1980): 370–72.

4. See David Goodman, "The Sixth Plenum of the 11th Central Committee of the CCP: Look Back in Anger?" *China Quarterly* 87 (1981): 518–27.

5. Published in *Red Flag* 23 (December 1982): 2–22.

6. Merle Goldman, *China's Intellectuals and the State: In Search of a New Relationship* (Cambridge, Mass., 1987), 12.

7. See Carol Lee Hamlin, "Conclusion: New Trends under Deng Xiaoping and His Successors," in *China's Intellectuals and the State,* ed. Goldman.

8. For these events, see Hamlin, "Conclusion: New Trends."

9. See "Summary of 'Art and Culture, Spirit and Language' Meeting," *Meishu* (1988.12): 4–9.

10. See *Meishu* (1980.5): 3.

11. See *Meishu* (1981.3), illustration no. 20.

12. See *Meishu* (1983.7).

13. See color plates in *Meishu* (1985.1): 26–30, and Chinese Artists Association, *The Sixth National Art Exhibition* (Beijing, 1984), an album of slides of prize-winning works.

14. For the airport decorations, see Cohen, *The New Chinese Painting,* 25–41.

15. For this and other mural decoration projects discussed here, see Wang Ziye, "Creation-Life (An Introduction to the Six Frescoes by Yuan Yunfu)," in People's

Fine Arts Publishing House, *Chinese Arts* 1 (Hong Kong, n.d.), 72–74.

16. This information was given to me by the recipient of Ding's confidences, who must remain anonymous. I have not been able to substantiate it, but include it as an instance of the rivalries and jealousies that persist among Chinese artists dependent upon the uncertainties of official patronage.

17. See Cohen, *The New Chinese Painting,* 44, fig. 44.

18. See Cohen, *The New Chinese Painting,* 53–59.

19. Ibid., 67–80.

20. For the Tongdairen, see *Meishu zuopin* 7 (Beijing, 1981) and Cohen, *The New Chinese Painting,* 76–81.

21. See *Meishu* (1981.4), and Cohen, *The New Chinese Painting,* 70–76.

22. See series of articles on the Four Studios in *Meishu yanjiu* (1987.1).

23. *Xiandai youhua* (Contemporary oil painting) (Shenyang, 1987), a conspectus of works from the First Oil Painting Exhibition, sponsored by the Beijing International Art Gallery, gives a good idea of the work then being shown, ranging from the academic nudes of Yang Feiyun to the abstractions of Ge Pengren and the trompe-l'oeil of Mao Lizhi. See also *Contemporary Oil Painting from the People's Republic of China* (New York, 1987), a collection from the Harkness House exhibition.

24. On Yuan Yunfu's earlier decorative work, see Su Lan, "The Art of Yuan Yunfu, *Chinese Literature* (1981.8): 96–102.

25. See Shui Tianzhong, *Cao Dali huaji* (Collected works of Cao Dali) (Beijing, 1990).

26. On Luo Erchun, see *Meishu* (1985.12): 16. For a brief biography and reproductions of his work, see the Hefner Galleries, *Luo Erchun: Recent Paintings* (New York, 1988).

27. On the Banjiezi, see Shao Daqian, "You gan yu banjiezi meizhan" (I have thoughts about the Banjiezi exhibition), *Meishu* (1985.12): 4–7. Color illustrations are included.

28. Ibid.

29. On Luo Zhongli, see Cohen, *The New Chinese Painting,* 106–7.

30. See "Wodi fuqin di zuozhe di laixin" (A letter from the painter of *My Father*), *Meishu* (1981.2): 4–5.

31. See *Shanghai youhua diaosu yuan* (Shanghai, n.d.), the official history of the Shanghai Oil Painting and Sculpture Research Institute.

32. See *Shanghai Daxue Meishu Xueyuan zanghua zhan* (Exhibition of the collection of paintings of the Shanghai University Institute of Painting) (Tokyo, 1987).

33. See Zao Wou-ki and Françoise Marquet, *Autoportrait* (Paris, 1988).

CHAPTER 23. GUOHUA REBORN AGAIN

1. For *nihonga* in China, see Bu Nai, "Ji shifa Riben huihua" (Recording ten Japanese paintings), *Meishu* (1979.8), color plates and 47–48; and illustrations in *Zhongguohua* (1982.2, 1983.1). For *nihonga*-style works by Pan Jiezhi, see *Meishu* (1983.5), color plates and 47–48.

2. See his biography in Li and others, *Zhongguo yishujia cidian (xiandai)* 1:529, and, for his Japanese beauties, *Zhongguo meishu* (1985.2).

3. Reproduced in Huang Mengtian, ed., *Huang Yongyu huaji* (Hong Kong, 1980).

4. See *Meishujia* 53 (1986): 24–35.

5. See essays on Li Keran by Wan Qingli in *Han Mo* nos. 25 (1992), 26 (1992), and 43 (1993).

6. With his great success abroad, the literature on Wu Guanzhong is rapidly increasing. See, for example, Lucy Lim, ed., *Wu Guanzhong: A Contemporary Chinese Artist* (San Francisco, 1989), with contributions by Xiong Bingming, Wu Guanzhong, Michael Sullivan, Richard Barnhart, James Cahill and Tsao Hsing-yüan, and Chu-tsing Li; and Anne Farrer, Michael Sullivan, and Mayching Kao, *Wu Guanzhong: A Twentieth-Century Chinese Painter* (London, 1992).

7. See *Poetic Imagery: New Paintings by Yang Yanping* (Hong Kong, 1981).

8. See Michael Sullivan, "The Calligraphic Works of Yang Yanping," *Apollo* (May 1986): 346–49.

9. See O. Sirén, *Chinese Painting: Leading Masters and Principles,* vol. 6 (London, 1958), pl. 37.

10. See Yin Guanghua, "Master Painter Zhu Qizhan," *Chinese Literature* (March 1982): 21–25.

11. See Xiling Seal Company, *Cheng Shifa shuhua,* 5 vols. (Hangzhou, 1979–80). These volumes show Cheng's great skill as a draughtsman in pen and pencil.

12. See *Lu Yanshao shuhua zangpin ji* (Collection of Lu Yanshao's Painting and Calligraphy), vol. 1 (Hong Kong, 1991).

13. See People's Fine Arts Publishing House, *Shi Lu shuhuaji* (Shi Lu: painting and calligraphy) (Beijing, 1990), with essays by Wang Chaowen, Wu Guanzhong, and others.

14. See Editors of *Meishujia, Jinling bajia huaji* (Painting collection of eight masters of Jinling) (Hong Kong, 1979). The eight masters include Qian Songyan, Ya Ming, Song Wenzhi, and Wei Zixi.

15. See Huacheng Publishing House, *Guangdong Huayuan jikan* (Collected works of the Guangdong Painting Academy) (Hong Kong, 1982).

16. For Chen Zizhuang and Li Huasheng, see Jerome Silbergeld with Gong Jisui, *Contradictions: Artistic Life, the Socialist State, and the Chinese Painter Li Huasheng* (Seattle, 1993).

CHAPTER 24. THE NEW WAVE

1. This material is based on recollections of her student days in Beijing given to me by Julie Xiu Huajing Maske.

2. These and many less important exhibitions were featured in *Zhongguo meishu bao* (Fine arts in China), published biweekly by the Art Research Institute of the Academy of Chinese Art (Zhongguo meishu yanjiu yuan) between 1985 and the summer of 1989.

3. For reports on New Space, see *Meishu* (1986.2): 44–48 and color plates.

4. On the *Dangdai,* see *Meishu* (1986.6).

5. See color plates in *Meishu* (1988.2–5).

6. See *Meishu* (1987.7), devoted to military history, and (1987.11), celebrating the sixtieth anniversary of the PLA.

7. See Chen Rong in *Meishu* (1987.3): 31–32.

8. This haunting work is reproduced in Richard Strassberg and Waldemar A. Nielsen, *Beyond the Open Door: Contemporary Paintings from the People's Republic of China* (Pasadena, 1987), 71.

9. For examples of oils by these artists, see Beijing International Art Gallery, *Xiandai youhua*.

10. For Jin Shangyi, see *Zhongguo meishu* 11 (1985.2): 3.

11. The work of He Datian, Wang Yidong, Ai Xuan, Chen Yanning, Luo Erchun, and others mentioned in this chapter was featured in exhibitions of the Hefner Gallery in New York in the late 1980s.

12. The Picasso exhibition, held in a lower room of the China Art Gallery, consisted of sixteen pictures, badly hung, with no attempt made to explain them to the general public. Artists and art students flocked to the show for the first three days, after which very few people came.

13. See, for example, Yan Han's prints reproduced in *Meishu* (1985.9): 4–5.

14. See inside back cover of *Meishu* (1985.5) for an example.

15. The Daludao carvings are featured in *Meishujia* 65 (1988.12): 64–73 and *Meishujia* 82 (1992.2): 92–103.

16. See Ai Duanwu, "Wang Ping—The Young Sculptress," *Chinese Literature* (Winter 1987): 87–89, and *Meishu* (1987.4): 26–27 and inside front cover.

17. Li Shaowen's masks are featured in *Meishu* (1986.5): 33 and inside front cover.

18. On tapestry and soft sculpture, see Yuan Yunfu, "Chinese Artistic Tapestry," *Chinese Arts* 1 (Hong Kong, n.d.): 102–11, and Alice King, *New Directions in Contemporary Chinese Tapestry* (Hong Kong, 1988).

19. For a brief introduction to the work of Varbanov and his pupils, see *Xin meishu* 1 (Chinese arts) (Hong Kong; n.d.).

20. See *Meishu* (1988.8): 48–51. For the work of another batik artist, Liu Zilong, see *Chinese Literature* (Summer 1986): 135–37.

21. For peasant art, including that of Miao Huixin, see *Meishu* (1987.7).

22. See Caroline Blunden in *Britain-China* (Spring 1987): 12.

23. For illustrations of these performances and a criticism of Concept 21, see *Zhongguo meishu bao* (1987.3): 1–2.

24. The meeting, and Hua Junwu's speech, are fully reported in *Meishu* (1985.7): 4–12.

25. See Fei Wei, "Dangdai meishu di tuichao" (The ebb tide of contemporary art), *Meishu* (1986.1): 20–22.

26. Lang Shaojun, "An Evaluation of Innovation," 103. Translation has been slightly modified.

27. *Zhongguo meishu bao* (1985.12): 21. Rauschenberg is ridiculed by Wang Luxiang and Li Jun in *Meishu* (1986.2): 64–67.

28. For the prizewinners, see *Meishu* (1985.7): 14–15.

29. See John W. Dower and John Dunkerman, eds., *The Hiroshima Murals: The Art of Iri Maruki and Toshi Maruki* (New York, 1985).

30. On Gu Wenda's early work, see Fan Jingzhong's interview with him in *Meishu* (1986.7): 46–52.

31. See Fan Jingzhong, "Artistic Exploration and Problems in Art: Impression of the Zhejiang Institute of Fine Arts Young Teachers' Exhibition," *Chinese Literature* (Summer 1986): 170 and plate opposite 173.

32. See Jason C. S. Kuo, "Mutilated Language: Politics and the Art of Gu Wenda," a paper delivered at the College Art Association meeting, San Francisco; revised 1989.

33. On Xu Bing, see color reproductions in *Meishu* (1988.12) and popular comments on his work in *Meishu* (1989.1): 20–24.

34. See Alisa Joyce, "Obstacles to Expression," *Far Eastern Economic Review* (November 27, 1986); An Yalan (Julia Andrews), "Zhongguo meishu cai Meiguo di jingyu" (The situation of Chinese art in America), *Meishu* (1989.1): 61–63; and Gu Wenda, "Cai Meiguo huajie kan Zhongguo meishu" (Chinese art as seen by American art circles), *Meishu* (1989.1): 64–66.

35. Odile Pierquin-Tien, *Peintres et sculpteurs chinois à Paris, 1947–1987* (Paris, 1987).

36. Translated from statement by the artist in Frederic Pajak, *Ma Desheng: Encres* (Lausanne, 1986).

37. See Bernard Zürcher, *Wang Keping* (Paris, 1988).

38. For Ai Weiwei, Xing Fei, Yan Li, and other members of this expatriate group in New York, see Michael Murray, *Avant-Garde Chinese Art: Beijing/New York* (New York, 1986).

39. See Museum of Victoria, *Siqing Zhou* (Melbourne, 1985).

40. Quoted in Joyce, "Obstacles to Expression."

41. Yuan Yunsheng, ed., *Annual of the Chinese United Overseas Artists Association* (New York, 1987).

42. See Bruce Parsons, *Gu Wenda: The Dangerous Chessboard Leaves the Ground* (Toronto, 1987).

43. Quoted in Gail Tirone, "Fusion of Opposites," *Free China Review* (January 1990): 68.

44. See Jonathan Hay, "Ambivalent Icons: Works by Five Chinese Artists Based in the United States," *Orientations* 23, no. 7 (July 1992): 37–43.

CHAPTER 25. TIANANMEN AND BEYOND

1. See *China Quarterly* 110 (June 1987): 336–37.

2. See Galerie Art East Art West, *5 Künstler aus Shanghai* (Hamburg, 1988).

3. *Zhongguo meishu bao* (1988.14): 2, and Galerie Art East Art West, *5 Künstler*, 15.

4. For a report on the Congress, see *China Quarterly* 117 (November 1989): 194–97.

5. Wu Yonglu, *Youhua renti yishu dazhan zuopinji* (Works of the Chinese nude oils exhibition) (Nanning, 1988).

6. Ibid.

7. See Catherine Sampson, "Naked truth in Peking brings men, and a few women, flocking," *Times* (London), December 23, 1988.

8. Ibid.

9. Much of the information about the planning of the avant-garde show was given to me by Gong Jisui, from an interview he taped in March 1991 with Meng Luding and Zhao Baiwei, to all of whom I am greatly indebted. See also Fei Dawei, "China/Avant-Garde," *Art Press* 141 (November 1989).

10. A number of the more controversial works were reproduced in color in Zhang Songren (Johnson Chang), ed., *Zhongguo xiandai yishuzhan* (China/Avant-Garde) (Beijing, 1989), with a foreword by Gao Minglu.

11. Translated by Bonnie McDougall. Bei Dao, *Notes from the City of the Sun,* 36.

12. Quoted in Xiang Pu, "Avant-Garde Show May Shock as Nudes Did," *China Daily* (February 1, 1989).

13. Wang Qingcai, Communist Party cadre at the No. 1 Light Industry Ministry, quoted by Andrew Higgins in "China's Avant-Gardists Do Their Best to Puzzle and Provoke," *The Independent* (London) (February 11, 1989).

14. My account of what follows is based on the conversation with Meng Luding that Gong Jisui recorded for me in March 1991. See also Ts'ao Hsing-yuan, "The Birth of the Goddess of Democracy," *California Monthly* (September 1989): 16–17.

15. Information from Gong Jisui.

16. For the prizewinners, see Pok Art House, *Zhongguo di qi jie chuanguo meishu zuopin zhanlan huosheng zuopin ji* (Prizewinning art works in the Seventh National Art Exhibition, 1989) (Hong Kong, 1990).

17. For post-Tiananmen developments, see *Fine Art Magazine* (January 1992), ed. Sheng Tian Zheng, with articles by Joan Lebold Cohen, Fred Martin, and others; and Richard E. Strassberg, ed., *"I Don't Want to Play Cards with Cézanne" and Other Works: Selections from the Chinese "New Wave" and "Avant-Garde" Art of the Eighties* (Pasadena, 1991).

18. See Nicholas Jose, "Notes from Underground: Beijing Art, 1985–1989," *Orientations* 23, no. 7 (July 1992): 53, which also includes illuminating articles by Wan Qingli and Bronwyn Thomas.

19. Chang Tsong-zung, in his introduction to Valerie C. Doran, ed., *China's New Art, Post-1989, with a Retrospective from 1979–1989* (Hong Kong, 1993).

20. Ibid.

In view of the great number of Chinese painters who have been active in the twentieth century, this index makes no claim to be complete or, in every case, accurate. Different sources give different dates for artists; biographical material is often inaccurate and seldom impartial; autobiographies are not always to be relied on. It is to be hoped that students of modern Chinese art will add to, and where necessary correct, these entries, leading eventually to the preparation of a substantial and accurate biographical index of modern Chinese artists.

The main entry for each artist is given in *pinyin* romanization. Many artists outside the People's Republic are best known in the west by a Wade-Giles romanization or another form of their own choosing. These forms are cross-referenced to the main entry.

ABBREVIATIONS

CAA	Chinese Artists Association
CAAC	Central Academy of Arts and Crafts, Beijing
CAFA	Central Academy of Fine Arts, Beijing (after Liberation)
NAA Beijing	The Beijing Academy of Art (before Liberation)
NAA Hangzhou	The Hangzhou Academy of Art (before Liberation)
NCU Nanjing	National Central University, Nanjing
NTNU	National Taiwan Normal University, Taipei
NZAFA	The Zhejiang Academy of Fine Arts, Hangzhou (after Liberation)

Xian (county) is abbreviated *x.*, as in *Guanx*.

A Yang. *See* Yang Jiachang

A Xian 阿仙 (b. 1960, Beijing) Painter, self-taught. 1980 became a professional artist. Member of the avant-garde movement. 1990 settled in Australia.

Ai Weiwei 艾未未 (b. 1957) Painter. Active in the Stars group. 1976–78 studied with CAFA teachers. 1978 worked in the Beijing Film Inst. 1981 to U.S.; studied painting and sculpture at Parsons School of Design and Art Students' League in New York. Settled in U.S. as professional artist.

Ai Xuan 艾軒 (b. 1947, Jinhua, Zhejiang) Oil painter. Son of poet Ai Qing. 1969–73 served on military farm in Tibet. After 1973, stationed in Chengdu as an artist, was unable to devote himself entirely to painting. 1987–88 visited U.S., where he met his idol, Andrew Wyeth. Specializes in Tibetan and borderland subjects.

Ai Zhongxin 艾中信 (b. 1915, Jiangsu; native of Shanghai). Oil painter. 1936 studied under Xu Beihong, Wu Zuoren, and Lü Sibai in art dept. of NCU Nanjing. 1937 attended Chinese Art Exhib. in Moscow. 1946 assoc. prof. at NAA Beijing. After 1949, head of oil painting dept. of CAFA.

Bai Jingzhou 白敬周 (b. 1947, Lanzhou, Gansu) Oil painter, best known for his serial picture stories. After 1976, took postgrad courses in the graphic arts dept. of CAFA, then joined the faculty. 1982 enrolled on Chinese govt. scholarship in M.F.A. program at Southern Illinois Univ., Carbondale. 1985 settled in New York.

Bai Tianxue 白天學 Huxian peasant painter, active in 1960s and 1970s.

Bai Xueshi 白雪石 (b. 1915, Beijing) Guohua painter. Began painting on his own. After 1949 travelled widely in China, then taught in Beijing Fine Arts Normal College. 1964 taught basic painting in ceramics dept. of CAAC. Decorated Beijing Hotel. 1982 assoc. prof. of CAAC.

Bao Jia 鮑加 (b. 1933, Shexian, Anhui) Painter. Prof. in Anhui Acad. of Fine Art, Hefei. Realistic oils and decorative panels in guohua technique, including panorama of Huangshan in Hefei bus station, 1982.

Bao Peili 包陪麗 (Cissy Pao; b. 1950, Hong Kong) Woman artist in mixed media. Studied and worked in U.S. from 1967. 1975 M.F.A., Washington Univ. in St. Louis. Settled in Tokyo in 1985.

Bao Shaoyou 鮑少游 (Pau Shiu-yau, 1892–1985; native of Guangdong) Woman guohua painter. Studied in Japan. 1918 lecturer in Beijing. Active in Shanghai, Canton, and (from 1928) Hong Kong, where she founded the Lai Ching Art Inst.

Bo Yun 薄雲. See Li Yongcun

Cai Chufu 蔡楚夫 (Choi Chor-foo; b. 1942, Wuzhaox., Guangxi) Oil painter. 1959–63 studied in Canton Acad. of Fine Arts. In early 1970s settled in Hong Kong, where he studied with Yang Shanshen and Ding Yanyong. Photorealist.

Cai Dizhi 蔡迪支 (b. 1918; native of Shudex., Guangdong) Guohua painter and wood-engraver. During WWII, engaged in anti-Japanese propaganda activities in southwest China. 1939 joined China Woodcut Research Soc. After 1943 taught at Guangxi Art College. 1947 joined Renjian Huahui in Hong Kong. 1959 in charge of organizing Canton Painting Acad., of which he became vice president.

Cai Ruohong 蔡若虹 (b. 1910; native of Jiujiang, Jiangxi) Cartoonist and party activist. Grad. from oil painting dept. of Shanghai Meizhuan. 1930 member of League of Left-Wing Artists, Shanghai. 1939 went to Yan'an, taught in Lu Xun Art Acad. 1949 edited the pictorial page for *People's Daily*. Elected member of the standing committee of the CAA, later appointed vice-chairman of CAA.

Cai Shuilin 蔡水林 (Tsay Shoe-lin; b. 1932, Taiwan) Sculptor, active in Taipei.

Cai Tianding 蔡天定 (Chhuah Thean Teng; b. 1914, Xiamen) Batik designer and decorative artist. Studied in Xiamen Art Acad. 1932 settled in Penang, Malaysia. Notable for developing the batik technique as a method of creating paintings.

Cai Weilian 蔡威廉 (1904–40; native of Shaoxing, Zhejiang) Oil painter. Daughter of Cai Yuanpei, wife of Lin Wenzheng. Studied oil painting in Belgium and Lyon, France. 1928 prof. in NAA Hangzhou. 1938 lived in Kunming. Noted for her portraits in oils.

Cai Yintang 蔡蔭棠 (Tsai Intang; b. 1909, Taiwan) Oil painter. Studied in Japan and from 1932 in Taipei under Li Shijiao. Prominent in conservative oil painting circles in Taiwan until settling in the U.S. in 1977. Lives in San Francisco.

Cao Dali 曹達立 (b. 1934, Beijing) Oil painter. At age six, emigrated with his family to Indonesia. 1956 returned to China. 1961 grad. from oil painting dept. of CAFA. Member of Oil Painting Research Soc. and Beijing Painting Acad.

Cao Li 曹力 (b. 1954, Guiyang, Guizhou) Oil painter. 1982 grad. from CAFA, became lecturer in wall painting dept. 1992 visiting artist in Madrid. Much influenced by Franz Marc.

Cao Liwei 曹立偉 (b. 1956, Liaoning) Oil painter. 1978–82 studied in CAFA, winning first prize on graduation; later became lecturer there. Travels frequently in Qinghai and Gansu provinces, which provide the material for his landscapes.

Cao Ya 曹牙 (Tsao Ya; b. 1956, Taiwan) Sculptor. Grad. from Nat. Taiwan Acad. of Arts.

Chai Xiaogang 柴小剛 (b. 1962, Jiangsu) Painter. Grad. 1985 from fine arts dept. of Nanjing Art Acad.Became art administrator of Lianyungang Municipal People's Art Museum. Expressionist-surrealist and member of avant-garde movement.

Chan, Gaylord. See Chen Yusheng

Chan Kin-chung. See Chen Jianzhong

Chan, Luis. See Chen Fushan

Chang, Arnold. See Zhang Hong

Chang Dai Chien. See Zhang Daqian

Chang, Margaret. See Hong Xian

Chang Qing 常青 (b. 1965, Sichuan) Painter. 1989 grad. from oil painting dept. of NZAFA. Realist.

Chang Shuhong 常書鴻 (1904–94; native of Zhejiang) Oil painter. From 1926 trained in Lyon and Paris. Upon his return to China in 1936, head of western art dept. of NAA Beijing. 1943 director of National Dunhuang Research Inst. 1979 visited Japan, 1986 France.

Chao Chung-hsiang. See Zhao Chunxiang

Chen Baiyi 陳白一 (b. 1926, Hunan) Guohua painter. 1946 studied art in Xiangtan. After 1949, did some serial pictures. In 1970s visited Dunhuang. Became chairman of artists assoc. of Hunan.

Chen Banding. See Chen Nian

Chen Baochen 陳寶琛 (1848–1935) Orthodox guohua painter. In 1880s commissioner for education in Jiangxi Prov., and later tutor to Pu Yi.

Chen Baoyi 陳抱一 (1893–1942; b. Shanghai) Oil painter. 1912 fellow student with Liu Haisu in Zhou Xiang's art school. 1913 to Japan. 1914–15 back in Shanghai, taught in Shanghai Meizhuan. 1916–21 studied in Japan again. 1921 organizer of Dawn Art Assoc. 1922 taught Western art in Shanghai Meizhuan and other schools. A prominent figure in Western art circles in Shanghai before WWII.

Chen Chengbo 陳澄波 (1895–1947; b. Jiayi, Taiwan) Oil painter. 1927 grad. from Tokyo Acad. of Fine Arts. 1929–33 taught in Xinhua Acad., Shanghai. 1933 returned to Taipei. Founded Taiyang Art Soc.

Ch'en Ch'i-k'uan. See Chen Qikuan

Ch'en Chong Swee. See Chen Zongrui

Chen Danqing 陳丹青 (b. 1953, Shanghai) Oil painter. Sent to rural Jiangxi at sixteen; stayed in countryside till 1973. 1974 joined his artist wife, Huang Suning, in Tibet. 1978 admitted to CAFA. Early 1980s painted life of Tibet. 1982 went to U.S.

Chen Dayu 陳大羽 (b. 1912; native of Chaoyang, Guangdong) Painter. Studied under Qi Baishi, later worked in Shanghai.

Chen Dehong 陳德弘 (b. 1936, Kunming) Painter and sculptor. 1960 grad. in sculpture from CAFA. 1982 went to study in Paris, where he settled. Has exhibited widely in Europe and the U.S.

Chen Dewang 陳德旺 (b. 1909, Taipei) Oil painter. Studied under Ishikawa Kin'ichirō. After further study in Japan returned to Taiwan, where he became active in the Cercle MOUVE.

Chen Fangming 陳芳明 (b. 1964, Taiwan) Sculptor. Grad. from dept. of arts and crafts, Fuxing Trade School, Taipei.

Chen Fushan 陳福善 (Luis Chan; 1905–95, born in Panama; native of Panyu, Guangdong) Painter. 1910 settled in Hong Kong. 1927 studied art by correspondence with Press Art School. 1953 formed Hong Kong Contemporary Artists Guild. Hon. advisor to Hong Kong Museum of Art since 1961. 1966 chairman of Hong Kong Art Club. 1986 One-man show of his eccentric paintings at City Hall Gallery.

Chen, Georgette. *See* Zhang Liying

Chen Hengke 陳衡恪 (Chen Shizeng; 1876–1924; b. Xiushui, Jiangxi) Guohua painter and critic. Studied in Japan. On his return, settled in Beijing; taught in Beijing Coll. of Art and Higher Normal Coll. 1919 organized Soc. for Research in Chinese Painting. Patron of Qi Baishi.

Chen Jialing 陳家泠 (b. 1937, Hangzhou) Guohua painter. Studied under Pan Tianshou and Lu Yanshao at NZAFA. 1987 teaching painting in art dept. of Shanghai Univ.

Chen Jianzhong 陳建中 (Chan Kin-chung; b. 1939, Canton) Photorealist painter. 1962–69 studied in Guangdong Prov. Art Acad.; later worked in Hong Kong. 1969 settled in Paris.

Chen Jiarong 陳家榮 (b. 1940, Yunlin, Taiwan) Oil painter. Studied medicine in Taipei and the U.S. until 1973, when he became a professional painter.

Chen Jin 陳進 (Ch'en Chin; b. 1907, Taiwan) Woman tempera and guohua painter in Japanese *nihonga* style. Studied painting first in Taipei and Gaoxiong. 1925–45 studied and worked in Tokyo. 1945 returned to Taipei, where her Japanese style eventually became popular again. Still active in 1996.

Chen Jinfang 陳錦芳 (b. 1936, Tainan, Taiwan) Oil painter and printmaker. Studied in Paris on French govt. scholarship. On returning to Taiwan became active in painting, writing, and organizing of cultural associations. Has held many exhibitions in U.S. and Europe.

Chen Jinghui 陳敬輝 (b. 1931, Jiayi, Taiwan) Oil painter. Trained in NTNU, where he became a teacher.

Chen Jingrong 陳景容 (b. 1934, Nantou, Taiwan) Oil painter. Studied art in NTNU and in Tokyo. Returned to teaching career in Taiwan.

Chen Kezhi 陳可之 (b. 1961, Sichuan) Oil painter. 1982 grad. from oil painting dept. of Sichuan Acad. of Fine Arts, Chongqing.

Chen Laixing 陳來興 (b. 1949, Zhanghua, Taiwan) Painter. 1972 grad. from Taiwan Coll. of Art. Developed in 1980s into an expressionist.

Chen Naiqiu 陳乃秋 (b. 1935) Painter, critic, essayist, and story-writer. Studied art in Shanghai and in Nanjing Normal Univ.

Chen Nian 陳年 (Chen Banding, 1876–1970; native of Zhejiang) Guohua painter and connoisseur. Self-taught, influenced by Ren Bonian. Noted for his flowers. Taught in NAA Beijing, later deputy principal of NAA Beijing.

Chen Ning'er 陳寧爾 (b. 1942, Hangzhou) Oil painter. 1966 grad. from NZAFA oil painting dept. 1987 moved to U.S. 1989 M.F.A., Pratt Inst., New York. Realist.

Chen Peiqiu 陳佩秋 (b. 1922, Nanyang, Henan) Woman painter. Studied guohua in NZAFA, later became interested in impressionists and post-impressionists. Married to Xie Zhiliu.

Chen Qiang 陳強 (b. 1957, Shanghai; native of Liaoning) Printmaker. 1985 grad. from CAFA; later became a teacher there.

Chen Qikuan 陳其寬 (Ch'en Ch'i-k'uan; b. 1921, Beijing) Architect and amateur painter. 1944 B.S. in architecture, NCU Chongqing. 1949 M.A. in architecture, Univ. of Illinois. 1952–54 instructor at M.I.T. 1960 dean of architecture dept., Donghai Univ., Taiwan. 1980 dean of engineering at Donghai Univ.

Chen Qiucao 陳秋草 (1906–88; b. Shanghai; native of Ningbo, Zhejiang) Guohua painter. Studied in Shanghai Meizhuan. 1924 founding member of White Goose Painting Society. After 1949 remained in China. Council member of CAA.

Chen Ren 陳仁 (b. Fujian) Oil painter. 1985 grad. from CAFA. Member of New Space group. Working 1992 in Fujian Art Gall., Fuzhou.

Chen Shaomei 陳少梅 (1909–54; native of Hengshan, Hunan) Guohua painter, esp. of flowers and human figures. Member of Hushe Art Soc. Active in Tianjin and Beijing.

Chen Shiwen 陳士文 (b. 1908, Zhejiang) Oil painter. 1928–37 studied in France. On his return became prof. in Shanghai Acad.

Chen Shizeng. *See* Chen Hengke

Chen Shuren 陳樹人 (1883–1948; b. Canton). Guohua painter. 1899 studied under Ju Lian in Canton and in Japan. 1905 member of Tongmenghui. 1917–22 Tongmenghui representative in Canada. After 1922 held various posts in Nationalist government. One of the three masters of the Lingnan School.

Chen Shuxia 陳淑霞 (b. 1963, Wenzhou, Zhejiang) Woman painter. 1987 grad. from CAFA with degree in folk arts. Her still life *Pink Flowers* won a silver award at the First Annual Exhib. of Chinese Oil Painting (Hong Kong, 1991).

Chen Shuzhong 陳樹中 (b. 1960, Liaoning) Oil painter. 1984 grad. from Lu Xun Acad. of Fine Arts. Specializes in scenes of north China rural life.

Chen Tiegeng 陳鐵耕 (1908–70; native of Xingning, Guangdong) Wood-engraver. Important figure in Muling Woodcut Soc. and Eighteen Art Soc. During WWII, went to northwest China.

Chen Tingshi 陳庭詩 (Ch'en Ting-shih; b. 1915, Fuzhou) Modern painter and graphic artist. Lost speech and hearing at eight; studied guohua at thirteen. Self-taught in oil painting. 1949 moved to Taiwan, worked a year as library assistant. 1956 founding member of the Fifth Moon group. Noted for his abstract compositions printed from cut-out fibre board.

Chen Wanshan 陳皖山 (b. 1962, Zhejiang) Oil painter and sculptor. 1985 grad. in sculpture from NZAFA. Teaches in Beijing. In Jan. 1989 became the first artist to hold one-man show of nude paintings in China Art Gallery.

Ch'en Wen-hsi. *See* Chen Wenxi

Chen Wenji 陳文驥 (b. 1954, Shanghai) Printmaker. 1978 grad. from CAFA. 1985 teacher in *nianhua* and serial picture dept. of CAFA.

Chen Wenxi 陳文希 (Ch'en Wen-hsi, 1906–91; b. Guangdong) Guohua and xihua painter. Trained in Xinhua Acad., Shanghai. 1949 settled in Singapore.

Chen Xianhui 陳獻輝 (Paul Men; b. 1962, Taiwan) Sculptor. Studied in NTNU art dept. Works in Taipei.

Chen Xiaonan 陳曉南 (b. 1909; native of Lixian, Jiangsu) Painter. Pupil of Xu Beihong in Nanjing. 1947–48 in

London on British Council scholarship. Later taught in Canton Acad.

Chen Xiayu 陳夏雨 (b. 1917, Taiwan) Sculptor. 1933–42 studied and worked in Tokyo, later in Taipei.

Chen Xinmao 陳心懋 (b. Shanghai) Painter. 1976–87 studied in Shanghai and Nanjing. In 1980s member of Shanghai avant-garde movement.

Chen Yanning 陳衍寧 (b. 1945, Canton) Realist oil painter, specializing in portraits and figure subjects. 1965 grad. from Canton Acad. 1985 visited Australia. 1986 visited Britain and emigrated to U.S.

Chen Yanqiao 陳煙橋 (1912–70; native of Canton) Wood-engraver. 1930 active in woodcut movement in Shanghai with Ye Fu. During WWII, taught in Chongqing Yu Cai middle school. After 1949, worked for CAA.

Chen Yifei 陳逸飛 (b. 1946, Zhenhai, Zhejiang) Oil painter. Studied in Shanghai Coll. of Art. 1965 founding member of Shanghai Oil Painting and Sculpture Institute. 1981 went to study in U.S. 1985 M.F.A., Hunter Coll., New York. Settled in U.S., where he became a highly successful painter of portraits, landscapes, and figure subjects.

Chen Yiming 陳逸鳴 (b. 1951, Shanghai) Oil painter. Younger brother of Chen Yifei. Trained in Shanghai Drama Acad. 1981 moved to U.S.

Chen Yingde 陳英德 (b. 1940, Taiwan) Painter and art critic. Studied art history in NTNU, then from 1969 continued Ph.D. study in art history in Paris. Later became professional artist and settled in Paris.

Chen Yiqing 陳逸青 Painter. His Out of Qinghai won a silver medal at the seventh National Exh., 1987.

Chen Yuandu 陳緣督 (1903–67; b. Meix., Guangdong) Guohua painter working in Beijing. Member of Hushe Soc. After 1949 taught in CAAC.

Chen Yujiang 陳聿疆 Printmaker, active in Hangzhou in 1980s and 1990s.

Chen Yuping 陳玉平 Printmaker. Beidahuang (Northern Wilderness) School. Active in north China in 1980s and 1990s.

Chen Yusheng 陳餘生 (Gaylord Chan; b. 1925, Hong Kong; native of Putian, Fujian) Electronic engineer and abstract artist. 1992 named artist of the year by the Hong Kong Artists Guild.

Chen Zhenghong 陳政宏 (b. 1942, Jiayi, Taiwan) Oil painter. Studied in Taipei under Liao Jichun and others. 1982 first solo exhib. Has won many awards.

Chen Zhengxiong 陳正雄 (b. 1935, Taipei) Abstract Expressionist painter. Participated in many exhibs. in Taiwan and abroad. 1981 founding member of Taipei Art Club.

Chen Zhifo 陳之佛 (Ch'en Chih-fu, 1896–1962; b. Ciqix., Zhejiang) Graphic designer and guohua painter, esp. of birds and flowers. 1918 studied in Japan. 1923 returned to Shanghai, taught in various art colleges and universities. Principal of Shanghai Nat. Arts Coll. Member of the Chinese and Arts committees of UNESCO. After 1949 director of CAA.

Chen Zhonggang 陳仲綱 Wood-engraver, active in 1930s. Worked in Canton.

Chen Zizhuang 陳子莊 (1913–76; b. Yongchuan, Sichuan) Guohua painter, influenced by Huang Binhong and Qi Baishi. Teacher in Chengdu Normal Univ.

Chen Zongrui 陳宗瑞 (Ch'en Chong Swee; b. 1911, Guangdong) Guohua painter. Trained in Shanghai Acad. Since 1931 has lived and worked in Singapore.

Cheng Chang. See Zheng Wuchang

Cheng Conglin 程叢林 (b. 1954, Wanx., Sichuan) Oil painter. 1977 entered Sichuan Acad., Chongqing. After grad. taught there and for two years at CAFA. 1991 in Germany.

Cheng Ji 程及 (b. 1912, Wuxi) Watercolor painter. Trained in England; taught in Shanghai. 1947 settled in U.S.

Cheng Shifa 程十髮 (b. 1921, Songjiangx., Jiangsu; native of Shanghai) Guohua painter, illustrator, and calligrapher. 1938 entered guohua dept. of Shanghai Coll. of Art. After 1949 on staff of People's Art Publishing House; produced many picture-stories, new year pictures, and book illustrations. 1959 won second prize for book illustration at the Leipzig International Exhib. of Book Decoration. Member of CAA, vice-president of Xiling Print Assoc.

Cheng Tsai-tung. See Zheng Zaidong

Cheng Ya'nan 程亞男 Woman sculptor, active in 1980s and 1990s.

Chen-ping, Dawn. See Dong Zhenping

Cheong Soo Pieng. See Zhong Sibin

Cheung Yee. See Zhang Yi

Chhuah Thean Teng. See Cai Tianding

Chia Yu Chian. See Xie Yuqian

Ch'iu Ya-ts'ai. See Qiu Yacai

Cho, Y. J. See Zhuo Yourui

Choi Chor-foo. See Cai Chufu

Choo Keng-kwang. See Zhu Qingguang

Chou, Irene. See Zhou Lüyun

Chou Su-ch'in. See Zhou Xiqin

Chow, C. T. See Zhou Zhentai

Chow Su-sing. See Zhou Xixin

Chu Ge (Ch'u Ko). See Yuan Dexing

Chu Hon-sun. See Zhu Hanxin

Chu Teh-chun. See Zhu Dequn

Chui Tze-hung. See Xu Zixiong

Cui Zifan 崔子范 (b. 1915, Laiyang, Shandong) Guohua painter. Studied with Wu Changshuo and Qi Baishi. 1940 went to Yan'an. Also worked as urban administrator. 1956 teacher and vice president of CAFA. 1980 visited U.S. and Japan.

Dai Dunbang 戴敦邦 (b. 1938, Shanghai) Book illustrator and guohua painter, active in Shanghai. 1980 participated in the Grasses exhib. In 1980s teaching at Jiaotong Univ. Inst. of Technology. Noted for his illustrations to The Dream of Red Mansions and Outlaws of the Marshes.

Dai Haiying 戴海鷹 (Tai Hoi-ying; b. 1946, Canton) Oil painter, educated in Canton and, from 1962, in Hong Kong. 1970 settled in Paris.

Dai Shihe 戴士和 (b. 1948, Beijing) Oil painter. Grad. in 1981 from CAFA wall painting dept. Teaches wall painting in CAFA.

Dawn Chen-ping. See Dong Zhenping

De Qin 德欽 (b. 1955, Inner Mongolia) Oil painter. 1979 grad. from Lu Xun Acad. of Fine Arts. Specializes in north China rural scenes.

Deng Lin 鄧林 (b. 1941, Shexian, Hebei) Painter. Daughter of Deng Xiaoping. 1962–67 studied in Chinese painting dept of CAFA. 1977 became professional painter. 1979 deputy director of bird and flower studio in Beijing Painting

Acad. After 1986 became abstract painter and silk tapestry designer.

Di Pingzi 荻平子 (1872–1949; native of Liyang, Jiangsu) Guohua painter and collector. Pupil of Wu Changshuo. Active in Shanghai guohua circles. Known for his landscapes in both academic and literati style.

Ding Cong 丁聰 (Xiao Ding; b. 1916, Shanghai) Cartoonist and illustrator. Son of cartoonist Ding Song. Before WWII edited pictorial magazines, chiefly in Guilin and Chengdu. Travelled and drew in border area. Active in Hong Kong and later west China during WWII. 1946 back to Shanghai, later Hong Kong, worked for several periodicals. 1948 visited Taiwan. After 1949 on staff of *China Pictorial*, Beijing. Noted for his social satire and his illustrations to Lu Xun's fiction.

Ding Fang 丁方 (b. 1956, Shanxi) Oil painter. 1986 M.A. in oil painting from Nanjing Acad. of Art. Professional artist and member of avant-garde movement.

Ding Lisong 丁立松 Graphic artist, active in 1980s and 1990s.

Ding Shaoguang 丁紹光 (b. 1939, Shanxi) Decorative artist. Studied decorative art under Pang Xunqin. 1962 taught in art school in Kunming. 1979–80 completed huge decorative wall panel for the Great Hall of the People. 1980 went to the U.S.; works in Los Angeles.

Ding Song 丁悚 (1891–?) Cartoonist. Father of Ding Cong. 1912 studied under Zhou Xiang in Shanghai. Later taught, edited journals, and drew cartoons in Shanghai. Still active after WWII.

Ding Xiongquan 丁雄泉 (Walasse Ting; b. 1929, Shanghai) Self-taught painter. 1953 went to Paris. 1963 settled in the U.S. Abstract painter in the 1960s; later developed an expressionistic figurative style.

Ding Yanyong 丁衍鏞 (Ting Yen-yung, 1902–78; b. Mouming, Guangdong) Guohua painter. 1919 studied in Japan. 1925 returned to Shanghai. Teacher of Western painting at Shanghai Coll. of Art, Xinhua Art Acad., and Guangdong Prov. Art Acad. in Canton. 1949 settled in Hong Kong. After 1957 teacher and chairman of fine arts dept. of New Asia College. Chiefly known for his eccentric figure paintings.

Ding Yi 丁乙 (b. 1963) Member of the post-1989 avant-garde movement.

Dong Kejun 董克俊 (b. 1939, Chongqing) Self-taught wood-engraver from a worker background. Settled in Guiyang. Chairman of Guizhou branch of CAA. Noted for his animals and tribal figures.

Dong Kingman. *See* Zeng Jingwen

Dong Shouping 董壽平 (b. 1904, Shanxi) Guohua painter. 1926 grad. from art coll. in Beijing. 1930 set up as professional bird and flower painter and connoisseur, later developed as landscapist. 1953 joined staff of Rongbaozhai, Beijing.

Dong Xiwen 董希文 (1914–73; native of Shaoxing, Zhejiang) Oil painter. 1933 studied in Suzhou Acad. 1934–37 studied in NAA Hangzhou. 1943–46 assisted Chang Shuhong at Dunhuang. 1946 taught under Xu Beihong in NAA Beijing. 1949 prof. at CAFA. 1953 painted huge canvas of the declaration of the founding of the P.R.C. at Tiananmen.

Dong Zhengyi 董正誼 (b. Huxian, Shaanxi) Peasant painter, active in 1960s.

Dong Zhenping 董振平 (Dawn Chen-ping; b. 1948, Taipei) Woman sculptor. Grad. from NTNU; M.F.A. from Utah State Univ. Works chiefly in stone.

Duan Haikang 段海康 Sculptor. 1988 grad. from CAFA.

Ecke, Betty. *See* Zeng Youhe

Fan Zeng 范曾 (b. 1938, Nantong, Jiangsu) Guohua painter. Studied in CAFA under Wu Zuoren, Li Keran, and others. 1986 dean of oriental art dept. of Nankai Univ., Tianjin. Noted for his paintings of historical figures. 1991 left China for Europe.

Fang Chao-ling. *See* Fang Zhaolin

Fang Ganmin 方干民 (1906–84; b. Wenlingx., Zhejiang) Oil painter. Studied in Shanghai Meizhuan and (1926–29) under Laurens at the Ecole Supérieure des Beaux Arts, Paris. Taught in Xinhua Acad. and NAA Hangzhou. During WWII worked on propaganda paintings for Nationalist government. 1948 had studio in Shanghai. 1959 returned to teach at NZAFA.

Fang Jinshun 方謹順 (Anthony Poon; b. 1945, Singapore) Painter. Trained in Nanyang Acad. in Singapore and Byam Shaw School of Art, London. Works in Singapore.

Fang Jizhong 方濟眾 (1923–87; b. Shaanxi) Guohua painter, well known for his goats. 1946–47 studied under Zhao Wangyun. After 1949 member of Friendship Assoc. of Shaanxi Province.

Fang Junbi 方君璧 (Fan Tchun-pi, 1898–1986; native of Fuzhou) Woman oil and guohua painter. 1912 went to Paris, admitted to Ecole des Beaux Arts. 1925 returned to China, taught in Guangdong Univ. 1926–30 stayed in Paris, then back to China again. 1949–56 lived in Paris, then in the U.S., with frequent visits to the Far East.

Fang Lijun 方力鈞 (b. 1963, Hebei) Painter. 1963 grad. from wall painting dept. of CAFA. Professional painter, participated in 1989 China/Avant-Garde exh.

Fang Rending 方人定 (1901–75; native of Zhongshan, Guangdong) Guohua painter, member of Lingnan School. 1923 studied in Chunshui Acad. under Gao Jianfu. 1929 studied in Japan. 1935 back to China, worked in Canton and Hong Kong. Became vice-director of Canton Painting Acad. Noted for his figure painting.

Fang Yong 方鏞 (1900–?, Sichuan) Oil painter. 1919 went to Paris. Impressionist style, in the school of Pissarro. 1948 returned to China, where he died in obscurity.

Fang Zengxian 方增先 (b. 1931, Lanxix., Zhejiang) Guohua painter, esp. of north China rural life. Also painter of serial pictures. Grad. and later assoc. prof. and chairman of guohua dept. in NZAFA. Prof. and head of Shanghai Acad.

Fang Zhaolin 方召麐 (Fang Chao-ling; b. 1914, Wuxi) Woman painter and calligrapher. 1930 studied under Tao Peifong. 1937 studied modern European history in England. 1949 settled in Hong Kong. 1953 studied under Zhang Daqian.

Fay Ming. *See* Fei Mingjie

Fei Chengwu 費成武 (b. 1914) Painter. Pupil of Xu Beihong. Sent in 1947 to Britain on British Council scholarship. There he gave up xihua for guohua, married the painter Zhang Jingying, and settled in London.

Fei Mingjie 費明杰 (Ming Fay; b. 1943, Shanghai) Painter and sculptor. 1952 moved with his family to Hong Kong. 1965 studied design in Columbus, Ohio; later studied sculpture in Kansas City and at the University of California, Santa Barbara. Lives in New York, where he teaches at the William Paterson College.

Fei Xinwo 費新我 (b. 1903, Zhejiang; native of Wuxi) Calligrapher and guohua painter. 1934 entered White Goose Preparatory Painting School to study Western painting. 1958 started to practice calligraphy with left hand. Wrote inscribed boards for many beauty spots and memorial halls.

Feng Chaoran 馮超然 (1882–1954; native of Changzhou, Jiangsu) Guohua painter and calligrapher. Active in Suzhou and Shanghai. Later moved to Taiwan.

Feng Fasi 馮法祀 (b. 1914, Anhui) Oil painter. 1933 studied under Xu Beihong, Yan Wenliang, and Pan Yuliang in NCU Nanjing. 1938 studied in Lu Xun Art Acad. 1939 taught in Sichuan. 1946–49 worked in Chongqing, Beijing, and Tianjin. 1950 head of painting dept. of CAFA and director of oil painting section. Strongly influenced by Soviet realism. 1957 painted *The Heroic Death of Liu Hulan*.

Feng Gangbai 馮鋼百 (1884–1984; b. Xinhui, Guangdong). Painter. 1904 went to find work in Mexico, then to U.S. to study painting. 1921 returned to China, taught in Canton Coll. of Fine Arts. 1945 went to Hong Kong. After 1949 returned to China, lived in Canton.

Feng Guodong 馮國東 (b. 1948, Panyux., Guangdong) Oil painter.

Feng Mengbo 馮夢波 (b. 1966, Beijing) Mixed media artist. 1991 grad. from printmaking dept. of CAFA. Became professional artist and member of the Beijing avant-garde.

Feng Zhongrui 馮鍾睿 (Fong Chung-ray; b. 1933, Henan) Abstract painter. 1949 moved to Taiwan. 1956 joined Liu Guosong in Fifth Moon group.

Feng Zikai 馮子愷 (1898–1975; b. Shimenwan, Zhejiang) Guohua painter, graphic artist, cartoonist, and essayist. 1915 studied art and music under Li Shutong. 1920 cofounder of Shanghai Private Arts Univ. with Liu Zhiping. 1921 went to Japan to study oil painting; returned in the same year, taught and drew cartoons. Later assist. prof. in Zhejiang Univ., prof. in NAA Chongqing. 1954 director of CAA. 1960 president of Shanghai Art Acad. 1962 vice-chairman of Joint Federation of Literature and Arts World in Shanghai.

Fong Chung-ray. *See* Feng Zhongrui

Fu, Alixe. *See* Fu Qingli

Fu Baoshi 傅抱石 (1904–65; b. Nanchang, Jiangxi) Guohua painter. 1914 apprenticed to ceramic shop. 1921 grad. from Jiangxi College of Education, Nanchang; taught there. 1933–35 studied in Tokyo Acad. of Art. 1935–49 prof. in NCU Nanjing. 1949 head of Jiangsu Art Acad. 1957 sent on painting tour to Eastern Bloc countries. 1960 chairman of Jiangsu Branch of CAA. Author of several books on Chinese painting.

Fu Luofei 符羅飛 (1896–1970s; b. Hainan) Oil painter. Studied painting and sculpture in Italy and Paris. 1926 became Communist Party member. 1946 cofounder of Renjian Huahui, Hong Kong. After 1949 taught in Canton.

Fu Qingli 傅慶豐 (Alixe Fu; b. 1961, Yunlin, Taiwan) Painter and lithographer. 1985 grad. from Chinese Culture Univ., Taipei. 1987 left for France, where he studied lithography in Hadad's studio. Settled in Paris.

Fu Sida 傅思達 (d. 1960) Painter. Trained in guohua in Beijing. 1937 visited U.S., India, Malaya. During WWII taught in Guilin. Jailed in 1950s and severly persecuted.

Fu Tianqiu 傅天仇 Sculptor. Worked in the Beijing Historical Museum after Liberation.

Fu Zhongwang 傅中望 (b. 1956, Wuhan) Sculptor. 1982 grad. from Central Inst. of Technology. Became teacher in Hubei Acad. of Fine Arts. Makes semiabstract sculpture in wood based on elements in traditional Chinese timber architecture.

Gao Jianfu 高劍父 (1879–1951; native of Canton) Guohua painter, founder of Lingnan School. 1892 began to study painting under Ju Lian. 1903 studied sketching in Canton with a French teacher. 1906 organized the Chinese Painting Research Soc. 1906 went to Japan for further study. 1908 to Shanghai. 1912 published *The True Record*. 1918 returned to Canton. 1923 founder of Chunshui Acad. 1930 went to India. 1936 prof. in NCU Nanjing. 1938 to Macao. 1945 returned to Canton. 1949 moved back to Macao, where he died.

Gao Qifeng 高奇峰 (1889–1933; native of Canton) Guohua painter, key figure in Lingnan School. Younger brother of Gao Jianfu. 1907 studied in Japan. 1912 returned to Shanghai, editor of *The True Record*. 1918 back to Canton. 1925 set up his own studio. 1933 representative of Chinese government to Sino-German Art Exhib. in Berlin.

Gao Xiaohua 高小華 Oil painter. Active in Sichuan in 1980s and 1990s.

Gao Xishun 高希舜 (b. 1895, Hunan) Guohua painter. Classmate of Mao Zedong in Changsha. 1919 entered Beijing Higher Normal Coll. Art Inst., taught Chinese painting there after graduation. 1927 went to Japan. 1929 president of Jinghua Coll. of Fine Arts, Beijing. During WWII, retired in Hunan.

Gao Yong 高邕 (1850–1921; native of Hangzhou) Guohua painter and calligrapher. 1909 one of the founders of Yuyuan Calligraphy and Painting Benevolent Assoc., Shanghai.

Ge Pengren 葛鵬仁 (b. 1941, Jilin) Oil painter. 1966 grad. from CAFA, 1980s M.F.A; teaches oil painting in Fourth Studio.

Geng Jianyi 耿建翌 (b. 1962, Zhengzhou, Hebei) Painter. 1985 grad. from oil painting dept. of NZAFA. Member of New Space group of mid-1980s. Teaches in fashion design dept. of Zhejiang Silk Inst.

Gu Dexin 顧德鑫 (b. 1962, Beijing) Self-taught professional artist, active in the post-1989 avant-garde movement.

Gu Linshi 顧麟士 (1865–1933; native of Sichuan) Guohua painter, Shanghai School. Pupil of Wu Changshuo. Specialized in landscapes.

Gu Mei 顧媚 (Koo Mei; b. 1934, Canton; native of Suzhou) Painter, actress, and singer. 1950 moved to Hong Kong. Began to study painting under Lü Shoukun. Later settled in North America, where she practices as a landscape painter in Vancouver.

Gu Qingyao 顧青瑤 (Koo Tsin-yau; 1900?–78; b. Shanghai) Woman Guohua painter. Taught in Shanghai Meizhuan before moving in 1950 to Hong Kong, in 1977 to Canada.

Gu Shengyue 顧生嶽 Graphic artist and *gongbi* figure painter. Prof. in NZAFA.

Gu Wenda 谷文達 (b. 1955, Shanghai) Guohua painter and creator of installations. Trained in Shanghai in wood-carving, then in guohua at NZAFA under Lu Yanshao and others. After 1981 did some painting in oils. After taking part in several avant-garde exhibs in mid-1980s, he went to Toronto in 1987; since then he has lived and worked in New York.

Gu Xiong 顧雄 (b. 1953, Chongqing) Painter and performance and installation artist. 1985 M.A. from Sichuan Acad. of Fine Arts., Chongqing. 1990 moved to Canada. Lives and works in Vancouver.

Gu Yuan 古元 (b. 1919, Zhongshan, Guangdong) Woodcut artist. 1938 went to Yan'an, studied wood-engraving at Lu Xun Art Acad. 1942 participated in Yan'an Art Forum. 1949–73 visited Czechoslovakia, Bulgaria, Vietnam, and Japan. 1979 vice president of CAFA. 1985 president of CAFA.

Guan Ce 管策 (b. 1957, Nanjing) Painter. 1981 grad. from Nanjing Normal Univ. Became teacher in Nanjing Xiaoqing Normal School. Abstract painter and member of avant-garde movement.

Guan Liang 關良 (1900–86; b. Panyux., Guangdong) Painter, esp. of Beijing Opera figures. 1918 studied oil painting in Tokyo under Fujishima Takeji. 1929 returned to China, taught in various art colleges in Shanghai, Canton, and Wuchang, and after 1949 in Zhejiang. In the 1950s had many exhibs. in China. 1957 exhib. in West Germany. 1983 prof. in NZAFA, vice-chairman of Shanghai Artists Assoc.

Guan Shanyue 關山月 (b. 1912, Canton) Guohua painter. 1940 started to study under Gao Jianfu. 1946 prof. and chairman of Chinese painting dept. of Canton Municipal Art Acad. 1949 moved to Hong Kong. After Liberation, returned to China; prof. at various art colleges in Canton. 1983 vice-chairman of CAA. Active in Party cultural politics.

Guan Wei 關偉 (b. 1957, Beijing) Painter. Son of opera singer and grandson of Manchu bannerman. Grad. from art dept. of Beijing Normal College. Active in post-1989 avant-garde movement. 1993 artist in residence at Tasmania School of Art, Australia.

Guo Baichuan 郭百川 (1901–73; b. Taiwan) Painter. 1926–37 studied oil painting in Tokyo. 1937 returned to Beijing, taught art with Qi Baishi and Xu Beihong in NAA Beijing. 1948 settled in Taiwan. Influenced by Umehara Ryūzaburō.

Guo Chengyi 郭成義 Peasant artist, active in Nantong, Jiangsu, in 1980s and 1990s.

Guo Dawei 郭大惟 (b. 1919; native of Beijing) Guohua painter. Studied under Qi Baishi and in Nanjing. 1954 settled in U.S.; lives in New Jersey. Specializes in figure and genre subjects.

Guo Hanshen 郭漢深 (Kwok Hon Sum; b. 1947; native of Guangdong) Painter. Grad. fine arts dept. of NTNU. Works in Hong Kong.

Guo Huairen 郭懷仁 (b. 1943) Painter and printmaker. Studied in CAFA. Worked in New York and later in Beijing. Noted for realist/symbolist paintings of life in Beijing in 1920s.

Guo Qixiang 郭其祥 (native of Sichuan) Sculptor, active in 1970s and 1980s.

Guo Ren 郭軔 (b. 1928, Beijing) Oil painter. Studied in NAA Beijing and NZAFA. 1960 grad. from Escuela Central de Bellas Artes de San Fernando in Madrid; 1961 founded "Neovisualismo." Later settled in Taipei, where he became professor in the fine arts dept. of NTNU. Abstract expressionist.

Guo Runlin 郭潤林 (b. 1940, Shanghai) Painter. Since 1960, worked as a designer in the Triumphant Song Radio Factory. 1979 member of the Grasses.

Guo Weiqu 郭味蕖 (1908–71; native of Weifang, Shandong) Guohua painter of birds and flowers and calligrapher. Grad. from western painting dept. of Shanghai Coll. of Arts; did research on Chinese painting in Palace Museum, Beijing. After 1949 teacher in CAFA. After 1959 director of birds and flowers section, CAFA.

Guo Xuehu 郭雪湖 (b. 1908, Taiwan) Guohua painter. Trained in Japan, later worked in Taiwan.

Ha Bik-chuen. See Xia Biquan

Han Likun 韓黎坤 (b. Suzhou) Wood-engraver and calligrapher. Worked in northeast and in Suzhou. 1980 grad. from NZAFA, 1992 chairman of graphic arts dept. there. Visited Japan and Germany. Won first prize in 1991 Nat. Art Exhib.

Han Meilin 韓美林 (b. 1936; native of Jinan, Shandong) Woman designer and animal painter. Specialist in Inst. of Arts and Crafts of Shandong.

Han Tianheng 韓天衡 (b. 1940, Suzhou) Guohua painter

and seal-carver. Studied under Xie Zhiliu, Lu Yanshao, and others. 1987 acting director of the Shanghai Painting Acad.

Han Xiangning 韓湘寧 (b. 1939, Xiangtan, Hunan) Painter and printmaker. 1960 grad. from dept. of fine arts, NTNU. Member of Fifth Moon group. 1968 settled in the U.S. Abstract expressionist.

Han Zhixun 韓志勳 (Hon Chi-fun; b. 1922, Hong Kong; native of Guangdong) Painter. Studied lithography and etching at Pratt Graphic Centre, New York. Member of Circle group, Hong Kong. Developed into abstract expressionist in 1960s. 1968–80 taught art in Hong Kong Univ. and Chinese Univ. of Hong Kong.

Hao Boyi 郝伯義 Printmaker. Beidahuang School. Active in north China in 1980s and 1990s.

He Daqiao 何大橋 (b. 1961, Harbin, Heilongjiang) Realist oil painter. 1983 grad. from PLA fine arts acad. Known for his paintings of military and historical subjects and, more recently, for his still lifes and nudes.

He Datian 賀大田 (b. 1950, Changsha, Hunan) Oil painter. Prominent in Hunan art circles. Notable for his paintings of courtyard and house interiors.

He Duoling 何多苓 (b. 1948, Chengdu) Oil painter. 1981 completed graduate study in Sichuan Acad. of Fine Art, later taught in Chengdu Painting Acad. 1985 visited U.S. Developed a realistic style, esp. of Tibetan subjects.

He Haixia 何海霞 (b. 1908, Beijing) Conservative guohua painter. At sixteen apprenticed to guohua artist. 1927 entered NAA Beijing. 1934 became Zhang Daqian's student. 1945 went to work with Zhang Daqian in Chengdu. 1983 vice president of Shaanxi Studio of Painting, Xi'an.

He Huaishuo 何懷碩 (b. 1941, Canton) Guohua painter. Grad. from NTNU art dept. Landscape painter in the Lingnan tradition.

He Jianshi 何劍士 (1877–1915; native of Hainanx., Guangdong) Cartoonist. Editor-in-chief of Shishi huabao in Canton.

He Kongde 何孔德 (b. 1925; native of Sichuan) Oil painter who worked in the Chinese Military Museum.

He Sen 何森 (b. 1968, Yunnan) Painter. Grad. from art education dept. of Sichuan Acad. of Fine Arts. Professional artist, active in post-1989 avant-garde movement.

He Tianjian 賀天健 (1891–1977; b. Wuxi) Guohua painter. Self-taught. Editor of Painting Monthly. After 1949, vice president of Shanghai Painting Acad. Compiled several model books for students of landscape painting.

He Weipu 何維樸 (1842–1922; native of Hunan) Qing official and amateur guohua painter, calligrapher, and seal-carver.

He Xiangning 何香凝 (1878–1972; b. Hong Kong; native of Nanhai, Guangdong) Woman guohua painter. Studied in Japan, where she joined the Tongmenghui. 1923 returned to China. Close to Sun Yatsen; became active in left-wing Guomindang politics and opponent of Chiang Kaishek. After 1949 prominent in cultural affairs of the P.R.C. Amateur painter, chiefly of figures.

He Youzhi 賀友直 (b. 1923, Shanghai; native of Zhenhai, Zhejiang) Graphic artist, illustrator, and cartoonist. Active in Shanghai, noted for his serial illustrations, esp. to works by Lu Xun, and to stories of northern rural life. 1980s visited Germany. Prof. in CAFA.

He Zhaoqu 何肇衢 (Ho Chao-ch'u; b. 1931, Taiwan) Abstract painter. Grad. from Taipei Normal School. Winner of many distinctions in Taiwan and abroad, including Cannes and Tokyo. An abstract painter.

He Zi 何子 Guohua painter, active in 1960s in Shanghai.

Ho Kang. *See* Huo Gang

Hon Chi-fun. *See* Han Zhixun

Hong Hao 洪浩 (b. 1965, Beijing) Painter and printmaker. Grad. from printmaking dept. of CAFA. "Political pop" artist, active in post-1989 avant-garde movement.

Hong Ruilin 洪瑞麟 (b. 1912, Taipei) Western-style painter. Studied under Ishikawa Kin'ichirō in Taipei and 1930–36 in Tokyo. Returned to Taipei to join Taiyang Art Soc., then founded Cercle MOUVE. Later settled in the U.S.

Hong Shiqing 洪世清 Professor and sculptor in NZAFA in 1980s. Spent several years carving in the rocks of Dalu Island.

Hong Tong 洪通 (1920–87; b. Tainan, Taiwan) Painter. Took up painting in 1970s, specializing in fantasy and mythical images.

Hong Xian 洪嫻 (Hung Hsien, Margaret Chang; b. 1933, Yangzhou, Jiangsu) Painter. 1948 went to Taiwan, studied briefly under Pu Ru in Taipei. 1958 moved to U.S., studied in Northwestern Univ., Ill. 1978–84 taught and worked in Hong Kong, then returned to U.S. 1984 settled in Houston. Professional painter. Semiabstract landscapist.

Hou Jinlang 侯錦郎 (b. 1937, Jiayi, Taiwan) Painter. 1963 grad. from fine arts dept. of NTNU. 1967–89 studied and worked in Paris. Returned to hold first solo exhib. in Taipei in 1989.

Hou Yimin 侯一民 (b. 1930) Oil painter. Studied in Maksimov's studio in CAFA. Noted for history paintings in Soviet realist manner; later turned to freer landscape style. 1980s prof. in CAFA.

Hu Gentian 胡根天 (1892–1985; native of Canton) Guohua painter. Studied in Japan. Member of Chishe society. 1926 director of Canton Municipal Art Acad.

Hu Kao 胡考 (b. 1912, Yuyao, Zhejiang) Guohua painter of birds and flowers. Studied in Xinhua Acad., Shanghai. In early 1930s well known for his cartoons. 1937 went to Yan'an. After 1949, chief editor of *China Pictorial*. From late 1950s to 1970s, artistic activities obscure. In early 1980s, resumed painting in Shanghai.

Hu Peiheng 胡佩衡 (1892–1962; native of Hebei) Guohua and oil painter. 1918, encouraged by Cai Yuanpei, studied in Painting Methods Research Soc. of Beijing Univ. 1927 founded first correspondence school of Chinese landscape painting. After 1949 teacher in Chinese Painting Studio and committee member of Research Soc. of Chinese Painting. Edited *Hushe yuekan*.

Hu Qizhong 胡奇中 (b. 1927, Zhejiang) Painter. Self-taught. 1950 went to Taiwan. 1952–58 became professional portrait painter. 1957 founder of Four Seas Artists Assoc. 1961 member of the Fifth Moon group. 1970 went to the U.S.

Hu Yichuan 胡一川 (1910–91; b. Fujian) Oil painter and woodcut artist. 1925 studied in Xiamen. 1929 entered NAA Hangzhou, member of Eighteen Art Soc. and League of Left-Wing Artists. Studied Chinese painting (under Pan Tianshou), Western painting, and woodcut. 1937 went to teach in Lu Xun Art Acad. in Yan'an. 1949 prof. in CAFA. Since 1958 president of Canton Art Acad.

Hua Junwu 華君武 (b. 1915, Suzhou; native of Jiangsu) Cartoonist. Studied in Shanghai. 1938 went to Yan'an, worked for *Liberation Daily*. 1949 put in charge of art dept. of *People's Daily*. Since 1953, key figure in political control of CAA.

Hua Sanchuan 華三川 (b. 1930, Ningbo, Zhejiang) Graphic artist and illustrator, active from the 1950s.

Hua Tianyou 滑田友 (1902–86; native of Huaiyin, Jiangsu) Sculptor. Before 1930, studied art and art history in Xinhua Art Acad. 1933 studied sculpture under Bauchard

and worked in Paris. 1947 returned to China, prof. in NAA Beijing. 1959 one of chief sculptors of Heroes' Memorial in Tiananmen.

Huang Banruo. *See* Huang Bore

Huang Binhong 黃賓虹 (1864–1955; native of Zhejiang) Guohua painter, connoisseur, and editor. Grew up in Jinhua, later Shexian. Studied painting at home from private tutors. 1913 head of Acad. of Arts and Literature. 1926 organized Chinese Calligraphy, Painting, and Seal-Engraving Soc. 1927 founded the Bees Painting Society. 1928 prof. in Xinhua Art Acad. 1937 went to Beijing. 1948 prof. in NAA Hangzhou. 1954 vice-chairman of the Eastern China Artists Assoc. Leading figure of the revived Anhui School of landscape painting.

Huang Bore 黃般若 (Huang Banruo, Wong Po Yeh, 1901–68; b. Canton) Guohua painter. Pupil of his uncle, painter Huang Shaomei. 1924–40 active chiefly in Canton and Hong Kong. 1941 returned to Canton. 1968 settled in Hong Kong. Specialized in landscapes.

Huang Fabang 黃發榜 (b. 1938, Jiangling, Hubei) Guohua and oil painter. Trained in NZAFA. Worked for some years in Hubei. 1984 joined staff of NZAFA, teaching guohua. Noted for 1985 oil portrait of his teacher, Pan Tianshou.

Huang Guangnan 黃光男 (b. 1944, Gaoxiong, Taiwan) Guohua painter. M.A. from NTNU; became assoc. prof. there. Director of Taipei Fine Arts Museum.

Huang Guanyu 黃冠余 (b. 1949, Nanhaix., Guangdong) Oil painter, active in Beijing in late 1960s and 1970s. Grad. from and teaching in CAAC.

Huang Huanwu 黃幻吾 (1906–85; native of Xinhui, Guangdong) Guohua painter. Worked chiefly in Shanghai. Noted for his bird and flower paintings.

Huang Huixiong 黃輝雄 (Huang Huei-shyong; b. 1941) Sculptor, active in Taipei.

Huang Jinsheng 黃金聲 (b. 1935, Jilin) Oil painter. 1956–61 studied under Wu Zuoren in CAFA. 1964–91 taught oil painting in Beijing Normal Coll.

Huang Jinxiang 黃金祥 (b. 1943, Wenzhou, Zhejiang) Oil painter. 1968 grad. from NZAFA, where he became a teacher of oil painting. 1983 commissioned to paint large mural for Shanghai Hotel. Many exhibs. in the U.S.

Huang Jinyu 黃錦圩 Printmaker. Active in Nanjing in 1980s and 1990s.

Huang Junbi 黃君璧 (1898–1991; b. Canton) Guohua painter. 1914 started to study painting under Li Yaoping. Organizer of Guihai Painting Cooperative, then the Soc. for Research in Chinese Painting. 1934 studied in Japan. 1941 head of Chinese painting dept., NAA. 1949 moved to Taiwan. Prof. and head of art dept. of NTNU. 1957, 1966, and 1969 visited the U.S. 1960 fellow of the Brazil Arts Inst.

Huang Junshi 黃君實 (Kwan S. Wong; b. Taishan, Guangdong) Calligrapher and guohua painter. B.A. Hong Kong Univ., M.A. Kyoto Univ. 1972 settled in U.S. Vice president of Chinese painting at Christie's, New York.

Huang Mingchang 黃銘昌 (b. 1952, Hualian, Taiwan) Oil painter. Studied in Taiwan and Paris. 1984 returned to teach in Taipei.

Huang Mingzong 黃明宗 (Wee Beng-chong; b. 1938, Singapore) Sculptor, guohua painter, and graphic artist. Studied in Nanyang Acad. in Singapore and sculpture dept. of Ecole Nationale Supérieure des Beaux Arts, Paris. 1964 founding member of Singapore Modern Art Soc.

Huang Peizhong 黃培中 (b. 1944, Rugao, Jiangsu) Print-maker and illustrator, active in Nanjing.

Huang Qiuyuan 黃秋園 (1913–79; b. Nanchang, Jiangxi) Guohua landscape painter. Self-taught. Before 1949 worked in a bank. Later became active promoter of traditional painting.

Huang Rongcan 黃榮燦 (native of Chongqing) Wood-engraver, active in 1930s and 1940s. Studied in Nat. Acad. of Art, Kunming. During WWII, active in southwest China.

Huang Rui 黃銳 (b. 1952, Beijing) Oil painter. 1968–75 sent to countryside in Inner Mongolia. 1980–81 founding member of the Stars and leading activist. 1984 settled in Tokyo.

Huang Shanshou 黃山壽 (1855–1919; native of Jiangsu) Guohua painter. Active in Shanghai after 1900.

Huang Tushui 黃土水 (1895–1930; native of Taiwan) Sculptor. Trained and worked in Tokyo.

Huang Wennong 黃文農 (?–1934) Cartoonist working in Shanghai in 1920s and early 1930s.

Huang Xinbo 黃新波 (1916–80; native of Canton) Wood-engraver. In his early years, worked under patronage of Lu Xun in Shanghai; member of League of Left-Wing Artists. 1937–41 active in anti-Japanese propaganda. 1946 went to Hong Kong, member of Renjian Huahui. 1949 back to Canton. 1979 vice-chairman of CAA.

Huang Xuanzhi 黃玄之 (b. 1924, Jiangsu) Graphic artist. 1947 grad. from western painting dept. of Suzhou Acad., then teacher and art editor. After 1954 teacher of graphics, esp. *shuiyin* woodblock printing, in NZAFA.

Huang Yan 荒煙 (b. 1921; native of Guangdong) Wood-engraver. Worked in Yan'an and liberated areas during and after WWII. After 1950 art editor of *Guangming ribao*.

Huang Yongping 黃永砅 (b. 1934, Fujian) 1982 grad. from NZAFA. Leader of Xiamen Dada. Lives in France.

Huang Yongyu 黃永玉 (b. 1924, Fenghuang, Hunan) Painter and graphic artist. Worked in a porcelain factory when young. During WWII studied with Lin Fengmian in Chongqing. 1946 studied woodcut in Shanghai. 1948 went to Hong Kong; art editor of *Dagongbao,* member of Renjian Huahui. 1953 returned to China, taught graphic art at CAFA. 1978 designed landscape tapestry for Mao Zedong Memorial Hall. 1989 settled in Hong Kong.

Huang Yongyuan 黃永原 Eccentric amateur guohua painter. Brother of Huang Yongyu. Member of Anhui Painting Acad., Hefei.

Huang Zhichao 黃志超 (Dennis Hwang; b. 1941, Hunan) Painter. Went to Taiwan. 1972 settled in New York.

Huang Zhongfang 黃仲方 (Harold Wong; b. 1943, Shang-hai) Guohua painter. 1948 settled in Hong Kong. Studied painting under Gu Qingyao. 1977 founded Hanart Gallery, Hong Kong. 1990 returned to painting full-time.

Huang Zhou 黃冑 (b. 1925, Lixianx., Hebei) Guohua painter. Studied under Zhao Wangyun in Xi'an. After 1945 joined the army. Condemned in Cultural Revolution and again by Jiang Qing in 1974. Noted for his paintings of Xinjiang people, horses, horsemen, and donkeys.

Hui Suet-bik, Pat. *See* Xu Xuebi

Hung Hsien. *See* Hong Xian

Huo Gang 霍剛 (Ho Kang; b. 1932, Nanjing) Painter. Found-ing member of Ton Fan group of Chinese and Italian artists. Lives in Milan.

Hwang, Dennis. *See* Huang Zhichao

Jao Tsung-i. *See* Rao Zongyi

Jia Youfu 賈又福 (b. 1942, Hebei) Guohua painter. Student of Li Keran in CAFA. Well known for his paintings of Taihang mountain.

Jiang Baolin 姜寶林 (b. 1942, Penglaix., Shandong) Guohua painter. 1962–67 studied under Lu Yanshao in NZAFA. 1981 grad. in guohua from CAFA. 1994 prof. in NZAFA.

Jiang Changyi 蔣昌一 (b. 1943, Xiangxiang, Hunan) Oil painter. 1966 grad. Nanjing Art Acad. Since 1988 president of the Shanghai Oil Painting and Sculpture Acad.

Jiang Danshu 姜丹書 (1885–1962; native of Jiangsu) Callig-rapher and guohua painter. Active in administration of art schools, chiefly in Shanghai and Hangzhou.

Jiang Feng. *See* Zhou Xi

Jiang Handing 江寒汀 (1903–63; b. Changshu, Jiangsu) Guohua painter. Taught in Shanghai, where he was noted for bird and flower paintings.

Jiang Mingxian 江明賢 (b. 1942, Taizhong, Taiwan) Guohua painter. 1968 B.A., NTNU. 1974 M.A., Madrid. 1975 studied art history in New York Univ. Many visits to U.S. and other countries. 1979 assoc. prof. at Donghai Univ., Taiwan.

Jiang Tiefeng 蔣鐵峰 (b. 1938, Ningbo, Zhejiang) Woman painter. Student of Huang Yongyu. 1985 went to teach in Acad. of Kunming, Yunnan. Leading member of the Mod-ern Heavy color group.

Jiang Xiaojian 江小鶼 (Jiang Xin, 1893–before 1937; native of Wux., Jiangsu) Sculptor. Before 1930s, spent two years in France. In Shanghai close friend of Xu Beihong.

Jiang Yan 姜燕 (1920–58; native of Wuchang, Hubei) Woman guohua painter. Graduated from NAA Beijing.

Jiang Yun 姜筠 (1847–1919; native of Huaining, Anhui) Guohua painter, poet, and calligrapher. Lived in Beijing. His pupil Xiao Sun ghost-painted for him.

Jiang Zhaohe 蔣兆和 (1904–86; native of Sichuan) Guohua painter. Taught painting in Nanjing and Shanghai during the early 1930s. 1935 went to Beijing, where he remained during WWII. After 1945 visited Hong Kong briefly. Famous for his realistic figure paintings, esp. his *Refugees* of 1942–43.

Jin Cheng 金城 (Jin Gongbo, 1878–1926; native of Wuxing, Jiangsu) Guohua painter. Studied law in U.K. Founder of Hushe soc. in Beijing. 1921 and 1924 visited Japan. Domi-nant figure in Beijing art world. Published *Hushe yuekan*.

Jin Daiqiang 靳埭強 (Kan Tai-keung; b. 1942, Guangdong) Guohua painter. 1957 settled in Hong Kong. Studied in extramural dept. of Hong Kong Univ. 1978–83 teaching member of One Art Society. Since 1984 teaching painting in Hong Kong Polytechnic.

Jin Gao 金高 (b. 1930, Beijing) Woman painter. Grad. from CAFA, then lived and painted in Mongolia for thirty years. 1960 member of CAA. 1984 settled in U.S. with her hus-band, sculptor Wang Jida.

Jin Gongbo. *See* Jin Cheng

Jin Jialun 金嘉倫 (King Chia-lun; b. 1936, Shanghai) Painter. Trained in NTNU and Chicago Art Inst. (M.F.A.). Earlier works are contemporary, including Hard-edge and avant-garde. Later work more traditional. In charge of extramural art dept. in Hong Kong Univ.

Jin Shangyi 靳尚誼 (b. 1934, Jiaozuox., Henan) Oil painter. Grad. from CAFA. Studied oil painting in Germany. 1979 vice president of CAFA; later president.

Jin Xuecheng 金學成 Sculptor. 1935 grad. from Tokyo Acad. In 1980 still living in Beijing.

Jin Ye 金冶 (b. 1913, Shenyang) Oil painter and art theorist. 1943 taught in Beijing. Teacher at NZAFA and (in 1980s) chief editor of *Xin meishu*. 1985 retired.

Ju Lian 居廉 (1824–1904; native of Canton) Guohua painter, chiefly of flowers. Important influence on Gao Qifeng and Chen Shuren.

Ju Ming. *See* Zhu Ming

Kan Tai-keung. *See* Jin Daiqiang

King Chia-lun. *See* Jin Jialun

Koo Mei. *See* Gu Mei

Koo Tsin-yau. *See* Gu Qingyao

Kuang Yaoding 鄺耀鼎 (Kwong Yeu-ting; b. 1922, Macao) Painter and printmaker. M.A. in landscape design, Kansas State Univ. Teaches art in Chinese Univ. of Hong Kong.

Kwok Hon Sum. *See* Guo Hanshen

Kwong Yeu-ting. *See* Kuang Yaoding

Lai Chi-man. *See* Li Zhiwen

Lai Chunchun 賴純純 (Lai Jun; b. 1953, Taipei) Woman sculptor and printmaker. Studied in Taipei and at Pratt Inst., New York. Works in cement and steel.

Lai Chusheng 來楚生 (1903–75; native of Zhejiang) Guohua painter and calligrapher. Studied in Shanghai Meizhuan under Wu Changshuo, then taught there and in Xinhua Acad. 1956 joined Shanghai Painting Acad. Specialist in birds, flowers, and animals.

Lai Fengmei 賴鳳美 (Lai Foong-moi; b. 1930s, Malaysia) Woman oil painter. Trained in Nanyang Acad., Singapore. 1955–59 studied in Paris. Returned to teach in Nanyang Acad.

Lai Jun. *See* Lai Chunchun

Lai Kit-cheung. *See* Li Jiexiang

Lai Shaoqi 賴少其 (b. 1915, Puning, Guangdong) Painter and calligrapher. Grad. from Canton Provincial Art Coll., where he joined the Modern Woodcut Soc. 1939 supported Woodcut Soc. in Guangxi, edited *Salvation Woodcut* and *Woodcut Art Monthly*. After Liberation became active in political control in the arts.

Lan Yinding 藍蔭鼎 (Ran In-ting; 1903–79; b. Yilan, Taiwan) Watercolor painter. Studied under Ishikawa Kin'ichirō and (1929) in Tokyo. Lived some years in Europe. 1954 visited U.S. at invitation of State Dept. Prominent in Taipei cultural life.

Lee, Aries. *See* Li Fuhua

Lee Joo For. *See* Li Ruhuo

Lee Kar-siu. *See* Li Jiazhao

Lee Kwok-hon. *See* Li Guohan

Lee Wai-on. *See* Li Wei'an

Lei Guiyuan 雷圭元 (b. 1905, Jiangsu) Painter, graphic artist, and designer. Studied in NAA Beijing. 1929 went to study in Paris. 1935 teacher at NAA Hangzhou, later head of art dept. of Nat. Sichuan Univ. 1966 editorial member of *Meishu*. 1985 taught design in CAAC.

Leng Joon-wong. *See* Ling Yunhuang

Leung Kui-ting. *See* Liang Juting

Li Binghong 黎冰鴻 (d. 1989) Oil painter. Vice president of NZAFA.

Li Chao 李超 (b. 1962, Shanghai) Member of Shanghai modern movement in 1980s.

Li Chaoshi 李超士 (1894–1971; native of Hangzhou, Zhejiang) Oil painter. 1912 went to Paris to study painting.

1920 returned to China and taught in Shanghai Meizhuan and in Beijing and Hangzhou. After 1949 taught in CAFA.

Li Chundan 李春丹 Wood-engraver. 1929 founding member of Eighteen Art Soc., Shanghai.

Li Dongping 李東平 Painter. Trained in Japan. Early 1930s returned to Shanghai. 1934 member of China Independent Art Assoc. 1935 participated in NOVA avant-garde exhib. in Shanghai.

Li Fengbai 李風白 (b. 1910, Zhejiang) Oil painter, watercolorist, and sculptor. Trained in Paris, where he became a leader of the Chinese art students with Hua Tianyou. Taught in NAA Hangzhou. 1933–53 lived in Paris again. 1953 back to Beijing, worked at Foreign Languages Press. 1983 returned to Hangzhou.

Li Fenggong 李風公 (1883–1967; native of Canton) Guohua painter. 1912 founder of a correspondence school of watercolor painting; set up Canton Sculptural Art Company. After 1938 lived and taught in Hong Kong.

Li Fenglan 李風蘭 Woman peasant painter in Huxian, active in 1960s and 1970s.

Li Fuhua 李福華 (Aries Lee; b. 1943, Hong Kong) Painter and designer. Studied in Tokyo Nat. Univ. of Arts until 1977, then in Dusseldorf. Works in Hong Kong.

Li Geng 李庚 (b. 1950, Beijing) Painter. Son of Li Keran. Studied in Tokyo Univ. of Art. 1982–83 held solo exhib. in Japan.

Li Guohan 李國翰 (b. 1950, Hong Kong) Realist oil painter. Studied in Hong Kong, and from 1971 in Ecole Nat. Sup. des Beaux Arts in Paris. 1976 settled in Paris.

Li Hongren 李宏仁 (b. 1931, Beijing) Painter and graphic artist. Trained in CAFA. 1985 assoc. prof. and head of lithography section of CAFA. 1983 visited Britain. 1986 was invited to participate in Ninth Print Biennale, Bradford, U.K.

Li Hu 李斛 (1919–75; b. Dazux., Sichuan) Guohua painter. Studied under Xu Beihong in NCU Nanjing. During WWII in Chongqing. After 1949 lectured in Chinese painting dept. of CAFA.

Li Hua 李華 (1907–94; b. Panyu, Guangdong) Wood-engraver. Studied oil painting first in Canton and 1931–32 in Japan. Founder of Modern Woodcut Soc. in Canton. Active in anti-Japanese propaganda during WWII. 1949 prof. in graphic arts dept. of CAFA, then chairman of Chinese Wood-Engravers Assoc. One of the leading figures in political control of the arts.

Li Hua 李華 (b. 1948, Shanghai) Painter. Studied in Shanghai. 1982 settled in San Francisco, where he paints semiabstract compositions. Inspired by Chinese archaic pictographs and Buddhist art, with some influence from medieval European art.

Li Huaji 李華吉 (b. 1931, Beijing) Oil painter. 1959 grad. from CAFA; remained there teaching oil painting. Member of Oil Painting Research Soc. Executed decorative paintings for Beijing Airport and Yanjing Hotel with his wife, Quan Zhenghuan. Director of wall painting dept. of CAFA.

Li Huasheng 李華生 (b. 1944, Yibin, Sichuan) Guohua painter of landscapes. Largely self-taught, but studied briefly in 1972–76 under Chen Zizhuang. Developed expressionist style. 1985 elected hon. member of Sichuan Acad. of Fine Arts. 1987 spent five months in the U.S.

Li Hui'ang 李慧昂 (b. 1954) Oil painter. Studied in Sichuan Acad. of Fine Arts. Bronze medal in Second National Youth Art Exhib.

Li Jiazhao 李加兆 (Lee Kar-siu; b. 1949, Canton) Oil painter.

1971 moved to Hong Kong, then 1975 to London to study in Sir John Cass Inst. of Art. Settled in Paris.

Li Jiexiang 李潔祥 (Lai Kit-cheung; b. 1950) Hong Kong artist. Photo-realist. 1976 settled in Paris.

Li Jinfa 李金髮 (1900–76; native of Meix., Guangdong) Guohua painter, sculptor. Studied in Paris in early 1920s, returning to China 1924. 1925 first major commission for bust of his patron, Cai Yuanpei. 1928–30 taught in NAA Hangzhou, later in Canton. Did many memorial statues. Chief contributor to *Meiyu zazhi*.

Li Keran 李可染 (1907–89; native of Xuzhou, Jiangsu) Guohua painter. Studied under Liu Haisu in Shanghai Meizhuan; later student of Qi Baishi, Huang Binhong, and Lin Fengmian. 1931 member of Eighteen Art Soc., taught in Sichuan. 1946 joined Xu Beihong in NAA Beijing. After 1950 prof. in CAFA. After 1954 travelled in China and visited Eastern Europe. Famous for landscapes, herd-boys, and buffaloes.

Li Kuchan 李苦禪 (1898–1983; b. Gaotangx., Shandong) Guohua painter, chiefly of landscapes, plants, birds. 1919 entered Beijing Univ. to study Chinese language. 1922 studied Western art in NAA Beijing. 1923 started to learn bird and flower painting under Qi Baishi. 1925 graduated and moved to Hangzhou. 1930 prof. of Chinese painting, NAA Hangzhou. 1946 joined Xu Beihong in NAA Beijing. After 1949 prof. in CAFA.

Li Meishu 李梅樹 (1902–83; b. Sanxia, Taiwan) Oil painter. Studied in Japan, and on his return became a founder of the Taiyang Art Soc. 1977–83 president of the Fine Arts Assoc. of the R.O.C. Pioneer of the Western art movement in Taiwan. 1990 memorial gallery opened in Sanxia.

Li Qimao 李奇茂 (b. 1931, Anhui) Painter. Moved to Taiwan after WWII.

Li Quanwu 李全武 (b. 1957, Wuhan) Oil painter and graphic artist. Studied in Hubei Fine Arts Inst. in Wuhan, then CAFA. 1986 studied in the U.S., and settled there. Noted for portraits and figure studies painted in a meticulous technique.

Li Qun 力群 (b. 1912; native of Shanxi) Wood-engraver. Studied in NAA Hangzhou, from which he was dismissed in 1930. Joined League of Left-Wing Artists. In 1940 teaching in Lu Xun Acad., Yan'an. Later asst. editor of *Meishu* and *Banhua*. After 1949 vice-chairman of China Woodcut Assoc. and active in political control of the arts.

Li Ruhuo 利如火 (Lee Joo For; b. 1929, Penang, Malaysia) Painter and graphic artist. 1957–64 studied art in England, later returned to teaching art in Kuala Lumpur. Controversial modernist.

Li Ruinian 李瑞年 (b. 1910, Tianjin) Oil painter. 1933 grad. from NAA Beijing. Further study in Brussels Royal Acad. and Paris. During WWII with Xu Beihong in Chongqing. Later in Beijing. 1961 set up studio with Wei Tianlin.

Li Ruiqing 李瑞清 (1867–1920; native of Linchun, Jiangxi) Qing official and amateur guohua painter and calligrapher. After 1900 president of Liangjiang Shifan Xuetang, the first school teaching Western art. 1919 taught calligraphy to Zhang Daqian.

Li Shan 李鱓 (b. 1944, Heilongjiang) Oil painter. Studied Soviet-style oil painting in Harbin. 1968 grad. from Shanghai Drama Acad., where he teaches theatrical design. Symbolist-surrealist, member of Shanghai avant-garde.

Li Shaowen 李少文 (b. 1942, Beijing; native of Shandong) *Gongbi* painter and graphic artist. Studied Western painting in Beijing Fine Arts Normal Coll. 1960 began to study guohua. 1978 grad. student of Ye Qianyu in CAFA, where he joined teaching staff in 1980. Noted for his book illustrations.

Li Shaoyan 李少言 (b. 1918, Linyin, Shandong) Wood-engraver who promoted social realism in Sichuan. As art editor and vice-director of Sichuan Art Acad., a longtime opponent of progressive artists such as Chen Zizhuang and Li Huasheng.

Li Shijiao 李石焦 (b. 1908, Taipei) Oil painter. 1931–36 studied painting under Ishikawa and in Tokyo Acad. 1944 returned to Taiwan; active in art world. 1963–74 taught in NTNU. 1981 cofounder of Taiyang Art Soc. Impressionist, influenced by Umehara Ryūzaburō.

Li Shinan 李世南 (b. 1940; native of Shaoxing, Zhejiang) Figure painter. Works in Xi'an Arts and Crafts Inst.

Li Shuang 李爽 (b. 1957, Beijing) Woman painter. Self-taught. Member of the Stars. Stage designer for the Chinese Youth Art Theatre. 1983 emigrated to France. Settled in New York.

Li Shutong 李叔同 (1880–1942, Tianjin) Painter, calligrapher, and musician. 1905–10 studied in Tokyo under Kuroda Seiki. 1911 founder of Wenmeihui, Shanghai. 1912 teacher in Zhejiang Normal Coll., art and literary editor of *Taipingyang bao*. 1918 became monk in Hangzhou; painted Buddhist pictures and practiced calligraphy. Pioneer in introducing Western arts, including commercial art, woodcut, theater, and music, into China.

Li Tianxiang 李天祥 (b. 1928, Hebei) Oil painter. Studied in NAA Beijing. 1953–55 studied in Leningrad Acad. 1985 director of newly established Shanghai Art Inst.

Li Tianyuan 李天元 (b. 1965, Heilongjiang) Oil painter. 1988 grad. from wall-painting dept. of CAFA. Many medals, including gold medal for his painting *The Seductress* in 1991 Exhib. of Chinese Oil Painting in Hong Kong.

Li Tiefu 李鐵夫 (1869–1952; native of Guangdong) Oil painter. 1885 taken to England, then to U.S. 1913 went to New York to study painting; worked there. 1930 returned to Canton. 1932–42 in Hong Kong. 1943–47 lived in China. 1947–49 back to Hong Kong. 1950 prof. in Huanan Art and Culture Inst., Canton.

Li Wei'an 李維安 (Lee Wai-on; b. 1937) Painter active in Hong Kong since 1964. Member of In Tao Art Assoc. 1973 completed 3400 sq. ft. mural for Furama Hotel, Hong Kong. Teacher in Chinese Univ. of Hong Kong.

Li Wenhan 李文漢 (b. 1924; native of Anhui) Painter. Studied in Shanghai Meizhuan under Liu Haisu. 1949 went to Taiwan. Joined Ton Fan group. Semiabstract style.

Li Xiongcai 黎雄才 (b. 1910, Gaoyaox., Guangdong) Landscape painter, Lingnan School. Student of Gao Jianfu. 1932–35 studied in Japan. From 1935 taught in Canton and Chongqing. After 1949 taught in different art colleges in Canton. Now deputy director and prof. in Canton Art Acad.

Li Yanshan 李研山 (1898–1961; native of Canton) Painter. Studied law and Western painting in Beijing Univ. Returned to Canton and joined Chinese Painting Research Soc. 1931 principal of Canton Municipal Coll. of Art. During WWII lived in Hong Kong and Macao; 1949 settled in Hong Kong, where he became a very traditional artist.

Li Yansheng 李延生 Guohua painter. Grad. of CAFA. Active in Beijing.

Li Yihong 李義弘 (Lee, I-hung; b. 1941, Taiwan) Painter. Grad. from Nat. Taiwan Acad. of Fine Arts. Studied under Jiang Zhaoshen. Teaches in Taiwan. Travels and exhibs. in Asia and U.S.

Li Yishi 李毅士 (1886–1942; native of Jiangsu) Painter. Studied in Japan and Scotland. 1916 teacher in Beijing Univ. school of engineering. 1922 one of founders of Apollo Soc. In the 1920s illustrated Bai Juyi's "Song of Unending Sorrow." In the 1930s changed his style to satirical painting, taught in Chongqing. Died in Guilin.

Li Yongcun 李永存 (Bo Yun; b. 1948, Shanxi) Painter. 1967 grad. from CAFA middle school. 1980 M.F.A. in art history from CAFA; began teaching at CAAC. 1979–80 played leading role in Stars exhibitions.

Li Youxing 李有行 (b. 1909, Sichuan) Oil painter. Studied under Xu Beihong in Nanjing, later in Paris. During WWII director of Sichuan Prov. Acad. of Art, Chengdu. After 1949 prof. in Sichuan Art Acad., Chongqing.

Li Yuanheng 李元亨 (b. 1936, Taizhong, Taiwan) Oil painter. 1959 grad. from NTNU. 1966 to Paris to study oil painting and sculpture. Settled in Paris.

Li Yuanjia 李元佳 (b. 1932, Guangxi) Painter. Founder of the international avant-garde group Ton Fan and the "Punto" movement. 1965 living in Bologna, Italy.

Li Zefan 李澤藩 (1906–89; b. Xinzhu, Taiwan). Oil and watercolor painter. Studied under Ishikawa and in Tokyo. Active in Taipei after WWII.

Li Zhigeng 李志耕 (native of Dinghai, Zhejiang) Wood-engraver, active in 1930s and 1940s. Studied painting in Shanghai. 1932 joined the National Salvation Dramatic Troupe, later went to Chongqing, joined Chinese Wood-Engravers Research Assoc.

Li Zhiwen 李志文 (Lai Chi-man; b. 1949, Hong Kong) Sculptor. 1973 grad. from Nat. Taiwan Acad. of Fine Arts. 1974–77 worked in Carrara, 1977–79 in U.S. Has participated in many group exhibs. in different countries.

Li Zhongliang 李忠良 (b. 1944, Beijing; native of Shanghai) Oil painter. Grad. from NZAFA; 1985 joined staff. Became professional artist in Beijing Painting Acad. Noted for heavy paintings of Tibetan scenes and for nudes.

Li Zhongnian 李忠年 Printmaker. Active in Yunnan in 1980s and 1990s.

Li Zongjin 李宗津 Oil painter, active in north China from 1940s.

Liang Baibo 梁白波 (native of Canton) Woman painter and cartoonist. Studied oil painting in Shanghai and in NAA Hangzhou. During WWII travelled to Tibet.

Liang Dingming 梁鼎銘 (1898–1959; b. Shanghai; native of Canton) Oil painter. Studied in Europe 1929–30. During WWII, taught in Chongqing and painted large war pictures. 1947 president of Zhongzheng Art Acad. in Jilin. Active in Guomindang politics. 1947 went to Taiwan. His brothers Zhongming and Yuming also painted propaganda pictures during WWII.

Liang Dong 梁棟 (b. 1926, Liaoning) Printmaker. 1954 grad. from CAFA. Became assoc. prof. and deputy director of graphic art dept., CAFA.

Liang Juting 梁巨廷 (Leung Kui-ting; b. 1945, Canton) Painter, designer, and sculptor. Studied under Lü Shoukun in Hong Kong. Since 1975 teacher in Hong Kong Polytechnic. 1980 formed Hong Kong Inst. of Visual Arts.

Liang Quan 梁銓 (b. 1948, Shanghai) Painter and print-maker. Grad. from NZAFA. M.A. from Acad. of Art, San Francisco. 1990 lecturer in printmaking, NZAFA.

Liang Weizhou 梁衛洲 (b. 1962, Shanghai) Oil painter. Works in Shanghai.

Liang Xihong 梁錫鴻 (native of Zhongshan, Guangdong) Oil painter, active in 1930s. 1931–33 studied in Japan. Eclectic modernist "Fauve" and member of the Chinese Independent Art Assoc..

Liang Yongtai 梁永泰 (native of Huiyang, Guangdong) Self-taught wood-engraver, active in 1930s and 1940s. Worked on Canton-Hankou railway, the subject of many of his woodcuts.

Liao Bingxiong 廖冰兄 (b. 1915, Canton) Cartoonist. Studied in Shanghai. During WWII, joined Guo Moruo's cartoon propaganda team. 1945–49 in Chongqing and Hong Kong, doing cartoons. After 1949 edited cartoon weekly for newspaper and did some teaching. 1983 major retrospective in China Art Gallery, Beijing.

Liao Jichun 廖繼春 (1902–76; b. Taizhong, Taiwan) Painter, active in Taipei. 1922 studied in Tokyo Acad. In 1960s member of Fifth Moon group. 1962 toured Europe and U.S. Until 1973 prof. in art dept. of NTNU.

Liao, Shiou-ping. See Liao Xiuping

Liao Xinxue 廖新學 (1901–58; native of Fumingxian, Yunnan). Sculptor and painter, both guohua and oils. Studied in Paris under Bouchard, Cormon, and others. Won many prizes in exhibs. in Paris, including a gold medal in 1946. Member of Société du Salon d'Automne. Returned to China after WWII and died in Kunming.

Liao Xiuping 廖修平 (Shiou-ping Liao; b. 1936, Taiwan) Painter and graphic artist. 1959 B.A., NTNU. 1962–64 studied in Japan. 1965–68 studied painting and graphic arts in Paris. Member of Société du Salon d'Automne. 1970 settled in U.S.

Lim Cheng-hoe. See Lin Qinghe

Lim Hak-tai. See Lin Xueda

Lin Fengmian 林風眠 (1900–91; native of Guangdong) Painter. 1919 went to France to study painting. 1926 returned to China; principal and prof. of NAA Beijing. 1927 founder of NAA Hangzhou. During WWII moved to west China. After 1949 spent time in Shanghai and Beijing. 1977 settled in Hong Kong. Creator of influential modern style. Many leading modern artists, including Zao Wou-ki, Huang Yongyu, Chu Teh-chun, and Wu Guanzhong, were his pupils in Hangzhou.

Lin Gang 林崗 (b. 1925, Shandong-Hebei border) Oil painter. Husband of Pang Tao. 1954–60 studied in Leningrad. Prof. in CAFA.

Lin Kegong 林克恭 (1901–92; b. Taiwan) Oil painter. Studied in Hong Kong and Cambridge Univ. 1924 B.A. in Economics. Studied art in London, France, and Switzerland. 1936 founded Xiamen Fine Art Inst. Lived in New York from 1973.

Lin Qinghe 林清和 (Lim Cheng-hoe) Watercolorist, active in Singapore since 1940s.

Lin Qinnan. See Lin Shu

Lin Shouyu 林壽宇 (Richard Lin; b. 1933, Taizhong, Taiwan) Sculptor and painter. 1949 to U.K. to study in London Polytechnic. Taught in Royal Coll. of Art and elsewhere. 1969 moved to west Wales. Many prizes and international exhibs.

Lin Shu 林紓 (Lin Qinnan, 1852–1924; native of Minghou, Fujian) Guohua painter and calligrapher, better known as a translator of Western literature.

Lin, Swallow. See Lin Yan

Lin Wenqiang 林文強 (b. 1943, Nantou, Taiwan) Oil painter. 1967 grad. from Nat. Inst. of Fine Arts, Taipei. Gold medal, 1977. 1980 went to France to study.

Lin Xueda 林學大 (Lim Hak-tai, 1895–?; native of Xiamen) Guohua and oil painter. Trained in Fuzhou Normal School. 1937 went to Singapore. 1938 founder and principal of Nanyang Acad. of Art, Singapore.

Lin Yan 林燕 (Swallow Lin; b. 1946, Zhejiang) Printmaker. Became deaf as a child. 1949 to Taipei. Member of Ton Fan group and Modern Graphic Arts Assoc., Taipei. Her prints, chiefly in line, are inspired by ethnic and folk-art motifs.

Lin Yushan 林玉山 (b. 1907, Taiwan) Guohua painter. Studied in Kyoto and lived many years in Japan. After WWII, returned to work in Taiwan. Later taught in NTNU.

Ling Yunhuang 凌運凰 (Leng Joon-wong; b. 1947, Singapore) Watercolorist. 1964 grad. from Nanyang Acad. Active in Singapore; founding member of Singapore Watercolor Society.

Liu Bingjiang 劉秉江 (b. 1937, Beijing) Painter. Studied in CAFA under Dong Xiwen. 1961 grad. and taught in Central Minorities Inst. 1982 chief artist of large mural painting for Beijing Hotel. 1983 visited Japan. Prof. in CAAC.

Liu Chunhua 劉春華 (b. 1944; native of Heilongjiang) Studied in Lu Xun Acad. middle school and CAAC. Most famous work is *Chairman Mao Goes to Anyuan* (1967).

Liu Conghui 劉聰慧 (Liu Tsung-hui; b. 1954, Taiwan) Sculptor. 1985 grad. from art dept. of NTNU.

Liu Dahong 劉大鴻 (b. 1962, Qingdao) Oil painter. 1985 grad. from NZAFA. 1993 teaching in art dept. of Shanghai Normal College. Active in post-1989 avant-garde movement.

Liu Dan 劉丹 (b. 1953) Guohua and oil painter. Brought up in Nanjing, where he studied under and became assistant to Ya Ming. 1980 moved with his American wife to Honolulu, where he became a prominent figure in the art world.

Liu Guohui 劉國輝 (native of Sichuan) Guohua painter and graphic artist. Grad. NZAFA. First known for serial pictures, later for guohua. Visited Germany. Prof. in NZAFA.

Liu Guosong 劉國松 (Liu Kuo-sung; b. 1932, Shandong) Painter. 1956 B.A., NTNU. 1956 founded Fifth Moon group. 1960 assoc. prof. in art at Chungyuan Coll., Taiwan. 1966–67 travelled around the world. Wrote widely on contemporary Chinese art. 1971 joined faculty of Chinese Univ., Hong Kong. 1982 first of several visits to P.R.C. 1983 one-artist exhib. in China Art Gallery, Beijing; exhib. toured China for 18 months.

Liu Haisu 劉海粟 (1896–1994; b. Jiangsu) Guohua and oil painter. 1911 studied under Zhou Xiang. 1912 founded Shanghai Meizhuan. 1914 introduced nude model. 1918–19 studied in Japan. 1929–31 studied in Europe, chiefly Paris; organized exhib. of contemporary Chinese art. 1933–35 again in Europe. 1939 to Southeast Asia; 1942 captured by Japanese in Java. 1943 returned to Shanghai, stayed until 1952. 1958 prof. in Nanjing Arts Coll. 1983 director and prof. in Nanjing Acad. of Art and prof. in Shanghai Acad. Awarded Gold Medal of Italian Acad. of Art. 1991 settled in Hong Kong.

Liu Huanzhang 劉煥章 (b. 1930, Balihan, Inner Mongolia; native of Leting, Hebei) Sculptor. Studied sculpture in CAFA. 1954 set up his own studio. 1981 first one-man show of sculpture ever held in post-Liberation China. Works in wood, stone, marble, and clay: figures, animals, and birds. Prof. in CAFA.

Liu Jian'an 劉建菴 (native of Shandong) Wood-engraver. Studied painting in Shanghai. Important figure in woodcut movement. 1938 cofounder of National Anti-Japanese Association of Wood-Engravers, Shanghai.

Liu Jiang 劉江 (native of Sichuan) Calligrapher and seal-engraver. Vice president of Xiling Seal-Engraving Society.

Liu Jintang. *See* Wang Yuezhi

Liu Jipiao 劉既漂 Oil painter. Studied in Paris in 1924. Took part in the Strasbourg Exhib. Famous for his large painting *Yang Guifei after the Bath*.

Liu Kaiqu 劉開渠 (1904–93; b. Xiaox., Anhui; native of Jiangsu) Sculptor. 1927 grad. from NAA Beijing. 1928 studied sculpture in Paris under Bauchard. 1934–40 taught in NAA Hangzhou. 1940–45 set up studio in Chengdu. 1946 returned to Shanghai. 1949 director of NAA Hangzhou. 1950 head of Huadong division of CAA. 1985 president of China Art Gall., Beijing.

Liu Kang 劉抗 (b. 1911, Xiamen) Oil painter. Grew up in Malaysia. 1926–29 studied in Shanghai Meizhuan. 1929–33 studied in Paris. 1934–37 taught in Shanghai Meizhuan. Since 1937 has lived and taught in Singapore. Founding member of Singapore Art Soc.

Liu Kuo-sung. *See* Liu Guosong

Liu Lun 劉侖 (b. 1913, Guangdong) Painter and wood-engraver. Studied in Canton Municipal Coll. of Art and then in Japan. 1936 participated in the woodcut movement. 1943 teacher at Nat. Sun Yatsen Univ., Guangdong. 1983 director of Guangdong Painting Acad.

Liu Ming 劉鳴 (b. 1957, Nanjing) Mixed media artist. Grad. from oil painting dept. of Nanjing Art Acad. Member of post-1989 avant-garde movement. 1991 emigrated to Paris.

Liu Ning 劉寧 (b. 1957) Painter and art director for films. Noted for academic still lifes.

Liu Pingzhi 劉平之 Wood-engraver, active in 1930s and 1940s. Grad. from Xinhua Acad., Shanghai. During WWII in west China. Noted for his prints of Miao people.

Liu Qixiang 劉啟祥 (b. 1910; native of Taiwan) Oil painter. 1927–30 studied in Tokyo. 1932–35 in Paris. 1935–46 back in Tokyo. Later worked in Taipei.

Liu Tianhua 劉天華 (native of Hebei) Wood-engraver. Studied in NAA Beijing. During WWII, went to Xi'an, then taught in Chongqing. Organizer of Chinese Wood-Engravers Research Assoc.

Liu Tianwei 劉天煒 (b. 1954, Shanghai) Guohua painter. Studied painting from his father, then painted at home during Cultural Revolution. 1982 went to study in the U.S., developed an abstract guohua painting style.

Liu Tsung-hui. *See* Liu Conghui

Liu Wei 劉葦 Guohua painter. Wife of Ni Yide.

Liu Wei 劉煒 (b. 1956, Beijing) Painter. 1989 grad. from wall painting dept. of CAFA. Professional painter, active in Beijing avant-garde.

Liu Wenxi 劉文西 (b. 1933, Zhengx., Zhejiang) Guohua painter. Studied in NZAFA under Pan Tianshou. Teacher and later president of Xi'an Acad. of Fine Arts. Well known for paintings of Shanxi peasants and serial pictures of Chairman Mao in Yan'an.

Liu Xian 劉峴 (b. 1915, Henan) Wood-engraver. 1934 studied oil painting and wood-engraving in Tokyo. 1937 returned to China, taught in Lu Xun Acad. Since 1949 engaged in art exhib. work. 1982 director of research department of China Art Gall.

Liu Xiaodong 劉小東 (b. 1963, Liaoning) Oil painter. Studied 1980–84 in Central Acad. prep school and 1985–89 in CAFA. Joined CAFA faculty as a lecturer. Active in avant-garde movement.

Liu Xun 劉迅 (b. 1923; native of Nanjing) Oil painter. Former vice president of Beijing Art Acad. Professional advisor to People's Govt. of Beijing Municipality. In 1990s became abstract expressionist.

Liu Yong 劉永 (native of Guangdong) Abstract expressionist painter in Chinese ink. Active in 1980s and 1990s.

Liu Yuan 劉元 (b. 1913, Nanjing) Painter. 1930 grad. from Shanghai Meizhuan. During WWII taught painting in Guangxi Acad. in Guilin.

Liu Zhengdan 劉正旦 Wood-engraver. In 1930s member of Eighteen Art Soc., Hangzhou.

Liu Zhide 劉志德 Huxian peasant painter, active 1960s and 1970s.

Liu Zijiu 劉子久 (1891–1975; b. Tianjin) Guohua painter. Active in Tianjin. His work after Liberation included realistic genre scenes of country life.

Liu Ziming 劉自鳴 (b. 1927, Kunming) Woman painter. 1946 studied in NAA Beijing. 1949 went to Paris to study life drawing. 1951 entered Ecole Nat. Sup. des Beaux Arts. 1983 in Kunming, council member of Yunnan branch of CAA.

Lo Ch'ing. *See* Luo Qing

Long Liyou 龍力游 (b. 1958, Xiangtan, Hunan) Oil painter. 1980–84 studied in CAFA; 1987 M.A. Became a teacher in CAFA.

Lu Hongji 盧鴻基 (native of Canton) Wood-engraver. Grad. from NAA Hangzhou. During WWII one of the organizers of National Anti-Japanese Assoc. of Wood-engravers and China Woodcut Research Soc. in Chongqing.

Lu Hui 陸恢 (1851–1920; native of Jiangsu) Guohua painter. Active in Shanghai. Landscapes and flowers.

Lu Shaofei 魯少飛 (b. 1903) Cartoonist. Active in Shanghai in 1920s and 1930s.

Lu Weizhao 陸維釗 (native of Zhejiang) Guohua painter, classical scholar, calligrapher, and seal-engraver. Former prof. in Zhejiang Univ. Invited by Pan Tianshou to be prof. in NZAFA.

Lu Yanshao 陸儼少 (1909–93; b. Shanghai) Guohua painter. Studied under Feng Chaoran. After 1929, moved around Nanchang, Yichang, and Chongqing. Did comic strips and cartoons for a while after 1949. 1957 member of CAA. 1962 joined Pan Tianshou in NZAFA to teach guohua. 1979 executive director of CAA, prof. in NZAFA, and master in Zhejiang Painting Acad. Became famous as a landscape painter.

Lu Yifei 陸抑飛 Guohua painter (esp. of flowers) and calligrapher. Prof. in NZAFA.

Lu Zhang 路璋 (b. 1939) Oil painter. Silver medal at Seventh Nat. Art Exhib.

Lü Fengzi 呂鳳子 (1885–1959; native of Jiangsu) Guohua painter. 1909 grad. from dept. of painting and handicraft of Nanjing High Normal School. Prof. of art in NCU Nanjing. Head of united Beijing/Hangzhou Acad. in Chongqing, 1940–42. Specialized in Buddhist subjects. Wrote a famous essay on guohua.

Lü Shengzhong 呂勝中 (b. 1952, Shandong) Painter and installation artist. 1978 grad. from Shandong Normal Univ. art dept. M.A. from folk arts dept. of CAFA. Representative artist of the Purified Language and Folk Arts movements of the 1980s.

Lü Shoukun 呂壽琨 (Lui Show Kwan, 1919–76; b. Canton) Guohua painter. Studied economics in Canton Univ. 1948 settled in Hong Kong. After 1950 took up painting and became an influential pioneer of the modern movement in Hong Kong. 1962 hon. advisor to the Hong Kong Museum of Art. 1968 with his students formed In Tao Art Assoc. Taught ink painting in Chinese Univ. of Hong Kong. 1971 awarded M.B.E.

Lü Sibai 呂斯百 (1905–73; native of Jiangsu) Oil painter. 1927 studied in NCU Nanjing. 1929 recommended by Xu Beihong to study in France. 1931 entered Franco-Chinese Inst. in Lyon to study oil painting. 1934–49 prof. and director of art dept. of NCU Nanjing. 1950 prof. and chairman of the Northwest China Teacher's Coll. art dept. 1957 prof. and chairman of art dept. of Nanjing Teacher's Coll.

Lü Wujiu 呂務佾 (Lucy Lu Wu-chiu) Painter. Daughter of Lü Fengzi. Active in Taipei. 1959 moved to U.S.; 1970 settled in Oakland. Abstract expressionist.

Lü Xiaguang 呂霞光 (b. 1906, Anhui) Oil painter. Went to study in Shanghai Art Univ. at age twenty. Member of Nanguo Society. Studied oil painting under Xu Beihong. 1931 to Paris. Returned to China during WWII and worked in Chongqing. 1948 back to Paris. 1982 returned to China for first of several visits. Major exhib. in Beijing in Dec. 1993. An accomplished painter and draughtsman in the European academic tradition.

Lui Show Kwan. *See* Lü Shoukun

Luo Erchun 羅爾純 (b. 1929, Hunan) Oil painter. 1951 grad. from Suzhou Acad., one of Yan Wenliang's last pupils. Worked in People's Fine Arts Publishing House, later became prof. in CAFA.

Luo Fang 羅芳 (b. 1937, Hunan) Painter. Wife of Huang Junbi. 1961 grad. from NTNU art dept.; 1971 assoc. prof. there. 1981 founding member of Taipei Art Club.

Luo Gongliu 羅工柳 (b. 1916, Guangdong) Oil painter. 1936 studied in NAA Hangzhou, then in Lu Xun Art Acad. After 1949 taught at CAFA. 1955–58 studied European oil painting in USSR. 1990 vice president and head of Communist Party in CAFA.

Luo Ming 羅銘 (b. 1912; native of Guangdong) Guohua painter with the Xi'an Acad.

Luo Qing 羅青 (Lo Ch'ing, Luo Qingzhi; b. 1948, Qingdao) Poet, painter, critic, and essayist in Taiwan. 1974 M.A., Univ. of Washington; later became prof. at Furen Univ. and Nat. Zhengzhi Univ., Taipei.

Luo Qingzhen 羅清楨 (1905–42; native of Xiangning, Guangdong) Wood-engraver. Grad. from Xinhua Art Acad. Before 1939 taught in Meix., Guangdong. Associated with Lu Xun in Woodcut Movement.

Luo Zhongli 羅中立 (b. 1948, Bishan, Sichuan) Oil painter. 1968–77 worked in the Daba Mountain area. 1978 entered Sichuan Acad. of Fine Arts. One of the founders of the Grasses. In 1980 his *Father* won first prize of the Second Nat. Youth Art Exhib. 1983–86 studied in Royal Belgian Acad., Antwerp. Became prof. in Sichuan Acad. of Fine Arts, Chongqing. A prominent realist.

Ma Desheng 馬德升 (b. 1952, Beijing) Expressionist painter in Chinese ink. Self-taught. Became industrial draughtsman. One of the chief organizer of Stars exhibs. in 1979 and 1980. 1985 moved to Switzerland.

Ma Gang 馬剛 (b. 1956) Graphic artist. Grad. from graphic arts dept., CAFA. 1986 teaching there. Woodcuts of peasants.

Ma Huixian 馬慧嫻 (Luisa Ma Hwei-hsien; b. 1930, Anhui) Woman painter. 1953 grad. from NTNU. 1955 went to Madrid to study art. Since then she has worked chiefly in Spain and exhibited frequently there and in Taiwan.

Ma Wanli 馬萬里 (b. 1900) Guohua painter. Taught in Beijing and Shanghai. Member of Bee Painting Soc.

Ma Xingchi 馬星馳 (early 20th century; native of Shandong) Cartoonist. Did cartoons in *Shenzhou manhua*. 1912 worked for *Xinwenbao*.

Ma Zhenrong 馬貞榮 Batik-designer. Trained and worked in CAAC in 1980s.

Mai Jinyao 麥錦銚 (b. 1940, Singapore) Oil painter. 1961–64 studied in St. Martin's School of Art, London, then taught art in various institutions in Britain. From 1971 coordinator of foundation studies at Berkshire College of Art and Design.

Mao Benhua 毛本華 (b. 1942, Zhejiang) Oil painter. 1964 grad. from oil painting dept. of CAFA. 1989 awarded bronze medal for his *Desert Wind* in Seventh Nat. Art Exhib.

Mao Lizhi 毛栗之 (Zhang Zhunli; b. 1950, Xianyang, Shanxi) Trompe-l'oeil oil painter. Grew up in Beijing. 1979–80 member of Stars. 1981 prizewinner in Nat. Youth Art Exhib. 1990 emigrated to Paris. Has exhibited widely in East Asia, Europe, and U.S.

Mao Xuhui 毛旭輝 (b. 1956, Chongqing) Painter. 1982 grad. in oil painting from Yunnan Acad. of Fine Arts, Kunming. Became art director of Kunming Film Company. Member of avant-garde movement.

Men, Paul. *See* Chen Xianhui

Meng Luding 孟祿丁 (b. 1962, Hebei) Oil painter. 1987 grad. CAFA. 1987–90 instructor in Fourth Studio, CAFA. 1989 went to West Germany, 1990 to the U.S. Since painting his well-known *Adam and Eve* and other realistic and surrealistic works, he has turned to abstraction.

Mi Gu 米谷 (Mi Ke; b. 1919; native of Zhejiang) Cartoonist. Grad. from Lu Xun Art Acad., Yan'an.

Miao Huixin 繆惠新 Peasant artist from Jiaxingx., Zhejiang, active in 1980s and 1990s.

Miao Jiahui 繆嘉蕙 (late 19th–early 20th c.; b. Kunming) Woman painter, esp. of flowers. Tutor and ghost painter to Empress Dowager Ci Xi in Beijing.

Mo Bu 莫朴 (b. 1915, Nanjing) Oil painter, graphic artist, and wood-engraver. 1942–49 taught in Lu Xun Art Acad., Yan'an; North China United Univ.; and Art Coll. of North China Univ. After 1949 vice president and later president of NZAFA.

Ng, Pansy. *See* Wu Puhui

Ng Yiu-chung. *See* Wu Yaozhong

Ni Haifeng 倪海峰 (b. 1964, Zhoushan, Zhejiang) Painter. 1986 grad. from NZAFA. Teaches in Zhoushan Normal College; member of avant-garde movement.

Ni Tian 倪田 (1855–1919; native of Yangzhou, Jiangsu) Guohua painter. Studied figure painting under Wang Su; influenced by Ren Bonian. Landscapes, flowers, and horses.

Ni Yide 倪貽德 (1901–70; b. Hangzhou) Painter and writer. 1919 studied in Shanghai Meizhuan. 1922 grad. and taught there. 1923 member of Creation Soc. 1927 studied in Japan. 1928 returned to China. 1931 prof. in Shanghai Meizhuan, chief editor of *Yishu xunkan*. 1931 founding member of Storm Soc. 1941 set up Nitian Studio. 1944 prof. in NAA Chongqing. 1949 prof. and vice president of NZAFA. 1955 director of editing dept. of *Meishu*. 1961 set up studio in NZAFA, Hangzhou.

Nie Ou 聶鷗 (b. 1948, Beijing) Woman guohua painter. Spent many years of her youth in the countryside. 1981 grad. from the graduate class of Chinese painting in CAFA. 1982 in the Spring of Beijing exhib. and joint exhib. of CAFA and Japanese South Acad. Member of the Beijing Painting Acad.

Niu Wen 牛文 Graphic artist and wood-engraver, active in 1980s and 1990s in Sichuan.

Ong Kimseng. *See* Wang Jincheng

Ouyang Wenyuan 歐陽文苑 (b. 1929, Jiangxi) Oil painter in abstract expressionist style. Member of avant-garde Ton Fan group and Modern Graphic Arts Assoc., Taiwan.

Pan Dehai 潘德海 (b. 1956, Dongbei) Painter. Grad. from Dongbei Normal Univ. Later taught in Yunnan. Member of avant-garde movement.

Pan Jiezi 潘絜茲 (b. 1915, Wuyix., Zhejiang) Guohua painter. Studied in middle school under Wang Daoyuan. 1932 entered Jinghua Coll. of Fine Arts, Beijing. After graduation, taught in Beijing. 1945 went to assist Chang Shuhong at Dunhuang. Drew from minorities in northwest China. 1950 one of the founders of Shanghai Municipality New Chinese Painting Research Soc. 1965 worked in Beijing Art Inst., later Beijing Painting Acad.

Pan Ren 潘仁 (b. Lishui, Zhejiang) Wood-engraver. Prominent figure in early history of the woodcut movement.

Pan Sitong 潘思同 (1903–70s) Watercolor painter. 1924 founded White Goose Painting Soc. Stayed in Shanghai until 1937. After Liberation, taught in NZAFA and elsewhere.

Pan Tianshou 潘天壽 (1897–1971; native of Ninghai, Zhejiang) Guohua painter, calligrapher, seal-engraver, and connoisseur. Studied under Wu Changshuo and Li Shutong. 1924 taught in Shanghai Meizhuan. 1928 settled in Hangzhou, prof. in NAA Hangzhou. 1929 study tour on Japanese art education. 1944–47 director of NAA Hangzhou. 1950 prof. and president of NZAFA. 1958 hon. fellow of Arts and Science Acad., USSR. 1963 visited Japan again. Wrote widely on Chinese painting and calligraphy.

Pan Ye 潘業 Wood-engraver. Active in Canton in 1930s and 1940s.

Pan Ying 潘纓 (b. 1962, Beijing) Woman painter. Trained in art college of PLA and CAFA. Works in fine arts dept. of Central Inst. of Minorities, Beijing.

Pan Yuliang 潘玉良 (1899–1977; native of Yangzhou, Jiangsu) Woman oil painter and sculptor. Studied in Shanghai Meizhuan under Liu Haisu. 1921–28 studied in Lyon, Paris, and Rome. 1928–35 taught in NCU Nanjing under Xu Beihong, then settled permanently in Paris. Member of Salon d'Automne, Salon des Indépendants, and Salon du Printemps.

Pan Yun 潘韻 (b. before 1907; native of Changxing, Jiangsu). Wood-engraver and painter. 1957 teacher in NZAFA, painting realistic subjects in guohua technique.

Pang Jen. *See* Peng Zhen

Pang Jun 龐均 (b. 1936, Shanghai) Oil painter. Son of Pang Xunqin. 1949–53 studied in NZAFA. 1979 taught in Central Acad. of Drama. 1980 settled in Hong Kong.

Pang Tao 龐濤 (b. 1934, Shanghai; native of Jiangsu) Oil painter. Daughter of Pang Xunqin. Grad. from CAFA and became prof. of oil painting in Fourth Studio. 1984–85 visited Europe, 1990 U.S.

Pang Xunqin 龐勳琴 (1906–85; native of Changshux., Jiangsu) Oil and guohua painter and designer. 1925 studied oil painting in Shanghai under a Russian teacher. 1925–30 studied in France. 1930 returned to Shanghai and joined Taimeng Painting Soc. 1931 founding member of Storm Soc. 1936 taught in NAA Beijing. 1939–40 worked in Central Museum in Kunming and collected decorative textiles and patterns of Southwestern minorities. 1940 taught in Prov. Art Coll. in Chengdu. 1947 taught in Canton.

1949 taught in East China Division of NAA Hangzhou. 1953 taught in CAFA, prepared for founding of CAAC. 1956–85 vice president and prof. of CAAC.

Pao, Cissy. *See* Bao Peili

Pau Shiu-yau. *See* Bao Shaoyou

Peng Peiquan 彭培泉 (b. 1941; native of Beijing) Woman guohua painter in CAFA. Decorative style.

Peng Wanchi 彭萬墀 (Peng Wants; b. 1939, Sichuan) Painter. Trained in dept. of fine arts, NTNU. Worked in Hong Kong. Since 1965 has lived in Paris.

Peng Zhen 彭貞 (Pang Jen; b. 1928, Jiangnan) Oil painter. Studied and worked for some years in Hong Kong and in Paris under Jean de Botton. Lives and works in the U.S.

Poon, Anthony. *See* Fang Jinshun

Pu Guochang 蒲國昌 (b. 1937) 1958 grad. from printmaking dept. of CAFA. 1986 teaching in Guizhou Prov. Art Acad., Guiyang. Makes woodcuts, carved and painted woodblocks, and wall hangings inspired by minority themes.

Pu Hua 蒲華 (1834–1911; native of Xiushui, Zhejiang) Guohua painter. Active in Shanghai; friend of Wu Changshuo. Visited Japan, where his ink landscapes and bamboo were much admired.

Pu Jin 溥伒 (Pu Xuezhai, 1879–1966; b. Beijing) Guohua painter. Member of Manchu imperial family. Until 1949 dean of college of art, Furen Univ., Beijing. Died as result of persecution in Cultural Revolution.

Pu Quan 溥佺 (Pu Songquan; b. 1912, Beijing) Guohua painter. Brother of Pu Jin and Pu Yi, the last emperor. Trained in Furen Univ., where he taught for some years. Later joined Beijing Painting Acad.

Pu Ru 溥儒 (Pu Xinyu, 1896–1964; b. Beijing) Guohua painter. First cousin of Pu Yi and son of Gong Wang. Studied in Berlin. 1929–30 taught in Kyoto. After 1934 taught in NAA Beijing. Remained in Beijing during WWII. 1937–49 in Hangzhou. 1949 to Taiwan, taught at Taiwan Normal Univ. Figure painting and landscapes.

Pu Songquan. *See* Pu Quan

Pu Xinyu. *See* Pu Ru

Pu Xuezhai. *See* Pu Jin

Qi Baishi 齊白石 (Qi Huang, 1863–1957; native of Xiangtanx., Hunan) Guohua painter, calligrapher, and seal-engraver. 1877 apprenticed to a carpenter, in 1878 to a wood-carver; studied painting, calligraphy, and seal-engraving under local painters. 1889 became professional painter, chiefly of figures, later of flowers, birds, insects, and fish. 1903–10 travelled around China. 1920 settled in Beijing. 1927–37 taught in NAA Beijing; lived in Beijing through the war. After 1949 honorary prof. in CAFA. 1953 named Outstanding Artist of the Chinese People by Ministry of Culture. 1955 awarded International Peace Prize by World Peace Council.

Qi Gong 啓功 (b. 1912, Beijing) Guohua painter, calligrapher, and scholar. Prof. of chinese literature and painting in Furen Univ., Beijing. Chairman of the Chinese Calligraphy Assoc. Important influence on Zeng Youhe.

Qian Binghe 錢病鶴 (1879–1944; native of Wuxing, Zhejiang) Figure painter and later professional cartoonist.

Qian Juntao 錢君匋 (b. 1906) Guohua painter, graphic designer, calligrapher, and seal-engraver. Studied in NAA Hangzhou in late 1920s, then worked for Kaiming Bookstore in Shanghai.

Qian Shaowu 錢紹武 Sculptor and graphic artist. 1953–55 studied sculpture in Leningrad. Teacher and later prof. in dept. of sculpture in CAFA.

Qian Shoutie 錢廋鐵 (1896–1967; b. Wuxi) Guohua painter. Taught in Shanghai Meizhuan. 1935–42 worked in Japan. After 1949 became painter in Shanghai Acad. of Art.

Qian Songyan 錢松喦 (1898–1985; native of Yixingx., Jiangsu) Guohua landscape painter. 1918–23 studied in the third Coll. of Education of Jiangsu. From 1923 taught in art schools in Suzhou and Wuxi. During WWII lived by selling paintings. 1945 resumed teaching. 1957 taught in Jiangsu Chinese Painting Acad., Nanjing. Close friend of Liu Haisu.

Qin Long 秦龍 Painter and book illustrator, active in Beijing after 1979.

Qin Song 秦松 (b. 1932, Anhui) Painter, poet, and graphic artist. 1948 began to paint in Nanjing. 1949 went to Taiwan. 1957 founded Modern Graphic Arts Assoc., Taipei. 1966 founded *Avant-Garde Monthly*. Developed abstract style.

Qin Xuanfu 秦宣夫 (b. 1906, Tianjin) Oil painter. 1930–34 studied in Paris. 1937 published strong defense of oil painting. Taught in Beijing, after WWII in Nanjing. Later prof. in Nanjing Normal College.

Qin Zhongwen 秦仲文 (1895–1974; native of Zunhuax., Hebei) Guohua painter. 1915 entered law dept. of Beijing Univ. and joined the Painting Methods Research Soc. organized by Cai Yuanpei and directed by Chen Hengke. 1920 researcher in Chinese Painting Research Soc. Before 1937 lecturer in NAA Beijing. 1937–45 studied calligraphy and painting at home. 1945 prof. of Chinese painting history in Beijing Univ.

Qiu Deshu 仇德樹 (b. 1948, Shanghai) Abstract oil painter and seal-engraver. 1968–77 worked in a factory, then art worker in Luwan District Culture Palace. Organized Grasses society. Member of Shanghai avant-garde.

Qiu Ti 丘堤 (1911–58) Woman oil painter. Wife of Pang Xunqin. Studied in Tokyo. 1931 returned to China; only woman painter in the Storm Soc. During WWII in southwestern China. Before 1949 major organizer of CAA; later standing member of the council of CAA.

Qiu Yacai 丘亞才 (Ch'iu Ya-ts'ai; b. 1949, Yilan, Taiwan) Oil painter, esp. of figures. Influenced by European expressionism. Lives and works in Taipei.

Qiu Zhijie 邱志傑 (b. 1969, Fujian) Printmaker and mixed media artist. 1992 grad. from printmaking dept. of NZAFA. Member of post-1989 avant-garde movement.

Qu Leilei 曲磊磊 (b. 1951) Painter. Active member of the Stars, 1979–80. Later settled in England.

Quan Shanshi 全山石 (b. 1930, Ningbo, Zhejiang) Oil painter. 1954–60 studied in Leningrad; on his return worked with Maksimov in CAFA and collaborated with Luo Gongliu on history pictures. After Cultural Revolution visited Xinjiang eight times; also visited U.S., Japan, France, and Spain. Dean of NZAFA.

Quan Zhenghuan 權正環 (b. 1932, Beijing) Woman oil painter, married to Li Huaji.

Ran In-ting. *See* Lan Yinding

Rao Zongyi 饒宗頤 (Jao Tsung-i; b. 1917, Zhao'an, Guangdong) Calligrapher, painter, and scholar. Has held professional appointments in Hong Kong Univ. and the Chinese Univ. of Hong Kong.

Ren Bonian. *See* Ren Yi

Ren Jian 任戩 (b. 1955, Liaoning) Painter. 1987 M.A. from Lu Xun Acad. Leading figure in 1980s avant-garde movement. Teaching in Wuhan Univ. architecture dept. in early 1990s.

Ren Ruiyao 任瑞堯 (native of Canton) Oil painter. Trained in Japan. 1921 returned to China, set up Chishe Society.

Ren Yi 任頤 (Ren Bonian, 1840–95) Professional guohua painter. Leading member of the Shanghai School.

Rong Ge 戎戈 (b. 1923, Ningbo, Zhejiang) Wood-engraver, active in Shanghai before WWII.

Rou Shi 柔石 (?–1931) Wood-engraver. Close friend and protege of Lu Xun. Member of Eighteen Soc. Executed by Guomindang.

Seeto Ki. *See* Situ Qi

Sha Menghai 沙孟海 (b. 1900; native of Zhejiang) Calligrapher. Pupil of Wu Changshuo. Vice president of Chinese Calligraphy Assoc.; hon. prof. in NZAFA. His calligraphy is much admired in Japan.

Shang Wenbin 尙文彬 (b. 1932, Jiangsu) Oil painter. 1955 grad. from fine arts dept. of NTNU. Later studied architecture in Belgium. A realist.

Shang Yang 尙揚 (b. 1942, Hubei) Painter. 1981 M.A. from Hubei Acad. of Fine Arts, where he became assoc. prof. Began as an expressionist landscape painter; his work has become progressively more abstract.

Shao Fei 邵飛 (b. 1954, Beijing) Woman painter. Wife of poet Bei Dao. Studied guohua with her mother, an oil painter. 1970–76 served in the army. 1976 joined the Beijing Painting Acad. 1979 and 1980 member of the Stars. Noted for her decorative fantasy paintings.

Shao Jingkun 邵晶坤 (b. 1932, Heilongjiang) Oil painter. Studied in Beijing under Xu Beihong, Dong Xiwen, and others. Active as oil painter and teacher for many years. 1962 went on painting tour of Tibet with Dong Xiwen and Wu Guanzhong.

Shao Yu 邵宇 (b. 1919, Dandong, Liaoning) Painter and wood-engraver. 1934 studied in art coll. in Shenyang. 1935 studied Western painting in NAA Beijing. Active in left-wing propaganda art from late 1930s to 1949. After 1949 published some albums of his paintings.

Shen Bochen 沈泊塵 (1889–1920; native of Tongxiang) Cartoonist in Shanghai after 1911 revolution. Contributor to *Shanghai Puck*.

Shen Fuwen 沈福文 (b. 1906, Fujian) Oil painter, lacquer craftsman and wood-engraver. 1924 studied in Xiamen Coll. of Art. 1929 went to Hangzhou to study painting and woodcut, joined the Eighteen Soc. 1932 taught oil painting in art school of Beijing Univ. 1933 prof. at NAA Beijing. 1935–37 studied lacquerware in Tokyo. 1939 involved in woodcut movement in Chongqing. 1946 went to Dunhuang to copy the frescoes. 1950 taught in Chengdu.

Shen Qin 沈勤 (b. 1958, Jiangsu) Painter. 1982 grad. from Jiangsu Chinese Painting Acad., where he became artist in residence. Member of post-1989 avant-garde movement.

Shen Xiaotong 沈小彤 (b. 1968, Chengdu) Painter. 1966 grad. from Sichuan Acad. of Fine Arts. Professional painter and member of avant-garde movement.

Shen Yaochu 沈耀初 (b. 1908, Fujian) Guohua painter. Studied in Xiamen. Schoolteacher for 30 years. 1948 settled in Taipei. Expressionist in the tradition of Zhu Da.

Shen Yiqian 沈逸千 (b. 1908, Shanghai) Oil painter. Trained in Shanghai Meizhuan. During WWII painted many guohua pictures of peasant life.

Sheng Song. *See* Te Wei

Shi Chong 石沖 (b. 1963) Oil painter. 1987 grad. from Hubei Art Acad. His *Dried Fish* awarded silver medal at Exhib. of Chinese Oil Painting (Hong Kong 1991).

Shi Hui 施惠 (b. 1955; native of Ningbo, Zhejiang) Tapestry artist. Pupil of Varbanov in NZAFA; became teacher there.

Shi Jihong 史濟鴻 Printmaker. In 1980s teaching in graphic arts department of CAFA.

Shi Lu 石魯 (1919–82; native of Renshoux., Sichuan) Painter. 1934 studied guohua painting in Dongfang Art Coll. in Chengdu. 1938 enrolled in the West China Union Univ. in Chengdu. 1939 went to Yan'an, where he took up propaganda work. From 1942 did cartoons, woodcuts, new year pictures. After 1949 editor in chief of the magazine *Northwest Pictorial*. His later landscapes and calligraphy are very expressionistic.

Shiy De Jiun. *See* Xi Dejin

Shu Chuanxi 舒傳喜 Painter and calligrapher. Studied western art in Germany. 1980s prof. in NZAFA.

Shu Tianxi 舒天錫 (b. 1922; native of Guangdong) Oil painter. Studied in NAA Hangzhou. Prof. and head of dept. of fine arts, Nanjing Acad.

Shyu, Onion. *See* Xu Yangcong

Si Zijie 司子傑 (b. 1956, Shandong) Oil painter. 1982 grad. from dept. of stage design of Central Acad. of Drama. Academic realist.

Situ Jian 司徒健 Sculptor. After Liberation, worked on Heroes' Memorial, Tiananmen Square, and in the Historical Museum in Beijing.

Situ Qi 司徒奇 (Seeto Ki, 1902–57; native of Kaiping, Guangdong) Guohua painter. After studying western painting in Canton became student of Gao Jianfu and painted in style of Lingnan School. Settled in Vancouver.

Situ Qiang 司徒強 (Szeto Keung; b. 1948, Canton) Hyperrealist painter. Trained at Pratt Inst. in Brooklyn (1979) and at NTNU (1983). Works in New York.

Situ Qiao 司徒喬 (1902–58; native of Kaipingx., Guangdong) Oil painter and graphic artist. 1928–30 studied in Paris and New York. Returned to China and taught at Lingnan Univ., Canton. Later editor in chief of the art section of *Dagongbao*. Close friend of Lu Xun. After WWII went to U.S.; returned to Beijing in 1950, where he taught at CAFA.

Song Haidong 宋海冬 (b. 1958, Yangzhou, Jiangsu) Painter and installation artist. 1985 grad. from NZAFA sculpture dept. Teaches in Shanghai. Member of avant-garde movement.

Song Huimin 宋惠民 (b. 1937, Jilin) Oil painter. 1962 grad. from Lu Xun Acad. of Fine Arts, where he later became professor and director.

Song Wenzhi 宋文治 (b. 1919, Taichongx., Jiangsu) Guohua painter of landscapes. 1937 studied art in Suzhou Acad., then taught at primary school. 1957 taught in Nanjing Acad. 1960 toured with Fu Baoshi and other Jiangsu painters. 1982 deputy director of Nanjing Acad.

Song Yinke 宋吟可 (b. 1902, Nanjing) Painter. Started work in art section of the Commercial Press; taught himself painting in his spare time. 1930s moved to Hong Kong. 1940s settled in Guiyang, Guizhou. After 1949 head of fine arts section of Guizhou People's Publishing House. 1950s prof. of Chinese painting in Southwest Nationalities Coll. and art dept. of Guizhou Univ.

Song Yonghong 宋永紅 (b. 1966, Hebei) Painter and printmaker. 1988 grad. from NZAFA. Member of avant-garde movement.

Song Yuanwen 宋源文 Printmaker of the Beidahuang School. Active in northern China in 1980s and 1990s.

Su Hui 蘇暉 Wood-engraver. Active in Yan'an during WWII.

Sui Jianguo 隋建國 (b. 1956, Shangdong) Sculptor. 1984 grad. from sculpture dept. of Shandong Art Acad. 1989 M.A. from CAFA, where he became a teacher. Member of post-1989 avant-garde movement.

Sun Duoci 孫多慈 Woman painter. Studied in Art Dept. of NCU Nanjing; favorite student of Xu Beihong. Later moved to Taiwan.

Sun Fuxi 孫福熙 (1898–1962; native of Shaoxing, Zhejiang) Watercolor painter. 1918 Lu Xun recommended him to Beijing Univ. library. 1920 Cai Yuanpei sent him to France on work-study program. Secretary of Franco-Chinese Inst., then studied painting and sculpture in Lyon. 1925 back to China, engaged in writing. 1928 one of the founders of NAA Hangzhou with Lin Fengmian and Pan Tianshou. 1930–31 studied literature and art theory in France. 1931 prof. in NAA Hangzhou and chief editor of *Yifeng.* 1937 went to Wuhan, joined the All-China Federation of Anti-Japanese Artists. 1938 returned to Shaoxing. 1945 went to Shanghai. 1949 schoolmaster in Shanghai Middle School.

Sun Gang 孫綱 (b. 1959) Oil painter. 1985 grad. from fine arts dept. of Hebei Normal Univ. 1986–87 studied printmaking in Canton Acad. of Fine Arts. 1991 M.F.A. from oil painting dept. of CAFA.

Sun Liang 孫良 Tapestry and soft-sculpture designer. Pupil of Varbanov in NZAFA. Active in Hangzhou in 1980s and 1990s.

Sun Mide 孫宓德 (b. 1947, Taiwan) Graphic designer and landscapist. 1967 B.A. from fine arts dept. of NTNU. 1970 illustrator for *China Times.* 1977 studied painting in the U.S. 1981 founding member of Taipei Art Club.

Sun Shaoqun 孫紹群 Sculptor, active in 1980s and 1990s in Hebei.

Sun Weimin 孫爲民 (b. 1946, Hulinx., Heilongjiang) Painter. Studied in middle school affiliated with CAFA. 1982 married painter Nie Ou. 1984 post-grad. in CAFA, won gold medal in sixth Nat. Art Exhib.

Sun Xiangyang 孫向陽 (b. 1956, Jinan, Shandong) Oil painter. 1983 grad. from PLA Art Acad., where he became a teacher. Known for his paintings of Shaanxi peasant life.

Sun Xiumin 孫修民 Guohua painter, active in Shanghai.

Sun Zongwei 孫宗慰 (b. 1912, Jiangsu) Painter in both guohua and Western style. 1934–37 studied Western painting under Xu Beihong in NCU Nanjing. During WWII went to front to sketch war scenes; 1940 to Dunhuang and Qinghai, painting life of Tibetans and Mongolians. 1942 research fellow in Chinese Art Research Inst., Chongqing. 1946 taught in NAA Beijing.

Szeto Keung. *See* Situ Qiang

Tai Hoi-ying. *See* Dai Haiying

Tam, Lawrence. *See* Tan Zhicheng

Tan Manyu 譯曼于 (Tan Doen; b. 1908, Changsha, Hunan) Woman guohua painter. Educated in Shanghai. 1950 settled in Hong Kong.

Tan Zhicheng 譯志成 (Lawrence Tam; b. 1933, Canton) Oil painter. 1947 settled in Hong Kong; educated in Hong Kong, Edinburgh, and London. 1968 president of In Tao Art Assoc., Hong Kong. 1970 M.A. in history of Chinese painting, Univ. of Hong Kong; taught in the dept. of extramural studies. Chief curator, Hong Kong Museum of Art.

Tang Di 湯滌 (1878–1946) Guohua painter and calligrapher, active in Beijing and Shanghai.

Tang Haiwen 唐海文 (1929–91; b. Xiamen) Painter. Raised in Vietnam. 1948 arrived in France. Settled in Paris.

Tang Jingsen 唐景森 (Tong Kim-sum; b. 1940, Hong Kong) Sculptor. Since 1982 instructor in Hong Kong Sculpture Assoc. Works chiefly in stone.

Tang Muli 湯沐黎 (b. 1947, Shanghai) Oil painter. 1979–81 post-grad. in CAFA, then worked in Shanghai University art dept. 1981–84 studied in Royal Coll. of Art, London; received M.A. Later settled in Montreal.

Tang Yihe 唐一和 (1905–44; native of Wuchang, Hubei) Oil painter. 1919 studied art in Wuchang. 1924 studied Western painting in Beijing Art Coll., 1930–34 in Paris. 1926 back to Wuchang. 1927 inaugurated Wuchang Art Coll.

Tang Yun 唐雲 (1910–93; b. Hangzhou) Guohua painter. Became art teacher in Hangzhou middle school. 1938 went to Shanghai. 1939–41 taught at Xinhua Art Acad. After 1949 joined Shanghai Inst. of Painting. Head of dept. of Chinese painting, Shanghai Coll. of Art. Later member of Shanghai Chinese Painting Inst.

Tao Lengyue 陶冷月 (1895–1955; b. Suzhou) Guohua painter. Held successive teaching posts in Jinan Univ., Henan Univ., and Sichuan Univ.

Tao Yiqing 陶一淸 (b. 1914, Beijing; native of Shanghai) Guohua painter. 1934 grad. from Jinghua Coll. of Fine Arts, then taught in Kaifeng. 1936–49 taught in middle schools and teachers' colleges in Beijing. 1961 joined staff of CAFA.

Tao Yuanqing 陶元慶 (1893–1929; native of Shaoxing, Zhejiang) Painter. In 1920s took up Western painting. 1925 held exhib. in Beijing; Lu Xun wrote preface to catalogue. 1928 prof. of design in NAA Hangzhou. Later vice pres. of Chinese Painting Research Soc., Beijing.

Te Wei 特偉 (Sheng Song; b. 1915) Cartoonist. Active in 1930s and 1940s in Shanghai and Guilin. Influenced by David Low.

Teng Baiye 滕白也 (Teng Gui, 1900–1980; native of Fengx., Jiangsu) Sculptor and guohua painter. Studied sculpture and painting in Seattle, where he met Mark Tobey, whose friend and teacher about Chinese art he became. 1931 returned to China; worked chiefly in Shanghai, and during WWII in West China. His career as an artist ended with "Liberation."

Tian Shixin 田世信 Sculptor. Active in 1980s and 1990s.

Ting, Walasse. *See* Ding Xiongquan

Ting Yen-yung. *See* Ding Yanyong

Tong Kim-sum. *See* Tang Jingsen

Tsai Intang. *See* Cai Yintang

Tsao Ya. *See* Cao Ya

Tsay Shoe-lin. *See* Cai Shuilin

Tseng Yu-ho. *See* Zeng Youhe

Ts'o, Beatrice. *See* Zhang Jiahui

Tuo Musi 安木斯 (b. 1934, Inner Mongolia) Oil painter. 1988 M.F.A. in oil painting from CAFA.

Van Lau. *See* Wen Lou

Wang, C. C. *See* Wang Jiqian

Wang Chaowen 王朝聞 (b. 1909; native of Hejiangx., Sichuan) Sculptor, aesthetician, and critic. Studied in NAA Hangzhou in early 1930s. 1937 joined anti-Japanese propaganda team. 1940 went to Yan'an, taught in Lu Xun Art Acad. After 1949 prof. at CAFA. General editor of *Meishu,* vice president of CAA. Has written widely on art and drama.

Wang Chuan 王川 (b. 1953, Chengdu) Painter. Grad. Sichuan Acad. 1984 moved to Shenzhen, where he helped to organize

independent artists. 1987 became full-time artist. Developed as abstract expressionist and installation artist. 1991 returned to Chengdu.

Wang Daoyuan 王道源 (active 1920s and 1930s) Oil painter. Grad. from Tokyo Acad. of Art. Later taught in Shanghai. Founding member of Storm Soc.

Wang Datong 王大同 (b. 1937, Anlong, Guizhou) Painter. Studied in Sichuan Acad. of Fine Arts, then remained to teach there. Developed from realism to post-impressionist and expressionist style.

Wang Dawen 王大文 (b. 1942, Shanghai) Guohua painter. Studied under Cheng Shifa. 1984 moved to New York.

Wang Dewei 王德威 (1927–84) Oil painter. In 1950s joined Maksimov's class in CAFA. In 1980s prof. in NZAFA, Hangzhou; later vice president.

Wang Fangyu 王方宇 (b. 1913, Beijing) Calligrapher, painter, authority on Zhu Da. Since 1936 has lived in U.S.; taught at Yale Univ.

Wang Geyi 王個簃 (1896–1988; native of Haimen, Jiangsu) Guohua painter, calligrapher, and seal-engraver. 1920 studied under Wu Changshuo in Shanghai. 1928 visited Japan with Zhang Daqian. Prof. in Xinhua Art Acad. 1929 prof. in Zhonghua Art Univ. 1930 head of Chinese painting dept. of Chongqing Art Coll. 1935 prof. in Shanghai Coll. of Art. 1956 founding member of Chinese Painting Acad. of Shanghai, later vice president of Xiling Seal-Engraving Soc.

Wang Guangyi 王廣義 (b. 1956, Harbin) Painter. Studied in NZAFA. Active in Shanghai modern movement in 1980s, and in *China/Avant-Garde* exhib. in 1989.

Wang Hai 王亥 (native of Chongqing) Printmaker and oil painter, active 1970s and 1980s.

Wang Hao 王浩 Photo-realist oil painter. Husband of Wei Rong. Works in Beijing.

Wang Henei 王合內 (b. 1912, Paris) French woman sculptor. 1933 studied sculpture in Paris. 1937 married Wang Linyi, went with him to China. 1937–48 made small sculptures at home. 1948 taught in the arts and crafts dept. of Beijing Normal Coll. 1955 became Chinese citizen. 1956 joined CAA. 1958 engaged in the relief sculpture of minorities in the Hall of Nationality Palace. 1985 associate prof. in CAFA.

Wang Hongjian 王宏劍 Oil painter. Active in 1980s and 1990s.

Wang Huaiqing 王懷慶 (b. 1944, Beijing) Oil painter. Army designer for song-and-dance group. 1980 enrolled as postgrad student in wall department of CAAC. At CAFA studied in Wu Guanzhong's studio. Joined staff of CAFA. Later developed as an abstract painter. 1991 gold medal at Exhib. of Chinese Oil Painting in Hong Kong. Exhibited at Paris Salon (1982) and in Italy (1983).

Wang Jianmin 王建民 Sculptor. Active in 1980s and 1990s.

Wang Jianwei 王建偉 (b. 1958, Shanxi) Painter. Studied in Chengdu. 1987 M.F.A. in oil painting from NZAFA. Became full-time professional painter in Beijing Painting Acad. Expressionist member of avant-garde movement. Gold medal in Sixth National Art Exhib.

Wang Jida 王濟達 Sculptor. Grad. from CAFA. 1966 moved to Mongolia. 1977 made the statue of Mao in the front hall of Mao's Memorial Hall. 1984 went to New York with his artist wife Jin Gao.

Wang Jincheng 王金城 (Ong Kimseng; b. 1945) Watercolorist, active in Singapore.

Wang Jingfang 王菁芳 (c. 1900–56; native of Xiaox., Anhui) Guohua painter. 1923 grad. from Nanjing Teachers' Coll. 1924–25 studied in NAA Beijing. After 1926 art teacher in Beijing middle school. 1942 part-time lecturer in NAA Beijing. Close friend of Qi Baishi, Li Kuchan. After 1949, lecturer in CAFA.

Wang Jingguo 王景國 (b. 1957, Harbin) Studied in theater design dept. of Shanghai Acad. of Drama. Stage designer and member of the avant-garde movement of 1980s in Shanghai and Beijing.

Wang Jingrong 王鏡蓉 (b. 1919, Zhanghua, Taiwan) Oil painter. Lives and works in Taipei.

Wang Jingsong 王勁松 (b. 1963, Heilongjiang) Painter. 1987 grad. from guohua dept. of NZAFA. Teaching in fine arts dept. of Beijing Normal Univ. in early 1990s. "Cynical realist" and member of avant-garde movement.

Wang Jiqian 王己千 (C. C. Wang; b. 1907, Suzhou) Guohua painter, connoisseur, collector, and art dealer. Trained in Shanghai under Wu Hufan. 1947 settled in New York. 1954 helped Cho Fulai establish Mi Chou Gallery. His career as landscape painter began in early 1960s. 1962–64 head of art dept. of New Asia Coll., Chinese Univ. of Hong Kong.

Wang Jiyuan 王濟遠 (1895–1974) Guohua and xihua painter. Studied under Liu Haisu in Shanghai, then in France and Japan. After returning to China, head of Western painting dept. at Shanghai Meizhuan. 1941 taught in New York and established school of Chinese brushwork.

Wang Junchu 王鈞初 (b. 1905, Henan) Oil painter. Trained in Shanghai Meizhuan. 1925 studied in Beijing Art Inst. 1929 taught in NAA Beijing. 1932 founded Beiping League of Left-Wing Artists. 1933 edited a secret left-wing art magazine. 1939 taught in Lu Xun Art Acad., Yan'an.

Wang Keping 王克平 (b. 1949, Beijing) Sculptor. Self-taught. Prominent activist and founding member of the Stars. Noted for his social satirical works. 1984 settled in Paris.

Wang Li 王里 (b. 1925) Guohua painter of the Lingnan School.

Wang Linyi 王臨乙 (b. 1908; native of Shanghai) Sculptor. 1927–28 studied painting under Xu Beihong in NCU Nanjing. 1928–35 studied in Lyon and Paris. 1937 returned to China, teaching sculpture in NAA Beijing. During WWII prof. and head of sculpture dept., NAA Chongqing. 1946 joined Xu Beihong in NAA Beijing. Since 1949 prof. and head of sculpture dept. of CAFA. Leading member of team that created reliefs for Heroes' Memorial, Tiananmen, Beijing.

Wang Meng 王夢 Oil painter, active from 1920s until 1949. Studied under Li Yishi and Wu Fading. Grad. from NAA Beijing. 1926 became first Chinese to study in Prague Acad. 1938 returned to China. 1948 exhib. of oil portraits, still lifes in Shanghai.

Wang Mengbai. *See* Wang Yun

Wang Panyuan 王攀元 (b. 1911, Jiangsu) Painter. 1936 grad. from Shanghai Acad., where he was student of Liu Haisu, Pan Yuliang, and Pang Tianshou. 1949 moved to Taiwan, where he became an art teacher and professional painter.

Wang Peng 王蓬 (b. 1964, Shandong) Oil painter. 1988 grad. from wall-painting dept. of CAFA.

Wang Ping 王平 Woman sculptor and ceramicist, active in Guiyang in 1980s and 1990s.

Wang Qi 王琦 (b. 1918, Chongqing) Wood-engraver. 1937 grad. from Shanghai Meizhuan. 1938 studied in art dept. of Lu Xun Acad. 1942 founded Chinese Wood-Engravers' Research Assoc. 1948 joined Renjian Huahui in Hong Kong. 1950 taught in art school founded by Tao Xingzhi in Shanghai. 1952 taught in CAFA, engaged in the design work for reliefs for Heroes' Memorial, Tiananmen, Beijing.

Wang Rizhang 王日章 (b. 1905, Fenghuax., Zhejiang) Oil painter. 1926–29 studied oil painting in Paris. 1929 head of Western art dept. of Xinhua Art Acad. and Changming Art Coll., Shanghai. With Pang Xunqin founded Taimeng Painting Soc. in Shanghai. 1937 chairman of All-China Federation of Anti-Japanese Artists. 1947 director of NAA Hangzhou.

Wang Rong 汪溶 (1896–1972) Guohua painter, specializing in birds and flowers. 1930s and 1940s, taught in NAA Beijing.

Wang Senran 王森然 (1895–1984; b. Dingxian, Hebei) Guohua painter, scholar, and critic in Beijing. Prof. at CAFA. Author of several books on Chinese painting.

Wang Shikuo 王式廓 (1911–73; native of Yex., Shandong) Oil painter. 1932 studied Western painting in NAA Beijing. 1933–35 in NAA Hangzhou and Shanghai Meizhuan. 1935–37 studied in Japan. 1938 walked to Yan'an, taught in Lu Xun Acad. 1942 attended the Yan'an Forum on Art and Literature. 1945 did portraits for Mao and Zhu De. After 1950 taught in CAFA.

Wang Shuhui 王叔暉 (1912–85; b. Shaoxing, Zhejiang) Woman guohua painter. Studied in Beijing under Xu Yan-sun and Chen Shaomei. Chiefly a figure painter. After 1949 served in the dept. of new year pictures and serial pictures.

Wang Tong 汪彤 (b. 1955, Hangzhou) Woman oil painter. Studied at NZAFA. 1982 grad. 1983 went to study at Rhode Island College of Design.

Wang Wei 王偉 (1883 or 1884–1950; native of Quyang, Jiangsu) Guohua painter of landscape, birds and flowers, fish, and insects. Trained in Japan, then taught in Shanghai Meizhuan. Member of Bee Painting Soc.

Wang Weibao 王維寶 (b. 1942; native of Jinjiangx., Fujian) Guohua painter and graphic artist. 1959 studied in the middle school affiliated with Canton Acad. of Fine Arts. 1963 entered Canton Painting Acad.

Wang Weixin 王維新 (b. 1938, Zhejiang) Painter and etcher. 1963 grad. from NZAFA. 1978–80 researcher at CAFA, then teacher in graphic arts dept. Did many etchings of Beijing scenes.

Wang Wenming 王問明 Oil painter. Active in 1980s and 1990s in Shanghai.

Wang Wuxie 王無邪 (Wucius Wong; b. 1936, Tongguanx., Guangdong) Painter. Moved to Hong Kong, where he joined the Hong Kong Art Club and in 1956 the Modern Literature and Art Assoc. He studied painting first under Lü Shoukun, then 1961–65 in the U.S. Became assistant curator in the Hong Kong City Hall Museum and Art Gall. After a prominent career as a landscape painter in Hong Kong, he moved in 1984 to the United States.

Wang Xin 王忻 (b. 1957, Beijing) Oil painter. 1982 grad. from CAFA. Salon-style figure and landscape painter. Teaches in Acad. of Chinese Drama, Beijing.

Wang Xuetao 王雪濤 (1903–82; native of Cheng'an, Hebei) Guohua painter. 1919 entered Beijing Higher Normal Coll. 1922–26 studied Chinese painting at NAA Beijing. 1926 taught there. 1954 director of Soc. for Study of Chinese Painting, research fellow of the Research Inst. of Ethnic Arts in CAFA. 1980 head of the Beijing Painting Acad.

Wang Yachen 汪亞塵 (1893–1983; native of Hengx., Zhejiang) Guohua painter. 1915–20 studied Western painting in Tokyo. 1920 taught in Shanghai Meizhuan. 1928–31 in Europe. 1931 director of Shanghai Art Acad.; founded Xinhua Art Teachers' Coll. 1937 sent by Ministry of Education to study crafts in Japan. 1948 studied in U.S., organized exhib. of modern Chinese painting. 1980 returned to China. Noted for his goldfish.

Wang Yidong 王沂東 (b. 1955; native of Linyix., Shandong) Oil painter. Grad. from CAFA, became teacher there. Noted for his portraits and figure studies, especially of the people of his native region.

Wang Yingchun 王英春 (b. 1942, Taiyuan, Shanxi) Woman painter. 1966 graduated from the Chinese painting dept. of Xi'an Acad. of Fine Arts. 1978 attended the Chinese painting grad. program in CAFA; later worked in Beijing Painting Acad.

Wang Yiting. See Wang Zhen

Wang Yongqiang 王永強 (b. 1945, Shanghai) Oil painter, member of Shanghai Oil Painting and Sculpture Inst. In 1980s specialized in realistic paintings on military themes.

Wang Youshen 王友身 (b. 1964, Beijing) Painter and editor of Beijing Youth Daily. Member of post-1989 avant-garde movement.

Wang Yuezhi 王悅之 (Liu Jintang, 1895–1937; b. Taizhong, Taiwan) Guohua painter. 1910 to Japan; entered Kawabata Acad. 1921 grad. from Tokyo Acad. Member of Apollo Soc. 1924 cofounded Beijing College of Art. 1930–34 principal of Beijing Professional Art School.

Wang Yu-jen. See Wang Yuren

Wang Yun 王雲 (Wang Mengbai, 1888–1934; native of Xinfeng, Jiangxi) Guohua painter and Shanghai businessman. Studied painting under Wu Changshuo, later taught in NAA Beijing.

Wang Yuping 王玉平 (b. 1962) Oil painter. Grad. from CAFA, where he became instructor in Fourth Studio.

Wang Yuqi 王玉琪 Oil painter, active 1980s and 1990s. Trained in CAFA.

Wang Yuren 王昱仁 (Wang Yu-jen; b. 1960, Taiwan) Sculptor. Grad. from dept. of sculpture, Nat. Taiwan Acad. of Arts.

Wang Zhen 王震 (Wang Yiting, 1867–1938; native of Wuxing, Zhejiang) Guohua painter. Apprenticed to picture-mounting shop in Shanghai, later became wealthy merchant. Studied under Xu Xiucang and later Wu Changshuo. Member of Haishang Tijingguan and many other guohua societies.

Wang Zhenghua 王征驊 (b. 1937, Henan) Oil painter. 1956–61 student of Wu Zuoren in CAFA. Later studied in Biera, Italy, and in France and England. 1990s living in New York.

Wang Zhijiang 王之江 Sculptor. In the 1930s studied in Japan. Close friend of Qi Baishi, of whom he made a bust in 1954.

Wang Ziwei 王子衛 (b. 1963, Shanghai) Painter. 1983 grad. from Shanghai Inst. of Technology. Worked for advertising agency until 1992, when he became full-time painter. Noted for his "political pop" paintings.

Wang Ziwu 王子武 (b. 1936, Xi'an) Guohua painter. 1963 grad. from Xi'an Acad. Active in affairs of CAA.

Wang Ziyun 王子雲 (1897–?; native of Xiaox., Anhui) Oil painter and sculptor. 1915 studied in Shanghai Meizhuan. 1920 entered NAA Beijing. 1922 taught in Beijing; cofounder of Apollo Soc. and Beijing College of Art. 1928 taught in NAA Hangzhou. 1931 studied sculpture in Paris. 1936 visited England, Belgium, Germany, Italy, and Greece. 1937 returned to China; prof. in sculpture dept., NAA Hangzhou. 1949 prof. of art history, Chengdu Art Acad. 1952 prof. in Northwest Art Acad. and Xi'an Acad.

Wee Beng-chong. See Huang Mingzong

Wei Chuanyi 魏傳義 (b. 1928, Daxian, Sichuan) Guohua painter. Studied in Sichuan Acad., in CAFA, and under Zhang Daqian; later taught in Sichuan Acad. In 1980s became pres. of the Fujian Acad. (South Fujian Branch) in Xiamen.

Wei Ershen 韋爾申 Oil painter. Active in 1980s and 1990s in Beijing.

Wei Guangqing 魏光慶 (b. 1963, Huangshi, Hubei) Painter and performance artist. 1985 grad. from oil painting dept. of NZAFA. Teaches in Hubei Acad. of Fine Arts. Participated in 1989 China/Avant-Garde exhib.

Wei Jia 韋加 (b. 1947) Modern painter trained in Beijing. Later settled in U.S.

Wei Jingshan 魏景山 (b. 1943) Oil painter and wall painter, working in Shanghai. Active from 1980s.

Wei Qimei 韋啓美 (b. 1923, Anhui) Oil painter. Studied in west China in WWII. Has taught for many years in CAFA.

Wei Rong 韋蓉 (b. 1963, Beijing) Photo-realist oil painter. Wife of Wang Hao. 1984 grad. from CAFA, where she became a lecturer.

Wei Tianlin 衛天霖 (1898–1977; native of Beijing) Oil painter. Studied oil painting in Tokyo under Fujishima Takeji and taught in Beijing. An impressionist, much admired by Wu Guanzhong.

Wei Yinru 魏隱儒 (b. 1916; native of Hebei) Guohua painter and calligrapher, active in Beijing. Studied in NAA Beijing. Pupil and close associate of Li Kuchan. Member of many painting and calligraphy soc.

Wei Zixi 魏子熙 (b. 1915; native of Suiping, Henan) Guohua painter. Member of Jiangsu Chinese Painting Acad., Nanjing. Close to Fu Baoshi. Landscapes and figures.

Wen Lipeng 聞立鵬 (b. 1941) Oil painter, son of Wen Yiduo. Studied in CAFA. Prof. in Fourth Studio, CAFA. 1989 one-man show in Paris.

Wen Lou 文樓 (Van Lau; b. 1933, Vietnam) Sculptor. 1959 grad. from fine arts dept., NTNU. 1960 settled in Hong Kong, where in 1982 he became president of the Hong Kong Sculptors Assoc. Has executed many commissions, chiefly in metal, for public buildings in Hong Kong, Europe, America, and Asia.

Wen Yiduo 聞一多 (1899–1946; native of Xishui, Hubei) Painter and writer. Studied classical literature at Qinghua Univ. 1922 entered Art Inst. of Chicago, immersed himself in English poetry while studying art. 1923 transferred to Colorado Coll., then Art Students' League, New York. 1925 returned to China, gradually giving up painting for literature and poetry. Assassinated by KMT agents in Kunming.

Weng Chenghao 翁承豪 Printmaker. Active in Nanjing in 1980s and 1990s.

Weng Tonghe 翁同龢 (1830–1904; native of Jiangsu) Guohua painter and calligrapher. Reformist and tutor to Guangxu emperor.

Wong, Harold. See Huang Zhongfang

Wong Po Yeh. See Huang Bore

Wong, Wucius. See Wang Wuxie

Woo, Nancy Chu. See Zhu Chuzhu

Wu Buyun 伍步雲 (b. 1904 in China) Oil painter. 1931 grad. from Univ. of Philippines, Manila. 1979–80 visiting prof. in CAFA. In 1970s emigrated to Canada.

Wu Changjiang 吳長江 Wood-engraver. Active in 1980s and 1990s.

Wu Changshuo 吳昌碩 (1844–1927; native of Anjix., Zhejiang) Guohua painter, seal-engraver, calligrapher, and poet. 1865 passed civil service examinations, practiced seal-engraving. 1877 started to learn painting under Zhang Xiong in Shanghai. 1896 magistrate of Andong district for one month. 1903 chairman of Xiling Seal-Engraving Soc. Dominant figure in the Shanghai School.

Wu Chengyan 吳承硯 (Wu Ch'eng-yen; b. 1921, Jiangsu) Oil and watercolor painter. Studied under Xu Beihong in NCU Nanjing. 1990s prof. in Univ. of Chinese Culture, Taipei.

Wu Dacheng 吳大澂 (1835–1902) Amateur guohua painter, calligrapher, archaeologist, and collector. Qing official. Grandfather of Wu Hufan.

Wu Dayu 吳大羽 (1903–88; native of Chaoyang, Guangdong) Oil painter. 1922–27 studied in Paris. On his return to China, taught at NAA Hangzhou, then deputy director of Shanghai Coll. of Art. After WWII rejoined NAA Hangzhou. Spent his last years in retirement in Shanghai.

Wu Deyi 伍德彝 (1854–1920; native of Canton) Guohua painter. Student of Ju Lian.

Wu Dongcai 吳棟材 (1910–81; b. Taipei) Oil painter. Pupil of Li Shijiao. Lived and worked in Taipei.

Wu Fading 吳法鼎 (1888–1924; native of Xinhui, Guangdong) Painter. 1911 went to Europe to study law but abandoned it for painting. One of the first Chinese painters trained in France. 1919 returned to China. After 1920 taught at Shanghai Meizhuan. 1922 cofounder of Apollo Soc. 1926 joined Painting Methods Research Soc., Beijing. Helped to establish NAA Beijing.

Wu Fan 吳凡 (b. 1924, Chongqing, Sichuan) Painter and graphic artist. 1944 entered NAA Chongqing to study guohua under Pan Tianshou and Li Keran. 1946 moved to Hangzhou, studied oil painting under Ni Yide. 1948 grad., returned to Chongqing. 1949 worked in fine arts section of Chongqing Municipal Culture Assoc. From 1950 did illustrations, cartoons, and graphic work.

Wu Fuzhi 吳弗之 (1900–77; b. Pujianx., Zhejiang) Guohua painter. Before WWII taught in Shanghai. After 1945 became prof. in NZAFA and head of the Chinese painting dept.

Wu Guanzhong 吳冠中 (b. 1919, Yixing, Jiangsu) Guohua and oil painter. 1937–42 studied in NAA Hangzhou under Pan Tianshou and Lin Fengmian, went to Yunnan and Sichuan with the Acad. 1942–46 taught in art dept. of Qinghua Univ. 1946–50 studied oil painting in Paris. 1950 taught in CAFA. 1955–64 taught oil painting in Beijing Fine Arts Normal Coll. 1964–74 taught at CAAC. Since 1980 his paintings have been widely exhibited in different countries. 1992 one-artist exhib., British Museum, London. Now prof. in CAFA.

Wu Hao 吳昊 (b. 1931, Nanjing) Oil painter, abstract expressionist style. Trained in Nanjing. 1947 moved to Taiwan. 1956 founder of the Ton Fan group. From 1963 began printmaking.

Wu Hufan 吳湖帆 (1894–1970; native of Wuxi) Guohua painter, calligrapher, and connoisseur. Grandson of Wu Dacheng. 1922 settled in Shanghai. Founder of Zhengshe Calligraphy and Painting Soc.; students included Xu Bangda. 1956 member of Shanghai Chinese Painting Acad. Leading member of Shanghai circle of traditional painters and connoisseurs.

Wu Jian 吳健 (b. 1942, Hangzhou) Oil painter. Studied in Shanghai Acad. of Fine Arts. Taught in Shanghai until 1986, when he moved to the U.S. Studied at first in the San Francisco Acad. of Art, and later at the Art Students' League in New York.

Wu Jingding 吳鏡汀 (1904–72; b. Beijing) Guohua painter. Had a long teaching career in Beijing, specializing in landscapes.

Wu Junfa 吳俊發 (b. 1927, Guangfengx., Jiangxi) Printmaker and art critic. Early 1940s, took correspondence course of All-China Woodcut Assoc. After 1943 started to make prints. 1946 joined China National Wood-Engravers Assoc. and

entered Zhengze Art Coll., Jiangsu; studied under Lü Feng-zi. After 1949 worked for art section in the army. After 1977 deputy-director of Jiangsu Provincial Art Gall.

Wu Puhui 吳璞輝 (Pansy Ng; b. 1937, Hong Kong) Painter. Studied under Lü Shoukun and from 1961 in Columbus, Ohio.

Wu Shanming 吳山明 Guohua painter, chiefly of figures. Teacher in NZAFA.

Wu Shanzhuan 吳山專 (b. 1960, Zhoushan, Zhejiang) Painter and installation artist. 1984 grad. from NZAFA. Member of avant-garde movement; now lives and works in Germany.

Wu Shiguang 鄔始光 Painter and graphic artist, active until early 1920s. Studied under Zhou Xiang in Shanghai. Founder in 1914 with Wang Yachen and others of Dongfang Huahui, a pioneer studio dedicated to Western methods of drawing and painting.

Wu Shixian 吳石僊 (?–1916; native of Changnong, Jiangsu) Guohua painter, noted for his use of Western techniques to achieve an atmospheric effect.

Wu Shuyang 吳叔養 (1901–66; b. Hangzhou) Guohua painter. Studied in Japan. After 1949 became prof. in Lu Xun Acad.

Wu Xiaochang 吳小唱 (b. 1940, Shouguangx., Shandong) Oil painter. 1986 lecturer in CAFA.

Wu Xuansan 吳炫三 (b. 1942, Yilan, Taiwan) Oil painter. 1968 grad. from art dept. of NTNU, and in 1973 from Escuela Superior de San Fernando, Madrid. Has lived, worked, and exhibited in Europe, Africa, and the U.S.A. Abstract expressionist.

Wu Yaozhong 吳耀忠 (Ng Yiu-chung; b. 1935, Hong Kong; native of Canton) Painter. Studied in Chinese Univ. of Hong Kong. 1968 studied under Lü Shoukun. One of the founders of In Tao group.

Wu Yongxiang 吳詠香 (1913–70; native of Minhou, Fujian) Woman guohua painter. Studied under Qi Baishi and Pu Ru. 1954 succeeded Pu Ru in teaching post at NTNU.

Wu Youru 吳友如 (1850–93) Graphic artist in Shanghai. Edited *Dianshizhai Huabao*.

Wu Zheng 吳徵 (1878–1963) Guohua painter, Shanghai School. Pupil of Wu Changshuo.

Wu Zuoren 吳作人 (b. 1908, Jiangyin, Jiangsu; native of Jingx., Anhui) Guohua and oil painter. 1927 entered Shanghai Univ. of Arts; 1928 transferred to Nanguo Acad. under Xu Beihong, later joined Nanguo Soc. organized by Tian Han. 1928 studied under Xu Beihong in NCU Nanjing. 1929–30 studied in France, then in Royal Brussels Acad., Belgium. 1931 awarded Gold Medal. 1935 returned to China; lecturer in dept. of fine arts, NCU Nanjing. During WWII moved to Chongqing, toured Qinghai and Tibet. 1946 back to Shanghai, organized the Shanghai Artists Assoc., joined Xu Beihong as prof. and provost of NAA Beijing. After 1949 held various leading posts at CAFA and as acting pres. of CAA.

Xi Dejin 席德進 (Shiy De Jiun, 1923–81; b. Sichuan) Oil and watercolor painter. 1941 entered Sichuan Prov. Acad. of Art in Chengdu; pupil of Pang Xunqin. 1943 studied in NAA Chongqing, then Hangzhou. 1948 went to Taiwan. 1957–66 studied in France. Returned to work in Taiwan.

Xia Biquan 夏碧泉 (Ha Bik-chuen; b. 1925, Xinhuix., Guangdong) Sculptor and printmaker. Settled in Hong Kong in 1967, since when he has exhibited widely in Asia, Australia, Europe, and the U.S.

Xia Feng 夏風 Wood-engraver, active in 1930s and 1940s in Yan'an and liberated areas.

Xia Peng. *See* Yao Fu

Xia Xiaowan 夏小萬 (b. 1959, Beijing) Oil painter. 1982 grad. from oil painting dept. of CAFA. 1993 teaching in Central Acad. of Drama, Beijing. Member of post-1989 avant-garde movement

Xia Yang 夏陽 (Xia Yan; b. 1932, Nanjing) Oil painter. 1963 went to Paris. Founded the international art group Ton Fan; member of Gruppo Ta in Italy. Became a Photo-realist.

Xiao Ding. *See* Ding Cong

Xiao Feng 蕭峰 (b. 1932, Jiangsu) Oil painter. 1953–60 studied oil painting in USSR, then taught in NZAFA. For some time director of oil painting studio in Shanghai. Since 1983 president and prof. in NZAFA.

Xiao Haichun 蕭海春 (b. 1944, Jiangsu) Jade carver and guohua painter. Trained in Shanghai Acad. of Arts and Crafts as a jade designer and carver; later became a largely self-taught painter. Vice pres. of CAAC.

Xiao Huixiang 蕭惠祥 (b. 1933, Changsha, Hunan) Woman painter. Worked on Beijing Airport decoration.

Xiao Lu 蕭魯 Painter and installation artist. Daughter of Xiao Feng. Active in Hangzhou. Creater with Tang Song of the controversial *Dialogue* at avant-garde exhibition of 1989. Emigrated to Australia.

Xiao Qin 蕭勤 (b. 1931, Shanghai) Oil painter. Went to Taiwan. 1956 studied modern painting in Spain; founding member of Ton Fan group. 1961 cofounder of "Punto" movement in Milan, later settled in New York.

Xiao Shufang 蕭叔芳 (b. 1911, Zhongshanx., Guangdong) Guohua painter, wife of Wu Zuoren. 1925 studied Chinese painting under Weng Shenzhi. 1926 studied Western painting in NAA Beijing. 1929 moved to art dept. of NCU Nanjing, studied under Xu Beihong. 1937–40 studied at Slade School, London. During WWII in west China. 1947 part-time assoc. prof. at NAA Beijing. After 1949 assoc. prof. at CAFA.

Xiao Sun 蕭愻 (1883–1944; native of Huaining, Anhui) Guohua painter. Student of Jiang Yun. 1920 one of the founders of Painting Methods Research Soc., Beijing. Later prof. in NAA Beijing.

Xie Gongzhan 謝公展 (1884–1952; native of Dantu, Jiangsu) Guohua painter of birds, insects and flowers, esp. chrysanthemum. Active in Shanghai.

Xie Haiyan 謝海燕 (1910–?; native of Jieyang, Guangdong) Guohua painter. 1927 entered art school in Canton. 1928 studied Western painting in Zhonghua Art Univ. under Cheng Wangdao and Chen Baoyi, then in Japan. 1931 returned to China. 1934 prof. at Shanghai Meizhuan. 1939 acting director of Shanghai Meizhuan when Liu Haisu, his close friend, was in Europe. During WWII in west China. 1944 taught in NAA Chongqing. 1945 deputy director of Shanghai Coll. of Fine Arts. 1952 prof. and head of art dept. in East China Art Coll. 1979 vice president of Nanjing Acad. of Art.

Xie Jinglan 謝景蘭 (Lalan Hsieh Ching-lan; b. 1924 in China) Woman painter, musician, choreographer, dancer and poet. Studied in NAA Hangzhou, then in Paris. Lives and works in Paris.

Xie Qusheng 謝趣生 (1906–59; native of Sichuan) Cartoonist. Active chiefly in Sichuan in 1930s and 1940s. Stopped producing cartoons in 1951.

Xie Xiaode 謝孝德 (b. 1940, Taoyuan, Taiwan) Oil painter. 1965 grad. from art dept. of NTNU. 1973–74 studied in Paris. Works in Taiwan.

Xie Yuqian 謝玉謙 (Chia Yu Chian; b. 1936, Johore, Malaysia) Oil painter. Studied in Nanyang Acad., Singapore. 1959

went on scholarship to Paris, where he studied for two years at Ecole Nat. Sup. des Beaux Arts. After retiring to Malaysia, he finally settled in Paris.

Xie Zhiguang 謝之光 (1900–76; b. Yuyao, Zhejiang) Guohua painter. Active in Suzhou and Shanghai, where he was a member of the Bee Painting Soc.

Xie Zhiliu 謝稚柳 (b. 1910, Changzhou, Jiangsu) Guohua painter and connoisseur. 1937 went to Chongqing, became close friend of Zhang Daqian; 1942 visited Zhang in Dunhuang. Prof. in art dept. of NCU Chongqing. After WWII in Shanghai, where in 1949 he became advisor to Shanghai Museum. 1979 prof. in Shanghai Acad.

Xin Haizhou 忻海洲 (b. 1966, Chengdu) Painter. 1989 grad. from Sichuan Acad. of Fine Art, where he became a teacher. Member of post-1989 avant-garde movement.

Xing Fei 邢飛 (b. 1958, Beijing) Woman painter. 1978–82 studied Chinese painting in CAFA. 1984 settled in New York.

Xiong Bingming 熊秉明 (b. 1922, Nanjing) Sculptor and landscape painter. Studied philosophy in Southwest United Univ. 1947 to Paris, where he studied sculpture under Zadkine and others. Settled in Switzerland, later returned to Paris.

Xu Anming 徐安明 (b. 1960, Beijing) Self-taught professional artist. Member of post-1989 avant-garde movement.

Xu Beihong 徐悲鴻 (1895–1953; b. Yixingx., Jiangsu) Painter in both guohua and Western style. At 17 art teacher in primary and middle school on Yixing. 1914 went to Shanghai, was helped by Gao Jianfu and his brother Gao Qifeng; entered Zhendan Univ. and studied French at Siccawei. 1917 six months in Japan. Appointed tutor in Painting Methods Research Soc. of Beijing Univ. by Cai Yuanpei. 1919 went to Paris, studied in Ecole Nat. Sup. des Beaux Arts. 1921–23 in Berlin. 1925 visited and painted in Singapore, then returned to Shanghai. 1926–27 studied and travelled in Europe. 1927 returned to China; head of art dept. of Nanguo Art Inst. 1928 head of art dept. of NCU Nanjing. 1933–34 organized modern Chinese painting exhibs. in France, Italy, Germany, and Soviet Union. 1935 went to Guangxi to set up art academy. During WWII travelled twice to Southeast Asia to raise funds for war relief by holding exhibs. and selling paintings. 1940 invited by Tagore to visit and lecture in India. 1942 organized Chinese Art Research Inst. at Panxi, Sichuan. 1946 president of NAA Beijing. 1949 attended world peace conference in Prague, pres. of CAFA, pres. of CAA.

Xu Bing 徐冰 (b. 1955, Chongqing, Sichuan) Wood-engraver, printmaker, and installation artist. 1977 entered CAFA; 1987 M.A.; 1988 instructor in CAFA. 1990 hon. fellow in art dept., Univ. of Wisconsin, Madison. Became active in New Wave of 1985. His *Tian shu* (A book from the sky) was featured in 1988 and again in the avant-garde exhib. of 1989, since when he has completed *Ghosts Pounding the [Great] Wall* (1990).

Xu Gu 虛谷 (1824–96; b. Xin'an, Anhui) Guohua painter. Escaped involvement in the Taiping rebellion by becoming a monk, spent most of his time in Suzhou and Yangzhou. Was influential in the Shanghai School with Ren Bonian, Hu Gongshou, and Wu Changshuo. Noted for his fish, plants, vegetables, and small landscapes.

Xu Hong 徐虹 (b. 1957, Shanghai) Woman painter. Member of Shanghai modern movement in 1980s.

Xu Jianguo 徐建國 (b. 1951, Shanghai) Studied at Shanghai Acad. of Drama. 1984 went to study in U.S. 1987 M.F.A., Bard College. Artist in residence for New York Foundation of the Arts. Abstract expressionist.

Xu Jin 徐進 Painter. Member of *Xin kongjian* (New Space) group, active in Beijing in mid-1980s.

Xu Kuang 徐匡 (b. 1938, Changsha, Hunan) Graphic artist and oil painter. 1958 grad. from middle school attached to CAFA. Engaged in graphic work in Chongqing branch of CAA, member of Chinese Graphic Artists Assoc., deputy-director of Chongqing branch of CAA.

Xu Lei 徐累 (b. 1963, Nantong, Jiangsu) Painter and writer on modern Chinese art and aesthetics. 1963 began to study guohua in Nanjing Chinese Painting Acad. Active in the avant-garde movement of 1988–89.

Xu Linlu 許麟盧 (b. 1916, Bohai, near Tianjin) Guohua painter and art expert. 1938 met Li Kuchan and through him Qi Baishi, whose last student he became. Paints landscapes in a dashing style.

Xu Mangyao 徐茫耀 (b. 1945, Shanghai) Painter. 1980 M.A. from NZAFA; from 1981 artist in residence and teacher at NZAFA. 1984–86 studied in Pierre Cardon studio, Paris. From being a realist oil painter, became a hyperrealist and surrealist member of the avant-garde.

Xu Wuyong 許武勇 (b. 1920, Tainan, Taiwan) Painter. Studied medicine and art in Tokyo. Later returned to Taiwan, where he was a pioneer cubist.

Xu Xi 徐希 (b. 1940, Shaoxing, Zhejiang) Guohua painter, trained in NZAFA. Staff member of People's Art Publishing House.

Xu Xinzhi 許辛之 (b. 1904, Yangzhou, Jiangsu) Oil painter. 1927 studied in Tokyo. On returning to China joined the Northern Expedition Army. After arrest and release by Guomindang, continued study in Japan. 1929 back to China, taught Western painting in Zhonghua Art Univ., joined the League of Left-Wing Artists. 1934–35 art designer for Tianyi Film Studio. 1940 taught in Lu Xun Acad. 1942 prof. of art in Zhongshan Univ. 1954 prof. at CAFA.

Xu Xuebi 許雪碧 (Pat Hui Suet-bik; b. 1943, Hong Kong) Studied philosophy at Hong Kong Univ., later art history. 1975–80 worked in silk-screen printing and fashion design. 1980 to Minneapolis. Established Hui Arts to print and exhibit contemporary Chinese art, esp. the work of Wucius Wong, with whom she collaborated in painting and calligraphy.

Xu Yangcong 徐陽聰 (Onion Shyu; b. 1953, Taiwan) Sculptor. 1979 grad. from dept. of sculpture, NTNU.

Xu Yansun 徐燕蓀 (1898–1961; b. Beijing) Guohua painter, active chiefly in Beijing.

Xu Yongqing 徐詠青 Painter. Student of Zhou Xiang. Made reputation as painter of calendars. Active in early 20th century.

Xu Zixiong 徐子雄 (Chui Tze-hung; b. 1936, Hong Kong) Guohua painter. Guest lecturer in Dept. of Extramural Studies, Hong Kong Univ. and Hong Kong Polytechnic.

Xue Baoxia 薛保瑕 (b. 1956, Taizhong, Taiwan) Oil painter. 1975 grad. from art dept. of NTNU. 1983 M.F.A. from Pratt Institute, Brooklyn. Works and exhibits in New York and in Taipei, where she is an art teacher.

Ya Ming 亞明 (Ye Yaming; b. 1924; native of Hefei, Anhui) Guohua painter. 1941 studied painting in Huainan Art Coll., then painted posters and cartoons and made prints. 1953 started to paint guohua. 1956 vice-chairman of Jiangsu branch of CAA. 1958 vice pres. of Jiangsu Chinese Painting Acad. 1978 leader of Chinese painters group visiting Pakistan. 1980 visited Japan. Dominant member of Jiangsu Artists' Assoc., Nanjing.

Yan Di 顏地 (1920–79; b. Rongchang, Shandong) Guohua painter. Active in cultural activities, chiefly in Beijing.

Yan Han 顏涵 (b. 1916, Donghaix., Jiangsu) Printmaker and graphic designer. 1935 entered painting dept. of NAA Hangzhou under Lin Fengmian and Pan Tianshou. 1938 studied in Lu Xun Acad., Yan'an. 1943 taught and made prints there. 1946–48 taught art in N. China Univ. 1949 taught in NZAFA. 1953 worked in CAA. 1961 taught in Beijing Teachers' Coll. 1980 prof. at CAFA. In 1980s his work became more abstract.

Yan Jiyuan 晏濟元 (b. 1901, Neijiang, Sichuan) Guohua painter. Childhood friend of Zhang Daqian. Worked chiefly in Chongqing.

Yan Li 嚴力 (b. 1954, Beijing) Modern painter and poet. Chiefly self-taught. 1979 and 1980, exhibited twice with the Stars. 1984 one-man show in the gall. of the People's Park in Shanghai. 1985 went to New York to study.

Yan Shuilong 顏水龍 (b. 1903; native of Taiwan) Oil painter. 1922–27 studied in Tokyo, 1929–32 in France. Thereafter worked in Taipei, where in addition to painting he took up handicrafts..

Yan Wenliang 顏文梁 (1893–1988; native of Suzhou) Oil painter. 1919 founded a nationwide painting competition, which lasted for 20 years. 1922 founder of Suzhou Art Coll. 1928–31 studied in Paris. 1931–37 principal of Suzhou Acad. 1933–35 also taught in art dept. of NCU Nanjing. 1940–44 prof. in Zhejiang Univ., Shanghai. 1952 prof. and vice-pres. of NZAFA.

Yang Bailin 楊柏林 (Yang Bor-lin; b. Yunlin, Taiwan) Self-trained sculptor. In early years carved images for Buddhist temples. Later matured as an abstract sculptor, chiefly in bronze. Works in Taiwan.

Yang Chihong 楊熾宏 (b. 1947, Taiwan) Oil painter. 1980 settled in New York.

Yang Feiyun 楊飛雲 (b. 1954; native of Baotou, Inner Mongolia) Oil painter. Grad. and staff member of CAFA. Noted for his figures and portraits.

Yang Guanghua 楊光華 (b. 1940) Guohua painter. Teaches in Inst. of Minorities; paints figures and landscapes in wet and splashed ink.

Yang Jiachang 楊嘉昌 (A Yang) Wood-engraver. One of the founders of the Woodcut Movement. With Ye Fu, ran the Wood-Engraving Tool Cooperative Factory in Shanghai.

Yang Lizhou 楊力舟 (b. 1942; native of Linyi, Shanxi) Guohua and oil painter. Studied in Xi'an Acad. Member of Chinese Painting Research Inst., Beijing.

Yang Mingyi 楊明義 (b. 1943; native of Suzhou) Guohua and watercolor painter and printmaker, working in Suzhou. Since 1984 has exhibited in England and Japan. Member of Suzhou Chinese Painting Acad.

Yang Mingzhong 楊明忠 (b. 1957, Taiwan) Sculptor. Grad. from dept. of sculpture, Nat. Taiwan Acad. of Arts.

Yang Qiuren 楊秋人 (1907–83, Guilin) Oil painter. 1928 entered Shanghai Meizhuan. Studied painting under Chen Baoyi and with Pang Xunqin in Storm Soc. During WWII returned to Guilin. 1949 member of Renjian Huahui in Hong Kong. After 1949 prof. at Zhongnan Art Coll. in Canton. Vice pres. of Canton Art Acad.

Yang Sanlang 楊三郎 (b. 1908; native of Taipei) Oil painter. 1931 grad. from Kyoto Coll. of Arts and Crafts, Japan. 1932–33 studied in Paris, then returned to Japan. 1946 went back to Taiwan, founded the Taiyang Art Soc. Later prof. at the Nat. Art Acad, Taipei.

Yang Shanshen 楊善深 (b. 1913; native of Chiqix., Guangdong) Guohua painter. 1935–38 studied art at the Domoto Art Inst., Japan. 1941 moved to Macao, organized the Xie-she Art Soc. with Gao Jianfu. 1949 settled in Hong Kong. 1988 moved to Vancouver.

Yang Taiyang 楊太陽 (b. 1909; native of Guilin) Guohua painter. 1928 studied in Shanghai Meizhuan. 1931 studied in Chen Baoyi's studio in Shanghai. 1931 organized Storm Soc. with Pang Xunqin, Ni Yide. 1935–37 studied in Japan. 1941 in Guilin. 1949 joined Renjian Huahui in Hong Kong. 1959 headed the fine arts dept. of Guangxi Art Acad.

Yang Xianrang 楊先讓 (b. 1930, Shandong) Printmaker. 1952 grad. from NAA, then assoc. prof. and head of the dept. of new year pictures and picture studies. Noted for his *shuiyin* and embossed prints.

Yang Xingsheng 楊興生 (b. 1938, Jiangxi) Oil painter. Grad. from NTNU art dept. Lives and works in Taipei. Abstract expressionist.

Yang Xuemei 楊雪梅 (b. 1952, Taipei) Woman pastel and abstract painter. In 1980s a staff member of Nat. Palace Museum, Taipei.

Yang Yanping 楊燕屏 (b. 1934, Beijing) Woman painter. Grad. in architecture from Qinghua Univ. Married to painter Zeng Shanqing. Member of Beijing Acad. of Painting. 1986 settled in Stony Brook, N.Y. Has exhib. widely in the U.S., Japan, Europe, Taiwan, and Hong Kong.

Yang Yanwen 楊燕文 (b. 1939) Oil painter and guohua land-scape painter.

Yang Yichong 楊鵏狆 (Yeung Yick-chung; b. 1921, Jieyangx., Guangdong) Guohua painter. 1949 settled in Hong Kong.

Yang Yingfeng 楊英風 (Yuyu Yang; b. 1926, Yilan, Taiwan) Sculptor. Studied in Tokyo Acad. of Arts, then in Furen Univ. in Beijing. Later went back to Taiwan. 1961–64 studied sculpture in Rome. 1963 returned to Taiwan. Noted for his monumental work in metal and for his laser sculpture.

Yang Yiping 楊益平 (b. 1947, Beijing) Amateur artist. 1979–80 member of Stars.

Yang, Yuyu. *See* Yang Yingfeng

Yang Zhiguang 楊之光 (b. 1930, Shanghai; native of Canton) Guohua painter, Lingnan School. 1950 studied in CAFA under Xu Beihong. In 1980s prof. in Canton Acad.

Yang Zhihong 楊識宏 (b. 1947, Taoyuan, Taiwan) Oil painter and printmaker. 1968 grad. from Nat. Fine Arts Acad., Taipei. 1976 went to New York to study printmaking; settled there. Wrote *The New Trend in Modern Art*.

Yao Fu 姚夫 (Xia Peng; ?–1936) Woman wood-engraver. Married to Hu Yichuan. Died in prison.

Yao Hongzhao 姚宏照 (Yeo, Thomas; b. 1936, Singapore) Painter of landscapes and abstractions. Grad from Nanyang Acad., Singapore. 1960–64 studied at Chelsea School of Art and Hammersmith College of Art and Architecture, London.

Yao Hua 姚華 (1876–1930; native of Guiyang, Guizhou) Guohua painter of landscape, flowers, religious images, and figures. Studied law in Japan. Prof. in NAA Beijing. One of the "eight masters of the early Republic" in Beijing.

Yao Qingzhang 姚慶章 (b. 1941, Taiwan) Photo-realist. Works in the U.S.

Yao Yuan 姚遠 (b. 1952, Ningbo, Zhejiang) Oil painter. Trained in Beijing. Specializes in borderland subjects.

Yao Zhonghua 姚鍾華 Oil painter, active 1970s and 1980s.

Ye Fu 野夫 (Zheng Chengzhi; native of Leqing, Zhejiang) Wood-engraver. Studied in Shanghai Meizhuan, organized Wild Wind Painting Soc. Joined Eighteen Art Soc. 1936 organized the Third Nat. Travelling Woodcut Exhib. with Li Hua.

Ye Gongchuo 葉恭綽 (1881–1968; native of Panyu, Guangdong) Guohua painter, esp. of bamboo. Calligrapher and govt. official. 1920 prof. in Jiaotong Univ. 1926 official and prof. of Nat. Art Exhib. 1933 joined the staff of Shanghai Museum. 1934 on committee for Exhib. of Chinese Art at Royal Acad., London. 1942 lived in retirement in Shanghai.

Ye Qianyu 葉淺予 (1907–95; native of Tonglux., Zhejiang) Self-taught painter. 1937 in charge of All-China Assoc. of Cartoonists for Nat. Salvation. Studied guohua in Sichuan with Zhang Daqian. 1945 visited India with dancer Dai Ailian. After 1949 head of Chinese painting dept. of NZAFA.

Ye Yaming. *See* Ya Ming

Ye Yongqing 葉永青 (b. 1958, Kunming) Painter. 1982 grad. from Sichuan Acad. of Fine Arts, where he became lecturer in education dept. Active in avant-garde movement.

Ye Yushan 葉毓山 (b. 1935, Deyangx., Sichuan) Sculptor. 1956 grad. from sculpture dept. of Sichuan Acad. of Fine Arts, Chongqing; became a teacher there. 1960 joined sculpture research class of CAFA. 1977 group leader for team that designed statue of Mao in Mao's Memorial Hall. 1978 deputy director of Sichuan Acad; 1983 director. Designed "Four Seasons" figures for Yangzi Bridge, Chongqing.

Ye Ziqi 葉子奇 (b. 1957, Hualien, Taiwan) Oil painter. Studied Western painting in Taipei. 1989 M.F.A., Brooklyn College. Has participated in exhibitions in Taipei, Hong Kong, and New York.

Yeo, Thomas. *See* Yao Hongzhao

Yeung Yick-chung. *See* Yang Yichong

You Jingdong 尤勁東 Illustrator of serial picture books; active in 1980s and 1990s.

You Shaozeng 尤紹曾 (Jackson Yu; b. 1911, Sichuan) Amateur painter and businessman. 1963 opened one of the first modern oil painting galleries in Hong Kong. Member of Circle group. After some years practicing guohua he became an expressionist, influenced by German expressionism.

Yu Ben 余本 (b. 1899, Taishan, Guangdong) Oil painter. 1918 went to Canada. 1928 entered Winnipeg Art School to study oil painting. 1929 transferred to Ontario Prov. Coll. of Art. 1936 returned to China, opened Yuben Studio in Hong Kong. 1956 settled in Canton, later vice pres. of Canton Painting Acad.

Yu Chengyao 余承堯 (b. 1898; native of Fujian) Guohua painter. Self-taught. Army officer; rose to rank of general in Guomindang army. Amateur musician. Took up painting after his retirement in Taiwan, developing an individualistic style inspired by classical models.

Yu Fei'an 于非闇 (1889–1959; b. Beijing; native of Penglai, Shandong) Guohua painter of *gongbi* flowers and birds. After 1949 devoted most of his time painting and teaching. Vice-chairman of Beijing Painting Research Soc., and vice-director of Beijing Painting Acad.

Yu Feng 郁風 (b. 1916; native of Fuyang, Zhejiang) Woman oil painter; niece of Yu Dafu, wife of Huang Miaozi. Studied oil painting in NCU Nanjing. 1938–41 lived in Hong Kong. 1944 joined Xu Beihong's Art Inst. in Chongqing. In 1950s and 1960s worked for CAA. Later taught in CAFA. 1990 settled in Brisbane, Australia, with her husband.

Yu, Jackson. *See* You Shaozeng

Yu Jianhua 俞劍華 (b. 1895; native of Jinan, Shandong) Painter, calligrapher, art historian, and critic. Active chiefly in Beijing. Author of *Zhongguo huihua shi* (History of Chinese Painting, 2 vols., 1937) and other works.

Yu Jifan 俞寄凡 Painter, trained in Japan. 1926 active in Shanghai, cofounder of Xinhua Art Acad. Member of the Bee Painting Soc.

Yu Peng 于彭 (b. 1955, Taipei, Taiwan) Guohua painter, sculptor, and ceramicist. Studied under Chen Yigeng, Zhang Mingshuo, and Xu Funeng. 1980 first one-artist show in Taipei. 1981 visited Europe. Individualist.

Yu Rentian 余任天 (native of Zhejiang) Guohua painter, esp. of landscapes. Friend of Huang Binhong. Active in Shanghai, later in NZAFA.

Yu Shichao 虞世超 (b. 1953, Shanghai) Guohua and oil painter. Studied ink painting under Cheng Shifa in Shanghai; later concentrated on oils. 1989 settled in U.S.

Yu Youhan 余友涵 (b. 1943, Shanghai) Painter. 1970 grad. from Central Inst. of Technology, Beijing. 1993 teaching at Shanghai Inst. of Industrial Arts. A key figure in the post-1989 Political Pop movement.

Yu Zhixue 于志學 (b. 1935, Heilongjiang) Guohua painter. Lives in north China. Specializes in snow and ice landscapes.

Yuan Chin-taa. *See* Yuan Jinta

Yuan Dexing 袁德星 (Ch'u Ko, Chu Ge; b. 1931, Hunan) Guohua painter, poet, and art critic. Joined KMT army during WWII. 1949 to Taiwan. Largely self-taught; also attended night classes, grad. 1967. Curator in bronze section of Nat. Palace Museum, Taipei. Since 1985 has visited the U.S. and Europe many times.

Yuan Jinta 袁金塔 (Yuan Chin-taa; b. 1949, Zhanghua, Taiwan) Guohua, oil, and watercolor painter. 1975 grad. from NTNU art dept.; M.F.A., City Univ. of New York. Instructor in NTNU. Expressionist.

Yuan Shun 袁順 (b. 1961, Shanghai) Painter. Trained in dept. of fine arts of PLA Art Inst., Beijing. From 1986 teaching in Shanghai Acad. of Art. Late 1980s, leading member of Shanghai avant-garde.

Yuan Yunfu 袁運甫 (b. 1933, Nantong, Jiangsu) Painter. Brother of Yuan Yunsheng. 1949 entered NAA Hangzhou, studying oil painting. 1952–54 postgrad. student at CAFA. 1956 joined staff of CAAC. 1979 did murals in Beijing Airport. 1980–81 did large mural for Jianguo Hotel, Beijing.

Yuan Yunsheng 袁運生 (b. 1937; native of Jiangsu) Painter. Brother of Yuan Yunfu. 1955 studied in CAFA, influenced by Dong Xiwen. 1962–67 artist in Workers' Cultural Palace in Changchun, then exiled to countryside. 1979 recalled to paint mural for Beijing Airport. 1981 visited Dunhuang. 1983 visiting artist in residence in several universities in U.S. From 1987 freelance artist in New York.

Zao Wou-ki. *See* Zhao Wuji

Zeng Fanzhi 曾凡志 (b. 1964, Wuhan) Oil painter. 1991 grad. from Hubei Acad. of Fine Arts. Member of the avant-garde movement of the early 1990s. A full-time professional painter.

Zeng Jingwen 曾景文 (Dong Kingman; b. 1911, Oakland, California) Western-style watercolor painter. 1916 moved with his family to Canton. 1942 settled in New York.

Zeng Shanqing 曾善慶 (b. 1932, Beijing) Oil and guohua painter. 1950 grad. from CAFA, became research student under Xu Beihong. Later taught in Qinghua Univ. After much suffering in Cultural Revolution, joined staff of CAFA. 1986 settled on Long Island, New York, with his wife, painter Yang Yanping.

Zeng Wu 曾嗚 Painter and poet, active in 1930s. Stayed in Japan for some time. 1934 founded China Independent Art Research Inst. in Tokyo. The same year returned to China, founded Chinese Independent Art Assoc. in Shanghai.

Zeng Xi 曾熙 (1861–1930; native of Hengyang, Hunan) Painter, noted for his trees and stones. Teacher of Zhang Daqian.

Zeng Xiaofeng 曾曉峰 Printmaker. Active in Yunnan in 1980s and 1990s.

Zeng Yannian 曾延年 Oil painter. Grad. 1911 from Tokyo Acad. Fellow student with Li Shutong. Returned to teach in Shanghai.

Zeng Youhe 曾幼荷 (Tseng Yu-ho, Betty Ecke; b. 1923, Beijing) Woman painter. Studied under and ghosted for Pu Quan at Furen Univ. 1945 married Gustav Ecke. 1948 left for Hong Kong, then Honolulu. After rigorous training as a guohua painter she developed in Honolulu a modern style, using mixed media, in which traditional and modern elements are combined.

Zhan Jianjun 詹建俊 (b. 1931, Liaoning) Oil painter. 1953 grad. from CAFA. In 1980s teaching in Third Studio, CAFA. Chairman of Oil Painting Committee, CAA.

Zhang Anzhi 張安治 (1911–91; b. Yangzhou, Jiangsu) Painter, calligrapher, and art historian. 1928 entered art dept. of NCU Nanjing; studied under Xu Beihong, Lü Fengzi. 1931 grad. and taught drawing in Nanjing Art Coll. 1936 invited by Xu Beihong to organize Guilin Art Acad. 1940 head of art section, Prov. Art Gall., Guangxi. 1944 assoc. researcher in Chinese Art Research Inst., Chongqing. 1947–48 in London on British Council scholarship. 1953 prof. in art dept. of Beijing Normal Coll. 1956–64 head of art dept. of various art colleges in Beijing. Later prof. in CAFA.

Zhang Bihan 張碧寒 (b. 1909) Guohua painter. Active in Hong Kong.

Zhang Bu 張步 (b. 1934, Fengrunx., Hebei) Decorative guohua painter. 1958 studied under Li Keran at CAFA. Member of Beijing Painting Acad.

Zhang Chongren 張充仁 (b. 1907, Suzhou; native of Shanghai) Painter and sculptor. 1931–35 studied sculpture in Royal Acad. of Belgium, travelled widely in Europe. 1935 returned to Shanghai, opened his own studio. 1938 prof. in architecture dept. of Zhejiang Univ. 1958 prof. in sculpture dept. in Shanghai Coll. of Fine Art. 1965 worked for Shanghai Oil Painting Acad. 1981 study tour to Belgium.

Zhang Daofan 張道藩 (1897–1968) Painter, playwright, and art bureaucrat. Studied at Slade School, London, and in Paris. Active chiefly in Shanghai. Moved to Taiwan.

Zhang Daqian 張大千 (Chang Dai Chien, 1899–1983; native of Neijiang, Sichuan) Guohua painter, collector, connoisseur, and forger. 1917 studied textiles in Japan. 1919 returned to Shanghai, studied under Zeng Xi, later learned calligraphy from Li Ruiqing. 1927 started to travel widely in China. 1929 executive member of the National Arts Exhib. 1936 joined Xu Beihong as prof. in NCU Nanjing. 1941–43 in Dunhuang coping wall paintings. 1943–46 in Chengdu. 1948–77 lived in Hong Kong, India, Argentina, Brazil, and the U.S. 1968 honorary doctorate from Coll. of Chinese Culture in Taiwan. 1977 settled in Taiwan. From guohua traditionalism, his art developed in 1960s, partly under Western stimulus, into a free expressionist style.

Zhang Dazhuang 張大壯 (1903–80; native of Hangzhou, Zhejiang) Guohua painter. Self-taught when young. Protege of the Shanghai collector and connoisseur Pang Laichen (Pang Yuanqi), in whose house he studied for over ten years. Member of Shanghai Chinese Painting Acad.; specialized in flowers, plants, and fruits.

Zhang Ding 張丁 (b. 1917; native of Heshanx., Liaoning) Guohua painter (gongbi style) and cartoonist. 1932 studied Chinese painting in Beijing Art Acad. 1936 went to Nan-jing and published cartoons there. 1937 joined cartoon propaganda team. 1938 taught in Lu Xun Acad., Yan'an. 1945 editor of North China Pictorial in Harbin. 1949 prof. in CAFA. 1954 started to paint from life in guohua style. 1957 vice pres. of CAFA. 1979 in charge of decoration of Beijing Airport Lounge. 1980 pres. of CAA.

Zhang Guangyu 張光宇 (1900–64; native of Wuxi) Painter, illustrator, designer, and cartoonist. Studied with Zhang Yueguang in Shanghai; in 1930s influenced by Covarrubias. 1937 went to Hong Kong. 1945 produced famous anti-Guomindang cartoon series Journey to the West. 1946 joined Renjian Huahui in Hong Kong. 1949–63 head of art dept., CAFA. Chief artist for cartoon film based on the original Journey to the West.

Zhang Hong 張宏 (1890–1968; b. Shunde, Guangdong) Painter, Lingnan School. Student of Gao Jianfu. Teacher in Shanghai and Hong Kong.

Zhang Hong 張洪 (Arnold Chang; b. 1954, New York; native of Jiashan, Zhejiang) Painter and art historian. Studied guohua technique with Wang Jiqian and others. Director of Chinese painting at Sotheby's, New York.

Zhang Hong 章虹 (b. 1957, Beijing) Woman oil painter. 1990 grad. from printmaking dept. of CAFA.

Zhang Hongnian 張洪年 (b. 1947, Nanjing) Oil painter. 1966 grad. from middle school attached to CAFA. 1969 sent to rural area to work. 1985 enrolled for M.F.A. at New York City Coll.

Zhang Hongtu 張宏圖 (b. 1943, Gansu) Painter. 1964–69 studied in CAFA. 1969–72 worked in countryside of Hebei province. 1973 designer for Beijing Jewelry Company. 1982 went to New York to study at the Art Students' League.

Zhang Huaijiang 張懷江 (d.1990; native of Wenling, Zhejiang) Printmaker. Prof. in NZAFA.

Zhang Jiahui 章家慧 (Beatrice Ts'o; b. 1914, Jiangsu) Painter. Studied in Univ. of Nanjing art dept. 1937 settled in Hong Kong.

Zhang Jianjun 張健君 (b. 1955, Shanghai) Painter. Trained in dept. of theater design, Shanghai Acad. of Drama. 1978–89 lecturer and member of staff of Shanghai Art Museum. Member of Shanghai avant-garde. 1989 settled in U.S., where he became an enviromental, conceptual, and installation artist.

Zhang Jiemin 章杰民 (b. 1951, Shanghai). Sculptor and painter. Trained in Shanghai. 1987 studying in U.S.

Zhang Jingying 張菁英 Woman artist. Trained in western art under Xu Beihong in Nanjing. 1947 sent on British Council scholarship to U.K., where she settled, becoming a guohua painter. Married to Fei Chengwu.

Zhang Juxian 張菊先 (b. 1955, Saõ Paulo, Brazil) Woman oil painter, sculptor, and installation artist. Studied art in Brazil and at UCLA.

Zhang Keduan 張克端 Sculptor. 1985 grad. from NZAFA.

Zhang Kunyi 張坤義 (1899–1967; native of Panyu, Guangdong) Woman guohua painter. Adopted daughter and favorite student of Gao Qifeng.

Zhang Leping 張樂平 (b. 1910, Haiyanx., Zhejiang) Cartoonist. 1930s influenced by Ye Qianyu. During WWII joined Anti-Japanese Cartoon Propaganda Team. 1935 his cartoon series San Mao became popular in Shanghai. After 1949 director of CAA.

Zhang Li 張利 (b. 1958, Beijing) Oil painter. 1983 grad. from PLA Inst. of Art, where he remained as a lecturer. An academic romantic who specializes in depicting the culture of the minorities.

Zhang Liying 張荔英 (Georgette Chen; d. 1992; native of Wuxi) Woman oil painter, active from 1930 until after 1960. Studied in Paris and at Art Students' League, New York; later worked in Shanghai. 1950 settled in Singapore, where she taught oil painting in Nanyang Acad. of Art.

Zhang Peili 張培力 (b. 1957, Hangzhou) Painter. 1985 M.S. from oil painting dept. of NZAFA. Member of New Space group in Zhejiang in mid-1980s. Became teacher in Hangzhou Inst. of Technology. Member of post-1989 avant-garde movement.

Zhang Peiyi 張佩義 (b. 1953, Shanxi) Graphic artist. 1960 grad. from Beijing Art Inst. 1986 teacher in graphic arts dept. of CAFA.

Zhang Qun 張群 Oil painter, active in Beijing in mid-1980s.

Zhang Shanzi 張善孖 (1895–1943; native of Neijiang, Sichuan) Guohua painter. Elder brother of Zhang Daqian. Specialized in tigers.

Zhang Shoucheng 張守成 (b. Shanghai) Guohua painter. Studied in Shanghai under Wu Hufan. From 1956, member of Shanghai Inst. of Chinese Painting. 1982 settled in U.S.

Zhang Shuqi 張書旗 (1899–1974; native of Pujiang, Zhejiang) Guohua painter, esp. of cranes, flowers, and birds. Student of Liu Haisu in Shanghai Meizhuan. 1924–40 taught at NCU Nanjing. 1937 moved with the univ. to Chongqing. 1941 went to lecture in the U.S. 1946 returned to Nanjing to resume teaching at NCU Nanjing. Later moved to U.S.

Zhang Songnan 張頌南 (b. 1942, Shanghai) Modern painter. 1964 grad. from CAFA. 1964–78 worked in a District Propaganda Unit. 1978 enrolled as grad. student in CAFA. After grad., joined staff in wall painting dept. 1982 went to study in Europe.

Zhang Wanchuan 張萬傳 (b. 1909, Taipei) Oil painter. Studied under Ishikawa Kin'ichirō and at Kawabata Inst. in Tokyo. 1938 taught in Xiamen Fine Arts Inst. Later returned to Taipei, taught oil painting in Nat. Taiwan Fine Art Inst. Since 1975 has visited Europe and the U.S. many times.

Zhang Wang 張望 (b. 1916; native of Canton) Wood-engraver. Early 1930s, one of the organizers of MK Woodcut Research Soc. in Shanghai. During WWII engaged in propaganda work and teaching. 1942 taught in Lu Xun Acad. in Yan'an. After 1949 taught at Northeast Lu Xun Art Acad. in Shenyang.

Zhang Wanli 張萬里 (b. Xinjiang) Woman graphic artist. Grad. 1984 from Xi'an Acad. of Fine Arts. Noted for her serial pictures and book illustrations.

Zhang Wei 張偉 (b. 1952, Beijing) Oil painter. Since 1979 stage designer with the Beijing Kunqu Opera. 1981 joined Nameless Art Soc. Developed abstract style. 1986 settled in U.S.

Zhang Wenyuan 張文元 (b. 1910, Jiangsu) Guohua painter and cartoonist. Studied in Shanghai. Active as cartoonist and in anti-Japanese propaganda during WWII. Later developed as a conservative landscape painter.

Zhang Xian 張弦 Oil painter, active in 1920s and 1930s. Trained in France, taught in Shanghai Meizhuan. 1931 founding member of Storm Soc. Died young of illness and poverty.

Zhang Xiaofan 張小凡 (b. 1950, Zhejiang) Oil painter. 1980 grad. from painting dept. of Tianjin Acad. of Fine Arts.

Zhang Xiaogang 張曉剛 (b. 1958, Kunming) Painter. 1982 grad. from oil painting dept. of Sichuan Acad. of Fine Arts, where he became a teacher. Symbolist-surrealist and member of avant-garde movement, influenced by Picasso and Dali.

Zhang Xiaoxia 張小夏 (b. 1957, Nanjing) Largely self-taught painter in trad. guohua in early career. 1986 studied in Brussels Acad. of Art, where he came under the influence of Joseph Beuys. Member of avant-garde movement.

Zhang Xinyu 張新宇 Printmaker. Active in Jiangsu in 1980s and 1990s. Sometimes collaborated with the woman printmaker Zhu Qinbao.

Zhang Xiong 張熊 (1803–86; native of Xiushui, Zhejiang) Guohua painter. Influential figure in Shanghai School. Teacher of Ren Yi; specialized in flowers and birds.

Zhang Yangxi 張漾兮 (1912–64; b. Chengdu, Sichuan) Wood-engraver and cartoonist. Studied in Chengdu. 1939 joined National Anti-Japanese Assoc. of Wood-Engravers. During WWII active in Chengdu. 1948–49 in Hong Kong. Later chairman of graphic arts dept. of NZAFA.

Zhang Yi 張義 (Cheung Yee; b. 1936, Canton) Sculptor. 1958 grad. from fine art dept. of NTNU, moved to Hong Kong. 1964 became professional sculptor. From 1970 he became leading sculptor in many media.

Zhang Yixiong 張義熊 (b. 1914, Jiayi, Taiwan) Oil painter. Studied in Tokyo 1938–40. Taught at Taipei Normal Coll. Later moved to Japan and Paris before returning to Taipei.

Zhang Yu 章玉 (1900–66; native of Sichuan) Oil painter. First studied oil painting in Japan. 1921 went to Paris to study and work. 1948 to New York as entrepreneur, promoting "ping-tennis." Returned to paint in increasing poverty.

Zhang Yuguang 張聿光 (1884–1968; native of Shaoxing, Zhejiang) Painter in both guohua and Western style, cartoonist. 1912 cofounder of Shanghai Meizhuan with Liu Haisu and others. 1916 opened his own studio in Shanghai. Studied in Japan. 1926 head of Xinhua Art Acad., Shanghai. During WWII, went to southwest China. 1945 returned to Shanghai.

Zhang Zhenggang 張正鋼 Oil painter. Member of PLA, active in Beijing in late 1980s and in 1990s.

Zhang Zhengyu 張正宇 (1900–76; native of Jiangsu) Cartoonist, decorative painter, and stage designer. Twin brother of Zhang Guangyu. Active in Shanghai before WWII. Later taught in CAFA.

Zhang Zhiwang 張之往 (1811–97) Orthodox landscape painter in Beijing.

Zhang Zhiyou 張志有 (b. 1941, Hebei) Printmaker. Grad. from CAFA.

Zhang Zhunli 張准立. See Mao Lizhi

Zhao Baokang 趙葆康 (b. 1953, Shanghai) Painter. Grad. from dept. of theater design, Shanghai Acad. of Drama. 1980s lecturer in Coll. of Fine Arts of Shanghai Univ.

Zhao Chunxiang 趙春翔 (Chao Chung-hsiang, 1913–91; b. Henan) Painter. Studied under Lin Fengmian and Pan Tianshou in NAA Hangzhou. 1949 to Taiwan. 1951–55 assoc. prof. in NTNU, Taipei. 1956 to Spain for travel and study, then settled in New York as abstract expressionist. 1990 retired to Sichuan, returned to painting in Chinese ink.

Zhao Gang 趙剛 (b. 1961, Beijing) Painter. Member of the Stars group. 1973–78 mainly worked on his own, with some guidance from a teacher at CAFA. 1978–79 studied mural painting at CAFA. 1983 went to study in Holland on art scholarship. 1984 in Vassar Coll. in U.S.

Zhao Mengzhu 趙夢朱 (1892–1984; b. Xiongxianx., Hebei) Guohua painter. Long career in north China as academic painter of landscapes, birds and flowers.

Zhao Shao'ang 趙少昂 (b. 1905, Canton) Guohua painter. 1920 studied with Gao Qifeng. 1927 taught in Fushan Municipal School of Art. 1929 established his Lingnan Art Studio

in Canton. 1937 head of Chinese painting in Canton Municipal Art Coll. During WWII in Guilin and Chongqing. 1948 prof. in art dept. of Canton Univ. Later settled in Hong Kong, engaged in painting and teaching.

Zhao Shou 趙獸 (b. 1910, Wuzhou, Guangxi) Surrealist painter. 1927 studied art in Canton. 1933 went to Japan, became involved in surrealist movement. On return to Shanghai, cofounder of Chinese Independent Art Assoc.

Zhao Wangyun 趙望雲 (1906–77; native of Sulu, Hebei) Painter in both guohua and Western styles. 1925 studied painting in Beijing. 1932 moved to Shanghai. During WWII, in west China. After 1949 active in Xi'an. 1949 chairman of Federation of Chinese Arts, Xi'an branch. 1965 visited Egypt.

Zhao Wuji 趙無極 (Zao Wou-ki; b. 1921, Beijing) Oil painter. 1935 entered NAA Hangzhou, studying under Lin Fengmian, Pan Tianshou, and Wu Dayu. 1941 prof. of drawing in Chongqing. 1948 settled in Paris, travelled widely in Europe. 1950–57 worked with Pierre Loeb. 1957–58 visited U.S. 1972 first return visit to China. 1983 exhib. in Beijing and Hangzhou. 1985 visiting prof. at NZAFA. Abstract expressionist and a distinguished member of the School of Paris.

Zhao Xiuhuan 趙秀煥 (b. 1946, Beijing) Woman painter. Studied in high school affiliated with CAFA. 1973 member of Beijing Painting Acad. Noted for decorative landscape and flower compositions. 1989 to New Mexico, then settled in California.

Zhao Yannian 趙延年 Wood-engraver. Before Liberation active in Shanghai.

Zhao Zhiqian 趙之謙 (1829–84; native of Shaoxing, Zhejiang) Guohua painter, calligrapher, poet, and seal-carver. Shanghai School.

Zhao Zongzao 趙宗藻 (b. 1931; native of Jiangyinx., Jiangsu) Printmaker. From 1947 educated in Suzhou Art Coll. and art dept. of Nanjing Univ. 1952 art teacher in Zhejiang Jinhua Teachers' Coll. After 1955 taught in graphic arts dept. of East China Division of CAFA. Prof. and head of graphic arts dept., NZAFA.

Zheng Chengzhi. *See* Ye Fu

Zheng Ke 鄭可 (b. Guangdong) Sculptor and medallist. Trained in France before 1937.

Zheng Wuchang 鄭午昌 (Cheng Chang, 1894–1952; native of Chengx., Zhejiang) Guohua painter and art historian. Director of art dept. of China Book Bureau, Shanghai. Later prof. in Shanghai Art Acad. 1991 major exhib. in Hangzhou.

Zheng Xiaoxu 鄭孝胥 (1860–1938; native of Fujian) Amateur guohua painter who became first Prime Minister of Manchukuo.

Zheng Xu 鄭旭 Printmaker. Active in Yunnan in 1980s and 1990s.

Zheng Zaidong 鄭在東 (Cheng Tsai-tung; b. 1953, Taipei) Self-taught sculptor and oil painter, esp. of figures influenced by surrealism and German expressionism. Works in Taipei.

Zhong Sibin 鍾泗濱 (Cheong Soo Pieng, 1917–83; b. Xiamen) Painter. Trained in Xinhua Acad. in Shanghai and Xiamen Acad. 1946 settled in Singapore. Travelled widely in Southeast Asia and taught in Nanyang Acad., Singapore. Figures and landscapes. In late years worked also in batik and metal.

Zhou Bichu 周碧初 (b. 1903, Pinghex., Fujian) Oil painter. 1928–30 studied in Paris. 1930 taught in Xiamen Acad.

1931 went to Shanghai, taught in Shanghai Meizhuan and Xinhua Art Acad., member of Storm Society. 1949 went to Hong Kong, 1951 Indonesia. 1959 returned to China, settled in Shanghai.

Zhou Changgu 周昌谷 (1929–86; b. Dongqing, Zhejiang) Guohua painter and calligrapher, specializing in beautiful women. Prof. in NZAFA.

Zhou Chunya 周春芽 (b. 1955, Chengdu) Painter. 1982 grad. from oil painting dept. of Sichuan Acad. of Fine Arts. 1983 artist in residence at Chengdu Inst. of Art. 1987 travelled to Germany for advanced study. Earlier works focused on the Tibetan landscape; later influenced by expressionism and surrealism. Active in post-1989 avant-garde movement.

Zhou Duo 周多 Oil painter, active 1920s to 1940s. Studied in Japan. Stopped painting after WWII. Died in Taiwan.

Zhou Ling 周菱 (b. 1941, Tianjin) Woman painter. 1960 studied in Central Nationalities Inst. After grad., worked in Yunnan. Since 1983 teaching in Central Nationalities Inst. With her husband, Liu Bingjiang, created huge mural painting in restaurant of Beijing Hotel.

Zhou Lüyun 周綠雲 (Irene Chou; b. 1924, Shanghai) Woman painter. 1945 grad. from St. John's Univ. After four years as reporter came to Hong Kong in 1949. Studied under Zhao Shao'ang and became teacher in dept. of extramural studies, Hong Kong Univ. Leading figure in the Hong Kong art scene; has held many exhibs. in Hong Kong and overseas. 1991 went to Australia.

Zhou Shaohua 周韶華 (b. 1929) Former army general and amateur guohua painter, active in Hubei. 1983 director of Hubei Prov. Art Acad., Wuhan.

Zhou Sicong 周思聰 (b. 1939, Ninghex., Hebei) Woman painter. 1955 studied in middle school attached to CAFA. 1958–63 studied Chinese painting in CAFA. 1963 member of Beijing Painting Acad. 1980 vice pres. of Beijing branch of CAA.

Zhou Xi 周西 (Jiang Feng, 1910–83; b. Shanghai) Art educator, theorist, wood-engraver, and guohua painter. Trained at White Goose Prep. Painting School in Shanghai. In early 1930s joined woodcut movement. 1938 went to Yan'an, taught in Lu Xun Art Acad. After 1949 vice-chairman of CAA; later vice pres. of NZAFA, president of CAFA. Leading figure in political control of art.

Zhou Xiang 周湘 (1871–1933) Oil painter, progressive Qing official. Studied in "Siccawei," Shanghai. 1912 set up Oil Painting School (*Youhua yuan*) and correspondence school for guohua in Shanghai.

Zhou Xianglin 周向林 (b. 1955, Wuhan) Oil painter. 1983 grad. from oil painting dept. of Hubei Acad. of Fine Arts. 1991 M.F.A. from CAFA. At 1991 Exhib. of Chinese Oil Painting in Hong Kong, his *Kaifeng, Nov. 12, 1969,* in memory of Liu Shaoqi, won the silver medal.

Zhou Xiqin 周西芹 (Chou Su-ch'in; b. 1945, Sichuan) Painter and wood-engraver. 1962–64 studied in CAFA. Joined staff of Natural History Museum, Beijing. Later worked in Los Angeles and Melbourne. Specializes in plants and animals.

Zhou Xixin 周西心 (Chow Su-sing; b. 1923, Suzhou) Guohua painter. Grad. from Suzhou Acad. Taught for ten years in Hong Kong before settling in Los Angeles in 1971. 1980 moved to Vancouver. Has written extensively on the history, aesthetics, and technique of Chinese painting.

Zhou Yuanting 周元亭 (b. 1904, Beijing) Guohua painter. From 1920 studied painting, worked, and exhibited in Beijing, Tianjin, and Shanghai. Teacher in the Beijing Acad. of Chinese Painting. Noted for his landscapes.

Zhou Zhentai 周眞太 (C. T. Chow; native of Changshu) Oil painter, active in 1930s. Studied in Japan. 1930 formed Taimeng Huahui with Pang Xunqin. Member of Independent Artists group in Shanghai.

Zhou Zhiyu 周至禹 (b. Hebei) Printmaker. After advanced study at CAFA, in 1984 opened first independent printmaking studio in Zhuox., south of Beijing.

Zhu Chonglun 祝崇倫 (b. 1955, Shenyang) Oil painter. 1989 grad. from fine arts dept. of Shenyang Coll. of Education. 1991 awarded gold medal for his *Summer* in Four Seasons Exhib.

Zhu Chuzhu 朱楚珠 (Nancy Chu Woo; b. 1941, Guangdong) Woman painter. 1963 B.A. in fine arts from Cornell Univ. 1964 M.A. from Columbia Univ. 1973 returned to Hong Kong, where she teaches in dept. of fine arts, Univ. of Hong Kong.

Zhu Danian 祝大年 (b. 1915, Hangzhou) Painter and decorative artist. Trained in NAA Hangzhou. 1933–37 studied art and ceramic technology in Tokyo. 1979 designed *The Song of the Forest* in ceramic tile for Beijing International Airport.

Zhu Dequn 朱德群 (Chu Teh-chun; b. 1920, Xiaoxian, Jiangsu) Modern painter. 1936 entered NAA Hangzhou. During WWII went to Changsha, then Chongqing, studying in NCU Nanjing art school. 1945 taught in NCU Nanjing. 1949 went to Taiwan. 1950–55 prof. in NTNU. 1955 settled in Paris. Abstract expressionist.

Zhu Hanxin 朱漢新 (Chu Hon-sun; b. 1950, Guangdong) Sculptor. 1975 grad. from fine arts dept., Chinese Univ. of Hong Kong. 1976–80 studied in Carrara, Italy. Works in Hong Kong.

Zhu Hui 朱慧 (b. 1959) Tapestry designer and soft-sculpture maker. Pupil of Varbanov in NZAFA; active in Hangzhou in mid-1980s.

Zhu Jinshi 朱金石 (b. 1954, Beijing) Amateur painter, active in Beijing. Exhib. 1979 and 1980 with Stars.

Zhu Lesan 諸樂三 (1902–84; native of Zhejiang) Guohua painter, calligrapher, and seal-engraver. Pupil of Wu Changshuo. Taught in Xinhua Acad. After 1949 prof. in Nanjing Acad., and later in NZAFA.

Zhu Ming 朱銘 (Ju Ming; b. Miaolix., Taiwan, 1938) Sculptor. Apprenticed to woodcarver Li Jinchuan, became independent carver of religious images. 1960 began to study modern sculpture. 1968–76 assistant to Yang Yingfeng. 1974 took up *taiji*. 1976 became independent sculptor, working in stone, bronze, wood, cast styrofoam, etc. By late 1980s had received many public commissions in Far East, Europe, and U.S. and had an international reputation.

Zhu Naizheng 朱乃正 (b. 1935, Haiyan, Zhejiang) Oil painter. Grad. of CAFA, where he became a prof.

Zhu Peijun 朱佩君 (b. 1920, Sichuan) Self-taught guohua painter. Active in Sichuan art politics. Friend of Jiang Qing (Madame Mao) and persecutor of Chen Naizhuang.

Zhu Qinbao 朱琴葆 Woman printmaker. Active in Jiangsu in 1980s and 1990s.

Zhu Qingguang 朱慶光 (Choo Keng-kwang; b. 1931, Singapore) Oil painter. 1953 grad. from Nanyang Acad. of Fine Arts. Lives and works in Singapore.

Zhu Qizhan 朱屺瞻 (b. 1892, Taicangx., Jiangsu) Oil and guohua painter. 1912 began to study oil painting in Shanghai Meizhuan. 1922 and 1930 studied in Japan. Later turned to Chinese painting. On return to China, taught in Shanghai Meizhuan and headed the painting research group at Xinhua Acad. Taught for many years at Hangzhou Acad. 1982 teaching in Shanghai Acad. of Chinese Painting. 1983 prof. in East China Normal Univ. in Shanghai.

Zhu Weibai 朱爲白 (b. 1929, Nanjing) Painter. Member of the Ton Fan group in Italy.

Zhu Yiyong 朱毅勇 (b. 1957) Oil painter, active in Sichuan. Realist.

Zhu Yuanzhi 朱沅芷 (1906–63) Painter. At age of 15 settled with his parents in San Francisco. Later lived in New York.

Zhuang Zhe 莊喆 (b. 1934, Beijing) Abstract expressionist painter. 1948 moved to Taiwan. 1958 grad. from art dept. of Taiwan Prov. Normal Univ., member of Fifth Moon group. Head of dept. of art and architecture at Donghai Univ. 1969 turned to oil painting. Later on staff of National Palace Museum, Taipei.

Zhuo Hejun 卓鶴君 Guohua painter. Pupil of Lu Yanshao. Assoc. prof. in NZAFA. 1990 visited U.S. and U.K.

Zhuo Yourui 卓有瑞 (Y. J. Cho; b. 1950, Taipei) Woman hyperrealist oil painter. 1973 B.F.A., NTNU. 1977 M.A., State Univ. of New York, Albany. Lives and works in New York.

Zou Ya 鄒雅 (1916–74; native of Jiangsu) Wood-engraver in Shanghai. 1938 to Lu Xun Acad., Yan'an. After 1949 took up guohua, influenced by Huang Binhong and Li Keran. Member of Beijing Painting Acad.

CHINESE SOURCES

Ai Zhongxin 艾中信. *Xu Beihong yanjiu* 徐悲鴻研究 (Researches in Xu Beihong). Shanghai, 1981.

Bao Limin 鮑立民. "Xu Beihong, Lin Fengmian shouci huimian kaoyi" 徐悲鴻、林風眠首次會面考異 (Research on the first meeting of Xu Beihong and Lin Fengmian). *Toyun (Duoyun)* (1990.4): 112–15.

Beijing International Art Gallery. *Xiandai youhua* 現代油畫 (Contemporary oil painting). Shenyang, 1987.

Beijing Painting Academy. *Beijing Huayuan zhongguohua xuanji* 北京畫院中國畫選集 (Selected traditional paintings from the Beijing Painting Academy). Beijing, 1982.

Bi Keguan 畢剋官. "Jindai meishu de xianqu Li Shutong" 近代美術的先驅李叔同 (Li Shutong, a pioneer of Chinese modern art). *Meishu yanjiu* 美術研究 (1984.4): 68–75.

Bi Keguan 畢剋官 and Huang Yuanlin 黃遠林. *Zhongguo manhua shi* 中國漫畫史 (History of Chinese cartoons). Beijing, 1986.

Chang Shuhong 常書鴻. "Bali Zhongguo huazhan yu Zhongguohua qiantu" 巴黎中國畫展與中國畫前途 (The Paris exhibition of Chinese painting and the prospects for Chinese painting). *Yifeng* 藝風 1, no. 8 (August 1933): 9–15.

Chen Baoyi 陳抱一. *Youhuafa zhi jichu* 油畫法之基礎 (Foundations of oil painting technique). Shanghai, 1926.

Chen Changhua 陳長華. *Zhongguo dangdai huihuajia* 中國當代繪畫家 (Contemporary Chinese artists). Taipei, 1980.

Chen Fan 陳凡, ed. *Huang Binhong huayulu* 黃賓虹畫語錄 (The *huayulu* of Huang Binhong). Hong Kong, 1961.

Chen Ruilin 陳瑞林. "Chen Baoyi he zaoqi de youhua yundong" 陳抱一和早期的油畫運動 (Chen Baoyi and the early oil painting movement in China). *Meishu yanjiu* (1986.2): 29–34.

Chen Yanqiao 陳煙橋. *Lu Xun yu muke* 魯迅與木刻 (Lu Xun and the woodcut). Beijing, 1949.

Chen Yingde 陳英德. *Haiwai kan Dalu yishu* 海外看大陸藝術 (Looking at Chinese art from abroad). Taipei, 1987.

Chinese Woodcutters Association. *Zhongguo banhuaji* 中國版畫集 (Contemporary Chinese wood engravings). Shanghai, 1948.

Dong Huaizhou 董懷周, ed. *Tian'anmen shichao chatu xuan* 天安門詩抄插圖選 (Selected poems of Tiananmen). Shanghai, 1979.

Feng Fasi 馮法祀, ed. *Xu Beihong huaji* 徐悲鴻畫集 (Collected paintings by Xu Beihong). 6 vols. Beijing, 1988.

Feng Zikai 豐子愷. *Zikai manhua quanji* 子愷漫畫全集 (Complete cartoons of Feng Zikai). 6 vols. Shanghai, 1945.

Fu Baoshi huaji 傅抱石畫集 (Collected paintings of Fu Baoshi). Nanjing, 1981.

Fu Baoshi Guan Shanyue dongbei xieshenghua xuan 傅抱石關山月東北寫生畫選 (Collection of paintings done in the northeast by Fu Baoshi and Guan Shanyue). Liaoning, 1964.

Gao Minglu 高名潞. *Zhongguo xiandai yishuzhan* 中國現代藝術展 (China/Avant-Garde). Beijing, 1989.

Gong Chanxing 龔產興. *Wu Youru jianlun* 吳友如簡論 (Brief discussion of Wu Youru). *Meishu yanjiu* (1990.3): 30–38.

Guo Jisheng 郭繼生. *Dangdai Taiwan huihua wenxuan 1945–1990* 當代臺灣繪畫文選 (Anthology of writings on contemporary painting in Taiwan). Taipei, 1991.

Hu Yichuan youhua fengjing xuan 胡一川油畫風景選 (Selection of oil landscapes by Hu Yichuan). Beijing, 1983.

Huacheng Publishing House. *Guangdong Huayuan jikan* 廣東畫院集刊 (Collected works of the Guangdong Painting Academy). Hong Kong, 1982.

Huang Mengtian 黃蒙田. "Huiyi 'Xianggang de shounan' huazhan" 回憶香港的受難畫展 (Recollections of the "Hong Kong in Agony" exhibition). *Meishujia* 美術家 47 (1984.12): 68–73.

———. "Huiyi Xinpo" 回憶新坡 (Recollections of Huang Xinpo). *Meishujia* 43 (1985.4): 46–55; *Meishujia* 55 (1987.4): 72–79; *Meishujia* 56 (1987.6): 46–53; *Meishujia* 61 (1988.4): 48–56.

———, ed. *Huang Yongyu huaji* 黃永玉畫集 (Collected works of Huang Yongyu). Hong Kong, 1980.

————, ed. *Ding Cong: Manhua, chatu, suxie* 丁聰漫畫插圖速寫 (Ding Cong: Cartoons, illustrations, sketches). Hong Kong, 1983.

Jiang Danshu 姜丹書. "Woguo wushinian lai yishu jiaoyu shi zhi yiye" 我國五十年來藝術敎育史之一頁 (A page in the history of art education in China in the past fifty years). *Meishu yanjiu* (1959.1): 30–31.

Jiang Fucong 蔣復璁 and Liang Shiqiu 梁實秋, eds. *Xu Zhimo quanji* 徐志摩全集 (Collected works of Xu Zhimo). 6 vols. Taipei, 1969.

Jin Tongda 金通達, ed. *Zhongguo dangdai guohuajia cidian* 中國當代國畫家辭典 (Dictionary of contemporary Chinese traditional painters). Hangzhou, 1990.

Jinling Shuhua She 金陵書畫社. *Fu Baoshi huaji* 傅抱石畫集 (Collected paintings of Fu Baoshi). Shanghai, 1981.

Ke Wenhui 柯文輝. *Yishu dashi Liu Haisu zhuan* 藝術大師劉海粟傳 (Biography of the master of art Liu Haisu). Jinan, 1986.

Lan Zhai 藍齋. "Waiguo manhua dui Zhongguo manhuajia de yingxiang" 外國漫畫對中國漫畫家的影響 (The influence of foreign caricatures on Chinese caricaturists). *Meishujia* 67 (1989.4): 44–49.

Lang Shaojun 郎紹君. *Lun Zhongguo xiandai meishu* 論中國現代美術 (On modern Chinese art). Nanjing, 1988.

Li Hua 李華, Li Shusheng 李樹生, and Ma Ke 馬剋, eds. *Zhongguo xinxing banhua yundong wushinian 1931–1981* 中國新興版畫運動五十年 (On the fifty years' development of the Chinese Woodcut Movement, 1931–1981). Liaoning, 1981.

Li Puyuan 李樸園. *Jindai Zhongguo yishushi* 近代中國藝術史 (History of recent Chinese art). Shanghai, 1936.

Li Runxin 李潤新 and others, eds. *Zhongguo yishujia cidian* 中國藝術家辭典 (Biographical dictionary of Chinese artists). 5 vols. Changsha, 1981–85.

Liao Xiuping 廖修平. *Banhua yishu* 版畫藝術 (The art of printmaking). Taipei, 1974.

Lin Fengmian 林風眠. *Yishu yu xin shengkuo yundong* 藝術與新生活運動 (Art and the New Life Movement). Nanjing, 1934.

————. *Yishu conglun* 藝術叢論 (Collected writings on art). Nanjing, 1936.

Lin Lü 林綠, ed. *Pu Xinyu shuhua quanji* 溥心畬書畫全集 (The complete paintings and calligraphy of Pu Xinyu). 4 vols. Taipei, 1978.

Liu Chengzhi 劉承智. "Huashuo Tao Yuanqing de yishu" 話說陶元慶的藝術 (Discussion of the art of Tao Yuanqing). *Meishu* 美術 (1979.9): 12–13.

Liu Haisu 劉海粟. *Liu Haisu youhua xuanji* 劉海粟油畫選集 (Selected oil paintings of Liu Haisu). Shanghai, 1981.

————. *Qilu tanyilu* 齊魯談藝錄 (Qilu discussions on art). Jinan, 1985.

Liu Mingyang 劉明楊. *Hongyiji* 弘藝集 (Record of the arts). Chengdu, 1946.

Liu Sixun 劉思訓. *Luosijin zhi yishu lun* 羅斯金之藝術論 (Ruskin's theory of art). Shanghai, 1927.

Liu Xilin 劉曦林. *Yihai chunqiu: Jiang Zhaohe zhuan* 藝海春秋蔣兆和傳 (Annals of art: Biography of Jiang Zhaohe). Shanghai, 1981.

Lu Yanshao shuhua cangpin ji 陸嚴少書畫藏品集 (Collection of Lu Yanshao's painting and calligraphy). Vol. 1. Hong Kong, 1991.

Lu Danlin 陸丹林. *Zhongguo xiandai yishujia xiangzhuan* 中國現代藝術家像傳 (Sketch biographies of modern Chinese artists). Hong Kong, 1978.

Luo Qing shi hua 羅靑詩畫 (Poems and paintings by Luo Qing). Taipei, 1990.

Meishujia 33, no. 7 (1983). Special issue devoted to Lin Fengmian.

Ministry of Education. *Meizhan tekan* 美展特刊 (Art exhibition special issue). Includes prefaces by Cai Yuanpei and Jiang Menlin. Nanjing, 1929.

————. *Shanghai Meishu Zhuanke Xuexiao* 上海美術專科學校 (Shanghai College of Fine Arts). Twenty-fifth anniversary volume. Shanghai, 1937.

Nanyi xuebao 南藝學報 1 (1983). Special issue on Liu Haisu.

National Central University. *Guoli Zhongyang Daxue Yishu Xuexi xixun* 國立中央大學藝術學系系訊 (National Central University Art Department news). Chongqing, 1944.

Pan Gongkai 潘公凱. *Pan Tianshou huaji* 潘天壽畫集 (Album of Pan Tianshou's paintings). Hong Kong, 1990.

Pan Tianshou 潘天壽. *Zhongguo huihua shi* 中國繪畫史 (History of Chinese painting). Shanghai, 1936.

Pan Yuliang meishu zuopin xuanji 潘玉良美術作品選集 (Selection of the art of Pan Yuliang). Nanjing, 1988.

Pang Xunqin 潘薰琴. *Jiushi zheyang zouguolai de* 就是這樣走過來的 (That is the way it happened). Beijing, 1988.

People's Art Publishing House. *Qi Baishi zuopinji* 齊白石作品集 (Collected works of Qi Baishi). 3 vols. Beijing, 1963.

————. *Situ Qiao huaji* 司徒喬畫集 (Oil paintings of Situ Qiao). 2d ed. Beijing, 1980.

————. *Wang Shikuo huaji* 王式廓畫集 (Oil paintings of Wang Shikuo). Beijing, 1982.

————. *Shi Lu shuhuaji* 石魯書畫集 (Shi Lu: painting and calligraphy). Beijing, 1990.

Pok Art House. *Zhongguo diqi jie quanguo meishu zuopin zhanlan huojiang zuopin ji* 中國第七屆全國美術作品展覽獲獎作品集 (Prizewinning art works in the Seventh National Art Exhibition, 1989). Hong Kong, 1990.

Qin Xuanfu 秦宣夫. "Women xuyao xiyanghua ma?" 我們需要西洋畫嗎 (Do we need Western art?). In *Xiandai Zhongguo meishu lunji* 現代中國美術論集 (Collected writings on contemporary Chinese art), ed. He Huaishuo 何懷碩, vol. 4, 19–27. Taipei, 1991.

Shaanxi People's Publishing House. *Huxian nongminhua xuanji* 戶縣農民畫選集 (Selection of peasant paintings from Huxian). Xi'an, 1974.

Shanghai Youhua Diaosu Yuan 上海油畫雕塑院 (The Shanghai Oil Painting and Sculpture Research Institute). Shanghai, n.d.

Shanghai Zhongguo Huayuan zuopin 上海中國畫院作品 (Works from the Shanghai Academy of Chinese Painting). Shanghai, 1981.

Shui Tianzhong 水天中. "Youhua chuanru Zhongguo ji qi zaoqi de fazhan" 油畫傳入中國及其早期的發展 (The introduction of oil painting into China and its early development). *Meishu yanjiu* (1987.1): 57–61.

————. *Cao Dali huaji* 曹達立畫集 (Collected works of Cao Dali). Beijing, 1990.

Song Zhongyuan 宋忠元, ed. *Yishu yaolan* 藝術搖籃 (The cradle of the arts). Hangzhou, 1988.

Su Zhenming 蘇振明. *Taiwan pusu yishu chutan* 臺灣樸素藝術初探 (Preliminary survey of Taiwan naive art). Taipei, 1990.

Tao Yongbai 陶詠白. *Zhongguo youhua 1700–1985* 中國油畫 (Oil painting in China, 1700–1985). Nanjing, 1988.

———. "Zhongguo youhua lishi de sikao" 中國油畫歷史的思考 (Thoughts on the history of Chinese oil painting). *Meishu* (1988.2): 41–44.

Teng Gu 藤固, ed. *Zhongguo yishu luncong* 中國藝術論叢 (Collected essays on Chinese art). Shanghai, 1937.

Wang Bomin 王伯敏. *Huang Binhong* 黃賓虹. Shanghai, 1979.

———. *Zhongguo meishu tongshi* 中國美術通史 (Comprehensive history of Chinese art). 10 vols. Jinan, 1988.

Wang Geyi 王個簃. *Wang Geyi suixianglu* 王個簃隨想錄 (Recollections of Wang Geyi). Shanghai, 1982.

Wang Gong 王工 and others. "Zhongyang Meishu Xueyuan jianshi" 中央美術學院簡史 (Short history of the Central Academy of Art). *Meishu yanjiu* (1988.4): 93–104, 72.

Wang Jingxian 王靖憲 and Ling Hubao 令狐彪. *Xiandai guohuajia bairen zhuan* 現代國畫家百人傳 (Biographies of one hundred contemporary traditional painters). Hong Kong, 1986.

Wen Lipeng 聞立鵬. "Yishujia Wen Yiduo" 藝術家聞一多 (The artist Wen Yiduo). *Meishu yanjiu* (1986.4): 39–55.

Wu Changshuo zuopinji 吳昌碩作品集 (Collected works of Wu Changshuo). 2 vols. Shanghai, 1984.

Wu Guanzhong 吳冠中. "Wode ganxiang he xiwang" 我的感想和希望 (My thoughts and hopes). *Meishu* (1981.1): 8–9.

———. *Dongxun xizhao ji* 東尋西找記 (Searching here and there). Chengdu, 1982.

———. "Wode yishu shengya" 我的藝術生涯 (My artistic career). *Meishujia* 30 (February 1983): 4–15.

———. *Fengzheng buduan xian* 風箏不斷線 (Kites with unbroken strings). Chengdu, 1985.

———. *Wu Guanzhong huaji* 吳冠中畫集 (Paintings of Wu Guanzhong). Beijing, 1987.

Wu Jiayou 吳嘉猷. *Wu Youru huabao* 吳友如畫寶 (The art of Wu Youru). 3 vols. Shanghai, 1983.

Wu Yongliu 吳永柳. *Youhua renti yishu dazhan zuopinji* 油畫人體藝術大展作品集 (Works from the nude oils exhibition). Nanning, 1988.

Xie Jiaxiao 謝家孝. *Zhang Daqian de shijie* 張大千的世界 (The world of Zhang Daqian). Taipei, 1968.

Xie Lifa 謝里法, ed. *Yishujia congkan* 藝術家叢刊 (Artists' collected series). Vol. 2, *Taiwan meishu yundong shi* 臺灣美術運動史 (The history of the Taiwan art movement). Taipei, [1988].

Xiling Seal Company. *Cheng Shifa shuhua* 程十發書畫 (Calligraphy and painting of Cheng Shifa). 5 vols. Hangzhou, 1979–80.

Yan Lichuan 閻麗川 and Zhang Mingyuan 張明遠. *Zhongguo jindai meishu baitu* 中國近代美術百圖 (One hundred works of recent Chinese art). Tianjin, 1981.

Yang Chengyin 楊成寅. *Shehuizhuyi xianshizhuyi shi shehuizhuyi shehui shenghuo de fanying* 社會主義現實主義是社會主社會生活的反映 (Socialist realism is the reflection of the life of socialist society). Shanghai, 1954.

Zeng Jinshun 曾進順, ed. *Zhang Leping huaji* 張樂平畫集 (Collected works of Zhang Leping). Shanghai, 1982.

Zeng Zhonglu 曾仲魯. "Jinian Fang Junbi" 紀念方君璧 (Recollections of Fang Junbi). *Meishujia* 57 (1987.8): 40–41.

Zhang Daofan xiansheng huaxuan 張道蕃先生畫選 (Selected paintings of Mr. Zhang Daofan). Taipei, 1969.

Zhang Qiang 張薔. *Huihua xinchao* 繪畫新潮 (The new tide of painting). Beijing, 1988.

Zhang Shaoxia 張少俠 and Li Xiaoshan 李小山. *Zhongguo xiandai huihua shi* 中國現代繪畫史 (History of modern Chinese painting). Nanjing, 1986.

Zhejiang People's Art Publishing House. *Pan Tianshou huihuace* 潘天壽繪畫冊 (Paintings of Pan Tianshou). Hangzhou, 1979.

———. *Zhejiang banhua wushinian* 浙江版畫五十年 (Fifty years of Zhejiang wood-engraving). Hangzhou, 1982.

Zheng Chao 鄭朝 and Jin Shangyi 靳尚誼. *Lin Fengmian lun* 林風眠論 (Writings on Lin Fengmian). Hangzhou, 1990.

Zhongguo meishu bao 中國美術報 (Fine arts in China). Published fortnightly from June 1985 to July 1989.

Zhu Boxiong 朱伯雄 and Chen Ruilin 陳瑞林. *Zhongguo xihua wushinian* 中國西畫五十年 (Fifty years of Western art in China). Beijing, 1989.

Zhu Pu 朱樸. *Lin Fengmian* 林風眠. Shanghai, 1988.

WESTERN-LANGUAGE SOURCES

Alisan Fine Arts. *Poetic Imagery: New Paintings by Yang Yanping.* Hong Kong, 1981.

———. *Chao Chung-hsiang.* Hong Kong, 1992.

Les Amis du VIe Arrondisement. *Artistes chinois de Paris.* Paris, 1983.

Andrews, Julia F. "The Peasant's Pen: Some Thoughts on Realism in Modern Chinese Art." *In the Arts* (Ohio State University) (Autumn 1987): 6–9.

———. "Traditional Painting in New China: *Guohua* and the Anti-Rightist Campaign." *Journal of Asian Studies* 49, no. 3 (August 1990): 555–86.

———. *Painters and Politics in the People's Republic of China, 1949–1979.* Berkeley and Los Angeles, 1994.

Barmé, Geremie. "*Arrière-Pensée* on an Avant-Garde: The Stars in Retrospect." In *The Stars: 10 Years,* ed. Chang Tsong-zung. Hong Kong, 1989.

Barmé, Geremie, and John Minford. *Seeds of Fire: Chinese Voices of Conscience.* Newcastle-upon-Tyne, 1989.

Bei Dao. *Notes from the City of the Sun: Poems by Bei Dao.* Revised edition. Translated with an introduction by Bonnie S. McDougall. Ithaca, N.Y., 1984.

Bennett, Adrian. *The Introduction of Western Science and Technology into Nineteenth-Century China.* Harvard East Asian Monographs, no. 24. Cambridge, Mass., 1967.

Biographical Dictionary of Republican China. 5 vols. New York, 1967–76.

Blaine, Julien. *Wild Lilies, Poisonous Weeds: Dissident Voices in People's China.* London, 1982.

Bobot, Marie-Thérèse. *Fan Tchun-pi: Artiste chinoise contemporaine.* Paris, 1984.

Bodde, Derk. *Peking Diary.* New York, 1950.

Briessen, Fritz van. *Shanghai Bilderzeitung 1884–1898.* Zurich, 1977.

Buck, Pearl. *China in Black and White.* New York, 1944.

Cahill, James. "Flower, Bird and Figure Painting in China Today." In *Contemporary Chinese Painting*, ed. Lucy Lim, 21–27. San Francisco, 1984.

————. "The Shanghai School in Later Chinese Painting." In *Twentieth-Century Chinese Painting*, ed. Mayching Kao, 54–77. Hong Kong and Oxford, 1988.

Caplow, Deborah. "Some Thoughts on the Chinese Woodcut Movement." Paper presented at symposium on modern Chinese art, University of Washington, Seattle, 1990.

Carl, Katherine. *With the Empress Dowager of China*. London, 1906.

Chang, Arnold. *Painting in the People's Republic of China: The Politics of Style*. Boulder, Colo., 1980.

————. "Tradition in the Modern Period." In *Twentieth-Century Chinese Painting*, ed. Mayching Kao, 21–53. Hong Kong and Oxford, 1988.

Chang, Arnold, and Brad Davis. *The Mountain Retreat: Landscape in Modern Chinese Painting*. Aspen, Colo., 1986.

Chang Tsong-zung. *The World of Luis Chan*. Singapore, 1987.

————. "Visionaries and Icon Painters: One Aspect of Hong Kong Contemporary Art." *Renditions* 29/30 (1988): 275–92.

————. *Jackson Yu: New Vision*. Hong Kong, 1990.

————, ed. *Ju Ming: Sculpture*. Hong Kong, 1986.

————, ed. *Les Etoiles: 10 ans*. Hong Kong, 1989.

————, ed. *The Stars: 10 Years*. Hong Kong, 1989.

Ch'en I-fan. "The Modern Trend in Contemporary Chinese Art." *T'ien Hsia Monthly* 4, no. 1 (January 1937).

Ch'en Kuei-miao. *The Paintings of Lin Feng-mien*. Text in Chinese and English. Taipei, 1989.

Chinese Artists Association. *The Sixth National Art Exhibition*. Beijing, 1984.

————. *Prize-Winning Art Works of the 7th Chinese National Art Exhibition, 1989*. Text in Chinese and English. Beijing, 1989.

Chinese Wood-Engravers Association. *Woodcuts of Wartime China, 1937–1945*. Text in Chinese and English. Shanghai, 1946.

Chuang Shen. "Art and Politics: Study of a Special Relationship in Contemporary Chinese Painting." In *Twentieth-Century Chinese Painting*, ed. Mayching Kao, 178–94. Hong Kong and Oxford, 1988.

Chung, Jerrow C. H., ed. *The Contemporary Chinese Artist Chin Sung: Paintings and Poems Primitive Black*. Taipei, 1967.

Clark, John. "Taiwanese Painting and Europe: Direct and Indirect Relations." In *China and Europe in the Twentieth Century*, ed. Yu-ming Shaw. Taipei, 1968.

————. "La Peinture à Taipei après 1945: le contexte politique et économique," *Etudes chinoises* 7, no. 1 (Spring 1988): 29–63.

Clunas, Craig. "Chinese Art and Chinese Artists in France, 1924–25." *Arts Asiatiques* 44 (1989): 100–106.

Cohen, Joan Lebold. *Painting the Chinese Dream: Chinese Art Thirty Years after the Revolution (Painting and Sculpture 1978–1981)*. Northampton, Mass., 1982.

————. *The New Chinese Painting, 1949–1976*. New York, 1987.

————. *Yunnan School: A Renaissance in Chinese Painting*. Minneapolis, 1988.

Croizier, Ralph. "Chinese Art in the Jiang Ch'ing Era." *Journal of Asian Studies* 38 (February 1979): 303–11.

————. "The Thorny Flowers of 1979: Political Cartoons and Liberalisation in China." In *China from Mao to Deng: The Politics and Economics of Socialist Development*. Armonk, N.Y., 1983.

————. *Art and Revolution in Modern China: The Lingnan (Cantonese) School of Painting, 1906–1951*. Berkeley and Los Angeles, 1988.

————. "Qu Yuan and the Artists: Ancient Symbols and Modern Politics in the Post-Mao Era." *The Australian Journal of Chinese Affairs* 24 (July 1990): 25–50.

————. "Art and Society in Modern China—A Review Article." *Journal of Asian Studies* 49, no. 3 (August 1990): 587–602.

Darwent, C. E. *Shanghai: A Handbook for Travellers and Residents*. 2d ed. Shanghai, 1920.

Destenay, P. "Zhang Guangyu, caricaturiste et imagier." *Cahiers de linguistique, d'orientalisme et de slavistique* 1, no. 1/2 (1973): 85–106.

Doran, Valerie C. *China's New Art, Post-1989, with a Retrospective from 1979–1989*. Introduction by Chang Tsong-zung. Hong Kong, 1993.

Duiker, William J. *Ts'ai Yüan-p'ei: Educator of Modern China*. Philadelphia, 1977.

Ellsworth, Robert Hatfield. *Later Chinese Painting and Calligraphy: 1800–1950*. 3 vols. New York, 1987.

Erickson, Britta. "Process and Meaning in the Art of Xu Bing." In *Three Installations of Xu Bing*. Madison, Wisc., 1991.

Fan Jingzhong. "Artistic Exploration and Problems in Art: Impression of the Zhejiang Institute of Fine Arts Young Teachers' Exhibition." *Chinese Literature* (Summer 1986): 162–76.

Fang Zhaoling. *Fang Zhaoling: Portfolio*. Hong Kong, 1983.

Farrer, Anne. *Wu Guanzhong: A Twentieth-Century Chinese Painter*. London, 1992.

Fathers, Michael, Andrew Higgins, and Robert Cottrell, eds. *Tiananmen: The Rape of Peking*. London, 1989.

Feng Qiyong. "On Reverend Zhu Qi-zhan's Pictures." In *A Chronicle of Zhu Qizhan's Life*. Shanghai, 1985.

Fine Art Magazine (January 1992). Special issue, edited by Sheng Tian Zheng.

Fogel, Joshua A. "Japanese Literary Travellers in Prewar China." *Harvard Journal of Asiatic Studies* 49, no. 2 (December 1989): 575–602.

Fong Wen. *Images of the Mind: Selections from the Edward L. Elliott Family and John B. Elliott Collection of Chinese Calligraphy and Painting at the Art Museum, Princeton University*. Princeton, 1984.

Foreign Languages Press. *Rent Collection Courtyard: Sculptures of Oppression and Revolt*. Beijing, 1968.

————. *Wrath of the Serfs: A Group of Life-Size Clay Sculptures*. Beijing, 1976.

Fu, Shen C. Y., and Jan Stuart. *Challenging the Past: The Paintings of Chang Dai-chien*. Washington, 1991. Contains a useful bibliography on the master.

Fung Ping Shan Museum, University of Hong Kong. *Art '84*. Hong Kong, 1984.

Galikowski, Maria. *Art and Politics in China, 1949–1986*. Ph.D. diss., University of Leeds, 1990.

Gesellschaft für Verständigung und Freundschaft mit China. *Holzschnitt im Neuen China*. Berlin, 1976.

Goldman, Merle. *Literary Dissent in Communist China*. Cambridge, Mass., 1967.

―――. *China's Intellectuals: Advise and Dissent.* Cambridge, Mass., 1981.

―――, ed. *China's Intellectuals and the State: In Search of a New Relationship.* Cambridge, Mass., 1987.

Goodman, David. *Beijing Street Voices: The Poetry and Politics of China's Democracy Movement.* London, 1981.

Gunn, Edward. *Unwelcome Muse: Chinese Literature in Shanghai and Peking, 1937–45.* New York, 1980.

Hall, Robert, and Edwin Miller. *Contemporary Chinese Paintings.* Lo Shan Tang. London, 1988.

―――. *Contemporary Chinese Paintings II: An Exploration.* Lo Shan Tang. Hong Kong and London, 1989.

Han Suyin. "Painters in China Today." *Eastern Horizon* 6 (1977): 15–20.

Harbsmeier, Christoph. *The Cartoonist Feng Zikai: Social Realism with a Buddhist Face.* Oslo, 1984.

Harkness House. *Contemporary Oil Painting from the People's Republic of China.* New York, 1987.

Hay, Jonathan. "Ambivalent Icons: Works by Five Chinese Artists Based in the United States." *Orientations* 23, no. 7 (July 1992): 37–43.

Headland, Isaac Taylor. *Court Life in China: The Capital, Its Officials and People.* New York, 1909.

Hironobu, Kohara. "The Reform Movement in Chinese Painting of the Early 20th Century." In *Proceedings of the International Conference on Sinology,* ed. Academia Sinica, 449–64. Taipei, 1981.

Ho Yung. "Illustrations of Serial Picture Books." *Chinese Literature* (1964.12): 105–11.

Holm, David. *Art and Ideology in the Yenan Period, 1937–1945.* D.Phil. diss., Oxford University, 1979.

Hong Kong Arts Centre. *A Retrospective Exhibition of the Works of Ting Yen-yung.* Hong Kong, [1979?].

―――. *Shui Mo: The New Spirit of Chinese Tradition.* Hong Kong, 1985.

―――. *Laser and Lifescape Sculpture by Yuyu Yang.* Hong Kong, 1986.

Hong Kong Institute for the Promotion of Chinese Culture. *Szeto Keung.* Hong Kong, 1981.

―――. *Y. J. Cho.* Hong Kong, 1988.

Hong Kong Museum of Art. *The Art of Kao Chien-fu.* Hong Kong, 1978.

―――. *Contemporary Singapore Painting.* Hong Kong, 1980.

―――. *The Art of Gao Qifeng.* Hong Kong, 1981.

―――. *The Chinese Response: Paintings by Leading Overseas Artists.* Hong Kong, 1982.

―――. *The Art of Xu Beihong.* Hong Kong, 1988.

―――. *Ink Paintings by Hong Kong Artists.* Hong Kong, 1988.

―――. *Artists and Art: Contemporary Chinese Paintings.* Hong Kong, 1989.

Hou Hanru. "China: New Self-Awareness and International Dialogue—Modern Art of the 1980s in the People's Republic." *Art Monthly Australia* 40 (May 1991): 3–5.

Hsü, K'ai-yü. *Wen I-to.* Boston, 1980.

Hu Qiaomu. "On the Ideological Remoulding of Writers and Artists." *Chinese Literature* 1 (Spring 1953): 5 ff.

Hu Shi. *The Chinese Renaissance.* The Haskell Lectures. Chicago, 1933.

Hua Junwu. *Chinese Satire and Humour: Selected Cartoons of Hua Junwu, 1955–1982.* Trans. W. J. F. Jenner. Beijing, 1984.

―――, ed. *Contemporary Chinese Painting.* Beijing, 1983.

Huang Kuang-nan. *China-Paris: Seven Chinese Painters Who Studied in France, 1918–1960.* Text in English and Chinese. Taipei, 1988.

―――, ed. *China: Modernity and Art.* Taipei, 1991.

Huang Miaozi. "Landscapes by Newer Painters." *China Reconstructs* (May 1982): 52–55.

―――. "From Carpenter to Painter: Recalling Qi Baishi." *Orientations* 20 (April 1989): 85–87.

Huang Yuanlin. "Cartoonist Zhang Leping." *Chinese Literature* (Summer 1984): 101–6.

L'Institut Franco-chinois de l'Université de Lyon. *Annales Franco-chinois* 1 (March 1927).

Jacobsen, Robert D. *Mountain Thoughts: Landscape Paintings by Wucius Wong.* Minneapolis, 1987.

Jenner, W. J. F. "1979: A New Start for Literature in China?" *China Quarterly* 86 (June 1981): 274–303.

Jiang Weipu, ed. *Chinese Comics.* China Exhibition Agency, n.d.

Ju Ming. *The Living World.* Taipei, 1989.

Juin, Hubert. *Chu Teh-Chun.* Paris, 1979.

Kao, Mayching (Kao Mei-ch'ing). *China's Response to the West in Art, 1898–1937.* Ph.D. diss., Stanford University, 1972.

―――. "The Spread of Western Art in China, 1919–1929." In *China: Development and Challenge,* ed. Lee Ngoc and Leung Chi-keung, 73–114. Hong Kong, 1981.

―――. *Kwong Yeu Ting.* Hong Kong, 1982.

―――. "The Beginning of the Western-style Painting Movement in Relationship to Reforms of Education in Early Twentieth-Century China." *New Asia Academic Bulletin* 4 (1983): 373–400.

―――, ed. *Twentieth-Century Chinese Painting.* Hong Kong and Oxford, 1988.

Kehoe, Moura. "Realism from China: A Search for the Universal Image in 19th Century European and Russian Art." In *Realism from China.* New York, 1986.

King, Alice. *New Directions in Contemporary Chinese Tapestry.* Hong Kong, 1988.

―――, ed. *Chao Chung-hsiang.* Hong Kong, 1992.

Kinkley, Jeffrey C. *After Mao: Chinese Literature and Society, 1979–81.* Cambridge, Mass., 1985.

Kuo, Jason C. S. (Guo Jisheng). "Mutilated Language: Politics and the Art of Gu Wenda." Paper presented at N.E.H. Summer Seminar, University of Chicago, 1988; revised 1989.

―――. *Innovation with Tradition: The Painting of Huang Pinhung.* With contributions by Richard Edwards and Tao Ho. Hong Kong, 1989.

Lai, T. C. *Ch'i Pai Shih.* Seattle, 1973.

―――. *Three Contemporary Chinese Painters: Chang Dai-chien, Ting Yen-yung, Ch'eng Shih-fa.* Seattle, 1975.

Laing, Ellen. "Chinese Peasant Painting, 1958–76: Amateur and Professional." *Art International* 27, no. 1 (January–March 1984): 2–12.

―――. *An Index to Reproductions of Paintings by Twentieth-Century Chinese Artists.* Portland, 1984.

―――. *The Winking Owl: Art in the People's Republic of China.* Berkeley and Los Angeles, 1988.

Lang Shaojun. "An Evaluation of Innovation in Chinese Painting." Trans. Simon Johnstone. *Chinese Literature* (Summer 1986): 173–88. Abridged from article in *Wenyi yanjiu* 2 (1985).

Lau, Michael, ed. *Chinese Painting by Irene Chou.* Hong Kong, 1986.

Lee, Leo Ou-fan. *The Romantic Generation of Modern Chinese Writers.* Cambridge, Mass., 1973.

————, ed. *Lu Xun and His Legacy.* Berkeley and Los Angeles, 1985.

Leymarie, Jean. *Zao Wou-ki.* Research by Françoise Marquet. Paris, 1986.

Li, Chu-tsing. *Rocks, Trees, Clouds and Water: The Art of Hung Hsien.* Lawrence, Kansas, 1978.

————. *Trends in Modern Chinese Painting.* The C. A. Drenowatz Collection, vol. 3. Ascona, Switzerland, 1979.

————. "Traditional Painting Development during the Early Twentieth Century." In *Twentieth-Century Chinese Painting,* ed. Mayching Kao, 78–108. Hong Kong and Oxford, 1988.

Liao Jingwen. *Xu Beihong: Life of a Master Painter.* Trans. Zhang Peiji. Beijing, 1987.

Liao Jingwen and Xu Fangfang. "Life of Xu Beihong." *Oriental Art,* n.s., 28, no. 1 (Spring 1982).

Lim, Lucy, ed. *Contemporary Chinese Painting: An Exhibition from the People's Republic of China.* San Francisco, 1984.

————, ed. *Wu Guanzhong: A Contemporary Chinese Artist.* San Francisco, 1989.

Link, Perry, ed. *Stubborn Weeds: Popular and Controversial Chinese Literature after the Cultural Revolution.* Bloomington, 1983.

Liu Haisu. *Chinesische Malerei der Gegenwart.* Berlin, 1934.

Liu Huanzhang. *Sculpture by Liu Huanzhang.* Beijing, 1984.

Liu Xilin. "Artist Jiang Zhaohe's Wartime Epic 'Refugees.'" *Chinese Literature* (Winter 1984): 151–52.

Lu Xun. *Selected Works of Lu Xun.* Edited by Yang Hsien-yi (Xianyi) and Gladys Yang. Vol. 4. Beijing, 1960.

McDougall, Bonnie S. *Mao Zedong's "Talks at the Yan'an Conference on Literature and Art": A Translation of the 1943 Text with Commentary.* University of Michigan Papers on Chinese Studies, no. 39. Ann Arbor, 1980.

MacFarquhar, Roderick. *The Hundred Flowers Campaign and the Chinese Intellectuals.* New York, 1960.

————. *The Origins of the Cultural Revolution.* 2 vols. New York, 1987.

Mao Zedong. *On Literature and Art.* Beijing, 1967.

Meisner, Maurice. *Mao's China: A History of the People's Republic.* New York, 1977.

Mindich, Jeffrey. "More Tales of China's Late, Great Master Artist." *Free China Review* (April 1985): 38–40.

Minick, Scott, and Jiao Ping. *Chinese Graphic Design in the Twentieth Century.* London, 1990.

Ministry of Education. *A Special Collection of the Second National Exhibition of Chinese Art.* Vol. 2, *Modern Chinese Painting and Calligraphy.* Nanjing, 1937.

Moss, Hugh. *Some Recent Developments in Twentieth Century Chinese Painting: A Personal View.* Hong Kong, 1982.

Murray, Michael. "The Power of Images." Introduction to *Avant-Garde Chinese Art: Beijing/New York* (exhibition catalogue). New York, 1986.

Musée Cernuschi. *Exposition de peintures chinoises contemporaines.* Paris, 1946.

————. *Fan Tchun-pi: Artiste chinoise contemporaine.* Paris, 1984.

————. *Collection des peintures et calligraphies chinoises contemporaines.* Paris, 1985.

Nacenta, Raymond. *The Painters and Artistic Climate of Paris since 1910.* New York, 1981.

National Museum of History, Taipei. *Five Chinese Painters.* Taipei, 1970.

National Taiwan Arts Center. *Graphic Art by the Contemporary Chinese Artist Chen Ting-shih.* Taipei, 1967.

"New Peasant Painting." *Peking Review* 23 (September 1958): 18.

Ni Chiang-huai and others. *Early Twentieth-Century Watercolours of Ishikawa Kin'ichirō.* Taipei, 1986.

Pan Ling. *In Search of Old Shanghai.* Hong Kong, 1982.

Parsons, Bruce. *Gu Wenda: The Dangerous Chessboard Leaves the Ground.* Toronto, 1987.

Pierquin-Tien, Odile. *Peintres et sculpteurs chinois à Paris, 1947–1987.* Paris, 1987.

Pollard, David. "The Controversy over Modernism, 1979–84." *China Quarterly* 85 (December 1985): 641–56.

Pommeranz-Leidtke, Gerhard. *Chinesische Kunstschaffen: Gegenwart und Tradition.* Berlin, 1954.

Qian Songyan. "Creating New Paintings in the Traditional Style." *Chinese Literature* (1972.11): 111–14.

Riley, Richard. *Modern Chinese Prints from the Central Academy of Fine Art, Peking.* Exhibition of the Lancashire Polytechnic. Preston, England, 1986.

Rothenstein, William. *Men and Memories.* 2 vols. London, 1931.

Roy, Claude. *Zao Wou-ki.* Paris, 1988.

Roy, David. *Kuo Mo-jo: The Early Years.* Cambridge, Mass., 1971.

Ryckmans, Pierre. *Modern Chinese Painters in the Traditional Style.* Melbourne, 1974.

Schram, Stuart. *Ideology and Policy in China since the Third Plenum, 1978–84.* London, 1984.

Schwarz, Vera. *The Chinese Enlightenment.* Berkeley and Los Angeles, 1986.

Scott, A. C. *Literature and Art in Twentieth-Century China.* London, 1963.

Shanghai University Press. *All about Shanghai and Environs.* 1934/5. Reprint, London, 1983.

Shui Tianzhong. "Oil: From Realism to Symbolism." *China Daily* (December 22, 1987): 4–5.

Silbergeld, Jerome. *Mind Landscapes: The Paintings of C. C. Wang.* Seattle, 1987.

Silbergeld, Jerome, with Gong Jisui. *Contradictions: Artistic Life, the Socialist State, and the Chinese Painter Li Huasheng.* Seattle, 1993.

Solidarité Chine. *Tian Anmen 4 Juin–4 Décembre: Je n'oublie pas.* Paris, 1989.

Soong, James Han-hsi. *A Visual Experience in Nineteenth-Century China: Jen Po-nien (1840–1895) and the Shanghai School of Painting.* Ph.D. diss., Stanford University, 1977.

Spence, Jonathan D. *The Gate of Heavenly Peace: The Chinese and Their Revolution.* New York, 1981.

Strassberg, Richard E., ed. *"I Don't Want to Play Chess with Cézanne" and Other Works: Selections from the Chinese "New Wave" and "Avant-Garde" Art of the Eighties.* Pasadena, 1991.

Strassberg, Richard, and Waldemar A. Nielsen. *Beyond the Open Door: Contemporary Paintings from the People's Republic of China.* Pasadena, 1987.

Su Fu, Martha. "Chinese Painting in Taiwan." In *Twentieth-Century Chinese Painting,* ed. Mayching Kao, 196–209. Hong Kong and Oxford, 1988.

Sullivan, Michael. "The Traditional Trend in Contemporary Chinese Art." *Oriental Art* 1, no. 3 (Winter 1949): 3–8.

―――. *Chinese Art in the Twentieth Century.* Berkeley and Los Angeles, 1959.

―――. *Paintings: Chang Ta-ch'ien.* Stanford, 1967.

―――. *Trends in Twentieth-Century Chinese Painting.* Stanford, 1969.

―――. "Oriental Art and Twentieth-Century Chinese Painting in the West." *Studio International* (October 1973).

―――. *The Masterworks of Chang Dai-chien.* Foreword to portfolio of six lithographs. San Francisco, 1974.

―――. "Art in China Today: Social Ethics as an Aesthetic." *Art News* 73 (September 1974): 55–57.

―――. "Orthodoxy and Individualism in Twentieth-Century Chinese Art." In *Artists and Traditions,* ed. Christian F. Murck, 201–5. Princeton, 1976.

―――. "New Directions in Chinese Art." *Art International* 25, no. 1/2 (1982): 40–58.

―――. "Chinese Painting Today: Traditional in Style, Modern in Feeling." In *Contemporary Chinese Painting: An Exhibition from the People's Republic of China,* ed. Lucy Lim, 10–33. San Francisco, 1983.

―――. "Art and the Social Framework." *Times Literary Supplement* (June 24, 1983).

―――. "The Chinese Art of 'Water-Printing,' *Shui-yin.*" *Art International* 27, no. 4 (September-November 1984): 26–33.

―――. "A Fresh Look at XX Century Chinese Painting." *Journal of the Royal Society of Arts* (June 1985).

―――. "The Calligraphic Works of Yang Yanping." *Apollo* (May 1986): 346–49.

―――. "Recollections of Art and Artists in Wartime Chengdu." *Register of the Spencer Museum of Art* (Lawrence, Kansas) 6, no. 3 (1986): 7–19.

―――. "Chu Teh-chun." Introduction to *Chu Teh-chun* (exhibition catalogue). Taipei, 1987.

―――. *The Art of Yü Ch'eng-yao.* Introduction to exhibition catalogue. Hong Kong, 1987.

―――. "The Meihua Collection." Introduction to *Contemporary Chinese Oil Painting from the People's Republic of China* (exhibition catalogue). New York, 1987.

―――. "Art and Reality in Twentieth-Century Chinese Painting." In *Twentieth-Century Chinese Painting,* ed. Mayching Kao, 1–20. Hong Kong and Oxford, 1988.

―――. *The Meeting of Eastern and Western Art.* 2d ed. Berkeley and Los Angeles, 1989.

―――. "Bliss Was It in That Dawn to Be Alive!" Introduction to *The Stars: 10 Years,* ed. Chang Tsong-zung. Hong Kong, 1989.

―――. "A Small Token of Friendship." *Oriental Art,* n.s., 35, no. 2 (Summer 1989): 76–85.

―――. "Li Huasheng." Introduction to *Li Huasheng* (exhibition catalogue). Hong Kong, 1990.

―――. "The Art of Ju Ming." Introduction to *Ju Ming: Taiji Sculpture* (exhibition catalogue). London, 1991.

―――. "Realism and the Art of the Revolution." *Britain-China* 47 (Autumn 1991): 3–6.

―――. "Chinese Art in the Twentieth Century." In *Wu Guanzhong: A Twentieth-Century Chinese Painter,* ed. Anne Farrer. London, 1992.

Sun, Shirley Hsiao-ling. *Lu Hsün and the Chinese Woodcut Movement, 1929–1936.* Ph.D. diss., Stanford University, 1974.

―――. *Modern Chinese Woodcuts.* San Francisco, 1979.

Taipei Fine Arts Museum. *An Exhibition of Contemporary Chinese Sculpture in the Republic of China.* Taipei, 1985.

―――. *The Art of Li Shih-ch'iao.* Taipei, 1988.

―――. *A Retrospective Exhibition of Liu Ch'i-hsiang.* Taipei, 1988.

Takashima Shuji and J. Thomas Rimer with Gerald D. Bolas. *Paris in Japan: The Japanese Encounter with European Art.* Tokyo, 1987.

Tam, Lawrence C. S. *1970–1980: Hong Kong Art.* Hong Kong, 1981.

―――. "The Lingnan School of Painting." In *Twentieth-Century Chinese Painting,* ed. Mayching Kao, 109–29. Hong Kong and Oxford, 1988.

Tang Tsou. *The Cultural Revolution and Post-Mao Reforms.* Chicago, 1986.

Till, Barry. *The Art of Xu Beihong, 1985–1953.* Victoria, B.C., 1987.

Tsao Hsing-yüan. "The Birth of the Goddess of Democracy." *California Monthly* (September 1989): 16–17.

Tseng Yu-ho (Zeng Youhe). "Chinese Painting Overseas: A Personal Account of Chinese Painters outside Chinese Society." In *Twentieth-Century Chinese Painting,* ed. Mayching Kao, 224–43. Hong Kong and Oxford, 1988.

Tseng Yuho and Howard Link. *The Art of Tseng Yuho.* Honolulu, 1987.

Unterreider, Else. *Glück ein Ganzes Mondjahr Lang* (Happiness the whole year long). Klagenfurt, Austria, 1984.

Valkenier, Elizabeth. *Russian Art, the State and Society: The Peredvizhniki and their Tradition.* Ann Arbor, 1977.

van Gulik, Robert. *Chinese Pictorial Art as Viewed by the Connoisseur.* Rome, 1958.

Wan Qingli. "The Formation of Li Keran's Painting Style." *Han Mo* no. 25 (1992): 4–20. "Biography of Li Keran." *Han Mo* no. 26 (1992): 12–27. "Li Keran's Position in 20th Century Chinese Painting History" and "Li Keran's Thoughts on Art and Painting Theory." *Han Mo* no. 43 (1993).

Wang, Y. C. *Chinese Intellectuals and the West, 1872–1949.* Chapel Hill, N.C., 1966.

Warner, John. *Chinese Papercuts.* Hong Kong, 1978.

Watt, J. C. Y. *Wong Po Yeh.* Hong Kong, n.d.

Weidner, Marsha, ed. *Views from Jade Terrace: Chinese Women Artists, 1300–1912.* Indianapolis, 1988.

Wen Yuanning. "Art Chronicle." *T'ien Hsia Monthly* 3, no. 1 (May-August 1936): 161–67.

Wharton, Dolores. *Contemporary Artists of Malaysia.* Petaling Jaya, Malaysia, 1971.

Widor, Claude. *Documents sur le mouvement démocratique chinois 1978–80.* 2 vols. Paris and Hong Kong, 1984.

Wong, Wucius. "Chinese Painting in Hong Kong." In *Twentieth-Century Chinese Painting,* ed. Mayching Kao, 210–23. Hong Kong and Oxford, 1988.

Wong, Wucius, and others, eds. *Lui Shou-kwan 1919–1975.* Hong Kong, 1979.

Woo, Catherine Yi-yu Cho. *Chinese Aesthetics and Ch'i Pai-shih.* Hong Kong, 1986.

Wu, Lawrence. "Kang Youwei and the Westernisation of Modern Chinese Art." *Orientations* (March 1990): 46–53.

Wu, Nelson I. "The Ideogram in the Modern Chinese Dilemma." *Art News* 56, no. 6 (November 1957): 34–37.

Wu Hung. "Tiananmen Square: A Political History of Monuments." *Representations* 35 (Summer 1991): 84–117.

Wu Tung. *Painting in China since the Opium Wars.* Boston, 1980.

Yang Shu-hwang. *XU Bei-hong, LIU Hai-su, LIN Feng-mian: Les peintres les plus importants de l'école de Shanghai et l'influence de l'art français.* Doctoral thesis, University of Paris, 1985–86.

Yu, Diana. "The Printer Emulates the Painter: The Unique Chinese Water-and-Ink Woodblock Print." *Renditions* 6 (Spring 1976): 95–101.

Yu Feng. "In Memory: Chilean Painter Jose Venturelli." *China Reconstructs* (March 1989): 29–31.

Yuan Yunsheng, ed. *Annual of the Chinese United Overseas Artists Association.* New York, 1987.

Zao Wou-ki and Françoise Marquet. *Autoportrait.* Paris, 1988.

Zhang Anzhi. "The Painter Ch'ien Sung-yen," *Chinese Literature* (1964.9): 103–11.

Zhang Songren (Johnson Chang), ed. *China/Avant-Garde* (Zhongguo meishu yishuzhan). In English and Chinese. Beijing, 1989.

Zhou Enlai. "Report to the Congress of Literary and Art Workers" (July 1949). In *Selected Works of Zhou Enlai.* Vol. 1. Beijing, 1980.

Zhu Guangqian (Chu Kwang-tsien). "The Problem of 'Formal Beauty' in Recent Discussions in China." *Eastern Horizon* 3, no. 5 (May 1964): 12–16.

Zürcher, Bernard. *Wang Keping.* Paris, 1988.

Designer:	Steve Renick
Compositor:	Integrated Composition Systems
Text:	10.5/13 Bembo
Display:	Frutiger Light and Snell Roundhand Bold
Printer and Binder:	Sung In, through Bolton Associates